THE SPIRITUAL IN ART: ABSTRACT PAINTING 1890–1985

Sudden Fright
from Annie Besant
and Charles W. Leadbeater,
Thought-Forms (1905)

THE SPIRITUAL IN ART: ABSTRACT PAINTING 1890–1985

Organized by MAURICE TUCHMAN *with the assistance of*

JUDI FREEMAN

in collaboration with

CAREL BLOTKAMP

FLIP BOOL

JOHN E. BOWLT

CHARLOTTE DOUGLAS

CHARLES C. ELDREDGE

ROBERT GALBREATH

LINDA DALRYMPLE HENDERSON

ROSE-CAROL WASHTON LONG

SIXTEN RINGBOM

W. JACKSON RUSHING

HARRIETT WATTS

ROBERT P. WELSH

LOS ANGELES COUNTY MUSEUM OF ART

ABBEVILLE PRESS · PUBLISHERS · NEW YORK

Library of Congress Cataloging in Publication Data

The Spiritual in art.

Exhibition schedule: Los Angeles County Museum of Art (opening
Nov. 1986); Museum of Contemporary Art, Chicago; and Haags
Gemeentemuseum, the Hague.

Includes index.

1. Painting, Abstract–Exhibitions. 2. Painting, Modern–19th
century–Exhibitions. 3. Painting, Modern–20th century–
Exhibitions. I. Tuchman, Maurice. II. Freeman, Judi.
III. Blotkamp, Carel. IV. Los Angeles County Museum of Art. V.
Museum of Contemporary Art (Chicago, Ill.)
VI. Haags Gemeentemuseum.

ND192.A25S6 1986 759.06'52074 86-14093

ISBN 0-89659-669-9

ISBN 0-87587-130-5 (LACMA : pbk.)

EDITOR: EDWARD WEISBERGER
DESIGNER: LAURIE HAYCOCK,
HAYCOCK KIENBERGER, LOS ANGELES
PHOTOGRAPHER: STEVE OLIVER
COVER: LAURIE HAYCOCK

ABBEVILLE PRESS
SENIOR EDITOR: NANCY GRUBB
PRODUCTION MANAGER: DANA COLE
MANAGING EDITOR:
SHARON GALLAGHER

TYPESET IN BEMBO TYPEFACES BY CONTINENTAL
TYPOGRAPHICS, INC.
PRINTED BY DAI NIPPON PRINTING, JAPAN.

This exhibition has been made possible by grants from the Atlantic
Richfield Foundation and the National Endowment for the Arts
and by an indemnity from the Federal Council on the Arts and the
Humanities.

EXHIBITION ITINERARY
LOS ANGELES COUNTY MUSEUM OF ART
23 NOVEMBER 1986–8 MARCH 1987
MUSEUM OF CONTEMPORARY ART, CHICAGO
17 APRIL–19 JULY 1987
HAAGS GEMEENTEMUSEUM, THE HAGUE
1 SEPTEMBER–22 NOVEMBER 1987

COPUBLISHED BY
LOS ANGELES COUNTY MUSEUM OF ART
5905 WILSHIRE BOULEVARD
LOS ANGELES, CALIFORNIA 90036
AND
ABBEVILLE PRESS, INC.
505 PARK AVENUE
NEW YORK, NEW YORK 10022

TONY SMITH
Untitled, 1962/80
Oil and alkyd on canvas
96 x 156 in. (243.8 x 396.2 cm)
Xavier Fourcade, Inc., New
York; Paula Cooper Gallery,
New York;
Margo Leavin Gallery,
Los Angeles

CONTENTS

•

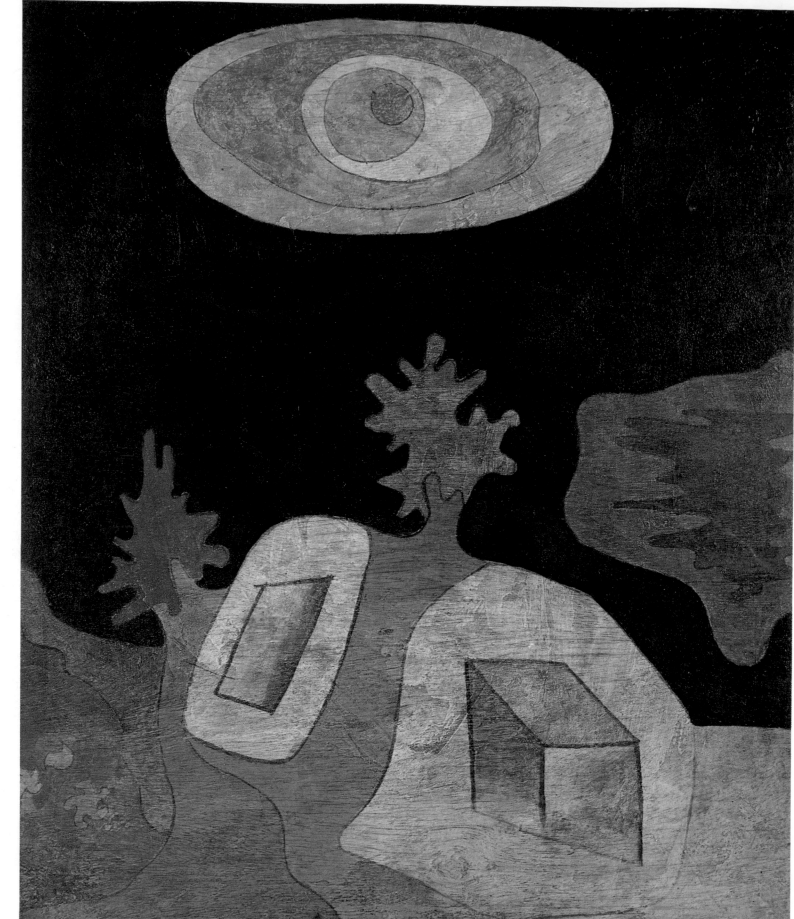

PAUL KLEE
Untitled, 1929
Oil over india ink on
plywood
17 ¼ x 15 in. (43.8 x 38.1 cm)
Los Angeles County
Museum of Art
Gift of the Robert Gore
Rifkind Collection and
purchased with funds from
the William Preston Harrison
Collection

FOREWORD

The great epoch of the Spiritual which is already beginning, or, in embryonic form, began already yesterday . . . provides and will provide the soil in which a kind of monumental work of art must come to fruition.

Wassily Kandinsky's words, written in 1910–11, prophesied the breadth and ambition of the artists whose careers are explored in this exhibition, *The Spiritual in Art: Abstract Painting 1890–1985*. Countless generations of artists have been intrigued by the mysteries offered by spiritual writings and belief systems. In the 1890s interest in the occult and mysticism fused with the genesis of abstract painting, then in its "embryonic form." Kandinsky in Germany, František Kupka first in Czechoslovakia and later in France, Kazimir Malevich and others of his circle in Russia, and Piet Mondrian in the Netherlands created a pure abstract vision that embodied their involvement with esoteric thought. Their legacy was spread by many of their contemporaries to subsequent generations of artists who found new means to unite abstraction with mystical concepts, thereby creating meaningful images, a fact that has largely been overlooked in much of the scholarship devoted to this period. This exhibition, in its international scope and conception, focuses on this issue.

As the inaugural exhibition in our new Robert O. Anderson Building, *The Spiritual in Art: Abstract Painting 1890–1985* signals the ongoing commitment of the Los Angeles County Museum of Art to presenting innovative and provocative exhibitions devoted to the art of this century. Contained in this exhibition are approximately 230 works of art produced over the past ninety-five years by more than one hundred artists throughout Europe and America, testifying both to the diversity of imagery and to the shared concerns of artists of the past century. We plan to present future exhibitions in this remarkable building that will further deepen our awareness of the century in which we live.

The Spiritual in Art: Abstract Painting 1890–1985 is an endeavor that began more than five years ago. The exhibition is the result of the efforts of Maurice Tuchman, senior curator of twentieth-century art, with the assistance of Judi Freeman, associate curator of twentieth-century art, in collaboration with a distinguished committee of international art historians and scholars from other humanistic disciplines. We are especially grateful to these scholars — Carel Blotkamp, Flip Bool, John E. Bowlt, Charlotte Douglas, Charles C. Eldredge, Robert Galbreath, Linda Dalrymple Henderson, Rose-Carol Washton Long,

Sixten Ringbom, W. Jackson Rushing, Harriett Watts, and Robert P. Welsh — for generously contributing their ideas. Their remarkable collective effort is reflected in the eighteen essays in this volume and the works selected for this exhibition.

It is particularly gratifying that the Museum of Contemporary Art, Chicago, our original partner in this endeavor, will present this exhibition. We are indebted to I. Michael Danoff, director, and John H. Neff, former director, for their unwavering support of this project. It is particularly appropriate that this international exhibition will be seen in Europe at the Haags Gemeentemuseum, The Hague, the Netherlands. The Gemeentemuseum has greatly enriched the loans, and we are indebted to Theo van Velzen, director, and Flip Bool, chief curator of modern art, for their assistance and dedication to this project.

We are pleased to have Abbeville Press as our copublisher. Abbeville's president, Robert E. Abrams, has shown great enthusiasm for this project from its inception.

Lenders to the exhibition, listed separately in this book, have agreed to part with cherished works from their collections for the presentations in Los Angeles, Chicago, and The Hague. The Los Angeles County Museum of Art extends its thanks to them for making this exhibition possible.

The Spiritual in Art: Abstract Painting 1890–1985 has received major funding from the Atlantic Richfield Foundation and the National Endowment for the Arts. The Drown Foundation has provided support for the interpretive components of the exhibition. This exhibition is supported by an indemnity from the Federal Council on the Arts and the Humanities. Without such support, an exhibition and publication of this magnitude would not have been possible.

EARL A. POWELL III
Director, Los Angeles County Museum of Art

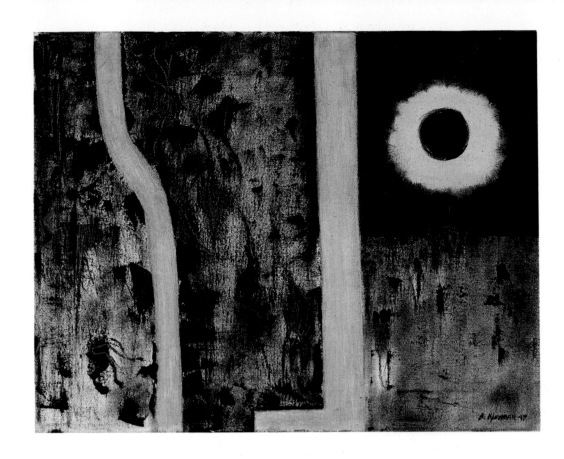

ACKNOWLEDGMENTS

The Spiritual in Art: Abstract Painting 1890–1985 is a project with a lengthy genesis. A body of research on the origins of abstract art and their connections with occult and mystical belief systems began forming in the mid-1960s and early 1970s. Pioneering studies by Sixten Ringbom and by Robert P. Welsh in particular addressed Wassily Kandinsky's and Piet Mondrian's involvement with Theosophy and set the stage for our project. Robert Rosenblum's 1975 *Modern Painting and the Northern Romantic Tradition: From Friedrich to Rothko* promoted a more receptive intellectual climate, and by the late 1970s numerous scholars had taken up the question of artists' interest in mysticism and the occult. (Many of the leading scholars in this area are the contributors to this book.)

In 1973 during conversations with critic Barbara Rose, the idea of a survey exhibition on the theme of mysticism in modern art was conceived. It was proposed to the Los Angeles County Museum of Art Board of Trustees in 1976. Gradually plans for the exhibition were refined to focus on abstraction. In 1980, when Earl A. Powell III assumed the directorship of the museum, the project was selected as the inaugural exhibition for the Robert O. Anderson Building. Simultaneously John Hallmark Neff, then director of the Museum of Contemporary Art, Chicago, and Konrad Oberhuber, curator of drawings, Fogg Art Museum, and professor of fine arts, Harvard University, were discussing an exhibition of the work of visionary artists who were influenced by the Anthroposophist Rudolf Steiner. Meetings with Neff led to the notion of collaboration between our institutions on the present exhibition.

A National Endowment for the Arts planning grant, submitted by the Museum of Contemporary Art, Chicago, provided research support for 1981–83. At conferences in New York, at the Metropolitan Museum of Art in April 1983, and in Chicago, at the Museum of Contemporary Art in November 1983, we had wide-ranging discussions of our theme with Oberhuber; Robert C. Hobbs, director, Museum of Art, University of Iowa; Gail Levin, then associate curator, Whitney Museum of American Art; and J. Kirk Varnedoe, Institute of Fine Arts, New York; and with Welsh and John E. Bowlt, University of Texas, Austin, among others. Welsh's ideas about the pertinence of Symbolism to the genesis of abstraction proved persuasive to

the evolving schema for the exhibition. His studies on Mondrian and Theosophy were well known, and his eagerness to extend those studies had a tonic effect, encouraging us to ask our scholar-participants for new initiatives in their individual areas of expertise. Bowlt, who had generously provided his vast knowledge of Russian art and culture when our museum was organizing its 1981 exhibition *The Avant-Garde in Russia, 1910–1930: New Perspectives,* offered to examine the subject of occultism in Russian society and art. Welsh and Bowlt ultimately contributed essays to this catalogue.

The NEA planning grant was reallocated in 1984 to the Los Angeles County Museum of Art. At a third conference, this time in Los Angeles in August 1984, Bowlt, Welsh, and Nicoletta Misler, Universitario Orientale, Naples, joined by an impressive group of scholars with diverse interests, reviewed the consistency of the argument we were building. Four among them — Charlotte Douglas, Dia Art Foundation, who, like Bowlt, had contributed to *The Avant-Garde in Russia*; Charles C. Eldredge, director, National Museum of American Art, who brought the New Mexican transcendentalists to our attention; Linda Dalrymple Henderson, University of Texas, Austin; and Rose-Carol Washton Long, Graduate Center of the City University of New York — are also authors of essays published herein. The fourth and final conference, addressing issues of contemporary art in particular and the content of the catalogue, was held in New York in May 1985 at the Metropolitan Museum of Art, again thanks to the Department of Twentieth-Century Art. Authors W. Jackson Rushing, University of Texas, Austin; Donald Kuspit, State University of New York, Stony Brook; Edward Kasinec, New York Public Library; Boris Kerdimun; and Harriett Watts, Boston University — all contributed fresh insights alongside several participants from earlier conferences.

The contributions made at these extensive conferences to the development of this exhibition and its catalogue were critically important. Apart from the conferences, Sixten Ringbom, who in 1966 convincingly demonstrated that abstract art emerged as an attempt to express ideas about the ineffable, made valuable suggestions on numerous aspects of the exhibition checklist and catalogue particularly during consultations in Sweden and Finland. Distinguished Dutch art historian Carel Blotkamp and scholar Geurt Imanse also made essential contributions.

Many of these scholars, identified on this volume's title page, compose the exhibition committee for *The Spiritual in Art.* For their constant availability and readiness to monitor countless details we are profoundly grateful. Many additional art historians as well as specialists in music, poetry, and philosophy offered their thoughtful advice on specialized matters during the project's lengthy planning period.

For information on the Symbolist period we acknowledge Marie-Amélie Anquetil, Marianne Barbey, Alf Boe, Caroline Boyle-Turner, Bram Dykstra, Eleanor Hill Edwards, William Innes Homer, Joop Joosten, Samuel Josefowitz, Christian Klemm, Steingrim Laursen, George Mauner, Dan Meinwald, Franz Meyer, Meda Mladek, Roald Nasgaard, Barbara Novak, Nicholas Olsberg, Melinda B. Parsons, Gert Schiff, and J. H. Trapp.

Information and good counsel on the period of early modernism through Abstract Expressionism were supplied by Herbert Bayer, Cor Blok, Marc Blondeau, Szymon Boyko, William Camfield, Barbara Cavaliere, Herschel Chipp, Rini Dippel, R. T. Doepel, Henri Dorra, Magdalena Droste, Betty Freeman, Tom Gibbons, Ann Gibson, Jurgen Glasemer, Alastair Grieve, Bruce Guenther, Christian Geelhart, Jelena Hahl, Juan Hamilton, Jane Hancock, Herbert Henkels, Robert L. Herbert, Robert Hughes, Pontus Hulten, Hilton Kramer, John R. Lane, Wies and Jan Leering, William S. Lieberman, Marianne Martin, Karin von Maur, Thomas M. Messer, Charles Miedzinski, Christine Poggi, Gerard Regnier, Brenda Richardson, Margit Rowell, Angelica Zander Rudenstine, Martica Sawin, Werner Schmalenbach, Pierre Schneider, Peter Selz, Margit Staber, Beat Stutzer, Germain Viatte, Mike Weaver, and Jorg Zutter.

Helpful leads and thoughtful opinions about contemporary artists were offered by Linda Cathcart, Jeffrey Deitch, Antije von Gravenitz, Jurgen Harten, Kaspar Koenig, Jean-Hubert Martin, Brian O'Doherty, Paul Schimmel, Nicholas Serota, and Anne Seymour.

For information about spiritual issues we benefited from conversations with Anne Atik, Joscelyn Godwin, Manly P. Hall, Hermann Kern, Franz Janssen, Mr. and Mrs. Joost Ritman, and Elmar Seibel. Advice on photography was proffered by Weston Naef and Samuel Wagstaff; on music by Lawrence Morton, curator emeritus of music, and Dorrance Stalvey, curator of music, at the museum.

I wish to express my warm gratitude to my colleagues John Elderfield of the Museum of Modern Art and Gert Schiff of the Institute of Fine Arts, New York University, for their special efforts on our behalf, speaking to the potential merit of this project in its development stage. Artist and art historian Avigdor Arikha warmly embraced and critically analyzed the project's thesis for several years.

Without the assistance of numerous galleries, auction houses, and dealers in Europe and America, we would have been unable to locate all the works needed to illuminate meaningfully the theme of the exhibition. I am grateful for their information and kind assistance. My thanks go to Paule Anglim, Richard Bellamy, Mary Boone, Dorothea Carus, Leo Castelli, Cyrille Cohen, James Corcoran, Raymond Creuze, Douglas Chrismas, Anthony d'Offay, Renato Danese, Kurt Del Banco, Marisa del Re, Martin Diamond, André Emmerich, Stuart Feld, Michael Findlay, Xavier Fourcade, Barry Friedman, John Gibson, Barbara Gladstone, Arnold Glimcher, Krystina Gmurzynska, Joni Gordon, Peter Goulds, Stephen Hahn, Arnold Herstand, Carroll and Sidney Janis, Miani Johnson, Annely Juda, Kasmin, Sami Kinge, Paul Kovestdy, Daniel Lelong, Gilbert Lloyd, Guy Loudmer, Mary-Anne Martin, Barbara Mathes, Jason McCoy, Annina Nosei, Carla Panicali, Gerald Peters, Lawrence Rubin, Helen Serger, Michael St. Clair, Jeffrey Solomons, Daniel Templon, Eugene V. Thaw, Joan Washburn, Daniel Weinberg, and Angela Westwater.

The Museum of Contemporary Art, Chicago, and the Gemeentemuseum, The Hague, as the two participating institutions in this exhibition, have demonstrated time and time again their faith in this ambitious endeavor. The support of their directors, I. Michael Danoff and Theo van Velzen, was unflagging. Flip Bool, chief curator at the Gemeentemuseum, played a vital role in expanding the checklist, particularly in the area of European contemporary art.

It is a fact of modern museum life that the organizers of thematic exhibitions face more difficulty in procuring loans than do the organizers of monographic exhibitions. For this reason we are doubly grateful to our lenders who through their generosity provide essential support to an exhibition that raises historiographic questions on modern art as it celebrates its achievements. Three museums in particular have granted major loans: the Gemeentemuseum, The Hague; the Städtische Galerie im Lenbachhaus, Munich; and the Musée National d'Art Moderne, Centre Georges Pompidou, Paris. In addition more than one hundred lenders around the world, from Sweden to California, have entrusted us with their important works of art. We hope that they share in our pleasure in presenting this exhibition in Los Angeles, Chicago, and The Hague.

An exhibition of this magnitude could not have been realized without the enthusiastic support of the staff of the entire museum and its Board of Trustees. Earl A. Powell III took a close and exceptional interest in this project throughout its lengthy development.

In the Department of Twentieth-Century Art, Judi Freeman, associate curator, who came to the museum in April 1985, swiftly assimilated the results of the project's planning and made splendid contributions to every aspect of the exhibition and catalogue. Richard Morris, my secretary, was called on for his diplomatic abilities along with secretarial skills and performed these with unflappable professional polish and endurance. Stephanie Barron, curator, listened sympathetically to the long-evolving thesis with her customary acuity and also supervised the department when I was away from the museum. Lynn Brylski and Lisa Kahn, department secretaries, also assisted with the voluminous typing involved in this project. Over the years of its development, many former members of the department's staff contributed to the project as well. Anne Carnegie Edgerton, associate curator from 1981 to 1985, and Maria de Herrera, research assistant, from 1984 to 1985, worked on the project in its formative stage, carried out a wide range of duties, and participated in our conferences with visiting scholars. Stella Paul, assistant curator, was involved as well for a shorter period and continued to support the project as area collector of the Archives of American Art. Also assisting were: Cathy Bloome, Lissa Burger, and Donna Wong, department secretaries; Adrian Biddell, Robyn Field, Christin Mamiya, John McClain, Josie Breger, and Jennifer Anger, interns; Grace Spencer, our veteran department archivist; Grete Wolf and Anita Stahl, volunteers. Outside the department Marlene Alter, Miriam Fenton, and Tom Jacobson also provided secretarial assistance.

Myrna Smoot, former assistant director for Museum Programs, developed the budget and schedule for the entire project, coordinating contractual and administrative matters. She was assisted by John Passi, exhibitions coordinator, Cecily MacInnes, supervising secretary, and Doria Leong, secretary. The museum's Development Office and its director Julie Johnston, former director Dia Dorsey, associate director Terry Monteleone, and grants coordinator Mark Stambler were extraordinarily resourceful in soliciting funding. Renee Montgomery, registrar, and Anita Feldman and Susan Melton, assistant registrars, were responsible for coordinating incoming loans and arranging the continuation of this exhibition in Chicago and The Hague. Pieter Meyers, head of Conservation, and members of his staff — Victoria Blyth-Hill and Joe Fronek — carried out with great care the conservation work required on the paintings, drawings, and books amassed for the exhibition. Press Officer Pamela Jenkinson Leavitt and her staff ably initiated and coordinated the publicity. Under the supervision of Dr. James Peoples, assistant director for Operations, James Kenion, project manager, and Dale Coffman, head of Construction and Maintenance, worked with us on the installation of this complex, challenging show. William Lillys, head of Education, and Christine Dyer, assistant museum educator, devised and implemented educational events, and M.E. Warlick wrote the exhibition brochure.

The museum's Research Library was an invaluable resource. Aside from numerous acquisitions that transformed our collection into a major holding for the study of the spiritual in twentieth-century art, nearly one thousand books were borrowed from more than fifty libraries as far afield as Winterthur, Switzerland. Thanks are due Eleanor Hartman, head librarian, and staff members Anne Diederick, Larry Margolies, and Grant Rusk.

This book was the result of more than two years of writing, editing, design, and production. Materials as they arrived at the museum were reviewed and discussed by an editorial committee on which I was joined by Judi Freeman, editor Edward Weisberger, and Mitch Tuchman, managing editor. Weisberger devoted more than a year to work on this project. For this feat, accomplished with good cheer, he is to be especially commended. In the book's final stages, Nancy Grubb, of Abbeville Press, read the manuscript with the keen eye that every author and editor appreciates. Steve Oliver, of the museum's Photographic Services Department, ably photographed and duplicated hundreds of works for the catalogue. Finally, Laurie Haycock, of Haycock Kienberger, brought her unique aesthetic sense to the task of designing this publication; its elegance testifies to her exceptional talent. She joined with museum designer Bernard Kester to design and assist in the installation of the exhibition. Malcolm Holzman of Hardy, Holzman, Pfeiffer Associates generously provided advice and ideas on the installation.

The major support group of the Department of Twentieth- Century Art, the Modern and Contemporary Art Council, under the leadership of Michael Smooke since 1982, was a special source of sustenance throughout the project, as it has been for more than two decades in all of our departmental activities.

I am grateful to my wife, Sari Shapiro, for her encouragement and support throughout this lengthy project. Her lively interest and that of my colleagues in *The Spiritual in Art: Abstract Painting 1890–1985*, its immense complexities of organization, and the strength and intricacy of its theme provided that extra measure of belief that sustains one in the pursuit of a goal that threatens to be forever unmastered and truly never ending.

MAURICE TUCHMAN

OVERLEAF

JASPER JOHNS
Book, 1957
Encaustic and book on wood
9 ¾ x 13 in. (24.8 x 33 cm)
Martin Z. Margulies

15

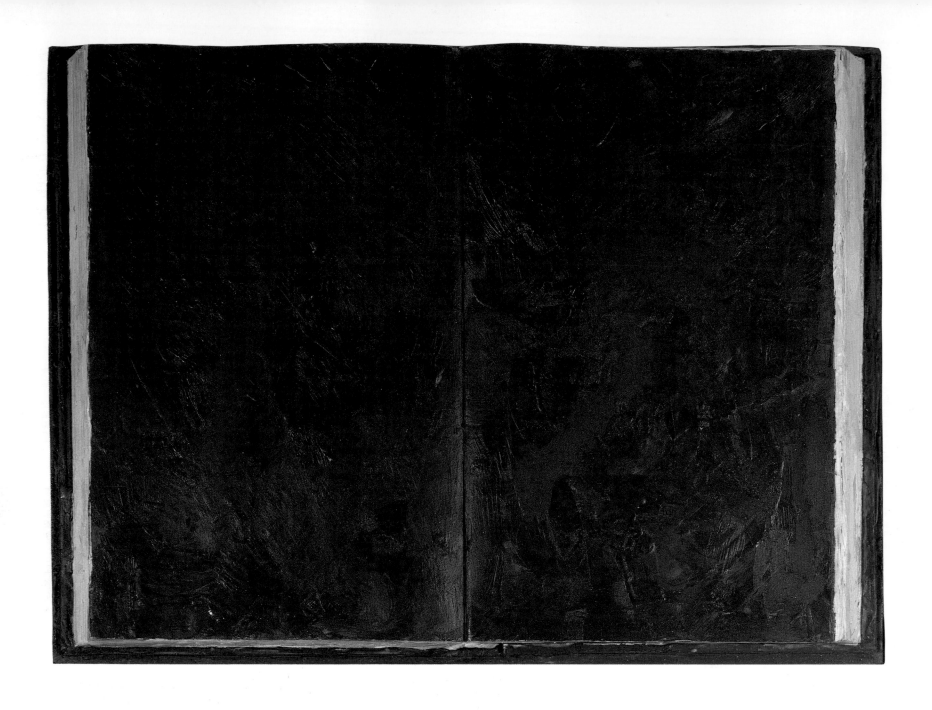

HIDDEN MEANINGS IN ABSTRACT ART

MAURICE TUCHMAN

Abstract art remains misunderstood by the majority of the viewing public. Most people, in fact, consider it meaningless. Yet around 1910, when groups of artists moved away from representational art toward abstraction, preferring symbolic color to natural color, signs to perceived reality, ideas to direct observation, there was never an outright dismissal of meaning. Instead, artists made an effort to draw upon deeper and more varied levels of meaning, the most pervasive of which was that of the spiritual. *The Spiritual in Art: Abstract Painting 1890–1985* demonstrates that the genesis and development of abstract art were inextricably tied to spiritual ideas current in Europe in the late nineteenth and early twentieth centuries. An astonishingly high proportion of visual artists working in the past one hundred years have been involved with these ideas and belief systems, and their art reflects a desire to express spiritual, utopian, or metaphysical ideals that cannot be expressed in traditional pictorial terms.

Our idea is not new. Modern art histories, beginning with Arthur Jerome Eddy's writings in 1914 and continuing in Sheldon Cheney's in the 1920s and 1930s, accurately reflected abstract artists' interest in expressing the spiritual. Eddy, writing at a time when purely abstract canvases were still virtually wet paint, identified as a contemporary artis-tic goal "the attainment of a higher stage in *pure art;* in this the remains of the practical desire are *totally separated* (abstracted). Pure art speaks from soul to soul, it is not dependent upon one use of objective and imitative forms."[1] He concluded pithily: "It is only when new and strange forms are used *because* they are necessary to express a spiritual content that the result is a *living* work of art. *The world reverberates; it is a cosmos of spiritually working human beings. The matter is living spirit.*"[2]

In 1924 Cheney reviewed connections between abstract art and music. He recognized that much of the beautiful was produced "by the inner need, which springs from the soul" and wondered if "perhaps we shall find that such things speak to us as we grow more spiritual"; "the ideal of abstraction somehow seems to underlie the whole modern art movement."[3] By 1934 Cheney was further attracted to mystical ideas, as evidenced by his book *Expressionism in Art.*[4] In 1945 Cheney, now deeply and personally involved with mysticism, wrote a popular history of mystical thought, but in it his disdain for "modern painters who try to isolate a geometrical

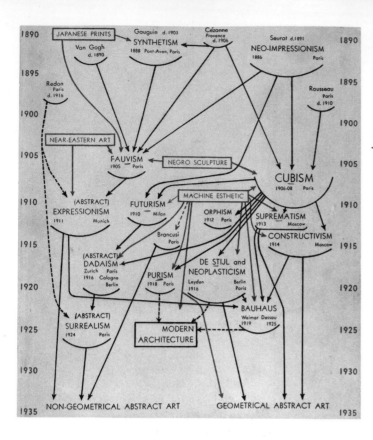

1

Jacket illustration from
Alfred H. Barr, Jr.,
Cubism and Abstract Art
(1936)

.

order in 'abstract' pictures, or those who
speak of revealing 'form' without serious
regard to subject'' reflected the new opposi-
tion in American society to the spiritual-
abstract connection.[5]

Increasingly in the 1930s and into the 1940s,
mystical and occult beliefs came under suspi-
cion because of their political associations,
which were clear and well known. The Nazi
theory of Aryan supremacy, for example, was
indebted to various versions of Theosophy,
such as theozoology, which pertains to birth
by electric shock into the astral ether, and
ariosophy, which fuses ideas of karma, the
ether, and sun worship with idolatry of Aryan
ancestry.[6] Adolf Hitler's confidant Otto
Wagener explained to Hitler the nineteenth-
century occult writer Karl von Reichenbach's
theory of Odic force, according to which
"every human being has an unknown source
of power that produces rays. These not only
inhabit the body but also radiate from it, so
that a person is surrounded by something like
a field laden with this Odic force." Hitler
immediately applied these ideas to the poten-
tial revivification of society by "the invisible
strength, which is transferred from them
[storm-trooper divisions] to us like an aura."[7]
No doubt the perception of a link between
alternative belief systems and fascism made
critics and historians in these decades reluc-
tant to confront the spiritual associations of
abstract art.[8]

To use the word *spiritual* in the late 1930s and
1940s, as Richard Pousette-Dart recently
acknowledged, was near-heresy and dan-
gerous to an artist's career.[9] Intellectuals inter-
ested in modernist issues became more
concerned with purely aesthetic issues. Alfred
Barr, director of the Museum of Modern Art,
was the outstanding example of an art his-
torian turned aesthetician. In *Cubism and
Abstract Art* (1936) he graphically charted
artistic movements from 1890 to 1935 (pl. 1).
Although intertwined and somewhat com-
plex, his chart showed each artistic movement
as the logical outgrowth of the aesthetic con-
cerns of preceding movements.[10] Barr's
views, which shaped the collection of the
Museum of Modern Art and in turn helped
New York become the focus of artistic activ-
ity in the United States during the second half
of this century, encouraged the wave of for-
malist criticism dominating studies of mod-
ern art in the United States and influencing
the popular view of modern art.

Clement Greenberg, whose career as a critic
began in the late 1930s, embellished Barr's
formalist lineage, identifying key movements
in the history of modern art and dismissing
others that were less central to his vision of the
appropriate direction for contemporary art.[11]
Greenberg lauded the formal achievements of
Henri Matisse, Pablo Picasso, Wassily Kan-
dinsky, and Piet Mondrian and the contin-
uation of these efforts by the Abstract Expres-
sionists; any lingering, legible content in
abstract art was dismissed. Later Harold
Rosenberg observed that the turning point for
Abstract Expressionism occurred when its
artists abandoned "trying to paint Art (Cub-
ism, Post-Impressionism)" and "decided to
paint . . . just to PAINT. The gesture on the
canvas was a gesture of liberations, from
Value — political, aesthetic, moral."[12] Rosen-
berg declared: "At a certain moment the can-
vas began to appear to one American painter
after another as an arena in which to act —
rather than as a space in which to reproduce,
re-design, analyze, or 'express' an object,
actual or imagined. What was to go on the
canvas was not a picture but an event."[13] By
the 1960s Greenberg's and Rosenberg's pro-
nouncements were clearly established as hav-
ing played an integral role in the development
of abstract painting in the 1950s.

All of this is not intended to imply that
abstract art's richer meaning was completely
overlooked for thirty years. There were
voices, Meyer Schapiro's foremost among
them, that objected to narrow art-historical
studies and criticism. Schapiro recognized the
restrictive formalism in Barr's analysis of
modern art, labeling it "essentially unhistor-
ical." He advocated a more thoughtful,
conceptual interpretation of art, especially
abstract art.[14] Schapiro's call for an alternative
interpretation of modern art was somewhat
neglected by contemporary critics, but
increasingly it attracted influential admirers.
In the late 1960s and early 1970s serious art-
historical research on the genesis of abstract
art and its connection to occult and mystical
belief systems began appearing. Pioneering
scholarly studies by Sixten Ringbom on Kan-
dinsky and the "epoch of the spiritual" and by
Robert P. Welsh on Mondrian and Theosophy
paved the way for newer scholars in the
field.[15] Robert Rosenblum's *Modern Painting
and the Northern Romantic Tradition: Friedrich to
Rothko* (1975) clearly identified the limitations
of Barr's lineage by establishing associations
between cultures and works of art that had not
been identified and analyzed.[16] Rosenblum's
book, along with Otto Stelzer's *Die Vorge-
schichte der abstrakten Kunst* (1964), helped

develop a more receptive intellectual climate in the late 1970s and encouraged numerous scholars to examine artists' interest in mysticism and the occult.[17]

Museums took up the subject, too, in exhibitions such as *Art of the Invisible* at the Bede Gallery, Jarrow, England, 1977; *Kunstenaren der Idee: Symbolistische tendenzen in Nederland ca. 1880–1930* at the Haags Gemeentemuseum, 1978; *Abstraction: Towards a New Art* at the Tate Gallery, 1980; *Origini dell'astrattismo 1885/1919* at the Palazzo Reale, Milan, 1980; and *Kosmische Bilder in der Kunst des 20. Jahrhunderts* at the Staatliche Kunsthalle, Baden-Baden, 1983. Although the 1984 Toronto exhibition *The Mystic North: Symbolist Landscape Painting in Northern Europe and North America 1890–1940* was primarily concerned with nature-based painting, it identified sources for this painting in Theosophy and various mystical and transcendental beliefs.[18] The Tate Gallery's volume of essays that accompanied the 1980 exhibition *Abstraction: Towards a New Art* was described by its editor as considering "the theme of mystical and anti-materialist ideas," but, conspicuously, it does not include a focused, separate essay devoted to the subject.[19]

Visual artists, from the generation born in the 1860s to contemporary times, have turned to a variety of antimaterialist philosophies, with concepts of mysticism or occultism at their core. Terms such as *occultism* or *mysticism* should be defined carefully because of the association with the ineffable that surrounds these words and because they are context-specific: art historians and artists use these terms differently than do theologians or sociologists. In the present context mysticism refers to the search for the state of oneness with ultimate reality. Occultism depends upon secret, concealed phenomena that are accessible only to those who have been appropriately initiated. The occult is mysterious and is not readily available to ordinary understanding or scientific reason.

Several ideas are common to most mystical and occult world views: the universe is a single, living substance; mind and matter also are one; all things evolve in dialectical opposition, thus the universe comprises paired opposites (male-female, light-dark, vertical-horizontal, positive-negative); everything corresponds in a universal analogy, with things above as they are below; imagination is real; and self-realization can come by illumination, accident, or an induced state: the epiphany is suggested by

heat, fire, or light.[20] The ideas that underlie mystical-occult beliefs were transmitted through books, pamphlets, and diagrams, often augmented by illustrations that, because of the ineffable nature of the ideas discussed, were abstract or emphasized the use of symbols.

Interest in the mystical and the occult naturally led to the formation of groups that were either religious or parareligious in nature. These groups had many superficial differences in practice, but all shared certain fundamental beliefs. These included a concern for the quality of inner life, an interest in spiritual development and wholeness, and a mistrust of material values and appearances. The means of attaining spiritual wholeness varied — some sought it through meditation and inspiration, others through reading and studying ancient history and religion — but all involved progressing by stages toward higher states of consciousness. Most mystical or occult groups sought enlightenment not only through the Bible and other holy books of conventional Western religions but also through the study of history that lay outside Judaism and Christianity: the holy or inspired writings of mystics, previously heretical sects, and elements that had once been part of Judeo-Christian practice but discarded in more recent times.[21] Eastern philosophy and religion were also brought into the sphere of study and speculation.

There is a major difference between belief in mystical-occult ideas and belief in institutionalized religion. The mystical-occult believer has direct access to the "source." There is no need for intermediaries or authorities, as in organized religious institutions. Thus reflection becomes a commonly sought, private activity. Increasingly in the nineteenth century the industrial revolution and consequent changes in the economic system, coupled with Charles Darwin's findings, not only undermined people's faith in conventional religion but also led to the perception of life as barren and devoid of meaning. There was a surge of interest in Theosophy and other related philosophical and metaphysical systems because they represented attempts to make sense of all aspects of an individual's life, projected an appealing vision of an afterlife — a notion that was no longer part of post-Darwinian rational belief — and stood outside established religious institutions.

James Webb noted, "The doctrine of 'spiritual progress' was resurrected by the prophets of the nineteenth-century occult revival. Theosophists, magicians, and mystics of all sorts eagerly affirmed that in following their

various systems they were emulating the saints of all religions and cultures in approaching Divinity." He quoted the influential writer on occultism Baron Karl du Prel: "It is to psychical indications in man that we have to look for the field of future evolution. Darwinism has thus dealt with but one half of the task prescribed by the doctrine of evolution; to solve the other the abnormal functions of the human psyche must be drawn into consideration." Webb concluded, "Various concepts of supernatural evolution . . . circulated at the same time as more materialist applications of Darwin's theory."[22] The promise of reincarnation flourished, too, as an antidote to the growing failure of positivist and materialist philosophies to explain existence.

Mystical and occult thinking, of course, antedates its wider reception among large numbers of people in the nineteenth century. A lineage of thinkers attempting to define an occult cosmogony can be established from antiquity, beginning with Plotinus and Hermes Trismegistus, to Paracelsus, Robert Fludd, Jakob Böhme, and Emanuel Swedenborg, and through Johann Wolfgang von Goethe, Honoré de Balzac, Victor Hugo, and Charles Baudelaire in the first half of the nineteenth century. The seventeenth-century German mystic Böhme sought to identify the forces and conflicts that lie beneath all human existence: "The eternal center and the Birth of Life . . . are everywhere. Trace a circle no larger than a dot, the whole birth of Eternal Nature is therein contained."[23] Efforts to find the underlying life-form (the Ur-form, the thyrsus, the double ellipse) were made over a long period of time. The Ur-form (see p. 31) is used here to describe the biomorphic shape that suggests the original and the primal and is the visual equivalent of "an inarticulate sound, uttered instead of a word that the speaker is unable to remember or bring out" (*Oxford English Dictionary*). In Baudelaire's writings the spiral is transformed into the thyrsus: "Around this staff, in capricious meanderings, stems and flowers play and frolic, some sinuous and transient, some bent like bells or over-turned goblets. . . . Would one not say that the curved and spiral line court the straight line, dancing around it in mute adoration? . . . The staff is your will, straight, firm, and immovable; the flowers are the voyaging of your fancy around your will."[24]

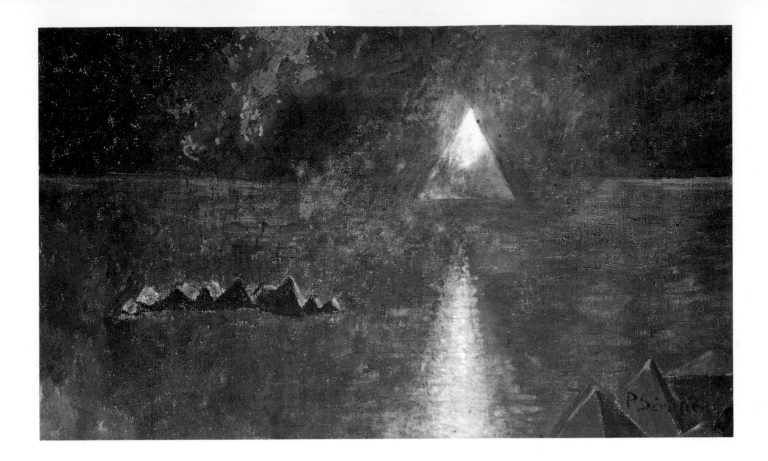

A fascination with synesthesia, the overlap between the senses — "sounds ring musically, colors speak"[25] — absorbed the energies of numerous writers and thinkers throughout the ages (see p. 27). By extension, the energy flow and vibrations pervading the physical world concerned many theorists (see p. 26). Baudelaire, for example, used vibrational imagery as an integral part of his vocabulary and interpreted the world as constantly in motion: "the more vigilant senses perceive more reverberating sensations" in which "all sublime thought is accompanied by a nervous shaking."[26] Many thinkers speculated on underlying laws that would explain the parallels and dualities in the cosmos (see pp. 22–25 and 28–29). Balzac provided a noteworthy example: "In going thoroughly into all human matters you will find in them the frightful antagonism of two forces that produce life."[27] He declared, "Movement, by reason of resistance, produces a combination that is life."[28]

The recurrence of sacred geometry as a means of describing nature and identifying life-forms also interested many writers, who published intricate diagrams and charts in lavish philosophical treatises (see pp. 30–31).

Friedrich von Schlegel wrote, "A philosophical work must have a definite geometrical form."[29] The 1794 publication of Charles F. Dupuis's *Origine de tous les cultes ou religion universelle*, replete with cabalistic and other occult texts, underscored this interest.

Three paintings from a remarkable series of geometric paintings made about 1910 by Paul Sérusier convey essential implications of the geometric-occult nexus. Caroline Boyle-Turner has recently shown that Sérusier hoped to restore forgotten rules based on geometry to a religious art that would be accessible to a wide audience. Sérusier derived most of his ideas from Desiderius Lenz, the German monk and theorist, with whom he stayed at the monastery of Beuron, and from Pythagoras and Plato; Plato's *Timaeus* provided the artist with an explanation of the pyramid as the origin of all other forms and provoked *The Origins,* circa 1910 (pl. 2). Boyle-Turner believes that Sérusier planned and may have executed a large series of geometric shapes, intending "to illustrate the basic geometric shapes available to any artist, which should form the base of all of the forms on the canvas . . . [and that] an artist should begin a painting with compass and ruler." At the heart of Sérusier's insistence on basic geometric shapes was the idea that art must depict

the fixed and unchangeable. These shapes, described in the theosophical terms he learned from Édouard Schuré's *Les Grands Initiés: Esquisse de l'histoire secrète des religions,* were the "building blocks to all other forms, particularly the human figure. By using these simple 'correct' shapes in correct proportional relationships, the painter could achieve what Sérusier called 'equilibrium.' This equilibrium would be felt by anyone contemplating the work, since the shapes, angles and proportions were universally understood by sensitive people, no matter what culture or time period."[30]

In 1980 Nigel Pennick summarized the perennial attraction to geometric form:

Sacred geometry is inextricably linked with various mystical tenets. . . . Thus, sacred geometry treats not only of the proportions of the geometrical figures obtained in the classical manner by straightedge and compass, but of the harmonic relations of the parts of the human being with one another; the structure of plants and animals; the forms of crystals and natural objects, all of which are manifestations of the universal continuum. . . . Since the earliest times, geometry has been inseparable from magic. Even the most archaic rock-scribings are geometrical in form. These hint at a

notational and invocational system practised by some ancient priesthood. Because the complexities and abstract truths expressed by geometrical form could only be explained as reflections of the innermost truths of the world's being, they were held to be sacred mysteries of the highest order and were shielded from the eyes of the profane. Specialist knowledge was required to draw such figures, and their mystic importance was unheeded by the untutored masses. Complex concepts could be transmitted from one initiate to another by means of individual geometrical symbols or combination of them without the ignorant even realizing that any communication had taken place. Like the modern system of secret symbols employed by gypsies, at best they would be puzzling enigmas to the curious.[31]

Spiritually inclined artists sought out others who shared their interests and studied diagrams and texts in original spiritual source material. William James contrasted "emotions of recognition" with "emotions of surprise" to explain the attraction of artists for kindred spirits of another era or medium.[32] In the present context, emotions of recognition allude to kinships that artists discovered as they formulated their own pictorial vocabulary. For example, Arthur Dove's *Distraction*, 1929 (pl. 3), may be understood to be an abstraction of William Blake's *The Body of Abel Found by Adam and Eve*, circa 1826; Dove almost certainly examined a reproduction of the earlier work (pl. 4). Such kinships leap across historical, stylistic, and national divisions. Witness, for example, Jackson Pollock's interest in Albert Pinkham Ryder or Alfred Jensen's obsession with Goethe's color boundaries. Marsden Hartley wrote vividly about just such an experience in 1944:

This picture was a marine by Albert P. Ryder . . . and when I learned he was from New England the same feeling came over me in the given degree as came out of the Emerson's Essays when they were first given to me — I felt as if I had read a page of the Bible. All my essential Yankee qualities were brought forth out of this picture . . . it had in it the stupendous solemnity of a Blake mystical picture and it had a sense of realism besides that bore such a force of nature itself as to leave me breathless. The picture had done its work and I was a convert to the field of imagination into which I was born.[33]

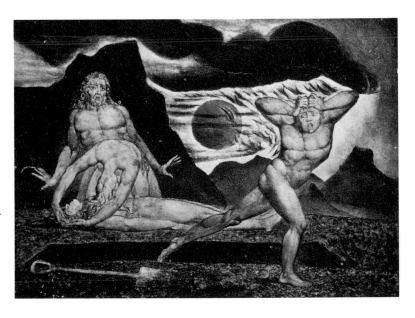

3
ARTHUR DOVE
Distraction, 1929
Oil on canvas
21 x 30 in. (53.3 x 76.2 cm)
Whitney Museum of
American Art, New York
Anonymous gift

·

4
WILLIAM BLAKE
*The Body of Abel Found by
Adam and Eve*, c. 1826
Tempera on panel
12 ¾ x 17 in. (32.4 x 43.2 cm)
Tate Gallery, London

·

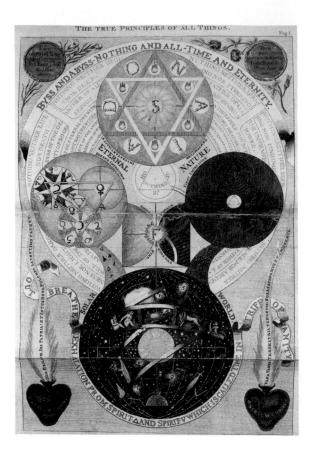

The True Principles of All Things, from Jakob Böhme, The Works of Jakob Böhme, vol. 2 (London: M. Richardson, 1764), Philosophical Research Library, Manly P. Hall Collection, Los Angeles

·

Figura Divina Theosoph. Cabalist. nec non Magica Philosoph. & Chymica, from Geheime Figuren der Rosenkreuzer aus dem 16tem und 17tem Jahrhunderts (Altona, 1785–88), Philosophical Research Library, Manly P. Hall Collection, Los Angeles

·

COSMIC IMAGERY

The First Table, from Jakob Böhme, The Works of Jakob Böhme, vol. 2 (London: M. Richardson, 1764), Philosophical Research Library, Manly P. Hall Collection, Los Angeles

·

From Henry Cornelius Agrippa, Three Books of Occult Philosophy (London: Gregory Moule, 1651), p. 214, Henry E. Huntington Library and Art Gallery, San Marino, California

·

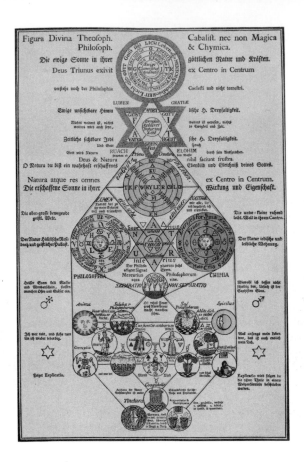

Pages 22–31 show the five underlying impulses identifiable in occult illustrations: cosmic imagery, vibration, synesthesia, duality, sacred geometry.

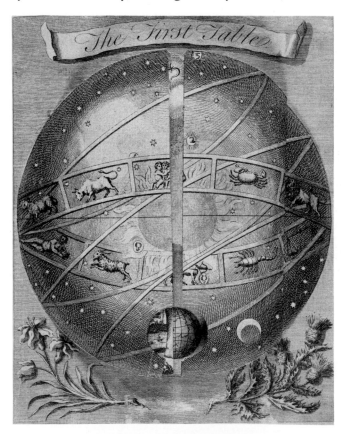

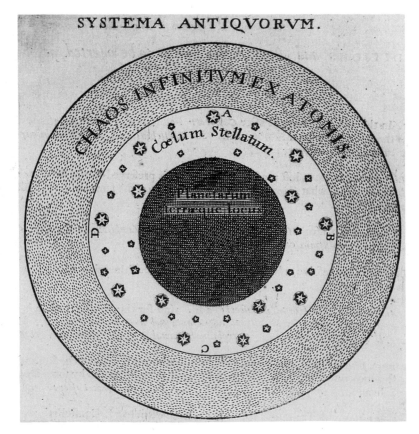

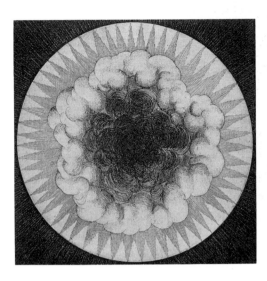
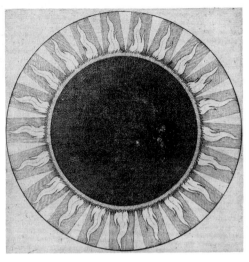
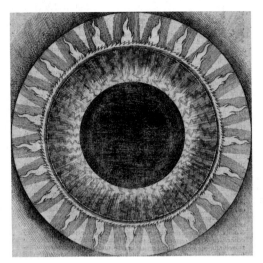

From Robert Fludd, *Utriusque cosmi* (Oppenheim, 1617), p. 37, Philosophical Research Library, Manly P. Hall Collection, Los Angeles

·

From Robert Fludd, *Utriusque cosmi* (Oppenheim, 1617), p. 55, Philosophical Research Library, Manly P. Hall Collection, Los Angeles

·

From Robert Fludd, *Utriusque cosmi* (Oppenheim, 1617), p. 58, Philosophical Research Library, Manly P. Hall Collection, Los Angeles

·

Cosmic imagery is suggestive of the mystical concept that the universe is a single, living substance.

COSMIC IMAGERY

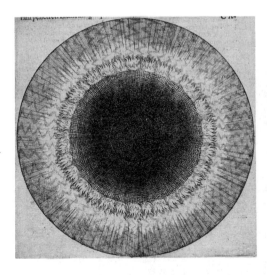
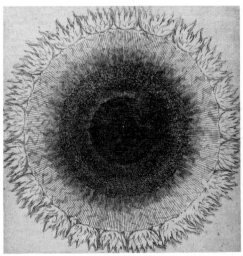
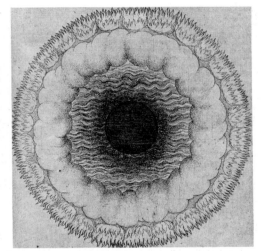

From Robert Fludd, *Utriusque cosmi* (Oppenheim, 1617), p. 63, Philosophical Research Library, Manly P. Hall Collection, Los Angeles

·

From Robert Fludd, *Utriusque cosmi* (Oppenheim, 1617), p. 66, Philosophical Research Library, Manly P. Hall Collection, Los Angeles

·

From Robert Fludd, *Utriusque cosmi* (Oppenheim, 1617), p. 69, Philosophical Research Library, Manly P. Hall Collection, Los Angeles

·

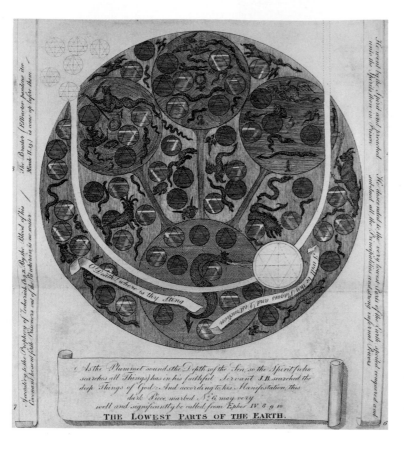

The Lowest Parts of the Earth,
from Jakob Böhme, *The Works of Jakob Böhme,* vol. 2 (London: M. Richardson, 1764), Philosophical Research Library, Manly P. Hall Collection, Los Angeles

•

Magnetismus Globorum Astralium, from Athanasius Kircher, *Mundi subterranei* (Amsterdam: Janssonio-Waesbergiana, 1678), p. 104, Philosophical Research Library, Manly P. Hall Collection, Los Angeles

•

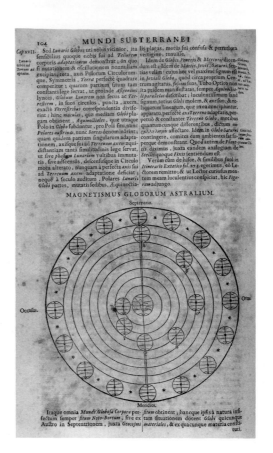

COSMIC IMAGERY Through cosmic imagery occult writers seek to investigate the forces that lie beneath human existence.

Systeme Ideale Pyrophylaciorum, from Athanasius Kircher, *Mundi subterranei* (Amsterdam: Janssonio-Waesbergiana, 1678), Philosophical Research Library, Manly P. Hall Collection, Los Angeles

•

Title page from Robert Fludd, *Philosophia moysaica* (Gouda: Petrus Rammazenius, 1638), Henry E. Huntington Art Gallery and Library, San Marino, California

•

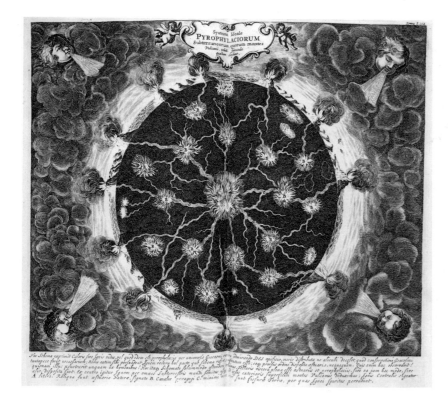

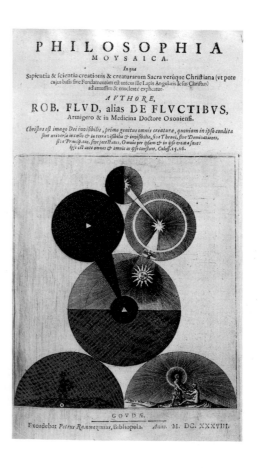

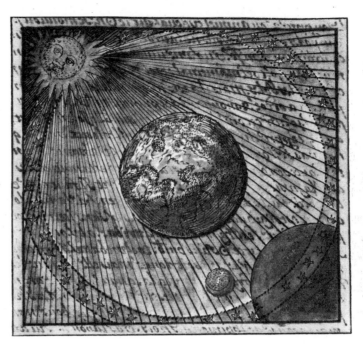

The eternal center and birth of life ... are everywhere. Trace a circle no larger than a dot, the birth of eternal nature is therein contained.
JAKOB BÖHME

COSMIC IMAGERY

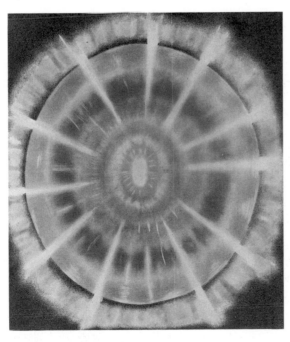

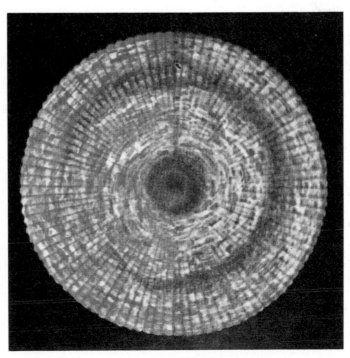

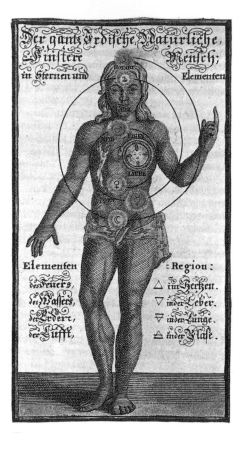

From Johann Georg Gichtel, *Theosophia Practica; Eine kurze Eröffnung und Anweisung der drei Prinzipien im Menschen* (Berlin and Leipzig: Christian Ulrich Ringmacher, 1736)

·

Man as Seen by Clairvoyant (4-Dimensional Vision), and by Ordinary Human Sight, from Claude Bragdon, *A Primer of Higher Space* (1913)

·

From Claude Bragdon, *A Primer of Higher Space* (1913)

·

VIBRATION

A Shock of Fear, pl. XIV from Charles W. Leadbeater, *Man Visible and Invisible* (1903)

·

A Sudden Rush of Devotion, pl. XII from Charles W. Leadbeater, *Man Visible and Invisible* (1903)

·

Intense Anger, pl. XIII from Charles W. Leadbeater, *Man Visible and Invisible* (1903)

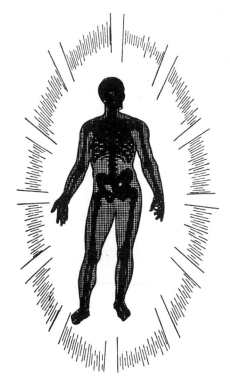

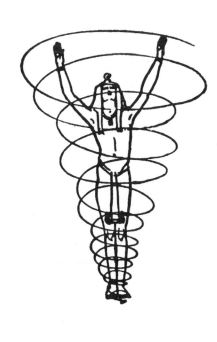

In theosophical and other occult texts vibration is understood to be the formative agent behind all material shapes.

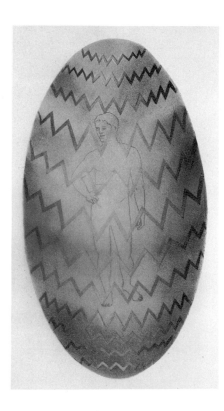

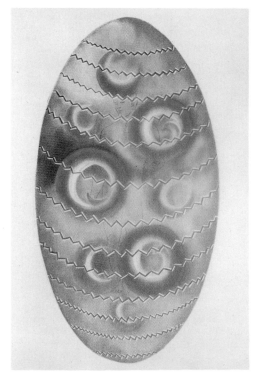

From Athanasius Kircher,
Phonurgia nova
(Kempten, 1673)

⋅

From Sir Francis Galton,
*Inquiries into Human Faculty
and Its Development* (1883)

⋅

SYNESTHESIA

*The Orphical Scale of the
Number Twelve,* from Henry
Cornelius Agrippa, *Three
Books of Occult Philosophy*
(London: Gregory Moule,
1651), p. 214, Henry E.
Huntington Library and Art
Gallery, San Marino,
California

⋅

Occult writers and artists are fascinated with synesthesia, the overlap between the senses: for example, colors evoking
musical tones or tastes suggesting colors.

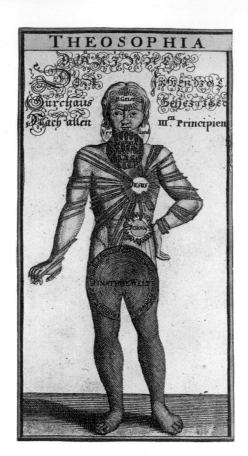

The Tree of Good and Bad Knowledge, from *Geheime Figuren der Rosenkreuzer aus dem 16tem und 17tem Jahrhunderts* (Altona, 1785–88), Philosophical Research Library, Manly P. Hall Collection, Los Angeles

·

Theosophia, from Johann Georg Gichtel, *Theosophia Practica; Eine kurze Eröffnung und Anweisung der drei Prinzipien im Menschen* (Berlin and Leipzig: Christian Ulrich Ringmacher, 1736)

·

DUALITY

For occult philosophers the laws of duality are predominant; everything is understood to correspond in a universal analogy: "things above are as they are below."

Typus Sympathicus Microcosmi cum Megacosmo, from Athanasius Kircher, *Oedipi aegyptiaci* (Rome, 1652), p. 358, Philosophical Research Library, Manly P. Hall Collection, Los Angeles

·

The Second Table, from Jakob Böhme, *The Works of Jakob Böhme,* vol. 2 (London: M. Richardson, 1764), Philosophical Research Library, Manly P. Hall Collection, Los Angeles

·

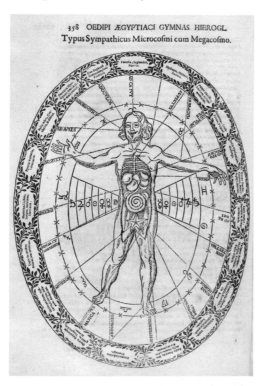

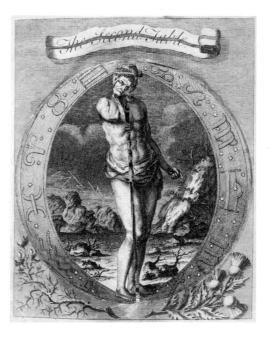

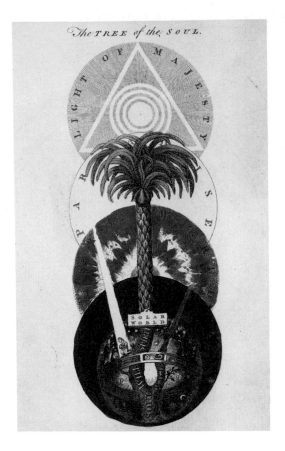

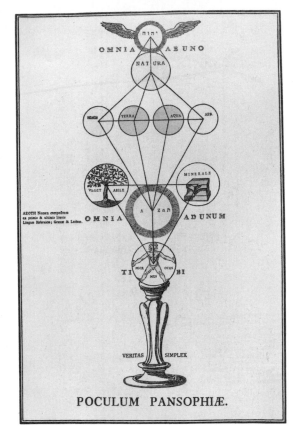

The Tree of the Soul, from Jakob Böhme, *The Works of Jakob Böhme,* vol. 2 (London: M. Richardson, 1764), Philosophical Research Library, Manly P. Hall Collection, Los Angeles

·

Poculum Pansophiae, from *Geheime Figuren der Rosenkreuzer aus dem 16tem und 17tem Jahrhunderts* (Altona, 1785–88), Philosophical Research Library, Manly P. Hall Collection, Los Angeles

·

DUALITY

The universe is conceived as being comprised of paired opposites (male-female, light-dark, vertical-horizontal), and all things evolve in dialectical opposition.

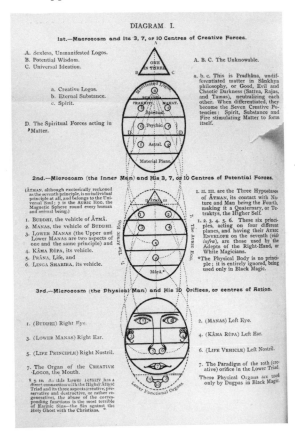

Diagram 1 from Annie Besant, *Hints on the Study of the Bhagavad-Gita* (London, 1908), Philosophical Research Library, Manly P. Hall Collection, Los Angeles

·

From Athanasius Kircher, *Oedipi aegyptiaci* (Rome, 1652), Philosophical Research Library, Manly P. Hall Collection, Los Angeles

·

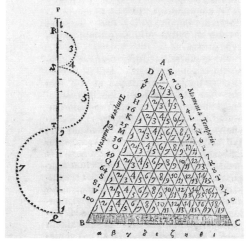

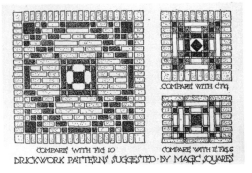

COMPARE WITH FIG 10
BRICKWORK PATTERNS SUGGESTED BY MAGIC SQUARES

SACRED GEOMETRY In sacred geometry the complexities and abstract truths expressed by geometric forms are linked to mystical tenets.

From Michael Maier, *Atalanta fugiens* (Oppenheim: H. Galleri, 1618), Philosophical Research Library, Manly P. Hall Collection, Los Angeles

·

From *Geheime Figuren der Rosenkreuzer aus dem 16tem und 17tem Jahrhunderts* (Altona, 1785–88), Philosophical Research Library, Manly P. Hall Collection, Los Angeles

·

Analogous to the search for the geometric essence is the effort to identify the underlying life-form: the Ur-form, the thyrsus, the spiral, the double ellipse.

SACRED GEOMETRY

Snakes Symbolizing Cosmic Energy Coiled Round an Invisible Lingam (Male Organ) Basohli, c. 1700 Gouache on paper 6 x 4 in. (15.2 x 10.2 cm) Ajit Mookerjee, New Delhi

·

A Solar Cyclone, May 5, 1857, from Edwin D. Babbitt, *The Principles of Light and Color* (1878)

·

The five underlying impulses within the spiritual-abstract nexus — cosmic imagery, vibration, synesthesia, duality, sacred geometry — are in fact five structures that refer to underlying modes of thought. That they are common to a wide variety of artists, writers, and thinkers is reminiscent of a similar pattern present in the "spiritual families" of artists and eras identified by art historian Henri Focillon in *The Life of Forms of Art* (1948). Focillon, and later George Kubler, recognized fundamental directions in history dependent on the interaction of traditions, influences, and experiments rather than their isolation.[34]

These five impulses appear in the work of Symbolist artists and writers at the end of the nineteenth century. While still conforming to nature-based language, the visual artists of this period nevertheless embraced new subjects and relatively reduced, simplified forms. They drew on a variety of sources in support of their art, and in turn those sources were nourished by spiritual ideas. For example, Charles Blanc's *Grammaire des arts du dessin* (1867), a bible for the Symbolist generation, drew upon Blanc's admiration (which he shared with Baudelaire and Eugène Delacroix) for the spiritualist school at the Sorbonne, founded by Victor Cousin in the early 1840s. Cousin's goal in reviving spiritualism was to oppose the "cold logic, the sterility, the excess of criticism" and what he regarded as the destructiveness of the nineteenth-century ideologues.[35] Blanc attempted to formulate an all-embracing universal notion of eternal geometry. Maurice Denis's influential comments on the idea of synthesis and the search for plastic equivalents by artists of his generation had their roots in Blanc's *Grammaire*.[36]

Two of the fundamental spiritual impulses — the interest in laws of duality and correspondences and in synesthesia — were hallmarks of Symbolist painting. Artists were intrigued with the prospect of intermingling senses and, more specifically, with painting's approximating music. Baudelaire's poetry as well as his studies of Delacroix and the Romantic artists' chromatic concerns provided considerable inspiration. Baudelaire stated, "I want to illu-

minate things with my mind and to project their reflection upon other minds," and asserted that this was Delacroix's goal as well.[37] Baudelaire spoke, too, of the "sensation of *spiritual and physical bliss, of isolation,* of the contemplation of *something infinitely great and infinitely beautiful,* of an *intensity of light* which rejoices *the eyes and the soul until they swoon*" and a "sensation of *space reaching to the furthest conceivable limits.*"[38]

Romantic painting on the whole approached, but never fully realized, Baudelaire's vision, although one exception can be found in Victor Hugo's works on paper (pl. 5). Hugo's extraordinary series of images of a human eye fused with a planet, which depict the "as above/so below" occult maxim, was revealed in an exhibition of his works of art at the Petit Palais in 1985. A mandalalike watercolor similarly projects Hugo's involvement with occult ideas (pl. 6). These images, made in the 1850s, are related to his profound commitment to spiritualism, which apparently commenced after the death of his daughter in 1843. It was then that Hugo began to read Pythagorean theory and the writings of Swedenborg and Comte de Saint-Simon; in 1852 he learned about the doctrines of the cabala from Alexandre Weil. The next year, ostensibly the date of his abstract watercolors, he began to conduct séances with his family, and with his son serving as medium he recorded his dialogues with Shakespeare, Dante, Aeschylus, and Molière. Shortly thereafter he was to turn away from these activities — not without some regret in later years.[39] Hugo, however, was not a professional artist, and it remained for Symbolism to attempt to express these qualities that had remained latent in Romanticism.

Richard Wagner was among the originators of the idea of correspondences and was the most articulate advocate of the *Gesamtkunstwerk* (total work of art). Baudelaire wondered why no painter excelled, as Wagner did in music, in evoking spiritual space and depth. He wrote: "What would be truly surprising would be to find that sound *could not* suggest colour, that colours *could not* evoke the idea of a melody, and that sound and colour were *unsuitable* for

the translation of ideas, seeing that things have always found their expression through a system of reciprocal analogy ever since the day when God uttered the world like a complex and indivisible statement."[40]

Nearly a half-century later in the United States, Arthur Jerome Eddy in his *Recollections and Impressions of James A. McNeill Whistler* (1903) published his ideas about the parallel of music and art, and the French artist Francis Picabia played a key role in transmitting synesthetic ideas to the American art world in the 1910s. Picabia went further than other contemporary artists in America in his verbal affirmation that subject matter was of no value in an art that "expresses a spiritual state [and] makes that state real by projecting on the canvas the finally analyzed means of producing that state in the observer."[41] Picabia made his claim for the power of art not only by suggesting an analogy between painting and music but also by emphasizing that the rules of painting, no less than of music, had to be learned:

If we grasp without difficulty the meaning and the logic of a musical work it is because this work is based on the laws of harmony and composition of which we have either the acquired knowledge or the inherited knowledge. . . . The laws of this new convention have as yet been hardly formulated but they will become gradually more defined, just as musical laws have become more defined, and they will very rapidly become as understandable as were the objective representations of nature."[42]

When Paul Cézanne described Claude Monet's eye as "only an eye, but what an eye," he inadvertently underscored Impressionism's evolutionary role as an artistic effort dominated by retinal issues. Although it has been asserted recently that the Impressionists never actually discarded meaningful content in favor of pure plays of light and color, it seemed to the Post-Impressionist generation that the Impressionists had replaced Romanticism's subjectivity with directly seen, objec-

tive reality.[43] The chief issue linking artists in the 1890s, from Paul Gauguin to Sérusier, Jan Toorop and Johan Thorn Prikker to Edvard Munch, was their conviction that Impressionism lacked ideas and that their role as artists was to reinvigorate modern painting with meaning.

In 1893 Munch was deeply affected by August Strindberg's studies of the occult and by the novels and psychological investigations into transmission of thought waves by his close friend Stanislaw Przybyszewski. Munch was aware of Swedenborg's belief in seeing auras around people and read *Spiritualism and Animism* (1890) by the Russian spiritualist Aleksandr Aksakov.[44] In Berlin Munch associated almost exclusively with a group of occultists, believers in mesmerism and Theosophy, a group that regularly attended spiritualist sessions and séances and was interested in physiological psychology. Przybyszewski, writing in 1894, labeled Munch's art "psychic naturalism," explaining that Munch, "the naturalist of the phenomena of soul," aimed at projecting a "psychical, naked process . . . directly in his color equivalents," identifying his tradition in the line of Stéphane Mallarmé and Maurice Maeterlinck.[45] Other literary associates of Munch, such as the German critic Franz Servaes, promulgated theories of synesthesia to suggest simultaneous crossover associations in the brain and the direct projection of rhythms from one mind to another. Carla Lathe has written that the basis of paintings concerned with psychic naturalism lay in medical studies, especially about the processes of disease.[46] The swirling lines of vibration, the projections of aura that characterize Munch's paint-

5
VICTOR HUGO
Planet-spots, c. 1853–55
India ink on paper
11 ¼ x 17 ½ in.
(28.5 x 44.5 cm)
Musée des Beaux-Arts,
Dijon, France

.

6
VICTOR HUGO
Rosace, c. 1850
Ink on paper
9 ⅟₁₆ x 7 ½ in. (23 x 19 cm)
Musée Victor Hugo,
Villequier, France

.

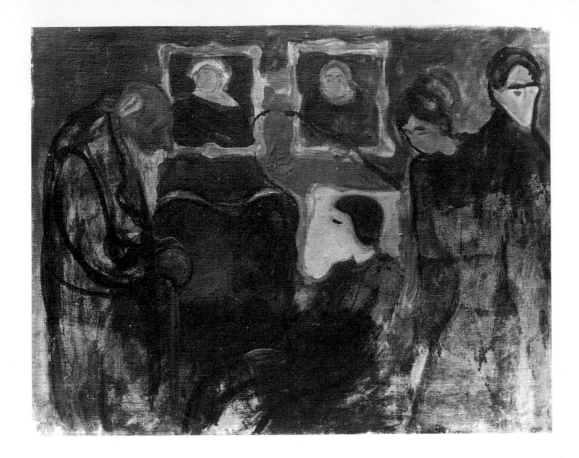

ings such as *The Son,* made after 1896 (pl. 7), were nourished by these interests.

The fascination with Munch's art among modern abstract artists was attested to by Joseph Beuys:

But what flows with Munch is something spiritual, a spiritual river, that is, something ethereal — powers of the spirit. Sometimes there was also a sort of demonic electricity, that flowed into the river. None of this had ever been perceived in this way before. . . . Apparitions are perceived, too, flowing into immediate perception. . . . "Upper" and "lower" experiences are drawn together: flowing powers of the spirit, from the demonic and ghostly up to the ultimate aura. . . . Therefore it cannot have been the *tree* that had interested him, neither the tree nor the landscape in itself. But he did provide for these insane circles, the same as he does with all other works; *these* he saw. He did not see any trees.[47]

American art at the end of the nineteenth century had a distinctly different character than did European art. It was symptomatic of an optimism manifest as the United States assumed a more important role among world nations. Parallels, however, can be drawn between the European *belle époque,* with its nascent apocalyptic auguries of revolutionary, antimaterial ways of thinking, and the American fin de siècle, with its own antimodern and mystical tendencies. The historian T. J. Jackson Lears has recently argued that anti-modernism is the central notion unifying leading American thinkers from the transcendentalists through Walt Whitman and William James. Modernism was regarded as something to be fought because it was synonymous with the loss of inner spiritual values.[48] James emphasized that the only way to attain true supremacy and higher consciousness was by losing oneself, by breaking down the confines of personality, and he pointed to the "immense elation and freedom as the outlines of confining selfhood melt down."[49] In *The Varieties of Religious Experience* (1902) James stated, "Our normal waking consciousness, rational consciousness as we call it, is but one special type of consciousness, whilst all about it, parted from it by the filmiest of screens, there lie potential forms of consciousness entirely different."[50] He acknowledged that sensory, symbolic elements could "play an enormous part in mysticism."

Between 1907 and 1915 painters in Europe and the United States began to create completely abstract works of art. It is neither our intention nor our interest here to resolve the issue of who was the first abstract painter or what was the first abstract painting. Instead we are more concerned with how this abstraction evolved and, in particular, how four leading abstract pioneers — Wassily Kandinsky, František Kupka, Piet Mondrian, and Kazimir Malevich — moved toward abstraction through their involvement with spiritual issues and beliefs. An examination of their development, and that of the generation following them, reveals how spiritual ideas permeated the environment around abstract artists in the early twentieth century.

In 1912 Kandinsky assessed the work of Matisse, pointing to his search for the "divine" but criticizing his "particularly French" exaggeration of color, and the work of Picasso, which "arrives at the destruction of the material object by a logical path, not by dissolving it, but by breaking it up into its individual parts and scattering these parts in a constructive fashion over the canvas."[51] For Kandinsky these approaches represented two dangers in contemporary art: "On the right lies the completely abstract, wholly emancipated use of color in 'geometrical' form (ornament); on

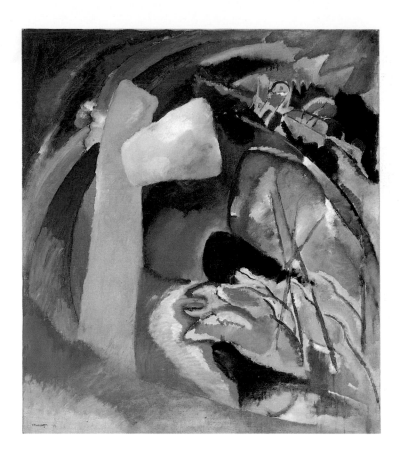

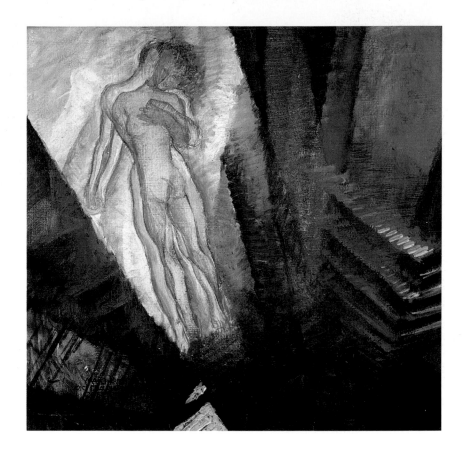

the left, the more realistic use of color in 'corporeal' form (fantasy)."[52] Kandinsky (pl. 8) advocated a different role for the artist:

The artist must have something to say, for his task is not the mastery of form, but the suitability of that form to its content. . . . From which it is self-evident that the artist, as opposed to the nonartist, has a threefold responsibility: (1) he must render up again that talent which has been bestowed upon him; (2) his actions and thoughts and feelings, like those of every human being, constitute the spiritual atmosphere, in such a way that they purify or infect the spiritual air; and (3) these actions and thoughts and feelings are the material for his creations, which likewise play a part in constituting the spiritual atmosphere.[53]

Nourishing Kandinsky's eventual commitment to abstraction, which was indebted to his convictions about the spiritual, was the time he spent in Paris in 1906–7 and the lessons he learned from Jugendstil (Art Nouveau in Germany).[54] Cubism was of little importance in his artistic evolution. His immersion in spiritual texts, however, seems to have established his rationale for abstraction. Kandinsky's paintings were very much a product of his close reading of theosophical and anthroposophical writings by Helena P. Blavatsky and Rudolf Steiner and of the visual impression made by the illustrations to Annie

Besant and Charles W. Leadbeater's *Thought-Forms* (1905) and Leadbeater's *Man Visible and Invisible* (1903).[55] Kandinsky's annotations in 1904–8 of Steiner's *Luzifer-Gnosis* reveal much about what he learned in his study of the spiritual (see p. 133).[56] Echoes from Steiner's book may be found in Kandinsky's *On the Spiritual in Art* (1912), perhaps the most influential doctrine by an artist of the twentieth century. From Theosophy, as Ringbom was the first to demonstrate thoroughly, Kandinsky derived his concept of vibration (directly connected with his use of the acoustic term *Klang*). He believed that human emotion consists of vibrations of the soul, and that the soul is set into vibration by nature: "Words, musical tones, and colors possess the psychical power of calling forth soul vibrations . . . they create identical vibrations, ultimately bringing about the attainment of knowledge. . . . In Theosophy, vibration is the formative agent behind all material shapes, which are but the manifestation of life concealed by matter."[57] As Ringbom summarized, Kandinsky's expressed purpose was "to produce vibrations in the beholder, and the work of art is the vehicle through which this purpose is served. . . .

The formative factor in the creation of a work of art is the artist's same vibration."[58] Kandinsky's works from the Bauhaus and Paris years feature abstractions that may be associated equally with cosmic and celestial concerns as with vibrations.

Kupka's involvement with the mystical and the occult dated from his early childhood in Bohemia. He was apprenticed as a youth to a saddler, a spiritualist who led a secret society.[59] Kupka's visionary experiences were translated into visual form in his painting as a transperceptual realm in which color is imaginary, space is infinite, and everything appears to be in a constant state of flux (pl. 9). From his training at the Prague Academy with Nazarene artists, who stressed geometry rather than life drawing, Kupka came to master golden section theory and practice and perhaps to pass it on later to his neighbors in Puteaux, the Duchamp-Villon family. In Vienna Kupka met Austrian and German Theosophists and found corroboration of his

8
WASSILY KANDINSKY
Painting with White Form,
1913
Oil on canvas
39 ¼ x 34 ¼ in.
(99.7 x 87 cm)
The Detroit Institute of Arts
Gift of Mrs. Ferdinand
Moeller

·

9
FRANTIŠEK KUPKA
The Dream, 1906–9
Oil on cardboard
12 x 12 ⅜ (30.5 x 31.5 cm)
Museum Bochum,
Kunstsammlung, West
Germany

·

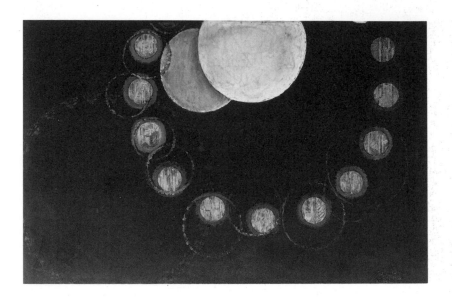

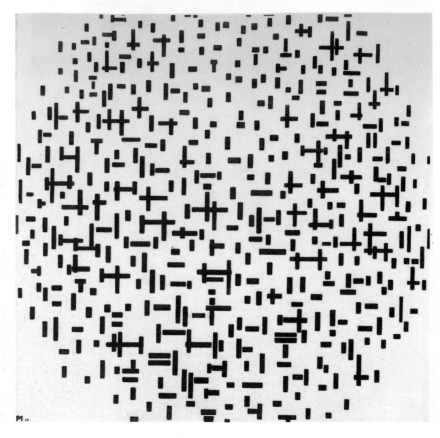

theory of reincarnation; in association with the painter Karl Diefenbach he further developed ideas about the reciprocal relationship of music and painting, and he became a sun worshiper, alert "to hues flowing from the titanic keyboard of color."[60] He credited Nazarenism with a desire to "penetrate the substance with a super-sensitive insight into the unknown as it is manifested in poetry or religious art."[61]

For Kupka, as for the Theosophists, the essence of nature was manifested as a rhythmic geometric force. Consciousness of this force was made possible by disciplined effort as a medium; Kupka was a spiritualist throughout his life. He announced in 1910 that he was preparing to state publicly his beliefs in theosophical principles and spiritualism; his 1910–11 letters to the Czech poet Svatopluk Machar note his fascination with the supernatural world, spiritualism, and telepathy and his need to express abstract ideas abstractly. *The First Step,* 1909–13 (pl. 10), is a painting whose imagery is rooted in astrology and pure abstraction. The painting may be interpreted as a diagram of the heavens and as a nonrepresentational, antidirectional image referring to infinity and evoking the

belief that one's inner world is truly linked to the cosmos. Years earlier Kupka had written of a mystical experience in which "it seemed I was observing the earth from outside. I was in great empty space and saw the planets rolling quietly."[62]

Mondrian joined Amsterdam's Theosophical Society in 1909, but there is evidence that his interest in spiritual ideas began around 1900. In this volume Carel Blotkamp demonstrates that Mondrian exposed himself to a variety of theosophical ideas shortly after the turn of the century: he read texts, including Schuré's *Les Grands Initiés,* and associated with theosophical sympathizers, including critics, collectors, and painters; in addition, he met the painter Jacoba van Heemskerck in 1908 at Domburg, while visiting the Symbolist Toorop. Unlike Kandinsky, Mondrian did not borrow visual imagery, such as aural projections, from theosophical texts but rather invented an abstract visual language to represent these concepts (pl. 11). His devotion to Theosophy and related beliefs was quite strong. Also contributing to Mondrian's artistic outlook were his impressions of the paintings by the Symbolist generation preceding him, most notably those by Toorop and Thorn Prikker, and the tradi-

tions of precise geometry in Dutch art, which set the stage for his experience of Cubism, first encountered in 1910. Mondrian's theories and art were based upon a system of opposites such as male-female, light-dark, and mind-matter. These were represented by right-angled lines and shapes as well as by primary colors plus black and white. His abstract language employed an unusually direct system of equivalences to express fundamental ideas about the world, nature, and human life and to evoke the harmonious unity of opposites.

In some of the spiritual movements that influenced twentieth-century artists, the bond between metaphysical ideas and science was an important element. Metaphysical thinkers, for example, were especially eager to learn about the advances in physics and chemistry. This new knowledge not only was adapted to confirm their beliefs but also allowed them to speculate about the invisible aspects of the material universe. Popularized beliefs about *n*-dimensional geometry, a theory of geometry based on more than three dimensions, were an essential basis for the Russian Futurist movement and the art of Malevich.[63] In the writings of P. D. Ouspensky the properties of time and space were united in a concept of the fourth dimension. Malevich fused his interest

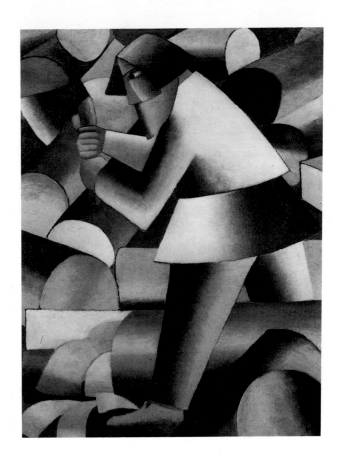

in the fourth dimension with occult, numerological notions shared with him by his close friend the poet Velimir Khlebnikov. Malevich's art moved from the Alogical representation of space to its final, totally abstract form: Suprematism. Suprematist works (pl. 12) were intended to represent the concept of a body passing from ordinary three-dimensional space into the fourth dimension. Malevich's knowledge of Cubism (pl. 13) helped him move in this direction, although he stated that his inclination toward abstraction predated this influence.

As Charlotte Douglas states in her essay here, the generation of Russian artists emerging after the turn of the century sought to break away from Cubo-Futurism in search of a new cosmic unity. Douglas points to *zaum* — the idea of a higher perceptual plane, a superconscious state that allows knowledge beyond reason — as being identical with the samadhi state in Yoga. There were widespread sources in Russian popular culture for such concepts, as Douglas, John Bowlt, and Edward Kasinec and Boris Kerdimun all document here. Bowlt explains that occult and mystical ideas were usually disseminated to artists indirectly rather than by textual studies, and he demonstrates that geometric abstraction in Russia was an extension of Symbolist and theosophi-

cal ideas. The pervasive idea of cosmic energy was derived from Blavatsky, Buddhist philosophy (nirvana), Ouspensky, and G. I. Gurdjieff.

The sources for the spiritual-abstract nexus in Saint Petersburg, Moscow, Paris, Munich, and New York were limited in number, strikingly similar, and almost simultaneous: Swami Vivekananda's lectures in the United States, such as those at the Chicago World's Fair in 1893, were translated into Russian in 1906; William James was widely translated in Russia, too, and in France, as were Whitman and Ralph Waldo Emerson. The more recondite brand of occultism often appeared in inexpensive paperback editions, such as M. V. Lodyzhenskii's *Superconsciousness and Ways to Achieve It* (1911), which Malevich read, and Albert Poisson's *Théories et symboles des alchimistes* (1891), which Marcel Duchamp read.

Cubism, because of its reduction of objects to increasingly geometric forms, has most often been cited as the intermediary between Post-Impressionism and abstraction. Two points need to be made regarding the relation of Cubism to early twentieth-century abstraction and to the spiritual issues under discussion. First, with few possible exceptions (the

most notable being, arguably, Malevich), Cubism was not essential to the progress of any major artist working from a representational mode and moving toward an abstract one, whereas exposure to spiritual ideas certainly was. Second, the most fertile aesthetic source for abstract artists working in the first two decades of the twentieth century was Symbolist painting and theory. Symbolism, the mystical wing of the Post-Impressionist generation, contained the seeds of abstract art; abstraction was also catalyzed by formal suggestions drawn from Fauvism as well as from Cubism. Abstraction's emergence throughout the twentieth century was continually nourished by elements from the common pool of mystical ideas. Just as the history of early abstract art, as written by many critics and historians of the 1930s through the 1960s, disregarded the presence of any meaning in these works, so too was Cubism stripped of its content. This process facilitated an easy formalist reading of abstract art, but it is now widely acknowledged that Cubist works do have content, that they are about something.

The Cubists' considerable interest in the fourth dimension has been established, and more recently it has emerged that occult ideas

12
KAZIMIR MALEVICH
Suprematist Painting, 1917–18
Oil on canvas
38 ³⁄₁₆ x 27 ½ (97 x 70 cm)
Stedelijk Museum,
Amsterdam

.

13
KAZIMIR MALEVICH
The Woodcutter, 1912
Oil on canvas
37 x 28 ⅛ in. (94 x 71.5 cm)
Stedelijk Museum,
Amsterdam

.

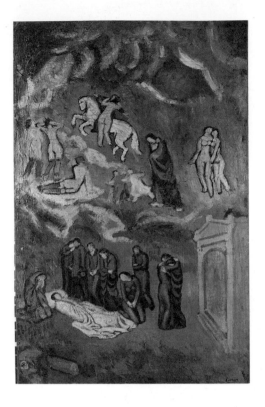

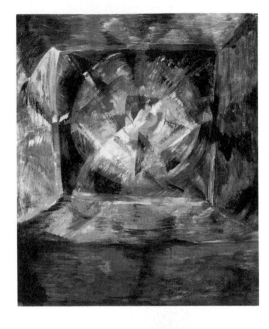

14
PABLO PICASSO
*Evocation (The Burial of
Casagemas)*, 1901
Oil on canvas
59 ⅛ x 35 ½ in. (150 x 90 cm)
Musée d'Art Moderne de la
Ville de Paris

·

15
GEORGII YAKULOV
Abstract Composition, 1913
Oil on canvas
25 ⅜ x 21 1/16 in.
(64.5 x 53.5 cm)
Musée National d'Art
Moderne, Centre Georges
Pompidou, Paris

·

16
HILMA AF KLINT
Page from *Automatic Séance
Sketchbook*, 1890s
Pencil on paper
Thirty-two pages
12 x 10 ¼ in. (30.5 x 26 cm)
Stiftelsen Hilma af Klints
Verk

·

were associated with the development of Cubism.[64] Jacques Lipchitz testified to the Cubist interest in the occult in a 1963 unpublished interview with Henri Dorra:

"The artists made determined, if good-humored, searches in the realm of practical magic and alchemy and tried to cultivate their spirit if not actually pursue their ends. Thus, we had read *The Emerald Table* by Paracelsus [in fact the work is attributed to Hermes Trismegistus]. . . . The Cubists were also very much interested in the occult properties of images."

Lipchitz then requested a gold ring, silk thread, and book of illustrations. He created a pendulum from the thread and the ring and allowed it to swing over the reproductions of paintings by various artists. He then continued:

"The oscillations are similar for works by the same artist, different for works by different artists. We used to spend hours playing this game, as if to prove to ourselves that there were intangible properties in matter that transcended physical reality."[65]

Picasso, too, for a brief, but critically important period was affected and nearly inundated by spiritual ideas. His painting of his friend Casagemas (pl. 14) may be interpreted as a rapturous expression of communion catalyzed by the death of a close friend; the configura-

tion of this painting was influenced by *Les Courses*, 1905, a painting by the Russian émigré Georgii Yakulov.[66] Yakulov's involvement with mystical ideas was a counterpart to Mikhail Matiushin's view of the fourth dimension as the occult myth of the "blue sun."[67] Yakulov's authoritative, early *Abstract Composition*, 1913 (pl. 15), reveals that his spirituality, nascent in 1905, was overt in 1913. Matisse also exhibited some interest in mystical ideas; specifically, he was attracted to the notion of a cosmogony. Pierre Schneider cites Matisse's own summary of this prewar stage in his work: "It was a time of artistic cosmogony." For Matisse, Constantin Brancusi, Georges Rouault, and Picasso, the years 1905–10 were characterized by an observable shift "toward the sacred in art," a shift that abruptly terminated with Cubism.[68] These artists and others associated with them are not featured in the exhibition *The Spiritual in Art* because their work was not abstract, but convincing links may be drawn between spiritual ideas and important aspects of their work and careers. Conversely, there were certainly abstract artists who were not interested in mystical or occult issues. Artists such as El Lissitzky and Lazló Moholy-Nagy produced purely abstract paintings; instead of consult-

ing nonrational belief systems, they tried to organize and systematize the world so that their art was related to idea systems as well as to architecture.

Further evidence that a knowledge of Cubism or other advanced European art was not required in order to arrive at abstraction is found in the case of Swedish artist Hilma af Klint. Af Klint's work has never been published or exhibited publicly outside Sweden; Åke Fant's essay in this volume is the first study on her in English. She devoted herself to painting as well as to spiritualism and meditation and in the 1890s led a weekly group in automatic drawing sessions (pl. 16). Her first abstract painting, *No. 1*, 1906 (pl. 17), consists of marks executed in a manner adapted from automatic drawings made during séances. In the last three months of 1907 af Klint, after having abandoned her previous work as a portrait and landscape painter and having prepared herself with a year of ascetic practice, created a series of ten enormous abstract canvases (pls. 18–19).[69]

After meeting Rudolf Steiner in 1908, af Klint ceased painting until April 1912. In 1914–15 she produced large square canvases that reveal a progression from a depiction of two inter-

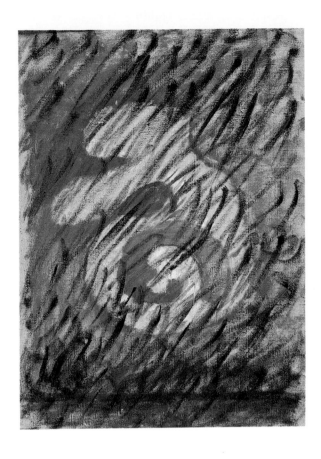

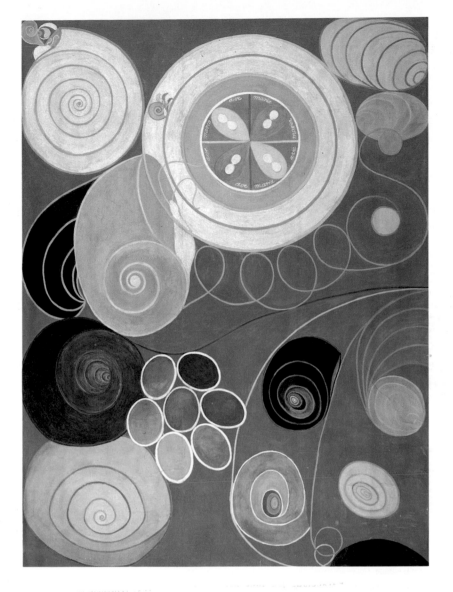

17
HILMA AF KLINT
No. 1, 1906
Oil on canvas
19 ¹¹⁄₁₆ x 14 ¹⁵⁄₁₆ in.
(50 x 38 cm)
Stiftelsen Hilma af Klints
Verk

·

18
HILMA AF KLINT
Ages of Man No. 3, 1907
Tempera on paper glued on
canvas
129 ¹⁄₁₆ x 94 ⁷⁄₁₆
(327.8 x 239.9 cm)
Stiftelsen Hilma af Klints
Verk

·

19
HILMA AF KLINT
Two pages from *Illustrated
House Catalogue Related to the
1907 Paintings*, 1907
Watercolors and photographs
Twenty-six pages
6 ¹¹⁄₁₆ x 8 ⁷⁄₈ in.
(17.6 x 22.5 cm)
Stiftelsen Hilma af Klinst
Verk

·

20
HILMA AF KLINT
Untitled No. 8 from the Series
S.U.W./Swan, 1914–15
Oil on canvas
59 1/16 x 59 1/16 in.
(150 x 150 cm)
Stiftelsen Hilma af Klints
Verk

·

21
HILMA AF KLINT
Untitled No. 1 from the Series
Altar Paintings, 1915
Oil and gold on canvas
72 13/16 x 59 13/16 in.
(185 x 152 cm)
Stiftelsen Hilma af Klints
Verk

·

locking swans to a completely abstract configuration (pls. 20–21). Again influenced by Steiner, in 1921 she abandoned her theosophical beliefs in favor of Steiner's preferred, nonabstract anthroposophical approach to painting, in which forms would emerge through layers of transparent paint. The progression toward abstraction in her work from the 1890s reveals an exceptional case of an artist of the Symbolist generation developing outside the mainstream of advanced European artistic circles but fueled by occult ideas and practices, many of which had their origins in writings by Böhme.

Italian Futurism, too, had a role in the spiritual-abstract nexus. That Futurism evolved from Italian Symbolist ideas is suggested, to name just one obvious example, by Filippo Tommaso Marinetti's magazine *Poesia,* which started in 1910 and was one of the most prominent Symbolist advocates in Italy. There was an intense fascination with spiritualism among Italian artists and writers during the second decade of the twentieth century.[70] Nonreferential paintings, such as Giacomo Balla's *Iridescent Interpenetration,* 1914 (pl. 22), and Gino Severini's Spherical Expansion of Light series of 1913–14 (pls. 23–24), would not have led to the dissolution of materiality without influence from spiritualism. The concept of the transparency of bodies that was basic to Futurism can be linked to photography and to occult ideas about "invisible beings."[71] Volumes of photography, published by the Comité d'Études de la Photographie Transcendentale, beginning in 1909 at the Sorbonne, constituted a mass of provocative material, alleging the existence of ghostly apparitions, weightless bodies, immateriality and boundlessness, double images of man and his astral projections — all suggesting the reality of antinaturalism. Anton Giulio Bragaglia's 1912–14 photographs of the invisible and his utilization of what was then considered to be the ultimate recorder of reality, the camera, for quintessential research in the immaterial raise intriguing questions regarding Futurist painting. When Bragaglia concluded in *Fotodinamismo Futurista* (1911) that his ultimate intention was to express "reality as

22
GIACOMO BALLA
Iridescent Interpenetration, 1914
Oil on canvas
39 ⅜ x 47 ¼ in.
(100 x 120 cm)
Private collection

.

23
GINO SEVERINI
*Spherical Expansion of Light
(Centripetal),* 1913–14
Oil on canvas
24 x 19 ½ in. (61 x 49.5 cm)
Private collection

.

24
GINO SEVERINI
Expansion of Light, 1912
Oil on canvas
26 ¹⁵⁄₁₆ x 16 ¹⁵⁄₁₆ in.
(68.5 x 43 cm)
Thyssen-Bornemisza
Collection, Lugano,
Switzerland

.

vibration," he was proclaiming a manifestolike declaration of hermetic ideas.[72] Bragaglia's continued insistence on making "a determined move away from reality," given "the transcendental nature of the phenomenon of movement," apparently conflicted with Marinetti and Umberto Boccioni and was a factor in his separation from the Futurists after 1913.

Boccioni's description of his goal for painting to take on "spiritualization" certainly reflects his interest in the fourth dimension.[73] "Theoretically," Boccioni wrote in 1908, "I'm for everything that is grandiose, symphonic, synthetic, abstract." He spoke of his search for a "new, definitive sublime in art," an art of "exaltation and self-oblivion" and cited photographic proof by the medium Eusapia Paladino of the existence of "luminous emanations of our body."[74]

The Italian Futurists played a special role in the development of abstract cinema. In 1912 Bruno Corra and his brother Arnaldo Ginna finished their abstract films, which have

recently been partially reconstructed (see p. 300). In Corra's article "Abstract Film: Chromatic Music" of the same year he described two years of abstract filmmaking: "Naturally, we applied and exploited the laws of parallelism between the arts which had already been determined."[75]

The innovative American art of the early twentieth century has traditionally been considered nature-based. The study of nature by American landscape painters is related to their quest for the underlying mystical qualities understood to reside in nature. For example, the primal form, or Ur-form, in European tradition is analogous to Emerson's "Over-Soul," which reveals "The day of days, the great day of the great feast of life . . . in which the inward eye opens to the Unity of things. . . . This beatitude . . . is not in us so much as we are in it."[76] In 1833 Emerson anticipated the premise of Schuré's *Les Grands Initiés* when he described "One Bottom" as the common source "of eminent men of each church, Socrates, à Kempis, Fénelon, Butler, Penn, Swedenborg, Channing."[77] Emerson's essays are replete throughout with themes that parallel some of the five spiritual concepts that have been focused upon here. "Natural

fact is a symbol of some spiritual fact. Every appearance in nature corresponds to some state of the mind," he declared, later reiterating: a "work of art is an abstract or epitome of the world"; "a leaf, a sunbeam, a landscape, the ocean, make an analogous impression on the mind."[78] Such attitudes prefigure the ideas of correspondences that can be traced from Ryder and Ferdinand Hodler through Hartley, Mondrian, and Johannes Itten to Pollock and Brice Marden.

Emerson admired Plato, the "great-eyed," for his expression "God geometrizes" and looked forward to "geometric astronomic morals."[79] He also admired Saint Augustine's cardinal mystical concept of God as "a circle whose center was everywhere, and its circumference nowhere."[80] This idea, which Emerson identified as a "higher thought or a better emotion," prefigured the sentiments and cosmic images of abstract painters from Odilon Redon and Sérusier through Kupka and Georgia O'Keeffe to Mark Rothko and Gordon Onslow-Ford among many others. In his essay in this volume Charles Eldredge makes clear the impact that Emerson had on the later European Symbolists, including Maeterlinck, who translated Emerson's work for an appreciative French and Belgian audience. Between Emerson and the pioneering American paint-

ers of the 1910s only Ryder intervenes as a spiritual painter of strength who possessed a resonant vision that was neither illustrative nor facile. Emerson was correct when he predicted in 1845, "After this generation one would say mysticism should go out of fashion for a long time."[81]

As noted earlier, mysticism in American art at the turn of the century was nature oriented and nonsacred in its associations. Painters of appropriate disposition generally began with landscape imagery, and their work gradually became abstract. Dove's paintings before 1920 coincide with his interest in vitalism; works after 1920 were directly inspired by Theosophy and reflect his interest in astrology, occult numerology, and the cabala.[82] Hartley's early involvement with the occult is evident in works inspired by Native American art, such as *Painting No. 48, Berlin,* 1913 (see p. 120). Certain of Hartley's Berlin abstractions made around 1914 refer to Paracelsus and to the English mystic Richard Rolle. O'Keeffe was influenced by texts in Alfred Stieglitz's *Camera Work,* particularly by Max Weber's 1910 essay on the fourth dimension. She conceived of making abstract paintings in a serial manner as early as 1918 (her watercolors date from

1916). *Blue Line 1,* 1918, and *Series 1 No. 1* and *Series 1 No. 8,* both of 1919 (pls. 25–26), were identified by the artist as part of a group of works titled with numbers rather than landscape evocations.[83]

At a time when abstraction was unpopular in the United States, especially outside New York, a remarkable fusion of the spiritual and the abstract occurred in Taos, New Mexico, when Raymond Jonson and Emil Bisttram founded the Transcendental Painting Group in 1938.[84] Chaired by Jonson (pl. 27), the group included Agnes Pelton, the Canadian artist Lawren Harris, and others who were involved with Theosophy. Kandinsky certainly influenced all these artists; *On the Spiritual in Art* no doubt was known to, if not read by, all members of the group. Jonson had read Kandinsky as early as 1921.[85] Later he was to recall that he experienced mystical sensations in 1929 and began a period of "really abstract" painting. He cited several key ways that the spiritual is expressed in art, particularly the use of occult symbols, as in Bisttram's work

(pl. 28), and the "purely imaginative," or "absolute," way that he intended for himself.[86] Another important influence upon the New Mexican Transcendentalists came from the Russian émigré Nikolai Roerich, who lived in Santa Fe in 1921 and directly affected the development of Bisttram and Jonson. They participated in the group founded by Roerich called Cor Ardens (flaming heart), which was dedicated to "universal expression."[87]

These artists working in New Mexico were not arrivistes, coming late to European abstraction; on the contrary they were seasoned artists. Pelton had an exhibition history dating back to the Armory Show of 1913; Harris had been central to the avant-garde Group of Seven, established in Canada in 1922. Compared with the art of Mondrian's followers in New York, the paintings made by the group in Taos appear strikingly spiritual — amazingly cosmic and symphonic as in

27
RAYMOND JONSON
Composition Four —
Melancholia, 1925
Oil on canvas
46 x 38 in. (116.8 x 96.5 cm)
Mr. and Mrs. Irwin L.
Bernstein, Philadelphia

·

28
EMIL BISTTRAM
Pulsation, 1938
Oil on canvas
60 x 45 in. (152.4 x 114.3 cm)
Lee Ehrenworth

29
LAWREN HARRIS
Untitled, 1939
Oil on canvas
56 x 46 in. (142.2 x 116.8 cm)
Georgia R. de Havenon,
New York
Courtesy Martin Diamond
Fine Arts

.

30
AGNES PELTON
White Fire, c. 1930
Oil on canvas
25 ½ x 21 in. (64.8 x 53.3 cm)
The Jonson Gallery of the
University Art Museum,
University of New Mexico,
Albuquerque

.

31
JEAN ARP
Flower Veil, 1916
Oil on wood
24 ⁷⁄₁₆ x 19 ¹¹⁄₁₆ x 3 ⅛ in.
(62 x 50 x 8 cm)
Haags Gemeentemuseum,
The Hague

.

Harris's *Untitled,* 1939 (pl. 29), or startlingly personal, yet strongly declarative of mystical intentions, as in Pelton's *White Fire,* circa 1930 (pl. 30) — and serve almost as manifestos about spiritual vibrations and the connections between above and below.

Abstract art that had developed during World War I benefited from the example of Kandinsky's nonfigurative formal vocabulary, and many European artists absorbed his vocabulary as well as various occult texts. The development of artists who could utilize pre-existing abstract forms naturally differed from that of the first generation of abstract pioneers, who greatly feared that meaning might be lost along with the discarded object. Artists of a later generation, such as Jean (Hans) Arp (pl. 31), accepted that abstract art was meaningful and indeed spoke to deep philosophical issues. He wrote, "The starting-point for my work is from the inexplicable, from the divine."[88] A single, quivering, inexact shape recurs in Arp's work: the Ur-form, the double-ellipse, "that archetypal figure, a designation of certain closed curves

that resemble the figure 8, described by Goethe in his poem 'Epirrhema': Nothing's inside, nothing's outside, / For what's inside's also outside. / So, do grasp without delay / Holy open mystery."[89]

Arp's interest in mystical and occult sources has parallels in the work of other artists who explored the possibility of a basic form underlying all life and the meaning of dualities in the cosmos. It is certainly true that Dada in Zurich, under Arp's influence, had considerably more of an occult orientation than Dada in Berlin or Paris. Occult ideas, for example, clearly lay beneath the decision to use low-grade materials to make high art. Something else that characterized the Zurich Dadaists Arp, Hugo Ball, Tristan Tzara, and Richard Hülsenbeck was "the secret patterning of that flux, the coexistence of dynamic chaos with elusive order," as Richard Sheppard wrote when he traced Dada's origins in Böhme, Lao-tzu, Chuang-tzu, Meister Eckhart, and Zen.[90] Despite a few noteworthy exceptions, however, the Dadaists generally can be characterized as having nonabstract goals. Aside from Arp, the most notable exception to this, however briefly he may have been interested in mystical concepts, is Kurt Schwitters. John

Elderfield recently assessed the spiritual influences upon Schwitters: a belief in animism and hylozoism and Kandinsky's ideas of the inner sound. Schwitters was delighted by Herbert Read's citation of "the mystic" in his work.[91] In 1924, when Schwitters called Dada "the spirit of Christianity in the realm of art,"[92] he was working on two canvases (pls. 32–33) of an unusually geometric cast, relating to the golden section, paintings that play on proportions and measurement in a distinctive manner.

Duchamp's involvement with the occult, a fascination tempered by his intellectualism, humor, irony, and detachment, is manifested in much of his work, especially in *The Large Glass,* 1915–23 (see p. 265). The main visual sources for Duchamp's interest in nonretinal matters, as first cited by Jean Clair, are the photographs by Charles Brandt and other photographers presented in Albert de Rochas d'Aiglun's 1895 volume, *L'Extériorisation de la sensibilité,* a compendium of spiritualism and psychokinesis.[93] Duchamp was also influenced by the involvement of his brother Raymond Duchamp-Villon with psycho-physiological thought and by Kupka's ideas

32
KURT SCHWITTERS
Constructivist Composition,
1923–24
Oil on canvas
23 5/8 x 19 11/16 in. (60 x 50 cm)
Private collection,
Amsterdam

·

33
KURT SCHWITTERS
Abstract Composition, 1923–25
Oil on canvas
30 x 20 in. (76.2 x 50.8 cm)
Haags Gemeentemuseum,
The Hague

·

34
SUZANNE DUCHAMP
*Vibrations of Two Distant
Souls*, 1916–18–20
Oil and various collage
elements on canvas
28 9/16 x 19 1/2 in.
(72.5 x 49.5 cm)
Private collection

·

35
SUZANNE DUCHAMP
*Multiplication Broken and
Restored*, 1918–19
Oil and collage with silver
paper on canvas
24 x 19 11/16 in. (61 x 50 cm)
Private collection

·

36
SUZANNE DUCHAMP
Masterpiece: Accordion, 1921
Oil, gouache, and silver leaf
on canvas
39 5/16 x 31 7/8 in.
(99.8 x 80.9 cm)
Yale University Art Gallery,
New Haven, Connecticut
Gift of Katherine S. Dreier to
the Collection Société
Anonyme

·

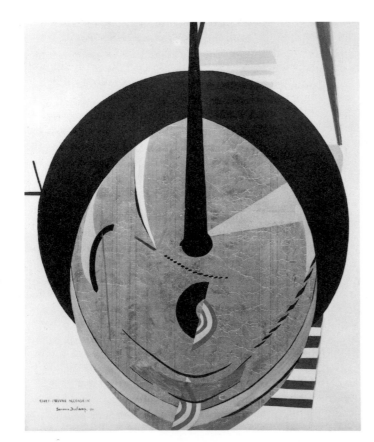

on spiritualism, which Kupka shared with Duchamp while the two were neighbors in Puteaux in 1901. Duchamp read extensively on alchemy, androgyny (manifested in his Rrose Sélavy persona), the tarot, and the fourth dimension. He created plastic metaphors from the literature of occult symbolism and insisted on the importance of the artist as a parareligious leader in modern life. During a three-month sojourn in Munich in 1912 Duchamp purchased Kandinsky's *On the Spiritual in Art* and conceived the plan for his *Large Glass*. He translated the most important passages of *On the Spiritual in Art* from German into French, line by line, probably for his brothers, Raymond Duchamp-Villon and Jacques Villon, who read no German.[94] (In the exhibition *The Spiritual in Art* Duchamp's copy of Kandinsky's book, with his own extensive translations, is presented.) The effect of Kandinsky's ideas upon Duchamp merits further investigation.

Maurizio Calvesi has recently uncovered likely sources for Duchamp's film *Anemic Cinema,* made with revolving disks, nine of

which carry word plays arranged in spirals, alternating with ten disks featuring abstract spirals. The combination of letters and numbers rotating in a celestial wheel, or zodiac, can be traced to the cabala and alchemy. In writings by Athanasius Kircher are found other references to "anemic machines" that pertain to the etymology of *anemia* in the words *breath* and *soul*. The soul is the mysterious force that animates Duchamp's "half-ironic, half-sympathetic, 'high-spirited' and 'spiritual'" expressiveness.[95] Certain artists deeply affected by Duchamp, including his sister, Suzanne, and her husband, Jean Crotti, who together invented Tabu-Dada, openly examined occult notions in their paintings (pls. 34–38). In Duchamp's work such ideas were characteristically hidden. Picabia was also interested in the occult significance of androgyny, the mystic spiral, and, toward the end of his career, astrology.

Few abstract artists in either Europe or America during the 1930s were involved with spiritual issues. Their reasons coincide with those of the critics and historians who moved away from associating the spiritual with the abstract. A strong international trend toward streamlined design and various forms of utili-

tarianism, moreover, helped to make something as apparently useless as the occult seem trivial or counterproductive. Linking artists with the occult was unpopular at a time when artists often rallied to become art workers.

Surrealism, with its prevailing concern for the ego and the self, only rarely led to abstract art.[96] A notable exception is Matta, whose "psychological morphologies," circa 1939–43 (see p. 230), are paintings involved with ideas of selflessness, in which each figure and object is formed by the action and interaction present around them. Yet another exception of consequence is the ongoing development of Onslow-Ford. As Linda Henderson documents in this book, Matta and Onslow-Ford arrived at an understanding of philosophy and metaphysics through reading various literary and mystical texts, such as Ouspensky's *Tertium Organum*. In the United States Onslow-Ford founded the Dynaton group

37
JEAN CROTTI
Chainless Mystery, 1921
Oil on canvas
45 ⅞ x 35 ¼ in.
(116.5 x 89.5 cm)
Musée d'Art Moderne de la
Ville de Paris

38
JEAN CROTTI
Circles, 1922
Oil on canvas
36 3/16 x 25 ⅝ in. (92 x 65 cm)
Musée d'Art Moderne de la
Ville de Paris

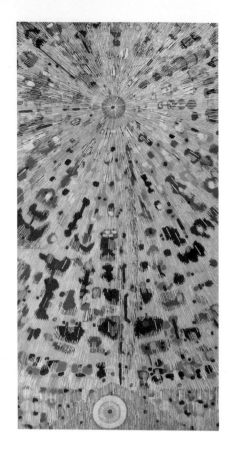

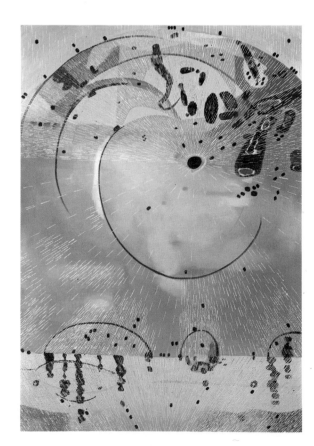

39
WOLFGANG PAALEN
The Cosmogons, 1944–45
Oil on canvas
96 x 94 in. (243.8 x 238.7 cm)
Robert and Edith Anthoine

·

40
LEE MULLICAN
The Ninnekah, 1951
Oil on canvas
50 x 25 in. (127 x 63.5 cm)
Herbert Palmer Gallery, Los
Angeles

·

41
LEE MULLICAN
The Measurement, 1952
Oil on canvas
50 x 30 in. (127 x 76.2 cm)
Herbert Palmer Gallery, Los
Angeles

·

with Wolfgang Paalen (pl. 39) and Lee
Mullican (pls. 40–41) in 1951. Dynaton was in
a sense a West Coast alternative to Abstract
Expressionism and was characterized by a
central attention to Zen, the *I Ching,* and the
tarot. The group was especially interested in
Herbert Read's novel *The Green Child* (1948);
Kenneth Rexroth, in his introduction to the
book, ranked it as a classic of mystical lit-
erature and compared it with the writings of
William Blake. Read wrote vividly of an
imaginary world in which "bells or gongs
were hung everywhere about the country to
guide people from one part to another; for
each direction had its particular note or chime
and only by listening for this sound could an
inhabitant of a country without sun or stars
tell which way to go,"[97] thus evoking the
synesthetic correspondence for a newly
emerging generation. "Without an object to
contemplate, . . . the eyes roll inwards, and
we become blind."[98] Without art, modern
man will lose his way. Read's hero ultimately
"looked forward to that time when the body
is released from the soul, and the soul from
the body, and the body exists in itself. . . .
The soul it is that incites the senses to seek
spiritual satisfactions."[99]

André Breton's interest in the tarot and other aspects of the occult manifested in his novel *Nadja* (1934) were translated pictorially by Matta, Paalen, and Onslow-Ford. Onslow-Ford continues to make objectless, nonreferential painting that stems from automatism and is infused with Zen and the techniques of calligraphy. According to the artist, he "continues the adventure into deep space of Jackson Pollock" from the line, circle, dot configuration to "their fusion into live-line Beings" (see p. 231).[100] Automatism, which was of central interest to the Surrealists and had a long history in the literary and visual arts, did not lead to other abstract art in Europe, despite the fact that it required a spiritual state of mind. Onslow-Ford, while recollecting that "automatism was a luminous word . . . synonymous with the spirit of creation, an ideal toward which a young painter could aspire" — as indeed he, Matta, Joan Miró, André Masson, and other Surrealists of the late 1930s did — has obliquely alluded to its unfulfilled promise. Nevertheless, he acknowledged Pollock's "quantum leap over many inner worlds to arrive in the Great Spaces of the mind . . . [Pollock's paintings] approached a primitive form of universal dimension."[101]

The Abstract Expressionists began painting in an abstract style almost as if Mondrian and Kandinsky never had done so. Nonetheless, in 1945 the exhibition in New York of two hundred paintings by Kandinsky and the reissuing of *On the Spiritual in Art* were of great interest to the emerging Abstract Expressionists. Barnett Newman, Pollock, Adolph Gottlieb, and Rothko may not have shared the so-called spiritual terminology of the earlier antimaterialist philosophies, but they seized upon contemporary counterparts with a fervor fully equal to Mondrian's abiding respect for Blavatsky or Kandinsky's for Steiner. The new American artists became a second wave of abstract pioneers, searching for expressive means appropriate to their generation and asserting the need for universal truths. Their spiritual sources tended to be not Theosophy and Anthroposophy but beliefs and practices associated with native and non-Western cultures: the art of Native Americans (especially Northwest Coast Indian painting), Zen, and Carl Gustav Jung's concepts of archetypal form, including his identification of the mandala in art ranging from that of the North American Indian to that of Asian cultures. In pointing to spiritual sources, Newman steered clear of references to ideas associated with Blavatsky or other occultists definitively out of favor with most New York artists of the 1940s.

Rothko, Newman, and Gottlieb sent an indignant letter to the *New York Times* in 1943 protesting that the purpose behind their art was not being properly understood or taken seriously. Their outrage distinguished them from earlier abstract artists who had been reluctant to discuss the underlying meaning of their work. Indeed, one could say that Kandinsky's fears that abstract art risked becoming mere ornament had been realized in the design-oriented abstraction of the 1930s. Certainly this was Newman's view in the mid-1940s:

The present feeling seems to be that the artist is concerned with form, color and spatial arrangement. This objective approach to art reduces it to a kind of ornament. The whole attitude of abstract painting, for example, has been such that it has reduced painting to an ornamental art whereby the picture surface is broken up in geometrical fashion into a new kind of design-image. It is a decorative art built on a slogan of purism.[102]

To this approach Newman opposed his own intentions and those of Gottlieb, Rothko, Pollock, and others of the emerging New York School:

The present painter is concerned not with his own feelings or with the mystery of his own personality but with the penetration into the world mystery. His imagination is therefore attempting to dig into metaphysical secrets. To that extent his art is concerned with the sublime. It is a religious art which through symbols will catch the basic truth of life. . . . The artist tries to wrest truth from the void.[103]

Newman spoke on behalf of the Abstract Expressionists when he declared that the "new painter feels that abstract art is not something to love for itself, but is a language to be used to project important visual ideas."[104] When he expressed his desire "that the shapes and colors act as symbols" that will elicit "sympathetic participation with the artist's thought,"[105] one is struck by the echo of Baudelaire's yearning "to illuminate things with my mind and to project their reflection upon other minds."

Thomas B. Hess identified the cabala as the source of Newman's "concept of secret symmetry, or of a power hidden within a power."[106] As announced in *Abraham,* 1949, these ideas continued throughout Newman's career in paintings as seemingly diverse as *The Voice,* 1950 (pl. 42), and *Shimmer Bright,* 1968, with their "invisible squares" within rectangles and measured bisections.[107] Hess argued for the relevance of the cabalistic doctrine of *Tsimtsum* (an act of concentration or with-

42
BARNETT NEWMAN
The Voice, 1950
Egg tempera and enamel on canvas
96 1/8 x 105 1/2 in.
(244.1 x 268 cm)
The Sidney and Harriet Janis Collection, gift to The Museum of Modern Art, New York

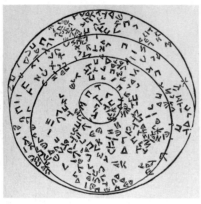

drawal) to the symmetrical zips and flashes of light in Newman's characteristic imagery. Gershom Scholem recounted the description in cabala doctrine when "a space opens up, as within God himself: it is as if God 'contracts' himself. The result is an area empty of God,"[108] a phase in the drama of Creation suggestive of a concept of space that may be taken to be the essential content of Newman's abstract art. Newman's synagogue project model of 1963, with its zigzag windows, is related to Tsimtsum, and the artist's text on the synagogue contained his most direct reference to Jewish mysticism, specifically to "the tension of that *Tsimtsum* that created light and the world."[109] Newman's eloquent description of the synagogue spoke to the ultimate intention of abstract art: "My purpose is . . . to deny the contemplation of the objects of ritual for the sake of that ultimate courtesy where each person, man or woman, can experience the vision and feel the exaltation."[110]

Another source for Newman's "new type of abstract thought," to use his words, can be traced to his seeing the Indian earthwork mounds in Ohio in 1949: "I was confounded by the absoluteness of the sensation, their self-evident simplicity."[111] In this as in many other instances, Native American philosophy and ritual provided sources for these artists, as W.

Jackson Rushing demonstrates in his essay in this book. Native American ways of making art offered an inspirational paradigm to American artists in the 1940s and 1950s. It is remarkable that in his influential essay "American Action Painters" Rosenberg made no connection between the idea of a painting as an arena of action and the ritualistic practices involved in the making of that painting. Ritual was unquestionably at the heart of Pollock's working methods, and it is probably to ritual practice that Willem de Kooning referred when he said that Pollock "broke the ice."

It is important to recognize that in the 1940s the first-generation Abstract Expressionists were already mature artists with considerable experience and intellectual resources. Newman was among the most adventurous curators at work in America. Artists such as Paalen and Gottlieb shared a passion for anthropology and a curiosity for things unknown. Their interest in Kurt Seligmann's articles on magic, published in *View* and other magazines in the 1940s and accompanied by scores of seventeenth-century and other illustrations (pls. 43–44), is indicative of their

range of exploration. These were artists for whom museums were places of learning and libraries were inviting.

If the 1940s and 1950s can be regarded as a period in which Romanticism came to a close, as Brian O'Doherty has suggested, then his insight that two concepts summarize ideas originally dramatized in the nineteenth century — "the quest — the search for transcendence . . . and the void, occupied in part by modernism's self-referential tactics"[112] — can illuminate the spiritual abstraction of this period. Inclining toward the idea of the quest is the biomorphic abstraction formulated by Kandinsky and echoed in the formulations of Rothko (pl. 45) and many others during the 1940s. Inclining toward the idea of the void is the grid, which reflects the horizontal-vertical rigors of Mondrian. The grid is infused with transcendental postulates: the law of correspondences is reflected in its above-below symmetries, for example. In the 1940s Pousette-Dart and Gottlieb filled the grid with content drawn from primitive sources.

Jungian ideas, widely disseminated in New York in the late 1930s and 1940s (especially by John D. Graham in the art world),[113] led to a strong interest in myth and the collective unconscious among American intellectuals. The decade of the 1940s has been referred to as the "mythic forties" because the response by artists to mythology and mythological symbolism was so widespread. The impact of these ideas was first expressed as pictographs, abstract symbols, and bird-and-eye forms. By the 1950s these recognizable symbols gave way to pure abstraction in the works of many artists.

The interest in myth and the unconscious, coupled with an interest in Native American sources, encouraged American artists' receptivity to other non-Western ideas, including Lao-tzu, Zen, and the *I Ching*. The *Singyo,* or *Heart Sutra,* sums up the central meaning of Zen thought, according to Alan Watts: "What is form that is emptiness, what is emptiness that is form."[114] To study a black painting by Ad Reinhardt involves a process similar to Zen meditation — a deceptively simple affair that "consists only in watching everything that is happening, including your own thoughts and your breathing."[115] Granting one's vision sufficient time to perceive the resonant hues and shapes in a painting by Reinhardt is equivalent to the assumption of a

meditative position. Then the painting seems to yield its essence all at once, recalling the comment of an Indian musician: "All music is in the understanding of one note."[116] This interest in Zen was present not only in New York, but also in other parts of the United States. In the Northwest Mark Tobey (pls. 46–48) and Morris Graves (pls. 49–51) made paintings as daring and as abstract as those by their New York counterparts.

Major developments in abstract-spiritual art after the heyday of Abstract Expressionism often pertain to Zen. Key influences include Eugen Herrigel's *Zen in the Art of Archery* and D. T. Suzuki's many writings. John Cage and Merce Cunningham transmitted Zen ideas through their music and dance; younger artists perceived them as living embodiments of Zen thought and action. It is noteworthy that *nothingness,* which came to be a vogue term of the 1960s, is not conceived in Zen as a culminating point but as a stage in the process of spiritual evolution. For example, in the famous fifteenth-century Oxherding series the ox, symbolic of spiritual life, gradually whitens and disappears, so that by the eighth picture (pl. 52) its disappearance is connoted by a circle; but in pictures nine (pl. 53) and ten (pl. 54) the shepherd, not the ox, reappears to

signify his newly gained freedom. Cage's interests in Zen and other non-Western, quasi-occult realms were of particular interest to Jasper Johns and Robert Rauschenberg. Zen ideas were also fundamental to the emerging group of younger abstract painters in Los Angeles, especially Robert Irwin.[117]

In the late 1950s San Francisco, particularly the North Beach area, was invaded by mystical poets and painters from across the country; it also witnessed a blossoming of talent native to the Bay Area. For some of these artists, such as the painter-collagist Jess, the spiritual legacy of and often actual training with Clyfford Still were formative. Still made abstract paintings of great importance, and his absence from the exhibition *The Spiritual in Art* is due only to a lack of understanding about his specific sources as an artist: only cryptic references in his teaching allude to his involvement with mystic belief systems. Abstraction did not thrive in the Bay Area after the mid-1950s. Still left the area, and Richard Diebenkorn turned from abstraction to figurative art.

A remarkable number of occult-abstract images were produced by Jess beginning around 1959 (pl. 55, compare pl. 56), includ-

46
MARK TOBEY
The World Egg, 1944
Egg tempera on canvas
24 ½ x 19 ¼ in.
(62.2 x 48.9 cm)
Carolyn Kizer
Woodbridge
.

47
MARK TOBEY
Totemic Disturbance, 1947
Egg tempera on canvas
14 ½ x 24 ½ in.
(36.8 x 62.2 cm)
Carolyn Kizer
Woodbridge
.

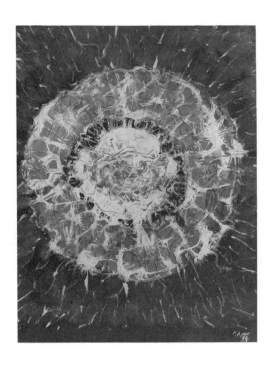

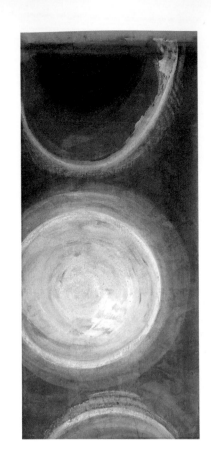

48
MARK TOBEY
Space Rose, 1959
Tempera on paper
15 ¾ x 12 in. (40 x 30.5 cm)
Galerie Jeanne Bucher,
Paris
·

49
MORRIS GRAVES
Rising Moon No. 3, 1944
Tempera on paper
26 ¾ x 12 ½ in.
(67.9 x 31.8 cm)
William Baker and
Peter A. Giarratano,
New York
·

50
MORRIS GRAVES
"Black Buddha" Mandala,
1944
Tempera on paper
26 ½ x 26 ½ in.
(67.3 x 67.3 cm)
Mr. and Mrs. Marshall
Hatch, Seattle
·

51
MORRIS GRAVES
*Twentieth-Century American
Left-Handed Tantra Yantra,
No. 1*, 1982
Tempera on paper
43 ¾ x 26 ½ in.
(111.1 x 67.3 cm)
Charles Campbell Gallery,
San Francisco

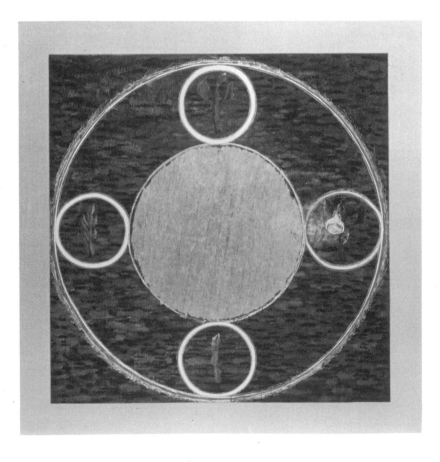

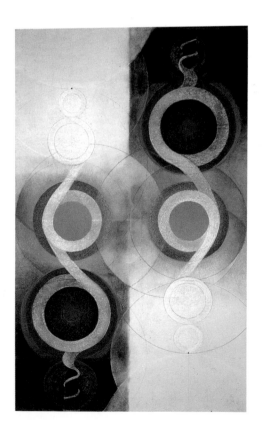

52
No. 8 of oxherding pictures
from D. T. Suzuki, *Manual of
Zen Buddhism* (1960 ed.)

.

53
No. 9 of oxherding pictures
from D. T. Suzuki, *Manual of
Zen Buddhism* (1960 ed.)

.

54
No. 10 of oxherding pictures
from D. T. Suzuki, *Manual of
Zen Buddhism* (1960 ed.)

.

55
JESS
De Macrocosmi Fabrica, 1969
Oil on canvas over wood
36 x 36 in. (91.4 x 91.4 cm)
Mrs. and Mrs. James
Harithas

.

56
De Macrocosmi Fabrica, from
Robert Fludd, *Utriusque cosmi*
(1617)

.

ing certain of his Translations paintings made from 1959 to 1971, and by Wally Hedrick, who began a series of paintings involved with magic and inspired by tarot cards (he was married to a practicing witch at the time). Certain of Hedrick's paintings were also translations — for example, *Hermetic Image,* 1961 (pl. 57), of which he said, "I think of it as a self-portrait."[118] Compare this painterly evocation with its source in the *Hermetic Scheme of the Universe* (pl. 58), after Thomas Norton's *Musaeum hermeticum,* 1749; this image was reproduced and widely seen by artists in Seligmann's *History of Magic* (1948).[119]

In the 1960s, as earlier in the century, it was also possible to make abstract art without reference to spiritual matters. Diebenkorn's return to abstraction in 1966, when he moved to Los Angeles and began his Ocean Park series, is a capital example of resonant abstraction that does not hinge on spiritual content.[120] In Frank Stella's view, sufficient abstract art was created between 1910 and the

mid-1950s for him to use as raw source material. Although Stella has maintained a professional position to the contrary, the fact that his black paintings suggest mandalas as well as tantric diagrams may have been the result of his interest in non-Western ideas. His interest in Celtic illumination, for example, is documented by his studies on the subject at Princeton as an undergraduate. By 1964, however, Stella was adamant that in his art "what you see is what you see."[121] Nevertheless, his black paintings, such as *Getty Tomb,* 1959 (pl. 59), were generally regarded as mandalalike when they were created.

New interest during the late 1960s in tantric diagrams as sources of abstract art was manifested in the exhibition *Fifty Tantric Mystical Diagrams* at the Los Angeles County Museum of Art in 1969. These diagrams were identified as yantras, which are "considered even more potent than an image because being an abstract concept divinity can only be conceived in abstract terms," or mandalas, "geometrical configuration[s] expressing in microcosmic terms the essence of macrocosm. . . . in all such yantras and mandalas the square and the circle predominate. . . . [and] are used in endless permutations."[122]

Ajit Mookerjee's publications *Tantra Art* (1971), *Yoga Art* (1975), and *Tantra Magic* (1978) reproduced many works that inevitably attracted contemporary sensibilities in the 1970s. Johns, for example, has acknowledged the impact of these publications upon his cross-hatch paintings.[123] In 1971 Philip Rawson wrote *The Art of Tantra* for a popular exhibition sponsored at the Hayward Gallery in London, and eight years later he published *Tantra: The Indian Cult of Ecstasy.* Serious scholarship is required to document tantras and their provenances; even more research needs to be devoted to the influence of tantric ideas upon European and American art. Similarly, the influence of Lao-tzu upon early twentieth-century European art in particular has yet to be systematically charted and will undoubtedly yield many provocative connections.

That certain contemporary artists incorporate mystical and occult ideas into their paintings is quite extraordinary when one considers how the audience for art has changed. In the 1890s private societies and small groups constituted the primary audience for works by

Symbolist artists; often artists' groups themselves were their own audience. Such coteries continued to be the painters' audience until the 1960s, when the audience for art became a mass audience. Art must now be comprehensible, or at least appear to be comprehensible, to this new, frequently immense group. Occultism, with its references to hidden meanings, is problematic when it becomes part of the content of contemporary art. The fact that Brice Marden, for example, with his interest in alchemical and numerological systems, makes works (pl. 60) today that are patently occult in meaning raises intriguing questions about the continuing role of the spiritual as a viable factor in serious contemporary abstract painting.

Minimalism, to date, has been insufficiently related to mystical thought, although certain artists, such as Marden, Yves Klein, and Carl Andre, have openly acknowledged their interest in alchemy. More recently, Sigmar Polke has utilized alchemy in both abstract and

60
BRICE MARDEN
Green Study, 1982
Oil on canvas
24 x 72 in. (61 x 182.9 cm)
Collection of Vance E.
Kondon, M.D.

61
SIGMAR POLKE
Yggdrasil, 1984
Silver, silver oxide, silver
nitrate, and natural resin on
canvas
119 x 88 ½ in. (303 x 225 cm)
Saatchi Collection,
London
·

62
MATT MULLICAN
*Untitled, (Subject, Sign, World
Framed),* 1985
Oil crayon on canvas
120 x 120 in.
(304.8 x 304.8 cm)
Collection of
Eva and Murray Roman
Promised gift to The Santa
Barbara Museum of Art,
California
·

hauntingly majestic, albeit representational
modes (pl. 61). Minimalist art's greatest
expressiveness occurred not on the wall but in
space. Minimalist sculpture, the extraction of
certain wall-bound ideas into room-sized pre-
sentations, represents an embodiment of mys-
ticism in more recent art. Minimalism is
linked to current artistic concerns in the work
of Robert Irwin and James Turrell. These
Los Angeles artists became interested in
synesthesia during their experimentation at
the Jet Propulsion Laboratory from 1967 to
1971, as participants in the Los Angeles
County Museum of Art's Art and Technol-
ogy Program. Among their projects was a test
of the relationship between the taste of certain
beers and corresponding sounds. They found
significant similarities; Irwin and Turrell sepa-
rately identified the same tone and taste as
directly related to particular lagers.[124] This
parallels the experience of Des Esseintes, the
Symbolist hero par excellence in Joris-Karl
Huysmans's novel *À rebours* (1884), and his
synesthetic associations between the drinking
of assorted liqueurs and identifying particular
tones and sounds, liqueurs substituting for
musical notes on a keyboard of tastes.

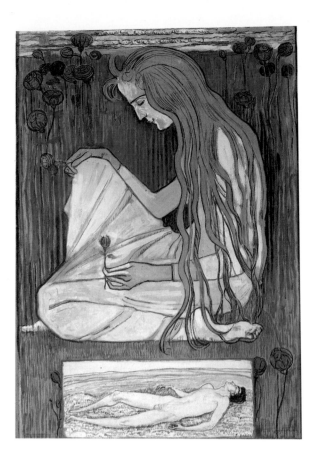

Although their creations define inhabitable spaces rather than discrete objects, the impulses of Irwin and Turrell toward immaterialization and toward the invisible transport the question of abstraction into a real and material world. In the hands of other artists in the 1980s, including such an innovative younger figure as Matt Mullican, the medium of painting still serves as an expressive vehicle for antimaterialist belief systems (pl. 62). Mullican has turned to hypnosis and often entered the trance state to free his imagining of pictorial configurations. Anthropology, the study of Native American sign systems, and sensitivity to the idea of microcosm-macrocosm persuasively fuse in his work and form fresh, evocative cosmogonies.

From yet another vantage the search for abstraction, the means to communicate that which is otherwise impossible to project, has come full circle: the inchoate abstraction of the Symbolist generation now reappears in the paintings of contemporary artists, who have so thoroughly absorbed lessons drawn from the history of nonrepresentation as to make the issue of abstraction less poignant. For example, a comparison of Hodler's *The Dream,* 1897 (pl. 63), with Bruno Ceccobelli's *Etrusco Ludens,* 1983 (pl. 64), shows that the image conjured in the earlier work is assimi-

lated pictorially and imaginatively in the recent painting. Indeed, this complete absorption of the unknown into the frankly expressed could not have occurred without the invention, development, and continual reinvention of abstract painting between the 1890s and the current period.

Another image may be taken as a veritable icon of this utter assimilation of abstraction in contemporary art. Anselm Kiefer, who is not interested in abstraction per se, created in 1976 an immense canvas entitled *Piet Mondrian: Arminius' Battle* (pl. 65). The painting depicts the growth of a tree from the vertical-horizontal abstraction of Mondrian. Just as Mondrian transformed the tree image, moving from representation to abstraction, with a mediating infusion of mystical ideas, so Kiefer now reverses the creative process by creating an image that commences from antimateriality and then evokes the meaning of a tree in winter. Arminius's victory over the

Roman invaders several years after the death of Christ was a triumph secured by the secret gathering of a great force of allies, and in a sense so, too, was the victory of Mondrian and his colleagues in the formulation of abstraction in the 1910s. Kiefer's transcendence of the abstract-representational polarity is a brilliant icon, a statement that true spiritual abstraction need no longer be doctrinaire in its exclusiveness.

63
FERDINAND HODLER
The Dream, 1897
Watercolor on paper
remounted on board
37 ⅜ x 25 ⅝ in. (95 x 65 cm)
Private collection,
Zurich, Switzerland

·

64
BRUNO CECCOBELLI
Etrusco Ludens, 1983
Oil and wax on paper
mounted on wood
78 x 93 in. (198.1 x 236.2 cm)
Sperone Westwater, New
York

·

65
ANSELM KIEFER
*Piet Mondrian: Arminius'
Battle,* 1976
Oil on canvas
96 7/16 x 44 1/4 in.
(245 x 112.5 cm)
Geert Jan Visser, on long-
term loan to the Stedelijk van
Abbemuseum, Eindhoven,
Netherlands

．

The first draft of this essay was
prepared by Judi Freeman, asso-
ciate curator of twentieth-century
art, on the basis of fifteen hours of
transcribed discussions taped in
June–July 1985. I am grateful to
Ms. Freeman for this effort and
for carefully reviewing subse-
quent drafts of the essay.

Many artists whose work is not
presented in the exhibition offered
suggestions and insights into the
spiritual and modern art; among
them are Avigdor Arikha, John
Baldessari, Susan Crile, Gianni
Dessi, Richard Diebenkorn, the
poet Robert Duncan, Newton
Harrison, David Hockney, Nancy
Holt, R. B. Kitaj, Sol LeWitt,
Roy Lichtenstein, Ann McCoy,
John McCracken, Isamu
Noguchi, Kenneth Noland, Frank
Stella, and James Turrell.

1. Arthur Jerome Eddy, *Cubists
and Post-Impressionism* (Chicago:
McClurg, 1914), 122.

2. Ibid., 134.

3. Sheldon Cheney, *A Primer of
Modern Art* (New York: Boni &
Liveright, 1924), 162, 166, 174.

4. Sheldon Cheney, *Expressionism
in Art* (New York: Liveright,
1934), 315.

5. Sheldon Cheney, *Men Who
Have Walked with God* (New York:
Knopf, 1945), 216.

6. The term *ariosophy* was coined
by Jorg Lanz von Liebenfels, who
founded the Order of the New
Templars in 1907 and published
the magazine *Ostara* to promul-
gate the development of a new
race of "Aryan heroes." Adolf
Hitler's lieutenants incorporated
Liebenfels's theories into their
concept of "race mysticism."
Race mysticism was also antici-
pated in the late 1890s by the Ger-
man writer Julius Langbehn, who
in his *Rembrandt the Educator*
(1890) described a movement "to

transform Germans into artists,"
men possessed of a cosmic life-
force that would inspire national
self-renewal. See James Webb,
The Occult Establishment (LaSalle,
Ill.: Open Court, 1976), 277, 281;
and G. L. Mosse, "The Mystical
Origins of National Socialism,"
Journal of the History of Ideas 22
(January–March 1961): 82–89.

7. Otto Wagener, *Hitler: Memoirs
of a Confidant,* ed. Harry Ashby
Turner, Jr., and trans. Ruth Hein
(New Haven and London: Yale
University Press, 1978), 35, 38.
Other notions of Hitler's in this
memoir also pertain to recent
historiographic studies of modern
art, for example, when he praised
the primitivism in German folk
art, pointing to "the carvings of
the Black Forest, in the alpine vil-
lages, or in the Erz Mountains,
pottery in the Fichtel Mountains
and elsewhere, cottages where
they were weaving and hooking
rugs and so much else" (p. 310).
From this Hitler directly in-
structed Joseph Goebbels to "see
the future of your duties, as they
relate to art, especially painting"
(p. 311).

8. The only contemporary writer
discussing the link between Na-
zism, occultism, and modernism
was T. H. Robsjohn-Gibbings in
1947. In what may only be char-
acterized as a hysterical diatribe,
Robsjohn-Gibbings, who consid-
ered abstract and modern art to be
a product of the insane, argued
that modern art was the by-
product of the supernatural,
primitive magic, and the Asian
occult: "In this year of grace 1947,
modern art is still deeply involved
in this miasma of the ancient sys-
tems of magic" (T. H. Robsjohn-
Gibbings, *Mona Lisa's Mustache:
A Dissection of Modern Art* [New
York: Knopf, 1947], 14–16).

9. Richard Pousette-Dart, inter-
view with author and Judi Free-
man, New York, 12 March 1985.

10. Alfred Barr's discussion of
abstract painting's meaning sum-
marized his formalist point of
view. "An abstract painting," he
wrote, "is really a most positively
concrete painting since it confines
the attention to its immediate,
sensuous, physical surface far
more than does the canvas of a
sunset or a portrait" (Alfred Barr,
Cubism and Abstract Art, exh. cat.
[New York: Museum of Modern
Art, 1936], 11–13).

11. See, for example, Clement
Greenberg, "The Crisis of the Ea-
sel Picture" (1948) and "On the
Role of Nature in Modernist
Painting" (1949), in idem, *Art and
Culture* (New York: Beacon,
1961), 154–57, 171–74,
respectively.

12. Harold Rosenberg, "The
American Action Painters," *Art
News* 51 (September 1952): 344.

13. Ibid., 342. It is curious that,
despite his passionate promotion
of action painting, Rosenberg
acknowledged Walt Whitman's
"gangs of cosmos," a "discipline
of vagueness by which one pro-
tects oneself from disturbance
while keeping one's eyes open for
benefits; and the discipline of the
Open Road of risk that leads to
the farther side of the object and
the outer spaces of the conscious-
ness." Rosenberg situated
Abstract Expressionism some-
where between Christian Science
and Whitman's mysticism, calling
the latter "serious" because Whit-
man "wanted the ineffable in *all*
behavior — he wanted it *to win the
streets.*"

14. Meyer Schapiro, "Nature of
Abstract Art" (1937), in idem,
Modern Art, Nineteenth and Twenti-

eth Centuries: Selected Papers (New York: Braziller, 1978), 187, 195.

15. Sixten Ringbom, "Art in the 'Epoch of the Great Spiritual': Occult Elements in the Early Theory of Abstract Painting," *Journal of the Warburg and Courtauld Institutes* 29 (1966): 386–418; idem, *The Sounding Cosmos: A Study in the Spiritualism of Kandinsky and the Genesis of Abstract Painting,* Acta Academiae Aboensis, ser. A, XXXVIII (Åbo, Finland: Åbo Akademi, 1970); Robert P. Welsh, *Piet Mondrian 1872–1944,* exh. cat. (Toronto: Art Gallery of Toronto, 1966); and idem, "Mondrian and Theosophy," in *Piet Mondrian 1872–1944: A Centennial Exhibition* (New York: Solomon R. Guggenheim Museum, 1971), 35–52.

16. Robert Rosenblum, *Modern Painting and the Northern Romantic Tradition: Friedrich to Rothko* (New York: Harper & Row, 1975).

17. Otto Stelzer, *Die Vorgeschichte der abstrakten Kunst* (Munich: Piper, 1964).

Noteworthy among recent scholarship are Laxmi P. Sihare, "Oriental Influences on Wassily Kandinsky and Piet Mondrian, 1909–1917" (Ph.D. diss., New York University, 1967); Carel Blotkamp et al., *Het Nieuwe Wereldbeeld: Het begin van de abstracte kunst in Nederland 1910–25* (The new image of the world: The beginning of abstract art in the Netherlands 1910–25), exh. cat. (Utrecht: Centraal Museum, 1972); Rose-Carol Washton Long, "Kandinsky and Abstraction: The Role of the Hidden Image," *Artforum* 10 (June 1972): 42–49; idem, *Kandinsky: The Development of an Abstract Style* (Oxford: Clarendon Press, 1980); Arturo Schwarz, "The Alchemist Stripped Bare in the Bachelor, Even," in *Marcel Duchamp,* exh. cat., ed. Anne d'Harnoncourt and Kynaston McShine (Philadelphia Museum of Art and Museum of Modern Art, New York, 1973), 81–98; Maurizio Calvesi, *Duchamp invisible: La costruzione del simbolo* (Rome: Officina, 1975); idem, "Essendo dati: 1. La

fame, 2. Il sesso," in *Avanguardia di Massa* (Milan: Feltrinelli, 1978); idem, "Duchamp und die 'Gelehrsamkeit,'" in *Marcel Duchamp,* exh. cat. (Cologne: Museum Ludwig, 1984), 61–69; Meda Mladek, "Central European Influences," in Meda Mladek and Margit Rowell, *František Kupka 1871–1957: A Retrospective,* exh. cat. (New York: Solomon R. Guggenheim Museum, 1975), 13–46; Harriett Watts, *Chance: A Perspective on Dada* (Ann Arbor: UMI Press, 1975); John Bowlt, "The Blue Rose," *Burlington Magazine* 118 (August 1976): 566–74; idem, "The Spirit of Music," in *Die Kunstismen in Russland,* exh. cat. (Cologne: Galerie Gmurzynska, 1977), 5–18; idem, "Symbolism and Modernism in Russia," *Artforum* 16 (November 1977): 40–45; Jean Clair, *Duchamp et la photographie* (Paris: Chêne, n.d.); Ulf Linde, "L'Ésotérique," in *L'Oeuvre de Marcel Duchamp,* exh. cat. (Paris: Musée National d'Art Moderne, 1977), 60–85; W. Sherwin Simmons, "The Step Beyond: Malevich and the *Ka,*" *Soviet Union* 5, pt. 2 (1978): 149–70; Geurt Imanse, "Die Entwicklung der abstrakten Kunst und das kunstlerische Klima von 1900 bis 1915" and "Die Jahre 1915–1918: Entstehung von De Branding und De Stijl," both in Geurt Imanse et al., *Van Gogh bis Cobra: Holländische Malerei 1880–1950,* exh. cat. (Stuttgart: Verlag Gerd Hatje, n.d.), 104–45, 146–85, respectively; John Steen, "Symbolismus," in Imanse et al., *Van Gogh bis Cobra,* 49–85; Richard Sheppard, "Dadaism and Mysticism: Influences and Affinities," in *Dada Spectrum: The Dialectics of Revolt,* ed. Stephen Foster and Rudolf Kuenzli (Madison, Wis., and Iowa City: University of Iowa/Coda Press, 1979), 91–114; Charlotte Douglas, *Swans of Other Worlds: Kazimir Malevich and the Origins of Abstraction in Russia* (Ann Arbor: UMI Research Press, 1980); Charles C. Eldredge, *American Imagination and Symbolist Painting,* exh. cat. (New York: Grey Art Gallery and Study Center, New York University, 1980); *Zeichen des Glaubens. Geist der Avant-Garde: Religiöse Tendenzen in der Kunst des 20. Jahrhunderts,* exh. cat., ed.

Wieland Schmidt (Stuttgart and Mailand: Electa/Klett-Cotta, 1980), including notably Hermann Kern, "Mystik und abstrakte Kunst," 127–31; and Tom Gibbons, "Cubism and 'The Fourth Dimension' in the Context of the Late Nineteenth-Century and Early Twentieth-Century Revival of Occult Idealism," *Journal of the Warburg and Courtauld Institutes* 44 (1981): 130–47.

A popular account of occult symbolism in art was published by Fred Gettings, *The Hidden Art* (London: Studio Vista, 1978), with a chapter on Mondrian and Kandinsky that draws upon Ringbom and other researchers and is informative about many occult sources.

Of special importance was work by Linda Dalrymple Henderson, including "A New Facet of Cubism: 'The Fourth Dimension' and 'Non-Euclidean Geometry' Reinterpreted," *Art Quarterly* 34 (Winter 1971); "The Artist, 'The Fourth Dimension' and Non-Euclidean Geometry 1900–1930: A Romance of Many Dimensions" (Ph.D. diss., Yale University, 1975); and *The Fourth Dimension and Non-Euclidean Geometry in Modern Art* (Princeton: Princeton University Press, 1983).

18. *The Mystic North: Symbolist Landscape Painting in Northern Europe and North America 1890–1940,* exh. cat., ed. Roald Nasgaard (Toronto: University of Toronto Press, 1984).

19. *Towards a New Art: Essays on the Background to Abstract Art 1910–1920,* exh. cat., ed. Michael Compton (London: Tate Gallery, 1980), 7.

20. For an interesting discussion of the underlying ideas of mystical thought, see John Senior, *The Way Down and Out: The Occult in Symbolist Literature* (1959; New York: Greenwood Press, 1968), 39–41.

21. See *The Other Bible,* ed. Willis Barnstone (New York: Harper & Row, 1984), which includes texts from early cabala, the Dead Sea Scrolls, Hermes Trismegistus, diverse Gnostic texts, the Zohar, the Book of Radiance, and Plotinus's *Enneads,* including "The Ascent to Union with the One."

22. James Webb, *The Occult Establishment* (Lasalle, Ill.: Open Court, 1976), 17–18.

23. Quoted in Georges Poulet, *The Metamorphoses of the Circle,* trans. Carley Dawson and Elliott Coleman (1961; Baltimore: Johns Hopkins Press, 1966), XIX–XX.

24. Quoted ibid., 288.

25. Quoted ibid., 266.

26. Quoted ibid., 266.

27. Quoted ibid., 138.

28. Quoted ibid., 138.

29. Quoted in Marshall Brown, *The Shape of German Romanticism* (Ithaca: Cornell University Press, 1979), 18.

30. Caroline Boyle-Turner to author, 10 October 1985. I am indebted to Boyle-Turner for sharing these insights with me; see also Caroline Boyle-Turner, *Paul Sérusier* (Ann Arbor: UMI Press, 1983).

31. Nigel Pennick, *Sacred Geometry: Symbolism and Purpose in Religious Structures* (New York: Harper & Row, 1980), 8, 12–13.

32. Quoted in Richard Boyle, foreword to Abraham A. Davidson, *The Eccentrics and Other American Visionary Painters* (New York: Dutton, 1978), xv.

33. Quoted in *Feininger/Hartley,* exh. cat. (New York: Museum of Modern Art, 1944), 61.

34. Henri Focillon, *The Life of Forms in Art* (New York: Wittenborn Schulz, 1948); and George Kubler, *The Shape of Time: Remarks on the History of Things* (New Haven: Yale University Press, 1962), especially chap. 2, 31–61.

35. Misook Song, *Art Theories of Charles Blanc 1813–1882* (Ann Arbor: UMI Press, 1984), 21.

36. Ibid., 67. Song develops an insight made by Herschel Chipp (*Theories of Modern Art* [Berkeley and Los Angeles: University of California Press, 1969], 94) and makes a compelling etymological comparison between Blanc's *Grammaire* and Denis's theories to prove Blanc's influence on the formulation of Symbolist theories.

In 1970 Ringbom (*The Sounding Cosmos,* 122 n. 20) identified the link between Humbert de Superville's "unconditional signs in art," made famous by Blanc, and Kandinsky's knowledge of them in their reproduction in

Albert de Rochas d'Aiglun's *Les Sentiments: La Musique et le geste* (1900).

Blanc's ideas fused with those of Humbert de Superville and spread in the Netherlands beginning with the publication of J. van Vloten's *Aesthetica of Schoonheidskunde, in losse hoofdstukken, naar uit- en inheemsche bronnen, voor Nederland geschetst* (Aesthetics or knowledge of beauty, in separate chapters, according to foreign and native authorities, prepared for the Netherlands) (1865), as Carel Blotkamp reveals here in his essay.

37. Charles Baudelaire, *The Painter of Modern Life and Other Essays,* trans. and ed. Jonathan Mayne (London: Phaidon, 1964), 49.

38. Ibid., 117.

39. See Christopher McIntosh, *Éliphas Lévi and the French Occult Revival* (New York: Samuel Weiser, 1974), 198. Maurice Levaillant, *La Crise mystique de Victor Hugo (1843–1856): D'après des documents inédits* (Paris: Librairie José Corti, 1954) is the source for McIntosh. With 1985 marking the centenary year of his death, new findings concerning Hugo's abstract-occult watercolors may emerge.

40. Baudelaire, *Painter of Modern Life,* 116.

41. Quoted in Howard Risatti, "Music and the Development of Abstraction in America: The Decade Surrounding the Armory Show," *Art Journal* 39 (Fall 1979): 9.

42. Quoted ibid., 11.

43. Meyer Schapiro stressed the content of Impressionism (and that of Cubism as well) in lectures at Columbia University commencing in the 1930s and in numerous essays, such as "The Apples of Cézanne: An Essay on the Meaning of Still Life" (1968), in Schapiro, *Modern Art,* in which, it is interesting to note, he referred to Jakob Böhme's epiphany upon a light-struck pewter object. In "Mondrian" (1978), ibid., Schapiro demonstrates "the continuity of abstract painting

with the preceding figurative art, a connection which is generally ignored," discussing Degas in particular, pp. 238–41, 250.

On the iconography of Impressionism, see Paul Tucker, *Monet at Argenteuil* (New Haven: Yale University Press, 1982); Richard Brettell, "Pissarro and Pontoise: The Painter in a Landscape" (Ph.D. diss., Yale University, 1977); Robert L. Herbert, "Method and Meaning in Monet," *Art in America* 67 (September 1979): 90–108; and *A Day in the Country: Impressionism and the French Landscape,* exh. cat. (Los Angeles: Los Angeles County Museum of Art, 1984).

44. Carla Lathe, *Edvard Munch and His Literary Associates,* exh. cat. (Norwich, England: Library, University of East Anglia, 1979), 12, 21–23.

45. Quoted in Carla Lathe, "Edvard Munch and the Concept of 'Psychic Naturalism,'" *Gazette des Beaux-Arts,* 6th ser., 93 (1979): 136.

46. Ibid., 135, 143.

47. Quoted in Dieter Koepplin, "Gespräche mit Beuys und Baselitz über Edvard Munch," in *Edvard Munch: Sein Werk in schweizer Sammlungen,* exh. cat. (Basel: Kunstmuseum, 1985), 140, 146.

48. T. J. Jackson Lears, *No Place of Grace: Antimodernism and the Transformation of American Culture 1880–1920* (New York: Pantheon, 1981), 212.

49. Ibid., 407; and quoted ibid., 175.

50. William James, *The Varieties of Religious Experience* (1902; New York: Penguin, 1982), 388.

51. Wassily Kandinsky, *On the Spiritual in Art* (1912), in *Kandinsky: Complete Writings on Art,* ed. Kenneth C. Lindsay and Peter Vergo (Boston: G. K. Hall, 1982), 1:151–52.

52. Ibid., 207.

53. Ibid., 213.

54. Jonathan David Fineberg, *Kandinsky in Paris 1906–07* (Ann Arbor: UMI Press, 1984), 25–26, 32, 86–87; and Peg Weiss, *Kandinsky in Munich* (Princeton: Princeton University Press, 1979), 22–27.

55. See Ringbom, *The Sounding Cosmos;* and his essay in this book.

56. Sixten Ringbom, "Die Steiner-Annotationen Kandinskys," in *Kandinsky und München: Begegnungen und Wandlungen 1896–1914,* exh. cat., ed. Armin Zweite (Munich: Städtische Galerie im Lenbachhaus, 1982), 102–5.

57. Ringbom, *The Sounding Cosmos,* 121–22; see also 119–30.

58. Ibid., 127–28.

59. I am indebted to Meda Mladek for discussing with me Kupka and his origins and for her groundbreaking essay, "Central European Influences," in Mladek and Rowell, *Kupka,* 15, 17, 28–37. I would also like to thank Krysztina Passuth for her insights and suggestions regarding Kupka in the context of the exhibition *The Spiritual in Art.*

60. Quoted in Mladek, "Central European Influences," 26.

61. Quoted ibid., 63.

62. Quoted ibid., 28–29.

63. This topic has been most comprehensively examined by Henderson in her seminal book, *The Fourth Dimension.*

64. See Gibbons, "Cubism and 'The Fourth Dimension,'" 130–47, and Henderson, *The Fourth Dimension,* 74–103.

65. I am grateful to Henri Dorra for sharing with me his typescript of an interview with Jacques Lipchitz, 1963.

66. This idea was suggested by Krysztina Passuth; see also Krysztina Passuth, "Jakoulov et Picasso," *Cahiers du Musée National d'Art Moderne,* no. 3 (1980): 91–97.

67. Krysztina Passuth, "Le Soleil bleu: Delaunay et les pays de l'est," *Cahiers du Musée National d'Art Moderne* 16 (1985): 109–11.

68. See Pierre Schneider, *Matisse,* trans. Michael Taylor and Bridget Stevens Romer (New York: Rizzoli, 1984), 298–300.

In 1943 the publication of a facsimile edition of *The Apocalypse of Saint-Sever* (c. 1028–72) catalyzed, it has been argued, the formation of Matisse's near-abstract style. Whether Matisse's interest in this and other medieval artwork, including his chapel at Vence, has a spiritual basis remains to be further studied. See *Two Books: The Apocalypse of Saint-Sever, Henri Matisse's Jazz,* exh. brochure, with essay by Avigdor Arikha (Los Angeles: Los Angeles County Museum of Art, 1973).

69. I first examined these with Åke Fant, Gustav af Klint, and Sixten Ringbom in Jarna, Sweden, in October 1984.

70. Germano Celant, "Futurism and the Occult," *Artforum* 19 (January 1981): 35–43.

71. Giovanni Lista, "Futurist Photography," *Art Journal* 41 (Winter 1981): 358.

72. Anton Giulio Bragaglia, *Fotodinamismo Futurista* (1911) (Turin: Giulio Einaudi, 1970), 53.

73. Quoted in Maurizio Fagiolo dell'Arco, *Futurism: Selected Works and Documents* (Rome: DeLuca, 1984), 68.

74. Ibid., 74.

75. Quoted in Birgit Hein, "The Futurist Film," in *Film as Film: Formal Experiment in Film 1910–1975,* exh. cat. (London: Arts Council of Great Britain, 1979), 20.

76. *Ralph Waldo Emerson: Selected Prose and Poetry,* ed. and with an introduction by Reginald L. Cook (San Francisco: Rinehart, 1969), VI.

77. Ibid., 522.

78. Ibid., 13.

79. Quoted in Sherman Paul, *Emerson's Angle of Vision: Man and Nature in American Experiences* (Cambridge: Harvard University Press, 1952), 97–98.

80. Quoted ibid., 98.

81. Quoted in Cook, *Emerson,* 551.

82. See Sherrye Cohn, "Arthur Dove: The Impact of Science and Occultism on His Modern American Art" (Ph.D. diss., Washington University, 1982); idem, "Arthur Dove and Theosophy," *Arts* 58 (September 1983): 86–91.

83. Juan Hamilton, conversation with author, Santa Fe, New Mexico, November 1985.

84. See *The Transcendental Painting Group, New Mexico, 1938–1941,* exh. cat., with introduction by James Monte and Anne Glusker (Albuquerque: Albuquerque Museum, 1982); Robert C. Hay, "Dane Rudhyar and the Transcendental Painting Group of New Mexico 1938–1941" (Ph.D. diss., Michigan State University, 1981); Sharon Rohlfsen Udall, *Modernist Painting in New Mexico 1913–1935* (Albuquerque: University of New Mexico Press, 1984); and Dane Rudhyar, *The Transcendental Movement in Painting* (Taos, 1938).

Martin and Harriet Diamond also provided valuable information on the paintings of the New Mexican Transcendentalists.

85. Udall, *Modernist Painting,* 93.

86. Ibid., 210, 211 n. 20.

87. Ibid., 94, 218 n. 20.

88. Quoted in Michel Seuphor, *The World of Abstract Art* (New York: Wittenborn, 1957), 153.

89. Quoted in Gottfried Richter, *Art and Human Consciousness,* trans. Burley Channer and Margaret Frohlich (Spring Valley, N.Y.: Anthroposophic Press, 1985), 213.

90. Richard Sheppard, "Dada and Mysticism," in *Dada Spectrum: The Dialectics of Revolt,* 98, 104–10.

91. Quoted in John Elderfield, *Kurt Schwitters,* exh. cat. (New York: Thames & Hudson for the Museum of Modern Art, 1985), 93; see p. 394 n. 48 for other mystical interpretations.

92. Quoted in Sheppard, "Dada and Mysticism," 97.

93. Quoted in Clair, *Duchamp et la photographie,* 107.

94. This volume was discovered in 1977 by Pontus Hultén among Jacques Villon's papers; I am grateful to him for bringing it to my attention and for his willingness to lend it to the exhibition.

95. Maurizio Calvesi, "Duchamp und die Gelehrsamkeit," in *Marcel Duchamp,* exh. cat. (Cologne: Museum Ludwig, 1984), 61–69.

96. On Picasso's nonabstract, but occult-related Surrealist work, see Lydia Gasman, "Mystery, Magic and Love in Picasso 1925–1938: Picasso and the Surrealist Poets," 4 vols. (Ph.D. diss., Columbia University, 1981).

97. Herbert Read, *The Green Child* (New York: New Directions, 1948), 159.

98. Ibid., 186.

99. Ibid., 191.

100. Onslow-Ford to author, 27 October 1985.

101. Gordon Onslow-Ford, *Yves Tanguy and Automatism* (Inverness, Calif.: Bishop Pine Press, 1983), 1, 28. One of automatism's most fertile applications is revealed in af Klint's use of it as a catalyzing element.

102. Quoted in Thomas B. Hess, *Barnett Newman,* exh. cat. (New York: Museum of Modern Art, 1971), 37. Hess devoted much of his study to the identification of references to Jewish mysticism given to him by Newman.

103. Quoted ibid., 38.

104. Quoted ibid.

105. Quoted ibid.

106. Quoted ibid., 61.

107. Quoted ibid., 67, 143.

108. Quoted ibid., 84.

109. Quoted ibid., 111.

110. Quoted ibid.

111. Quoted ibid., 73.

112. Brian O'Doherty, *American Masters: The Voice and the Myth in Modern Art* (New York: Dutton, 1982), XVI, XVII.

113. For the best edition of Graham's most important book, see John D. Graham, *System and Dialectics of Art,* with introduction and annotations by Marcia Epstein Allentuck (Baltimore: Johns Hopkins Press, 1971).

114. Alan Watts, *In My Own Way: An Autobiography 1915–1965* (New York: Vintage, 1973), 421.

115. Ibid., 426.

116. Quoted ibid., 450.

117. Robert Irwin, interview with author, Los Angeles, 14 August 1985.

118. Wally Hedrick, telephone interview with author, 17 August 1985. Hedrick also told me of the extensive occult library he had at that time and provided other biographical data. The artist responded to my question about his relationship with Jasper Johns, whose Flags series was shown with Hedrick's work in the Museum of Modern Art exhibition *Sixteen Americans* in 1959, with the statement: "We understood each other."

119. Kurt Seligmann, *The History of Magic* (New York: Pantheon, 1948), pl. 57, p. 154.

120. Frank Stella and Richard Diebenkorn are, among others, notable examples of artists who distinguished their artistic concerns from those presented in the exhibition *The Spiritual in Art.* Diebenkorn responded sensitively to this issue, writing to me, 23 March 1985, after having read the prospectus for the exhibition:

"I have one reservation — otherwise for me it will be a grand show and book. I'm writing this down so that it will come out as I mean it which is usually not the case when I try to put something conversationally.

"You do refer to the 'formal experiments' of Cézanne, Post-Impressionists, and the Cubists as culminating in abstraction and you called it the 'traditional viewpoint.'

"But the over-all impression I get from your *alternative* interpretation is that you give it all to the mystics and the spiritualists in regard to the genesis and development of abstract and non-objective painting. For me, in large part, the prospectus shapes up as a kind of refutation of the traditional viewpoint rather than a much needed illumination of the total picture.

"My exception is based on the fact that abstract painting *was a formal invention.* Also, that major turns or changes in art historical styles are not come by easily, overnight, or by individual artists (another 'traditional viewpoint' tells us that Kandinsky invented non-objective painting). What seems to get lost in your prospectus is that the formalist line from Cézanne through Cubism arrived at a point on the threshold of total abstraction wherein it was implicit, and for the most astute artists a clear option. That both Picasso and Matisse at different points in their careers rejected the crucial step is irrelevant. They had come the distance in a difficult and prolonged process of abstracting and simplifying, as did several of their 'formalist' peers."

"From my view, in about 1910, advanced artists were presented, so to speak, with a vehicle, which in the case of the mystics and spiritualists was made to order for their expressive needs.

"Finally, to compare the early abstractions of Kandinsky wherein the space is chaotic and without intellectual fabric to those of 1910 Analytical Cubism of Braque and Picasso, which cling to objectivity only by virtue of the inclusion of fragments of a pipe or violin, is revealing in matters of awareness, depth, and total concept. In these latter works there is the weight of working and developing within a tradition. It is some time before the mystical converts catch up conceptually and it's perhaps as late as the mature Mondrian or even later with abstract-expressionism that a fully developed abstract fabric and style comparable to Analytical Cubism is realized."

121. "Questions to Stella and Judd," *Art News* 65 (September 1966): 59. This interview, conducted by Bruce Glaser, was edited by Lucy R. Lippard.

122. *Fifty Tantric Mystical Diagrams,* exh. brochure (Los Angeles: Los Angeles County Museum of Art, 1969), with introduction by Maurice Tuchman and Gail Scott and essay by Pratapaditya Pal. This was, surprisingly, the first exhibition of tantric diagrams in an American museum.

123. Jasper Johns, interview with author, New York, 8 February 1986.

124. Jane Livingston documented their experiments in *A Report on the Art and Technology Program of the Los Angeles County Museum of Art 1967–1971,* exh. cat., ed. Maurice Tuchman (Los Angeles: Los Angeles County Museum of Art, 1971), 136.

OVERLEAF

PAUL RANSON
Nabi Landscape, 1890
Oil on canvas
35 1/16 x 45 1/4 in.
(89 x 115 cm)
Josefowitz Collection

SACRED GEOMETRY: FRENCH SYMBOLISM AND EARLY ABSTRACTION

ROBERT P. WELSH

Sacred signs and symbols have played a role in all historical religions and hence in the art that religions have inspired. The most readily understood function of such signs has been to distinguish one religious belief from another: the cross serves commonly as the emblem of Christianity and the six-pointed star as that of Judaism. Yet such categorization greatly oversimplifies the meanings that symbolic forms in art and religion have embodied through the ages. Overlap and interchange in the use of symbolic modes is often encountered in the history of religion. Fusions of symbol and meaning occur with particular frequency within such religious beliefs as Hinduism and Buddhism, which allow for cross-fertilization from external doctrine and thus lay no exclusive claim to a specific sign or image. Within Western religious history openness to outside influence was most prevalent among those heterodox Christian or Jewish sects with leanings toward the occult, especially insofar as this led back to an interest in the age-old mystical arts of alchemy and astrology. Whereas these interests had been manifested in the teachings of such isolated figures as Paracelsus, Jakob Böhme, and Emanuel Swedenborg in earlier centuries, only after the French Revolution had seriously challenged the doctrines and authority of orthodox Christianity did fascination with the occult begin to flourish without fear of official opposition.

The underlying precepts of occult thought and the geometrizing signs and diagrams with which they were often illustrated in esoteric texts gradually became widely known within artistic circles. In France it was within the late nineteenth-century group of artists who called themselves Nabis (after the Hebrew word for *prophet*) that this intellectual fascination was most clearly manifested, and following the turn of the century occultism was of fundamental importance to a number of artists who practiced some form of what is called abstract art. The various involvements of Nabi and abstract artists with the sacred geometries of occult tradition were means by which spiritual content could be retained in their art.

With their use of crosses, triangles, squares, and circles, Nabi and abstract artists embraced long-established iconographic motifs, esoteric sign language, and, finally, pure geometric forms. Despite the variety of applications, this devotion to geometry reflected a shared reliance by the artists upon a body of spiritualist religious, philosophical, and scientific writings, which constituted one major aspect of nineteenth-century thought. Although in terms of artistic style the progression was

away from a residual naturalism toward ever more reductive forms of abstraction, this need not imply any lessening in the spiritual significance of the so-called nonrepresentational forms of art. It is now becoming clear that for artists like František Kupka, Piet Mondrian, Kazimir Malevich, and Wassily Kandinsky the purification of natural into abstract forms implied the proposition that geometric configurations function as paradigms of spiritual enlightenment.

If the tenets of the Theosophical Society founded in 1875 under the leadership of Helena P. Blavatsky, the revival about a decade later of Rosicrucianism in France, and the fusion of these doctrines somewhat later in the Anthroposophy of Rudolf Steiner are the best-documented sources of occult teachings for Symbolist and abstract artists, it should not be imagined that this recrudescence of arcane forms of mysticism constituted a spontaneous revival of a long-interrupted tradition. Instead it should be viewed as the culmination of studies in comparative religion that began with the Enlightenment and were successively enriched throughout the nineteenth century. A fundamental point of departure for writers who followed was the multivolume *Origine de tous les cultes ou religion universelle,* a work first published in 1794 by Charles F. Dupuis, member of the French Academy and minister of education during the First Republic.[1] His approach was that of a one-man encyclopedist of world religions; his bias, that of an astronomer who believed the study of heavenly bodies to have been the common source of all ancient religions, which had as their primary function the understanding of natural laws and the application of those laws to horticulture and navigation. Blavatsky disapproved of Dupuis's rationalism and materialism but called upon his "scientific" authority on several occasions. She was doubtless impressed by his emphasis upon ancient Egypt as a fountainhead of religious knowledge, especially as this concerned the truths to be learned from the primordial zodiac and the myth of Isis and Osiris. Dupuis's assertion that all ancient sacred mythologies embodied heaven-and-earth, sun-and-moon, male-and-female dualities along with a tripartite matter-mind-spirit concept (as evidenced in the universality of triune godheads) acknowledged these basic components of mystical iconography without accepting an occult reality. Similarly his reduction of Christian monotheism and trinitarianism to the status of latter-day imitations of earlier doctrines and his synthesis of

Eastern and Western religious experience into a single system of thought provided themes that were to be reiterated regularly by subsequent authors of both rationalist and occult persuasions. No wonder that Lady Caithness, Duchesse de Pomar, the first honorary president of the French chapter of the Theosophical Society and a self-declared Christian Theosophist, could in 1886 describe the *Origine de tous les cultes* as "a veritable treasure house for true Theosophy."[2]

Another such treasure house was Richard Payne Knight's *Symbolical Language of Ancient Art and Mythology: An Inquiry,* first published in 1818, then again in 1876 as edited by Dr. Alexander Wilder, a confidant of Blavatsky, who assisted in editing her monumental, two-volume *Isis Unveiled* (1877).[3] Like Dupuis, Knight propounded a syncretic view of ancient religions participating in a shared matrix in which gods are defined as personifications of nature: sun, moon, stars, earth, water. A male-female, heaven-earth duality was stressed by Knight, whose interpretation of ancient art and religion concedes a central role to fertility rites and symbols. He also emphasized the similarities of Eastern and Western myths and symbols, deriving, for example, the Egyptian lotus from Hinduism and equating the Isis and Osiris myth with Greek, Near Eastern, and Indian counterparts. Of particular importance, he sometimes interspersed his analysis of naturalistic symbols, such as animals and flowers, with references to geometric forms. Thus he cited the Egyptian tau cross as a reference to perpetual re-creation, and on the basis of Plutarch's story of Isis and Osiris linked the Egyptian divine triad with a simple triangle.[4] While by no means an initiate himself, Knight regularly attributed a higher degree of insight to mystic traditions than to what he termed "popular" or "vulgar" mythology.

By the time Blavatsky published *Isis Unveiled* and *The Secret Doctrine* (1888), a considerable body of literature existed in support of the proposition that ancient religious mythologies shared a common content including an essentially dualistic principle of male-female, heaven-earth (for the cosmic generative process) and a triune godhead (reflecting the progression of matter-mind-spirit). In

France an important example of this genre was the occult writer Antoine Fabre d'Olivet's *Histoire philosophique du genre humain* (1824). Although writings by Fabre d'Olivet are not mentioned in the major works of Blavatsky, she would have been made aware of them by the mid-1880s at the latest through the publicity given them in the writings of one of her then-collaborators, Papus (pseudonym of Gérard Encausse). Moreover, Fabre d'Olivet was the single most important source for the interpretation of ancient mystery religions contained in Édouard Schuré's *Les Grands Initiés: Esquisse de l'histoire secrète des religions* (1889). In *The Secret Doctrine* Blavatsky frequently does refer for support to *A Book of the Beginnings* (1881) and *The Natural Genesis* (1883) by the British writer Gerald Massey, yet another author who, while not a Theosophist, relied heavily upon mystical writings and discussed in depth the meaning of geometric and other religious symbols. Massey's writings repeatedly state his unwillingness to accept theosophical dogmas over his own theory of "natural genesis" for the origin of religious cosmologies.

Writers on the occult in particular were prone to illustrating duality, the triune godhead, and related principles by diagrams made up largely, if not solely, of easily readable geometric shapes. These include references to the signs of the zodiac, schematized astral bodies, various alphabets and numerologies, stylized figures, religious instruments, and, sometimes, purely linear configurations. The geometrizing illustrations in Éliphas Lévi's *Dogme et rituel de la haute magie* (1856) and *Histoire de la magie* (1860) are typically accompanied by elements of allegorical figuration or at least alphabetical and zodiacal signs, but this does not render them less significant as a source for the later diagrams of Blavatsky, Papus, and Stanislas de Guaita. The multiplicity and interchangeability of geometric symbols often was the subject of detailed exegesis by the authors who employed such diagrams. Hence in *Theology*, volume two of *Isis Unveiled*, the two foldout diagrams devoted to the Hindu and Chaldean doctrines (pls. 1–2) are accompanied by six closely worded pages of explanatory text, and in *The Secret Doctrine* eighteen consecutive pages are devoted to the esoteric meanings of the cross and circle; squares and triangles are elsewhere treated in similar detail.[5]

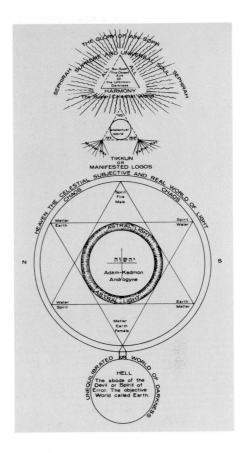

Apart from her formidable attainments as a encyclopedist of world religions, Blavatsky must be considered a major synthesizer of numerological and geometric symbol systems. She consistently stressed an identification between the mystical decimal numbers and sacred geometrical forms, which she found immanent to the major world religions as esoterically understood. A basic premise is the masculinity of odd numbers and femininity of even ones, with the related geometric forms also so characterized. Thus the number one is inherent to either a point or a vertical line, the latter having connotations of the phallus, fire, and ascending spiritual rays. Number two in natural contrast is contained in the horizontal female line having connotations of water, matter, and earth. These respectively active solar and passive lunar principles are recapitulated in the numbers three and four, which are symbolized in the triangle and the square. The triangle, the most rudimentary true geometric shape, is associated with the universal triune godhead and sides of pyramids, while the square represents terrestrial life and the base of the pyramid. The numbers five and six are signified by the five-pointed star, or pentagram, emblematic of the microcosm and of the "five-limbed," thinking, conscious man, and by the six-pointed star, or hexagram, which (from before its realization in the star of David, or Solomon's seal) is emblematic of the macrocosm, the physical world, and, accepting the assignment by Pythagoras of six as the sacred number of Venus, the generative principle, both on the sexual and astral planes.[6]

Seven is the most sacred number to occultists, because it contains the principle of life itself. It is manifested geometrically by either the hexagon with a point of unity added at the center or by a triangle placed above a square, which is equally symbolic of the unity of spirit and of matter producing life. Essentially the same concept is inherent in the Egyptian, or tau, cross because it is considered to combine the number seven with the Greek letter *gamma*. Blavatsky was adamant in contesting with her critics for the primacy of seven over any other sacred number, and it is noteworthy that the official emblem of the Theosophical Society features a six-pointed star, the added point at the center of which figures as the intersection of the vertical and horizontal lines of an inscribed ankh (a tau cross surmounted by a circle), an ancient Egyptian emblem of life.

1
Foldout diagram of Hindu cosmogony from Helena P. Blavatsky, *Theology,* vol. 2 of *Isis Unveiled* (1877)
.

2
Foldout diagram of Chaldeo-Jewish cosmogony from Helena P. Blavatsky, *Theology,* vol. 2 of *Isis Unveiled* (1877)
.

3
CLAUDE-ÉMILE SCHUFFENECKER
Design for cover of *Le Lotus
bleu,* 27 October 1892
Black crayon on paper
23 ½ x 17 ¾ in.
(59.7 x 45.1 cm)
Norman MacKenzie Art
Gallery, University of
Saskatchewan,
Regina

In contrast to the exaltation of the number seven and its geometric surrogates, the following two decimals are treated summarily to the point of disdain. The number eight, termed *Ogdoad,* is related to the Greek caduceus and the mathematical symbol for infinity and explained as "the eternal and spiral motion of cycles . . . the regular breathing of the Kosmos," at least a useful function. Less fortunate is the number nine, which, as "the triple ternary" — for example, three triangles in a row — "reproduces itself incessantly under all shapes and figures in every multiplication" and is thus to be considered "our earth informed by a *bad* or evil spirit."[7] It is obvious that the numbers eight and nine were lacking in simplicity due to their divisibility and that serial geometric rendering was anathema to the founder of modern Theosophy.

The final number in Blavatsky's decimal cycle was ten, which apart from the obvious merit of combining seven plus three, allowed for a final reconciliation of the male and female principles. Thus not only did "*Ten,* or the Decade, bring all . . . digits back to unity" but it was also intimately related to the tau cross.[8] The further attribution of divine qualities to the circle, both of perfect completion and perpetual recurrence, was only one instance of Blavatsky's attempts to reconcile her personal esoteric Buddhism with an assertion of a universal world religion.

Beginning in 1884, the year Blavatsky made a proselytizing visit to Paris, a series of publications appeared, which by the end of the decade had made the essentials of Theosophy available to a French audience. Caithness's *Fragments glanés dans le théosophie occulte d'Orient* (1884) was in large part based upon *Esoteric Buddhism,* which Blavatsky's follower Alfred Percy Sinnett had published the previous year in London.[9] Caithness's *L'Aurore: Revue mensuelle,* despite its dedication to Christian Theosophy over what she termed Universal Theosophy, was advertised as a sister periodical in *Le Lotus: Revue des hautes études théosophiques* (subtitled "under inspiration from H. P. Blavatsky") when the latter was first published in March 1887. *Le Lotus* included not only articles by the so-called Anglo-Indian Theosophists, such as excerpts from Blavatsky's *The Secret Doctrine* when it appeared in 1888, but also contributions by the cabalistic Rosicrucian Guaita; the writer

and eventual founder of the Ordre de la Rose + Croix, "Sâr" Joséphin Péladan; and the future founder of the Martinist Esoteric Society, Papus.[10]

Despite being a follower of Lévi and earlier nineteenth-century French occultists (like Fabre d'Olivet and Claude de Saint-Martin, founder of the Martinist movement) and exalting the historical role of Jesus, Papus visited Blavatsky in London, was a declared member of the Theosophical Society, and served its interests in a number of his writings, including several important contributions to *Le Lotus.* The depth of this relationship is evidenced in the announcement in the December 1887 issue under "Publications Nouvelles" of the forthcoming *Traité élémentaire de science occulte* by this "young, modest writer," who was commissioned by Isis (the French branch of the Theosophical Society) to assemble symbols of cabalism, alchemy, and so forth as a body of doctrine to be discussed in subsequent issues of *Le Lotus. Traité élémentaire* includes a virtual paraphrase of the equation between the decimal numbers and geometric forms as outlined by Blavatsky, and in March 1889 *Revue théosophique* (successor to *Le Lotus,* it listed Blavatsky as its editor-in-chief) included Papus's detailed exegesis of the emblem of the Theosophical Society.[11]

This sign had appeared regularly on the various publications of Caithness, Guaita, Papus, and the Theosophical Society; it was also featured on the cover of *Le Lotus bleu,* yet another French journal founded by Blavatsky, the first issue of which appeared March 1890. The artistically most satisfactory cover design for any of these journals was introduced during the year following Blavatsky's death, in the 27 October 1892 issue of *Le Lotus bleu* (pl. 3). The artist was Claude-Émile Schuffenecker, a former friend of Paul Gauguin, and his design included the circular emblem of a snake biting its tail (the ancient *ouroboros*), a smaller circle enclosing a swastika where the snake's head and tail meet, a sacred hexagram within the circle of the snake, the ankh form of the tau cross centered within the hexagram, and, another logo of the Theosophical Society, a pseudocaduceus formed by a simple tau with entwined snake. The inclusion of an aged seer, possibly the Buddha, seated between a tree of knowledge and a lotus blossom hovering over a body of water and before the sun, utilizes iconographic elements appropriate to the emphasis accorded ancient Egyptian and Indian religions within the Theosophical Society. And if the founding of

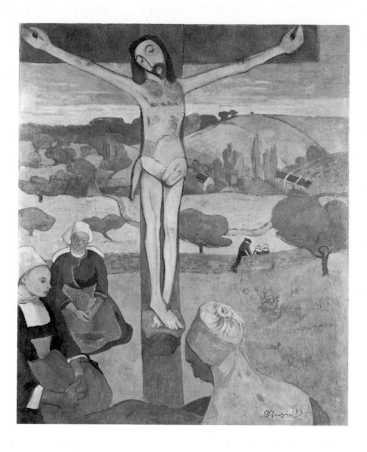

Le Lotus bleu coincided with the emerging antagonism between Theosophy and Rosicrucian-Martinist loyalties within French occultists' circles, this should not obscure the magnitude of their cooperation during the previous half-decade nor the many intellectual sources, esoteric symbols, and mystical preoccupations they continued to share.

How then did the Nabis become interested in sacred geometry and how was it manifested in their art? One possible explanation is to suppose a stimulus from Gauguin, whose 1888–90 paintings from Brittany are generally seen as having provided a basis for the emergence of a more or less common Nabi style. Assertions of Gauguin's acquaintance with occult writings and Theosophy, moreover, have raised the issue of the extent to which this knowledge may have derived from an interchange of ideas with his associates Schuffenecker and the Nabi leader Paul Sérusier.[12] As early as an often-cited 14 January 1885 letter to Schuffenecker, Gauguin alluded both to the straight line as a sign of infinity and the need for greater discussion of the numbers three and seven. These references, however, were more likely derived from a

reading of Honoré de Balzac's Swedenborgian novel *Louis Lambert* than from direct study of occult treatises about lines and numbers.[13]

Similarly Gauguin's documented awareness during his years spent in the South Pacific of such encyclopedic studies of universal religious systems as J. A. Moerenhout's *Voyages aux îles du grand océan* (1837) and Massey's *A Book of the Beginnings* is less indicative that he had accepted the basic tenets of modern Theosophy than that he shared in the belief that all religions, including that of the Polynesian Maori peoples, participated in a common metaphysical dualism between the realms of heaven and earth.[14] Moerenhout's representation of Oceanic religion emphasized a male-female, heaven-earth duality derived from astronomical consideration in accordance with other historical religions, especially that of ancient Greece.[15] In contrast Massey made ancient Egypt and Africa the cradle of religious systems, including that of the Maori,[16] as had Dupuis before him.[17]

In her analysis of the cross and circle Blavatsky credits Massey as providing "more information . . . on the cross and circle than in any other book we know of,"[18] although it is difficult to imagine that Gauguin would have

been directly aware of either author's analysis of, for example, the tau cross before he encountered the writings of Massey in Tahiti. Gauguin's conclusion, based on Massey, that "the Jesus Christ of the Gospels is none other than Jesus Christ of the Myth, the Jesus Christ of the astrologers,"[19] and his anti-Roman Catholic diatribes had as ultimate ancestor the atheistic theories of Dupuis rather than the systematic occultism of Lévi or Blavatsky.

These considerations notwithstanding, it is likely that Gauguin's Brittany-period paintings encouraged Sérusier and his fellow incipient Nabis toward a mystical conception of art in which sacred geometry figured as one component. It has recently been proposed, for example, that *Yellow Christ* of 1889 (pl. 4) in its two groupings of three mundane worshipers plus Christ, for a total of seven, echoes Gauguin's call to Schuffenecker for an examination of these numbers in art, and it is difficult not to agree that the crucifix should be read as a tau cross, with at least some of its spiritualist connotations being presumed.[20] The circular mandorla in which *La Belle Angèle*, 1889 (pl. 5), is situated offers another possibility of symbolic significance for this

6
PAUL SÉRUSIER
Blind Force, 1892
Oil on canvas
36 ¼ x 28 ⅝ in.
(92.1 x 72.7 cm)
Private collection,
France

.

7
ROBERT DELAUNAY
Round Forms, 1913
Oil on canvas
25 ³⁄₁₆ x 39 ⅜ in.
(64 x 100 cm)
Stedelijk Museum,
Amsterdam

.

perfect geometric form, which the oriental background figure in a pose of meditation expressively implies. Even though it remains doubtful that by 1889 Gauguin commanded so sophisticated a knowledge of such Indian gestural conventions, the sitter's handclasp strangely approximates (with left and right hands reversed) the so-called diamond mudra of Indian Buddhist usage, which signifies the power to destroy worldly passions and attain enlightenment.

The rigidly supine position of the female figure in Gauguin's *Loss of Virginity,* 1890/91, apart from its many other associations,[21] lends itself to identification with the horizontal line as emblematic of matter, a standard occult precept doubtless available to the artist from a wide range of popularized sources. Finally, while the use of the title *Nirvana,* 1889 or 1890, may not prove a profound understanding of this Hindu and Buddhist concept, its use by Gauguin for a portrait of his friend Jakob Meyer de Haan, a Dutch Jew said to be versed in oriental religions, may well reflect the popularization in France of the general concept of nirvana within writings devoted to the esoteric Buddhist doctrines of the Theosophical Society. By 1884 Caithness had

already provided the French public with Theosophy's definition of nirvana as "the complete subjugation of the passions and the practice of universal charity" rather than as the final cessation of material existence.[22] The related doctrines of reincarnation and the immortality of the spiritual soul were equally stressed in other literature of or about the society.

Given their well-known penchant for mystical inquiry, the Nabis may easily have perceived more spiritualist overtones in Gauguin's art than were actually intended. Whereas it has yet to be shown that Gauguin was a reader of specific occult texts before his departure early in 1891 for Tahiti, it seems certain that by this date at least Sérusier and Paul Ranson among the emerging Nabis had been exposed to some basic esoteric literature. Sérusier was, like Gauguin, an avid reader of the esoteric novels of Balzac, such as *Louis Lambert* and *Séraphîta,* and by 1891–92 had introduced Nabi acolyte Jan Verkade to Schuré's *Les Grands Initiés.*[23] Ranson's penchant for esoterica is even easier to establish:

his library included an 1889 edition of Papus's *Traité élémentaire,* the same author's *Clef absolue de la science occulte: Le Tarot des Bohémiens* (1889), and the slightly later writings of Jules Bois.[24] In 1889 both Sérusier and Ranson were twenty-five years old and may be presumed to have shared their reading materials with younger colleagues from the Académie Julien.

Although *Traité élémentaire* comprised a lexicon of occult signs and symbols drawn from a variety of occult publications, this is hardly true of *Les Grands Initiés,* where references to pyramids, triune godheads, and sacred numbers are unaccompanied by diagrams, being integrated instead into Schuré's narrative description of his chosen eight ancient visionary seers and their respective contributions to the history of religion. The long-lived popularity of this volume (by 1927 it had reached the one hundredth edition) owed much to the

8
FRANTIŠEK KUPKA
Disks of Newton, 1911–12
Oil on canvas
19 ½ x 25 ⅝ in.
(49.5 x 65 cm)
Musée National d'Art
Moderne, Centre Georges
Pompidou, Paris
·

fact that it synthesized a broad range of previous writings, scholarly, anti-Christian, and occult, into one esoteric whole without assuming a partisan position among the competing spiritualist sects then active in France. In keeping with an 1885 article in which he stressed the analogy between the careers and teachings of Jesus Christ and the Buddha, Schuré's concluding invocation in *Les Grands Initiés* is for "the reconciliation of Asia and Europe" through greater understanding of the common base of their religions as esoterically comprehended.[25] His retention of personal loyalty to the historical Jesus, combined with an openness to the mystical insights to be derived from all the world's religions, in large part explains his great popularity with Sérusier and the other Nabis.

Despite its value as a fountain of knowledge about the "secret history of religions," as its subtitle indicated, *Les Grands Initiés* did not in itself immediately produce a derived outpouring of pictorial imagery among the Nabis, especially geometric configurations. Presuming the title was given by the artist, one exception may have been Sérusier's *Blind Force,*

1892 (pl. 6). This term was used several times by Schuré in association with such negative influences as the tyranny of Babylon and the bacchantes in the service of an orgiastic and thus "blind" nature.[26] The association might explain the brown coloration of the figure and the background rings, which are, however, interspersed with rings of yellow, orange, and red. Whether or not these warm colors of the spectrum can be read as symbolic of lowly passion or some infernal realm is not decipherable in reference to Schuré's text, and further speculation as to possible esoteric meaning for the background's abstract circular elements seems hazardous. Nonetheless, without its single figure this painting would be as abstract as the solar disks of Robert Delaunay of 1913 (pl. 7), and Kupka of 1911–12 (pl. 8), and to some degree implies the presence of sacred geometry.

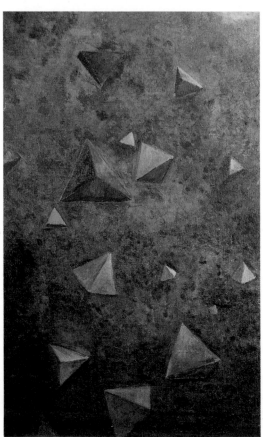

9
PAUL SÉRUSIER
The Gold Cylinder, 1910
Oil on canvas
35 ¾ x 22 in. (90.8 x 55.9 cm)
approx.
Musée des Beaux-Arts,
Rennes, France
·

10
PAUL SÉRUSIER
Tetrahedrons, c. 1910
Oil on canvas
35 ¹³⁄₁₆ x 22 ¹⁄₁₆ in.
(91 x 56 cm)
TAG Oeuvres d'Art
·

It is tempting to read such interesting, if rare, paintings by Sérusier as *The Origins* (see p. 20), *The Gold Cylinder* (pl. 9), and *Tetrahedrons* (pl. 10), all circa 1910, as an attempt by the artist to indicate the underlying geometric basis of his larger oeuvre, as his later claim to have been a forerunner of Cubism might seem to justify.[27] Yet in overall typology these examples appear closer to Odilon Redon's early lithographic compositions, in many of which spheres (pl. 11) hover above vast stretches of water or land. In *The Origins* the playing off of foreground pyramidal shapes against the ascending triangle inevitably evokes two of the most significant emblems of spiritual essence found within late nineteenth-century occultism.[28] Like other esoteric writers, Schuré equated pyramids with sacred numbers and geometry, calling them "geometric figures of the tetragram and of the sacred septenary, losing themselves at the horizon, spacing out their triangles in the light gray of the air."[29] It is noteworthy that a few years after completing these geometrically based compositions Sérusier produced for his home at Châteauneuf-du-Faou a series of wall murals on the theme of the zodiac, in which geometric designs play a role equal to that of the Egyptianizing figural symbols.

The earliest manifestation of Sérusier's interest in esoteric sign language was his *Portrait of Paul Ranson* (pl. 12), a painting dated 1890, which in some measure reflects the interests and activities of the fledgling Nabis as they began that year to meet on a weekly basis in Ranson's atelier-cum-"temple." It is now generally believed that the priestly costume in which Ranson is depicted represents a fictional garment created by the artist. A report that the staff held by Ranson was one executed by Nabi sculptor Georges Lacombe should be disbelieved, both because by 1890 Lacombe had not yet begun to sculpt and because the crown of the staff patently derives from the type of late medieval bishops' crosiers produced at Limoges, where Ranson was born and grew up. This Christian reference is not incompatible with the zodiacal signs visible along the neck band of Ranson's garment nor with the pentagram or hexagram upon which his right hand rests. Like the circular orange halo situated behind Ranson's head and the five- or six-pointed star and less-than-complete ouroboros of the staff, the zodiacal signs refer both to their own geometrical components and those of the stellar dispositions themselves. Whether a five- or six-pointed

star was intended is uncertain because the geometric figure is largely covered by Ranson's hand, just as only a Greek cross and the sign of the planet Jupiter are clearly indicated on the neck band. One might conjecture that the bright green jewel (a pyramid seen from above?) within the large central disk of the neck band refers to the ancient mystical text the *Tabula smaragdina* (The emerald tablet), attributed to Hermes Trismegistus, especially since Papus cites this as a source for his own explication of pentacles and geometric signs.[30] In any case we can be sure that in this portrait Sérusier wished to commemorate the reading of occult literature on the theme of sacred signs as central to the weekly meetings of the Nabis.

It remains uncertain whether Sérusier included the various esoteric insignia on his own inspiration or that of Ranson. By 1890 both men surely were familiar with a number of occult texts, but it was Ranson who would prove more dedicated to studying sacred insignia and incorporating them into his art. Ranson's *Rama,* 1890, includes a host of images drawn from *Les Grands Initiés,* in which the role of Rama in founding Hindu civilization is outlined.[31] The inclusion of a five-pointed star inscribed with the sign of the

planet Mercury relates to an episode in the story of Rama, but it may also be read as symbolic of the successful reconciliation of cosmic forces. The upward-pointing pentagram represents man or human intelligence, while the sign of Mercury, according to Papus, represents a synthesis of its geometric components: a male solar circle, a female crescent moon, and, as product of these active and passive forces, a cross of the four elements of matter.[32] This same sign of Mercury figures even more prominently in Ranson's drawing *Astrology,* early 1890s (pl. 13), where it occurs, along with a blazing sun, on a tablet held by a female figure seated above a disk rimmed with signs of the zodiac. The pentagram recurs in other examples by Ranson, although when pointing downward, as in

11
ODILON REDON
The Vision, from *Dans le rêve,* 1879
Lithograph
10 ¾ x 7 ¹³⁄₁₆ in.
(27.4 x 19.8 cm)
Private collection

·

12
PAUL SÉRUSIER
Portrait of Paul Ranson, 1890
Oil on canvas
27 ⁹⁄₁₆ x 17 ¾ in.
(70 x 45.1 cm)
Private collection, France

·

13
PAUL RANSON
Astrology, early 1890s
Drawing
Dimensions unknown
Location unknown

·

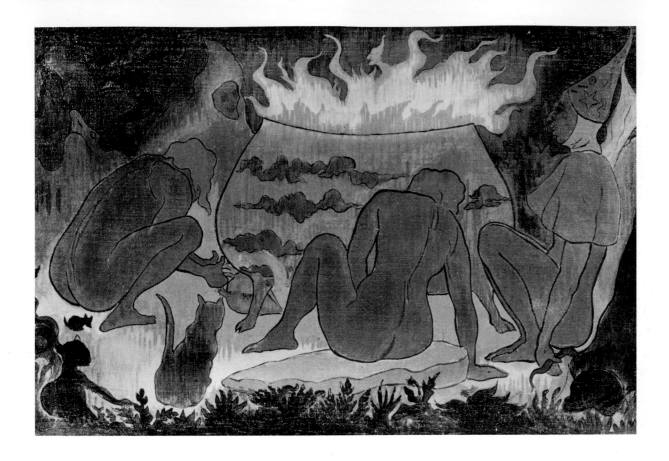

14

PAUL RANSON
The Sorceresses, 1891
Oil on canvas
14 ¹⁵⁄₁₆ x 21 ⅝ in. (38 x 55 cm)
Musée Départemental du
Prieuré, Saint-Germain-en-
Laye, France

·

Alchemy, 1893, and as on the conical cap of the witch at the right in the painting *The Sorceresses,* 1891 (pl. 14), it signifies black magic or the dominance of matter.[33] The downward pointing pentagram was described by Blavatsky at the very outset of *The Secret Doctrine* as "the sign of human sorcery, with its two points (horns) turned heavenward," a passage readily available to Ranson from a French translation of this segment of Blavatsky's text.[34]

Unexpectedly it is not the pentagram but the hexagram, symbolic of the balance of spirit and matter, that occurs in what would first appear to be one of Ranson's most overt invocations of thematic diabolical content, the watercolor *Support Sathan* (*Support Satan*) (pl. 15), another work presumably of the early 1890s. The female figure, who clutches her head and whose garment along the right edge is ornamented with two crescent moons and the hexagram, must be considered susceptible to union with some spiritual force if the presence of a six-pointed star is to be justified. However ambiguous Ranson's depiction of his stated satanic theme may be, there is sufficient reason to doubt a purely negative iconographic intent on the basis of his known chief

source of knowledge about modern-day worship of Satan: the writings of Bois. Bois's *Les Petites Religions de Paris* (1894) and *Le Satanisme et la magie* (1895) appeared about the same time that he was editor of *Le Coeur.* This elegant occult journal was founded by Antoine de La Rochefoucauld, who had broken with the Rosicrucianism of Péladan in part due to the latter's growing antagonism to the cabala and oriental religions. Bois was as open to the teachings of the various world religions as was La Rochefoucauld, and his analysis of satanism separates the negative black-magic tradition from the more positive mysticism that he discovered in some of the then-contemporary satanic cults. This esoteric interpretation of modern satanism as no more sinister than other systems of occult belief was available to Ranson not only in the two volumes that he acquired when Bois published them in the mid-1890s but also in Bois's *Les Noces du Sathan: Drame ésotérique* (1890), the title of which includes the unorthodox spelling of *Sathan* also used by Ranson in *Je support Sathan.*[35] In Bois's theater piece, modeled on the ancient Eleusinian mysteries, an androgynous Satan is guided by the god Hermes into a transcendent embrace with a Psyche/Persephone figure, thereby being saved and transformed into "the Jesus of a former age." Thus, if not representing a specific

scene from Bois's drama, the "support" of Satan vouchsafed in Ranson's watercolor may be thought to lead not to the practice of black magic or other evil rituals but to the union of spirit and matter symbolized in the sacred hexagram.

In other works of the 1890s by Ranson the occult symbols are submerged in curvilinear decorative imagery, making specific meanings difficult to identify. In the large drawing *Woman in Prayer* (pl. 16), probably intended as a tapestry design, it is easy enough to locate the crucifix upper left and the upward pointing pentagram top center, but should one stop there? Does the undulating embellishment of the cross so strongly resemble the snake in the upper right of Schuffenecker's cover design for *Le Lotus bleu* that it is impossible to consider this merely an abstract adornment? And the three fleur-de-lis blossoms at right and the quatrefoils on the flowing gown are also cruciform in nature. Given these possibly camouflaged geometric figures, is it inconceivable to imagine those other two flying crosses, the dragon lower left and dove upper right, as possessing the potential of transmogrification

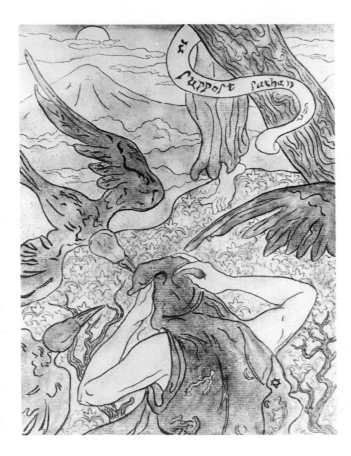

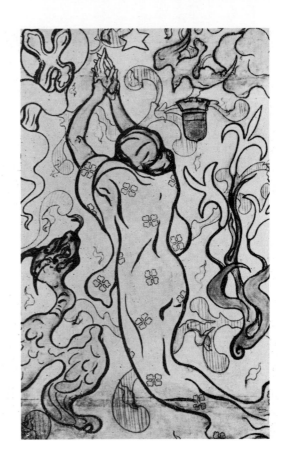

of one into the other? The pentagram might be considered susceptible to a similar transformation: in Schuré's description of Egyptian initiation rituals a five-pointed star symbolic of immortality is metamorphosed into the mystical white rose of Isis.[36] However thoroughly embedded the equation of geometric and organic forms may have been in *Woman in Prayer,* the ease of her gravity-defying levitation toward the crucifix forebodes yet another union between the realms of matter and spirit, a union expressed in the art of Ranson with ingenious diversity.

Less covert in its allusions to religious imagery is Ranson's *Christ and Buddha* of about 1890–92 (pl. 17), an apparent variation on the theme of Gauguin's *Yellow Christ.*[37] It is difficult to assess the degree to which Ranson read into Gauguin's painting an interest in sacred signs and numerology similar to his own. Ranson's crucifix is less clearly a tau cross and his figural content less readily readable in reference to the numbers three and seven than in Gauguin. Nonetheless it seems likely that the five stylized lotus blossoms were meant to suggest the theosophical association of five with such connotations as microcosm and human intelligence, while the cross in any form connotes interaction of mat-

ter and spirit and thus represents, as Papus stated, an "image of the absolute."[38] In addition the fact that in nature the lotus ascends from the dark waters toward celestial light is commemorated by Ranson as another symbolic equivalent of the eternal search for a union of matter with spirit. The presence of such esoteric doctrines in both Christianity and Buddhism is another assumption inherent to the iconography of this painting and one that owed some inspiration to the writings of Schuré.

If Sérusier and Ranson were the Nabis most intimately involved with theosophical precepts and sacred signs, it should not be thought that these preoccupations were their exclusive domain either within or beyond the Nabi circle. It has been shown, for example, that during the early to mid-1890s Édouard Vuillard produced a number of compositions in which the tau and other cross forms are integrated in architectural interiors so as to suggest the presence of some eternal spiritual entity. Similarly, the Nabi sculptor Lacombe produced, circa 1894–96, four carved bed panels representing human conception, birth, and death in figural imagery. Adding the ouroboros along with a double pentagram on the headboard, Lacombe probably indicated not only his interest in the modern theosophi-

cal movement but also in the Hindu-derived doctrine of reincarnation.[39]

In the art of the fervently Roman Catholic Maurice Denis the use of geometric signs remains within a distinctly Christian context, but the means of utilization are by no means traditional. Hence the positioning and truncation of the cross in *The Way to Calvary,* 1889 (pl. 18), renders it readable as both a Latin and a Saint Andrew's cross, the X form of which defines a set of triangles, and it may not be incidental that the number of female followers present is seven. Blavatsky explained the X cross as pointing to the four cardinal points, hence infinity, and as indicating the presence of God in humanity, ideas that, if known to Denis, might not have seemed inimical to his Christian faith.[40] In the three finished versions of Denis's *Catholic Mystery,* from the years 1889–91 (see, for example, pl. 19), cross forms are present not as a necessary part of the annunciation theme but as defined by the window mullions, their dematerialized shadows on the curtains at left and right, and the design on the sleeve of the figure at left. This figure is not a winged archangel but an officiating priest accompanied by two altarboys. The

15
PAUL RANSON
Support Sathan (Support Satan), early 1890s
Watercolor
9 ⁷⁄₁₆ x 7 ¼ in. (24 x 18.4 cm)
Formerly Galleria del Levante, Milan

.

16
PAUL RANSON
Woman in Prayer, c. early 1890s
Charcoal and pastel on paper mounted on canvas
59 ¹⁄₁₆ x 35 ⁷⁄₁₆ in. (150 x 90 cm)
Location unknown

.

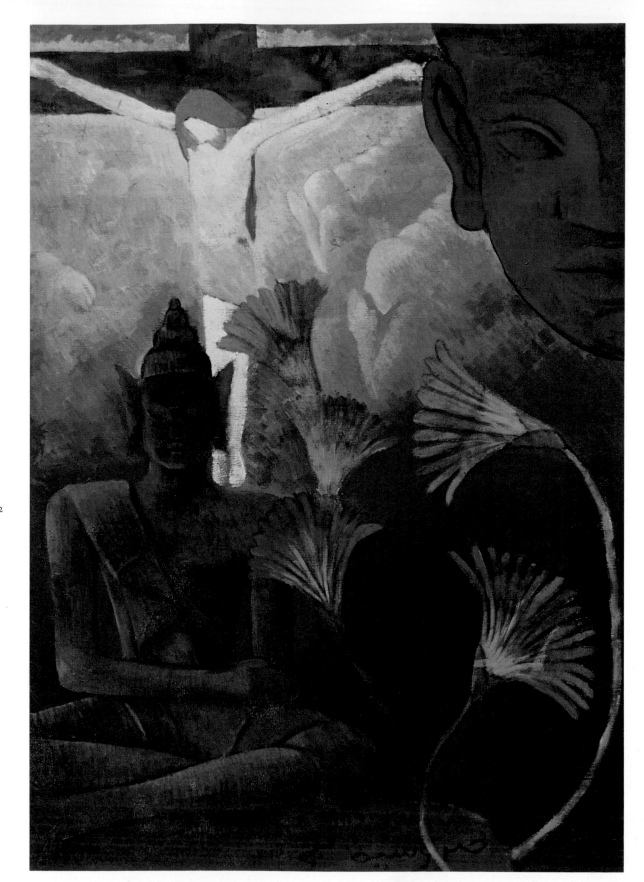

17
PAUL RANSON
Christ and Buddha, c. 1890–92
Oil on canvas
28 ⅝ x 20 ¼ in.
(72.7 x 51.4 cm)
Mr. and Mrs. Arthur G.
Altschul, New York
.

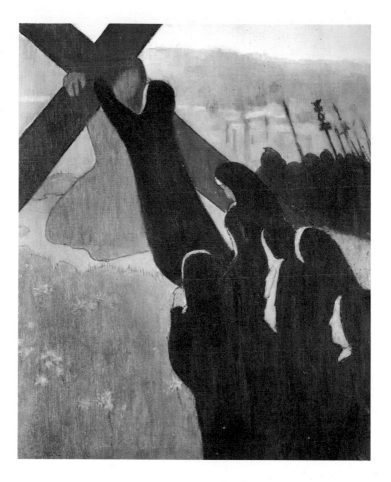

18
MAURICE DENIS
The Way to Calvary, 1889
Oil on canvas
16 ⅛ x 12 ¹³⁄₁₆ in.
(41 x 32.6 cm)
Private collection,
France

.

19
MAURICE DENIS
Catholic Mystery, 1889
Oil on canvas
38 ³⁄₁₆ x 56 ⁵⁄₁₆ in.
(97 x 143 cm)
Musée Départemental du
Prieuré, Saint-Germain-en-
Laye, France

.

20
MAURICE DENIS
The Mass, c. 1890
Oil on board
9 ⁷⁄₁₆ x 7 ½ in. (24 x 19 cm)
Private collection, France

a.

b.

priest (and the boys in one version) is depicted with a halo conforming to no orthodox representation of a scene from the life of the Holy Virgin. These iconographic liberties combine to suggest that the geometric figures of the cross and circle (according to esoteric doctrine each in its own way is indicative of immortality) are as essential to understanding this Catholic mystery as the narrative scene.

In similar fashion various forms of crosses, sometimes ringed with circles, so frequently appear in Denis's woodcut and lithographic illustrations (made in the 1890s but only published in 1911) for Paul Verlaine's poem cycle *Sagesse* that they assume a symbolic identity in whole or in part independent of any imaginable narrative meaning.[41] In a painting of the same period known as *The Mass,* circa 1890 (pl. 20), Denis depicts a priest who wears a robe with a large cross, at the intersection of which is placed an oval. The priest looks and gestures toward a yellow disk suspended in

front of an altar. With no further indication provided as to the liturgical significance of the act being depicted, independent of any narrative context, the viewer is left to ponder the ultimate mystical meaning of the cross and circle for Christianity specifically. One may not presume that Denis viewed Christian symbols as merely a single expression of esoterically uncovered truths common to all world religions.[42] Yet his close association with Sérusier and other occult-inclined Nabis makes it unthinkable that he would have remained unaware of such doctrines. It might be safest to suppose that he simply accepted the syncretic view of the origins and cosmologies of the ancient religions that preceded Christianity while believing that the latter had superseded the others by the depth of its mystical teachings.

The apparent mixture of Christianity and geometry in the art of Filiger is even more difficult to unravel than in the case of Denis. In large part this is due to the habits (not the least of which was his failure to date his oeuvre) of this unfortunately obscure artist, whose career, apart from difficulties due to homosexuality and alcoholism, did not produce a clear record of artistic development.[43] Nonetheless he represents the best example of an artist with established connections with Gauguin

and the Nabis who systematically progressed from dependence upon the general Pont-Aven style to pure geometric abstraction. Doubtless this progression depended upon continuing contacts with Sérusier and the latter's intermittent involvement with the geometrizing theories of Father Desiderius Lenz and the school of Beuron.[44] Pythagorean theories of geometric proportion, Byzantine mosaic decorations, and medieval art may have been relevant to Filiger's work, but from his more geometric designs (the multiplicity of heads inscribed within a plethora of forms) it is clear that French occultism's basic vocabulary of sacred geometry (cross, circle, square, triangle) was predominant (see pls. 21–22). His anticipations of such canons of design in earlier work notwithstanding, the strictly geometric icons that he produced from about 1903 show Filiger to have been, no less than Sérusier, a believer in the value of sacred geometry as a concomitant to artistic productivity throughout his career. Whereas it is tempting to perceive the geometric configurations of Filiger as either anticipatory of or analogous to the Cubist style, his virtual isolation in the Brittany peninsula for most of his career renders such an exertion of influence problematic.

21
CHARLES FILIGER
a. *Head of a Lion* (recto) and
b. *Geometric Figure* (verso),
c. 1903
Crayon, gouache, and
watercolor on paper
9 ¼ x 11 ¹⁄₁₆ in.
(23.5 x 28.1 cm)
Mr. and Mrs. Arthur G.
Altschul, New York

·

22
CHARLES FILIGER
Chromatic Notations, 1886
Watercolor on paper
10 ⅝ x 9 ⅞ in.
(27 x 25 cm)
Beatrice Altarriba-Recchi

·

23
JEAN DELVILLE
Mysteriosa (Portrait of Mrs. Stuart Merrill), 1892
Chalk on paper
13 ¹⁵/₁₆ x 11 in. (35.5 x 28 cm)
Edwin Janss, Thousand Oaks, California

·

It should not be thought that the Nabis' fascination with geometric occult symbols remained a closely guarded secret and was unique to themselves. When Eugène Carrière drew a portrait bust of Sérusier, for example, the sitter was shown wearing a fancifully decorated costume with a pendant escutcheon containing only simple geometric forms and featuring one upward and one downward pointing triangle.[45] In *Mysteriosa (Portrait of Mrs. Stuart Merrill)*, 1892 (pl. 23), Jean Delville's approach was even more rudimentary, using only a single upward pointing triangle (paralleled in the sitter's ecstatic heavenward gaze) to indicate the nature of the book held by Merrill, whose husband was already a recognized Symbolist poet and friend of Denis.

Like Delville, La Rochefoucauld exhibited work at the first Salon de la Rose + Croix, organized in 1892 by Péladan. In keeping with the well-known cover illustration for the catalogue executed by Carlos Schwabe (pl. 24), a now-lost work by La Rochefoucauld, *The Good Goddess Isis Initiates the Shepherd* (pl. 25), combined naturalistic with geometric imagery to contrast the earthly and heavenly realms.[46] The latter work includes a banderole carrying an inscription taken from an ancient statue of Isis, which appears at the top of the first page of Blavatsky's *Isis Unveiled,* "I am all that has been, all that is, all that ever shall be; and no mortal has ever raised my garment." Considering his blatant tribute to the Egyptian goddess and her abstract symbols, variations on the emblems of the Theosophical Society, it must have struck La Rochefoucauld as ironic when in 1893 Filiger, to whom he was then providing an annual stipend and who also had exhibited at the inaugural Salon de la Rose + Croix, declared himself incapable of including Egyptianizing elements in a requested page head design for the La Rochefoucauld-sponsored occult journal *Le Coeur.*[47] Filiger's loyalty to Christianity notwithstanding, he had no difficulty in having his work illustrated and discussed in *Le Coeur,* which was edited by Bois and contained arti-cles on esoteric Buddhism and the cabala. The occult meanings attached to simple geometric forms had become so thoroughly popularized in the numerous reviews specializing in esoteric subjects that exclusive use of any particular sign by a single cult or religion was difficult to justify within intellectual and artistic circles interested in the occult. This helps explain why members of the Nabi group, even as they utilized sacred geometries according to individual preference, were little troubled by sectarian differences and remained lifelong friends.

How does the Nabis' use of sacred geometries compare with that of the leading abstract artists in the early twentieth century? Because this question as it concerns Kandinsky and Malevich is answered in the essays by Sixten Ringbom and Charlotte Douglas, respectively, in this volume, the brief discussion that follows is confined to the careers of Kupka and Mondrian. Kupka alone among the four

artists arrived in Paris as early as the mid-1890s; he is the only one who might have had direct contact with the occultism that flourished there before the turn of the century. His immersion in this ambience remains hypothetical, however, both because he is said to have left central Europe for France precisely in order to escape a previous involvement with esoteric pursuits and because of a lack of published documentation about his first years in Paris.[48] Yet it is known that beginning around 1884 he successively practiced as a medium, accepted the disciplines of vegetarianism and physical culture, and avidly studied Greek, German, and oriental philosophy along with a variety of theosophical texts. These texts might easily have included *Sphynx,* the German organ of the Theosophical Society, which had first appeared before the years he spent in Vienna in 1892–95.[49]

Vienna was in fact where Kupka painted the first, now lost, version of *Quam ad causum sumus* (Why are we here?); a surviving variant, executed around 1900 and known as *The Way of Silence* (pl. 26), includes an inscription of the earlier title and features a small depiction of the artist standing on a roadway flanked by rows of sphinxes, which seem to look longingly toward the brilliantly starlit sky above. For modern Theosophy the sphinx, especially if asleep, represents the lower, material world of illusion (the Hindu maya). But according to the explanation accompanying the frontispiece diagram to Franz Hartmann's theosophical text *Magic: White and Black* (1886) (pl. 27), the sphinx also "meditates on the solution of the great problem of the construction of the Universe, on the nature and the destiny of man, and its thoughts take the form of that which is represented above itself, which is to say the Macrocosm and the Microcosm in their combined actions."[50] In the diagram are found not only a cross, a circle, one pentagram, and two hexagrams but also the signs of the zodiac and the planets plus letters and words that allude to the central theme of the cosmic balance between light and darkness, spirit and matter.

This diagram, a visual synopsis of theosophical doctrines on the nature of the universe, was merely one of many such diagrams available at the time and possibly known to Kupka.[51] In *The Way of Silence* Kupka's patent reliance upon Egyptian and stellar imagery to enhance the mystery surrounding the tiny figure and his rhetorical inscription provide additional reason to interpret the content of this example of representational symbolism as essentially the same as that of Hartmann's frontispiece.

Another representational work of art that may be described as implanted with theosophical meaning is Kupka's *The Beginning of Life,* an aquatint of around 1900 (pl. 28). This example too has a thematic precedent, namely, the colored tripartite drawing, dated 1898, *Soul of the Lotus* (pl. 29). Even disregarding the Hindu prince and female entourage included in the latter, one can attribute theosophical content to both depictions because of the mystical and cosmological connotations that the lotus has in Indian religion and in Theosophy and because of the repetition of circular forms. Blavatsky explained this flower not only in terms of Hindu-Buddhist and ancient Egyptian belief systems (of which the Christian Lily of the Annunciation is seen as a historical offshoot) but also as a primordial symbol of creation, insofar as its roots in water and daily response to the sun combine the water-fire duality that she, like Dupuis and others before her, viewed as exemplary of all ancient cosmologies.[52] Whereas it is possible that *Soul of the Lotus* refers to some specific incarnation of a Hindu god, *The Beginning of Life,* with its embryo suspended in a circle and attached umbilically to a flattened flower blossom, itself the seeming offspring of the lotus blossom below, clearly refers to a more geometrically conceived symbolism.

In terms of both form and iconography *The Beginning of Life* may have functioned as a precedent for the crucial 1909–13 painting *The First Step* (see p. 36), which in turn was a precedent for the 1911–12 series Disks of Newton (see p. 69) and, at least in respect to the two overlapping disks, for *Amorpha: Fugue in Two Colors,* 1912.[53] Thus despite the other less esoteric sources sometimes rightly suggested as having contributed to the emergence of Kupka's disk-based abstractions, their various solar, lunar, and planetary evoca-

27
Frontispiece from Franz Hartmann, *Magic: White and Black* (1886), reproduced in *Le Lotus* 1 (March 1887)

.

28
FRANTIŠEK KUPKA
The Beginning of Life, or *Water Lilies,* c. 1900
Colored aquatint
13 ⅝ x 13 ⅝ in.
(34.5 x 34.5 cm)
Musée National d'Art Moderne, Centre Georges Pompidou, Paris

.

tions may also be read as rooted in the circular lotus blossoms and pads that float on the surely sacred waters and symbolize cosmic birth in *The Beginning of Life*. It is not inconceivable, finally, that Kupka's multiple-disk paintings were to a degree influenced by *The Planetary Chain,* a well-known diagram from Sinnett's *Esoteric Buddhism,* a standard theosophical text. The diagram appeared in a French version (pl. 30) when excerpts from Sinnett's book appeared in an 1890 issue of *Revue théosophique*.[54] Significantly, like so many other theosophical diagrams, this one schematizes the reciprocal interaction between the "descent of spirit into matter," called *involution,* and the "ascent of spirit beyond matter," called *evolution*. Because the interaction of macrocosmic and microcosmic worlds is also implied, this may have had an effect on Kupka's thinking in relation to his circular stylizations as much as it obviously had when he artistically examined the issue "Quam ad causum sumus?"

Kupka's ongoing involvement with mediumistic clairvoyance and also with standard theosophical symbolism is very likely inherent to his many paintings based on the theme of vertical planes.[55] In theosophical texts the vertical line stands for male spirituality leading heavenward, and it is a striking aspect of Kupka's oeuvre that, except for a number of post–World War I paintings that include rectangles or other vertical-horizontal line contrasts, there is a pronounced absence of series based upon horizontal planes. The several series leading to the Vertical Planes series (pl. 31), apart from the usual tendency of Kupka to collate his abstract geometric forms from multifarious naturalistic images, all imply upward movement consistent with the principle of levitation, a principle common to the artist's continuing activities as a medium and to the theosophical idea of ascent from the world of matter to that of spirit. A

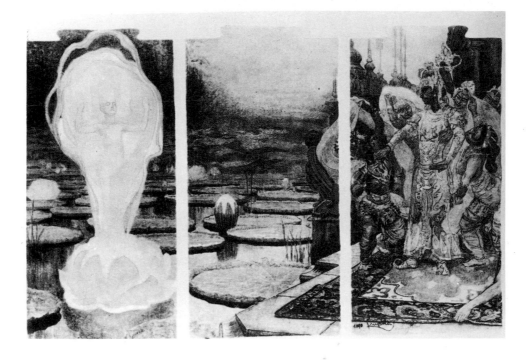

29
FRANTIŠEK KUPKA
Soul of the Lotus, 1898
Colored drawing and
gouache
15 ³⁄₁₆ x 22 ¾ in.
(38.6 x 57.8 cm)
Narodni Galerie, Prague

30
The Planetary Chain, diagram
adapted from A. P. Sinnett,
Esoteric Buddhism (1883)

31
FRANTIŠEK KUPKA
Vertical Planes, 1912–13
Oil on canvas
40 ¹⁵⁄₁₆ x 26 ¾ in.
(104 x 68 cm)
Musée National d'Art
Moderne, Centre Georges
Pompidou, Paris

32
FRANTISEK KUPKA
Piano Keys — Lake, 1909
Oil on canvas
31 ⅛ x 28 ⅜ in.
(79.1 x 72.1 cm)
Narodni Galerie,
Prague

relatively early instance of such an iconographic image of levitation is in the painting *Piano Keys — Lake,* 1909 (pl. 32): the striking of an A-major chord by the fingers seen lower right seems to produce an ascendant jettisoning of the keyboard with the intent of ultimately veiling the lake by a screen of narrow vertical planes. The progressive transformation of this visual motif into the Vertical Planes series embraces a myriad of imagery too complicated for simple exegesis, but it can be stated without equivocation that the sense of kinesis is predominantly upward in the great majority of relevant examples.[56] The "involutions" of Kupka's pictorial grammar notwithstanding, it is evident that in his vertical plane compositions a theosophically conceived idea of evolution upward from matter to spirit is one of the chief ideological factors.

The complex and fecund artistic career of Kupka is only partly served by this résumé of his involvement with sacred geometries. There is no reason, for example, to believe him to have been an inscribed member of the Theosophical Society or a regular participant at its meetings in any of his cities of residence; indeed it is important to note that by 1889, when Blavatsky published *The Key to Theosophy,* she had declared herself adverse to mediumistic exercises. Nevertheless Kupka's persistent dabbling in the realm of esoterica may be considered one of the most seminal ingredients in his extraordinarily productive career. If his lifelong interest in the occult sciences is not taken into account, our understanding of the many-faceted nature of his creativity is impoverished.

Of the four founding fathers of abstract art, Mondrian doubtless was the most consistent and systematic in his use of simple geometric figures. This is particularly true for the years of his transition from naturalism to abstraction, from around 1910 to 1919, which, not incidentally, roughly coincided with the period of his most intense involvement with Theosophy.[57] Because I have discussed this involvement in relation to Mondrian's use of geometric figuration elsewhere,[58] what follows is a brief summation of how sacred geometry affected the style and content of his art.

The earliest unmistakable occurrence of theosophical signs in Mondrian's art are the hexagrams, circles, and triangles that accompany the figures in his triptych painting *Evolution,* 1910–11 (see p. 101), in which the cardinal theosophical doctrine of the primacy of spirit over matter is encapsulated in the varying degrees of spiritual elevation signified by the three female figures. This tribute to the teachings of the Theosophical Society, moreover, was not unprecedented: Mondrian's *Woods near Oele,* 1908 (pl. 33), painted one year before he became a member of the society's Dutch chapter, contains such a studied opposition between the ascending lines of the tree trunks and the horizontals of the ground plane that male-female, spirit-matter polarity may be assumed. This opposition is equally applicable when only one linear direction is emphasized, such as the isolated vertical church towers and windmills and the horizontal expanses of dunes and sea that pervade his landscapes of 1909–10. On certain occasions, when neither linear direction seems dominant, as in some works of the Red Tree and Dune series (pl. 34), one senses that the normally random contours of natural forms are seeking to attain the identity of an upward-pointing triangle. This striving for geometric definition is also observable in several of the artist's most important flower paintings.[59]

During his Cubist years, 1912–14, Mondrian's reduction of forms observed in nature to rudimentary geometric shapes gained momentum to the point that contemporary critics were unaware of underlying vegetal and architectonic motifs (pl. 35).[60] The stimulus that Cubism afforded Mondrian for experimentation in purely formal terms while seeking a mature personal style must not be underestimated, but Mondrian's adoption of the Cubist style was in part due to his conviction that it embodied the greatest potential for evolving a truly spiritual form of art. This belief was nurtured by the remarkable speech given by Jan Toorop in 1911 at the opening of the first Moderne Kunstkring exhibition in Amsterdam, at which Mondrian was a presiding officer and Cubist paintings made their first appearance in the Netherlands.[61] Toorop's call was above all for "spiritual purity," as in the art of Cézanne, for a style "simplified into straight or quietly undulating vertical or horizontal lines" and relating to architecture. As means to this end he suggested the use of "contrasting complementary colors" and the incorporation of triangles as found "in the interesting work of the young French Cubists." His ultimate praise was for the work of Father Lenz, which was planned for exhibition the following year. This last reference not only reflects Toorop's friendship with Verkade (a former Nabi) but also, with his attribution of similar ideas to the "young French Cubists," a willful syncretism of the geometric basis of the Beuron school's style. At the very least Mondrian would not have been shocked by the declaration of these associations, and it is more likely that he shared in their predication.

From the outset Mondrian's Cubism was informed by the inclusion of linear patterns in which some form of contrast is invariably present: straight versus curved lines, crosses versus enclosed squares and rectangles, and verticals versus horizontals. Mondrian's use of the oval as a compositional format may have owed as much to the Hindu-theosophical image of the universal procreative egg as to

33
PIET MONDRIAN
Woods near Oele, 1908
Oil on canvas
50 ⅜ x 62 ⅛ in.
(128 x 158 cm)
Haags Gemeentemuseum,
The Hague

34
PIET MONDRIAN
Dune VI, 1909–11
Oil on canvas
52 ¾ x 76 ¾ in.
(134 x 195 cm)
Haags Gemeentemuseum,
The Hague

·

35
PIET MONDRIAN
Tree, 1912
Oil on canvas
37 x 27 ½ in. (94 x 69.8 cm)
Museum of Art, Carnegie
Institute, Pittsburgh

·

the formalist motivation of Georges Braque and Pablo Picasso. Similarly a sizable number of Mondrian's Cubist paintings include multiple manifestations of the tau cross (see p. 102), allowing the suspicion that for Mondrian this sign had not altogether lost its theosophical significance as an indicator of life.[62]

The subsequent participation of Mondrian in De Stijl witnessed his gradual disenchantment with the strict precepts of Theosophy, particularly regarding the use of symbolism and the depiction of such mystical phenomena as "aural emanations."[63] In 1919 he was not, however, deterred from suggesting to his colleague Theo van Doesburg that a work of this period was inspired by a "starry sky." Most likely he had in mind one of his diamond-shaped grid compositions (for example, pl. 36), which uses the "popping effect" caused as an optical illusion by the intersection of lines to suggest a visual analogy with the sparkles of a starry sky.[64] In this respect he was creating, in terms of one of the most strictly geometric or mathematical compositions yet produced, an abstract equivalent to Kupka's *The Way of Silence* of two decades earlier. Worlds apart in stylistic means, the two artists' ultimate purposes seem unexpectedly parallel: to employ art not only as a vehicle of aesthetic satisfaction but also as a conduit between the microcosm of earthly existence and the macrocosm of everlasting spiritual existence.

It would be overstating the case to claim an allegiance to the ideal of sacred geometries as the prime motivation in the minds of either the Nabis or the leading artists of modern abstract art. Neither should one imagine that without the existence of the Theosophical Society in all its international manifestations abstract art would not have emerged, survived, and flourished. It is also noteworthy that the esoteric symbolism evident in the work of the Nabis did not produce any appreciable effect upon those European artists of the next generation most seminal in the abstract movement. In fact the foremost exemplars of this later tendency developed their individual styles in relative isolation: Malevich in Russia, Kandinsky in Germany, Mondrian in the Netherlands, and Kupka in France. Does this not tell us something essen-

tial about the historical breeding ground in which the fledgling abstract art movement was nourished? The individual artists each showed inventive ingenuity in escaping from the confines of native cultural and artistic tradition in order to enter a world of ideas where national, cultural, and religious allegiances took second place to the ideal of an international brotherhood bonded by a common interest in the history of religion and science. This common interest could flourish in large part due to the richness and widespread availability of theosophical literature wherever these artists were located. Whatever doubts may be cast upon the importance of specific theosophical diagrams in relation to the creation of specific works of art, the importance of these diagrams as a shared system of reference is easily established. The fact that the reputed origin of Theosophy, the rediscovered ancient wisdom, was to be traced to no less august personages than Pythagoras and Plato, and to the combined religions of India, Egypt, and Greece provided an added attraction for those seeking a sense of historical continuity in a period of impending change.

36
PIET MONDRIAN
Diamond Composition with Grey Lines, 1918
Oil on canvas
47 ⅝ in. (121 cm)
point to point
Haags Gemeentemuseum,
The Hague

1. Charles F. Dupuis's *Origine de tous les cultes ou religion universelle* (Paris, 1794) was first published in three-volume quarto and twelve-volume octavo editions, followed in 1795 and 1798 by single-volume summary editions. In 1822 another complete edition appeared, accompanied by Charles Dupuis's 1806 astronomical tract, *Mémoire sur le zodiaque de Tentyra*, in which his naturalistic and syncretistic interpretation of the origin and function of early religions was said to be reflected in a recently discovered Egyptian zodiacal decoration at Dendera (the ancient city of Tentyra). Despite his professed rationalism, Dupuis employed various cabalistic and mystical texts as support for his thesis.

2. Lady Caithness, *Théosophie universelle: La Théosophie chrétienne* (Paris: Carré, 1886), 167. Despite much discussion of Egyptian, Hindu, and Buddhist religious esotericism, Caithness distanced herself from the oriental leanings of Helena P. Blavatsky: "for Universal Theosophy Jesus is *one* Christ, but for Christian Theosophy he is *the* Christ" (p. 30).

3. In Dr. Alexander Wilder's introduction to Richard Payne Knight, *The Symbolical Language of Ancient Art and Mythology: An Inquiry* (New York: Bouton, 1876), xxv, the Rosicrucians and Freemasons are credited with having preserved something of the ancient mystery religions.

4. Knight, *Symbolical Language*, especially 30, 167ff.

5. See *Isis Unveiled* (1877), in H. P. Blavatsky, *Collected Writings* (Wheaton, Ill.: Theosophical Publishing House, 1972), 2:266–71, and idem, *The Secret Doctrine* (1888; Pasadena: Theosophical University Press, 1974), 2:545–82, 590–98.

6. This standard esoteric identification is also found in Éliphas Lévi, *Dogme et rituel de la haute magie* (Paris: Ballière, 1860), 66–67, 88–89, 225–28.

7. Blavatsky, *Secret Doctrine*, 2:580–81.

8. Ibid., 2:581.

9. Not only did Lady Caithness, *Fragments glanés dans le théosophie occulte d'Orient* (Nice: Gauthier, 1884) contain extended excerpts from Alfred Percy Sinnett, *Esoteric Buddhism* (London: Trübner, 1883), but the latter was also made available in a complete French translation as *Le Bouddhisme ésotérique ou Positivisme hindou* (Paris, 1890); idem, *The Occult World* (London: Trübner, 1881) was available in French as *Le Monde occulte* (Paris: Carré, 1887).

10. After having published in 1886 under auspices of the Theosophical Society a preliminary version of the *Essais de sciences maudites: I. Au seuil du mystère* (Paris: Carré, 1890), Stanislas de Guaita presented in *Le Lotus* (March 1888): 221–47, a "fragment of a book in preparation," *Le Serpent de la Genèse*, or vol. 2 of *Essais de sciences maudites*, which was to appear in 1891. The submissions of Papus (Gérard Encausse) to *Le Lotus* covered such diverse ground as comments on a symbolic diagram (March and May 1887) taken from Franz Hartmann, *Magic: White and Black* (London: Redway, 1886), which would appear in 1905 in a full French translation; an article on the philosophical stone of the alchemists (May 1888); and a summary of the ideas of Antoine Fabre d'Olivet and of Marquis Saint-Yves d'Alveydre, author of the cabalistic *Mission des Juifs* (Paris: Calman Levy, 1884), another important source for Guaita, Édouard Schuré, and Papus.

11. Papus, *Traité élémentaire de science occulte* (Paris: Carré, 1888), 107–10, and "Société Théosophique Hermès," *Revue théosophique* 1 (March 1889): 23–28.

12. Jehanne Teilhet-Fisk, *Paradise Reviewed: An Interpretation of Gauguin's Polynesian Symbolism* (Ann Arbor: UMI Research Press, 1983), especially 19–20, 47, 54. It remains to be proven that either Sérusier or Claude-Émile Schuffenecker had become a member of the Theosophical Society before Paul Gauguin's first departure for Tahiti and, if so, that either had transmitted a knowledge of the doctrines of Blavatsky directly to Gauguin. Caroline Boyle-Turner, *Paul Sérusier* (Ann Arbor: UMI Research Press, 1983), 24–25, while correctly pointing out that for Sérusier, Roman Catholicism and Theosophy remained compatible belief systems, fails to situate with chronological exactness Sérusier's initial involvement with Theosophy.

13. Filez Eda Burhan, "Vision and Visionaries: Nineteenth-Century Psychological Theory, The Occult Sciences and the Formation of the Symbolist Aesthetic in France" (Ph.D. diss., Princeton University, 1979), 140–43.

14. It is not known whether Gauguin first encountered these ideas only by a reading of J. A. Moerenhout, *Voyages aux îles du grand océan* (Paris: 1837), in Tahiti or already by knowing a summation that appeared in Henri le Chartier, *Tahiti et les colonies françaises de la Polynésie* (Paris: Farne, Jouvet, 1887), as suggested by Christopher Gray, *Sculpture and Ceramics of Paul Gauguin* (Baltimore: Johns Hopkins Press, 1963), 49.

15. Moerenhout, *Voyages aux îles*, 561ff.

16. For Gauguin's use of Gerald Massey's writings, culminating in the essay "L'Esprit moderne et le Catholicisme," circa 1897–1902, (manuscript in The Saint Louis Art Museum), see Paul Gauguin, *The Writings of a Savage* (New York: Viking, 1978), especially Wayne Andersen's introduction, XVII–XX, and Daniel Guérin's editor's note, 161–63.

17. Charles F. Dupuis, *Origine de tous les cultes ou religion universelle* (Paris: La Librarie Historique d'Émile Babeuf, 1822), 1:498ff.

18. Blavatsky (*Secret Doctrine*, 2:546) credits Gerald Massey, "Typology of the Cross," in *A Book of the Beginnings* (London: Williams & Norgate, 1881), 1:408–55.

19. Gauguin, "L'Esprit moderne," 47.

20. Bogomila M. Welsh-Ovcharov, *Vincent van Gogh and the Birth of Cloisonnism*, exh. cat. (Toronto: Art Gallery of Ontario, 1981), 208, and George Mauner, "The Nature of Nabi Symbolism," *Art Journal* 23 (Winter 1963–64): 102. The model for the cross in *Yellow Christ* was a Latin cross, namely, the polychrome crucifix sculpture in the church at Trémalo near Pont-Aven.

21. For these associations, see Wayne Andersen, *Gauguin's Paradise Lost* (New York: Viking, 1971), 98–108; Émile Bernard's *Portrait of the Artist's Sister in the Bois d'Amour*, illustrated ibid., pl. 68, a source cited by Andersen for Gauguin's *Loss of Virginity*, so starkly contrasts the horizontal pose of the reclining figure with the vertical lines of the tree trunks that an embodiment of the material-spiritual duality accorded to this opposition of linear configuration by esoteric interpretation may be suspected.

22. Caithness, *Fragments glanés*, 22, 53–57.

23. Because *Les Grands Initiés* was favorably reviewed in the 21 July 1889 issue of *Revue théosophique* and was also listed among the "books received" for that month, it most probably had appeared not long before. Although the earliest proof of Sérusier's intense interest in the writings of Honoré de Balzac and Schuré derive from his 1891–93 contacts with Jan Verkade (P. Sérusier, *A B C de la peinture* [1921; Paris: Floury, 1950], 66–67; Dom Willibrord [Jan] Verkade, *Le Tourment de Dieu: Étapes d'un moine peintre* [Paris: L. Rouart and J. Watlin, 1923], 210–12; and Boyle-Turner, *Sérusier*, 83–86), he doubtless was familiar with some theosophical writings by the time he executed the 1890 *Portrait of Paul Ranson*.

24. That the editions cited in this essay were those in the Ranson family archive was ascertained by the author, 13 November 1973.

25. Édouard Schuré, *Les Grands Initiés: Esquisse de l'histoire secrète des religions* (Paris: Perrin, 1889), 553. In idem, "Le Bouddha et sa légende," *Revue des deux mondes* (1 August 1885): 589–622, while not referring specifically to Theosophy, Schuré emphasized various parallels in the lives and doctrines of Jesus Christ and the Buddha and alluded to both "esoteric Buddhism" and the arcane (especially, pp. 618–22).

26. Schuré, *Les Grands Initiés*, 161, 228, 348.

27. Although accepted by Marcel Guicheteau, *Paul Sérusier* (Paris: Side, 1976), 148, this claim is effectively refuted by Boyle-Turner, *Sérusier*, 157, 167.

28. Whereas the title *The Origins* likely involved a tribute to Redon's 1883 lithographic cycle of the same name (Boyle-Turner, *Sérusier*, 161 n. 128), Sérusier's pictorial imagery is more directly reminiscent of the cover illustration of the *Revue théosophique*, which included a foreground sphinx, middle-distance pyramid, and radiating sun disk on the horizon of a similarly vast expanse of space.

29. Schuré, *Les Grands Initiés*, 153.

30. Papus, *Traité élémentaire*, 90ff., 170.

31. Mauner, "Nabi Symbolism," 100, relates virtually all images in *Rama* to the main theme of Schuré's chapters on Rama, namely, his victory over the savagery of the religion of the prehistoric Druidesses by their conversion to the role of domestic women.

32. Papus, *Traité élémentaire*, 111.

33. *Alchemy* is illustrated (pl. 7) and fully interpreted in Mauner, "Nabi Symbolism," 100.

34. Blavatsky, *Secret Doctrine*, 1:5; translation in *Revue théosophique* (October 1889): 76ff.

35. In 1892 this brief theater piece not only was republished with a twelve-page explanatory preface by Jules Bois but was presented on 28 March at the Théâtre d'Art along with Schuré's *Vercingétorix*, a play based on Celtic themes, for which Sérusier provided the settings and Odilon Redon a lithographic advertisement (Guicheteau, *Sérusier*, 82–83, 90 n. 120). By this date Sérusier and almost certainly Ranson had become personally acquainted with both Bois and Schuré.

36. Schuré, *Les Grands Initiés*, 142–43.

37. Because this 1889 painting by Gauguin was in the collection of his friend Schuffenecker and not publicly exhibited (Welsh-Ovcharov, *Vincent van Gogh*, 206), a visit by Ranson to Schuffenecker may be hypothesized, possibly during winter 1890–91, when Gauguin supposedly joined the Nabi meetings at the Ranson atelier on more than one occasion. See Agnès Humbert, *Les Nabis et leur époque 1888–1900* (Geneva: Cailler, 1954), 43.

38. Papus, *Traité élémentaire*, 108.

39. The identification of these images as employed by Vuillard and Lacombe was made in Mauner, "Nabi Symbolism," 101–3.

40. Blavatsky, *Secret Doctrine*, 2:556.

41. The edition of *Sagesse* as published by Ambroise Vollard (Paris, 1911) contained seventy-two illustrations by Maurice Denis.

42. Another of these circa 1890 paintings by Denis, who was known to friends as the "Nabi of the beautiful icons," is *Orange Christ* (illustrated and discussed in Welsh-Ovcharov, *Vincent van Gogh*, 380), which presents a red crucifix as the real symbolic goal of the shadowy throng of female worshiper-mourners who surround and move toward it.

43. The nearest there is to a monographic study of Charles Filiger is the excellent exhibition catalogue by Marie-Amélie Anquetil et al., *Filiger: Dessins — gouaches — aquarelles* (Saint-Germain-en-Laye: Musée Départemental du Prieuré, 1981).

44. Guicheteau, *Sérusier,* 95–129; and Boyle-Turner, *Sérusier,* 111–34.

45. Illustrated in Marie-Amélie Anquetil, Marianne Barbey, and Georges Gomez y Caceres, *Musée du Prieuré: Cinq années d'acquisitions 1980–1985,* exh. cat. (Saint-Germain-en-Laye: Musée Départemental du Prieuré, 1985), 45.

46. The example by Carlos Schwabe is discussed in and reproduced on the cover of Robert Pincus-Witten, *Les Salons de la Rose + Croix,* exh. cat. (London: Piccadilly Gallery, 1968), and that by La Rochefoucauld cited in Philippe Jullian, *Dreamers of Decadence* (New York: Praeger, 1971), 209.

47. For documented illustrations of this commission, see Anquetil, *Filiger,* cat. nos. 42–43, pp. 58–59; for La Rochefoucauld's more Egyptianized cover design for *Le Coeur,* see p. 77.

48. This and subsequent statements about František Kupka's career derive from Meda Mladek and Margit Rowell, *František Kupka 1871–1957: A Retrospective,* exh. cat. (New York: Solomon R. Guggenheim Museum, 1975), especially Meda Mladek, "Central European Influences," 13–37, and Meda Mladek and Margit Rowell, "Chronology," 305–11.

49. *Sphynx* was first published in 1886 in Leipzig and, like its French counterparts, carried excerpts of writings sponsored by the Theosophical Society.

50. As retranslated into English by me from "Explication du Frontispiece," *Le Lotus* 1 (March 1887): 5.

51. See, for example, from *Theology,* the second volume of Blavatsky's *Isis Unveiled,* the standard foldout diagrams of the "Hindu" and "Chaldean" doctrines.

52. Blavatsky, *Secret Doctrine,* 1:379–86.

53. On the acknowledged juxtaposition of illustrations of *The Beginning of Life* and *The First Step* (Ludmila Vachtová, *Frank Kupka* [London: Thames and Hudson, 1968], 78–79), Rose-Carol Washton Long (*Kandinsky: The Development of an Abstract Style* [Oxford: Clarendon Press, 1980], 142–23) posits a theosophical meaning for these works of art, as she also does for the "circular forms" of Robert Delaunay.

54. *Revue théosophique* 2 (21 February 1890): 260.

55. Mladek and Rowell, *František Kupka,* 28–29, 75–77, 130–62, 187–95.

56. One might better say upward and inward, because Rowell in *František Kupka* (p. 45) has imaginatively seen the subject of the Organization of Graphic Motifs series of around 1912–13 as having derived from the same spatial and iconographic consideration present in the earlier Quam ad causum sumus treatments.

57. Although Piet Mondrian's initial contact with Theosophy is sometimes given as around 1900, his first recorded membership in the Theosophical Society was in 1909. Around 1913 he was asked to write an article on art for the Dutch organ of the Theosophical Society, and in his early De Stijl essays he still mentions the movement with honor. No mention of Theosophy is found in his subsequent writings, but in 1938 he reregistered with the society in Paris.

58. Robert P. Welsh, "Mondrian and Theosophy," in *Piet Mondrian 1872–1944: Centennial Exhibition,* exh. cat. (New York: Solomon R. Guggenheim Museum, 1971); and idem, "Piet Mondrian: The Subject Matter of Abstraction," *Artforum* 11 (April 1973): 50–53.

59. For example, no. 26, p. 110, and no. 43, p. 126, in *Piet Mondrian,* and classified cat. no. 163, p. 371, in Michel Seuphor, *Piet Mondrian: Life and Work* (New York: Abrams, 1956).

60. Robert P. Welsh, *Piet Mondrian 1872–1944,* exh. cat. (Toronto: Art Gallery of Toronto, 1966), no. 67, pp. 134–35, and no. 70, pp. 140–41; for the statement in reference to Mondrian's contributions to Le Salon des Indépendants of spring 1913 as comprising "la peinture très abstract," see Guillaume Apollinaire, *Chroniques d'Art,* ed. LeRoy C. Breunig (Paris: Gallimard, 1960), 294.

61. Reported anonymously in "Rondom den Moderne Kunstkring," *Den Tijd* (7 October 1911).

62. For example, see Welsh, *Piet Mondrian 1872–1944: Centennial Exhibition,* nos. 58, 62, 66–67, pp. 141, 145, 148–49, respectively.

63. Piet Mondrian in *De Stijl* 1 (January 1918): 30 n. 3, declared himself against the "imitation of astral colours" and in *De Stijl* 1 (February 1918): 48, warned of the too frequent use of symbols.

64. Welsh, "Subject Matter of Abstraction," 53.

OVERLEAF

PIET MONDRIAN
Composition No. 3 with Color Planes, 1917
Oil on canvas
18 ⅞ x 23 ⅝ in. (48 x 60 cm)
Museum Boymans-van Beuningen, Rotterdam

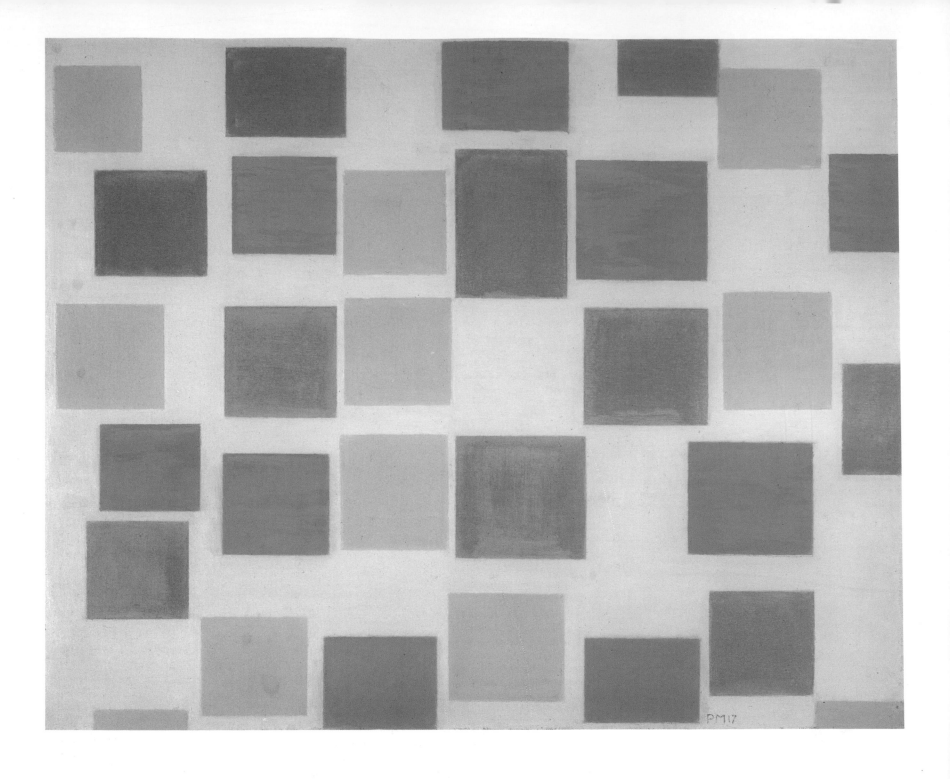

ANNUNCIATION OF THE NEW MYSTICISM: DUTCH SYMBOLISM AND EARLY ABSTRACTION

CAREL BLOTKAMP

In 1984 Frank Stella gave a lecture in Amsterdam in which he clearly stated his position as a contemporary abstract painter in respect to his predecessors:

> I have no difficulty appreciating (and up to a point understanding) the great abstract painting of modernism's past, the painting of Kandinsky, Malevich and Mondrian, but I do have trouble with their dicta, their pleadings, their defense of abstraction. My feeling is that these reasons, these theoretical underpinnings of theosophy and anti-materialism have done abstract painting a kind of disservice which has contributed to its present-day plight.[1]

Stella is not alone in expressing mixed feelings; they also exist among art historians. Even though esoteric philosophies figure in many of the more recent studies that have been devoted to the genesis of abstract art, their importance is the subject of considerable debate. Like Stella, many art historians have difficulty accepting that such a great artist as Piet Mondrian would have been attracted to something as vague as they perceive Theosophy to be. They have felt that if such ideas had been of any use for artists, it was only as nourishment for the soul and certainly not as a determining factor in their artistic work. This opinion is not only based on a certain skepticism regarding the occult, rather common among today's intellectuals, but is representative of a typically modern view of abstract art as something completely autonomous.

Against this view it may be hard to imagine that artists in the beginning of this century could have felt so excited and at times so desperately lost when they entered the as yet unexplored territory of abstraction. Mondrian's question, "Do we err now, or don't we?"[2] in one of his Parisian sketchbooks is certainly not rhetorical; it is indicative of his strong feeling that the old artistic, philosophical, and religious systems had fallen apart. In his search for new artistic meaning Mondrian found support in the new spiritual movements that were flowering throughout the Western world at the turn of the century, and this is true even if the sources of inspiration seem obscure in comparison with the directness of his abstract paintings. To borrow an expression from his contemporary and compatriot, the writer Frederik van Eeden, Mondrian's paintings are like the white water lily whose slithery stems are rooted in muddy black soil.

It is generally acknowledged that Mondrian's art has its origins in early nineteenth-century

1
JAN TOOROP
Organ Sounds, c. 1890
Pencil, black and colored
crayon on board
21 ¼ x 27 ³⁄₁₆ in. (54 x 69 cm)
Rijksmuseum Kröller-
Müller, Otterlo,
Netherlands
.

Romanticism and more immediately in Symbolism and Cubism. There has been, however, a tendency to disregard the importance of his immediate environment and his contacts with artists in his native country. Mondrian was a rather provincial artist until 1911, when he joined with the international avant-garde. Thus his art and theory were largely shaped within the context of the artistic and spiritual life in the Netherlands at the turn of the century and after, in which mysticism and esotericism played a major part. A proper understanding of his position as an artist requires a discussion of Dutch Symbolism and early Dutch abstract art and particularly of the close ties between art and Theosophy in the period from 1890 to 1920.[3]

The year 1885 is of landmark significance in the cultural history of the Netherlands, the year when a group of young people started the magazine *De Nieuwe Gids* (The new guide).[4] Although the magazine had a small circulation, its importance can hardly be overestimated. In a highly passionate tone it presented a new generation of writers, such as Willem Kloos, Albert Verwey, Frederik van Eeden, and Lodewijk van Deyssel, and visual artists, such as Jan Veth, Willem Witsen, and R. N. Roland Holst. Also closely connected with the publication were such proponents of the rising socialism of the day as Frank van der

Goes and such creative philosophers as G. J. P. J. Bolland, who later on, as a neo-Hegelian, became a kind of cult figure, particularly among artists.[5] The young editors of *De Nieuwe Gids* were extremely critical about their older countrymen, whom they accused of being bourgeois and amateurish. They claimed to do no less than free the Netherlands from its provincialism and to push it to the forefront of European culture. Consequently the journal was heavily international in orientation, and generally only foreign artists were up to the high standards set by the editors and contributors. Their literary heroes were such English Romantic poets as Percy Bysshe Shelley and such French contemporaries as Paul Verlaine and Émile Zola. Only in the visual arts was there an equally divided admiration for French painting, from the Barbizon school to early Impressionism, and for the indigenous school of The Hague.

Around 1890 a change of artistic direction toward Symbolism, analogous with the situation in the leading avant-garde circles in Brussels and Paris, became evident in *De Nieuwe Gids*. In 1891 the title of a famous book review by Lodewijk van Deyssel, "De dood van het naturalisme" (The death of natu-

ralism), exemplified this change.[6] Zola's meticulous description of reality now became the lowest stage in a sequence that, according to van Deyssel, led from observation, by way of impression, to sensation and finally ecstasy. Maurice Maeterlinck was the new hero. In van Deyssel's and van Eeden's prose of the 1890s there was a strong effort to reach the highest stage of ecstasy through the writing itself. It was, however, the poet Herman Gorter who came closest to this goal with his extremely daring phonetic constructions, which show an almost religious enchantment. In contrast, Verwey expressed the change of direction through an assimilation of philosophic principles into his literary oeuvre. The development of Symbolism, however, was not generally acclaimed. When asked to contribute to the *Tweemaandelijksch Tijdschrift* (Bimonthly magazine), which Verwey and van Deyssel started in 1894, the psychiatrist Gerbrandus Jelgersma expressed his concerns to van Deyssel by asking if it would not "become the organ of mysticism also rising in our country."[7] In fact the leading young artists were obsessed with a new and more spiritual concept of art and life.

The first symptoms of an antirealist and antimaterialist stance in the visual arts became noticeable in the late 1880s with the apprecia-

tion of Odilon Redon and then from the end of 1890 onward, of Vincent van Gogh.[8] Jan Toorop and Antoon Derkinderen, followed soon by Roland Holst and Johan Thorn Prikker and a host of minor artists, such as Étienne Bosch, Michel Duco Crop, Herman van Daalhoff, Samuel Jessurun de Mesquita, and Simon Moulijn, began to practice a kind of art that differed radically from the more moderate Impressionism practiced by the schools of The Hague and Amsterdam. The difference is not only visible in the style and subject matter of their work but is also noticeable in their opinions about art and the role of the artist. The young painters were no longer interested in recording the changing appearances of nature's beauty. They opted, as the painter-critic J. Veth said, "for such a category as the pure art of expression."[9] Spiritual values, considered suprapersonal and timeless, the basic principles of life, should be expressed, not personal experiences and feelings.

Together with this change in mentality rose a growing interest in idealist philosophies, particularly early nineteenth-century German philosophy. The influence of Benedict de Spinoza, who had been rediscovered a few decades earlier by the agnostic Johannes van

Vloten, was also perceptible. In the 1890s Spinoza inspired Verwey, who was van Vloten's son-in-law, and Gorter to metaphysical poetry. In the Netherlands there was, moreover, a broad interest in the mystical elements of Christianity and Eastern religions. Thomas à Kempis, Jan van Ruysbroeck, Jakob Böhme, and Emanuel Swedenborg found new admirers; Rémy de Gourmont's *Le Latin mystique* and the occult works of writers like Stanislas de Guaita were also read. In 1892 when "Sâr" Joséphin Péladan, founder of the Ordre de la Rose + Croix, gave several lectures in Amsterdam, The Hague, and Leiden, he was criticized because of his eccentric clothing and behavior, but his plea for a new, ideal art found a willing audience among artists. Toorop and Thorn Prikker, the two most important Dutch Symbolists, became members of the order, and the former sometimes included mystical Rosicrucian elements in his Symbolist drawings.[10] These two artists deserve further consideration, not only because of the mystical tenor of their work but also because of its far-reaching abstraction. In both respects they were forerunners of Mondrian and other early abstract artists in the Netherlands.

Living in Brussels, Toorop was in touch with the local avant-garde movement from the

middle 1880s onward and also with avant-garde artists in France and England. After a period of painting delicate landscapes and works with socially oriented themes in the French Pointillist manner, around 1890 he developed a more linear style. But he also continued working in other styles. Toorop was a highly eclectic artist who was affected by the most diverse influences, ranging from Flemish primitives, English Pre-Raphaelites, Belgian and French Symbolists, such as Fernand Khnopff and the school of Pont-Aven, to art from Egypt, Assyria, Japan, and Indonesia. Utilizing the formal means of all these influences, he drew fantastic and symbolic images, often inspired by his reading of contemporary Symbolist writers and old and new mystics like Ruysbroeck, à Kempis, and Péladan. Many of his drawings (pl. 1) refer explicitly, through titles and inscriptions, to poems and prose by Charles Baudelaire, Émile Verhaeren, Jules Laforgue, van Deyssel, van Eeden, Verwey, and in one case even to Walt Whitman.

Toorop's drawing *Song of the Times,* 1893 (pl. 2), represents the battle between good and evil, between the material and the spiritual, which he considered humankind to be fight-

2
JAN TOOROP
Song of the Times, 1893
Pencil and black crayon on paper
30 ¹¹/₁₆ x 38 ⁹/₁₆ in.
(78 x 98 cm)
Rijksmuseum Kröller-Müller, Otterlo, Netherlands
·

ing. This battle is personified by the middle figure, who suppresses with a strong hand the seductive sphinx. Following religious tradition, to the left of the figure are the evil, destructive powers and to the right are the countering powers of good. On the far left stands Cain, the first murderer according to the Bible, next to a tree trunk, symbol of life destroyed. On the far right is his victim, his brother Abel, who carries a lamb, symbol of newborn life. Immediately flanking the central figure are representations of material anarchy, left, and spiritual anarchy, right. The figure of material anarchy, conceived as a negative phenomenon, breaks a stick and holds a scale in which a pickax is being weighed against a crown and treasury, a symbol both of labor's domination by capital and the power of the state. Spiritual anarchy is valued as a positive principle and is represented as a woman who covers her eyes with one hand in introspection; from her body springs a bleeding heart and a budding flower that may symbolize compassion and hope.[11]

As with many of Toorop's Symbolist works, the exact meaning of *Song of the Times* can hardly be understood without the explanations he gave, although these were often rather confused and subject to change.[12] On a more general level, Toorop tried to clarify the meaning of his work to the uninitiated viewer by his special use of lines. Thus the evil powers, left, are surrounded by spiky lines, which arise from and return to the skull on the frame. Other sharply pointed lines, bent downward, come from Cain's mouth. The bundles of lines that emanate from the skull to the good powers, right, are considerably more flowing and rise to the clear, starry sky at the top of the frame, indicating a hopeful future. Ascending, softly flowing lines also emanate from Abel's mouth and a few flowers on the right. The lines, and to a lesser extent the colors, appear in Toorop's Symbolist works (pls. 3–4) as means of expression in their own right. In this respect he may have been influenced by the early nineteenth-century artist and theorist Humbert de Superville, whose theories of expression, popularized by Charles Blanc, influenced many artists in the late nineteenth and early twentieth centuries, among them Georges Seurat, Paul Signac, van Gogh, and also Mondrian.[13]

3
JAN TOOROP
The Three Brides, 1893
Pencil and black crayon on paper
30 ¹¹⁄₁₆ x 38 ⁹⁄₁₆ in.
(78 x 98 cm)
Rijksmuseum Kröller-Müller, Otterlo, Netherlands

.

4
JAN TOOROP
Ascendancy with Opposition of Modern Art, 1893
Crayon on paper
23 ⅝ x 26 in. (60 x 66 cm)
Haags Gemeentemuseum, The Hague

.

Thorn Prikker was less eclectic than Toorop. In choice of subject matter his paintings and drawings of the 1890s such as *The Bride of Christ* (pl. 5) and *End of an Era* are comparable with Toorop's work; the former treats the popular theme of the virginal bride of Christ, whereas the latter is a vision of contemporary life, or the zeitgeist, much in the same way as Toorop's *Song of the Times*. The extent to which Thorn Prikker explored the expressive, mystical power of line and color can be read in his letters to a friend, the writer Henri Borel. On 18 March 1893 Thorn Prikker mentioned that he had started a large triptych representing the Trinity, interpreted not in a biblical but rather in a mystical sense: the Father as "the beginning of things," the Holy Ghost as "the purest essence of pure things."[14] Although he still used figures, the artist was clearly more concerned with the expressive qualities of formal elements. Each panel of the triptych was to have a predominant color, blue, purple, or yellow; lines crossing the whole picture were to link the figures. The execution of the work caused much trouble. Thorn Prikker wrote to Borel on 29 March, "It's an awful nuisance, I have to express the

purity of God in lines and forms, and that's a horrendous job. I think it is stupid to make the Father a distinguished old gentleman with a nice gray beard, or something like that."[15] A few months later Thorn Prikker was still dissatisfied with the triptych, and it was destroyed.

The letters to Borel reveal that Thorn Prikker tried to free himself from the type of symbolic imagery that bothered him in the work of such colleagues as Toorop, imagery whose affectations disturbed him. Searching for a more natural alternative, he created some surprising works, such as *The Epic Monk,* 1894 (pl. 6). This drawing is based upon rock studies he made in 1893 during a trip to Visé, Belgium, studies in which he already inter-

preted the rock formations somewhat anthropomorphically. In the final drawing he enhanced the anthropomorphic aspect, inspired by a poem from Verhaeren's *Les Moines* (The monks). From a labyrinthine pattern of lines loom a hand and foot of a gigantic figure. On the right one recognizes a tiny monk, on the left, a landscape. Overall *The Epic Monk* is one of the most abstract works done in the 1890s.

5
JOHAN THORN PRIKKER
The Bride of Christ, 1892–93
Oil on canvas
57 ½ x 34 ⅝ in. (146 x 88 cm)
Rijksmuseum Kröller-
Müller, Otterlo,
Netherlands

·

6
JOHAN THORN PRIKKER
The Epic Monk, 1894
India ink, black chalk, and
pencil on parchment
38 ⁹⁄₁₆ x 28 ¹¹⁄₁₆ in.
(98 x 72.8 cm)
Centraal Museum, Utrecht,
Netherlands

·

7
JAN TOOROP
*Three Figures Among Trees:
Expulsion from Paradise* (study
for *Annunciation of the New
Mysticism*), 1893
Gouache, watercolor, and
pencil on paper
8 ⅜ x 14 ³/₁₆ in. (21.5 x 36 cm)
Josefowitz Collection

With the examples from the works of Toorop and Thorn Prikker, it becomes clear that such Symbolists put subject matter and formal means into the service of the annunciation of a spiritual renaissance. Art replacing religion and the artist as visionary and prophet were popular notions in the Netherlands in the 1890s and were carried over into the first decades of the twentieth century, especially in the artistic circles that were to develop abstract art. During this protracted period some artists tried to realize their ideals within political or religious organizations: Roland Holst and the poet Gorter associated themselves with socialism and communism in the 1890s, and Chris Beekman and other artists working on the periphery of De Stijl did the same around 1920; others tried to realize their utopian visions in egalitarian communities such as the Walden colony, founded in 1898 by van Eeden after the famous example of Henry David Thoreau; and still others started a flirtation with Catholicism.

The relationship between artists' lofty aspirations and the existing political and religious institutions was, however, in general rather

tense. For example, Toorop's drawing *Song of the Times* reflects his view of the contemporary conditions of mankind: critical of the destructive nature of the political anarchist movement, more or less symbolized by the figure of Cain, he did not think much of institutionalized Christianity either. It is remarkable that the scale, an attribute of material anarchy, is hanging from a cross. Evidently Toorop meant that the church plays a mediating role in the exploitation of labor by worldly powers. The same form and attributes reappear in Toorop's watercolor *Annunciation of the New Mysticism* (pl. 7). Another drawing from 1893, *Anarchy*, shows a raging figure trampling a bishop with a cross and a king with a crown, each carrying a bag of money.[16] The cross on the right, traditionally the side of the good, in *Song of the Times* is similarly treated negatively. The figure of Christ is only a skeleton; the arms of the cross are bent downward and limp forms flow from the nail holes, ending in faded flowers. It is not by chance that the female figure under the cross is called spiritual "anarchy." In Toorop's opinion, the spiritual revival was apparently happening outside the church, an opinion shared by many Symbolists and early abstract artists, including Mondrian.

Although existing institutions might have failed when it came to the spiritual and social changes that many artists had in mind during the 1890s and after, there were alternatives in the form of newly founded movements. One of them was the Ordre de la Rose + Croix, but this exclusive artistic society was mainly active in Paris and only lasted from 1892 to 1898. More ambitious in scope and of longer lasting influence was the Theosophical Society, founded in New York by Helena P. Blavatsky and Colonel Henry S. Olcott in 1875. The fact that Blavatsky reduced the basic truths of all the world religions and philosophies to one common denominator undoubtedly contributed to the success of Theosophy. These truths were stated in her elaborate books *Isis Unveiled* (1877) and *The Secret Doctrine* (1888). She also incorporated new scientific developments such as Darwin's theory of evolution, although drastically reinterpreted in terms of the occult.

Artists were strongly attracted to Theosophy for several decades. This was true not only of the few who became members but also of a much larger group that remained officially outside the organization. In France the painters of the school of Pont-Aven and the Nabis were influenced by Édouard Schuré's inter-

pretation of Theosophy. His book *Les Grands Initiés: Esquisse de l'histoire secrète des religions* (1889) was widely and fervently read. Schuré was also read in the Netherlands by Toorop and van Eeden, who was very interested in spiritualism and lectured in 1890 about the rise of Theosophy, and later on by Mondrian, among others. A Dutch chapter of the Theosophical Society was founded in November 1890.

An important moment, in the context of spiritual abstraction, occurred when K. P. C. de Bazel and J. L. M. Lauweriks became members of the Theosophical Society in Amsterdam on 31 May 1894, followed two weeks later by their friend H. J. M. Walenkamp.[17] De Bazel came to occupy a prominent position in architecture, and from 1900 he was considered the most important Dutch architect, after Hendrik Berlage. The three friends had an education in architecture and the crafts but did a lot of graphic work as well, such as commercial graphics and illustrations for books and magazines. Particularly interesting are the woodcuts by de Bazel and Lauweriks, published in 1894–95 in *Licht en Waarheid* (Light and truth), the magazine of the society Wie Denkt Overwint (He who thinks, conquers). The magazine's text and illustrations show an anarchistic tendency, but

as with Toorop, the denunciation of governmental and ecclesiastical institutions is sublimated in a spiritual anarchy, a longing for a spiritual revival with a decidedly theosophical tenor.

De Bazel's woodcut *The Natural Development of Humankind out of the Mineral, Plant, and Animal World,* 1894 (pl. 8), clearly represents one of the most important theosophical dogmas: the principle of evolution. A figure representative of the Creator has male and female characteristics, mustache and breast, and directs a life-giving ray from a crystal at inert, dark matter from which grows a white plant, which in turn generates a butterfly. These higher forms of life receive rays from the winged head of the Creator and are anointed by his blessing, protective hand.[18] The woodcut shows Art Nouveau-type arabesques subordinated to the narrative. De Bazel also made typographical works that completely consist of abstract patterns that are not just decorative but have a deeper meaning, as is demonstrated by an announcement he designed for his own wedding in 1895 (pl. 9). The symmetrical pattern of undulating lines has at its center an oval shape with a tau cross, a symbol of the harmonious fusion of the male and female, vertical and horizontal,

within the cosmic egg. This symbolic concept, clearly appropriate for a couple about to be married, was adopted from Hinduism by Theosophy and is also present in Mondrian's later work.[19]

The theosophical iconography of de Bazel, Lauweriks, and Walenkamp contains descriptive elements and abstract signs that go back to an often exotic symbolic tradition. After 1895 their own profession, architecture, demanded their attention more and more, and they did not continue developing this iconography in graphic arts. The three men did not repudiate their theosophical beliefs; instead they expressed them in their architectural, interior, and furniture designs. In numerous lectures and articles in the journal *Architectura* (published 1893–1926) and other publications, they affirmed their high notion of architecture and the role of the architect as intermediary in a divine construction plan.

De Bazel, Lauweriks, and Walenkamp paid special attention to the symbolism of forms and the mathematical principles possessed by the great architecture of all ages and cultures. Thus in 1904–5 Walenkamp wrote a series of

8
K. P. C. DE BAZEL
The Natural Development of Humankind out of the Mineral, Plant, and Animal World, 1894
Woodcut
5 ½ x 4 ⁷⁄₁₆ in. (14 x 11.3 cm)
Nederlands Documentatiecentrum voor de Bouwkunst, Amsterdam
.

9
K. P. C. DE BAZEL,
announcement for his wedding, 1895, woodcut, Nederlands Documentatiecentrum voor de Bouwkunst, Amsterdam
.

articles about the meaning of "the aesthetic effect of the duodecimal system," with the Blavatskian title "Voor-historische wijsheid" (Prehistoric wisdom).[20] These theosophical architects differed from nineteenth-century rationalistic systems, as professed by Eugène Viollet-le-Duc among others, in that they emphasized the unity between a mathematical architectural order and nature, even the whole cosmos. This occult concept regarding mathematics would play an important role in the Netherlands after 1900, not only in architecture but also in painting.

De Bazel, Lauweriks, and Walenkamp spread their ideas within the Theosophical Society as well. In 1897 they even founded their own lodge, the Vahana lodge, where they taught drawing, art history, and aesthetics. A list of students published in 1898 mentions the architect H. Baanders and the graphic designer J. G. Veldheer.[21] The goldsmith and silversmith Frans Zwollo, Sr., also entered the Theosophical Society around that time. Lauweriks was most indefatigable when it came to convincing kindred spirits and outsiders that art was preeminently suitable to the visualizing of the fundamental theosophical truths. In 1904 he published the short book *De ladder van het zijn* (The ladder of being), in which he utilized line, color, and mathematical bodies as symbols to eloquently describe the theosophical concept of evolution.[22] He also gave numerous lectures for the various Theosophical Society lodges that had been founded in the Netherlands; and he continued to do so even after he had been invited by the German architect Peter Behrens to teach architecture at the Art Academy in Düsseldorf.

Lauweriks was also actively involved in curating exhibitions of theosophical art that took place regularly during the annual international conventions of the Theosophical Society: among others, Amsterdam in 1904, London in 1905, Munich in 1907, and Brussels in 1910. He presided over the art section during the convention in Amsterdam, at which were presented the lectures "The Mission of Art" by the Belgian Symbolist Jean Delville and "Theosophy and Art" by the German artist Fidus. The large exhibition during this convention consisted entirely of works by members of the Theosophical Society in the Netherlands and Belgium. The sections of the graphic arts, applied art, and architecture, with entries by Lauweriks,

Walenkamp, and Zwollo, appear to have been of good quality. Among the painters and sculptors only Johannes Tielens's name remains somewhat known. In all there were no fewer than forty Dutch participating artists in the 1904 exhibition. Given the fact that the membership of the Theosophical Society in the Netherlands was only little more than seven hundred in 1904, the large number of artist-members is remarkable.

The extent to which these artists expressed their theosophical convictions in their artwork is difficult to determine. In the beginning clear artistic directions and standards could certainly not be deduced from the extensive theosophical literature, which mainly offered a notion of the unity of all being. There were, however, various means available to depict this unity. First, it was possible to accentuate renderings of visible reality in ways that could be interpreted theosophically. Second, from around 1900 onward theosophical literature became available on how to visualize such appearances from the invisible world as auras and astral bodies. Annie Besant and Charles W. Leadbeater's *Thought-Forms* (1905) and Leadbeater's other books give examples. Third, artists could utilize symbols: ancient ones, which were taken from Eastern and Western religions and extensively dealt with by Blavatsky in *The Secret Doctrine,* and new ones, which were developed within Symbolism. In practice the varying influences were not mutually exclusive.

On the whole, in the Netherlands there appears to have been a strong emphasis on mathematics in the visualization of theosophical concepts, mathematics not perceived scientifically but as a manifestation of the ancient knowledge of cosmic order. As discussed, the architects de Bazel, Lauweriks, and Walenkamp used mathematical principles in their architecture as well as in the applied art they taught at the Vahana lodge. They were supported by the engineer J. H. de Groot, who extended these mathematical principles to a systematic aesthetic in such books as *Driehoeken bij het ontwerpen van ornament voor zelfstudie en voor scholen* (Triangles in designing ornament) (1896), *Kleurharmonie* (Color harmony) (1911), and *Vormharmonie* (Harmony of form) (1912), which were very influential.[23] The mathematician H. A. Naber published material about Pythagoras's theorem and the proper use of the Egyptian triangle, and M. H. J. Schoenmaekers synthesized his esoteric points of view, which he had been developing and discussing for years, in his well-known book *Beeldende*

Wiskunde (Visual mathematics) in 1916.[24] Their names have been found in connection with the Theosophical Society: Schoenmaekers became a member in 1905 and lectured in 1906; Naber's books were published by the society, and he lectured at the Vahana lodge in 1909.

Interest in the visual arts within the Dutch Theosophical Society culminated in 1910. In that year two of the society's quarterly national meetings were completely devoted to the subject of Theosophy and art. The first was held in Hilversum on 10 April and was organized by de Bazel.[25] He opened the meeting with a number of aphorisms in which he advocated the unity of Theosophy, socialism, and art. Lauweriks gave a lecture about the practice of art, which had the programmatic title "The concepts of Theosophy are preeminently suited to be expressed by art because of their magnitude and profundity." The report that exists of his lecture is rather obscurely written, but some sense of the lecture can be extracted. According to the report, Lauweriks stated that the workings of karma should be determined separately for each art and each work of art: "In painting it is colors or forms against each other, or light and shadow, etc. etc. In architecture it is support and weight." A concrete statement regarding the symbolism of light was reported: "During the day, everything is lit by the sun, and light is the unity which governs everything and for which darkness retreats. We see this aspiration in modern painters."[26] This remark brings to mind Mondrian's paintings of that time.

No reports are known to have been published of the second quarterly meeting, held in Nijmegen on 25 September 1910, but from the announcement it is known that discussions were scheduled to deal with such questions as "1. What is the relationship between Theosophy and art? 2. Does theosophical art exist? 3. If so, how should it be practised and cultivated? . . . 6. What value does the subject have in art?"[27] These issues would preoccupy many artists in their exploration of abstraction in subsequent decades.

Mondrian became a member of the Dutch Theosophical Society on 25 May 1909. This decision followed his growing interest in spiritual matters during the preceding decade.[28] Albert van den Briel, who had been

acquainted with Mondrian since 1898, noted that the artist freed himself gradually from the strict Calvinism he grew up with and became deeply involved in studying various Eastern and Western religions and philosophies. His interest in Theosophy emerged around 1900. At that time he designed a bookplate in Art Nouveau style but with such theosophical symbols as the lotus flower and the hexagram.[29] Mondrian also read Schuré's *Les Grands Initiés* eagerly, according to van den Briel, but probably only after 1907 when the Dutch translation was published, although the part about Jesus had been published in 1901.[30] What we know about Mondrian's thinking during the first decade of the century is scarce and often not very accurate, but the direction is clear. Henriette Mooy, a writer Mondrian met before 1910, characterized him poignantly in an autobiographical novel as the painter Willem van Tije, shy, dark, serious, and friendly: "Rita whispered to me that he was a 'philosopher,' that he was familiar with all the religions of the world and was a 'famous artist.' I saw his paintings at the museum exhibition; father thought they were 'wild,' but they radiated fire."[31]

These words are very appropriate for the work that Mondrian created in 1908–9, around the time he became an official member of the Theosophical Society. Earlier in his career he had painted mainly peaceful landscapes (pl. 10) and a few vaguely symbolic figurative works, which generally suggest an artist of contemplative nature. In 1908 Mondrian's style changed radically (pls. 11 12) and became more outspoken in content. At that time he became acquainted with such painters as Jan Sluyters and Leo Gestel, who were oriented toward the Parisian avant-garde, in particular Fauvism. He was also frequently in contact with the more moderate painter Cornelis Spoor, a Theosophist, who in turn was acquainted with Toorop and the writer-critic Israel Querido.[32] Mondrian spent the summer of 1908 with Toorop in Domburg, where he would return almost annually for an extended period and where he

10
PIET MONDRIAN
Evening on the Gein, 1906–7
Oil on canvas
25 ⅝ x 33 ¾ in. (65 x 86 cm)
Haags Gemeentemuseum,
The Hague

11
PIET MONDRIAN
Spring, 1908
Crayon on paper
27 ⅜ x 18 ⅛ in.
(69.5 x 46 cm)
Haags Gemeentemuseum,
The Hague

12
PIET MONDRIAN
Devotion, 1908
Oil on canvas
37 x 24 in. (94 x 61 cm)
Haags Gemeentemuseum,
The Hague

became acquainted with the collector Marie Tak van Poortvliet and her friend the painter Jacoba van Heemskerck (pls. 13–14), both Theosophists. In these circles he found the spiritual atmosphere he felt comfortable with.[33] Differences in religious background did not hinder congeniality of mind. Mondrian mentions in a letter to Spoor in October 1910 that he had had another intimate discussion with Toorop and that they agreed upon the main issues: "He sees Roman Catholicism like A. Besant in its ancient times: Isn't Roman Catholicism originally the same as Theosophy? I agreed with Toorop on the main line and noticed that he really delves deeply and wants the spiritual."[34]

A letter to Israel Querido in 1909 reveals that Mondrian searched for adequate means to express his theosophical vision in his work. Querido quoted this letter in his next article; it is thus the earliest theoretical reflection of Mondrian's that appeared in print. In the letter Mondrian explained that he was aiming at a connection of art and philosophy, which he felt distinguished him from other progressive Dutch artists; probably he meant such figures as Sluyters. Mondrian said that he recognized the danger that art representing the occult might become unintelligible to the general public and that for the present at least he would continue "to work within ordinary, generally known terrain, different only because of a deep substratum, which leads those who are receptive to sense the finer regions."[35]

With few exceptions Mondrian stayed away from the use of fanciful occult images of the kind that can be found in Besant's and Leadbeater's work, images in which aural appearances play a large role. Mondrian's point of view is reminiscent of Thorn Prikker's fifteen years earlier, when he rejected the affected symbolism of his fellow Symbolists. Mondrian's opinion was that one could obtain higher knowledge within visual reality, a view that Rudolf Steiner had advocated during his lectures in the Netherlands in 1908. The booklet in which these lectures were published was treasured by Mondrian for the rest of his life.

Even Mondrian's ordinary themes could hold a deeper meaning for the already initiated. For example, one is able to perceive in Mondrian's series of high-rising towers on a flat ground (pl. 15) both a traditional Christian reference to God and a non-Christian symbol of the

15
PIET MONDRIAN
Church at Domburg, 1910–11
Oil on canvas
44 ⅞ x 29 ½ in. (114 x 75 cm)
Haags Gemeentemuseum,
The Hague
.

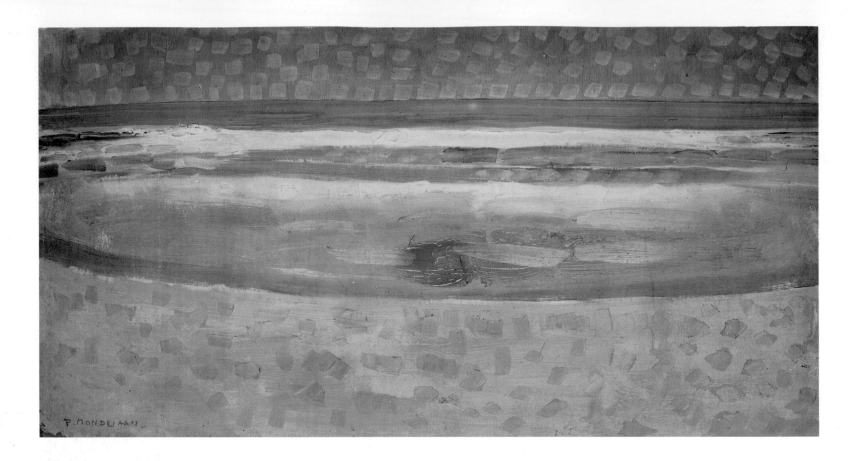

combination of the male and female principles. His series of coastal scenes could be interpreted as the unity between water, earth, fire, and air (pl. 16) or in their purest state, with only water represented, as an image symbolizing the beginning of things. Dying chrysanthemums and sunflowers could be perceived as the workings of evolution, according to which lower life-forms have to die to enable a higher form of life to come into existence.[36]

For Mondrian his themes and his technique of painting were equally meaningful: "It seems to me that clarity of thought should be accompanied by clarity of technique," he wrote to Querido.[37] Through intensified hues and the use of strongly articulated brushstrokes, the objects in his paintings appear to radiate, as if consisting of unearthly substance. The visionary character of this kind of work induced the critic W. Steenhoff to state that "Mondrian's perception is highly sensitivistic, a perplexed observation of the staring eye, which tries to measure the secrets of living organism in the flat appearances of color. . . . Perception exceeds its normal boundaries."[38] An important change occurred in Mondrian's work at

the end of 1909 and the beginning of 1910. The loose brushwork is replaced by a more controlled design, in which colors are evenly applied in clearly defined fields. Without a recognizably strict system, the paintings show a strong preference for symmetry and geometric division of the surface along its horizontal and vertical axes, further defined by a grid of oblique lines. These characteristics are most strikingly present in the monumental triptych *Evolution,* 1910–11 (pl. 17), Mondrian's clearest confession of his theosophical conviction and as such quite exceptional in his entire oeuvre because of its unnatural character and overt symbolism.[39] The triptych represents the theosophical doctrine of evolution, man's progression from a low and materialistic stage toward spirituality and higher insight. One can easily follow the process from the left panel, then to the right panel, and finally to the center panel. Virtually everything plays a part in Mondrian's symbolization of evolution: the position of the figure's head, the eyes, the shape of the nipples and navel, the flowers — all details supported by subtle changes of color.

It should be emphasized that the geometric tendency in Mondrian's paintings preceded an acquaintance with French Cubism. In fact it followed traditions that already existed in the

Netherlands in both the visual arts and architecture. One can detect correspondences between Mondrian's work and the precise geometric constructions in the work of the prominent Dutch painter Willem van Konijnenburg. Van Konijnenburg's archaic style and themes may appear at first glance to be far from those of the avant-garde artist Mondrian, but van Konijnenburg's theoretical writings contain numerous notions that would have appealed to Mondrian. For example, in 1910 van Konijnenburg published *Karakter der Eenheid in de schilderkunst* (The character of unity in painting), in which he emphasized that art should not aim at visualizing sensory perceptions and personal feelings but at the underlying unity of reality, based on simple mathematical systems. The straight line had an absolute value for him.[40]

Also the geometric tendency in Mondrian's work around 1910–11 adheres to the esoteric interpretation of mathematics that had been playing an important role in aesthetic thought in Dutch theosophical circles for many years. It is not certain whether Mondrian attended meetings of the Vahana lodge or knew such figures as Lauweriks and de Bazel personally, but he must have been familiar with the ideas that were prevalent in their circles, ideas regu-

17
PIET MONDRIAN
Evolution, 1910–11
Oil on canvas, triptych
Two panels, each 70 ¹⁄₁₆ x
33 ⁷⁄₁₆ in. (178 x 85 cm)
One panel 72 ¹⁄₁₆ x 34 ½ in.
(183 x 87.5 cm)
Haags Gemeentemuseum,
The Hague

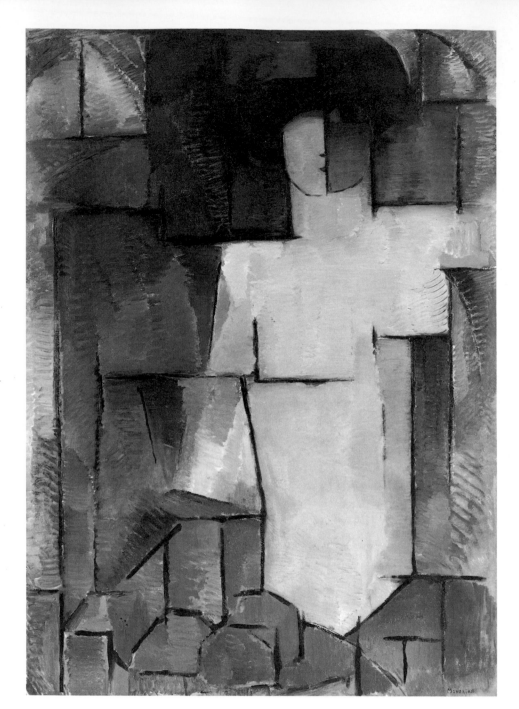

18

larly published in the theosophical magazines and proclaimed with great emphasis in the quarterly meetings of 1910.

With this background in mind, it is understandable that Mondrian was very receptive to the influence of Cubism, when in 1911 he encountered the first real examples at an exhibition of the Moderne Kunstkring (modern art circle) in Amsterdam, which he assisted in organizing. Pablo Picasso's and Georges Braque's work offered a more advanced formal method, which seemed preeminently suited to visualizing the essence of things by way of their dematerialization. Mondrian moved to Paris in late 1911 or early 1912 and rented a room in the headquarters of the French Theosophical Society before he found a studio of his own.[41] Living in the same city as the Cubists he admired, Mondrian developed his work into a radical Cubism within a short period of time, while maintaining his theosophical concepts of art and life. Steenhoff recognized this when he described Mondrian's new paintings at an exhibition in Amsterdam in October 1912: "I perceive a favorable development now, in spite of very daring abstractions, in terms of spiritual self-containment and introspection. The work is less pretentious; the painter has found himself in a purer sense; even if it seems to me that he groans naively under the constraints of the preconceived notion that art should totally negate matter."[42]

Mondrian's goals were different from those of the French Cubists, a difference evident in the very personal choice of subject matter to which he remained faithful. He painted, for example, a few female figures with large staring eyes (pl. 18), flowers, trees, and seascapes —all subjects that are rare in Cubism. As unemphatically as before, these themes have theosophical associations; they are quite ordinary subjects, but for the initiated they carry higher meanings. Paris also offered Mondrian such new subjects as views of dilapidated buildings, which for him was probably a modernized version of the dying-flower theme: dying houses will be replaced by new ones. In this way Mondrian transposed the concept of evolution from natural to cultural life, a vision that would play an essential role in his Neoplasticism.[43]

Mondrian also deviated from orthodox Cubism by making line and color, his visual means, absolute (pl. 19). In his evolutionary thinking line and color, reduced to essential contrasts between horizontal and vertical and between the three primary colors, were sup-

posed to express the unity that was the final destination of all beings, the unity that would resolve harmoniously all antitheses between male and female, static and dynamic, spirit and matter. This all-encompassing visual system, of the utmost importance for the future evolution of his work, is already rudimentarily indicated in a few sketchbooks with annotations.[44] Thus the foundations for Mondrian's Neoplasticism were laid in Paris from 1912 to 1914. Back in the Netherlands during World War I, he further developed his concept in a critical, but stimulating dialogue with the artists with whom he started the magazine *De Stijl* in 1917, particularly Theo van Doesburg and Bart van der Leck.[45]

Mondrian remained in touch with theosophical circles in these years, although he found in them little understanding of his work and ideas. While in Paris, in 1913–14, he had been solicited to write an article for the Dutch journal *Theosophia* about Theosophy and art, but the article was rejected: "it was too revolutionary for the guys," he wrote to the painter Lodewijk Schelfhout.[46] Mondrian was also mentioned in the newsletter of the society as possible juror for a new cover to be designed for *Theosophia* in 1916.[47] In the beginning of 1917 he read the introduction to his theoretical series of articles "De Nieuwe Beelding in de schilderkunst" (Neoplasticism in painting) at an evening gathering of the Theosophical Society, but he felt that people were not ready for it.[48]

Even the now-former Theosophist Schoenmaekers did not fundamentally understand Mondrian.[49] Upon reading Schoenmaekers's books in 1918, van Doesburg asked Mondrian if they had been of any use to him, but Mondrian responded by denying this categorically: "*I* got everything from the Secret Doctrine (Blavatsky), not from Schoenm., although he says the same things."[50] In a letter to van Doesburg in 1922, Mondrian relates how disappointed he was in the spiritual movements and their leaders, who he thought should be receptive to manifestations of "the finer regions." At the same time he confirmed the crucial meaning of Theosophy for his art, not only his early figurative work but also his abstract Neoplastic work:

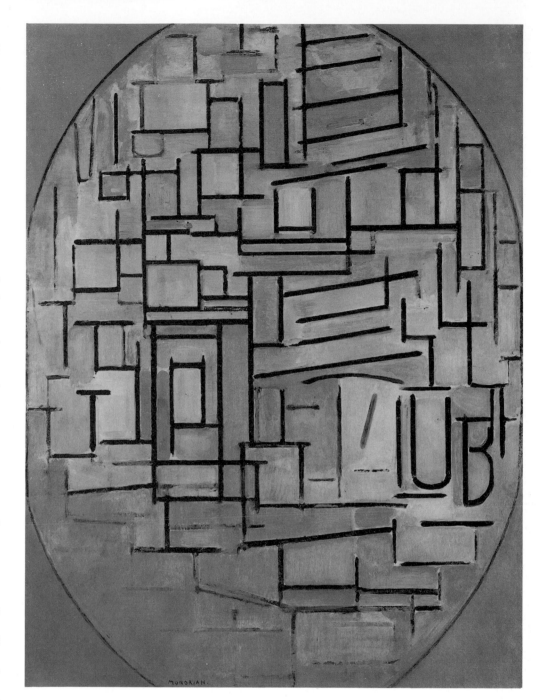

19
PIET MONDRIAN
Oval Composition, 1914
Oil on canvas
44 ½ x 33 ¼ in.
(113 x 84.5 cm)
Haags Gemeentemuseum,
The Hague

I totally agree with what you write about the followers of Steiner. And maybe . . . Steiner himself as well. Just as Schoenmaekers and Bolland: one-sided and stubborn. When Steiner visited Holland last summer, I wrote him a letter and included my brochure! *Not even a reply!* I will burst out to those guys one day, but I'm not in a hurry. It is Neoplasticism that is purely a theosophical art (in the true sense). Whoever calls themselves Theosophists or Anthroposophists are misfits.[51]

Mondrian's Neoplasticism, although directly affected by Cubism, is ultimately rooted in the esoteric concept of mathematics that was already operative in certain Dutch artistic-theosophical circles from about 1895. Apparently, Mondrian was not receptive to other forms of theosophical imagery as developed by Besant and Leadbeater in their books *Thought-Forms* and *Man Visible and Invisible,* which were full of peculiar images of auras. Mondrian surrounded objects and persons

with an auralike radiance in the paintings of 1908 to 1911, but he only intended to create a suggestion of finer matter not to express thoughts or feelings through specific forms and colors. His point of view regarding this important aspect differed fundamentally from most early Dutch abstract artists, such as van Heemskerck, Janus de Winter, the early van Doesburg, and the painter Jacob Bendien, a friend and admirer of Mondrian.

It is essential to note that abstract art was, in fact, initiated in the Netherlands not by Mondrian or any artist of the De Stijl movement but by the relatively unknown painters Bendien and Jan van Deene.[52] After a stay in Paris, they, together with a few friends, exhibited in Amsterdam in 1913 paintings with large forms and flowing contours that were evenly filled with bright colors (pls. 20–21). A critic described them as "idiotic expressions of young people who . . . have gone to the extreme — they make paintings that don't represent a thing."[53] Van Deene wrote a text, hung in the exhibition and published in a weekly, in order to create some understanding for this kind of work. He

wrote that the works represented only "inner things"; a painting should not render personal feelings but "the wonder of life, its beauty and sweetness. . . . It is a picture of the beautiful image of the world . . . a picture of our Lord one might say, or of animated nature in abstracto."[54] In general terms this explanation indicates a mystically oriented concept of life.

Recent research has shown that Bendien had definite connections with Theosophy. He was possibly stimulated by the theosophical painter Spoor, with whom he studied around 1910. In 1912 Bendien, who had moved to Paris in the meantime, wrote, "The Good is most beautiful at the fair, and most delicious at the theosophical meeting."[55] The same year he painted, as portraits of people he knew, highly stylized heads with undulating lines and colors that were apparently meant to express certain qualities of character. Bendien went quite far in analyzing and granting specific meaning to line and color, as well as to composition and paint handling. This appears from writings published later in his life, in which he gave an interesting explanation of his own work, which consisted of both pure abstractions and fine realistic images next to each other.[56] Bendien clearly intended to create a legible language through visual means. With that in mind, he addressed Mondrian's

Neoplastic work in one of the most perceptive articles published during Mondrian's lifetime.[57] It contains a detailed analysis of Mondrian's use of line and color. In the end, however, Bendien admitted that Mondrian's paintings defied interpretation and that Mondrian sought to express the general not the specific, thus revealing the underlying difference between the two of them.

Mondrian's adherence to Theosophy was also an important issue in his relationship to van Doesburg, painter, theoretician, and propagandist of De Stijl. In terms of spiritualism van Doesburg's early diaries and literary work are often rather exalted and contain numerous esoteric notions.[58] It is not certain whether he was ever a member of the Theosophical Society, but he definitely sympathized with Theosophy. In 1914–15 he replaced his naturalistic way of painting with an expressive, semiabstract style, influenced by Wassily Kandinsky and in particular by the Dutch painter de Winter (pls. 22–23). Van Doesburg was very impressed with the latter's work and personality.[59] His own work of that period (pls. 24–27) shows aural images and "spiritual portraits" similar to de Winter's. Drawings of

22
JANUS DE WINTER
Aura of an Egotist, 1916
Pencil on paper
22 1/16 x 30 1/16 in.
(56 x 76.3 cm)
Centraal Museum, Utrecht,
Netherlands

·

23
JANUS DE WINTER
Musical Fantasy, c. 1916
Gouache on cardboard
26 3/8 x 33 3/4 in.
(67 x 85.7 cm)
Centraal Museum, Utrecht,
Netherlands

·

that kind are amply represented in a sketchbook that carries van Doesburg's personal inscription, "expressionistic-theosophical." The two artists became estranged, and van Doesburg gravitated toward the work and ideas of more "conscious" artists (as he called them, meaning "less intuitive"), like Mondrian, whom he had met in the meantime.

During the first years of De Stijl van Doesburg kept reasonably in tune with Mondrian's theosophically tinged art and thought. The extent to which van Doesburg esoterically interpreted the many new ideas, whether pseudoscientific or scientific theories, that he came across in his restless curiosity is remarkable. He was equally enthusiastic about Schoenmaekers's mystical mathematics, Hendrik Lorentz's and Albert Einstein's relativity theories, Sigmund Freud's psychoanalysis, and the concepts of the biologist Jakob Johann von Uexküll, about whom he wrote in 1916: "I have met the highest and newest science of life: Uexküll's biological concept of life. It beats everything."[60]

After about 1919 van Doesburg gradually moved away from the elevated concepts of art and life he had long cherished, and this would eventually bring him into conflict with Mondrian. Throughout the early years of De Stijl they had been in close contact, mainly through correspondence; they actually met only very rarely. At one such meeting shortly before Mondrian returned to Paris in 1919, Mondrian's "theosophical confessions" still surprised van Doesburg.[61] Above all, van Doesburg could not agree with Mondrian's idea, no doubt inspired by Theosophy, that Neoplasticism was the final phase of artistic evolution and thus the end of all art. Van Doesburg quoted with astonishment the explanation given by Mondrian: "When I look through the canvas — when I pass through a wall — what will I then still see on that canvas or that wall?"[62] Van Doesburg's skepticism became definitive under the influence of Dada's nihilism. As I. K. Bonset, his Dadaist alter ego, he published in 1922 a Dadaist manifesto in French in which he definitively broke and settled accounts with the Netherlands and all the great names that had been so sacred to him: the philosopher

25
THEO VAN DOESBURG
Cosmic Sun, 1915
Pastel on paper
9 7/16 x 12 9/16 in. (24 x 32 cm)
J. P. Smid, Art Gallery
Monet, Amsterdam

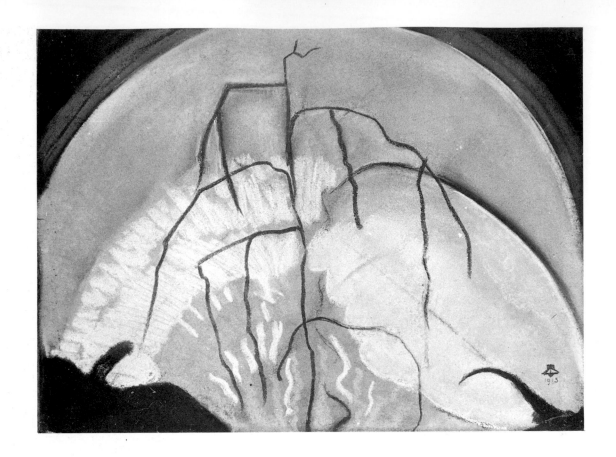

26
THEO VAN DOESBURG
Winter, 1915
Pastel on paper
9 7/16 x 12 9/16 in. (24 x 32 cm)
J. P. Smid, Art Gallery
Monet, Amsterdam

.

27
THEO VAN DOESBURG
Untitled, 1915
Pastel on paper
12 7/16 x 9 7/16 in.
(31.7 x 24 cm)
Rijksdienst Beeldende Kunst,
The Hague

.

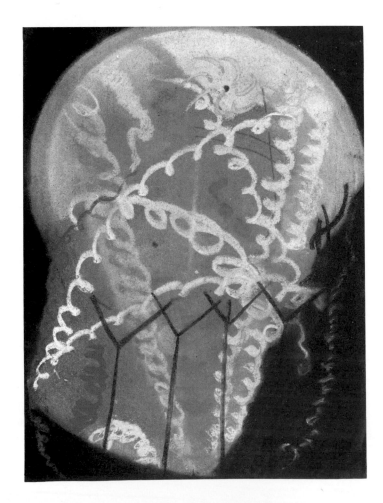

Bolland ("*Diarrhée de Monsieur Hegel*" [diarrhea of Mr. Hegel]), and the writers van Deyssel ("*Bas-bleu lardé de la littérature catholique*" [larded blue-stocking of Roman-Catholic literature]) and van Eeden ("*Traitre de la barbe de Jésus-Christ*" [traitor of the beard of Jesus Christ]).[63] Soon the breach with Mondrian was a fact, largely because of the differences in their philosophies of life.[64]

This essay has examined only a narrow aspect of early Dutch abstract art, a major part of which was esoterically oriented, particularly toward Theosophy. There were only a few exceptions, the sharp-minded Erich Wichman, for example, a painter of extremely interesting abstract works, who never had anything to do with the high ideas of most of his colleagues and made fun of them.[65] The outside world also expressed often witty criticism, as in a review of 1917 that called an abstract work, "a scrambled-egg vision by Laurens van Kuik, representing The Hidden One, praised by the Soul," or as in a quatrain written by E. du Perron in 1925: "And what did aunt Mary say lately / whose colon starts to atrophy / All those abstract colored carpets / also are a kind of theosophy."[66] Serious contemporary discussions among critics or art historians on the philosophical basis of early abstract art in the Netherlands were virtually nonexistent. More surprising is the lack of response from people who in principle shared the artists' beliefs, Theosophists and the like. This helps to explain why an artist as faithful to Theosophy as Mondrian was ultimately disappointed in his brethren and placed all his hope on "the man of the future."[67]

1. Frank Stella, *The Dutch Savannah/De Hollandse savanne* (Amsterdam: Stichting Edy de Wilde-lezing & Openbaar Kunstbezit, 1984), 6.

2. Quoted in Robert P. Welsh and J. M. Joosten, *Two Mondrian Sketchbooks 1912–14* (Amsterdam: Meulenhoff, 1969), 61.

3. The relationship between Symbolism and early abstract art in the Netherlands is the subject of Carel Blotkamp et al., *Kunstenaren der Idee: Symbolistische tendenzen in Nederland ca. 1880–1930* (Artists of the idea: Symbolist tendencies in the Netherlands c. 1880–1930), exh. cat. (The Hague: Haags Gemeentemuseum and Staatsuitgeverij, 1978).

4. For *De Nieuwe Gids* (The new guide) in a broad cultural context, see G. Colmjon, *De Beweging van Tachtig: Een cultuurhistorische verkenning in de 19e eeuw* (The movement of the eighties: A cultural-historical exploration in the nineteenth century) (Utrecht and Antwerp: Het Spectrum, 1963).

5. G. J. P. J. Bolland's influence on early Dutch abstract artists is discussed briefly in Geurt Imanse and John Steen, "Achtergronden van het Symbolisme" (Background of Symbolism); and Andrea Gasten, "Pseudo-mathematica en beeldende kunst" (Pseudo-mathematics and the visual arts); both in Blotkamp et al., *Kunstenaren der Idee,* 34, 60–61, respectively.

6. Lodewijk van Deyssel, "De dood van het naturalisme" (The death of naturalism), *De Nieuwe Gids* 6, no. 4 (1891): 114–22.

7. Quoted in *De briefwisseling tussen Lodewijk van Deyssel en Albert Verwey* (The correspondence between Lodewijk van Deyssel and Albert Verwey), ed. Harry G. M. Prick (The Hague: Nederlands Letterkundig Museum en Documentatiecentrum, 1981), 1:170.

8. See Carel Blotkamp, "Art Criticism in *De Nieuwe Gids,*" *Simiolus* 5, no. 1/2 (1971): 132–36. For the symbolistically oriented appreciation of Vincent van Gogh in the Netherlands, see Carol M. Zemel, *The Formation of a Legend: Van Gogh Criticism 1890–1920* (Ann Arbor: UMI Press, 1980), 11–32.

9. Jan Veth, "Van enkele Hollandsche teekenaren in Arti" (Of a few Dutch graphic artists in Arti), *De Nieuwe Gids* 7, no. 2 (1892): 143.

10. For the influence of idealist philosophies and mysticism, as well as Joséphin Péladan's influence in the Netherlands, see Imanse and Steen, "Achtergronden van het Symbolisme," 26–28, 32–35.

11. My interpretation of *Song of the Times* largely follows that in Bettina Polak, *Het Fin-de-Siècle in de Nederlandse schilderkunst* (The fin de siècle in Dutch painting) (The Hague: Martinus Nijhoff, 1955), 142–45.

12. Jan Toorop himself did not publish any interpretive texts about his work. Writers such as Julius de Boer, G. H. Marius, H. M. van Nes, Albert Plasschaert, and Willem Steenhoff included information given by the painter in their publications. It is remarkable that Toorop interpreted his early Symbolist works in a much more orthodox Christian way later on in his life, once he became a Roman Catholic in 1905, than during the time they were actually made.

13. In an unpublished sketchbook from 1907–8, now in the Royal Library, The Hague, Toorop made a drawing after Humbert de Superville's highly stylized representation of three faces with different expressions. The drawing was kindly brought to my atten-

tion by Gerard van Wezel and Paul van den Akker. For the influence of certain theories of de Superville, intermediated by Charles Blanc, on the art of the end of the nineteenth and the beginning of the twentieth centuries, see Barbara Maria Stafford, *Symbol and Myth: Humbert de Superville's Essay on Absolute Signs in Art* (Newark: University of Delaware Press, 1979), 176–85. The ideas of de Superville and Blanc were spread in the Netherlands by J. van Vloten, *Aesthetica of Schoonheidskunde, in losse hoofdstukken, naar uit-en inheemsche bronnen, voor Nederland geschetst* (Aesthetics or knowledge of beauty, in separate chapters, according to foreign and native authorities, prepared for the Netherlands) (Deventer: A. ter Gunne, 1865), a source not mentioned by Stafford.

14. *De Brieven van Johan Thorn Prikker aan Henri Borel en anderen 1892–1904* (The letters of Johan Thorn Prikker to Henri Borel and others), ed. Joop M. Joosten (Nieuwkoop: Uitgeverij Heuff, 1980), 116.

15. Ibid.

16. For interpretations of *Annunciation* and *Anarchy,* see Polak, *Het Fin-de-Siècle,* 147–49, 292.

17. Names of society members may be found in the archives of the Theosophical Society, Amsterdam, which unfortunately are only reasonably complete until about 1905 because a large part was destroyed during World War II. For K. P. C. de Bazel, see A. W. Reinink, *K. P. C. de Bazel architect* (Leiden: Universitaire Pers, 1965); for Lauweriks, see Nic. H. M. Tummers, *J. L. Mathieu Lauweriks, zijn werk en zijn invloed op architectuur en vormgeving rond 1910: "De Hagener Impuls"* (J. L. Mathieu Lauweriks, his work and influence on architecture and design around 1910: "The impulse of Hagen") (Hilversum: Uitgeverij G. van Saane, 1968); and for both men and H. J. M. Walenkamp, see *Architectura 1893–1918,* exh. cat. (Amsterdam: Architectuurmuseum, 1975), which includes an extensive bibliography.

18. This interpretation follows largely the one in Blotkamp et al., *Kunstenaren der Idee,* 135; see also Ernst Braches, *Het boek als Nieuwe Kunst 1892–1903: Een studie in Art-Nouveau* (The book as New Art 1892–1903: A study in Art Nouveau) (Utrecht: Oosthoek's Uitgeversmaatschappij BV, 1973), 210–23.

19. See Robert Knott, "The Myth of Androgyne," *Artforum* 14 (November 1975): 38–41; Robert P. Welsh, "Mondrian and Theosophy," in *Piet Mondrian 1872–1944: Centennial Exhibition,* exh. cat. (New York: Solomon R. Guggenheim Museum, 1971), 36–37, 48–50, about Mondrian's use of the horizontal/vertical within the oval; and Els Hoek, "Piet Mondriaan," in Carel Blotkamp et al., *De beginjaren van De Stijl 1917–1922* (The early years of De Stijl 1917–1922) (Utrecht: Reflex, 1982), 55–58. Connections between Mondrian and his theosophical predecessors have been suggested by Welsh, "Mondrian and Theosophy," 45, 48; and Tummers, *J. L. Mathieu Lauweriks,* 10–11.

20. H. J. M. Walenkamp, "Voorhistorische wijsheid" (Prehistoric wisdom), *Architectura* 12, no. 41 (1904): 333–36a, 376–85; and *Architectura* 13, no. 23 (1905): 185–88; published in two installments; reprinted in *Architectura 1893–1918,* 62–68.

21. The list of students was published in *Theosophia* 7, no. 1 (1898): 16–17. Regarding the Vahana lodge, see also Braches, *Het boek als Nieuwe Kunst,* 110–12; and Margaretha Verwey, *De Smidse* (Santpoort: C. A. Mees, 1947), 44–46; and *Frans Zwollo Sr. (1872–1945) en zijn tijd* (Frans Zwollo, Sr. [1872–1945], and his time), exh. cat. (Rotterdam: Museum Boymans-van Beuningen, 1982), 18–25.

22. J. L. M. Lauweriks, *De ladder van het zijn* (The ladder of being) (1904).

23. J. H. de Groot and Jacoba M. de Groot, *Driehoeken bij het ontwerpen van ornament voor zelfstudie en voor scholen* (Triangles in the design of ornament for self-study and for schools) (Amsterdam: Stemler, 1896); J. H. de Groot, *Kleurharmonie* (Color harmony) (Amsterdam: Wed. J.

Ahrend & Zoon's Uitgevers-Maatschappij, 1911); and idem, *Vormharmonie* (Harmony of form) (Amsterdam: Wed. J. Ahrend & Zoon's Uitgevers-Maatschappij, 1912).

24. See H. A. Naber, *Das Theorem des Pythagoras: Wiederhergestellt in seiner ursprünglichen Form und betrachtet als Grundlage der ganzen pythagoräischen Philosophie* (Haarlem: Visser, 1908); see also his later publications, such as *Meetkunde en Mystiek: Drie Voordrachten* (Geometry and mysticism: Three lectures) (Amsterdam: Theosofische Uitgeversmaatschappij, 1915) and *De rol der meetkunde in de beeldende kunsten* (The role of geometry in the visual arts) (Amsterdam: Theosofische Uitgeversmaatschappij, 1919). Theo van Doesburg and probably Georges Vantongerloo were at any rate familiar with the latter.

M. H. J. Schoenmaekers, an ex-priest, was active in "spreading a new theology-free religion" (quoted from letter to Albert Verwey, 31 January 1907, University Library, Amsterdam). He published articles in Verwey's magazine *De Beweging* (The movement) from 1905 and in *Eenheid* (Unity) and other periodicals from 1910. He also published among others the following books: *Ontgin U Zelven* (Explore yourself) (Amsterdam: Theosofische Uitgeversmaatschappij, 1906), *Het Geloof van den Nieuwen Mensch* (The belief of the new man) (Amsterdam: Maatschappij voor goede en goedkoope lectuur, 1908), *Christosophie* (Christosophy) (Amsterdam: Meulenhoff, 1911), *Mensch en Natuur* (Man and nature) (Bussum: van Dishoeck, 1913), *Het Nieuwe Wereldbeeld* (The new image of the world) (Bussum: van Dishoeck, 1915), and *Beginselen der Beeldende Wiskunde* (Principles of visual mathematics) (Bussum: van Dishoeck, 1916). For an explanation of Schoenmaekers's theories, see Gasten, "Pseudo-mathematica en beeldende kunst," 59–66.

25. The program of this meeting was published in *De Theosofische Beweging* (The theosophical movement) 6, no. 4 (1910): 1–4. Extensive summaries of the various lectures may be found in *De Theosofische Beweging* 6, no. 5 (1910): 66–70; 6, no. 8 (1910): 118–32; and 6, no. 9 (1910): 143–52.

26. *De Theosofische Beweging* 6, no. 9 (1910): 146–49.

27. Ibid., 141–42.

28. For information regarding the early development of Mondrian's thinking, see Herbert Henkels, "Mondrian in His Studio," in *Mondrian, Drawings, Watercolors, New York Paintings,* exh. cat. (Staatsgalerie, Stuttgart; Haags Gemeentemuseum; and Baltimore Museum of Art, 1980–81), 219–85; and Carel Blotkamp, "Mondriaan-Architectuur," *Wonen-TABK,* no. 4/5 (1982): 12–27. Henkels's suggestion that Mondrian had immediate knowledge of de Superville's *Essai sur les signes inconditionnels de l'art* and of the Neoplatonic theories of the sixteenth-century writer Girolamo Benivieni seems rather doubtful.

29. Bookplate illustrated in Herbert Henkels, *Mondriaan in Winterswijk: Een essay over de jeugd van Mondriaan, z'n vader en z'n oom* (Mondrian in Winterswijk: An essay about Mondrian's youth, his father, and his uncle) (The Hague: Haags Gemeentemuseum, 1979), 42.

30. Albert van den Briel's memories were first recorded in Michel Seuphor, *Piet Mondrian: Life and Work* (New York: Abrams, n.d.), 53–57.

31. Henriette Mooy, *Maalstroom* (Whirlpool), pt. 1 of *Van de ankers* (Adrift) (Amsterdam: Maatschappij voor goede en goedkoope lectuur, 1927), 169. Harry G. M. Prick gave me the first indication of Mondrian's presence in this novel.

32. Cornelis Spoor and his wife were active in the Theosophical Society; she gave lectures, "The Temple of Art" and "The Influence of Art with the Evolution of the Soul," at the lodges in Amsterdam and The Hague in 1909. Letters to Spoor from various friends, including Mondrian, have been published. See *Algemeen Handelsblad* (General trade paper), 27 December 1969; and L. van Ginneken and J. M. Joosten, "Documentatie: Kunstenaarsbrieven Kees Spoor" (Documentation: Letters by artists to Kees Spoor), *Museumjournaal* (Museum journal) 15, no. 4 (1970): 206–8; 15, no. 5 (1970): 261–67.

33. Regarding the artistic circle in Domburg, see A. B. Loosjes-Terpstra, *Moderne Kunst in Nederland 1900–1914* (Modern art in the Netherlands 1900–1914 (Utrecht: Haentjens Dekker & Gumbert, 1959), 111–25; Adriaan Venema, *Nederlandse schilders in Parijs 1900–1940* (Dutch painters in Paris 1900–1940) (Baarn: Het Wereldvenster, 1980), 74–88; and *Jacoba van Heemskerck 1876–1923: Een kunstenares van het expressionisme* (Jacoba van Heemskerck 1876–1923: An expressionist artist) (The Hague: Haags Gemeentemuseum, 1980).

34. Van Ginneken and Joosten, "Kunstenaarsbrieven Kees Spoor," 263.

35. Mondrian to Querido, n.d., quoted in Welsh and Joosten, *Two Mondrian Sketchbooks*, 9–10.

36. As to these interpretations, see Welsh, "Mondrian and Theosophy," 40–51; and Blotkamp, "Mondriaan-Architectuur," 17–27.

37. Quoted in Welsh and Joosten, *Two Mondrian Sketchbooks*, 10.

38. W. Steenhoff, "Naar aanleiding van de Lucastentoonstelling" (On the occasion of the Lucas exhibition), *De Ploeg* (The plow) 3 (1910): 366–67.

39. About the triptych *Evolution*, see Welsh, "Mondrian and Theosophy," 43–51; and C. Blotkamp, *Triptieken in Stijl* (Triptychs in Style) (Amsterdam: VU Boekhandel/uitgeverij, 1984), 5–10. Remarkably, a geometric division of the surface, although not according to a grid pattern, is present in so-called sketchbook no. 3, dated 1911, in Joosten, "Mondrian's Lost Sketchbooks from the Years 1911–1914," in *Mondrian, Drawings, Watercolors, New York Paintings*, 65–68.

40. W. A. van Konijnenburg, *Karakter der Eenheid in de schilderkunst* (The character of unity in painting) (The Hague: Mouton, 1910), in particular, 16–18, 31–32, 45–48. Van Konijnenburg's major theoretical work, *De Aesthetische Idee* (The aesthetic idea) (The Hague: Mouton, 1916), shows, aside from major differences, interesting parallels with the theories of De Stijl, particularly as to the relationship of architecture and visual art.

See also Gasten, "Pseudo-mathematica," 59–60.

41. This information was provided by Mary Simon, Mondrian's close friend from before 1910 and a Theosophist herself, in a conversation with Mrs. van der Schoot of the archives of the Theosophical Society, Amsterdam, who subsequently revealed it to the author in 1985.

42. W. Steenhoff, "Beeldende kunst: Opmerkingen over de tentoonstelling van den 'Modernen Kunstkring' en over enkele der aanwezige werken" (Visual art: Comments about the exhibition of "Modern art circle" and a few of the works shown), *De Ploeg* 5 (1912): 147.

43. For the meaning of architectural motifs in Mondrian's work, see Blotkamp, "Mondriaan-Architectuur," 12–27. Mondrian leads three figures along seven locations, from capricious nature to the atelier of the Neoplastic painter, in his important trialogue/drama "Natuurlijke en abstracte realiteit" (Natural and abstract reality), published in installments in *De Stijl* 2, no. 8 (1919), through 3, no. 10 (1920), a clear example of evolution in a theosophical sense.

44. Welsh and Joosten, *Two Mondrian Sketchbooks*.

45. The interaction between the artists is discussed in detail in Blotkamp et al., *De beginjaren van De Stijl*.

46. Mondrian to Schelfhout, 12 June 1914, in J. M. Joosten, "Documentatie over Mondriaan (1)" (Documentation about Mondrian [1]) *Museumjournaal* 13, no. 4 (1968): 215. The manuscript of Mondrian's article is lost, but it seems justified to assume that the annotations in Mondrian's Paris sketchbooks were made in preparation for the article.

47. Mondrian is mentioned with the painter J. L. H. Heyenbrock and the architects de Bazel and M. Brinkman in *De Theosofische Beweging* 12, no. 1 (1916): 1–3. Eventually, the jury consisted of de Bazel, L. Ehrenfeld, and J. D. Ros.

48. Mondrian to the collector Rev. H. van Assendelft, 26 January 1917, published as a summary in J. M. Joosten, "Documentatie over Mondriaan (4)" (Documentation about Mondrian [4]), *Museumjournaal* 18, no. 5 (1973):

220; "De Nieuwe Beelding in de schilderkunst" (Neoplasticism in painting) was published in monthly installments in *De Stijl* 1, no. 1 (1917), through 2, no. 2 (1918).

49. Schoenmaekers's influence on Mondrian is still disputed. It was first mentioned in M. Seuphor, "Christen-calvinist" (Christian-Calvinist), *Opbouwen* (Construction) (1937), reprinted in *Seuphor*, ed. Herbert Henkels (Antwerp: Mercator Fonds NV, 1976), 176. Consequently H. L. C. Jaffé discussed extensively the similarity between Mondrian's and Schoenmaekers's theories in *De Stijl 1917–1931: The Dutch Contribution to Modern Art* (Amsterdam: Meulenhoff, 1956), 53–62. In "Mondrian and Theosophy," Welsh argues, based on the annotations in the Paris sketchbooks of 1912–14, that Mondrian's theories were fully developed before he met Schoenmaekers or before he could have been familiar with Schoenmaekers's *Het Nieuwe Wereldbeeld* (1915) and *Beginselen der Beeldende Wiskunde* (1916). Welsh concludes that Mondrian and Schoenmaekers used the same or similar theosophical-aesthetic sources independently. This seems correct, although it is known from other sources that Mondrian must have come across Schoenmaekers's early writings because Mondrian had a subscription to the esoteric-philosophical weekly *Eenheid* from its beginning in 1910, which published *Christosophie* serially in the first volume. Mondrian, however, was not influenced by Schoenmaekers until they met in late 1914 or early 1915 through the composer Jacob van Domselaer. Mondrian and Schoenmaekers saw a lot of each other in 1915 and 1916, so that upon visiting Mondrian for the first time in February 1916, van Doesburg wrote that Mondrian and van Domselaer were "totally swayed by the concepts of Dr. Schoenmaekers" (van Doesburg to Antony Kok, 7 February 1916, quoted in *Theo van Doesburg 1883–1931: Een documentaire op basis van materiaal uit de schenking Van Moorsel* [Theo van Doesburg 1883–1931: A documentary based on material from the Van Moorsel donation], ed. Evert van Straaten [The Hague: Staatsuitgeverij, 1983], 56). Schoenmaekers's

influence was mainly limited to the terminology Mondrian used in his theoretical texts, published from 1917. Their opinions about art differed substantially; their characters also clashed; and Schoenmaekers's planned contribution to De Stijl was never realized. For the relationship between Mondrian and Schoenmaekers, see M. van Domselaer-Middelkoop, "Herinneringen aan Piet Mondriaan" (Memories of Piet Mondrian), *Maatstaf* (Standard) 7, no. 5 (1959): 273–79; and Hoek, "Piet Mondriaan," 58–59.

50. Mondrian to van Doesburg, n.d., probably May 1918, quoted in Hoek, "Piet Mondriaan," 59.

51. Mondrian to van Doesburg, 7 January 1922, Rijksdienst Beeldende Kunst, The Hague. Mondrian's letter to Steiner, which he refers to, has been kindly provided to the author by R. Friedenthal of the Rudolf Steiner Nachlassverwaltung, Dornach. In it Mondrian explicitly links Neoplasticism with Theosophy and Anthroposophy.

52. For more about Jacob Bendien and Jan van Deene, see Matsya Hoogendoorn, "Nederlanders in Parijs" (Netherlanders in Paris), *Museumjournaal* 17, no. 6 (1972): 247–53; Jan F. van Deene, *Rechtvaardiging* (Justification) (Utrecht: Centraal Museum, 1977); and Elina Tazelaar, *Jacob Bendien 1890–1933*, exh. cat. (Fries Museum, Leeuwarden, and Centraal Museum, Utrecht, 1985).

53. A. T., *Het Leven* (Life), 25 December 1913, 1491, quoted in Hoogendoorn, "Nederlanders in Parijs," 251.

54. Quoted in Hoogendoorn, "Nederlanders in Parijs," 252–53.

55. Quoted in Tazelaar, *Jacob Bendien 1890–1933*, 7.

56. See, for example, J. Bendien and A. Harrenstein-Schräder, *Richtingen in de hedendaagsche schilderkunst* (Directions in contemporary painting) (Rotterdam: W. L. & J. Brusse's Uitgeversmaatschappij, 1935), 103–7, in which Bendien calls his abstract style "meditism" (from meditation).

57. J. Bendien, "Piet-Mondriaan-60 jaar," *Elsevier's Geïllustreerd Maandschrift* (Elsevier's illustrated monthly) 42, no. 2 (1932): 168–74.

58. Fragments of van Doesburg's early writings are quoted in van Straaten, *Theo van Doesburg 1883–1931*; for the early developments of his ideas, see Carel Blotkamp, "Theo van Doesburg," *De beginjaren van De Stijl*, 15–21.

59. Van Doesburg honored Janus de Winter with a poem "De Priester-kunstenaar" (The priest-artist) published in *Eenheid*, 22 January 1916; and a short book, Theo van Doesburg, *De schilder de Winter en zijn werk: Psychoanalytische studie* (The painter de Winter and his work: Psycho-analytic study) (Haarlem: J. H. de Bois, 1916).

60. For van Doesburg's interest in mathematics and in particular his initially esoteric concept of the fourth dimension, see Gasten, "Pseudo-mathematica," 59–60; and Blotkamp, "Theo van Doesburg," 39–46. Van Doesburg's *De Schilder de Winter* reveals that he was not only interested in Freud but also interpreted Freud's ideas somewhat esoterically. Around 1916 van Doesburg in general attributed a prominent role to the unconscious as a source for artists to draw from. According to him, his own work, de Winter's, and that of Rotterdam group De Branding, with which he collaborated at that time, were good examples. Van Doesburg later claimed that he and the Rotterdam painter Laurens van Kuik had explored the unconscious in their art long before the Surrealists (Theo van Doesburg, "Der Kampf um den neuen Stil," *Neue Schweizer Rundschau*, 1 January 1929, 41–46). Van Doesburg's temporary enthusiasm for Jakob Johann von Uexküll, whose book *Bausteine zu einer biologischen Weltanschauung* (1913) he had read, was probably instigated by Adolf Behne's "Biologie and Kubismus," *Der Sturm* 6, no. 11/12 (1915): 68–71. The quoted passage is from van Doesburg to Antony Kok, 5 August 1916, Rijksdienst Beeldende Kunst, The Hague.

61. Van Doesburg to J. J. Oud, 24 June 1919, quoted in Hoek, "Piet Mondriaan," 80.

62. Ibid.

63. I. K. Bonset [Theo van Doesburg], "Chronique scandaleuse des Pays-Plats," *Mécano*, no. 3 (1922), unpaginated.

64. Regarding the nature of Mondrian and van Doesburg's split, see Blotkamp, "Mondriaan-Architectuur," 41–43.

65. Imanse and Steen, "Achtergronden van het Symbolisme," 35.

66. Chapeau Claque, "Kunstenarijen" (Artistic follies) *De Forens* (The Commuter) 1, no. 28 (1917): 393–94; and E. du Perron, *Parlando: Verzamelde gedichten* (Amsterdam, Antwerp: Uitgeverij Contact, n.d.), 31.

67. Piet Mondrian, *Le Néoplasticisme: Principe général de l'équivalence plastique* (Paris: Éditions de l'Effort Moderne, 1920), was dedicated to "the man of the future."

OVERLEAF

GEORGIA O'KEEFFE
Abstraction, 1917
Watercolor on paper
15 ¾ x 10 ⅞ in.
(40 x 27.6 cm)
Collection of Mr. and Mrs. Gerald P. Peters

NATURE SYMBOLIZED: AMERICAN PAINTING FROM RYDER TO HARTLEY

CHARLES C. ELDREDGE

When Arthur Dove brushed his first series of abstractions in 1910 (pls. 1–4), he assumed a pioneering position among nonobjective artists. At the same time, he continued a distinguished American tradition of imagery reliant upon landscape or natural inspiration. Dove's accomplishment embodies the paradoxical marriage of innovation and tradition in the genesis of abstract art in America, a union that fired the creativity of inventive painters in the early years of this century, yet whose roots were firmly planted in nineteenth-century imagination. Janus-like, these pioneers greeted the new era with a novel artistic language while reflecting the philosophical precepts of their forebears. Until recently critics and historians paid attention almost exclusively to formal innovations in commenting on these artists' works; belatedly their ties to idealist thought and imagery, particularly transcendentalism, have been stressed in critical discussions. In fact, the significance of the work derives from the painters' abilities to wed their concerns for artistic form and subjective content.

Albert Pinkham Ryder is customarily cited as the exemplar of this introspective mood in American painting of the turn of the century. His reputation as a figure apart, a reclusive visionary outside the mainstream, has lately been modified by studies that place the artist in community and in context.[1] Nevertheless

Ryder's imaginative compositions, often based upon literary or musical inspirations, have none of the slavish fidelity to details nor optical plays with daylight and color found in the work of many of his contemporaries. While they mimicked the observable world, Ryder sought other ends. As his friend Elliott Daingerfield recalled, "Fact did not interest him — truth and beauty did."[2] In a rare discussion of his work Ryder admonished: "The artist should fear to become the slave of detail. He should strive to express his thought and not the surface of it. . . . The artist has only to remain true to his dream and . . . must see naught but the vision beyond."[3] To describe the quest for that vision Ryder chose an unconventional simile: "Have you ever seen an inch worm crawl up a leaf or twig, and there clinging to the very end, revolve in the air, feeling for something to reach something? That's like me. I am trying to find something out there beyond the place on which I have a footing."[4]

It was probably Ryder's risk taking as much as the large forms and vital rhythms of his compositions that led Jackson Pollock to admire him as "the only American master who interests me."[5] American abstract paint-

ing had atrophied in the decades between Ryder and Pollock, especially when artists' (and critics') considerations of content yielded to formal concerns, when intellectual fascination with geometric ideals superseded the translation of feeling into form. By extending himself beyond his foothold and carefully studying his subject, be it literature, music, or nature — indeed immersing himself in it, just as Pollock lost himself in the act of painting — Ryder discovered new forms, new rhythms, a new pictorial language that quickened his images and gave them their unique power of abstraction. His paintings convey the essence rather than the details of his subjects, absorbed and distilled through close study and long association.

In later years Ryder recalled the discovery of his distinctive technique:

When I grew weary with the futile struggle to imitate the canvases of the past, I went out into the fields, determined to serve nature as faithfully as I had served art. In my desire to be accurate I became lost in a maze of detail. Try as I would, my colors were not those of nature. My leaves were infinitely below the standard of a leaf, my finest strokes were coarse and crude. The old scene presented itself one day before my eyes framed in an opening between two trees. It stood out like a painted canvas — the deep blue of a midday sky — a solitary tree, bril-

liant with the green of early summer, a foundation of brown earth and gnarled roots. There was no detail to vex the eye. Three solid masses of form and color — sky, foliage and earth — the whole bathed in an atmosphere of golden luminosity. I threw my brushes aside; they were too small for the work in hand. I squeezed out big chunks of pure, moist color and taking my palette knife I laid on blue, green, white and brown in great sweeping strokes. As I worked I saw that it was good and clean and strong. I saw nature springing into life upon my canvas. It was better than nature, for it was vibrating with the thrill of a new creation. Exultantly I painted until the sun sank below the horizon, then I raced around the fields like a colt let loose, and literally bellowed for joy.[6]

The compositions that resulted from this spontaneous technique anticipate Dove's abstractions in their earthy tonalities, broad strokes, and simplified forms. In *Moonlight Cove*, 1880–90 (pl. 5), Ryder arranged masses of dark color in an illusion of three-dimensional space that at the same time adheres closely to the flat plane of the canvas. While the spatial recession in Dove's *Abstraction No. 4* (pl. 3) is more ambiguous, its layers of heavily brushed earthen and vegetal forms within a shallow space suggest strong affinities with

Ryder's painting. Similarly the dark traceries of limb and foliage in *Abstraction No. 3* echo landscape forms in Ryder's *Forest of Arden*.

Ryder's special landscape sensibility was early noted by commentators. In 1880, in the first extended discussion of his work, Clarence Cook lauded Ryder for painting "exactly what he sees in nature" and noted, "We must look for his qualities outside the usual order of exercises in which artists are trained." Ryder appeared as a special rarity "in a civilized, artificial society like our own; he has really none but the most temporary relations to it." Cook perceptively linked the painter to the imaginative tradition of Walt Whitman, Henry David Thoreau, and William Blake and claimed that "in its own way, the work he has produced thus far is as sweet, as natural, and as innocently wise as theirs."[7] The tie to Blake's visionary lineage was often repeated by subsequent critics and historians. Equally telling, but less remarked upon, was the analogy to American literary and philosophical tradition. For Ryder and many of his contemporaries the reliance upon self and the primacy of nature, represented by Whitman, Thoreau, and Ralph Waldo Emerson, continued as a lively force well into the modern era.

Bliss Carman, one of Boston's leading poets and essayists at the turn of the century, pro-

5
ALBERT PINKHAM RYDER
Moonlight Cove, 1880–90
Oil on canvas
14 ⅛ x 17 ⅛ in.
(35.9 x 43.5 cm)
The Phillips Collection,
Washington, D.C.
.

vides an instructive example of Emerson's vital legacy. Carman turned to the transcendentalist "for that assurance to the spirit which Nature is preaching in her own dumb way from a thousand mountainsides to-day."[8] Following Emerson's lead Carman sought "the kinship of Nature," which "wakens glimmerings of the golden age within us."[9] In nature's beneficent embrace, Carman found "sanity first of all," a "sedative and tonic" for the strains of modern urban life, which, without her palliation, "may mean madness and death." "To know the kindliness of Nature we must take constant care to abide by her customs, not to hurry over duty nor to tarry too long, but to move with the appointed rhythm she has bestowed upon us, each man true to his own measure, and so in accord with his fellows and not at variance with the purpose of creation."[10]

Carman's redemption through nature comes as a result of organic process — moving "with the appointed rhythm" — rather than empirical study of natural facts. In this he offers a contemporary parallel with Ryder, who rejoiced at the sight of nature springing into life upon the canvas, "vibrating with the thrill of a new creation." Both were aligned with Emerson, who wrote, "Regard nature as a phenomenon, not a substance," into whose secrets "a dream may lead us deeper . . . than

a hundred concerted experiments."[11] In his essay "Nature" Emerson claimed that, prior to the advent of reason, "the despotism of the senses" ruled natural perception. "Until this higher agency intervened, the animal eye sees, with wonderful accuracy, sharp outlines and colored surfaces. When the eye of Reason opens, to outline and surface are at once added grace and expression. These proceed from imagination and affection, and abate somewhat of the angular distinctness of objects." When man's reasoned imagination and affection are "stimulated to more earnest vision, outlines and surfaces become transparent, and are no longer seen; causes and spirits are seen through them. . . . The best moments of life are these delicious awakenings of the higher powers."[12]

Ryder's transcendence of "sharp outlines and colored surfaces" as he sought expression of thought, of the "vision beyond," is akin to Emersonian practice. And his coltish romp through sunset fields after he saw nature spring into life suggests that, like Emerson, he had gained one of the "best moments of life." Likewise Dove's 1910 paintings are abstractions of organic process, visions of cause and spirit rather than outline and surface. They are an extension of Ryder's aesthetics and Emerson's faith, siting creative

inspiration in the spiritual experience of the natural world. Both painters would likely have concurred with Emerson's estimation that "the greatest delight which the fields and woods minister is the suggestion of an occult relation between man and the vegetable."[13]

Coincident with the transcendentalist vitality in America and its spread to Europe were the various innovations of the Symbolist writers and painters centered in Paris. Although wildly diverse in approach and style, the Symbolists were generally united by their acclaim of the imaginative life and their exception to the dominant rationalism of the day. Their quest for verities that transcended the frenetic moment was similar in sincerity and import to that of America's Romantic writers. In Boston, particularly, Symbolist precepts found a responsive audience, not surprising in view of Emerson's lively legacy there. Maurice Maeterlinck, Belgium's mystic essayist and playwright, admired Emerson to the point of translating him. Maeterlinck's belief in the "oneness of the individual with the absolute" echoed the transcendental faith and understandably won him adherents among aesthetes in Boston and beyond.[14] Edward Steichen, for example, was "stirred" by Maeterlinck's essay "Silence" and "went out to paint pictures of night and silence in that mood."[15] Steichen passed on this enthusiasm

to his fellow artist and collaborator, Alfred Stieglitz. Even those who, unlike Steichen, did not have the chance to meet the Symbolist writers succumbed to the charms of their work as it was reprinted in American reviews, especially *The Chap-Book,* which regularly featured Maeterlinck, Paul Verlaine, Stéphane Mallarmé, and other heroes of the Symbolist camp. The popular press also took notice of the European innovators; the critic James Gibbons Huneker especially used his columns to acquaint readers with the work of Charles Baudelaire, Joris-Karl Huysmans, Richard Wagner, Auguste Rodin, and other modern visionaries.[16]

In time Symbolist painters also became familiar to American audiences. While the Armory Show's surprising concentration of works by Odilon Redon (seventy-five paintings and graphics) provided his first wholesale introduction to America, news of his achievements and other Parisian novelties was earlier shared through the press as well as through firsthand accounts of students and other pilgrims to Paris. For several Americans abroad the expatriate James Whistler served as the entré to Mallarmé's rarified circle of Symbolist painters and writers. Even the curious coterie around the French mystic and self-styled "Sâr," Joséphin Péladan, leader of the Ordre de la Rose + Croix, included an American

painter, Pinckney Marcius-Simons (who also held the unlikely distinction of being Theodore Roosevelt's favorite artist). In short, acquaintance with the Symbolist innovators in both art and letters was sufficiently common to discredit the familiar notion that the materialistic American was indisposed to the mystical or the visionary. In retrospect, given the congruence of European Symbolist theory and American philosophical tradition, the artistic acquaintance seems natural, almost inevitable.

The receptivity of Americans to transcendentalism and Symbolist aesthetics was abetted by the late nineteenth century's general interest in subjective states and mental process. The era's preoccupation with spiritualism and the vogue for Theosophy and other alternative creeds, ranging from Swedenborgianism to Buddhism, has often been noted. A fascination with psychology and aberrant personalities dawned at the same time. These and other phenomena suggest an inward turning as the century wound down. Together such varied interests, at times overlapping, at times contradictory, provided a heady amalgam for the generation of artists and thinkers whose conceptions would shape the new era.

Thus when Arthur Dove created six unprecedented abstractions from nature, he was acting as the legatee of a complex association of theories and values shaped at the century's turn. The organic subjects were ones that an Emersonian would have understood and appreciated. European Symbolists might have applauded the personal response to the subject, even if they were ignorant of the native tradition from which it sprang. The mystically minded might have responded to the artist's effort to achieve unity between the specifics of his landscape motif and the larger forms and forces of the world, of some universal truth. Just as surely, the lack of recognizable motifs would have baffled nineteenth-century artists or critics, however intuitively they might have responded to the sense of natural energy and rhythm in the pictures.

Dove never exhibited the Abstractions. His motivation may have been similar to Georgia O'Keeffe's: "I have a curious sort of feeling about some of my things — I hate to show them — I am perfectly inconsistent about it — I am afraid people won't understand — and I hope that they won't — and am afraid they will."[17] That visual images could convey such strong subjective content for O'Keeffe and, speculatively, for Dove suggests that the Sym-

8
GEORGIA O'KEEFFE
Blue I, c. 1917
Watercolor on paper
30 ¾ x 22 ⅜ in.
(78.1 x 56.8 cm)
Robert L. B. Tobin

bolist emphasis upon mood and Mallarméan *correspondance* survived translation into abstract forms. The Symbolist writers, most notably Mallarmé, strove for a union of image and sensual effect or meaning, an equivalence that the representational painter was denied as long as he clung to vestiges of recognizable form.

In his poetry Mallarmé made important use of chromatic language to accomplish his Symbolist ends. For Mallarmé, as explained by critic Françoise Meltzer, "color is overwhelmingly used to create an abstractionism, to erase, in fact, the cumbersome catalogues of *signifiés* to which common language is shackled." For the Symbolist poem to succeed in transporting the reader beyond the objective, phenomenal world, "it will have to make use of a language . . . which will avoid, if not annihilate, the concrete realm." Meltzer compared Mallarmé's sonnet to the swan with Baudelaire's earlier *Albatross,* finding that the latter,

extended simile, forceful though it is, has the same limitations as Poe's *Raven;* there is still a distance between the poet and the image of the bird. As soon as a simile is used, analogy appears, in itself a parallel but not an embodiment of a concept.

Mallarmé, on the other hand, manages the union of effect and image through the use of color. All three realms of the poem ["Le Cygne"], landscape, "poet," and feeling, are white. They become inextricable and synonymous — precisely the intent of the Symbolist poem.

Synonymy is finally achieved through Mallarmé's use of language with a dual quality: "words without nominata, and sense or image without words."[18]

The interest of American artists in color and its evocative potential is reminiscent of the Symbolist poets and painters. Dove's series (with the exception of the colorful *Abstraction No. 2*) is unified by its earthy, secondary hues; O'Keeffe's early works often used a dominant hue, as in the lava reds of *Painting No. 21 (Palo Duro Canyon)*, 1916, or even explored the possibilities of a single tone, as in her 1916–17 watercolors (pls. 6–8). Dove's paintings of 1910 and O'Keeffe's of a few years later made a breakthrough comparable with that of the Symbolist writers. By dispensing with realistic depiction, they also managed the merger of abstract image and subjective meaning. Like Mallarmé's, their pictorial language is marked by dualism: forms without explicit reference, and sense or meaning without specific objects. In their exceptional inventions Dove and O'Keeffe drew upon the heritage of the late

nineteenth century to craft a decidedly modern idiom, an abstract Symbolism.

Charles Caffin had presaged their intent as early as 1907, when in Stieglitz's *Camera Work* he noted that "with the idealists in landscape, a new motive is at work. It is to address themselves, not to that faculty in man of getting to the bottom of things, but to his consciousness of the mystery all about him — the indefinable, impenetrable, limitlessness of spirit."[19] O'Keeffe's teacher, Arthur Wesley Dow, had gained similar insights through his study of Japanese masters and the principles of oriental design, and in his influential book, *Composition,* he reminded students, "It is not the province of the landscape painter merely to represent trees, hills and houses — so much topography — but to express an emotion."[20] The significance of novel expressions like Dove's and O'Keeffe's was appreciated by others of their generation, for instance Oscar Bluemner, who understood that "art springs from within, while that which is caused from without is imitation. . . . Whatever inner impulse we address towards nature is abstract. Thus a landscape as a motive for expression undergoes a free transformation from objective reality to a subjective realization of personal vision."[21]

O'Keeffe and Dove, whose artistic goals were already so similar, eventually came to be part of the family of artists around Stieglitz at his "291" gallery, which at various times included Bluemner, Steichen, Marsden Hartley, Konrad Cramer, and other like-minded creators. The Stieglitz circle shared an attitude of introspection and vaguely spiritual concerns. Their approach to art and discourse, like that of the Symbolists, relied upon intuition and evocation, suggesting analogies with Mallarmé's fear of the objective and specific.[22] This disposition made them naturally receptive to comparable concerns in others. Issues of *Camera Work* regularly contained evocative writings by a variety of artists and authors who shared a penchant for advanced art and metaphysics. An early instance of the journal's exposure of European innovations to American audiences was Maeterlinck's interpretation of Rodin's sculpture, published in 1903, shortly after the writer met Steichen in Paris.[23] An extract from Henri Bergson's influential treatise, *Creative Evolution,* appeared in October 1911 and was followed by another Bergson essay in January 1912. And in July 1912, soon after its initial publication in Europe, an excerpt from Wassily Kandinsky's *On the Spiritual in Art* was printed, exciting the imagination and offering direction and affirmation to the American avant-garde.

Dove early obtained a copy of Kandinsky's book from Stieglitz and in 1913 acquired as well *Der Blaue Reiter,* Kandinsky and Franz Marc's revolutionary almanac; in later years he recalled being "impressed with Kandinsky (in his 'kaleidoscopic' phase)."[24] O'Keeffe was referred to Kandinsky's *On the Spiritual in Art* in 1912 or 1913 by her teacher Alon Bement. Although she insisted that "it was sometime before I really began to use the ideas," Kandinsky's subjective emphasis ultimately helped to change the course of her art. As she explained in 1923, "I found I could say things with colors and shapes that I couldn't say in any other way — things that I had no words for."[25] Hartley, like many of his compatriots, was deeply affected by Kandinsky's book; but unlike most of them, in January 1913 he had the opportunity of meeting Kandinsky in Munich and knowing his theory translated into art. Hartley wrote, "My first impulses came from the mere suggestion in Kandinsky's book *The Spiritual in Art.* Naturally I cannot tell what his theories are completely [since the edition was in German] but the mere title opened up the sensation for me — and from this I proceeded."[26]

Kandinsky's insistence that art's force and endurance do "not lie in the 'external' but in the deep roots of mystical inner thought" accorded well with Hartley's quest for art's deeper meaning beyond the empirical world.[27] A generation of American modernists, steeped in the tradition of landscape yet seeking to transcend it, was inspired by Kandinsky's words, curiously reminiscent of the transcendentalists or Ryder: "The mood of nature can be imparted . . . only by the artistic rendering of its inner spirit."[28] The inner necessity that motivated Kandinsky was shared by the American avant-garde, and his theory and intellectual example remained for many young Americans a powerful force. Curiously, this respect for his intellectual attainments notwithstanding, Hartley, like Dove, in time lost his enthusiasm for the Russian's paintings, perhaps suggesting an American antipathy to strongly programmatic art. "It is without (for me) the life germ — It is the philosoph painting — the theorist demonstration — not the artist's will bent on creating. He gets it in his writing but not in his painting," Hartley later explained.[29]

Henri Bergson's theory of the creative role of intuition and its primacy over analytical thinking ran counter to the empirical pragmatism passed on from the late nineteenth century. The French philosopher was widely acclaimed by modernists, and the Stieglitz circle discussed and praised his work; it offered further validation for their break with the representational tradition. As opposed to analysis, "the operation which reduces the object to elements already known," Bergson believed that "an absolute can only be given in an intuition . . . the sympathy by which one is transported into the interior of an object in order to coincide with what there is unique and consequently inexpressible in it."[30] Bergson's theories were meaningful to Dove, seemingly endorsing his struggle for the empathetic merger of the self and the object, observer and observed, as well as his search for the abstract essence of his subject. Hartley was also impressed by Bergson's thought as he was beginning his restless search for an individual artistic voice. By 1912 he reported to Stieglitz from Paris that he had renounced his still lifes "in favor of intuitive abstractions . . . [which] I call for want of a better name subliminal or cosmic." Hartley admitted, "I am convinced of the Bergson argument in philosophy, that the intuition is the only vehicle for art expression and it is on this basis that I am proceeding."[31]

In Paris, and subsequently Berlin, Hartley's progress was subject to the period's enthusiasm for the writings of Christian mystics; he later confessed that it was "out of the heat of the reading" that he had started to work on his abstractions.[32] His mystical curriculum was diverse and far-ranging, dictated by personal whim or period taste rather than conventional scholarship as he lurched from one enthusiasm to another. In December 1912 he reported to Stieglitz that he had read Richard Maurice Bucke's *Cosmic Consciousness* (1901) and fragments by the sixteenth-century mystic Jakob Böhme. A few months later he catalogued other influences, which comprehended "a universal essence — I came to it by way of James' pragmatism — slight touches of Bergson — and directly through the fragments of mysticism that I have found out of Böhme — Eckhart, Tauler — Suso — and the Bhagavad Gita."[33] Having absorbed these varied influences and guided by his unconscious, Hartley created during his first year in Paris (1912–13) a series of lyrical abstractions in which a loosened Cubist structure is scattered with calligraphic lines and occasional mystic symbols. The investment of self in these works individualized them; as Hartley wrote to Stieglitz, quoting the Symbolist Redon: "I have made an art after myself."[34] Hartley had hoped to create a spiritual art that would suggest the universal and transcend specific meaning. He was disappointed when an occultist visitor read them literally and observed, "You have no idea what you are doing — these pictures are full of Kabbalistic signs and symbols."[35] For Hartley the goal was not an occult cryptogram, but a suggestion of the spiritual perceived through the self. He took pains to distinguish his approach, which was rooted in American experience, from the mystic symbols used by his European contemporaries and congratulated himself that previously

no one has presented just this aspect in modern tendency — Kandinsky is theosophic — Marc is extremely psychic in his rendering of the soul life of animals. . . . I could never be French. I could never become German — I shall always remain the American — the essence which is in me is American mysticism just as [Arthur B.] Davies declared it when he saw those first landscapes [of about 1909, which] . . . were so expressive of my nature — and it is the same element I am returning to now with tremendous increase of power through experience.[36]

The Romantic penchant for filling subjects with personal meaning and significance had been announced in Hartley's early Ryderesque landscapes. That this trait persisted even after representation had been discarded importantly separates Hartley's abstract genesis from that of Kandinsky and more closely aligns him with the other abstract Symbolists of Stieglitz's circle.

For Hartley the breakthrough to abstraction achieved in Paris led to even more sophisticated imagery produced in Berlin in 1913–15. Explaining his move to Stieglitz, Hartley noted, "It is with Germans that I have always found myself . . . and now it is in Germany that I find my creative conditions . . . among the German mystics."[37] Among his new friends Hartley discovered lively encouragement for his advanced art.

From the outset his work in this German environment showed a new strength and delicacy. While he was still fired by Kandinsky's theories of spirituality in art, a work like *Painting No. 1* (pl. 9), probably his first Berlin canvas, revealed an increasingly individual style; a more lyrical delicacy replaced the nervous contours and ragged lines of the earlier paintings created more directly under Kandinsky's influence. The sights and sensations of wartime Berlin provided new inspirations for Hartley, who was moved by the spectacle to paint ambitious designs based upon German military regalia, "part of a series which I had contemplated of movements in various areas of war activity."[38] The painter claimed that "there is no hidden symbolism whatsoever in them," yet many of his Berlin paintings (for example, *Painting No. 48, Berlin* [pl. 10] and *Pre-War Pageant* [pl. 11], both 1913), seem loaded with symbolic meaning, especially those that present complex emblematic portraits of Lieutenant Karl von Freyburg, his friend who was killed in action in October 1914.[39] The symbolic content of Hartley's Berlin paintings is conveyed through such signs as the mystical figure eight, with its occult implications of physical or spiritual regeneration, or the Iron Cross, with its references to Christian and Prussian sacrifice; through such symbolic forms as the Christian mandorla and Kandinsky's spiritual triangle; and through bright, allusive color, including martyr's red, the "painful shrillness" of yellow's "disturbing influence," and celestial blues, which Kandinsky had identified as "the typical heavenly color . . . [with] a call to the infinite, a desire for purity and transcendence."[40]

9
MARSDEN HARTLEY
Painting No. 1, 1913
Oil on canvas
39 ¾ x 31 ⅞ in. (101 x 81 cm)
Sheldon Memorial Art
Gallery, University of
Nebraska, Lincoln
F. M. Hall Collection

10
MARSDEN HARTLEY
Painting No. 48, Berlin, 1913
Oil on canvas
47 3/16 x 47 1/8 in.
(119.9 x 119.7 cm)
The Brooklyn Museum,
New York
Dick S. Ramsay Fund

.

11
MARSDEN HARTLEY
Pre-War Pageant, 1913
Oil on canvas
39 x 31 1/2 in. (99.1 x 80 cm)
Robert Miller Gallery,
New York

.

12
KONRAD CRAMER
Abstraction, c. 1914
Oil on canvas
26 x 22 in. (66 x 55.9 cm)
Ahmet and Mica Ertegun

.

The intuitive or cosmic abstractions of
Hartley's early European period were shown
at "291" in the course of the artist's brief
return to America during the winter of 1913–
14. The show was a critical and financial suc-
cess and led Hartley to boast to Gertrude
Stein, "The artists are elated and enthusiastic
and the people say queer and interesting
things — It all seems to start up new phases of
emotion in people."[41] One of the artists
moved by the exhibition was Konrad Cramer,
a frequent visitor (although never an exhibi-
tor) at the "291" gallery, who enjoyed the
distinction of having known the work of the
German avant-garde prior to emigrating to
New York in 1911. Cramer's debt to Kandin-
sky was evident in the abstractions he began
shortly after his arrival in this country, includ-
ing his Improvisations series painted in 1912–
13. Hartley's influence was to add momen-
tum to Cramer's own search for an abstract
visual language. A Cramer abstraction of
about 1914 (pl. 12), composed around an em-
phatic orange peak, seems to derive from
Hartley's *The Warriors,* 1913.[42] The embrac-
ing foreground figures and the conjoined
emblems of male and female within the cen-
tral orange peak suggest that, unlike Hartley's
fascination with the masculine military,
Cramer is celebrating the spiritual and phys-

ical union between man and woman, an abstract joie de vivre.

Pioneers like Hartley, Dove, and O'Keeffe made unique contributions to the abstract idiom that was evolving internationally. Through intuition and by individual avenues, they had arrived by the mid-1910s at a distinctly American expression of the Symbolist ideal defined by Albert Aurier. As Gauguin's leading apologist, he had called for an art that was

Idea-ist, because its unique idea would be the expression of the Idea; Symbolist, because it would express this idea through forms; Synthetic, because it would write these forms, these signs, following a method of general comprehension; Subjective, because the object perceived by the subject; [and, hence] *decorative* — for decorative painting, accurately described . . . is nothing else than a manifestation of art that is all at once subjective, synthetic, symbolist and idea-ist.[43]

Aurier's ideal fits the inventions of the most advanced American painters who congregated about Stieglitz. Their approach was not unprecedented; certainly Whistler, Gauguin, and the Nabis, among others, had in places verged upon such nonobjective solutions. What distinguished the modern innovators in America was their conscious pursuit of such ends through significant bodies of work, either in sporadic periods of great intensity (Hartley) or sustained throughout a lifetime (Dove and O'Keeffe).

In April 1916, shortly after his return from Germany, Hartley again had an exhibition at the "291" gallery, featuring his Military series. Forced by the European war to work in this country for the balance of the decade, Hartley's advanced abstractions of the mid-1910s shortly yielded to other pictorial concerns. Within two years of his show of German work, he had abandoned the abstract idiom and was painting the landscape in New Mexico. "I am an American discovering America," he wrote. "I like the position and I like the results." He predicted that the quest for native subjects by him and his compatriots would yield "a sturdier kind of realism, a something that shall approach the solidity of landscape itself and for the American painter the reality of his own America as Landscape."[44] A decade later, he announced the completion of his conversion to objectivism in an extraordinary confessional, "Art — and the Personal Life." Casting his lot with "the ranks of the intellectual experimentalists," Hartley could "hardly bear the sound of the words 'expressionism,' 'emotionalism,' 'per-

sonality,' and such, because they imply the wish to express personal life, and I prefer to have no personal life. Personal art is for me a matter of spiritual indelicacy." To the "vast confusion of emotional exuberance in the guise of ecstatic fullness or poetical revelation," Hartley had grown to prefer the formal pleasure of "two colors in right relation to each other," since "intellectual clarity is better and more entertaining than imaginative wisdom or emotional richness. . . . I have lived the life of the imagination, but at too great an expense. I do not admire the irrationality of imaginative life. . . . I have made the complete return to nature, and nature is, as we all know, primarily an intellectual idea."[45]

Although he would stray from native subjects during several more foreign sojourns, only briefly in 1932–33 would he revert to the mystic symbolism that had inspired his revolutionary canvases of the prewar period but with scarcely the same results. Hudson Walker, the artist's patron and friend in his later years, was typical of many in dismissing Hartley's year in Mexico as the "one painting experience [that] produced inferior work. . . . He was not well, and with certain notable exceptions . . . beat up an esoteric side-current more literary than plastic, doing symbolic works."[46] In Mexico the artist purposefully pursued specific mystic subjects rather than the general expression of spirituality that characterized most of the Berlin works. The Mexican paintings revitalized Hartley's interests in the occult mysteries of nature and prepared him for the grand landscape statements of his late period. At the time, however, most viewers, unfamiliar with Hartley's obscure sources, thought them merely odd, and in their first exhibition they failed to attract a single buyer.[47]

The experience of Mexico's ancient cultures rekindled Hartley's interest in the spiritual inner necessity of primitive art, and access to a friend's library on occult subjects reawakened his spiritualist interests: "As a result, I am so much clearer about the superior aspect of introspection than I have ever been and I learn from men like Ruysbroeck, Rolle, et cet. — how much of a science introspection can be."[48] To the fourteenth-century English mystic Rolle, Hartley paid homage in a verse of glowing praise as well as in *The Transference of Richard Rolle*, 1932–33 (pl. 13). In the paint-

13
MARSDEN HARTLEY
The Transference of Richard Rolle, 1932–33
Oil on canvas
28 x 26 in. (71.1 x 66 cm)
Anonymous loan

14
MARSDEN HARTLEY
Yliaster (Paracelsus), 1932
Oil on canvas
25 x 28 ½ in. (63.5 x 72.4 cm)
Babcock Galleries Collection,
New York

.

15
ARTHUR DOVE
Nature Symbolized No. 3,
1911–12
Pastel on wood panel
18 x 21 ½ in. (45.7 x 54.6 cm)
Terra Museum of American
Art, Evanston, Illinois
Daniel J. Terra
Collection

.

ing Rolle's monogram hovers above a desolate landscape, emblazoned within a spiritual triangle against a similarly formed cloud, whose whiteness denotes a transcendent world.

In *Yliaster (Paracelsus),* 1932 (pl. 14), Hartley recalled another legendary occultist, Philippus Paracelsus, the sixteenth-century Swiss alchemist whose cabalistic philosophy of evolution predated Darwin's theory by three centuries. According to Paracelsus, it is Yliaster, the *protomateria,* or base matter, that is the source of all elements: "When Evolution took place the Yliaster divided itself . . . melted and dissolved, developing from within itself the *Ideos* or *Chaos . . .* or Primordial Matter." With the action of the "individualizing power," from Yliaster "all production took place in consequence of separation," yielding the four basic elements. These are the phenomena that Hartley visualized. The uncharacteristically intense colors and distorted spaces in his representation of cosmic meltdown seem perfectly appropriate to the extraordinary event, Creation itself. The radiant sphere of Yliaster, already dividing into arcs, beams into the stylized cone of Popocatépetl, a sexual metaphor in landscape guise. The forms of earth, glowing as if molten, thrust upward into the excited air; in the

foreground an ovoid pool of water repeats the caldera's form, its central jet responding to the downward dissolve of Yliaster and recalling Paracelsus's claim that "all the activity of matter in every form is only an effluvium of the same fount." Hartley, returning to occult concerns after years of relatively naturalistic landscape practice, must have been particularly moved by Paracelsus's conclusion that the earth, indeed all nature's elements, are "of an invisible, spiritual nature and have souls."[49]

Although adhering to no conventional denomination, Hartley was before nature a man of faith. He recalled his excitement upon first encountering Emerson's essays: "I felt as if I had read a page of the Bible."[50] In Mexico, in the philosophy of Paracelsus and other mystics, he found another book of creation, and, while the paintings these writers immediately inspired may have been less cosmic than cabalistic, the impetus they provided for the merger of natural and metaphysical concerns, of objective and subjective, revitalized Hartley's creativity throughout his final decade.

Although similar to Hartley in spirit, Dove and O'Keeffe pursued abstraction more consistently through their entire careers, and in a different form. Following the break-

through of his series of six abstractions, Dove's work rarely reverted to the representational, although his dedication to nonobjectivity initially vacillated between organic form and the more geometric vocabulary of the Cubists. In 1911–12 he produced a series of pastels, the Ten Commandments.[51] The motifs encompass various subjects, ranging from architecture and boats to plant and animal forms, and are unified only by their format, medium, and advanced technique. Two examples represent the poles of Dove's artistic language at the time: *Nature Symbolized No. 3* (pl. 15), using angular geometry to suggest architecture in landscape, and *Nature Symbolized No. 2* (pl. 16), employing curved, directional lines and swelling, organic shapes to convey the sense of natural force and vegetal form. *No. 3* implies the artist's acquaintance with the Cubism of Georges Braque and Pablo Picasso; *No. 2* suggests an equivalent familiarity with the force lines of Futurist style and the freer forms of Kandinsky's Improvisations and Compositions. It was particularly the Kandinsky-like morphology, which Dove expanded over the next several decades, that was to become his primary pursuit and most familiar contribution.

Nature Symbolized, No. 2 has as its subject the wind on the hillside (as it is often subtitled), a natural phenomenon that inspired Dove to create "a rhythmic painting which expressed the spirit of the whole thing."[52] In 1912 many of Dove's viewers found the pastel, and the notion of visualizing wind, "absurd and unthinkable."[53] As if to counter such doubters, Dove admitted: "Yes, I could paint a cyclone. Not in the usual mode of sweeps of gray wind over the earth, trees bending and a furious sky above. I would paint the mighty folds of the wind in comprehensive colors; I would show repetitions and convolutions of the rage of the tempest. I would paint the wind, not a landscape chastised by the cyclone."[54] The wind blows through other compositions as well. In *Thunderstorm* (pl. 17), a charcoal drawing of 1917–20 preparatory to a painting of 1921, the forces of wind and storm are again abstracted in an artful design; jagged lightning bolts from ponderous clouds to the abstracted land mass, which turns like some global ratchet wheel, bowing to the force of the elements.

The extraction from nature, the distillation of its essence (as Dove often explained his goal),[55] remained a favorite pursuit for the artist and several of his contemporaries. John Marin, another Stieglitz intimate, once wrote

16
ARTHUR DOVE
Nature Symbolized No. 2,
1911–12
Pastel on paper
18 x 21 ⅜ in. (45.7 x 54.7 cm)
The Art Institute of Chicago
Alfred Stieglitz Collection,
1949
·

17
ARTHUR DOVE
Thunderstorm, 1917–20
Charcoal on paper
21 x 17 ¾ in. (53.3 x 45.1 cm)
University of Iowa Museum
of Art, Iowa City
Purchase, Mark Ranney
Memorial Fund
·

that "the true artist must perforce go from time to time to the elemental big forms — Sky, Sea, Mountains, Plain . . . to sort of re-true himself up, to recharge the battery."[56] Of particular interest was the elemental sky, to which a number of the modernists turned. Stieglitz himself focused upon the celestial realm in his Equivalents series of cloud photographs, which Rosalind Krauss has discussed as embodiments "of the deepest level of Symbolist thought."[57] The limitless expanse of the sky was the locus of the sun, the universal generative force, which assumed a central role in many works, for example, Dove's *Golden Sunlight,* 1937, and O'Keeffe's several views of glowing orbs above pulsating horizons. Lightning, another primal force of nature, recurred in a number of works from the Stieglitz circle, including Marin's stylized, but still representational *Storm, Taos Mountain, New Mexico,* 1930; in O'Keeffe's more abstract *Lightning at Sea* and *A Storm* (pl. 18), both of 1922; and continuing as late as Dove's *Thunder Shower* of about 1939–40 (pl. 19).

During the 1920s Dove and O'Keeffe continued their well-established practice of extracting pictorial essences from the study of natural phenomena. In *Golden Storm,* 1925 (pl. 20), Dove returned to the symbolization of "mighty folds of the wind," repeated and convoluted, which abstractly evoke nature's vital forces, as the tempest billows above the contrapuntal spikes of green land below. The serrated forms are descended from his *Thunderstorm;* it is a shape that also appears in O'Keeffe's *From the Plains I,* 1919, where it suggests the turning of the cosmic sphere. The link to nineteenth-century vitalist philosophies was recognized by contemporaries, such as Paul Rosenfeld, who wrote, of his early works, that "Dove begins a sort of 'Leaves of Grass' through pigment."[58] Through their pictorial imaginations, O'Keeffe and Dove transported themselves from the mundane plane to a God's-eye view, witnessing the world wheeling in the infinite. Through their abstractions they sought to capture the vital essences of nature, a unity of micro and macro, of man and universal spirit. In this endeavor they were part of America's spiritual tradition. As Emerson had written, "In the tranquil landscape, and especially in the distant line of the horizon, man beholds somewhat as beautiful as his own nature." Like Emerson, gazing into the cosmos, the painter may be "uplifted into infinite space, — all mean egotism vanishes. I become a transparent eyeball; I am nothing; I see all; the currents of the Universal Being circulate through me; I am part or parcel of God."[59]

The translation of nonvisual phenomena into painted form was a challenge as sophisticated as Dove's depiction of the essence of wind, but one similarly rooted in late nineteenth-century aesthetics with its emphasis upon synesthesia, the simultaneity and equivalence of sensations. Kandinsky was an heir to this tradition when he discussed the comparison of one art's fundamental elements with another's: "A painter . . . in his longing to express his internal life . . . naturally seeks to apply the means of music to his own art. And from this results that modern desire for rhythm in painting, for mathematical, abstract composition, for repeated notes of color, for setting color in motion, and on." He foresaw new "symphonic compositions" as represented by his own series of Impressions, Improvisations, and Compositions.[60]

Among American modernists, Hartley's *Musical Themes* and Dove's *Sentimental Music,* a pastel of 1917, provide early instances of the correlation between music and abstract art.

O'Keeffe was influenced by the example of Bement: to the sounds of "a low-toned record . . . students were asked to make a drawing from what they heard. So I sat down and made a drawing, too. Then he played a very different kind of record — a sort of high soprano piece — for another quick drawing. This gave me an idea that I was very interested to follow later — the idea that <u>music could</u> be <u>translated into something for the eye</u>."[61] A group of canvases from 1919 demonstrates her solutions: the languid rhythms and swelling forms of *Music: Pink and Blue No. 1* (pl. 21) and the livelier staccato and emphatic, dark-barred chords of *Blue and Green Music.* Not all aural inspiration was musical; the jagged form rising from dark ground to dark sky in O'Keeffe's *Orange and Red Streak,* also 1919, may be her painted recollection of Texas cattle lowing for their calves, "a sound that has always haunted me. It had a regular rhythmic beat like the old Penitente songs, repeating the same rhythms over and over all through the day and night. It was loud and raw under the stars in that wide empty country."[62] Similarly unmusical were Dove's *Fog Horns,* 1929 (pl. 22), which pulsate in concentric rings through the gray mist.

20
ARTHUR DOVE
Golden Storm, 1925
Oil and metallic paint
on plywood
19 ¼ x 21 in. (48.8 x 53.3 cm)
The Phillips Collection,
Washington D.C.

.

21
GEORGIA O'KEEFFE
*Music: Pink and Blue
No. 1,* 1919
Oil on canvas
48 x 30 in. (121.9 x 76.2 cm)
Mr. and Mrs. Barney A.
Ebsworth

22
ARTHUR DOVE
Fog Horns, 1929
Oil on canvas
18 x 26 in. (45.7 x 66 cm)
Colorado Springs Fine Arts
Center, Colorado
.

23
AUGUSTUS VINCENT TACK
Storm, 1920–23
Oil on canvas mounted on
composition panel
37 x 48 in. (94 x 121.9 cm)
The Phillips Collection,
Washington D.C.
.

Other painters, such as Augustus Vincent Tack, William Schwartz, and Will Henry Stevens, pursued similar strains in the development of their abstract vocabularies. Tack achieved note as a painter of portraits and religious subjects but also privately practiced abstraction, as evident in *Storm,* 1920–23 (pl. 23). Tack's was no mere summer thundershower any more than was Dove's. According to Duncan Phillips, Tack created an "awe-inspiring symmetry out of thundering chaos . . . a symbol of a new world in the making, of turbulence stilled after the tempest by a universal God."[63] Phillips served simultaneously as the primary patron of both Tack and Dove, while also making a significant commitment to the work of O'Keeffe, which connotes much about the collector and his taste. It also suggests that, in their quest for expression of the ineffable, the artists whom Phillips favored, while individual in style, were united in spirit and intent and the pursuit of a mystical abstraction.

Raised as a devout Catholic, Tack as an artist recalled his youthful beliefs in his representational, but still distinctive, scriptural subjects. Yet the spirit that infuses his decoratively patterned abstractions derives from no single or conventional faith. Rather it reflects a general

24
WILLIAM SCHWARTZ
Symphonic Forms No. 16, 1932
Oil on canvas
36 ⅛ x 40 in.
(91.8 x 101.6 cm)
Hirschl and Adler Galleries,
New York

yearning for union with first causes and primal forces, a vision and intent similar to those that motivated Dove and O'Keeffe. From these disparate influences Tack fused an abstract evocation of nature and spirit that Phillips aptly called a "landscape of the mind."[64]

The vogue for the translation of sound, particularly music, into painted images continued to capture many artists beyond the late 1910s. William Schwartz of Chicago, Russian-born painter and concert singer, was in many respects representative, although he differed from his colleagues in the acclaim he had enjoyed as an operatic tenor prior to receiving notice as a painter in the early 1920s. He achieved regional repute for his landscapes with figures, often poetically titled allegories à la Davies. As early as 1924 he began to produce a series of abstractions based upon musical motifs, collectively known as Symphonic Forms (pl. 24). As with Tack's compositions, however, these were privately done, and Schwartz withheld them from prairie salons for more than a decade. In later discussing the Symphonic Forms, Schwartz explained that he sought harmony of color, form, and line, just as he had in music. "In looking at nature, therefore, I search for materials which may be interpreted and manipulated until they become unified wholes and reveal the . . . harmony . . . representative of my own personality — my thoughts and my feelings."[65] In the musical analogies and the search for an abstract expression of personality, the artist generally echoed Kandinsky's precepts. In looking to the external world for his materials, however, Schwartz closely followed the path of American spiritual abstraction.

In New Orleans from the 1920s onward, Will Henry Stevens, like Schwartz, developed an abstract style that reflects the surviving vitality of the natural ethos. Stevens developed his youthful love of nature through readings of favorite American authors, especially Emerson and Thoreau, Whitman and Mark Twain, and in solitary rambles through his native Indiana countryside. Stevens always recalled Ryder's congratulatory words to him at his first solo exhibition in 1901 and his admonition, "Remember, you are a poet. Don't do what so many painters are doing today — painting out before nature all the time. Just walk out in the pleasant time of evening."[66]

Ryder's praise was shortly followed by another signal event in the young artist's career, his discovery of Sung dynasty paintings. Stevens responded intuitively and forcefully to the unfamiliar Chinese masters: "I could not look at Sung without realizing that it had the same kind of philosophy that I had discovered in Walt Whitman."[67] Pursuing his new interest in oriental art and philosophy, Stevens was eventually led to P. D. Ouspensky's *Tertium Organum* and the writings of Confucius and Lao-tzu, among others. His self-education, as well as his landscape painting, continued during his seasonal orbit between New York and the Midwest or, after 1921, Newcombe College in Louisiana, where he began his long art-teaching career.

Stevens found particular inspiration in the words of Lao-tzu: "Man at his best, like water . . . / Loves living close to the earth, / Living clear down in his heart."[68] "Rivers have meant very much to me," Stevens once acknowledged. "Inland rivers. I remember being charmed by Huckleberry Finn. If only one could get that spirit into painting!" In New Orleans he had the greatest subject of them all close at hand, the Mississippi, and

25
WILL HENRY STEVENS
Untitled, 1938
Pastel on paper
22 ½ x 18 ½ in.
(57.2 x 47 cm)
Robert P. Coggins,
M.D., The Coggins
Collection of Southern
American Art
.

not far away the exceptional bayou country. In "these bayou people [who] have never tried to subdue nature but have harmonized their lives with natural order," Stevens found vindication of oriental wisdom.

Prepared by his transcendentalist readings, surrounded by Louisiana's abundant and evocative verdure, and inspired by the oriental philosophers, Stevens began to move beyond the representation of his surroundings to new pictorial concerns. "The best thing a human can do in life," he advised, "is to get rid of his separateness or selfness and hand himself over to the nature of things — to this mysterious thing called the Universal Order, that an artist must sense. To put yourself in the way of that Thing so that you become a vehicle of it — that will be your only merit — to put yourself in the way." As Stevens sought to get closer to nature, to the universal order, his imagery changed from description to abstraction. His discovery of Kandinsky and Klee in the 1930s

lent impetus to this new direction in his art, finally leading to lyrical abstractions in an experimental variety of media (pl. 25).

Among American artists, Stevens's case, like Schwartz's, is instructive. Their example suggests the difficulty of creating a novel abstract language and the diverse paths by which that objective was achieved. But even more important, it demonstrates that abstraction in the expression of nature's forces and materials was not the exclusive province of the Stieglitz circle but, by the 1930s, had become a more broadly based phenomenon, representing the native flavor of abstract art in America.

In memory of John William Ward (1922–1985)

1. See Eugene Goossen, " 'Student of the Night': Albert Pinkham Ryder," *Vogue* 156 (15 August 1970): 96; and Elizabeth Johns, "Albert Pinkham Ryder: Some Thoughts on His Subject Matter," *Arts* 54 (November 1979): 164–71.

2. Elliott Daingerfield, "Albert Pinkham Ryder: Artist and Dreamer," *Scribner's* 63 (March 1918): 381.

3. Albert Pinkham Ryder, "Paragraphs from the Studio of a Recluse," *Broadway* 14 (September 1905): 10.

4. Ibid.

5. Quoted in *Readings in American Art, 1900–1975,* ed. Barbara Rose (New York: Praeger, 1975), 122–23.

6. Ryder, "Paragraphs," 10.

7. Clarence Cook, "Society of American Artists," *New York Daily Tribune,* 11 April 1880.

8. Bliss Carman, *The Kinship of Nature* (Boston: Page, 1904), 254.

9. Ibid., 130.

10. Ibid., 143–44.

11. Ralph Waldo Emerson, "Nature," in *Selections from Waldo Emerson,* ed. Stephen E. Whicher (Boston: Houghton Mifflin, 1960), 43, 51.

12. Ibid., 43.

13. Ibid., 24.

14. Quoted in Jean Gibran and Kahlil Gibran, *Kahlil Gibran: His Life and World* (Boston: New York Graphic Society, 1974), 57.

15. Quoted in Joseph Shiffman, "The Alienation of the Artist: Alfred Stieglitz," *American Quarterly* 3 (1951): 249–50.

16. For a review of contemporary criticism, see Peter Plagens, "The Critics: Hartmann, Huneker, De Casseres," *Art in America* 61 (July–August 1973): 66–71.

17. Quoted in Jo Gibbs, "The Modern Honors First Woman: O'Keeffe," *Art Digest* 20 (1 June 1946): 6.

18. Francoise Meltzer, "Color as Cognition in Symbolist Verse," *Critical Inquiry* 5 (Winter 1978): 256–58, 260, 263–64.

19. Charles H. Caffin, "Symbolism and Allegory," *Camera Work* 18 (April 1907): 22.

20. Arthur Wesley Dow, *Composition* (1899), 5th ed. (New York: Baker & Taylor, 1903), 32.

21. Oscar Bluemner, "Statement," in *The Forum Exhibition of Modern American Painters,* exh. cat. (New York: Anderson Galleries, 1916).

22. Ann Lee Morgan, "Toward the Definition of Early Modernism in America: A Study of Arthur Dove" (Ph.D. diss., University of Iowa, 1973), 207.

23. Maurice Maeterlinck, "On Rodin's Thinker," *Camera Work* 2 (April 1903).

24. William Innes Homer, *Alfred Stieglitz and the American Avant-Garde* (Boston: New York Graphic Society, 1977), 209.

25. Georgia O'Keeffe, *Georgia O'Keeffe* (New York: Viking, 1976), facing pls. 12–13.

26. Hartley to Stieglitz, December 1912, Stieglitz Archives, Beinecke Rare Book and Manuscript Library, Yale University, New Haven, Connecticut.

27. Wassily Kandinsky, *Concerning the Spiritual in Art* (1912; New York: Wittenborn, 1966), 53.

28. Ibid., 40.

29. Hartley to Stieglitz, May 1913, Stieglitz Archives.

30. Quoted in Barbara Haskell, *Arthur Dove,* exh. cat. (San Francisco: San Francisco Museum of Art, 1974), 33.

31. Hartley to Stieglitz, December 1912, Stieglitz Archives.

32. Hartley to Stieglitz, February 1913, Stieglitz Archives.

33. Ibid.

34. Hartley to Stieglitz, 1 February 1913, Stieglitz Archives.

35. Quoted in Barbara Haskell, *Marsden Hartley,* exh. cat. (New York: Whitney Museum of American Art, 1980), 29.

36. Hartley to Stieglitz, February 1913, Stieglitz Archives.

37. Quoted in Roxana Barry, "The Age of Blood and Iron: Marsden Hartley in Berlin," *Arts* 54 (October 1979): 167.

38. Marsden Hartley, "Statement," in *Exhibition of Paintings by Marsden Hartley,* exh. cat. (New York: Photo-Secession Gallery, 1916).

39. See Barry, "Blood and Iron," 166–71; and Gail Levin, "Hidden Symbolism in Marsden Hartley's Military Pictures," *Arts* 54 (October 1979): 154–58.

40. Kandinsky, *Concerning the Spiritual in Art,* 58.

41. Hartley to Stein, 16 January 1914, Stieglitz Archives.

42. Gail Levin, "Konrad Cramer: Link from the German to the American Avant-Garde," in Tom Wolf and Franklin Riehlman, *Konrad Cramer: A Retrospective,* exh. cat. (Annandale-on-Hudson, N.Y.: Avery Center for the Arts, Bard College, 1981), 10.

43. Albert Aurier, "Le Symbolisme en peinture: Paul Gauguin," *Mercure de France* (March 1891): 162–63.

44. Marsden Hartley, "America as Landscape," *El Palacio* 5 (December 1918): 340–41.

45. Marsden Hartley, "Art — and the Personal Life," *Creative Art* 2 (June 1928): XXI–XXIV.

46. Hudson D. Walker, "Marsden Hartley," *Kenyon Review* (Spring 1947): 255.

47. Haskell, *Marsden Hartley,* 93–94.

48. Hartley to Adelaide Kuntz, April 1932, Archives of American Art, Smithsonian Institution.

49. Quoted in Helena P. Blavatsky, *The Secret Doctrine: The Synthesis of Science, Religion, and Philosophy* (1888; Point Loma, Calif.: Aryan Theosophical Press, 1909), 1:283–84.

50. "Statements by Marsden Hartley," in *Feininger/Hartley,* exh. cat. (New York: Museum of Modern Art, 1944), 61.

51. For a review of the series' components, see William Innes Homer, "Identifying Arthur Dove's 'The Ten Commandments,'" *American Art Journal* 12 (Summer 1980): 21–32.

52. Dove to Samuel Kootz, 1910s, quoted in Barbara Haskell, *Arthur Dove* (Boston: New York Graphic Society, 1974), 134.

53. *Chicago Evening Post,* 29 March 1912, quoted in Homer, " 'Ten Commandments,' " 25.

54. Quoted in H. Effa Webster, "Artist Dove Paints Rhythms of Color," *Chicago Examiner,* 15 March 1912.

55. "Perhaps art is just taking out what you don't like and putting in what you do. There is no such thing as abstraction. It is extraction, gravitation toward a certain direction, and minding your own business. If the extract be clear enough its value will exist." (Arthur G. Dove in *Arthur G. Dove of Long Island Sound,* exh. cat. [Huntington, N.Y.: Heckscher Museum, 1967], 3).

56. John Marin, *The Selected Writings of John Marin,* ed. Dorothy Norman (New York: Pelligrini & Cudahy, 1949), 127.

57. Rosalind Krauss, "Alfred Stieglitz's 'Equivalents,' " *Arts* 54 (February 1980): 136.

58. Quoted in Frederick S. Wight, *Arthur Dove,* exh. cat. (Berkeley and Los Angeles: University of California Press, 1958), 45.

59. Emerson, "Nature," 24.

60. Kandinsky, *Concerning the Spiritual in Art,* 40, 76.

61. O'Keeffe, *Georgia O'Keeffe,* facing pl. 14.

62. Ibid., facing pl. 3.

63. Quoted in *The Mystic North: Symbolist Landscape Painting in Northern Europe and North America 1890–1940,* exh. cat., ed. Roald Nasgaard (Toronto: University of Toronto Press, 1984), 230.

64. Duncan Phillips, "The Romance of a Painter's Mind," *International Studio* (March 1916): XX.

65. Quoted in Douglas Dreishpoon, *The Paintings, Drawings, and Lithographs of William S. Schwartz,* exh. cat. (New York: Hirschl & Adler Galleries, 1984), 6.

66. Quoted in Bernard Lemann, "Will Henry's Nature" (c. 1946–47), 25; manuscript copy courtesy Robert P. Coggins.

67. Ibid., 25. All Stevens quotations are from this text.

68. Quoted ibid., 2.

OVERLEAF

PAUL KLEE
Above the Mountain Peaks,
1917
Gouache on paper
12 3/16 x 9 7/16 in. (31 x 24 cm)
Haags Gemeentemuseum,
The Hague

.

The great truth, or the absolute truth, makes itself visible to our mind through the invisible.[1] GEORGES VANTONGERLOO

TRANSCENDING THE VISIBLE:
THE GENERATION OF THE ABSTRACT PIONEERS

SIXTEN RINGBOM

REPLACING THE MISSING OBJECT

The most obvious and pressing problem facing the early pioneers of nonrepresentational art concerned the meaning of the abstract work. As figurative forms were suppressed or dissolved, the work clearly threatened to lose its content altogether. Color, line, and form remained, but was that enough? Was the entire work of art being reduced to a mere ornament? This nagging feeling was not easy to dispel. Nor did it do to shrug off the whole question of meaning, for it seemed at the time that a work of art had to mean something. The time was not ripe for accepting the idea of zero content, the work of art as empty nonsense or as an outright negation. In 1913 Kandinsky described the dilemma:

A terrifying abyss of all kinds of questions, a wealth of responsibilities stretched before me. And most important of all: what is to replace the missing object? The danger of ornament revealed itself clearly to me; the dead semblance of stylized forms I found merely repugnant. . . . It took a very long time before I arrived at the correct answer to the question: What is to replace the object? I sometimes look back at the past and despair at how long this solution took me.[2]

This passage exudes Kandinsky's satisfaction over a crisis already passed. We are given to understand that he knows the answer to the question. As we read on, however, we feel that Kandinsky approaches the problem only indirectly; we never learn just what was to replace the missing object. Instead he gives a detailed account of his struggle to experience visual forms purely, in an abstract manner. Only after many years of patient, hard work, engrossing himself "more and more in these measureless depths," did he arrive at the forms that he was then working on and that he hoped to develop further. The forms sometimes "ripened" within him after a long struggle: "Such inner ripenings do not lend themselves to observation: they are mysterious and depend on hidden causes."[3]

Kandinsky's answer to the painful question of meaning was given by way of implication: surely forms so laboriously conceived must be significant and meaningful even if they do not resemble or represent objects. Kandinsky expressly equated the artist's "inner aspiration" with the "content," which peremptorily determines form.[4] Is the missing object to be replaced with the artist's inner aspiration? Not literally, for we know from other declarations by Kandinsky that he never wanted to paint psychic states. What the artist aimed at with his inner experiences was a spiritual reality behind the corporeal forms, a cosmos of spiritual entities that Kandinsky felt was

becoming increasingly important as the world was entering the "Epoch of the Great Spiritual."[5] In this epoch abstract art would be the appropriate means of artistic expression. The forms of the hard material object would be superseded by abstract forms, just as coarse feelings would be replaced by finer emotions not yet dreamt of.

It so happens that we do know a little about the nature of the training undertaken by Kandinsky during the years preceding the breakthrough to abstraction. For example, in *On the Spiritual in Art* (1912) he praised the paths of inner consciousness that were made known in the West by the Theosophical Society: "Their methods, which are the complete opposite of those of the positivists, take their starting point from tradition and are given relatively precise form."[6] The credit for this precision was given to Rudolf Steiner, whose book *Theosophie* (1904) and articles in the journal *Lucifer-Gnosis* are recommended by Kandinsky.[7] Before 1911 the artist is also said to have pursued exercises in "contemplation after Indian models."[8] His preoccupation with meditation and spiritual training can also be followed in the annotations and marginal comments that he made in the occult publications in his library. The following instance is a quite telling example. In *On the Spiritual in Art* Kandinsky referred to an occult article by a Dr. Franz Freudenberg in which the author described a patient and friend who had the remarkable faculty of experiencing taste as color.[9] Here was a topic that interested Kandinsky: synesthesia, the tendency to hear color, see sounds, and the like, was given an important place in his theory, and in his reminiscences he even reported a personal experience of this nature. In his personal copy of the occult article Kandinsky underlined Freudenberg's characterization of his friend as "spiritually unusually developed." And he added in the margin: "The harmonic reverberation [*Zusammenklingen*] of the highest developed parts certainly attainable to many by early *exercise* as a result of perfect reaction to higher stimuli; thereby the exclusion of distracting, accidental stimuli and highest concentration and absorption."[10] This spontaneous comment gives an insight into Kandinsky's hopes and expectations: he believed that one could produce synesthesia by exercise. He thought that by screening off accidental impressions, a procedure that is the classic preliminary to mystical meditation, one could learn to receive higher stimuli.

It was in the hope of achieving such higher perception that Kandinsky wrote meticulous notes after he read Steiner's occult texts. From Steiner's rather verbose writings he extracted the basic precepts, carefully numbering them (pl. 1). To learn to perceive the higher worlds, the occult disciple should possess "six qualities," including "control of thoughts (focusing on one thought)," "endurance," and "open-mindedness." There were also seven "prerequisites (it is but a matter of wishing to enter this path)." Finally there were five "practical hints," such as patience and calm observation of "the finest nuances of psychical life," all to be supplemented with "the teachings of Bhagavad-Gita, the Gospel of St. John, Thomas à Kempis."[11] Kandinsky also recommended Steiner's *Theosophie,* in which the chapter "The Path to Knowledge" offers similar instructions for the reader wishing to develop his higher faculties.[12]

What, apart from synesthesia, did Kandinsky hope to gain by the exercise of such precepts? For all we can tell he regarded mystic absorption not as a goal in itself but as a means of realizing artistic ends. It is because of this that the nature of the reality disclosed through meditation becomes significant. In effect Steiner had already answered the nagging question of the missing object by offering to teach his reader "the faculty of forming images even where no sensible objects are present"; "in [the occult disciple] something else has to replace the 'outer object.' He must learn to produce images, even where there is no object to arouse his senses."[13]

THE FORMLESS WORLD IN MYSTICAL TRADITION

You see the splendor over all the manifold forms or ideas; well we might linger here: but amid all these things of beauty we cannot but ask whence they come and whence the beauty. This source can be none of the beautiful objects; were it so, it too would be a mere part. It can be no shape, no power, nor the total of powers and shapes that have had the becoming that has set them here; it must stand above all the powers, all the patterns. The origin of all this must be formless — formless not as lacking shape but as the very source of even shape intellectual. . . .

When therefore we name beauty, all such shape must be dismissed; nothing visible is to be conceived, or at once we descend from beauty to what but bears the name in virtue of some faint participation. This formless form is beautiful as form, beautiful in proportion as we strip away all shape. . . .

Take an example from love: so long as the attention is upon the visible form, love has not entered: when from that outward form the lover elaborates within himself, in his own partless soul, an immaterial image, then it is that love is born, then the lover longs for the sight of the beloved to make that fading image live again. If he could but learn to look elsewhere, to the more nearly formless, his longing would be for that: his first experience was loving a great luminary by way of some thin gleam from it. (Plotinus, *Enneads* 6.7.32–33)[14]

Plotinus's *Enneads,* from which this exalted praise of the "formless form" comes, was a classic mystical text that provided a philosophical basis for much subsequent mystical thinking, both Christian and non-Christian. Neoplatonic thought adopted Plato's division of intellectual activity into levels of increasing truth and value — ranging from the child's naive acceptance of flimflam, the illusory, to the philosopher's inquiry into the nature of ideas — and introduced the notion of mystical absorption as a shortcut to the highest level. The visible forms occurring at the lower stages, in the material world, were represented by Plotinus as unwanted distractions on the path to truth. The insistence that true reality must be free from visible forms and the belief in the possibility of exploring the formless world by procedures involving training are themes that recur time and time again in later mystical tradition.

In medieval psychology the sense of sight was frequently defined in terms of a classification first proposed by Saint Augustine. The lowest type is corporeal vision, direct perception of the material object; the next higher type is

spiritual vision, based on recollection and imagination; and intellectual vision, the highest form, is contemplative and discards all likenesses. In later tradition spiritual vision was sometimes referred to as "imaginative" because the soul was thought to employ images in the process. The mystic should try to ascend to the highest level. "You have not gone a long way unless you are able by purity of mind to transcend the phantasms of corporeal images that rush in from all sides," preached Saint Bernard, whose late medieval German followers distinguished between imaginative devotion and a state of imageless contemplation.[15]

Similar conceptions about the levels of inner experience have played a prominent part in Eastern traditions. The aspiration toward formless meditation is central to both Hindu and Buddhist tantric teaching. In tantric meditation visual aids are regularly employed, and these yantras (meditation images) may in fact be classed as early instances of nonrepresentational art (pl. 2). Partly for this reason tantric imagery has become popular in the last decades, and a whole literature has recently grown up on the subject.[16]

In Buddhism the technique of concentration had developed into a minutely articulated routine for the express purpose of attaining a formless state. According to Buddhist esotericism, the adept is to pass through seven successive levels, the four lower levels being called *rupa* (form, body), the three higher, *arupa* (formless, incorporeal). *Arupa-dhyana,* a state of complete freedom from forms and images, is the ultimate goal, just as imageless, intellectual vision was the goal of the Christian mystics of the Middle Ages. This parallel between Eastern and Western mystical traditions, which was to become so important to the Theosophists, has puzzled historians of

1
Instructions for meditation after Rudolf Steiner's articles in *Lucifer-Gnosis,* pages 1 and 7 from Wassily Kandinsky's notebook, c. 1908, Städtische Galerie im Lenbachhaus, Munich, Gabriele Münter und Johannes Eichner Stiftung

.

2
Pure Conscience, tantra illustration from 17th-century illuminated manuscript, Museum and Picture Gallery, Baroda, pl. 97 from Ajit Mookerjee, *Tantra Asana* (1971)

.

3
Undisciplined, no. 1 of the oxherding pictures, c. 1585, Chinese woodcut, from D. T. Suzuki, *Manual of Zen Buddhism* (1950)

·

4
All Forgotten, no. 6 of the oxherding pictures, c. 1585, Chinese woodcut, from D. T. Suzuki, *Manual of Zen Buddhism* (1950)

·

5
Both Vanished, no. 10 of the oxherding pictures, c. 1585, Chinese woodcut, from D. T. Suzuki, *Manual of Zen Buddhism* (1950)

·

religion, one of whom compared the doctrine of the arupa-dhyana with the sayings of the German mystic Meister Eckhart, who declared that "the spirit must transcend object and objectivity, form and formedness."[17] Zen sometimes illustrated the attainment of the imageless state with the Ten Oxherding Pictures (pls. 3–5). This series exists in different versions: a "fundamentalist" version, in which the exercise ends with an empty circle, and a modified version that does not place the circle as the last picture in the series, thus avoiding the notion that emptiness is all important and final.[18]

THEOSOPHY AS THE CONNECTING LINK

There is no need to assume that Kandinsky, Piet Mondrian, or any of the other abstract pioneers had much firsthand knowledge of either Western or Eastern teachings about the objectless state. Some of them may have gone to the sources, but there was no difficulty in learning about the notion indirectly. The last decades of the nineteenth century saw an upsurge in popular publications on Eastern mysticism. Eight editions of Alfred Percy Sinnett's *Esoteric Buddhism,* a theosophical

interpretation of the subject, appeared between 1883 and 1903, and it was translated into many languages, including German in 1884.[19] During the same decades the Theosophical Society, founded in 1875, reoriented itself eastward. Its founder, Helena P. Blavatsky, had started with spiritualism, then turned her attention to the cabala, hermeticism, Jakob Böhme, and European occultism; but in the end Indian religions became an increasingly important source of inspiration. This last trend became even stronger under her successor Annie Besant.

It was in German theosophical circles that the Bhagavad Gita, the classical text of Indian transcendentalism, was systematically collated with classics of medieval mysticism as well as with writings by Meister Eckhart, Thomas à Kempis, and such later teachers as Paracelsus and Böhme. In 1892 the Theosophist Franz Hartmann published such a collation of texts, in which Meister Eckhart is quoted more frequently than the others.[20] And it was around the turn of the century that Steiner, as the German theosophical leader, precipitated the return to Western mystical traditions, at least as far as the German branch of the society was concerned. A Steiner book published in 1901 contained accounts of the teachings of Western mystics exclusively:

Meister Eckhart, Johannes Tauler, Heinrich Suso, and others.[21]

During the same period the distinction between the world of forms and the formless world was described with a growing amount of vivid detail by the English Theosophists Besant and Charles W. Leadbeater. Besant described the effect of the thinker's thought vibrations on the arupa level:

These vibrations, which shape the matter of the plane into thought-forms, give rise also — from their swiftness and subtlety — to the most exquisite and constantly changing colours, waves of varying shades like the rainbow hues in mother-of-pearl, etherealised and brightened to an indescribable extent, sweeping over and through every form, so that each presents a harmony of rippling, living, luminous, delicate, colours, including many not even known to earth. Words can give no idea of the exquisite beauty and radiance shown in combinations of this subtle matter, instinct with life and motion. Every seer who has witnessed it, Hindu, Buddhist, Christian, speaks in rapturous terms of its glorious beauty.[22]

This formless world, witnessed by Hindu, Buddhist, and Christian seers, became the principal subject of two lavishly illustrated books published after the turn of the century: Leadbeater's *Man Visible and Invisible* and Besant and Leadbeater's *Thought-Forms*.[23] Both were issued in German translations in 1908; Kandinsky owned a copy of the latter.[24] He probably knew the former volume because the later book contains cross-references to it, and Steiner recommended both in the articles that Kandinsky read and excerpted. The illustrations in the two books show the organization of the world (pl. 6); the colorful auras visible to the trained observer (pl. 7); and the "thought-forms" produced by vibrations in these auras, which, once detached from the auras, move in the spiritual atmosphere and exert influence on other per-

6
The Planes of Nature with dividing line between the world of forms (*rupa*) and the formless levels (*arupa*), pl. IV from Charles W. Leadbeater, *Man Visible and Invisible* (1902)

.

7
Aura of the Devotional Type, pl. XIX from Charles W. Leadbeater, *Man Visible and Invisible* (1902)

.

8

Definite Affection, fig. 10 from Annie Besant and Charles W. Leadbeater, *Thought-Forms* (1905)

.

9

On the First Night, thought-form of an actor waiting to go on stage, fig. 31 from Annie Besant and Charles W. Leadbeater, *Thought-Forms* (1905)

.

sons (pls. 8–10). Both books also contain a color chart, *Key to the Meanings of Colors* (pl. 11). The clairvoyant ascending to the higher planes of nature perceives "higher octaves of colour"; in the auras and thought-forms the "quality of thought" determines color, whereas the "nature of thought" determines form.

The colorful and abstract illustrations of these two theosophical books and the equally vivid verbal descriptions of the formless worlds by Besant, Leadbeater, and Steiner made a deep impression on Kandinsky, who carefully listed the color meanings in his Steiner annotations. For Kandinsky an experience like the sights described by these authors would have made almost any amount of spiritual exercise worthwhile. Kandinsky had also listed Steiner's prerequisites for "meditation, concentration, etc., for temporary with-drawal of the soul from its connection with

the sense organs" (pl. 1). Whether he ever suc-ceeded in having any experiences of the kind he apparently hoped for is not known, and some may feel that this is a question that should not even be posed by the historian.

What is known is what happened to Kandinsky's art during the very years, from about 1908 to 1912, when his interest in the occult reached its culmination. It was during this period that he gradually ceased to depict the forms of the visible world, replacing the missing object with a content that he referred to as being dictated by "inner aspiration." The transition is reflected in *Reminiscences* (1913), in which Kandinsky wrote that he used to have a capacious visual memory continuously fed by vivid observation; the training of concentration "leads, on the other hand, to a decline of one's other faculties." He felt that such a decline was taking place in himself, and he believed that his capacity for continual observation was being channeled into another direction by his "improved pow-ers of concentration": "My capacity for engrossing myself in the inner life of art (and, therefore, of my soul as well) increased to such an extent that I often passed by external events without noticing them, something which could not have occurred previously."[25]

FORMLESS VOID OR ABSENCE OF PHYSICAL FORMS

How formless is formless? To insist on abso-lute formlessness must, in terms of visual rep-resentation, result in a complete void: the empty circle of the Oxherder series, the blank space of the tantric representation of pure con-science. At the beginning of this century, however, Zen and tantrism were virtually unknown to the general public; the direct and immediate impact of this radical iconoclasm on abstract art was to be felt only decades later. There is also a looser interpretation of the word *formless* that does not entail an abso-lute absence of form but merely the absence of physical shape. This is something altogether different from the arid emptiness that results from a strict application of the concept. It offers a virtually limitless freedom in the choice of line, shape, and color as long as the artist sees to it that representational forms are excluded.

Whatever one might otherwise think about the claims and intellectual quality of the theo-sophical teachings, the crucial role of Theoso-phy in the emergence of nonrepresentational art is becoming increasingly clear. In a seem-ingly endless stream of publications Theoso-phy provided artists with a wealth of artistically exploitable ideas and images. Most

important was its interpretation of the spiritual as being formless in a physical but not an absolute sense. Theosophy envisioned a new realm of color and form, at first in verbal descriptions and later by means of color illustrations. The *arupa* of Buddhism and the intellectual vision and imageless contemplation of the medieval mystics became common knowledge, and if hopeful disciples could not conjure up the formless before their inner eye, they could always resort to the accounts and illustrations of such clairvoyants as the Theosophists.

There remained yet another path, which was implicitly acknowledged by Theosophy. In Devachan, the theosophical heaven that is situated on the mental plane (see pl. 6), the thinker feels his or her own inner life to be the real world and the outside world to be an illusion; on this plane the thinker's creative nature is manifested "in a way and to an extent that down here we can hardly realise":

On earth, painters, sculptors, musicians, dream dreams of exquisite beauty, creating their visions by the powers of the mind, but when they seek to embody them in the coarse materials of earth they fall far short of the mental creation. The marble is too resistant for perfect form, the pigments too muddy for perfect colour. In heaven all they think is at once reproduced in form, for the rare and subtle

matter of the heaven-world is mind-stuff, the medium in which the mind normally works when free from passion, and it takes shape with every mental impulse. Each man, therefore, in a very real sense, makes his own heaven, and the beauty of his surroundings is indefinitely increased, according to the wealth and energy of his mind.[26]

Although the artist cannot recover the richness of inner visions in the coarse materials of the everyday world, art is given a role in the quest for the spiritual. In theosophical aesthetics the work of art is in its own way a thought-form, shaped by the artist's thought vibrations and itself transmitting these vibrations to the beholder. Kandinsky took over this principle, vibrations and all,[27] and for him there were also other ways in which the theosophical idea of artistic creativity could be adapted to an artistic program. Could not artistic sensibility as such represent an alternative to meditation and similar exercises in the search for the spiritual? Although not elaborated, this possibility was occasionally suggested in theosophical literature, and it was also eagerly adopted by Mondrian, another of the abstract pioneers.

Mondrian took Theosophy seriously enough to join the society in 1909. He kept Blavat-

sky's portrait on the wall of his studio and also became acquainted with the Dutch theosophist M. H. J. Schoenmaekers. Mondrian referred with approval to Kandinsky's view that "Theosophy (*in the true sense of the word; not as it is usually understood*) is another manifestation of the same spiritual movement that is to be seen in painting."[28] Like Kandinsky, Mondrian believed that the theosophical conception of matter was being proved by modern science, but unlike Kandinsky he does not seem to have put much faith in individual exercise and meditation:

There are two paths leading to the Spiritual; the path of learning, of direct exercises (meditation, etc.) and the slow certain path of evolution. The latter manifests itself in art. One may observe in art the slow growth towards the Spiritual, while those who produce it remain unaware of this. The conscious path of learning usually leads to the corruption of art. Should these two paths coincide, that is to say that the creator has reached the stage of evolution where conscious, spiritual, direct activity is *possible,* then one has attained the ideal art.[29]

10
Gounod, thought-form produced by the performance of "Soldiers' Chorus" from *Faust,* pl. G from Annie Besant and Charles W. Leadbeater, *Thought-Forms* (1905)

.

11
Key to the Meanings of Colors, from Charles W. Leadbeater, *Man Visible and Invisible* (1902)

.

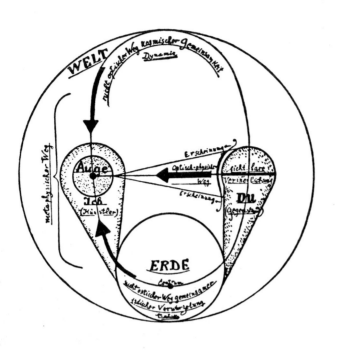

12
Ways of Studying Nature,
illustration from Paul Klee,
"Wege des Naturstudiums,"
*Staatliches Bauhaus Weimar
1919–23* (1923), p. 24

.

13
WASSILY KANDINSKY, studies
for *Study* and *Klänge,* c.
1909–10,
from sketchbook, Städtische
Galerie im Lenbachhaus,
Munich, Gabriele Münter
und Johannes Eichner
Stiftung

.

Mondrian concluded that the spiritual could be sought by purely graphic means. He emphasized that the words *spiritual* and *transcendental* can mean anything from the purely spiritual to that which is on the steps between the physical plane and that highest stage. It is vain to concern ourselves with the purely spiritual, which cannot be expressed. The absolutely formless void of Zen or tantrism would probably not have appeared fruitful to Mondrian had he known these movements. He was concerned with the less than absolutely spiritual, with levels that are visually relevant. Below the highest level the spiritual manifests itself not only in invisible forms but also in physical forms, and it is here that the artist's task begins:

If one conceives these intermediate forms as increasingly simple and pure, commencing with the physical visible forms of appearance, then one passes through a world of forms ascending from reality to abstraction. In this manner one approaches Spirit, or purity itself. It follows from this that Spirit is more easily approached by means of a form which is closer to Spirit — and indeed least of all by the physical form.[30]

Abstract art represents a gradual approximation of the spiritual, but how is complete arbitrariness to be avoided? And why did Mondrian end up with geometrical forms as being closer to the spirit than other forms? To Mondrian himself the conclusions seemed to follow with inexorable logic from the premises. He accepted the theosophical idea of the higher, ethereal planes penetrating the physical world on whose surface the spiritual is thus reflected. For that reason the artist has to look "through the surface," which is possible because even as we behold the surface "the inner image is formed in our souls."[31] Matter is nothing to ignore or deny; on the contrary, by intense study of matter we can reach beyond reality's mere appearance: "This explains logically why primary forms are employed."[32] For Mondrian primary forms are the ones most removed from physical reality. This is a platonic notion that he probably became acquainted with through Theosophy, where Plato was frequently quoted as saying that "God geometrizes."

The idea that the penetration of the surface of visible reality will lead to abstract art was shared by several pioneers of abstraction: Kandinsky, František Kupka, most of the Russian avant-garde, and many of Mondrian's De Stijl colleagues. Paul Klee summa-

rized the idea in a diagram (pl. 12).[33] In the "World" defined by the circle are two forms on each side of a smaller circle signifying "Earth." The "Self (Artist)" is represented by the left-hand shape, "You (Object)" by the right-hand shape. There are three channels of information on the object, all meeting in a point in the artist's "eye." "The optic-physical path" merely records the appearance of the object, an outer shell indicated by a shielding membrane. In contrast to this superficial method, the two other, nonoptical paths of "cosmic community" and "common earthly rooting" reach behind appearances, into the object itself. The knowledge of the inner object is intuitive, acquired through intense study and inner vision. The final synthesis of outer and inner vision may "totally diverge from the optical image of an object, and still not, in a totality context, contradict it."[34] The exact procedure of this extraphysical observation is not elaborated by Klee any more than by Mondrian; it is taken for granted that the artist can develop this faculty and that art represents one of several paths to the inner truth. It is in this way that artistic authority reasserted itself: the abstract pioneers were artists, not occult teachers, however much

they may have borrowed from Theosophy and similar teachings. The closer we come to the actuality of artistic practice, the more the emphasis is on the artist's subjective sensibility.

PARALLEL REPRESENTATION

as above so below

Among the ideas drawn from occultism there was one that lent itself most readily to translation into pictorial terms, namely the idea that actions and thoughts upon the normal physical level are paralleled on some higher spiritual plane. Such duplication will be called "parallel action," and the pictorial rendering of it, "parallel representation."

The notion of parallel action is basic to theosophical belief and is a natural corollary to the assumption of higher levels of nature. The ethereal counterparts of material objects and actions constitute "the hidden side of things," as in fact one of Leadbeater's books was called. Every human being possesses "higher bodies" in addition to the physical body, the only body known to and recognized by the materialist, and these higher bodies manifest themselves as immaterial colors and forms unlike the physical bodies. The higher levels form a spiritual atmosphere where colored formations "thrown off" by the higher bodies move about, calmly, energetically, or frantically, as the case may be.[35] It was these manifestations that were described and illustrated in Besant's and Leadbeater's books (see pls. 6–11), and Steiner's written accounts on the subject were hardly less suggestive.

Kandinsky adopted the theosophical notion of "spiritual atmosphere," which "like the air, can either be pure or filled with foreign bodies"; and "not only actions that can be observed, thoughts and feelings that can find external expression, but also perfectly secret actions that 'no-one knows about,' unuttered thoughts, and unexpressed feelings (i.e., actions that take place within people) are the elements that constitute the spiritual atmosphere."[36] He believed that this spiritual atmosphere could be expressed by artistic means, and it is here that we encounter one of the stranger fancies of this fanciful art theory: the correlation of the spiritual atmosphere with Richard Wagner's famous leitmotiv. To Kandinsky the use of leitmotiv represented an attempt to characterize the hero not by theat-

rical props and contrivances but by a certain precise motif and by purely musical means: "This motif is a kind of musically expressed spiritual atmosphere preceding the hero, which thus emanates from him at a distance." In a footnote Kandinsky explained that such spiritual atmosphere accompanies "not just heroes, but every man" and is perceptible to "sensitive people" even at a distance in time and space.[37]

Kandinsky's interest in the musical leitmotiv as a means of expressing occult emanations, of parallel representation, can be seen against the background of his graphic experiments at the time. In sketch after sketch he vacillated between "theatrical props" and pure patches of color as a means of enhancing the action of his protagonists. In two small sketches of circa 1909–10 (pl. 13) are two alternative pictorial techniques. In the top sketch he used forms that are given a figural pretext — tree, hill, cloud, rainbow — which are still connected with the human protagonists, while in the sketch below a similar encounter of humans is accompanied by color clouds: "black," "violet," "king's blue," "carmine." The former technique derived from Art Nouveau, but the latter was an invention of Kandinsky's. His numerous experiments with self-sufficient forms are interesting as documents of his gradual emancipation from Art Nouveau, in which such natural forms as trees were widely used as semidisguised expressions of feeling.

The most prolific inventor of expressive props was Edvard Munch, in whose soul landscapes of the 1890s the entire view is subordinated to the mood and expression. The horizon, the sky and clouds, the trees, and the vegetation down to the tiniest details are intertwined, literally and symbolically, with the protagonists. An example is *Separation,* of which Munch made variations in several media. A preparatory drawing for the lithograph dating from 1896 (pl. 14) shows the miserable gentleman in a bowler hat clutching his heart in anguish,

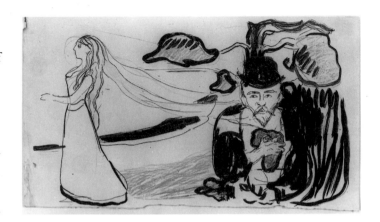

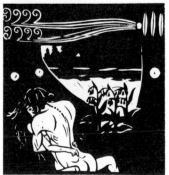

14
EDVARD MUNCH
Study for "Separation," 1896
Pen, brush, and
ink with crayon
10 ⁷⁄₁₆ x 18 ⁷⁄₈ in.
(26.6 x 48 cm)
Oslo Kommunes
Kunstsamlinger

15
ERNST LUDWIG KIRCHNER,
Seduction and *Union* (from
Man and Woman series),
1905, woodcuts

a motif that in the painted versions was transformed into a flaming red bush reminiscent of a dissected heart. The dark branches hover above his head as a symbolic expression of his gloomy thoughts. The woman is moving along the horizon, toward freedom. Only a few barely visible threads, perhaps strands of hair, connect her with her deserted companion. Munch employed his expressive technique in the major compositions of his Life Frieze project and in portraits such as the famous lithograph of August Strindberg, where the author is characterized with a surrounding, angry zigzag line gradually merging into a nude woman. Whether influenced by Munch or not, similar devices can be seen in the early work of the German Expressionists. An interesting variant appears in Ernst Ludwig Kirchner's Man and Woman woodcut series, where an abstract Jugendstil pattern accompanies the story (pl. 15).

Other examples could be cited to indicate that Kandinsky was clearly not alone in experimenting with expressive props, but what makes his experiments so important is the fact that they provided a starting point for an entirely new departure: the abstract forms

floating around the figures. To him the configurations were not meaningless or arbitrary patches of color; they represented a painterly equivalent to the musical leitmotiv. They were thus charged with meaning pertaining to the spiritual cosmos that he wanted to make the content of his art, the same spiritual universe of colorful thought-forms that the Theosophists had explored in their books. In Steiner's articles Kandinsky had read about the everyday world as it appears to the higher vision of the clairvoyant: street scenes where people mingled with their multicolored emanations, feelings and thoughts floating about as colored clouds. Kandinsky also noted that "the hovering of color 'without ground or support'" is the manifestation of beings that surround us all the time.[38]

A drama of parallel action is enacted before our eyes in Kandinsky's *Lady in Moscow,* painted in three versions in 1912 (pls. 16–17).[39] On the material plane is the lady, somewhat surprisingly placed in the middle of a street, standing next to a small table with a lapdog and holding a rose in her hand. On another plane, presumably the spiritual atmosphere, are the manifestations of thoughts and feelings. A nasty black shape seems to be traveling across the field of vision, threatening to

eclipse the sun. According to theosophical belief it is from the sun that the human etheric double or "health aura" draws its strength; the health aura is seen as a gray double around the lady. The situation is critical: will the black spot shut off the life-giving light? Perhaps countering the influence of the blackness, on the left of the lady is another thought-form, which may emanate from the lady or from some other source and whose rose-red color and heart-shaped nucleus indicate the presence of love and goodwill. It seems that these thought-forms were distinctly contrasted against the physical forms by way of experiment because at exactly the same time Kandinsky was at work on another picture that restated the drama in more or less abstract terms.

The oil version of *Lady in Moscow* bears the number 152 in Kandinsky's own oeuvre catalogue. Number 153 is called *Black Spot I* and is a work to which he devoted much effort and

18
WASSILY KANDINSKY
Black Spot I, 1912
Oil on canvas
39 ⅜ x 51 ³⁄₁₆ in.
(100 x 130 cm)
Russian Museum, Leningrad
.

19
WASSILY KANDINSKY
*Study for the Composition of
"Black Spot I,"* 1912
Pencil on gray support
8 ⅝ x 10 ¾ in.
(21.9 x 27.3 cm)
Städtische Galerie im
Lenbachhaus, Munich
.

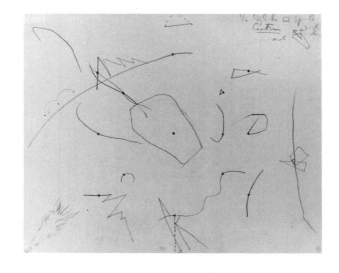

20
WASSILY KANDINSKY
Study for "Black Spot I," c.
1912
Black pen and red crayon on
gray support
4 ⅛ x 6 ⁷⁄₁₆ in.
(10.5 x 16.4 cm)
Städtische Galerie im
Lenbachhaus, Munich
.

meticulous preparatory sketching (pls. 18–20).[40] If *Lady in Moscow* was a parallel representation of a material reality with an occasional influx of spiritual atmosphere, *Black Spot I* can be said to present spiritual atmosphere with occasional references to material reality. In the latter we can hardly speak of parallel representation any longer because Kandinsky's attention has shifted from the material to the spiritual sphere. Yet the main opposition between life-giving light and menacing blackness remains: the spot is traveling toward the source of light in the upper right-hand corner; small human figures can just barely be made out in various places of the picture space; even the carriage of the preceding painting recurs. The figural forms are faintly suggested, and the representation is on the verge of becoming completely abstract. The technique of parallel representation, therefore, constitutes one possible path to the complete elimination of visible reality: of the two parallel renderings, the material one merely has to be suppressed to make the image nonrepresentational.

Parallel representation can also be observed in the work of the Swedish occult painter Hilma af Klint.[41] It is employed by af Klint in other-wise matter-of-fact illustrations of occult observations of plants and other organic forms, in representations of human relationships, and in vast panoramas of cosmic evolution. For example, in a botanical illustration from 1919 (see p. 160) five species of violets — standing for the Baltic region, Denmark, Sweden, Finland, and Norway — are represented as examples of "humility" and "joy." Next to each plant af Klint appended geometrical motifs, which she referred to as "guidelines"; these she believed she had received from the higher regions. Af Klint was familiar with the basic tenets of Theosophy: a formless higher reality, the geometrizing of God and nature, and a meaningful connection between the appearance of the physical world with the abstract forms of higher truth.

Parallel representation of a more elaborate kind was used by af Klint in her Man and Woman series. In *Silence,* 1907 (pl. 21), are two figures and an abstract pattern charged with meaning. The two light circles belonging to the man and woman contain motifs that ultimately derive from theosophical diagrams but that af Klint had developed into an iconography of her own. Between the spiritual circles is a slim cross connecting them with the material bodies of the couple. The cross is a really appropriate motif: according to Blavatsky, "it is a sign that the fall of man into matter is accomplished."[42]

As a historical phenomenon the case of af Klint is singularly illuminating. Unlike psychologists, historians are rarely in a position to double check their conclusions through the use of control groups, but af Klint can almost be seen as a one-person control group. In essential respects her case agrees with those of the mainstream abstract pioneers: professional training before the turn of the century, belief in the spiritual as the main concern for visual creation, familiarity with occult sources. But unlike them she worked in isolation, without knowing anything about the abstract art emerging on the Continent, and yet she arrived at similar results. She even developed a pictorial technique, parallel representation, also employed by Kandinsky. This alone demonstrates the visual potential of the theosophical teachings, that for these artists — with fertile imagination, visual creativity, and perhaps a suitable lack of inhibition — the esoteric fantasies of Theosophy provided a rich source for pictorial discoveries.

21
HILMA AF KLINT
First Large Series No. 6: Silence, 1907
Oil on canvas
64 9/16 x 58 1/4 in.
(164 x 148 cm)
Stiftelsen Hilma af Klints Verk

ABSTRACTION AS DEMATERIALIZATION

Perhaps the closest graphic analogy to the mystical ascent to objectless vision is presented by another method that was employed by the abstract pioneers: the step-by-step dissolving of the material objects of the image. The physical forms are manipulated until they bear no resemblance to the forms of the visible world, a procedure that normally results in a series of designs. Such a series is treated by the artist in one of two ways: as merely preparatory work for the definitive version, in which case the artist normally prefers to keep the studies private, or else the process as such is so sufficiently interesting that the artist exhibits the series in its entirety. The artist may even anticipate the future display of the studies by deliberately stressing the consistency of the transformations taking place in picture after picture, and there will thus not always be a definitive work that forms the end and climax of the series.[43]

To Kandinsky the dematerialization of an initially recognizable subject represented only one method among others. Prior to his decisive step into abstraction, he had already studied the hidden construction of his paintings, as shown by a sketchbook page of about 1910 containing variant designs for *Improvisation 7* (pl. 22). He was not yet prepared to lay bare the construction, and the finished painting followed the topmost design with its recognizable forms. In the following years he became bolder. From about 1910 to 1913 he worked on several parallel series where the starting point was a fairly representational picture and the end result a more or less abstract work. A landscape with a church was, step by step, dematerialized into a painting with mere fragments left of the original subject; pictures of the Apocalypse and All Saints' Day served as starting points for a vast series culminating in *Composition VII;* and the glass painting *Deluge* (pl. 23) was transformed into the almost completely abstract *Composition VI.*

The last-mentioned series deserves special attention because we have the artist's own comments on its history. When the *Deluge* was finished Kandinsky decided to paint a composition on the subject and felt that he had a clear idea of how to do it:

But this feeling quickly vanished, and I lost myself amidst corporeal forms, which I had painted merely in order to heighten and clarify my image of the picture. In a number of sketches I dissolved the corporeal forms; in others I sought to achieve the impression by purely abstract means. But it didn't work. This happened because I was still obedient to the expression of the Deluge, instead of heeding the expression of the *word* "Deluge." I was ruled not by the inner sound, but by the external impression. Weeks passed and I tried again, but still without success. I tried the tested method of putting the task aside for a time, waiting to look at the better sketches again all at once, with new eyes. Then I saw that they contained much that was correct, but still could not separate the kernel from the shell. I thought of a snake not quite able to slough its skin. The skin itself looked perfectly dead — but it still stuck.[44]

Not all the preparatory work is extant, but enough remains to give a rough idea of Kandinsky's method. A group of drawings in the Städtische Galerie is connected with the *Deluge I* (pl. 24): a design still rather dependent on the motifs of the glass painting, it may be classed as belonging to the studies

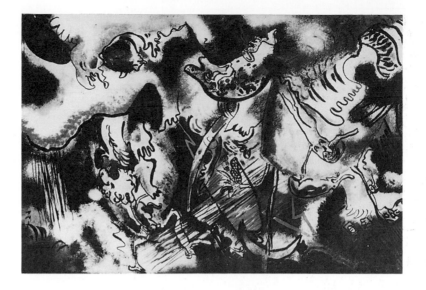

where Kandinsky "dissolved the corporeal forms." *Improvisation Deluge,* 1913, shows further dematerialization (pl. 25); indeed it is more abstract than the final *Composition VI.*

Kandinsky's comments on the creative process leading up to the final work remind us of the mystical classics. His shunning of corporeal forms and external impressions parallels Saint Bernard's transcending of the phantasms of corporeal images rushing in from all sides. A visitor in 1912 reported Kandinsky's interest in "mystical books and the lives of the saints," so he may well have been familiar with the Western mystical tradition and not only with more recent occultism.[45]

There is another parallel with the Western mystical tradition: Kandinsky's "new symphonic" paintings, which are connected with the advent of "the Epoch of the Great Spiritual." According to his categories, "Impressions" are just that, impressions of external nature expressed in painterly form. The next higher type is represented by the "Improvisations," which consist of "expressions of events of an inner character, hence impressions of 'internal nature.'" The highest class is that of "Compositions," which are "the expressions of feelings that have been forming

23
WASSILY KANDINSKY
Deluge, 1911
Painting on glass
Dimensions unknown
Lost

·

24
WASSILY KANDINSKY
Deluge I, 1912
Oil on canvas
39 ⅜ x 41 ⁵⁄₁₆ in.
(100 x 105 cm)
Kaiser Wilhelm Museum,
Krefeld, West Germany

·

25
WASSILY KANDINSKY
Improvisation Deluge, 1913
Oil on canvas
37 ⅜ x 59 ¹⁄₁₆ in.
(95 x 150 cm)
Städtische Galerie im
Lenbachhaus, Munich

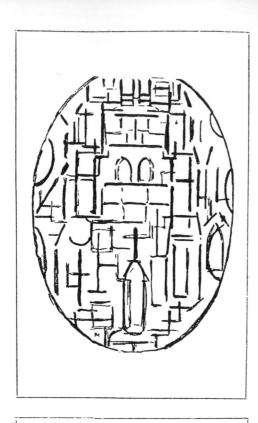

within me in a similar way (but over a very long period of time), which, after the first preliminary sketches, I have slowly and almost pedantically examined and worked out."[46] This tripartite division displays the same step-by-step ascent from the world of sense impressions to the level of intellectual deliberation as the classical Augustinian scheme of sight.

The Dutch abstract artists employed dematerialization systematically, with the pedantic rigor of a textbook exercise. There are many reasons for this, but the most important was certainly the commonly held belief in an immutable, ordered, and mathematically defined reality behind appearances. Schoenmaekers, the Dutch Theosophist who inspired Mondrian as well as other De Stijl members, emphasized that his "formative mathematics" was based on exact knowledge and exact images.[47] He even questioned the Theosophist habit of using oriental ways of thinking: Western thinking can only be developed in "a positive, exact, verifiable manner, not through oriental-lovable, poetical softness."[48] In this respect Mondrian and Schoenmaekers are literally worlds apart from Kandinsky and Steiner. They sought objective truths and immutable generalities, a reality independent of individual feeling, whereas Kandinsky had invoked a "cosmos of spiritually active beings,"[49] a dynamic space in which individual emotions manifest themselves in softly expressed color and form.

The systematic step-by-step dematerialization employed by many De Stijl artists aimed at laying bare the immutable gridwork behind the outer shell of visible reality. Mondrian accepted the theosophical notion of matter as a denser variant of the spirit. The spirit itself cannot be perceived through our senses; we are confined to observing matter. Gradually we approach the spiritual and leave material forms behind us in the process: "Hence, as matter becomes redundant, the representation of matter likewise becomes redundant. We arrive at the representation of other things such as the laws which hold matter together. These are the great generalities, which do not change."[50] Mondrian's increasingly geometrized designs became a reflection of his idea that "one passes through a world of forms ascending from reality to abstraction."[51] The ascent to abstraction was also dis-

cussed by Theo van Doesburg in terms of the Augustinian tripartite scheme. Like the mystics in the tradition of Saint Augustine, van Doesburg postulates three types of knowledge: sensory, psychic, and spiritual.[52]

Today Mondrian's and van Doesburg's series have become common knowledge. In this context it will suffice to refer to an example connected with both: two church facades by Mondrian, published and commented on by van Doesburg in *De Stijl* in 1918 (pl. 26).[53] The commentary repeats Mondrian's ideas, published in the same issue, about the role of *tijdsbewustzijn* (zeitgeist): this period consciousness determines the artist's aesthetic sense and acts as the formative agent in the shaping of the spiritualized form. We recall that Mondrian, in contrast to Kandinsky, showed faint interest in direct exercise and meditation; to him artistic work was a fully equivalent alternative.

Dematerialization was also employed by other artists, such as Kupka in his well-known series of abstractions, Girl with a Ball I–IV.[54] But as the advocates of nonrepresentation moved their line of defense from abstraction to what soon came to be called *concrete art,* dematerialization lost favor. In contrast to "abstract" work, which was distilled from visual reality, "concrete" work was presented as existing in its own right. Instead of trying to reach the spiritual by a slow ascent marked by the gradual receding of corporeal form, by a kind of meditation, the artist attempted the more direct approach of independent creation without any starting point in the object world.

Klee's essay "Ways of Studying Nature" closes with a passage defining the student's development in the dialogue with nature:

The more the student ascends in his conception of the world, the more does his development in the observation and perception of nature help him to the free creation of abstract forms, which, by way of the willed-schematic, reach a new naturalness, the naturalness of the work. He then creates a work, or takes part in the creation of works that are a simile to the work of God.[55]

Kandinsky had expressed a similar idea: art is a realm in itself, which like nature, science, and political institutions is regulated by its own laws.[56] He elaborated on the idea of artistic creation as analogous to natural events: "It seems to me that this process of spiritual fertilization, the ripening of the fruit, labor and birth, corresponds exactly to the physical process of the conception and birth of man. Perhaps worlds, too, are born in this way."[57] This analogy dates back to German Romanticism of the eighteenth century. Johann Wolfgang von Goethe exclaimed that just as with the works of nature, the finest works of art are made by man according to natural laws, and "the beautiful is a manifestation of natural laws that otherwise had remained hidden forever."[58] It so happens that during the late nineteenth century Steiner was one of the greatest exponents of Goethe's ideas. He specifically expounded the Goethian idea that "artistic creation cannot be essentially different from natural knowledge."[59] Steiner had also popularized the notion of inner perception as participation in the work of God, quoting extensively from such mystics as Meister Eckhart and Angelus Silesius.[60] The idea of the work of art as an analogy to the work of nature raised questions of truth and validity. How do we or the artist know whether a form does follow natural laws? Kandinsky had his answer ready: harken to the inner sound and submit to inner necessity. This may not be very helpful, but to Kandinsky it seemed convincing enough. Furthermore he lived in the hope of a future *kunstwissenschaft* (science of art), which would provide pictorial art with a "thorough bass" of formal rules.[61]

There were other possibilities. Mathematics, the purest of all branches of knowledge, seemed to offer a helping hand. The Theosophists had popularized the saying attributed to Plato, "God geometrizes."[62] "'Dots, Lines, Triangles, Cubes, Circles' and finally 'Spheres' — why or how?" Madame Blavatsky asked, continuing: "Because, says the Commentary, such is the first law of Nature, and because Nature geometrizes universally in all her manifestations."[63] This doctrine influenced Mondrian even before he became acquainted with the teachings of Schoenmaekers, and the artist's gradual transition to a gridwork of horizontals and verticals can be seen in the light of his documented interest in Blavatsky.[64] Then, at the critical stage, came the further encouragement provided by Schoenmaekers's ideas of a graphic language with "figurative propositions in the strict sense, that is, propositions for which a definite figure can be exactly constructed"; he also provided De Stijl artists with the idea of two-dimensional surfaces as especially appropriate to the representation of the reality beyond the skin of nature.[65] Other lines of mathematical and physical speculation also looked promising to many abstract pioneers, especially the exploration of the fourth dimension,[66] an approach that van Doesburg pursued with the greatest enthusiasm.

Even acoustics was searched for possible channels to the invisible, and here again Theosophy gave the lead. Among the ideas taken over from Buddhist cosmology by Blavatsky and her followers was the notion of vibration as a force producing all the shapes of the visible as well as the invisible world. In the hands of Besant and Leadbeater this idea was fused with Western occult speculation that was based on the perfectly respectable scientific investigations by Ernst Chladni. These two authors argued that the thought-forms in etheric matter are the result of thoughts and feelings. The higher matter is structured by the vibrations in man's higher bodies in the same manner as physical matter is shaped by vibration. The Theosophists referred to Chladni's sound-plates made of glass or metal: as the plate is set into vibration by a violin bow, the fine sand on the plate is arranged into patterns that can be varied by touching the edge at selected points (pl. 27).[67]

27
The operating principle of the Chladni plate, figs. 1–3 from Annie Besant and Charles W. Leadbeater, *Thought-Forms* (1905)

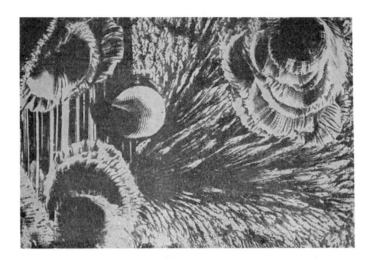

28
Vibration pattern, pl. XVI
from A. de Rochas d'Aiglun,
*Les sentiments, la musique et le
geste* (1900)
.

29
GEORGES VANTONGERLOO,
figure derived through
vibration, from *De
Stijl* 9 (1918)
.

30
GEORGES VANTONGERLOO
Study, 1917
Oil on canvas
19 ¹¹⁄₁₆ x 19 ¹¹⁄₁₆ in.
(50 x 50 cm)
Max Bill
.

Kandinsky adapted Theosophy's vibration model for his theory: finer emotion consists of vibration, vibration shapes the work of art, the work vibrates, and the soul of the beholder is set into vibration.[68] Kandinsky felt this model to be plausible in a subjective way, and in his account of the genesis of *Composition VI* he mentions that the germinal glass painting *Deluge* affected him just like many real objects and concepts that had the power of awakening within him "by means of a vibration of the soul, purely pictorial images."[69] In the same notebook where Kandinsky had written down his excerpts from Steiner there is a reference to the French occultist Albert de Rochas d'Aiglun's books, among them *Le Sentiment, la musique et le geste* (1900).[70] A vibration pattern published by de Rochas (pl. 28) as well as a musical thought-form illustrated by Besant and Leadbeater (pl. 10) seem to have had a direct impact on Kandinsky's pictorial idiom; in the thought-form even Kandinsky's troika motif seems to be prefigured near the lower left border.

De Stijl artist Georges Vantongerloo adopted the vibration model in order to generate a gradual abstraction à la Mondrian and van Doesburg. In a drawing published in *De Stijl* (pl. 29) he explained the genesis of his painting *Study,* 1917 (pl. 30): the form is born

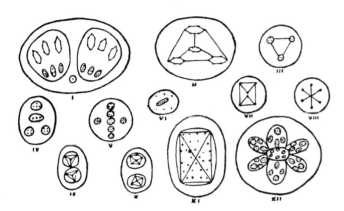

thanks to the interference between the vibrations of volume (continuous circles), the vibrations of exterior or juxtaposed volumes (dashed circles), and the vibrations of emptiness (dotted circles).[71] Despite occasional attempts to resuscitate the method, form generation through real or imagined vibrations seems to have had rather limited success.

The artistic exploration of the inner side of nature also had a precedent in Besant and Leadbeater's second venture in clairvoyant observation: occult chemistry. Their findings were made known from 1895, and they first published a diagram of the chemical elements (pl. 31), soon to be followed by the most extravagantly fantastic diagrams and plates (pl. 32).[72] In the top row of the first diagram is the "ultimate atom," composed entirely of spirals, which in turn consist of spirilla. This atom is the fundamental unit of the physical universe, a heart-shaped form into which force is poured into the depression at the top. Besant and Leadbeater acknowledged that their conception of the ultimate atom was based on Edwin D. Babbitt's.[73] Babbitt, in turn, seems to have modeled his heart-shaped atom on one of the fundamental diagrams of Rosicrucian imagery.[74]

31
The Resolution of the Chemical Elements: Hydrogen, Oxygen and Nitrogen, diagram published in *Lucifer* 17 (November 1895), reprinted in Annie Besant and Charles W. Leadbeater, *Occult Chemistry* (1908)

32
Types of Proto-Elemental Matter, from Annie Besant and Charles W. Leadbeater *Occult Chemistry* (1908), p. 11

33
HILMA AF KLINT
Group 6, No. 15 from the Series
W.U.S./Pleiad, 1908
Oil on canvas
40 $^{15}/_{16}$ x 52 ¾ in.
(104 x 134 cm)
Stiftelsen Hilma af Klints
Verk

Along with the symbols and text illustrations in Blavatsky's two major works, *Isis Unveiled* and *The Secret Doctrine,* the diagrammatic imagery of Besant and Leadbeater's occult chemistry seems to have been one of the starting points for af Klint's mystical images. The heart shape is one of her recurrent motifs, but it is varied, transformed, and charged with meanings alluding to the artist's cosmic-erotic universe;[75] she may also have been familiar with the Rosicrucian symbolism connected with that emblem. Other recurring motifs suggest that af Klint's rich visual imagination was stimulated by the curious forms of Theosophy's ultimate atoms. Just as very simple theosophical symbols — dots, horizontals, crosses — elicited a whole complex of pictorial elaborations in af Klint's art,[76] so too the more elaborate occult chemical diagrams apparently enriched the artist's vocabulary of nonrepresentational forms. Small bodies connected with strings, wormlike spirilla, multifoil patterns, and surrounding ovals are some of the themes that recur in af Klint's paintings. Like so many other works in af Klint's oeuvre, the painting *Group 6, No. 15 (from the series W.U.S./Pleiad)* (pl. 33) deals with evolution; the spiral in the center reflects a Blavatsky diagram depicting evolution.[77] The seed of the multifoil pattern,

developed into other forms in the subsequent paintings in the series, was probably sown by occult illustrations.

From the point of view of epistemology, Besant and Leadbeater's occult chemistry, af Klint's mediumistic work, and the mainstream abstractionists' insights into nature's inner processes are of the same class. Kandinsky, Klee, Mondrian, van Doesburg, and other abstract pioneers made claims to supernatural knowledge in stating that they had penetrated the outer shell of nature while still upholding the connection with the cosmos and its laws. To quote Kandinsky again: "Abstract painting leaves behind the 'skin' of nature, but not its laws. Let me use the 'big words' cosmic laws. Art can only be great if it relates directly to cosmic laws and is subordinated to them."[78]

In this perspective it is irrelevant whether the artist gets useful graphic hints from a work on occult chemistry, as af Klint apparently did, or from perfectly respectable handbooks in the sciences, as both Kandinsky and the Theoso-

phists did. It is the principal claim that matters: the idea that by inner perception the artist is able to reach hitherto untouched levels of reality, even cosmic laws. Kandinsky's *Variegation in the Triangle,* 1927 (pl. 34), is primarily a work of art, and to the majority of us this is the essential thing. By attaching remarkable claims about cosmic laws to his work, Kandinsky at the same time makes such a painting a counterpart to occult chemical diagrams. "Who knows, maybe all our 'abstract' forms are 'forms in nature,'" Kandinsky declared in 1937.[79] It seems that Kandinsky never quite came to grips with the question of the missing object. In his dread of the danger of ornament and "the dead semblance of stylized forms," he adopted occult claims that made nonrepresentational painting not only an art movement but also an offshoot of mystical tradition.

34
WASSILY KANDINSKY
Variegation in the Triangle,
1927
Oil on board
19 11/16 x 14 9/16 in.
(50 x 37 cm)
Formerly Galerie Maeght,
Paris
.

1. Georges Vantongerloo, "Réflexions," in *De Stijl: Complete Reprint* (Amsterdam: Athenaeum, 1968), 1:152; originally published in *De Stijl* 1, no. 9 (1918): 100.

2. Wassily Kandinsky, "Reminiscences" (1913), in *Kandinsky: Complete Writings on Art*, ed. Kenneth C. Lindsay and Peter Vergo (London: Faber & Faber, 1982), 1:370.

3. *Complete Writings*, 2:892 n. 54. This quotation is from "Stupeni" (Steps), the 1918 Russian edition of "Reminiscences," in which Kandinsky made significant changes from the German version. See ibid., 887–97 nn. 7-111.

4. Kandinsky, "Reminiscences," 1:373.

5. Ibid., 381–82; and idem, *On the Spiritual in Art* (1912), in *Complete Writings*, 1:219.

6. Kandinsky, *On the Spiritual in Art*, 1:143–44.

7. Ibid., 145. Laxmi P. Sihare, "Oriental Influences on Wassily Kandinsky and Piet Mondrian 1909–1917" (Ph.D diss., New York University, 1967); this dissertation was not available to me.

8. Johannes Eichner, *Kandinsky und Gabriele Münter* (Munich: F. Bruckmann, 1958), 19.

9. Kandinsky, *On the Spiritual in Art*, 1:158.

10. Sixten Ringbom, "Kandinsky und das Okkulte," in *Kandinsky und München: Begegnungen und Wandlungen 1896–1914*, exh. cat., ed. Armin Zweite (Munich: Städtische Galerie im Lenbachhaus, 1982), 92 and pl. 7.

11. Sixten Ringbom, "Die Steiner-Annotationen Kandinskys," in *Kandinsky und München*, 102–5.

12. Rudolf Steiner, "Der Pfad der Erkenntnis," in *Theosophie: Einführung in die übersinnliche Welterkenntnis und Menschenbestimmung* (Leipzig: Max Altmann, 1908), 146–67.

13. For Steiner's text, see Rudolf Steiner, *Die Stufen der höheren Erkenntnis* (Dornach: Rudolf Steiner-Nachlassverwaltung, 1959), 18–19: "Nun aber erwirbt sich der Geheimschüler eben die Fähigkeit, Bilder zu formen, auch wo keine Sinnesgegenstände vorhanden sind. Es muss dann bei ihm an die Stelle des 'äusseren Gegenstandes' ein anderer treten. Er muss Bilder haben können, auch wenn kein Gegenstand seine Sinne berührt."

14. Plotinus, *The Enneads*, trans. S. MacKenna (London: Faber & Faber, 1956), 586ff. See also Sixten Ringbom, "Mystik und gegenstandslose Malerei," in *Mysticism*, ed. S. Hartman and C. M. Edsman, vol. 5, *Scripta Instituti Donneriani Aboensis* (Stockholm: Almqvist & Wiksell, 1970), 168–88; and Hermann Kern, "Kunst als Gestaltung des Gestaltlosen," in *Expansion: Internationale Biennale für Graphik und Visuelle Kunst* (Vienna, 1979), 69–97.

15. Saint Augustine, *De genesi ad litteram*, 12:1–30, in J.-P. Migne, *Patrologiae cursus completus* (Paris: J.-P. Migne, 1887), cols. 453–80. Saint Bernard, *Cantica*, 20:8, in Sixten Ringbom, "Devotional Images and Imaginative Devotions: Notes on the Place of Art in Late Medieval Private Piety," *Gazette des Beaux-Arts*, 6th ser., 73 (1969): 159–70.

16. The tantra vogue is largely due to Ajit Mookerjee and his publications, notably *Tantra Art* (Basel, Paris, New Delhi: Ravi Kumar, 1971), *Yoga Art* (London: Thames & Hudson, 1975), and *Tantra Magic* (Edinburgh and London: Charles Skilton, 1978). See also Philip Rawson, *The Art of Tantra* (Delhi and London: Vikas, 1973). Little scholarly research seems to have been devoted to the subject, however, and dates, provenances, and essential information on specific works remain uncertain.

17. Quoted in Friedrich Heiler, *Die buddhistische Versenkung: Eine religionsgeschichtliche Untersuchung* (Munich: Ernst Reinhardt, 1918), 25–26 and n. 148.

18. D. T. Suzuki, *Manual of Zen Buddhism* (1950; London and New York: Rider, [1956]), 128–29.

19. Alfred Percy Sinnett, *Esoteric Buddhism* (London: Trübner, 1883).

20. *Die Bhagavad Gita*, annotated by Franz Hartmann (Brunswick: Schwetzke, 1892), 140, 147.

21. Rudolf Steiner, *Die Mystik im Aufgange des neuzeitlichen Geisteslebens und ihr Verhältnis zu modernen Weltanschauungen* (Berlin: Schwetzke & Sohn, 1901).

22. Annie Besant, *The Ancient Wisdom: An Outline of Theosophical Teachings*, 2d ed. (1897; London: Theosophical Publishing Society, 1899), 146; published in German in 1898; for arupa and rupa, see pp. 143, 195.

23. C. W. Leadbeater, *Man Visible and Invisible* (London: Theosophical Publishing Society, 1902); Annie Besant and C. W. Leadbeater, *Thought-Forms* (London and Banaras: Theosophical Publishing Society, 1905).

24. Annie Besant and C. W. Leadbeater, *Gedankenformen* (Leipzig: Theosophisches Verlagshaus, 1908). The volume is today part of the Kandinsky collection at the Musée National d'Art Moderne, Paris.

25. Kandinsky, "Reminiscences," 1:370–71.

26. Besant, *Ancient Wisdom*, 185.

27. Sixten Ringbom, *The Sounding Cosmos: A Study of the Spiritualism of Kandinsky and the Genesis of Abstract Painting*, Acta Academiae Åboensis, ser. A, XXXVIII (Åbo, Finland: Åbo Academi, 1970), 126–27, 141.

28. Piet Mondrian, "De nieuwe beelding in de schilderkunst, IV" (New imagery in painting, IV) in *De Stijl*, 1:82; originally published in *De Stijl* 5 (1918): 54 n. 9. For Mondrian and Theosophy, see the publications by Robert P. Welsh cited herein nn. 29, 64. On Mondrian and M. H. J. Schoenmaekers, see also M. Seuphor, *Piet Mondrian: Leben und Werk* (Cologne: Du Mont, 1957), 54, 56ff; H. L. Jaffé, *De Stijl 1917–31* (London: Alec Tiranti, 1956), 55ff; and Carel Blotkamp's essay in the present volume.

29. Robert P. Welsh and J. M. Joosten, *Two Mondrian Sketchbooks 1912–1914* (Amsterdam: Meulenhoff, 1969), 33–35.

30. Ibid., 36.

31. Ibid., 52–53, 40, 39.

32. Ibid., 53.

33. The diagram was published in *Staatliches Bauhaus Weimar 1919–1923* (Munich and Weimar: Bauhaus-Verlag, 1923), 24–25; and Paul Klee, "Wege des Naturstudiums," in *Schriften: Rezensionen Aufsätze*, ed. Christian Geelhaar (Cologne: Du Mont, 1976), 124–26 and pl. 60.

34. Klee, "Wege des Naturstudiums," 124–26.

35. Annie Besant and C. W. Leadbeater, *Thought-Forms* (1905; Adyar, India: Theosophical Publishing House, 1961), 8, 26.

36. Kandinsky, *On the Spiritual in Art*, 1:192.

37. Ibid., 148. I have changed the translation since Lindsay and Vergo render the German *vorausgehen* "proceed" instead of "precede" and *geistige Atmosphäre* "spiritual ethos" instead of "spiritual atmosphere." Not long afterward Kandinsky changed his opinion about Wagner's leitmotiv; see idem, "On Stage Composition" (c. 1912), in *Complete Writings*, 1:261, where he compares it with "an old, well-known label on a bottle."

38. Ringbom, "Steiner-Annotationen," 103.

39. For a detailed analysis of *Lady in Moscow*, see Ringbom, *Sounding Cosmos*, 94–102.

40. For a more detailed discussion of the structure of *Black Spot I*, see ibid., 100–102, and Rose-Carol Washton Long, *Kandinsky: The Development of an Abstract Style* (Oxford: Clarendon Press, 1980), 132. The group of preparatory drawings also comprises five schematic composition sketches in the Gabriele Münter Stiftung, Städtische Galerie, Munich (GMS 539/1–5). Because of Kandinsky's own annotation "VI" on the five designs, they have been connected with *Composition VI*, although there is no obvious relation to that work. Did Kandinsky at some stage perhaps try out *Black Spot* as a starting point for *Composition VI*? Erika Hanfstaengl is certainly correct in saying that the connection with *Composition VI* calls for a "thorough examination of the entire problem." See Erika Hanfstaengl, *Wassily Kandinsky, Zeichnungen und Aquarelle: Katalog der Sammlung in der Städtische Galerie* (Munich: Städtische Galerie im Lenbachhaus, 1974), 86. Felix Thürlemann associates the five drawings, GMS 539/1–5, with *Black Spot*. See Felix Thürlemann, "Kandinskys Analyse-Zeichnungen," *Zeitschrift für Kunstgeschichte* 48, no. 3 (1985): 364–78, which appeared after the completion of the present manuscript. He rejects drawing GMS 431 as a study for *Black Spot*, an association hitherto asserted by many, including Kandinsky.

41. Fundamental for the study of Hilma af Klint's work is a typescript catalogue of Olof Sundström, "Förteckning över Frk. Hilma af Klints efterlämnade verk sammanställd av Olof Sundström 1945" (List of Miss Hilma af Klint's works compiled posthumously by Olof Sundström 1945). A copy of this catalogue together with a virtually complete set of color slides of af Klint's paintings is in the Donner Institute for the Study of Religion and Culture, Åbo, Finland. Åke Fant, who is working on the af Klint oeuvre, has published essays on the artist, including "Synpunkter på Hilma af Klints Måleri" (Opinions on Hilma af Klint's paintings), *Studier i konstvetenskap tillägnade Brita Linde* (Studies in the science of art dedicated to Brita Linde), ed. M. Rossholm Lagerlöf and B. Sandström (Stockholm: Konstvetenskapliga Institutionen vid Stockholms Universitet, 1984), 45–54.

42. H. P. Blavatsky, *The Secret Doctrine: A Facsimile of the Original Edition of 1888* (1888; Los Angeles: Theosophy Co., 1947), 1:5.

43. For a recent survey of the discussion of the series in modern art, see Katharina Schmidt, "Das Prinzip der offenen Serie," in *Alexej Jawlensky 1864–1941*, ed. Armin Zweite (Munich: Städtische Galerie im Lenbachhaus, 1983), 87–105.

44. Wassily Kandinsky, "Composition 6" (1913), in *Complete Writings*, 1:385–86.

45. M. T. Sadler, *Michael Ernest Sadler 1861–1943* (London: Constable, 1949), 238.

46. Kandinsky, *On the Spiritual in Art*, 1:218.

47. M. H. J. Schoenmaekers, *Beginselen der Beeldende Wiskunde* (Principles of visual mathematics) (Bussum, Netherlands: van Dishoeck, 1916), 27, 49ff.

48. Ibid., 55.

49. Wassily Kandinsky, "On the Question of Form" (1912), in *Complete Writings*, 1:250.

50. Welsh and Joosten, *Mondrian Sketchbooks*, 68. I have modified the translation to preserve the original's symmetry: "representation [*afbeelden*] of matter" and "representation of other things."

51. Ibid., 36.

52. Theo van Doesburg, *Grundbegriffe der neuen gestaltenden Kunst*, trans. Max Burchartz (Munich: Verlag Albert Langen, 1925), 11. The text dates from 1917 and was originally published in *Het Tijdschrift voor Wijsbegeerte*, vols. 1–2 (1919).

53. Theo van Doesburg, "Aanteekeningen bij twee teekeningen van Piet Mondriaan" (Comments on two sketches by Piet Mondrian) in *De Stijl: Complete Reprint*, 1:160–63; originally published in *De Stijl* 1, no. 9 (1918): 108–11.

54. See Ludmila Vachtová, *Frank Kupka* (London: Thames & Hudson, 1968), 77, 80–81.

55. Klee, "Wege des Naturstudiums," 126.

56. Kandinsky, "Reminiscences," 1:370, 376.

57. *Complete Writings*, 2:892 n. 54.

58. Johann Wolfgang von Goethe, *Werke*, sect. 1, no. 48 (Weimar: H. Böhlau's Nachf., 1897), 179.

59. Rudolf Steiner, *Goethes Weltanschauung* (Weimar: Emil Felber, 1897), 31. The relevance of Goethe and Steiner's Goethe interpretations has been pointed out by L. D. Ettlinger in *Kandinsky's "At Rest,"* Charlton Lectures on Art (London: Oxford University Press, 1961), 10–11. See also Sixten Ringbom, "Art in 'The Epoch of the Great Spiritual': Occult Elements in the Early Theory of Abstract Painting," *Journal of the Warburg and Courtauld Institutes* 29 (1966): 386–418, especially 390–91.

60. Steiner, *Die Mystik*, especially 24–25, 110–11.

61. Kandinsky, *On the Spiritual in Art*, 1:176. For the term *science of art*, see, for example, idem, "The Basic Elements of Form" (1923), in *Complete Writings*, 2:500.

62. H. P. Blavatsky, *Isis Unveiled* (1877; Pasadena: Theosophical University Press, 1960), 506–7; C. W. Leadbeater, *The Aura* (Madras: Theosophist, 1895), 5–6.

63. Blavatsky, *Secret Doctrine*, 1:97.

64. Robert P. Welsh, "Mondrian and Theosophy," in *Piet Mondrian 1872–1944: Centennial Exhibition* (New York: Solomon R. Guggenheim Museum, 1971), 35–51, especially 36ff, 48–49.

65. Schoenmaekers, *Beginselen*, 49, 102–3.

66. Linda Dalrymple Henderson, *The Fourth Dimension and Non-Euclidean Geometry in Modern Art* (Princeton: Princeton University Press, 1983).

67. Besant and Leadbeater, *Thought-Forms* (1961), 16–17.

68. For a survey of the relevant passages in Kandinsky's writings, see Ringbom, *Sounding Cosmos*, 119–30.

69. Kandinsky, "Reminiscences," 1:386.

70. Ringbom, "Steiner-Annotationen," 105.

71. Vantongerloo, "Réflexions," 149–54.

72. The first report of this new departure in occultism came in *Lucifer* 17 (November 1895); reprinted as a separate pamphlet in 1905. A subsequent series of articles in *The Theosophist* was published as a book, Annie Besant and C. W. Leadbeater, *Occult Chemistry: A Series of Clairvoyant Observations on the Chemical Elements* (Madras: Theosophist Office; and London: Theosophical Publishing Society, 1908); the German translation appeared in 1909.

73. Edwin D. Babbitt, *The Principles of Light and Color*, ed. Faber Birren (New York: University Books, 1967), 7 ill.

74. See, for example, *Geheime Figuren der Rosenkreuzer aus dem 16ten und 17ten Jahrhundert* (Altona, Germany, 1785), 16.

75. Typical instances are Sundström, *Hilma af Klints*, cat. nos. 76–78, 193.

76. Instances of this are the simple dots, horizontals, and crosses in Blavatsky, *Secret Doctrine*, 1:4–5, 2:30, which recur in Sundström, *Hilma af Klints*, cat. no. 49, or the "quaternary" in Blavatsky, *Isis Unveiled*, 1:506, which recurs in Sundström, *Hilma af Klints*, cat. no. 62.

77. Blavatsky, *Secret Doctrine*, 2:300 ill.

78. Wassily Kandinsky, "Interview with Karl Nierendorf" (1937), in *Complete Writings*, 2:807.

79. Kandinsky, "Assimilation of Art" (1937), in *Complete Writings*, 2:803.

OVERLEAF

HILMA AF KLINT
Portfolio, No. 5, 1920
Oil on paper
Page from portfolio
19 11/16 x 11 13/16 in.
(50 x 30 cm)
Stiftelsen Hilma af Klints
Verk

THE CASE OF THE ARTIST HILMA AF KLINT

ÅKE FANT

Hilma af Klint was born in Sweden on 26 October 1862, into a family that included several generations of naval officers skilled in navigation, mathematics, and astronomy.[1] She herself was interested in mathematics and even more so in botany. In addition, she began at an early age to study portrait painting. She neglected the study of languages and is said to have understood only the Scandinavian ones, a factor that may have intensified her subsequent isolation from the artistic movements of Europe. As a child and during her student years she was susceptible to extrasensory experiences and at seventeen became seriously involved in spiritualism. At the same time af Klint continued to develop her abilities as an artist and in 1882 entered the Royal Academy in Stockholm, where she was esteemed by the faculty. After five years of study she was awarded a studio of her own in which she worked professionally as a portrait and landscape painter.

Together with four other women she formed a spiritualist group during the 1890s. The Friday Group, or the Five, as they called themselves, began as an ordinary spiritualist group that received messages through a psychograph (an instrument for recording spirit writings) or a trance medium. The members of the group — af Klint, Anna Cassel, Cornelia Cederberg, Sigrid Hedman, and Mathilde N. (family name unknown) — met in each other's homes and studios. Over the years af Klint became mediumistically adept and eventually functioned as the sole medium of the group. During the Friday Group's séances spirit leaders presented themselves by name and promised to help the group's members in their spiritual training; such leaders are common in spiritualist literature and life.

Through its spirit leaders the group was inspired to draw automatically in pencil, a technique that was not unusual at that time (pls. 1–2). When the hand moved automatically, the conscious will did not direct the pattern that developed on the paper; the women thus became artistic tools for their spirit leaders. In a series of sketchbooks, religious scenes and religious symbols were depicted in drawings made by the group collectively. The group's drawing technique developed in such a way that abstract patterns, dependent on the free movement of the hand, became visible. There was a gap between af Klint's spiritualist work and her work as a professional painter, a gap that was not bridged until much later.

Af Klint was not alone in Swedish art history in working with spiritualist, automatic drawings; the painter Ernst Josephson

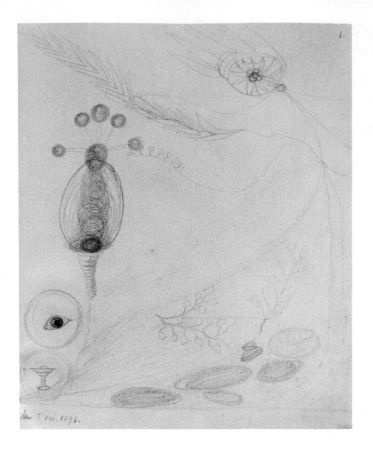

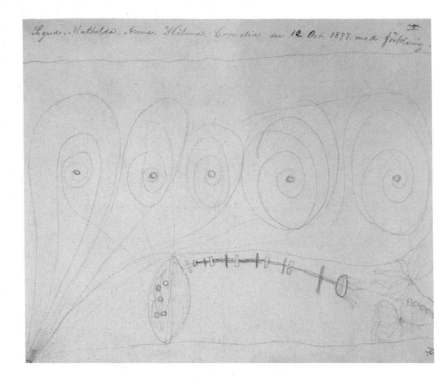

worked during the 1880s in a manner similar to that of af Klint's group. Josephson became mentally ill, but his delusions that he was Michelangelo, Raphael, or Christ led to extraordinarily free and revolutionary drawings. His work was exhibited in the same building where af Klint had her studio, and he was much discussed among contemporary artists.[2] The members of the Friday Group were afraid of the kind of mental instability experienced by Josephson, and in the end only af Klint dared to continue the work with automatic drawings.

Af Klint was on visiting terms with a number of Swedish artists around the turn of the century, a time when artistic life in Sweden was not particularly radical. The most revolutionary work to be seen was that of Edvard Munch, a Norwegian (Norway was then ruled by Sweden). Munch was probably one of the few artists not based in Stockholm whose work af Klint encountered. Responsible for the care of her aging mother, she was unable to leave Stockholm and visit artistic communities in other cities. In 1894 Munch exhibited in her studio building; *The Kiss, Vampire, Jealousy,* and *The Scream* were among the works shown. Munch's work was less esteemed in Sweden than in Germany, where it was highly influential and where he lived for a time. In Munch's paintings she had a chance to experience an art that was attempting to convey strong emotions, an art that differed radically from the academic painting tradition in Sweden. Like others, Munch and his friend August Strindberg had strong occult leanings during the 1890s. Af Klint was influenced by Munch, not in technique, but perhaps in her awareness of the psychological states that could be expressed in painting.

The inspiration for af Klint's work cannot be found within the cultural life of Sweden around 1906, when she first explored spiritual abstraction in art. Her personal library included, in addition to botanical works and the Bible, translations of spiritualist and theosophical publications.[3] In general the books that she owned are not the ones that figure in the history of the origins of abstract art; it is possible that she was familiar with the more relevant texts, but this cannot be verified. She had a very specific creative technique, working through a dialogue between the unconscious and the conscious, and her knowledge of occult texts may have been a subliminal influence that led to her inspired mediumistic messages as well as to her later, more conscious work.[4] For example, af Klint was evidently inspired by the evolutionary theories of Helena P. Blavatsky, but she transformed them in her art. Her mediumistic capacities and experiences, with their inherently unconscious nature, made her a sort of antithesis to Wassily Kandinsky, whose exploration into the spiritual in art was a very conscious process.[5]

Af Klint was not able to discuss how and why she came into contact with the persons or forces that she referred to as her "leaders," "gurus," or "guides," but her notes written after the turn of the century reveal their importance to her. During the Friday Group's séances these leaders presented themselves by name — Amaliel, Ananda, Gregor, Georg — and promised to help the group's members in their spiritual training. Amaliel, who played an especially important role, gave af Klint a task to fulfill through her art: in 1905 she promised him that she would devote one year exclusively to painting a message to mankind. She fulfilled her promise from May 1907 to April 1908. Beginning in November 1906 she executed preparatory paintings. She also prepared herself ascetically, through prayer and fasting, and gave up portrait and landscape painting. A note in the Friday Group's séance book for 7 November 1906 reads:

You H. [Hilma] when you are to interpret the color hearing and seeing tones: try to tune your mind into harmony and pray: "O Thou, give me the picture of inner clarity. Teach me to listen and receive in humility the glorious message that Thee in Thy dignity deign to send the children of the earth. . . ."

Amaliel draws a sketch, which H. then paints. The goal is to represent a seed from which evolution develops under rain and tempest, lightning and storm. Then heavy grey clouds are coming from above.[6]

This text also describes the first preparatory painting (pl. 3), followed by thirty-three others, which constitutes the basis for the later Drawings for the Temple (executed, with interruptions, between 1907 and 1915). These paintings vary in size, color, and degree of abstraction. There are often words written within them, such as "Vestal-Ascetic" (meaning a virgin living a life dedicated to higher morality and asceticism, the kind of person af Klint tried to be), which appear to indicate connections to Jakob Böhme's published writings from 1682. Böhme did not use these exact words but others that suggest a similar morality. Af Klint also used abstract symbols — the cross, the triangle, the sphere — similar

to those in Böhme's books. Other forms and symbols in af Klint's paintings, however, cannot be traced to Böhme or to other occultists. These forms appear to be unique to af Klint, and all represent, in af Klint's words, the "knowledge of duality." In the paintings from 1907 and 1908 a rich, creative strength emerged.

Af Klint stressed that she was a tool for her guides and that her hand was led by them. The year dedicated to Amaliel culminated in the Ten Large Paintings series, painted between October and December 1907 (pl. 4). Af Klint made very few statements about her work and her sources, and the few statements that she did make revealed nothing of her own personality. She was constantly surprised by the results of her unconscious activities and was unable to explain them. She wrote of the Ten Large Paintings in her journal on September 27, 1907: "Ten paradisaically beautiful paintings were to be executed; the paintings were to be in colors that would be educational and they would reveal my feelings to me in an economical way. . . . It was the meaning of

the leaders to give the world a glimpse of the system of four parts in the life of man. They are called *childhood, youth, manhood, and old age.*" As with all of her paintings from that period af Klint said that the theme as well as the execution was carried out according to orders from her spirit leaders.

Af Klint was working in an unconscious automatic way without knowing what the results would be. Thus in her figurative paintings there are anatomical errors that, given her academic training, would not have been possible had she been conscious of her actions. For example, in *First Large Series No. 6: Silence* (see p. 143) the anatomy of the female figure does not fit together properly, which demonstrates that af Klint had worked in a trancelike state. More importantly, she was so faithful to the mediumistic result that she did not change it afterward, when she saw that the execution was anatomically wrong.

In 1908 af Klint met with Rudolf Steiner for the first time and showed her paintings to

3
HILMA AF KLINT
No. 1 from the Series Paintings for the Temple, 1906
Oil on canvas
19 11/16 x 14 15/16 in.
(50 x 38 cm)
Stiftelsen Hilma af Klints Verk

.

4
HILMA AF KLINT
Ages of Man: Middle-Age, No. 7 from the Series Ten Large Paintings, 1907
Tempera on paper and canvas
94 1/2 x 129 1/8 in.
(240 x 328 cm)
Stiftelsen Hilma af Klints Verk

.

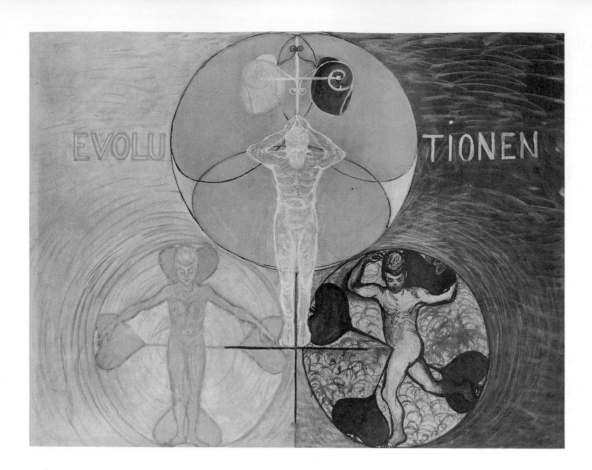

5

HILMA AF KLINT
Evolution No. 2, 1908
Oil on canvas
40 ¹⁵⁄₁₆ x 52 ¾ in.
(104 x 134 cm)
Stiftelsen Hilma af Klints
Verk
.

him. She herself did not understand the message in these pictures (pl. 5), and Steiner did not analyze them for her. She considered this inability to understand her own work the tragedy of her life.

Following a break in her work from April 1908 until April 1912, af Klint again took up spiritual painting and continued the Drawings for the Temple, but now in a more active way. In her notebooks she wrote that she saw and heard exactly what she was expected to paint; she herself did not control the intellectual process. Earlier she had been a direct tool, and her hand had been guided. Now she saw and heard visions and worked inspired by them; as a medium she simply received the message and then painted it. In spite of af Klint's acquaintance with Theosophy and Steiner's Anthroposophy, she continued to work in her own spiritualist way until 1915. The delayed shift in her way of working may have been the result of her needing to live with new ideas for a long time before totally assimilating them; the ideas had to become a part of her unconscious before she could turn them into new creations or new ways of thinking.

In 1914 af Klint began to work with watercolors and oil paintings on a smaller scale than previously (pls. 6–7, see also p. 40). In accordance with theosophical ideals she tried to depict the different planes of experience through horizontal divisions of the picture plane (pl. 8). For the most part three planes are represented in her paintings: a lower plane, the underworld where elementary beings of lower nature actively try to disturb the physical and mental balance of man; a middle plane, the physical reality in which man strives to reach harmony in his inner and outer life; and a higher plane, the plane of grace, which is the astral world that helps man to fulfill his mission on earth and sustains him from above. Only the middle plane, physical reality, has forms that can be observed with the physical eye.

By referring to such a schematic system, af Klint was no longer so dependent on her spirit leaders. Her contact with them was now freer and more personal, and she was able to travel through spiritual worlds in her own more conscious way. Af Klint considered herself to be a distinct part of the different planes. She had gone through an occult education and had, she said, become clairvoyant; thus she could go beyond the limits of physical reality.

She began to research the astral world, entering that plane herself. Subsequently af Klint resumed her botanical studies (pl. 9) by painting plants not only as they appear to the eye but also as they appear in the astral world. These studies depict both close, delicate observations from nature and geometrical, abstract patterns that represent her astral impressions of the same plants. She had returned to a more natural, more conscious way of working, but now her observations extended beyond nature to the astral world.

In 1920 her mother died, and for the first time af Klint was free to travel. She moved to the south of Sweden and soon took a trip to visit Steiner in Dornach, Switzerland, where she was introduced to quite another method of painting, one that had been developed during Steiner's building of the first Goetheanum there (1913–23). Steiner had expanded Goethe's color theory and worked out a technique by which shadows and lines were eliminated. Forms would occur within color itself through layers of fluid, transparent paint, one layer on top of another. Steiner called this method "painting out of the color." The result would present a more mobile painting surface without fixed contours. Af Klint realized that Steiner's theory of art differed profoundly from theosophical thinking. Of

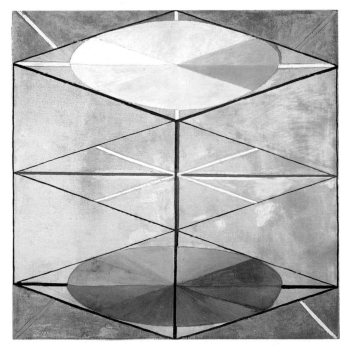

6
HILMA AF KLINT
*Untitled No. 14 from the Series
S.U.W./Swan*, 1914–15
Oil on canvas
61 x 59 ¹³/₁₆ in.
(155 x 152 cm)
Stiftelsen Hilma af Klints
Verk

·

7
HILMA AF KLINT
*Untitled No. 17 from the Series
S.U.W./Swan*, 1914–15
Oil on canvas
61 x 59 ¹³/₁₆ in. (155 x 152 cm)
Stiftelsen Hilma af Klints
Verk

·

8
HILMA AF KLINT
*Untitled No. 22 from the Series
S.U.W./Swan*, 1914–15
Oil on canvas
61 x 59 ¹³/₁₆ in. (155 x 152 cm)
Stiftelsen Hilma af Klints
Verk

·

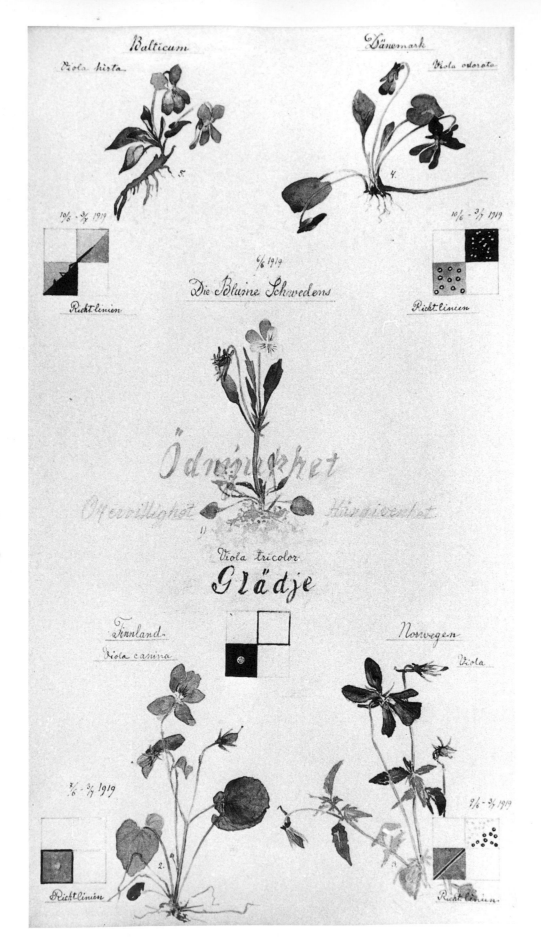

9
HILMA AF KLINT
Violets with Guidelines, 1919
Watercolor and pencil on
paper
90 11/16 x 10 5/8 in. (50 x 27 cm)
Stiftelsen Hilma af Klints
Verk

special significance for her was Steiner's naming two fundamental sins in painting: the first, copying nature; the second, fancying that one could depict the spiritual world directly.[7] Precisely contradicting all she had been doing throughout her occult career, Steiner's prohibitions created a crisis for af Klint. For two years she ceased to paint.

In June 1922 she took up painting again but in a more explicitly anthroposophical way, using soft watercolors flowing into each other without any underlying drawing. She continued her work with plants, and the titles of her watercolors, such as *Looking at the Rose Hip II* (pl. 10) and *Looking at Mallow,* give an idea of how she worked. They convey her inner experiences while she studied the specific plant. Those experiences are expressed through the anthroposophical painting technique; one is able to trace af Klint's connections with the plants through her use of colors. She struggled to fill her personality with the impressions that the colors and forms of the plants evoked within her and then to give expression to them and her knowledge of botany. Add to this the influence of Steiner's proposal that one had to work out the experience of the color itself, and the result is an inner experience that is expressed through flowing forms of color.

This is the technique adopted by af Klint from that time onward. She visited Dornach regularly over the years and continued to work in an anthroposophical manner through her last paintings, which were made in 1941.

Af Klint considered the knowledge of duality to be the main theme, or message, of her work. She believed that the sexes of men and women in the real world are reversed in the astral world; and that this reversal provides a resolution of the duality within human existence. The struggle between male and female is an expression of creation, and af Klint believed that this struggle was the fundamental idea behind all creative power. Formal elements and colors in her paintings can be related to this duality. Her work leads the observer to the conclusion that when the balance between male and female is attained one can leave the physical plane and join the angels. This problem of duality is evident in paintings throughout her career. For example, the closing picture (pl. 11) of the Swan series, which consists of twenty-four abstract and representational paintings, portrays a black swan and white swan embracing each other.

The background is divided into four equal fields of rose, gray, brown, and white. The wings of the swans form diagonals, and the beaks meet in a kiss in the center of the painting. Around the beaks are symbols from the whole series: yellow and blue forms, a hook and eye (representing male and female forces), a divided circle, and an intricate geometrical form describing the cube. The swans and the symmetrical cube represent harmonious oneness after the long struggles between dualities that were shown in all the preceding pictures in the series. Af Klint strived for such harmonious oneness in all her work.

Af Klint was unwilling to exhibit her occult paintings during her lifetime. She died in 1944, and her will stated that her output of more than one thousand occult paintings should be kept together and should not be exhibited publicly for twenty years. She expected that toward the end of this century it would at last be possible to show her pictures to a responsive public. Now a selection is being exhibited for the first time.

10
HILMA AF KLINT
Looking at the Rose Hip II,
1922
Watercolor on paper
7 1/16 x 9 13/16 in. (18 x 25 cm)
Stiftelsen Hilma af Klints
Verk

.

11
HILMA AF KLINT
Final Picture from the Series
S.U.W./Swan, 1915
Oil on canvas
61 x 59 7/8 in. (155 x 152 cm)
Stiftelsen Hilma af Klints
Verk

.

HILMA AF KLINT
Portfolio, No. 6, 1920
Oil on paper
Page from portfolio
19 ¹¹⁄₁₆ x 11 ¹³⁄₁₆ in.
(50 x 30 cm)
Stiftelsen Hilma af Klints
Verk

1. Technical books written by members of the af Klint family include Erik Gustaf af Klint, *Lärobok i navigationsvetenskapen med tillhörande nautiska och logaritmiska tabeller samt förberedande avhandlingar om logaritmer och trigonometri* (Textbook on navigation science with a nautical appendix, logarithm table, and introductory essay about logarithms and trigonometry) (Stockholm: Hörbergska boktryckeriet, 1842); and Victor af Klint, *De första grunderna till teoretisk mekanik* (The first fundamentals to theoretical mechanics) (Stockholm: Centraltryckeriet, 1878).

2. For more about Ernst Josephson and his place in Swedish art, see Erik Blomberg, *Ernst Josephson* (Stockholm: Wahlström och Widstrand, 1951).

3. The books that Hilma af Klint possessed in their Swedish editions included F. W. Bain, *Modern Spiritualism;* Annie Besant, *The Inner Teachings of Christianity;* Helena P. Blavatsky, *The Secret Doctrine;* Franz Hartmann, *Magic: White and Black;* Nizida, *The Astral Light;* and Baron Karl du Prel, *Teachings on the Soul.* She also subscribed to a Swedish spiritualist periodical.

4. For detailed descriptions of similar mediumistic situations, see John L. Lowes, *The Road to Xanadu: A Study in the Ways of the Imagination,* 2d ed. (London: Constable, 1951), 59, 81–82, 305, 346; Théodore Flournoy, *Nouvelles observations sur un cas de somnambulisme avec glossolalie* (Paris: Archives de Psychologie, 1901), 1:101–255.

5. For a detailed examination of Kandinsky and the spiritual in art, see Sixten Ringbom, *The Sounding Cosmos: A Study of the Spiritualism of Kandinsky and the Genesis of Abstract Painting,* Acta Academiae Aboensis, ser. A, XXXVIII (Åbo, Finland: Åbo Academi, 1970).

6. All the writings, notebooks, and works of art by Hilma af Klint have been preserved since her death in 1944 in the Stiftelsen Hilma af Klints verk, Jarna, Sweden. The collection is faithfully overseen by her nephew, Commander Gustav af Klint. Her work has been catalogued by Olof Sundström in "Förteckning över Frk. Hilma af Klints efterlämnade verk sammanställd av Olof Sundström 1945" (List of Miss Hilma af Klint's works compiled posthumously by Olof Sundström 1945).

7. For Rudolf Steiner's ideas about painting, see his lectures "Das Sinnlich-Übersinnliche in seiner Verwirklichung durch die Kunst" (1918), published in *Kunst und Kunstlerkenntnis* (Dornach, Switzerland: Verlag der Rudolf Steiner–Nachlassverwaltung, 1961), 49–50; and Rudolf Steiner, *Der Baugedanke des Goetheanum* (1921) (Stuttgart: Verlag Freies Geistesleben, 1958), 93.

OVERLEAF

KAZIMIR MALEVICH
Suprematist Painting, 1917–18
Oil on canvas
41 ¾ x 27 ¾ in.
(106 x 70.5 cm)
Stedelijk Museum,
Amsterdam

·

ESOTERIC CULTURE AND RUSSIAN SOCIETY

JOHN E. BOWLT

The creative wealth and diversity of the Russian avant-garde (the constellation of artists that contributed to Russia's cultural renovation just before and after 1917) is indicated by the enormous range of aesthetic and philosophical ideas that they formulated and practiced. One of the central concerns of the modernist artists in Russia was the exploration of nonobjective painting, an exploration that found its most elegant conclusions in the Improvisations and Compositions of Wassily Kandinsky, the Suprematism of Ivan Kliun and Kazimir Malevich, the Painterly Formulae of Pavel Mansurov, the architectonic paintings of Liubov Popova, and the Constructivist paintings of Aleksandr Rodchenko. There were many artistic systems operative in the Russian avant-garde, and many artists are still unfamiliar, especially of the "second generation" during the 1920s — for example, Kliment Redko and Konstantin Vialov. There can be no question that, from the beginning of their careers, all these artists were exposed to the spiritual in art, especially because many facets of their culture still reflected the esoteric concerns of Symbolism. But the curious fact remains that only one of the major avant-garde painters, Kandinsky, maintained a consistent and studious interest in psychic phenomena, arguing at all points of his development that any investigation into the creative process must be undertaken with the help of both scientists and occultists.[1] In contrast Malevich seems to have associated his Suprematist researches with esoteric ideas that he learned of casually and sporadically, not as a direct consequence of a measured study of subjects such as Theosophy, Yoga, Buddhism, or black magic. The artists Pavel Filonov and Mikhail Matiushin (as well as the latter's disciples) were also open to questions of the occult, but its presence within their world views should not be exaggerated, especially because such artists were ready to assimilate ideas from a whole range of disciplines and cultures. Another artist, Serge Charchoune (pl. 1), took a studious interest in the teachings of Rudolf Steiner and oriental philosophy, but Charchoune can scarcely be considered a member of the Russian avant-garde since he spent practically all his working life outside Russia.[2]

When asked in December 1981 whether he felt that his artistic reductions had been inspired by a spiritual quest, Mansurov replied in his usual terse manner, "No, not at all."[3] Mansurov, younger than his mentors Malevich and Vladimir Tatlin and thus further removed from the nervous mood of the fin de siècle, out of which many of the avant-garde

1

SERGE CHARCHOUNE
*Movement of a Painted Film
Based on a Folk Song,* 1917
Oil on canvas
18 ⅛ x 13 ¾ in. (46 x 35 cm)
Collection Raymond Creuze,
Paris
.

artists evolved, may have misjudged and mis-
understood the genesis of his own abstrac-
tion. Indeed this essay questions and corrects
the materialistic attitudes of artists such as
Mansurov who, in reviewing the initial
impact of the avant-garde from the standpoint
of the late 1920s, chose to omit or negate its
debt to the spiritual in art. A completely con-
trary opinion cannot be adopted, however,
because by and large the Russian avant-garde
was guided not by a close reading of occult
texts but by often fortuitous and uninitiated
responses to the intellectual climate in Russia.
Thus this essay examines the Symbolist leg-
acy and the ways in which its ideas and ideals
could have been transmitted to artists who
experimented with abstraction, specifically
via the Symbolist magazines and salons in
Moscow and Saint Petersburg, and the rela-
tionship of this ambience to particular artistic
products. The word *product* is meant to
accommodate phenomena that transcend the
usual barriers of art; for example, the "new
body" (the attempt to develop a physically
and psychologically superior being) was
offered as an artistic result, not as a mere
component of an intellectual milieu.

If, as playwright Igor Terentiev once asserted,
"We are neither Theosophists, nor Hindus,
neither Yogis, nor followers of Steiner, no
way!"[4] why include primary examples of
Russian modernism in this exhibition? How
can their presence be justified in an ambience
of "lyrical chemistry," as the painter Georgii
Yakulov might have called it?[5] The answer lies
in "environmental," or what Symbolist poet
and philosopher Andrei Bely might have
called "meteorological," issues rather than in
substantive, thematic ones.[6] The parallels
between the ideas of the numerous mystical
groups in Russia at the beginning of the
twentieth century, as refracted in the press, at
conferences, and in the activities of these
groups and the ideas of the modernist artists
are sometimes very striking, and many
indirect links can be established.[7] Indeed,
artistic consciousness is perhaps fashioned

more by veiled allusion and free association than by the specific readings and scheduled meetings often documented as primary influences.

It is worth noting that leading Russian artists of the 1900–1930 period, such as David and Vladimir Burliuk, Filonov, Malevich, Matiushin, and even Kandinsky, derived much of their creative vigor from their interests in spontaneity, fortuitousness, gesture, and intuition rather than from established, ordered philosophical systems. For example, Malevich recognized the objective value of laboratorial analyses, but he maintained that such data were ultimately irrelevant to the artist's vision.[8] A panoramic examination of metaphysical, eschatological, and transcendental ideas manifest in Russia during the early 1900s promises to enhance our understanding of the Russian avant-garde, even though the question of any immediate influence of the prevailing occult systems on the evolution of that avant-garde remains debatable. By establishing connections between the artistic experiments of, for example, Malevich and the mystical impulses of his society, some unexpected counterparts and coincidences are pinpointed.

One of the more perspicacious critics of the modernist era, Genrikh Tasteven, once referred to the Cubo-Futurists as a "weak parody of the tragic individualism of the great Symbolists."[9] Actually Tasteven was a keen proponent of the Cubo-Futurists and did much to further their cause through his translations of Italian Futurist manifestos and his regular commentaries and critiques. Although in his book *Futurizm* (1914) Tasteven was being provocative and rhetorical for the sake of argument, his basic premise was and is a legitimate one: the Russian avant-garde was an outgrowth of Symbolism and not its denial. There is no question that car-dinal ideas of the avant-garde painters — for example, the concept of abstraction, the concentration on monumental or synthetic art, the aspiration to create a new language of expression, and the therapeutic potential of art — were discussed at great length by the Russian Symbolists, who referred to themselves as mystics in no uncertain terms.[10] As Aleksandr Blok wrote: "Through a thin mist of doubt, / I look into a bluish dream."[11] In other words, there existed a mystical context from which the artists of the Russian avant-garde evolved, even if they themselves tended to react fiercely and arrogantly against their Symbolist forefathers, as they did, for example, in their explicitly condemning declaration of 1912, *Poshchechina obshchestvennomu vkusu* (A slap in the face of public taste).

The cultural atmosphere of Moscow and Saint Petersburg in the first decade of the twentieth century was so highly charged with the Symbolist ether that it was virtually impossible for young artists to escape its effects, either visual or philosophical. Filonov, Kliun, Mikhail Larionov, Malevich, and even Rodchenko began their careers as Symbolist painters, and some of their pieces of the 1900s, such as Kliun's *Portrait of the Artist's Wife,* 1910 (pl. 2), and Malevich's *Woman in Childbirth,*

1908 (pl. 3), are compelling manifestations of the Russian *style moderne,* or Art Nouveau, reliant on the conventional, if still esoteric vocabulary of consumptive maidens, embryos, lotuses, lilies, and so forth.

In fact, during his attendance at the Moscow Institute of Painting, Sculpture, and Architecture in 1904–5 and at Fedor Rerberg's studio in Moscow during 1905–10, Malevich became deeply interested in the metaphysical concerns of the Blue Rose group of Symbolist painters led by Pavel Kuznetsov; he even tried to participate in their single exhibition in March–April 1907. The motif of women and embryos that appears in some of his early works, such as *Woman in Childbirth* and *The Nymphs,* 1908 (pl. 4),[12] relates directly to the concurrent Symbolist interpretation of woman as the incarnation of a higher, purer, more spontaneous realm, as refracted variously in the poetry of Vladimir Solov'ev and Blok and in the concurrent paintings of mothers and babies by Kuznetsov.[13] The Blue Rose artists aspired to capture and register ulterior reality through their allusive vocabulary of

maidens, fetuses, fountains, cosmic disks, and muted tones, just as Malevich and, to some extent, Kliun were doing. While their imagery was connected with Romantic and Symbolist literature and philosophy, the Blue Rose artists did not compile and crystallize their world view; in their sparse statements they hardly used the terms *metaphysical* or *occult.* Like Malevich and Kliun, they seemed to have embraced the Symbolist or spiritual idea but not to have explored it intellectually. For artists such as Viktor Borisov-Musatov, Mikalojus Čiurlionis, Kuznetsov, and Mikhail Vrubel,[14] Symbolism was the primary component of their world views, whereas for Malevich, Kliun, and their colleagues it was a transitory concern.

Filonov, Larionov, and Rodchenko, affected by the mood of the fin de siècle, also transmuted their spiritual lexicons, expanding them far beyond the confines of the Symbolist program. It is precisely this extension and reprocessing of occult ideas that is of great relevance to the premise of spirituality in abstract art. Consciously or unconsciously the avant-garde developed affirmatory, practicable systems from the often disparate thoughts of the Symbolists. They asserted "optimism

of feeling"[15] and linked their art to everyday life, as with Natalia Goncharova and Larionov's Neoprimitivism, or to broad social, utilitarian issues, as with Malevich's and Tatlin's design projects. They created a credible doctrine out of the "haze of the unspoken."[16] In 1906 Blok wrote, "Religion is what will be, mysticism is what is and was."[17] And the following year Bely wrote, "Art has no meaning beyond a religious one."[18] The grandiose commitments of the Russian avant-garde in the 1920s, from Malevich's Suprematist spaceships to Tatlin's glider of 1929–32, might be interpreted as consequences of "religious" rediscovery and restoration of solid social and ethical values instead of the relativism of the Symbolist mystics. It is not by chance that the leaders of the avant-garde were often described in religious terms: Filonov and Malevich, for example, were both referred to as "apostolic."[19]

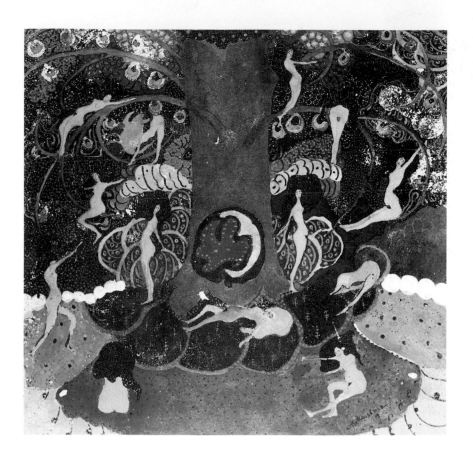

4
KAZIMIR MALEVICH
The Nymphs, 1908
Gouache on paper
12 ¾ x 13 in.
(32.4 x 33 cm)
Collection Manoukian, Paris

In the mid-1920s many observers felt that religiosity, not Constructivism, was the common denominator of the Soviet arts. For one critic conclusive evidence of this dominance was offered by the fact that in 1925 the Tretiakov Gallery in Moscow opened a retrospective exhibition of the Blue Rose artists, that "group of mystics and obscurantists."[20] New manifestations of belief (Kliun and Malevich's Suprematism, Matiushin's see-know system, Popova's Constructivism) answered the Symbolists' call for a return to the religious basis of art. All of the leading Symbolist philosophers (Bely, Nikolai Berdiaev, Viacheslav Ivanov) repeated that the "arts are of a temple, cultist origin; they derived from a certain organic unity in which all the parts were subordinate to a religious center";[21] "in the divine service, and only in the divine service, do the systems of art find their natural axis."[22] The relation of such words to the deeds of Kandinsky, who was interested in the "forms of occultism, spiritualism, monism, the 'new' Christianity, Theosophy and religion in its broadest sense,"[23] is immediate. As Kandinsky implied in his memoirs, the integrated or choral artistic structure was of particular importance to him, for example, in the context of Wagnerian opera: "*Lohengrin* seemed to me to be the complete realization of my fairy-tale Moscow . . . mentally I saw all my colors, they stood before my eyes. Frenzied, almost insane lines drew themselves before me."[24]

One suspects that a central reason for Kandinsky's concern with synthetic or monumental art such as the opera and the circus was that their interactions reminded him of the divine worship service. In turn Kandinsky could sympathize with Aleksandr Scriabin's endeavors to draw parallels between the seven notes of the diatonic scale and the seven colors of the spectrum and Scriabin's further expansions of the liturgy in his *Prometheus: The Poem of Fire* and *Mysteria*.[25] In this context of religious ritual or liturgy, the priest and mathematician Pavel Florensky is also important: it was Florensky who just after the revolution advocated the preservation of the Orthodox service because it could be regarded as a total art form involving all the senses, not because of its conventional function as a way of praising God. Florensky was in contact with many artists during the 1910s and 1920s — for example, Mikhail Nesterov and Lev Zhegin — and he served, as did Kandinsky, as a bridge between the Symbolist and avant-garde periods. He had started his philosophical career by contributing to Zinaida Gippius and Dmitrii Merezhkovsky's Symbolist journal *Noyvi put* (New path) in 1904; he reached maturity in his sophisticated lectures on spatial perception at the Higher State Art-Technical Studios in Moscow in 1912–24.[26] The continued presence of Kandinsky and Florensky was indicative of the intense, creative relations between the fin de siècle generation and the avant-garde. Even though the vociferous Cubo-Futurists such as the Burliuks and Vladimir Mayakovski referred to the "paper armor" and "perfumed lechery" of their literary fathers,[27] they owed more to the Symbolists than they cared to admit.

During the time of Russia's spiritual regeneration between the late 1890s and circa 1910, the Symbolist poets and philosophers formulated a vast conglomerate of ideas and ideologies. Some were axiomatic, but many were extraordinary in the sense that, while rejecting the

heavy materialism of the nineteenth century, they anticipated audacious, experimental concerns and actions of the twentieth century. In their endeavor to synthesize the arts, to invent more dynamic media, the Symbolists explored several areas of intellectual and metaphysical inquiry — for example, Bely's investigation of Theosophy and Anthroposophy, Blok's of alcohol, Ivanov's of pagan ritual, and Valerii Briusov's of black magic. These gentlemen were convinced that the phenomenal world covered and concealed the real world ("nature is not nature"),[28] and that the former was, therefore, alien to the "substance" or the "essential." They affirmed that technology and science were major contributors to this division because materialism relied on categorized data, as Bely implied: "In aspiring to name everything that enters my field of vision, I am in fact defending myself from a hostile and incomprehensible world pressing upon me on all sides."[29] Consequently, the Symbolists maintained that the path of true illumination lay via intuition and cognition, not via objective knowledge, and that the artist could tread this path only by discovering and using a more appropriate means of communication. Blok wrote, "the writer's soul has . . . wearied of abstractions, it has grown sad in the laboratory of words."[30]

The Symbolists attempted to perceive the essential, what P. D. Ouspensky would later call the "Miracle,"[31] which on many occasions they identified as rhythm or "incalculable, musical time . . . the musical wave effusing from the global orchestra."[32] This process of thought is very close to Kandinsky's "inner sound" in On the Spiritual in Art[33] and to Nikolai Kulbin and Matiushin's ideas about the "music" of nature. Like the Symbolists, Kandinsky, Kulbin, and Matiushin felt that music undermined the cult of objects. In encountering the "new harmony," the object diffused and "vanished like smoke."[34] Like the Symbolists, they apprehended the inner sound during instants of supersensory, or deviant, perception. For example, Kandinsky remembered how he "saw" an abstract painting when he was ill with typhus,[35] and Kulbin maintained that he could induce special psychic sensations by inserting a blunt needle into his skin at a depth of 0.01 mm.[36] For Kulbin true music also included dissonance and microtonic combinations — "like the nightingale, the artist of free music is not restricted by tones and half tones" — and he encouraged the use of smaller chromatic intervals both in music and in painting.[37]

A vital argument espoused by Symbolists and to some extent by particular artists of the avant-garde, above all Kandinsky, was that the more an art form aspired toward music, the closer it approached the ultimate revelation, whereas the more spatial or material it was (for example, architecture), the more static and distant it became.[38] This explains, in part, their fascination with the musical painter Čiurlionis, who, in "fusing time and space,"[39] created his pictorial symphonies from the "boom of the waves and the mysterious language of the age-old forest, from the twinkling stars, from our songs and our immeasurable grief."[40] Like Kulbin and Matiushin, Čiurlionis sensed the presence of a titanic strength in natural phenomena not only in the more obvious manifestations such as lightning or a tree bending in the wind but also in those phenomena that are ostensibly serene but are in fact variable and dynamic. That is one reason why Čiurlionis "humanized" some of his landscapes, imbuing trees and clouds with anthropomorphic forms (for example, Day, 1904–5, and part 3 of Summer, 1907), thereby symbolizing the supernatural, gargantuan force inhabiting every component of the natural world. This concept of the inner energy of nature underlay the philosopher Berdiaev's argument that "painting is passing from physical bodies to ether and astral ones. . . . The terrifying pulverization of the material body began with Vrubel. The transition to the other plane can be sensed in Čiurlionis."[41] Berdiaev, Bely, and Ivanov might have praised Čiurlionis for his advance toward the "global orchestra," but the artists of the avant-garde actually had little patience with him. Alexei Grishchenko, a pupil of Tatlin and one of the first to write about the connections between modern Russian art and Byzantine art, responded to Berdiaev by dismissing Čiurlionis, "who for me and any real painter is just individualistic-synthetic nonsense."[42]

The trouble with the Russian Symbolist philosophers is that they did not see very well. They were persons of literature rather than of visual perception, and with few exceptions, they had no training in art or art history, unlike many of the Cubo-Futurist poets. Bely was a naturalist, Briusov loved mathematics, Blok and Ivanov were "humanists," and they disclosed little understanding of or interest in

the avant-garde artists. Bely was in the audience at one of Matiushin's lectures in 1921,[43] but by and large the Symbolist philosophers remained aloof from what they considered "artistic adventurism that feared neither contradiction, nor dilettantism."[44] Moreover, their stature as philosophers found no counterpart in the world of Symbolist visual arts. For example, one of their favorites, Konstantin Somov, was charming and decadent, but there was nothing musical or transcendental about his art. Somov's work appeals to us for other reasons, as a carrier of nothingness, but it fails as a visual counterpart to Bely's, Blok's, and Ivanov's ideas. Lev Bakst was known to the Symbolist poets and philosophers, and he attended some of their venues, such as Ivanov's Tower with its "Wednesdays" and the Society of Free Aesthetics, but he was not really accepted as a fellow Symbolist in spite of his contribution to the refined syntheses of the Ballets Russes. Nikolai Roerich also comes to mind in this context, especially because he became deeply interested in Anthroposophy while resident in New York and the Himalayas, but he was regarded as a charlatan and an intriguer and was not welcomed into the Symbolist fold. Russia was forced to wait several years before the central ideas of the Symbolists were fulfilled by artists. In this respect the avant-garde served, in Tasteven's words, as the "maximalists" of the Symbolist aesthetic.[45]

Positive references by the avant-garde to mystics, including the Symbolists, and to particular facts and figures related to them are rare. Kandinsky aside, the only mention of substantial importance is Matiushin's reference to Ouspensky in his review of Albert Gleizes and Jean Metzinger's Du Cubisme in 1913.[46] The context is strengthened, however, by including the many general references to mystical pantheism by Kulbin and Matiushin, to orientalism by Goncharova and Yakulov, and to eschatology as in Goncharova's Misticheskie obrazy voiny (Mystical images of the war).[47] Such artists picked up fashionable ideas at dacha parties, at public lectures, and in the popular press, often without knowing where they came from or who invented them. It would be misleading to say that the avant-garde studied occult texts in earnest, attended spiritualist séances, or experimented with hypnosis, galvanism, or Yoga. Nevertheless, such issues were in vogue in Moscow and Saint Petersburg and even in the provinces "auditoria were filled with people listening to lectures on god-seeking."[48]

A primary channel through which the avant-garde assimilated occult ideas, even if they divorced them from their original and legitimate meaning, was the Symbolist magazines, both the luxurious reviews such as *Mir iskusstva* (World of art) (Saint Petersburg, 1898–1904), *Vesy* (Scales) (Moscow, 1904–9), and *Zolotoe runo* (Golden fleece) (Moscow, 1906–9) and the more modest specialty journals such as *Noyvi put* (Saint Petersburg, 1904), *Iskusstvo* (Art) (Moscow, 1905), and *Logos* (Moscow, 1910–14). Of importance also was *Vestnik teosofii* (Herald of Theosophy) (Saint Petersburg, 1908–18), which carried articles by Alexandra Unkovskaia, whose experiments in color and sound were known both to Kandinsky and to Kulbin. As far as the intermingling of the spiritual with the visual arts was concerned, *Iskusstvo* and *Zolotoe runo* in particular played a major role, the more so since both were close to the Blue Rose group of Symbolist artists.

The short-lived *Iskusstvo* was the forerunner of *Zolotoe runo* both in its negative attitude toward nineteenth-century realism and in its positive attitude toward modernism. Founded by Nikolai Tarovaty, *Iskusstvo* filled the need for an artistic and doctrinal platform for the new Symbolist artists because *Mir iskusstva* had just ended its days and *Vesy* was a literary rather than an artistic review. The first issue of *Iskusstvo* established the aesthetic direction that the journal was to pursue through its publication of Viktor Gofman's introductory article "Chto est iskusstvo" (What art is). Gofman defined Symbolism as the science of the individual, of the subjective "I," of "mystical intimism" and deduced that Symbolism was valid as an aesthetic and theurgic force. In the following issue, this idea was expanded by the critic B. L.'s (initials not deciphered) "Emotsializm v zhivopisi" (Emotionalism in painting), in which the author implied that emotional experience, not narrative depiction, was the true justification for painting. This critic advanced Kuznetsov and Vrubel as key exponents of this condition, speaking of the "musical emotions" of their painting. The author might also have referred to the concurrent work of Larionov, a member of the journal's staff, which still expressed his keen awareness of Borisov-Musatov and the Nabis.

Two impressive contributions to *Iskusstvo* were devoted to the art of Japan and Mexico: seventeen photographs of old-master Japanese paintings and twenty-three photographs of Mexico taken by the Symbolist poet Konstantin Balmont. Their appearance coincided with a growing tendency to document and research primitive and oriental cultures rather than to regard them as merely colorful phenomena alluring to the Western palate, as in Bakst's interpretation of *Schéhérazade* of 1910 or Somov's honeyed illustrations to *One Thousand and One Nights*. The oriental aspect of early Russian modernism has yet to be studied in depth and, no doubt, further investigation will establish valuable precedents to Kulbin's Buddhism of 1910 and Goncharova and Larionov's praise of the East in 1912–13. It is known that Yakulov's simultanist perception of space and light derived from his experiences in Manchuria in 1904–5; Kuznetsov and Martiros Sarian, the "Russian Gauguinists,"[49] traveled extensively in Kirghiz and Armenia as they were producing their Symbolist masterpieces; and Kuzma Petrov-Vodkin painted his strong impressions of North Africa in 1910 just as the first reproductions of Assyrian drawings appeared in Kulbin's book, *Studiia impressionistov* (Studio of the Impressionists). Such disparate experiences, part of the entire complex of Russian orientalism, prepared the ground for the general assessment of the East as a receptacle of mystical truth and for the more down-to-earth statements of the Neoprimitivists to the effect that "[we] aspire toward the East. . . [and] protest against servile subservience to the West."[50]

Iskusstvo collapsed after its eighth number, and there arose immediately the urgent need for a well-organized, progressive art journal that could champion the ideals of the Moscow Symbolist artists. This vacuum was filled in January 1906 with the appearance of *Zolotoe runo*, launched by the Moscow banker and playboy Nikolai Riabushinsky. The first number came when Russia was recuperating from the troubles of the first Russian revolution and the Russo-Japanese War, and its editorial statement demonstrated its total disregard for mundane reality: "*Art* is eternal for it is founded on the intransient, on that which cannot be rejected. *Art* is whole for its single source is the soul. *Art* is symbolic for it bears within it the symbol, the reflection of the Eternal in the temporal. *Art* is free for it is created by the free impulse of creativity."[51]

Zolotoe runo was one of the major exponents of Symbolist philosophy, even though Bely, Blok, and Ivanov maintained a highly ambiguous, even hostile, attitude toward the magazine and its despotic owner. It was in the first issue of *Zolotoe runo* that Blok published "Slova i kraski" (Words and colors), in which he argued that a child's primary medium of expression was color, not words, implying that the art of children, as of primitive peoples, was more genuine, more immediate than professional art. The Burliuks, Marc Chagall, Goncharova, Larionov, and Aleksandr Shevchenko returned to this idea in 1910–14, and it was explored at great length individually and institutionally in the 1920s. Alexandre Benois's "Khudozhestvennye" (Artistic heresies), his condemnation of extreme individualism, appeared in the second issue, and Bely's appreciation of Borisov-Musatov in the third.

Perhaps the most exciting, most prescient article in *Zolotoe runo* was "Zhivopis i revoliutsiia" (Painting and revolution) published in the fifth issue by D. Imgardt (pseudonym not deciphered). This essay was concerned not so much with the position of painting vis-à-vis the sociopolitical events of 1905 as with the revolution that was occurring in painting itself. In Imgardt's opinion the traditional aims of art had been exhausted and new artistic criteria would have to be established for the application and evaluation of colors and musical tones. He asserted that the resolution of this issue would lie in the invention of "visual music and phonic painting without themes"[52] — in other words, the artistic synthesis and abstraction that Kandinsky would advocate three years later.[53]

Although champions of Symbolism, the supporters of *Zolotoe runo* were not too introverted to realize that by 1909 Symbolism was experiencing a deep crisis as a creative force.

The magazine's farewell editorial informed the reader, "The *Zolotoe runo* has realized . . . that for the renaissance of art it is essential to cross from purely negative, subjective individualism to a new, religious vitality."[54] Similar sentiments, to the effect that a reassertion of values, a new optimism, was needed to replace the impractical Symbolist world view, were heard elsewhere in many quarters, not least in the preface to the famous *Zolotoe runo* exhibition of 1909.[55]

Even if the artists of the avant-garde chose not to read the Symbolist press, they could not fail to have attended at least some of the many cultural events in Moscow and Saint Petersburg offered in the late 1800s up until the revolution, especially during 1907–12. *À jours fixes* at private homes, such as Balmont's "Tuesdays," Briusov's "Wednesdays," and Bely's "Sundays"; evening entertainments at the new cabarets and intimate theaters such as the Bat (established in 1908 in Moscow) and the Stray Dog (established in Saint Petersburg in 1911); and philosophical groups such as the Theosophical Society, the Religious-Philosophical Society, the Spiritualist Circle (in which Briusov and the musician Vladimir Rebikov played an enthusiastic part), the Way, the House of Song, and so forth — all featured lectures on all kinds of topical issues, including psychic and occult phenomena. Still, there was a sharp difference between the intellectual meetings of the Symbolist poets and philosophers — where determined, vigorous efforts were made to examine such questions as synesthesia, artistic synthesism, the theophanic mission of art, and formal analysis — and the socialite salons that offered entertainment more than enlightenment. It was precisely within this environment of philosophical dilution that members of the nascent avant-garde gleaned many pearls of wisdom, which they then inserted into the distorting or neutralizing contexts of Cubo-Futurist and Suprematist manifestos.

One of the most sophisticated distribution centers of this wisdom was the Society of Free Aesthetics. Founded in 1906 on the Bolshaia Dmitrovka in downtown Moscow, the Society of Free Aesthetics arranged lectures, exhibitions, and dinner parties, and most of Moscow's artists and patrons visited it. Under the leadership of Bely and Briusov, the society did much to propagate Symbolism, although it broadened its interests considerably after 1909–10, when mercantile members began to "raise their voices."[56] The intellectual membership of the society was dominated by painters and musicians, including all the Blue Rose artists; the painters Goncharova, Larionov, Vasilii Perepletchikov, Valentin Serov, and Yakulov;[57] and the musicians Leonid Sabaneev and Scriabin, both highly esteemed by Kandinsky. Like other cultural clubs in Moscow and Saint Petersburg, the society inspired a continuous cross-fertilization among the representatives of various disciplines, something that resulted in many joint projects. The society lasted until 1917, when it closed, as Bely recalls, because of an "excess of lady millionaires."[58]

Of course, there were other meeting places in Moscow, such as the Polytechnic Museum, which sponsored all kinds of public lectures, from Bely's "Art of the Future" in 1907 and the Cubo-Futurists' escapades of 1912–13 to M. Ya. Lapirov-Skobl's discussion of interplanetary travel in 1924. There were also bohemian cafés such as the Café Grècque on Tverskoi Boulevard, which inaugurated the Moscow café culture that culminated in the brilliant but ephemeral Café Pittoresque; opened in January 1918, the latter seems to have been distinctly unmystical.[59]

Although the list of visitors to these establishments is long and diverse — for example, Henri Matisse, Émile Verhaeren, and Vincent d'Indy made appearances at the Society of Free Aesthetics — there is no evidence to suggest a particular concern with occult practices. Similarly, in spite of allegations that the Moscow patronesses, such as Genrietta Girshman, Evfimiia Nosova (Riabushinsky's sister), and E. I. Loseva, organized "mystical evenings," including table tappings and telepathic experiments,[60] there is no concrete proof of this or of visits to them by Russian avant-garde artists relevant to our purposes here. Actually it would seem that, generally speaking, the artists of Saint Petersburg (Elena Guro, Kulbin, Matiushin) were more open to occult influences than their southern colleagues and that the pronounced expressionist tendencies identifiable with the Saint Petersburg-based Impressionist, Triangle, and Union of Youth groups owed an appreciable debt to this particular concentration.

By 1908 the Saint Petersburg occult market was well developed, manifesting itself not only in numerous private meetings convoked for the heeding of the inner sound but also in the wide public response to oriental medicine, generated in no small degree by the Tibetan doctor Petr Alexandrovich Badmaev and his Buddhist powders,[61] ritual and eurythmical dancing (supported, for example, by Prince Sergei Volkonsky),[62] Yoga, and vegetarianism. It is amusing to recall that the great realist painter Ilia Repin — whose companion, Natalia Nordman, turned their residence, Penaty, just across the Finnish border into a focal point for many of the avant-garde, including David Burliuk, Velimir Khlebnikov, Mayakovski, and Ivan Puni — became a strict vegetarian after meeting Nordman in 1905 and was clearly affected by the Theosophists who visited him.[63] Repin and Nordman's two-tiered, revolving table full of vegetarian specialties received much comment, especially the presiding *repa* (turnip), symbol of the Repin family. Repin's "enthusiasm for hay as the best kind of food"[64] and barefoot ritual dancing to the phonograph indicated how easily a famous artist could succumb to the occult fashion. It also indicated that these interests were not the exclusive property of any one social or cultural group since Repin, artistically speaking, was diametrically opposed to the avant-garde.

Between December 1911 and 1914 a popular rendezvous for Saint Petersburg bohemia, including apologists of occult systems, was the cabaret called the Stray Dog. Although the artists who came there were moderate or "decorative" rather than highly experimental, for example, Sergei Sudeikin and Boris Grigoriev, it is certain that Malevich, Matiushin, and their colleagues passed by from time to time, and it is known that Kulbin, with the playwright Nikolai Evreinov, was a keen supporter of its cultural program. Ouspensky and his friend the music and ballet critic Akim Volynsky also frequented the Stray Dog, where they discoursed on a range of esoteric themes: "the Tarot, theosophy, Alexandrian Christianity, the French magical revival, Russian orthodoxy, neo-Platonism, Jakob Böhme, the monks of Athos."[65] It is tempting to assume that Ouspensky's *Tertium Organum*, published in 1911, was advertised and appreciated by artists through cocktail conversation

at the Stray Dog rather than through avid readings of the text. Still, the more reliable memoirs of the period do not make reference to the Stray Dog as a propaganda platform for occultism, and once again, it is reasonable to assume that private encounters rather than public programs supplied the practical way in which occult ideas were accepted and interpreted.

Of course, there were closed meetings in Saint Petersburg houses that promised "hallucinations of hashish and ether,"[66] but as far as we know they were not frequented by artists of the avant-garde. A case in point is the Saint Petersburg society the Golden Ship, which held séances devoted to the synthesis of art and theurgy. The concentration on the subjective experience in art was inflated into a mystical diet, bland and sedative. The Golden Ship pronounced: "God is the spirit, His garments are beauty, His prayer — creation, His temple — art. . . . God is that which creates through us. . . . this divine quality of the soul we call genius. . . . the Holy Spirit is belief in its genius. . . . Individual creation in art should be merely preparation for a form of ritual; only the latter, fused with religion, will regenerate man and bring him closer to the light of Heaven."[67]

Some idea of the remarkable ingenuousness of the clients of these salons can be gained from the recollections of Thomas Hartmann and his wife and those of Anna Butkovskaia, who was close to Evreinov, Kulbin, and Ouspensky and financed a series of monographs on Saint Petersburg's modern artists. It is hard to understand how drinking tea without sugar and walking in high-heeled shoes (two requirements recalled by Thomas Hartmann) could have been considered requisite to the spiritual penance that must precede illumination.[68] It is also hard to understand why these comfortable, cultured people would donate enormous sums to be initiated into "the Work" when many intellectuals believed that the humblest peasant possessed powers of divination and was the keeper of the higher truth. Certainly some of the more enterprising novices tried to free themselves of material ties and donned the peasant smock, but in most cases their maids were never far away; with relatives in Paris and New York, the absence or presence of money, even after the revolution, did not seem to pose a particular hindrance to the spiritual quest. Genuine converts to a life of physical denial were very few among Russian intellectuals; perhaps only Filonov and Khlebnikov adopted a truly sectarian severity to the benefit of their artistic creativity.

We can trace certain important links between the occult practices of Saint Petersburg circles in particular and the Russian avant-garde, between Theosophy in its widest sense and the move toward abstraction. For example, it is of great interest to realize that the formal Symbolists whom Benois mentions also contributed to Kulbin's Impressionist and Triangle exhibitions in 1909–10, that until 1909 Guro and Matiushin were part of Kulbin's group, that Butkovskaia was a follower of Ouspensky and a close friend of Evreinov, who was in turn a close friend of Kulbin, and that Kulbin was a good friend of Unkovskaia, a Theosophist who also knew Ouspensky. The contacts were limited and the relations uneasy, but there can be no doubt that Kulbin's "great unconscious art attained by intuition,"[69] Guro's and Matiushin's concentration on natural forms and sounds, Evreinov's experiments with vegetarianism,[70] and Butkovskaia's conversations with Ouspensky on "music, alchemy, Vivekananda, Wagner, the Holy Grail"[71] were all manifestations and perhaps further vulgarizations of the "beautiful rites" observed in darkened parlors. The voices of Helena P. Blavatsky and Steiner echoed loud and clear:

I am aware of the nature of true art; I believe I understand how it seizes upon the essentials of life and presents to our souls the true and higher reality. I seem to feel the beating of the pulse of time when I permit such art to influence me. . . .

. . . so many works of art are imperfect, for the creative function leads of itself beyond nature, and the artist cannot know the appearance of what is outside his senses.[72]

A primary reason why the voices of Blavatsky and Steiner were heeded so carefully in Russia at this time lies in the fact that the Symbolists had been repeating similar things for several years. There is essentially no difference between attitudes toward the inner or higher reality on the part of Steiner and Bely, Blavatsky and Ivanov. Bely was already reading Blavatsky in the late 1890s, and he "gave himself up to Steiner" in 1905,[73] but his study of such texts merely confirmed rather than signaled his philosophical direction.

By the time Kulbin began to formulate his ideas on harmony and dissonance in 1909–10 and Matiushin began his manuscript "Opyt khudozhnika novoi mery" (An artist's experi-

ence of the new direction) in 1913, both parties were well aware of the Moscow and Saint Petersburg Symbolist discourses, and the occult vogue in Saint Petersburg salons could have enhanced and accelerated their searches but scarcely have inaugurated them. Even so, reference to the popularization of Theosophy, especially in the issues of *Vestnik teosofii*, is important because this journal and other analogous literature presented, in schematic form, concepts that Kulbin and others broadcast further and that seem to have resounded as far as Filonov, Malevich, and Matiushin. One of these concepts is that of the artist as clairvoyant, a leitmotiv in the writings of Annie Besant, Blavatsky, Steiner, Bely, Blok, and Ivanov, which is repeated almost parrot fashion in subsequent tracts by artists such as Kandinsky, Matiushin, and Petrov-Vodkin. Another is the argument, formulated by Unkovskaia, that the "music of the spheres" is heard in the "sounds of nature" and that there is an organic parallel between sounds and colors.[74]

Kulbin repeated and expanded these ideas in his various lectures and in essays such as "Garmoniia, i dissonans i tesnye sochetaniia v iskusstve i zhizni" (Harmony, dissonance, and close combinations in art and life) in 1911.[75] Matiushin acted upon them, creating, for example, his canvas *Red Ringing* in 1913 and assembling a collection of roots of trees.[76] Like Unkovskaia, Kulbin also focused attention on the artistic forms of nature such as the crystal and the cell; as he stated in 1911, "Apart from art created by man the artist, and apart from the art in the kingdoms of the minerals and the plants that surround him, there exists in nature an art of animals, of primitive man, of the child."[77]

What is especially striking is not only the immediate reverberations of these rudimentary theosophical or Symbolist ideas but also their subsequent application within the nonobjective movement and their appearance in contexts that are conventionally recognized as painterly and formal. One such context is the experimental department at the Museum of Artistic Culture/State Institute of Artistic Culture in Petrograd/Leningrad in 1923–24.

Directed by Mansurov, the department worked to "analyze the reasons for the appearance of plastic forms according to the character of their body and the materials utilized. This research concerned itself with costumes, architecture, sculpture, and painting, their birth and evolution [and I did this] taking as my departure-point minerals, the mush of vegetables, the constructions of insects, birds, and other animals."[78] In the studies that Mansurov used at the museum/institute (where Malevich headed the department of organic culture and Matiushin the department of formal and theoretical systems), there are many references to natural forms side by side with artistic forms. Photographs of rocks, fossils, feathers, spiderwebs, and so forth demonstrate Mansurov's deep interest in the intrinsic, natural laws of color and form.

No doubt Mansurov was indebted to Matiushin's Studio of Spatial Realism at the Petrograd State Free Art-Teaching Studios, which he visited from 1919 onward and where, with Matiushin and the Enders (Maria, Boris, Xenia, and Yuri), he studied common visual structures in groups of animals as well as accidental forms: roots of trees and driftwood. Knowing all this, we can identify an unexpected but unbroken line back to the prerevolutionary occult concerns of Kulbin, Unkovskaia, and others in Mansurov's own Painterly Formulae — the precise, nonobjective reductions to basic geometric forms that he always maintained were "paintings and nothing else."[79]

Related to Unkovskaia's examination of natural forms is the subsequent deduction by several artists, including Filonov and Malevich and perhaps also Mansurov, that the work of art is an organic entity, a real creation that lives. This meant not only that their painting or construction could affect the viewer emotionally but also that it was a living organism. Filonov argued that his paintings had a life of their own and that they continued to grow after he had set down his brush,[80] while Malevich, in referring to his *Black Square* as a "regal infant" and to paintings "growing like a forest, a mountain, a stone," surely meant this literally.[81] This uncanny theme can be traced back to the Romantic trends of the early nineteenth century and to the fantastic literature of Nikolai Gogol in such stories as *The Portrait*.

The Theosophists relied substantially on the teachings of the Indian esoteric philosophers, whom they identified as part of the oriental tradition. Blavatsky investigated the concept of nirvana in Buddhist philosophy, and

Ouspensky claimed that he found the "Miracle" in India in 1913. Several direct and indirect references to nirvana can be found in the writings of the avant-garde artists and critics, from Kulbin's commentary on nirvana as "complete harmony . . . to which aspires the tired 'I' "[82] to Kandinsky's scheme of the spiritual triangle[83] and Malevich's remarks on the "white beyond" that conclude his essay "Suprematizm" (1919).[84] It should be emphasized that the apparent occult (in this case nirvanic) associations in Malevich's writings and paintings — for example, his white on white series — are implied rather than applied. Furthermore, the theosophical interpretation of nirvana as the final dissolution of matter (a formula reminiscent of Malevich's Suprematist paintings) and the attainment of pure illumination coincided with other, analogous tendencies in the Russian culture and philosophy of this period.

The Symbolist poets and painters had thought much about "nothing," alternating between positive and negative comprehensions of the beyond: the pure sound envisioned by Blok and Kandinsky or *"le grand Néant"* (the great nothing) of Fedor Sologub and Somov and also Blok during his decadent phase. In Symbolist literature and painting can be recognized particular methods used to evoke nothing, whether representing a higher consciousness or a total vacuum. "In the dream," wrote Blok, "all is white,"[85] and he proceeded to emphasize white as the symbol of the ulterior reality in most of his plays of 1906–12. The process of dematerialization identifiable with Symbolist imagery — the result of a "dying naturalism" as B. L. wrote in 1905[86] — in Blok's writings or in the paintings of Borisov-Musatov and the Blue Rose artists revealed either mystical harmony (nirvana) or nothing. Blok masterfully intertwined these two opposed conclusions in his 1906 play *Balaganchik* (The fairground booth), in which Pierrot dives into emptiness while mystics await the moment of truth.

The avant-garde artists were also fascinated by nothing. In 1913 the Cubo-Futurist poet Vasilii Gnedov published a poem "Poema kontsa" (Poem of the end), the last section of which was a blank page. In 1916 Kliun maintained that "before us has arisen the task of creating a form out of nothing."[87] Malevich's

"zero of forms"[88] and his affirmation that the "world . . . is nothing"[89] also seem to carry associations with the philosophy of nothing. In addition mention should be made here of the Nothingists, the group of Rostov-on-Don and Moscow poets and painters established at the end of 1919 that declared "Write nothing! Read nothing! Say nothing! Print nothing!"[90] They regarded themselves as Russian Dadaists, and their praise of nothing was motivated by a set of historical conjunctions that had little to do with the ambience from which Suprematism evolved; any apparent parallel between the two phenomena is probably coincidental.

As far as Malevich is concerned, however, a legitimate way of explaining the arrival of geometric abstraction in Russia is again to consider it as an extension of Symbolist and theosophical ideas. The Symbolists, by their very nature, merely alluded to possibilities without exploiting them. Indeed they were often afraid to disclose nothing and tried desperately to scatter "flowers, flowers above the tomb."[91] Somov's concentration on masks, garlands of flowers, fireworks is a case in point, and his contemporary critics were quick to perceive these objects as symbols of emptiness and his characters as "ghosts playing at being people."[92] The avant-garde, however, removed the mask and found that nothing was not so terrifying after all. Perhaps the fin de siècle critics who censured the first experiments in total abstraction actually concealed a secret envy and admiration beneath their harsh words. Benois wrote of Malevich's *Black Square:* "It is an integrated and very powerful philosophy. . . . The art of the futurists . . . is the total affirmation of the cult of emptiness, of the gloom of 'nothing.' "[93]

But what did the "zero of forms" designate for the abstract artists in Russia? In most cases, it represented energy, although in various interpretations, physical or mystical. Ivan Kudriashev (see his *Luminescence,* 1926 [pl. 5]) and Redko interpreted nothing scienti-

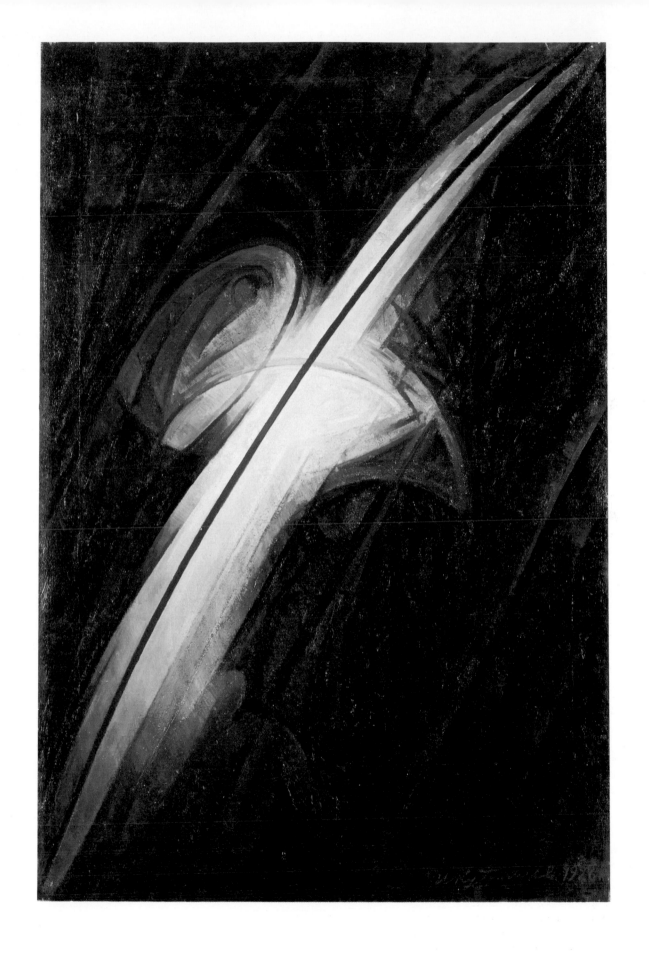

5

IVAN KUDRIASHEV
Luminescence, 1926
Oil on canvas
42 x 28 in. (106.7 x 71.1 cm)
The George Costakis
Collection (owned by Art
Co. Ltd.)
© George Costakis,
1981

fically as the energy latent in all matter and used abstract painting as an illustration of or metaphor for energic phenomena such as fission, particle bombardment, and speed of light.[94] Liubov Popova regarded painterly forms as vehicles of energy in different degrees.

Malevich's interpretation was both factual and fictive. He could argue on the one hand that a ball, a motor, an airplane, and an arrow all used and represented the same power of dynamism. On the other hand, he referred to the "energies of black and white"[95] and the energies of Suprematist forms as if they contained a real, traceable, applicable force that could be harnessed to drive machines. This notion brings to mind esoteric understandings of energy: Wilhelm Ostwald's "energetic imperative"[96] and G. I. Gurdjieff's psychic translocation of objects over distances and transference of telepathic power. It was this discovery of cosmic energy, whatever its philosophical derivation, that provided Malevich with the conviction to explore the world of abstraction in the Suprematist paintings, especially in those of 1917 onward (pl. 6). Nothing, he felt, had given him everything. As the heroes in *Victory over the Sun* proclaim, "There will be no end! We are conquering the universal."[97] Malevich's aerial Suprematism of the 1920s relates the story of

this infinite journey into space. When we realize how thematic Malevich's Suprematism was, how it distilled and allegorized non-painterly ideas, we can better comprehend why it elicited criticisms from his soberer colleagues; why Malevich and Tatlin engaged in a fist fight in 1915, why his earnest supporter Nikolai Punin once described Malevich's ideas as a "hymn to despair,"[98] and why Kliun rejected Suprematism as the "corpse of painterly art,"[99] even though Kliun's own paintings of the early 1920s such as *Red Light, Spherical Composition* (pl. 7) invite cosmic, nonpainterly interpretations.

In March 1907 a certain "Mme K." performed Greek dances at a musical evening organized in connection with the Blue Rose exhibition in Moscow. Mme K., accompanied by Nikolai Cherepnin, Rebikov, and Scriabin, was benefiting from the vogue for such dances in Russia inaugurated by Isadora Duncan during her first Russian tour in 1905, when the Symbolists, among others, attended her sessions with great interest. The vogue continued throughout the 1910s and early

1920s, when eurhythmic gymnastics according to the Dalcroze method attracted a very large following in metropolitan and provincial centers. This also coincided with an unprecedented burst of interest in Taylorism, the economical and expedient use of body movements in the performance of work tasks in factories; in biomechanics, Vsevolod Meierkhold's application of Taylorism to the Constructivist stage; in the fashion designs of Popova, Rodchenko, Varvara Stepanova, and Tatlin; in Alexandra Kollontai's espousal of free love, which legitimized the permissiveness of Saint Petersburg and Moscow socialites just as the revolution legitimized abstract art; in rejuvenation and attempts, such as Konstantin Melnikov's, to overcome the problem of death.[100]

How do Mme K. and rejuvenation relate to the Russian avant-garde? There is evidence that many of the abstract artists regarded their paintings not only as art for a new social and political order but also for a new man, physically and psychologically superior to his counterparts of the past. They tended to use their paintings and designs as blueprints for the embodiment of the higher consciousness; the new man's new body was to be the ultimate realization of their artistic experiments. The investigations in abstract art by Matiushin and the Enders, for example, were linked to a broader framework of elaborate physiological investigations. Matiushin's see-know system of 1913 onward — whereby he hoped to extend our optical perception to 360 degrees by reactivating what he believed to be dormant optical reflexes on the back of the head and the soles of the feet — led him to paint "landscapes from all points of view" and was a constituent part of the collective endeavor to create a new man.[101] Occultists might have interpreted Matiushin's experiments as a scientific justification of their own searches for the higher consciousness, and no doubt Matiushin, in turn, was guided as much by his familiarity with Ouspensky as by the natural sciences. Matiushin's research actually paralleled analyses of color theory and perception by conventional scientists such as Sergei Kravkov and Petr Lazarev at the Psycho-Physical Laboratory of the State Academy of Artistic Sciences in Moscow.[102] Laboratory work was also carried out at the center for the Scientific Organization of Labor in Moscow, with which both Malevich and Meierkhold were affiliated.[103]

In many occult doctrines, from the Theosophists' concern with vegetarianism to Gurdjieff's Haida Yoga, the judicious control of the body through diet, physical exercise, and endurance tests is the key to attaining spiritual revelation. The Dalcroze eurythmic method was a gesture, essentially, to the same

world view that maintained that the Western, "civilized" treatment of the body tended to cloud its potential since "our heads may be ablaze, but our body hardly lives."[104] The task was to rediscover latent energies, especially through Eastern, "uncivilized" practices, something that many felt would lead to rejuvenation, elimination of disease, triumph over death, and higher consciousness. Some were drawn to this argument by what they regarded as symptoms of a necrosis and imminent breakdown of the Western body. Bely noted that the chest cavity was in the process of changing its structure, and therefore the "laws of change in the composition of matter are analogous to the laws of change in the spatial or temporal elements of art."[105] Vrubel had once complained of the need for a "supplementary body" so that the "wrist could move more freely in all directions."[106] Consequently, vegetarianism, barefoot dancing, gymnastic movements (which were later adapted to the mass gymnastic and athletic displays of Stalin's Russia that served as the prelude to the formation of a different new body), and, in general, the concept of "listening" to one's body were accepted consciously or unconsciously as remedial activities that improved physical and psychological well-being.[107] This explains, for example, why Filonov, struck by the slow eating habits of an Arab peasant, became extremely attentive to the process of masticating and digestion, maintaining that this practice, also observed by Yogis, gave him the maximum benefit from the food.[108]

Disciplining and improving the body through Yoga practices, including fasting, and gymnastics was also a ritual of preparation for the day of awakening when the converted would be summoned to make the final journey, the ultimate pilgrimage. The theme of the long and arduous journey, of vagabondism and nomadism assumes an added significance in the context of Russian bohemia. Whether genuine pilgrimages (Filonov's trip to the Holy Land in 1908),[109] spasmodic meanderings (Khlebnikov's treks across Russia), nostalgia for the steppes (Kuznetsov), marathon marches across the Caucasus (Gurdjieff), artistic grand tours (Petrov-Vodkin's bicycle trip to Western museums in 1901), or simply the "mobility and instability of the Russian social mass,"[110] the rootlessness of the Russian bohemians was a prominent and important element. Artistic researches coincided with physical searches, a condition that lasted right up until the late 1920s when one writer referred to the "tramp-like and nomadic

tribe" of the Soviet intelligentsia.[111] During the 1930s and 1940s this nomadism continued with the forced migrations of individuals and entire peoples, although by then it was scarcely the extension of a mystical impulse.

The endeavor to create a new consumer for the new art, which coincided with the aims of social transformation advocated by the revolution, is reflected in many futurological efforts of the time. The fantastic architecture of Yakov Chernikhov, Nikolai Ladovsky, Ivan Leonidov, and Melnikov; the artistic interpretations of interplanetary space travel; the proposals to use atomic energy as a power source; Malevich's figures of the late 1920s–early 1930s, their faces carrying nothing — all such optimistic gestures were entertained as if the new body would be created within a decade rather than a millennium. In 1920–23 El Lissitzky even drew and published his idea of a new man as a character from the spectacle *Victory over the Sun*,[112] which with its "men of the future" might be considered an extension of this quest for the new body, even though the spiritual or occult dimension does not seem to have been primary in it.

The new body, whether theosophist or socialist, was to have conquered death and to have been eternal, a fundamental prerequisite that stimulated careful research into child psychology and children's art by scientists, occultists, and artists during the 1910s and 1920s. It is well known that the first wave of the Russian avant-garde (the Burliuks, Chagall, Goncharova, Larionov, Shevchenko) collected, studied, and exhibited primitive and children's art in their attempts to capture a more intuitive, spontaneous apprehension of reality; that Matiushin used a drawing by Guro's seven-year-old niece for the cover of the collection *Nebesnye verbliuzhata* (Baby camels of the sky) (Saint Petersburg, 1914); that Khlebnikov insisted that two poems by a thirteen-year-old girl be included in *Sadok sudei* (A trap for judges 2) (Saint Petersburg, 1913); and that Alexei Kruchenykh coauthored *Porosiata* (Piglets) (Saint Petersburg, 1914) with an eleven-year-old girl. It is less well known that Unkovskaia taught art and music to young children in Kaluga; that Matiushin's second wife, Olga, taught blind children; and that at precisely this time, around 1910, the first se-

rious studies of child perception began to appear, such as Yuliia Boldyreva's *Risunki rebenka: Kak material dlia ego izucheniia* (Children's drawings: Materials for the study of the child) (Moscow, 1913). The critic Abram Efros observed in his study of Chagall that a distinguishing feature of children's art was "suddenly": the accident, the coincidence, the miracle.[113] Such a tenet served as a primary justification for the antics of the Cubo-Futurists: happenings and performances, instant works of art, illogical exhibition and publication titles, unreasonable combinations of dress. Once again, however, there were precedents: in the 1890s Vrubel used to color his nose and walk around Kiev.[114]

Both the scientific and artistic approaches to children's creativity continued into the 1920s. Psychologists published important theses on the development of the senses,[115] and major efforts were made to grant children's art a legitimate status in art history and criticism. For example, in his plan for the reorganization of the Academy of Arts in 1922–23 Filonov proposed the establishment of a section on children's art, while the State Academy of Artistic Sciences in the mid-1920s actually housed the Cabinet for Primitive Art and Children's Creativity, where the critic Alexei Bakushinsky produced a number of important findings.[116]

Some of Bakushinsky's conclusions have relevance to the issue of the new body. One of his central arguments was that the first stage of a child's artistic development was characterized by motor, tactile impulses, and that the child artist was therefore interested in movement, in the continuum, not in the crystallized result. It is tempting to trace a connection from this idea to the avant-garde's sudden interest in kinetic art just after the revolution, from Tatlin's *Monument to the III International* with its four revolving sections and Naum Gabo's dynamic light constructions to the touch constructions of Karel Johannson[117] — all pieces that were intended to inhabit the environment of the new body. One culmination of the concern with children's art and, in turn, with the creation of a higher body for the higher consciousness was

the organization of the *International Exhibition of Children's Art* in Moscow in 1934 and the publication of a major study of the subject the following year.[118] Not only was children's art examined by professional artists but professional artists' art was also examined by children, and particular notice was given to their responses. To the chagrin of the avant-garde, it was discovered that children, like the public at large, did not like the new art.[119]

By the time socialist realism was advanced in 1934 as the exclusive artistic style in Soviet culture, much of the energy of the avant-garde and of the idealist philosophers had been lost. Kulbin died in 1917; Butkovskaia, Evreinov, Gurdjieff, Kandinsky, and Ivanov emigrated, and with them also went the community that had supported and investigated esoteric deviations. Popova died in 1924, Bely and Matiushin in 1934, Malevich in 1935, and the hard-edge abstract artists, such as Kliun, Lissitzky, and Rodchenko, either returned to a figurative aesthetic or transferred their talents to other creative areas, such as photography, posters, and stage design. What was left was "closed by the police" just as the Stray Dog had been in 1914.[120] The imagery that replaced the art of the avant-garde was no less visionary and no less supernatural. At the First All-Union Congress of Soviet Writers in 1934, Andrei Zhdanov spoke of a "romanticism of a new kind, a revolutionary romanticism."[121] This was not a romanticism that derived from alchemy or Yoga, but it still contained an element of divination ("a glimpse of tomorrow," as Zhdanov said),[122] of religious belief in the communist ideal and the new body. Above all, after the desanctification of the Cubo-Futurists, socialist realism returned sanctity to art and literature, an attitude that is still a salient feature of Soviet culture, official and unofficial.

The artists detailed in this essay represented but a very small component of the Russian avant-garde. If their work can be associated, although not filled, with mystical content, the concurrent paintings of Gustav Klucis, Lissitzky, Popova, Olga Rozanova, Sergei Senkin, and the constructions of Rodchenko, the Sternberg brothers (Georgii and Vladimir), and Tatlin stand almost outside this context. If the antimystical statement of *Lef* (Left front of the arts) in 1924 means anything,[123] most members of the postrevolutionary avant-garde would be highly indignant at being linked with the occult traditions of the fin de siècle, as Mansurov implied in 1981. The pioneers of abstract art in Russia did not consistently and continuously support systems of higher meditation in the way that Blavatsky, Gurdjieff, and Ouspensky did. We should beware of regarding the art of the avant-garde as a pictorial counterpart to the esoteric teachings of the time. Still, it is highly improbable that without this mosaic of ideas, without this mystical impetus, artists such as Kandinsky, Malevich, and Matiushin would have created the innovations that they did or would have linked their abstractions with the world of the future. For them, painterliness was next to godliness. Ultimately, the exact correlation between the spirit and its embodiment is impossible to determine, and we must remain content with allusions, insinuations, and veiled connections; after all, these are the essential ingredients of the spiritual in art.

KAZIMIR MALEVICH
The Bather, 1910
Gouache on paper
41 5/16 x 27 3/16 in.
(105 x 69 cm)
Stedelijk Museum,
Amsterdam
·

KAZIMIR MALEVICH
Floor Polishers, 1911
Gouache on paper
30 9/16 x 27 15/16 in.
(77.7 x 71 cm)
Stedelijk Museum,
Amsterdam
·

1. Wassily Kandinsky, "Program for the Institute of Artistic Culture" (1920), in *Kandinsky: Complete Writings on Art*, ed. Kenneth Lindsay and Peter Vergo (Boston: G. K. Hall, 1982), 1:455–74.

2. Serge Charchoune has received some attention through exhibitions and publications, for example, *Charchoune*, exh. cat. (Paris: Galerie de Seine, 1974); and Raymond Creuze, *Serge Charchoune*, 2 vols. (Paris: Creuze, 1979). Unfortunately, his creative and theoretical writings, often referring to esoteric systems, have not been the subject of extensive scholarly investigation in part, perhaps, because Charchoune published his own books in very limited editions and in Russian.

3. Pavel Mansurov, interview with author, Nice, December 1981, recording in the archives of the Institute of Modern Russian Culture, Blue Lagoon, Texas.

4. Igor Terentiev, *Traktat o sploshnom neprilichii* (A tract about constant indecency) (1920), in *Dada russo*, ed. Marzio Marzaduri (Bologna: Il Cavaliere Azzurro, 1983), 125.

5. Georgii Yakulov's formulation is mentioned in Semen Aladzhalov, *Georgii Yakulov* (Yerevan: Tipografiia No. 1, 1971), 34.

6. Andrei Bely was fond of drawing parallels between changes in the spiritual climate and meteorological events, such as the remarkable dawns and twilights that, he maintained, resulted from the eruption of Krakatau in 1883. Bely often referred to the late 1890s and early 1900s in Russia as the "era of the dawn" (Andrei Bely, *Na rubezhe dvukh stoletii* [On the edge of two centuries] [Moscow: Zemlia i fabrika, 1930], 10).

7. For commentary on the mystical ambience of prerevolutionary Russia and on the principal intellectuals involved in Symbolist activities, see Bernice Rosenthal, *D. S. Merezhkovsky and the Silver Age: The Development of a Revolutionary Mentality* (The Hague: Nijhoff, 1975); Christopher Read, *Religion, Revolution and the Russian Intelligentsia 1900–1912* (London: Macmillan, 1979); Temira Pachmuss, *Zinaida Hippius: An Intellectual Profile* (Carbondale: Southern Illinois University, 1971); Avril Pyman, *The Life of Aleksandr Blok*, 2 vols. (Oxford: Oxford University Press, 1979–80); Viktor Lobanov, *Kanuny* (Moscow: Sovetskii khudozhnik, 1968); and *Russkaia khudozhestvennaia kultura kontsa XIX–nachala XX veka* (Russian artistic culture of the end of the nineteenth century and beginning of the twentieth century), ed. A. Alexeev et al., 4 vols. (Moscow: Nauka, 1968–80). The following books are also useful as sources of information on the primary religious or mystical philosophers of the time, such as Sergei Bulgakov and Vladimir Solov'ev: Nicholas Zernov, *The Russian Religious Renaissance* (London: Darton, Longman & Todd, 1963); *Russkaia religiozno-filosofskaia mysl XX veka*, ed. Nikolai Poltoratsky (Pittsburgh: University of Pittsburgh, 1975); and Jutta Scherrer, *Die petersburger religiös-philosophischen Vereinigung* (Berlin and Wiesbaden: Harrassowitz, 1973).

8. Kazimir Malevich's description accompanying chart no. 13 from his researches at the State Institute of Artistic Culture, Leningrad, is reproduced and translated in Troels Andersen, *Malevich*, exh. cat. (Amsterdam: Stedelijk Museum, 1970), 134.

9. Genrikh Tasteven, *Futurizm* (Moscow: Iris, 1914).

10. Bely, *Na rubezhe dvukh stoletii*, 16.

11. Aleksandr Blok, "Otvet" (A response), in *Alexandr Blok: Sobranie schoinenii* (Aleksandr Blok: Collected works), ed. Vladimir Orlov (Moscow and Leningrad: Khudozhestvennaia literatura, 1960), 1:537.

12. According to the inscription on the reverse of one of Malevich's paintings of 1906–7 in the State Russian Museum, Leningrad, Malevich tried to contribute to the Blue Rose exhibition in Moscow in March–April 1907, but his request was rejected. For information on the Blue Rose group, see John Bowlt, "The Blue Rose: Russian Symbolism in Art," *Burlington Magazine* 118 (August 1976): 566–74.

13. For an interpretation of Malevich's *Nymphs*, placing it in its Symbolist context, see Margy Betz, "Malevich's *Nymphs*, Erotica or Emblem?" *Soviet Union* 5, pt. 2 (1978): 204–24.

14. For further information, see Alla Rusakova, *V. E. Borisov-Musatov* (Leningrad and Moscow: Iskusstvo, 1966); Mark Etkind's book on Mikalojus Čiurlionis, *Mir kak bolshaia simfoniia* (The world as a great symphony) (Leningrad: Iskusstvo, 1970); *Čiurlionis*, ed. Antana Gedminas et al. (Vilnius: Vaga, 1977); Aleksis Rannit, *Mikalojus Konstantinas Čiurlionis: Lithuanian Visionary Painter* (Chicago: Lithuania Library Press, 1984); Alla Rusakova, *Pavel Kuznetsov* (Leningrad: Iskusstvo, 1977); Stepan Yaremich, *Mikhail Alexandrovich Vrubel* (Moscow: Knebel, 1911); and Petr Suzdalev, *Vrubel: Lichnost, mirovozzrenie, metod* (Vrubel: Personality, philosophy, method) (Moscow: Izobrazitelnoe iskusstvo, 1984).

15. Tasteven, *Futurizm*.

16. Nikolai Tarovaty, "Na vystavke 'Mir iskusstva'" (At the exhibition of the "World of art"), *Zolotoe runo*, no. 3 (1906): 124.

17. Aleksandr Blok, *Zapisnye knigi* (Notebooks), ed. Vladimir Orlov (Moscow and Leningrad: Khudozhestvennaia literatura, 1965), 73.

18. Andrei Bely, "Smysl iskusstva" (Meaning of art) (1907), in idem, *Simvolizm* (Moscow: Musaget, 1910), 223.

19. The critic Abram Efros referred to Filonov as an apostle in his article on the painter Aristarkh Lentulov, "Ob Aristarkhe Lentulove," in *A. M. Efros: Mastera raznykh epokh* (A. M. Efros: Masters of different epochs), ed. M. Tolmachev (Moscow: Sovetskii khudozhnik, 1979), 249. Efros also referred to the "apostolic" nature of Malevich's declarations in his article "K. Malevich," *Khudozhestvennaia zhizn* (Artistic life), no. 3 (1919): 39.

20. "Nastuplenie pravykh" (Assault of the rightists), *Zhizn iskusstva* (Life of art), no. 26 (1925): 2.

21. Nikolai Berdiaev, *Krizis iskusstva* (Crisis of art) (Moscow: Leman, 1918).

22. Viacheslav Ivanov, *Borozdy i mezhi* (Furrows and borders) (Moscow: Ory, 1916), 347.

23. Vasilii Kandinsky, "Kuda idet 'novoe' iskusstvo" (Within the "new" art), *Odesskie novosti* (Odessa news), 9 February 1911, 3.

24. Vasilii Kandinsky, *Tekst khudozhnika* (An artist's text) (Moscow: IZO NKP, 1918), 18.

25. The question of Kandinsky's artistic connections with Aleksandr Scriabin has been examined at some length by Nicoletta Misler, "Towards a Liturgy of the Senses," *Prospettive* (forthcoming). Jelena Hahl-Koch, *Arnold Schoenberg–Wassily Kandinsky: Letters, Pictures and Documents* (London: Faber & Faber, 1984) touches on relevant aspects as does the special issue, "Spiritual in the Arts," of the *American Theosophist* (Spring 1982).

26. Nicoletta Misler, *Pavel Florenskij: La prospettiva rovesciata e altri scritti* (Rome: Casa del Libro, 1983).

27. Quoted in Vladimir Markov, *Russian Futurism* (Berkeley: University of California, 1968), 46.

28. Andrei Bely, *Lug zelenyi* (The meadow green) (Moscow: Altsiona, 1910), 22.

29. Andrei Bely, "Magiia slov" (The magic of words) (1909), in idem, *Simvolizm*, 430.

30. Aleksandr Blok, "Slova i kraski," in *Sobranie sochinenii* (Collected works) (Moscow, 1928–59), 5:22.

31. P. D. Ouspensky, *In Search of the Miraculous* (London: Routledge & Kegan Paul, 1950).

32. Aleksandr Blok, "Krushenie gumanizma" (The collapse of humanism), in *Sobranie sochinenii*, 6:101, 112.

33. Vasilii Kandinsky, "O dukhovnom v iskusstve" (On the spiritual in art), in *Trudy Vserossiiskogo sezda khudozhnikov v Petrograde* (Proceedings of the All-Russian Congress of Artists in Petrograd) (Petrograd: Golike ane Vilborg, 1914), 47–76. This is the Russian version of *On the Spiritual in Art* that was read in Kandinsky's absence by Nikolai Kulbin at the congress in December 1911. See *The Life of Vasilii Kandinsky in Russian Art: A Study of "On the Spiritual in Art,"* ed. John Bowlt and Rose-Carol Washton Long (Newtonville, Mass.: Oriental Research Partners, 1980).

34. Kazimir Malevich, *Ot kubizma i futurizma k suprematizmu* (From Cubism and Futurism to Suprematism) (Moscow: Obshchestvennaia polza, 1916), 3.

35. Kandinsky, *Tekst khudozhnika*, 25.

36. Lev Diakonitsyn, *Ideinye protivorechiia v estetike russkoi zhivopisi kontsa 19–nachala 20 vv* (Ideological contradictions in the aesthetics of Russian painting of the late nineteenth and early twentieth centuries) (Perm: Permskoe knizhnoe izdatelstvo, 1966), 151.

37. Nikolai Kulbin, "Die freie Musik," in *Der Blaue Reiter*, ed. Wassily Kandinsky and Franz Marc (Munich: Piper, 1912), 125.

38. Andrei Bely, "Printsipy formy v estetike" (The principles of form in aesthetics) (1906) and "Smysl iskusstva" (The meaning of art) (1907), in *Simvolizm*, 178–80, 219–20, respectively.

39. Ivanov, *Borozdy i mezhi*, 321.

40. "M. K. Chiurlienis," in *Khudozhestvennyi kalendar: Sto*

pamiatnykh dat, 1975 (An artist's calendar: One hundred memorable dates, 1975), ed. V. Kalmykov and Andrei Sarabianov (Moscow: Sovetskii khudozhnik, 1974), 195.

41. Quoted in Alexei Grishchenko, *"Krizis iskusstva" i sovremennaia zhivopis* ("The crisis of art" and contemporary painting) (Moscow: Gorodskaia tipografiia, 1917), 16; the reference is to Berdiaev's lecture "The Crisis of Art," which he gave in Moscow on 1 November 1916.

42. Ibid., 10.

43. Mikhail Matiushin delivered the lecture "An Attempt at a New Sensation of Space" in Moscow in May 1921. See Mikhail Matiushin, "Russkie kubo-futuristy," in Nikolai Kharardzhiev, *K istroii russkogo avangarda* (On the history of the Russian avant-garde) (Stockholm: Almqvist & Wiksell, 1976), 132; Khardzhiev also mentions that Bely was in the audience, 156.

44. Sergei Makovsky, *Siluety russkikh khudozhnikov* (Silhouettes of Russian artists) (Prague: Zaria, 1922), 36.

45. Tasteven, *Futurizm.*

46. Mikhail Matiushin, "O knige Glez i Metsanzhe 'Du Cubisme'" (Concerning the book by Gleizes and Metzinger "Du Cubisme"), *Soiuz Molodezhi* (Union of youth), no. 3 (1913): 25–34. For a discussion of this essay and of Ouspensky in the context of the Russian avant-garde, see Linda Dalrymple Henderson, *The Fourth Dimension and Non-Euclidean Geometry in Modern Art* (Princeton: Princeton University Press, 1983), especially 265–73, and for a translation of the Matiushin essay, 368–75.

47. This was a set of fourteen black-and-white lithographs that Natalia Goncharova made at the beginning of the First World War. They were published as the album *Misticheskie obrazy voiny* (Mystical images of the war) (Moscow: Kashin, 1914).

48. Aleksandr Mantel, "Populiarnost iskusstva" (The popularity of art), in Aleksandr Mantel et al., *Na rassvete* (At dawn) (Kazan, 1910), 1:34.

49. Abram Efros, *Profili* (Profiles) (Moscow: Federatsiia, 1930), 101.

50. Preface to *Mishen* (The target), exh. cat. (Moscow, 1913), unpaginated; the quotation is from points five and six.

51. Unsigned editorial statement, *Zolotoe runo*, no. 1 (1906): 4.

52. D. Imgardt, "Zhivopis i revoliutsiia" (Painting and revolution), *Zolotoe runo*, no. 5 (1906): 59.

53. Vasilii Kandinsky, "Soderzhanie i forma" (Content and form), in *Salon: Mezhdvnarodnaia khvdozhestvennaia vysatvka* (Salon: International art exhibition) (Odessa, 1911), 14–16. This is the catalogue of Vladimir Izdebsky's second salon.

54. "K nashim chitateliam" (To our readers), *Zolotoe runo*, no. 11/12 (dated 1909; printed 1910): 106.

55. Nikolai Riabushinsky, preface to *Zolotoe runo*, exh. cat. (Moscow, 1909).

56. Bely, *Na rubezhe dvukh stoletii*, 219.

57. Yakulov delivered a lecture at the Society of Free Aesthetics on his theory of the derivation of artistic styles (Aladzhalov, *Georgii Yakulov*, 37).

58. Andrei Bely, *Mezhdu dvukh revoliustii* (Between two revolutions) (Leningrad: Izdatelstvo pisatelei, 1934), 219.

59. The most detailed source of published information on the Café Pittoresque is Vladimir Lapshin, "Iz tvorcheskogo naslediia G. V. Yakulova" (From the creative legacy of G. V. Yakulov), in *Voprosy sovetskogo izobrazitelnogo iskusstva i arkhitektury* (Questions of Soviet visual art and architecture), ed. Irina Kriukova et al. (Moscow: Sovetskii khudozhnik, 1975), 275–304.

60. André Harley, son of the Girshmans, interview with author, December 1972.

61. Petr Alexandrovich Badmaev was famous for his Tibetan medicines, which he sold in the form of powders for all ailments; although he had received medical training, his qualifications were dubious.

62. Sergei Volkonsky was a keen proponent of the Dalcroze system and was sympathetic to the Theosophists' cause. He also rec-

ognized the importance of Kandinsky's lecture "O dukhovnom v iskusstve" and commented on this. See Bowlt and Long, *Kandinsky in Russian Art*, 100–101; and Volkonsky's memoirs, *Moi vospominaniia* (Berlin: Mednyi vsadnik, [1923?]); translated as *My Reminiscences* (London: Hutchinson, 1924).

63. Natalia Nordman seems to have been involved in a number of occult tendencies, including dancing barefoot on the ice (from which she contracted pneumonia and died). For information on Nordman and Ilia Repin in this context, see Igor Grabar, *Repin* (Moscow: Giz, 1937), 2:147–48; Igor Grabar and Ilia Zilbershtein, *Repin* (Moscow and Leningrad: Academy of Sciences, 1948), 1:310–13. Repin's contemporary the prominent sculptor Paolo Trubetskoi was also sympathetic to theosophical ideas and was a vegetarian and confirmed antivivisectionist.

64. Grabar, *Repin*, 2:197.

65. James Moore, *Gurdjieff and Mansfield* (London: Routledge & Kegan Paul, 1980), 54–55.

66. Sergei Makovsky, *Stranitsy khudozhestvennoi kritiki* (Pages of art criticism) (Saint Petersburg: Panteon, 1909), 3:60.

67. In Diakonitsyn, *Ideinye protivorechiia*, 141; original source not provided.

68. Such were the practices that Thomas Hartmann recalled about his quest for initiation into G. I. Gurdjieff's "Work" (Thomas de Hartmann, *Our Life with Mr. Gurdjieff* [Baltimore: Penguin, 1972], 6). Gurdjieff described his philosophical system in his book *Vestnik griadushchego dobra* (The herald of the coming good) (Paris: Giurdzhiev, 1933).

69. Nikolai Kulbin, "Garmoniia, i dissonans i tesnye sochetaniia v iskusstve i zhizni" (Harmony, dissonance, and close combinations in art and life), in *Trudy Vserossiiskogo sezda khudozhnikov v Petrograde*, 36. Kulbin delivered this as a lecture at the All-Russian Congress of Artists on 30 December 1911.

70. Nikolai Evreinov's wife, Anna Kashina-Evreinova, was a keen Christian Scientist, and, like Anna Butkovskaia (at one time a close companion of Evreinov), she was also interested in Theosophy.

71. Moore, *Gurdjieff and Mansfield*, 56; also Anna Butkovsky-Hewitt, *Gurdjieff in St. Petersburg and Paris* (London: Routledge & Kegan Paul, 1978).

72. Rudolf Steiner, *The Portal of Initiation*, trans. H. Collison (1910; New York: Putnam, 1920), 1, 109–10.

73. Andrei Bely, *Vospominaniia ob Alexandre Blok* (Reminiscences of Aleksandr Blok) (Letchworth, England: Bradda, 1964), 170.

74. Alexandra Unkovskaia, "Metoda tsveto-zvuko-chisel" (The method of color-sound-numbers), *Vestnik teosofii* (Herald of Theosophy), no. 1 (1909): 77–82.

75. Kulbin, "Garmoniia."

76. Matiushin showed his *Red Ringing* at the Union of Youth exhibition in Saint Petersburg in 1913–14, where he also showed roots of trees as works of art. *Red Ringing* was then sent to the Salon des Indépendants in Paris in 1914 but was not returned.

77. Kulbin, "Garmoniia," 36.

78. Pavel Mansurov, "Deuxième partie" (undated), 2–3, collection Bruno Lorenzelli, Milan. For information on Mansurov, see Carlo Belloli, *Mansouroff o delle funzioni lineari* (Milan: Salto, 1963); and Pietro Marino et al., *Mansouroff: Opere 1918–1980*, exh. cat. (Rome: Il Carpine, 1985).

79. Mansurov, interview with author.

80. Viktor Sklovskij, *Testimoni di un' epoca: Conversazioni con Serena Vitale* (Rome: Riuniti, 1979), 43–44.

81. Malevich referred to his *Black Square* as a "regal infant" in *Ot kubizma i futurizma k suprematizmu*, 28. He also referred to paintings growing like forests, according to Eugenii Kovtun, "Khudozhnitsa knigi Vera Mikhailovna Ermolaeva" (The book artist Vera Mikhailovna Ermolaeva), in *Iskusstvo knigi 68/69* (The art of the book 68/69), no. 8 (1975): 76.

82. Nikolai Kulbin, "Svobodnoe iskusstvo, kak osnova zhizni" (Free art as the basis of life), in *Studiia Impressionistov* (Studio of the Impressionists), ed. Nikolai Kulbin (Saint Petersburg: Butkovskaia, 1910), 3.

83. Kandinsky discussed and illustrated his concept of the spiritual triangle at length in his *On the Spiritual in Art*. See, for example, Bowlt and Long, *Kandinsky in Russian Art*, especially 65ff.

84. For an English translation of Malevich's *Suprematizm*, see John Bowlt, *Russian Art of the Avant-Garde: Theory and Criticism 1902–1934* (New York: Viking, 1976), 145.

85. Aleksandr Blok, "Pesnia sudby" (The song of destiny), in *Sobranie sochinenii*, 4: 104.

86. B. L., "Emotsializm v zhivopisi" (Emotionalism in painting), *Iskusstvo* (Art), no. 2 (1905): 18.

87. Ivan Kliun, "Primitivy xx-go veka" (Primitives of the twentieth century), in Alexei Kruchenykh, Ivan Kliun, and Kazimir Malevich, *Tainye poroki akademikov* (Secret of the academician) (Moscow, [dated 1915; printed 1916]), 30.

88. Malevich, *Ot kubizma i futurizma k suprematizmu*, 3.

89. Kazimir Malevich, *Suprematist Mirror* (1923), in Troels Andersen, *Malevich: Essays on Art* (Copenhagen: Borgen, 1968), 1:224.

90. "O nichevokakh v poezzi" (On the Nothingists in poetry) (1920), in *Sobachii iashchik* (Dog box) (Moscow: Hobo, 1921), 8. "O nichevokakh v poezzi" was the first manifesto of the Nothingists.

91. Ivanov identified this sentiment with the "snobs and desperados" of decadence (Ivanov, *Borozdy i mezhi*, 177).

92. Vgevolod Dmitriev, "Konstantin Somov," *Apollon* (Apollo), no. 9 (1913): 35. For information on Somov, see Sergei Ernst, *K. A. Somov* (Saint Petersburg: Obshchina Sv. Evgenii, 1918); *Konstantin Andreevich Somov*, ed. Yuliia Podkopaeva (Moscow: Iskusstvo, 1979); and Elizaveta Zhuravleva, *Konstantin Somov* (Moscow: Iskusstvo, 1980).

93. Quoted in Natalia Sokolova, *Mir iskusstva* (World of art) (Moscow: Gosudarstvennoe izdatelstvo izobrazitelnykh iskusstv, 1934), 201.

94. For information on Ivan Kudriashev, Kliment Redko, and their colleagues, see Vladimir Kostin, *OST* (Leningrad: Khudozhnik RSFSR, 1976); John Bowlt, "The Society of Easel Artists (OST)," *Russian History* 9, pts. 2–3 (1982): 203–26; and Angelica Zander Rudenstine et al., *Russian Avant-Garde Art: The George Costakis Collection* (New York: Abrams, 1981), 223–32, 440–44.

95. Malevich's reference to the energy of the ball, motor, airplane, and arrow is in his essay "An Attempt to Determine the Relation between Color and Form in Painting" (1930), in Andersen, *Malevich,* 2:138. His reference to the energy of black and white is from his introduction to *Suprematizm: 34 risunka* (Suprematism: Thirty-four drawings) (1921), translation in Andersen, *Malevich,* 1:125.

96. Edwin E. Slosson, "Wilhelm Ostwald," in *Major Prophets of Today* (Boston: Little, Brown, 1920), 203.

97. Alexei Kruchenykh and Velimir Khlebnikov, *Pobeda nad solntsem* (Victory over the sun) (Saint Petersburg: EUY, 1913), 4.

98. Andersen, *Malevich,* 1:256.

99. Quoted in Bowlt, *Russian Art,* 143.

100. S. Frederick Starr, *Konstantin Melnikov: Solo Architect in a Mass Society* (Princeton: Princeton University Press, 1978), especially 24off.

101. For information on Matiushin's ideas, see Alla Povelikhina, "Matyushin's Spatial System," in *Die Kunstismen in Russland/The Isms of Art in Russia 1907–1930,* exh. cat. (Cologne: Galerie Gmurzynska, 1977), 27–41. This catalogue also contains statements by Matiushin.

102. For information on the cabinet, see *Revoliutsiia, iskusstvo, deti* (Revolution, art, children), ed. N. Staroseltseva (Moscow: Prosveshchenie, 1966–67), 2:346–47; also *GAKhN: Otchet 1921–1925* (GAKhN [State Academy of Artistic Sciences]: Report 1921–1925) (Moscow: GAKhN, 1926), 58.

103. Viacheslav Zavalishin discusses Malevich's work at the Scientific Organization of Labor in a forthcoming monograph on Malevich.

104. Vasilii Rozanov, "Balet ruk" (A ballet of hands), *Mir iskusstva,* no. 12 (1900): 41.

105. Bely, "Printsipy formy v estetike," 190.

106. Quoted in Nikolai Prakhov, *Stranitsy proshlogo* (Pages of the past) (Kiev: Derzhavne vidavnitstvo, 1958), 139.

107. Perhaps listening to the body inspired Kruchenykh and Terentiev to entertain the idea of "anal poetry" and "anal drama." See Markov, *Russian Futurism,* 362; and Nicoletta Misler and John Bowlt, *Pavel Filonov: A Hero and His Fate* (Austin: Silvergirl, 1983), 34–38.

108. Evgeniia Glebova, "Dnevniki Filonova v vospominaniiakh ego sestry E. N. Glebovoi" (The diaries of Filonov in the recollections of E. N. Glebovoi, his sister), *SSR: Vnutrennie protivorechiia* (USSR: Internal contradictions), no. 10 (1984): 154.

109. It has not been established exactly when Filonov made his trip to Jerusalem, although 1908 seems to be a reliable date (Misler and Bowlt, *Pavel Filonov,* 65–66).

110. Petr Suvchinsky, "Dva renessansa" (Two renaissances), *Versty* (Verse), no. 1 (1926): 142; quoted in Elena Tolstaia-Segal, "Naturfilosofskie temy v tvorchestve Platonova 20-kh–30-kh godov" (Platonov's creativity during the twenties and thirties), *Slavica Hierosolymitana* 5 (1979): 223–54.

111. M. Reisner, "Bogema i kulturnaia revoliutsiia" (Bohemia and cultural revolution), *Pechat i revoliutsiia* (The press and revolution), no. 5 (1928): 92.

112. This is image no. 10 in El Lissitzky's album of lithographs *Die plastische Gestaltung der elektro-mechanischen Schau "Sieg über die Sonne"* (Hannover: Leunis & Chapman, 1923). It is of interest to remember that Michel Fokine, at one time much impressed by Isadora Duncan's dancing, was cofinancier of *Victory over the Sun* in its 1913 Saint Petersburg productions. Perhaps he was drawn to the Kruchenykh-Malevich "men of the future" after studying Duncan's "movements of the future" (Khardzhiev, *K istroii russkogo avangara,* 152).

113. Abram Efros and Yakov Tugendkhold, *Iskusstvo Marka Shagala* (The art of Marc Chagall) (Moscow: Gelikon, 1918), 5.

114. Prakhov, *Stranitsy proshlogo,* 116.

115. For example, the brochures *Osnovnye printsipy Edinoi Trudovoi Shkoly* (The basic principles of the United Working School) (Moscow, 1918); and *Esteticheskoe razvitie v iskusstve* (Aesthetic development in art) (Moscow, 1919). For a discussion of child psychology in the 1920s and 1930s, see Staroseltseva, *Revoliutsiia, iskusstvo, deti.*

116. E. Rudeneva, "Khudozhestvennoe vospitanie v novoi shkole" (Art education in the new school) (1925), in Starolseltseva, *Revoliutsiia, iskusstvo, deti,* 2, 40–41.

117. According to a description of a Johannson construction in the journal *Egyseg,* no. 1 (1922): 10, the artist invited the viewer to touch his constructions and set them in motion.

118. *Iskusstvo detei* (The art of children), ed. Osip Beskin (Leningrad: Oblastnoi soiuz, 1935).

119. E. Dmitrieva, "Khudozhestvennoe vospitanie v praktike moskovskikh shkol" (Art education in the everyday practice of the Moscow schools) (1927), in Staroseltseva, *Revoliutsiia, iskusstvo, deti,* 2, 136.

120. Mikhail Matiushin, "Russkie kubo-futuristy," in Khardzhiev, *K istorii russkogo avangarda,* 146.

121. Partial translation of Zhdanov's untitled speech in Bowlt, *Russian Art,* 293.

122. Ibid., 294.

123. "Razval VKhUTEMAS" (The collapse of VKhUTEMAS [Higher State Art-Technical Studios]), *Lef* (Left front of the arts), no. 4 (1924): 27–28.

How shall I see my cat in the new dimension? MIKHAIL MATIUSHIN, 1915

BEYOND REASON: MALEVICH, MATIUSHIN, AND THEIR CIRCLES

CHARLOTTE DOUGLAS

It is no coincidence that the musician and painter Mikhail Matiushin was pondering his cat's fourth-dimensional shape just as his friend Kazimir Malevich was painting his first Suprematist pictures. They wrote to each other often that year, Matiushin from Petrograd, Malevich from Moscow, both trying to break out of the stylistic and philosophical confines of Cubo-Futurism. It was evident by then that the appearance of the world was about to be radically transformed and that even companions as close and comfortable as the family cat might be unrecognizable in the new art.

The ideas discussed by the two artists were natural extensions of Cubo-Futurist aesthetic theory expounded, primarily in 1912 and 1913, by the poet Alexei Kruchenykh and published by Matiushin's small artists' press. Malevich elaborated similar ideas in painting. All three men in 1913 belonged to the Saint Petersburg-based Union of Youth organization and had exhibited in the group's shows. To put their ideas about a new art into further practice, Kruchenykh, Matiushin, and Malevich together produced the Cubo-Futurist opera *Victory over the Sun* in December 1913.

The Cubo-Futurists had evolved gradually between 1911 and 1913 from a group of poets associated with the Jack of Diamonds exhibition society in Moscow. The new movement's members included the three Burliuk

brothers: David, a poet, painter, and the group's organizing force; Vladimir, a painter; and Nikolai, a poet. The poets Velimir Khlebnikov and Kruchenykh were its primary theorists. Artists who were initially associated with the Cubo-Futurists, primarily as illustrators of small booklets of prose and poetry, included Malevich, Mikhail Larionov, and Natalia Goncharova (the latter two broke completely with David Burliuk and the Cubo-Futurists late in 1912). The poet Vladimir Mayakovski, who was to become the group's most renowned literary member, was "discovered" by Burliuk in 1911 while Mayakovski was still an art student.

Early in 1913 the Cubo-Futurists associated themselves as an independent division with the Union of Youth art organization in Saint Petersburg. This brought them into contact with Matiushin, the artist and poet Elena Guro, and the painter Olga Rozanova. Others who participated in Cubo-Futurist activities included Alexandra Exter, Benedict Livshits, Vasily Kamensky, and Vladimir Tatlin. By 1915, due especially to the pressures of World War I, the group had lost its cohesion.

In 1914 many of these artists were becoming dissatisfied with the stylistic limitations of

Cubism and Futurism, and when the Union of Youth dissolved early in the year they eagerly explored new directions. Malevich's solution to the stylistic impasse was his development in 1915 of Suprematism — a final rejection of the world of visible objects upon which all earlier styles in art and poetry had been based. For a while Matiushin joined Pavel Filonov's World Flowering, a group of artists named in anticipation of a future time of cosmic unity. Filonov, a close friend of the Cubo-Futurists, had been a member of the Union of Youth. He called his painting style "analytic" and was working on a theory of "made paintings" that would capture the inner laws of the natural world. In 1915 Matiushin published Filonov's *Propeven o prorosli mirovoi* (Chant of universal flowering), two long, neologistic poems, litanies of the horrors of war succeeded by mankind's ultimate transcendence in Filonov's vision of light and harmony.[1]

The Russian revolutions of 1917 mandated the restructuring of all social institutions, including museums and art schools, and gave the avant-garde an opportunity to participate more actively in the art establishment. In the fall of 1918 Matiushin was appointed professor at the Petrograd State Free Art-Teaching Studios, the reorganized Imperial Academy of Arts, where he devoted his studio to the study of "spatial realism." Here and later in his department of organic culture at the State Institute of Artistic Culture, Leningrad, Matiushin and his students derived their art from laboratory experiments on perception.[2] Filonov briefly headed the State Institute's department of general ideology, which tried to create a synthetic theory of modern art based on the results achieved in the other departments. In 1925 he organized the Collective of Masters of Analytical Art, where he taught his method of made paintings to a large group of students.[3] From October 1924 to February 1926 Malevich served as director of the State Institute and also conducted his own experiments in the formal and technical department, which he headed. The work of these artists assumed a more experimental and pedagogical character in the 1920s, but in every case it was an unbroken extension of artistic ideas begun long before the revolutions.

For Malevich, Kruchenykh, and Matiushin, Cubo-Futurism had always been the art of the transcendent, expressing the highly developed consciousness of a future species of humanity that would possess radically new organs of sight as well as a new and universal language. The theories of painting and writing associated with Cubo-Futurism — as stated by Kruchenykh in a variety of writings[4] — postulate a revolution in human consciousness, an evolutionary psychic change that would alter the consciousness to a state similar to that achieved through the spiritual discipline of Yoga. Indeed, Eastern mystical concepts so infused Cubo-Futurist theory that it is now difficult to isolate them as mere sources for avant-garde ideas. They are the very conceptual foundation of the entire aesthetic; they motivated its approach to poetic language and to the making of art in general.

Central to the Cubo-Futurist understanding of the new art is Kruchenykh's notion of *zaum language*, a transcendental language of the future that would be the outward manifestation of an artist's evolutionary change in consciousness as well as the mode for conveying his consequent altered perceptions. Zaum, meaning "beyond reason" or "beyond the logical mind," is a higher level of consciousness in which one has an expanded sense of logic and reason; it is not entirely emotional in concept nor merely anti-intellectual in intention. Although Khlebnikov worked with Kruchenykh on the theory of zaum and shared his belief that it would be the language of the future, Khlebnikov's approach was more consciously intellectual than Kruchenykh's. Khlebnikov saw everyday language as having evolved from older, root meanings of speech sounds; he constructed his zaum words from these primary units of meaning, which he believed were common to all languages. Predictably, Malevich found Khlebnikov too rational and preferred Kruchenykh's approach: "To me Khlebnikov's poetry belongs to reason, every letter built by him is a note for the renewed practical world's song."[5]

Kruchenykh's idea of zaum as a higher perceptual plane, beyond reason, is identical in meaning with the samadhi state in Yoga. According to Swami Vivekananda, Yoga teaches that "the mind itself has a higher state of existence, beyond reason, a superconscious state, and that when the mind gets to that superconscious state, then this knowledge

beyond reasoning comes."[6] Vivekananda taught a version of Advaita, a school of Vedantic philosophy, and *Raja-Yoga,* the influential book compiled from his popular lectures given in the United States in 1895 and 1896, was translated and published in Russia in 1906.[7] It is one of many books on Yoga, Theosophy, and related subjects that enjoyed wide popularity in Russia in the years before World War I.[8]

The spiritual and mental discipline of Yoga, especially as popularized by Vivekananda and his followers, was a consistent and far-reaching inspiration for the Russian Theosophist P. D. Ouspensky and all the theosophical writers. The related theories of William James, Henri Bergson, and Charles Howard Hinton, were also popular in Russia.[9] Ouspensky brought together and published several non-Russian versions of popular Eastern mystical thought. In *Chetvertoe izmerenie: Opyt izsledovaniia oblasti neizmerimago* (The fourth dimension: A study of an unfathomable realm) (1909) and *Tertium Organum: Kliuch k zagadkam mira* (Tertium Organum: The key to the enigmas of the world) (1911), he quoted at length from *Cosmic Consciousness* by the Canadian physician Richard Maurice Bucke, Walt Whitman's friend and editor, and from the work of Edward Carpenter, the English socialist-mystic.[10] Ouspensky also quoted extensively from Hinton's two books, *A New Era in Thought* and *The Fourth Dimension.* The theosophical works of Helena P. Blavatsky and Annie Besant, originally published in English, were also translated and read widely. All of these writers made wide use of James as a source.

Ouspensky, too, was widely influential. Kruchenykh referred to him particularly in his important theoretical essay "Novye puti slova" (New ways of the word), and Matiushin was a well-known early adherent to Ouspensky's hyperspace philosophy.[11] How-

ever, Matiushin and several other Cubo-Futurists studied Yoga and Eastern practices more directly. Ouspensky himself published a little book in 1913, *Iskaniia novoi zhizni: Chto takoe Ioga* (Search for the new life: What Yoga is), which briefly surveys the various schools. But the Cubo-Futurists were probably most affected by M. V. Lodyzhenskii's popular book *Sverkhsoznanie i puti k ego dostizheniiu* (The superconsciousness and ways to achieve it), which first appeared in 1911.[12] In this book Lodyzhenskii explained the methods employed by Raja-Yoga and by Christian asceticism to achieve the superconscious, or expanded conscious, state. Together with his discussion of these two major traditions Lodyzhenskii adopted the view — expounded by Bucke, Ouspensky, and the Theosophists and taken up by the Cubo-Futurists — that heightened consciousness is an inevitable product of organic evolution. He predicted a turning point soon to take place in human development that would permit a kind of mental clairvoyance through new physically based organs of perception.

In *Tertium Organum,* published in the same year as Lodyzhenskii's book, Ouspensky described four stages of spiritual development that are characterized in part by the ability to perceive each of the four spatial dimensions. He described the perception in the fourth and highest stage: "A feeling of four-dimensional space. A new sense of time. The live universe. Cosmic consciousness. Reality of the infinite. A feeling of communality with everyone. The unity of everything. The sensation of world harmony. A new morality. The birth of a superman."[13] This kind of synthetic vision of psychic and organic evolution is the conceptual basis for a large part of the Cubo-Futurist aesthetic.

The Cubo-Futurists generally held the panpsychic view that the universe and everything in it, organic and inorganic, is alive and possesses an inner or psychic being. This idea was inherited from a long line of panpsychists, including the Renaissance philosophers Giordano Bruno and Tommaso Campanella; Gottfried W. Leibniz, Friedrich von Schelling, and other eighteenth-century vitalists; and many scientists and philosophers of the late nineteenth and early twentieth centuries, including Gustav Fechner, Wilhelm Wundt, Arthur Schopenhauer, Ernst Haeckel, and Bergson.[14] At the turn of the century in Russia, panpsychism and neovitalism — the revival of the idea that the life in organisms is conditioned by a vital force that cannot be

reduced to inanimate substance — were among the most widely discussed topics in the popular and scholarly press.[15] Such panpsychist ideas are related to Ouspensky's "cosmic consciousness" as well as to the notion of a pervasive "world soul," a cosmic continuum of consciousness in which everyone participates to a greater or lesser degree, an idea popularized at this time by William James and by writers on Yoga. For the Cubo-Futurists, who thought that artists and prophets were more advanced than the masses, the proof of their advanced evolutionary state was the increasing participation in this consciousness of a vital universe.

The stylistic explorations of the early Russian modernists were motivated by the need for an adequate way to convey these concepts in art and poetry. Seeking a poetic expression for the elevated plane of human consciousness, Kruchenykh and the Cubo-Futurists turned to the ecstatic speech of the Russian religious sects. As early evidence of mankind's new and future clarity, Lodyzhenskii cited the ecstatic "speaking in tongues" of the Russian sectarian enthusiasts and referred to D. G. Konovalov's *Religioznyi ekstaz v russkom misticheskom sektantstve* (Religious ecstasy in Russian mystical sectarianism) (1908).[16] Lodyzhenskii claimed that at the moment of religious ecstasy, when the sectarians emit an automatic stream of senseless words, they are "in a state close to samadhi."[17] Detailed information about the methods of worship practiced by groups such as the Flagellants and the Castrators had been buried in the anthropological and ethnographical field reports made by various governmental bodies during the nineteenth century; in 1908 this information was compiled and analyzed by Konovalov. In *Religioznyi ekstaz* he gave a physical description of the ecstatic state: the change in organic functioning of the participants, their excited facial expressions and bodily movements, and at the moment of most extreme ecstasy their automatic utterances, the speaking in tongues. From the ethnographic field reports he reproduced a variety of the nonexistent "words," sometimes rhyming and in verse, produced by the worshipers and related the claim by some that their glossolalia, or

tongue, was actually a new language. Some sectarians considered their automatic speech to be in foreign languages unknown to them, languages in which conversations might even be conducted; one group called it the "language of Jerusalem."[18]

"Art goes in the vanguard of the psychic evolution," Kruchenykh quoted Ouspensky approvingly in 1913.[19] He wrote that "for the depiction of the new and the future *completely new words and a new combination of them* are necessary"; "a new content is only revealed when new devices of expression, a new form, is attained."[20] In *Vzorval* (Exploded), published in June 1913, Kruchenykh acknowledged sectarian automatic speech as a source for zaum and quoted from Konovalov's examples. In "Novye puti slova" (New ways of the world), published in September, he again drew his discussion of language from Konovalov's book on religious ecstasy.[21] Furthermore, in a humorous but direct imitation of the sectarian beliefs quoted by Konovalov, he reported that "On 27 April, at 3 o'clock in the afternoon, I momentarily commanded all languages."[22]

Kruchenykh's zaum poetry was modeled on the directly expressed perception of a person in the superconscious state of samadhi. Malevich, before he discovered Suprematism, had hoped that his Cubist style of painting could function as the visual expression of zaum. Matiushin had interspersed quotations from Ouspensky's *Chetvertoe izmerenie* and *Tertium Organum* with his translation of excerpts from Albert Gleizes and Jean Metzinger's *Du Cubisme* (1912), drawing an analogy between the Cubist vision, with its implication of higher geometries, and zaum.[23] For the same reason Malevich characterized the style of his 1912–13 Cubist depictions of peasant figures embedded in a landscape, such

as *Morning in the Village after the Snowstorm,* 1912 (pl. 1), and *Carpenters' Scene,* circa 1912 (pl. 2), as "Zaum realism"; clearly he did not intend them to be irrational but to express a concrete, but higher, order of reality. He wrote to Matiushin in the summer of 1913:

> We have come as far as the rejection of reason, but we rejected reason because another kind of reason has grown in us, which in comparison with what we have rejected can be called beyond reason [*zaumnyi*] which also has law, construction and sense, and only by learning this shall we have work based on the law of the truly new "beyond reason." This reason has found Cubism for the means of expressing a thing. . . .
>
> We have arrived at beyond reason. I don't know whether you agree with me or not, but I am beginning to understand that in this beyond reason there is also a strict law that gives pictures their right to exist. And not one line should be drawn without the consciousness of its law; then only are we alive.[24]

Thus even before the development of Suprematism what Malevich had in mind for his art was not a personal intuitive expression but an ultimately rational and well-thought-out art, an art calculated to demand from the viewer the superlogic available only in the state of zaum.

In 1914 Malevich turned to a new style of painting but with the same purpose in mind. His Alogist pictures, such as *An Englishman in Moscow,* 1913–14 (pl. 3), and *Composition with Mona Lisa,* 1914, project a dense collection of whole and partial images, words, collage elements, objects fastened to the canvas, and puzzling titles. These hermetic works, although ultimately decipherable, resist any easy understanding by the viewer because they replace the structural "higher geometries" of Cubism with the secret logic of content devised by the artist.

By the spring of 1915 Malevich had resolved to abandon the depiction of objects and the use of representational forms altogether.[25] Rather than attempt to induce the zaum or samadhi state in the viewer through Cubo-Futurist styles of painting, he tried to give direct visual form on the canvas to zaum perceptions. He decided that the objects of even partially representational styles tie the mind to limited forms of reason and so prevent the viewer's final step into the state of higher consciousness.

Probably Malevich solved the problem of giving a visual image to zaum through reading descriptions by Hinton and Ouspensky of the geometric cross-sections produced by a cube falling through a plane. This sort of visual analogy had often been used to help explain the concept of perceiving four-dimensional figures in a three-dimensional world. Claude Bragdon, known for his writings on the fourth dimension, had even illustrated this process in two books, and it seems likely that these provided some of the formal vocabulary of Suprematism.[26] The motivation to adopt objectlessness, indeed the very word itself, which was used by the Russian avant-garde in preference to the Western term *abstraction,* is related to the objectless perception described by the teachings of Yoga as characteristic of the superconscious state of samadhi. Vivekananda explained how to achieve this way of seeing:

> [If one is] able to reject the external part of the perception and meditate only on the internal part, the meaning, that state is called samâdhi. . . . This meditation must begin with gross objects and slowly rise to finer, until it becomes objectless. . . . If the mind can first concentrate upon an object, and then is able to continue in that concentration for a length of time, and then, by continued concentration, can dwell only on the internal part of the perception, of which the object was the effect, or gross part, everything comes under its control. This meditative state is the highest state of existence.[27]

Malevich's writings at the time he created Suprematism demonstrate his familiarity with the mental discipline and practice of Yoga, especially with its primary idea that "each man is only a conduit for the infinite ocean of knowledge and power that lies behind mankind."[28] Yoga of the Vedanta school and as taught by Vivekananda maintains that meditation on the self can give access to the cosmos. As the sensation of the self expands, the individual encompasses the totality of the world, losing all particularity and becoming identical with the universe as a whole, with the pure consciousness of the divine being. Through close observation of the self, an intense concentration directed toward the internal world, one can attain knowledge of all things: "No books, no scripture, no science, can ever imagine the glory of the Self, which appears as man — the most glorious God that ever was, the only God that ever existed, exists, or ever will exist. I am to worship, therefore, none but my Self. 'I worship my Self,' says the Advaitist. 'To whom shall I bow down? I salute my Self.'"[29] Malevich's writing at the time of early Suprematism revealed a similar understanding of the self: "This is how I reason about myself and elevate myself into a Deity saying that I

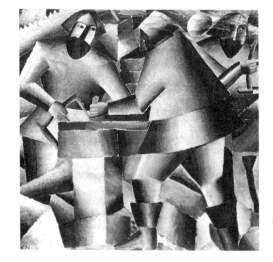

1
KAZIMIR MALEVICH
Morning in the Village after the Snowstorm, 1912
Oil on canvas
31 ¾ x 31 ⅞ in.
(80.6 x 81 cm)
Solomon R. Guggenheim
Museum, New York

·

2
KAZIMIR MALEVICH
Carpenters' Scene, c. 1912
Oil on canvas
31 ½ x 31 ½ in. (80 x 80 cm)
Location unknown

·

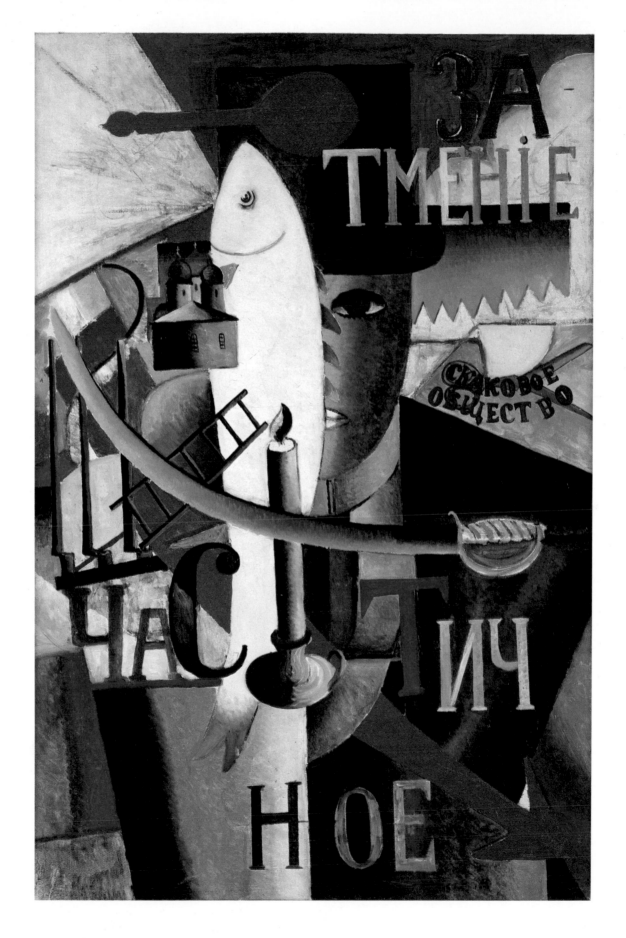

3
KAZIMIR MALEVICH
An Englishman in Moscow,
1913–14
Oil on canvas
34 5/8 x 22 7/16 in. (88 x 57 cm)
Stedelijk Museum,
Amsterdam

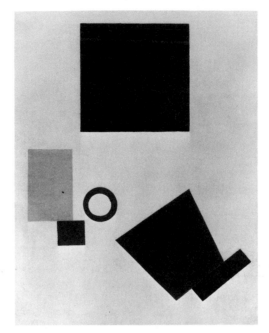

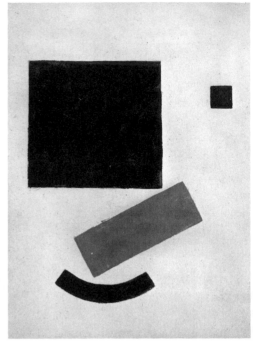

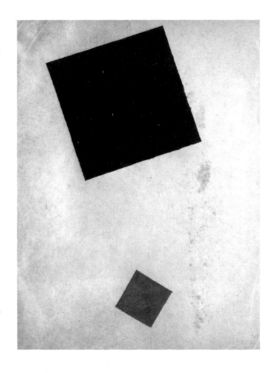

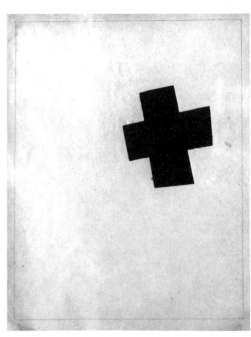

4
KAZIMIR MALEVICH
Suprematist Composition: Red
Square and Black Square, 1914
or 1915?
Oil on canvas
28 x 17 ½ in. (71.1 x 44.5 cm)
The Museum of Modern Art,
New York

·

5
KAZIMIR MALEVICH
Suprematist Painting, 1915
Oil on canvas
31 ½ x 24 ⅜ in. (80 x 62 cm)
Stedelijk Museum,
Amsterdam

·

6
KAZIMIR MALEVICH
Suprematism, c. 1915
Pencil and gouache on paper
12 ½ x 9 ½ in.
(31.8 x 24.1 cm)
Ahmet and Mica
Ertegun

·

7
KAZIMIR MALEVICH
Suprematism, c. 1915
Pencil and gouache on paper
11 ⅝ x 8 ⅞ in.
(29.5 x 22.5 cm)
Ahmet and Mica
Ertegun

·

8
KAZIMIR MALEVICH
Suprematism, c. 1915
Pencil and gouache on paper
12 ¾ x 9 ½ in.
(32.4 x 24.1 cm)
Ahmet and Mica
Ertegun

·

am all and that besides me there is nothing and
all that I see, I see myself, so multi-faceted and
polyhedral is my being''; and ''I am the begin-
ning of everything, for in my consciousness
worlds are created. I search for God, I search
within myself for myself. God is all-seeing,
all-knowing, all-powerful. A future perfec-
tion of intuition as the oecumenical world of
supra-reason.''[30]

Malevich has often been mistakenly regarded
as the champion of the intuitive in art. His
notion of intuition is not the common one; in
Malevich's usage it takes on the same special
connotation that it has in the practice of Yoga.
Far from being a passive and anti-intellectual
approach to art, in both Malevich's work and
in Yoga intuition is regarded as an active way
of thinking, the result of concentrated intel-
lectual effort. Analytical logic alone is under-
stood to be too limiting, but the intuitive
principle includes analytical logic, even as it
aspires to acquire knowledge beyond what
that logic can offer. Indeed, Malevich often
called this intuition, which was the psychic
source of Suprematism, ''intuitive reasoning''
or ''intuitive will.''[31]

Malevich's early Suprematist works (pls. 4–8)
are contemplative images, aids to attaining the
zaum state, visions of that ''empty place
where nothing is perceived but sensation,'' as

he described it.[32] Suprematist images were images of the supreme reality, the product of the yogi's search within himself for the world and the discovery of his own image, his own face, in the face of nature: "I search for God, I search for my face, I have already drawn its outline and I strive to incarnate myself."[33]

Although in the years following 1915 Malevich attempted to move beyond complete abstraction, for a long time he found figurative images constricting and unsatisfactory: the square became the most affective image. Through successive elimination, the stripping away of distinctive attributes, a method recommended in the Upanishads, he seems to have attained the profound sensation of the invariable self as all; all human distinctions were finally illusory. In 1923 Malevich's group at Petrograd's Museum of Artistic Culture exhibited blank canvases, and he published "Suprematicheskoe zerkalo" (The Suprematist mirror):

Amongst all the changing phenomena the essence of nature is invariable. The World as human distinctions (God, The Soul, The Spirit, Life, . . .) = 0.

1. Science and art have no boundaries because what is comprehended infinitely is innumerable and infinity and innumerability are equal to nothing. . . .

8. There is no existence either within or outside me; nothing can change anything, since nothing exists that could change itself or be changed.[34]

Directly after the revolution Malevich and his students often combined space-flight imagery with Suprematism, giving it a veneer of cosmic utopianism. A more abstract treatment of this theme was developed by Ivan Kudriashev, who learned Suprematism in Malevich's painting classes at the State Free Art Studios in Moscow in 1918 and 1919. Kudriashev was interested in satellites and space travel and probably pointed Malevich in that direction. Kudriashev's father built the working models for Konstantine Tsiolkovsky, the great Russian pioneer of rocketry. More than by the mechanical possibilities of interplanetary flight, Kudriashev was undoubtedly attracted by the cosmic philosophy enthusiastically espoused by Tsiolkovsky, whom he knew personally and admired greatly. Tsiolkovsky, who had once been a student of the cosmic-utopian philosopher Nikolai Fedorov, was a panpsychist, and his philosophy synthesized Eastern and theosophical concepts with ideas drawn from natural science.[35] Tsiolkovsky's philosophy had natural affinities with Suprematism, and in Kudriashev's hands Malevich's style was turned into a colorful cosmic abstraction (pl. 9). Throughout the

1920s his work was geometrically based and depicted dynamic motion through a deep and limitless space.

Before the introduction of Malevich's Suprematism, Matiushin also had thought that Cubism would provide the method of depicting the unseen, unified cosmos. In his 1913 introduction to excerpts from Gleizes and Metzinger's *Du Cubisme,* he wrote: "Artists have always been knights, poets, and prophets of space, in all times, sacrificing to everyone, dying, they were opening eyes and teaching the crowd to see the great beauty of the world concealed from it. So also now; Cubism has raised the flag of the New World, of the new learning about the merging of time and space."[36] By the following year, however, Cubism began to seem limiting to him, too mechanical for the expression of ideas on a cosmic scale and, like Filonov and Malevich, Matiushin began to look for a new style in art, one that would more adequately reflect his understanding of a great natural world.

In 1914 Filonov had organized a small group of painters whom he invited Matiushin and Malevich to join. Its synthetic philosophy, which he called "world flowering," was based on an aesthetic evolutionism that had much in common with Ouspensky's ideas but that, in addition, insisted on the same extremes of intellectual and physical effort called for in Raja-Yoga. Filonov gave primary importance in his art to *sdelannost* (the quality of being made, well made, or finished). Working continuously and intensely on a piece until he considered it "made," he eschewed all sketches and preliminary studies.

For Filonov the idea of concentrated work was not only a practical approach to art and the basis of his aesthetics of "made paintings" but also a mode of spiritual discovery for the artist: "Revelation occurs only after long, persistent work . . . the new is discovered through hard work," he wrote in his declaration "Sdelannye kartiny" (Made paintings) of 1914. Through persistent effort the artist embodies "his immortal soul" in the work of art, imparting to it a fully religious significance. A made painting demands that the artist attend to all the complexities of the universe with "purity," "exactness," and "control" so that the resulting work becomes the concrete intermediary between the universe and humanity. Paintings produced in this way "should be such that people would come from all the countries of the world to pray to them."[37]

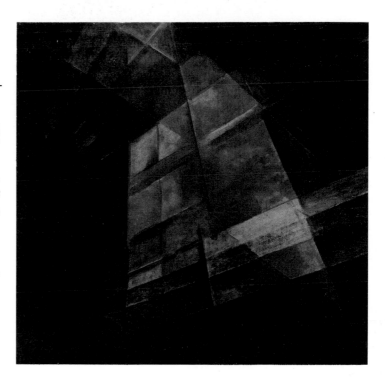

9
IVAN KUDRIASHEV
Construction of a Rectilinear Motion, 1925
Oil on canvas
26 1/8 x 27 13/16 in.
(66.3 x 70.7 cm)
The George Costakis Collection (owned by Art Co. Ltd.)
© George Costakis, 1981

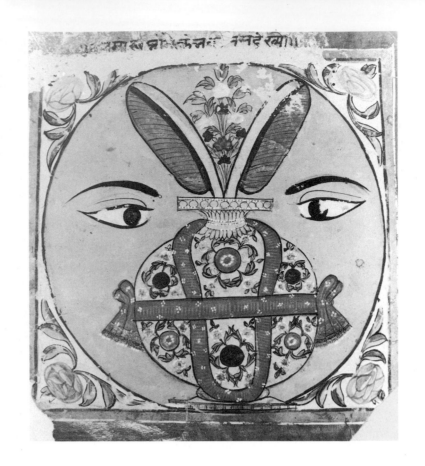

10
PAVEL FILONOV, illustration for Velimir Khlebinikov, "To Perun," from *Selection of Poems* (1914)

.

11
Tantra Divinity on Ceremonial Water-Pot, Rajasthan, 19th century, gouache on paper, no. 31 from Philip Rawson, *Tantra: the Indian Cult of Ecstasy* (1984)

.

There is no clear indication in his writings that Filonov was a panpsychist, although it is apparent from both his art and writing that he was familiar with Indian tantric art and ideas and that he was a neovitalist, believing in a vital force that operates within all living things (pls. 10–11). Filonov's universe is complex and fluid, and the artist is obliged to use all means, rational and irrational, to encompass it: "I know, analyze, see, feel by intuition that in any object there are not just the two predicates of form and color, but a whole world of visible and invisible phenomena, their emanation, reactions, interfusions, geneses, separate realities, and known or unknown qualities which, in turn, sometimes contain innumerable predicates."[38] Filonov even maintained that the process of making a painting should reproduce the growth process as closely as possible (pl. 12).

It is understandable that Matiushin comprehended Filonov's art in terms of the living universe. The idea that humanity's evolution is but one component of the world's evolution may be expanded easily into a vision of the earth as a living creature or of the world as an organism analogous to the human body, existing in interdependence with its environment and producing other living organisms as a

consequence of its own vitality. Matiushin praised Filonov's world flowering for revealing

the expanded limits of the new sound, the new understanding of the word as a self-sufficient sound, and finally, the slow rhythm of life beating in the inorganic life of a crystal.

All has become understood in a new way. The world has become inhabited, not with a scattered humanity, but with the great general body of a god.[39]

The subject of several of Matiushin's paintings is crystals in which he perceived "the slow rhythm of life." He even produced a kind of self-portrait as a crystal (pl. 13). In the shapes of trees, branches, and roots Matiushin and his students saw the manifestation of the invisible vitality of the earth and its interactions with its creatures (pl. 14). At the 1919 First State Free Art Exhibition, in the same room with Filonov's paintings, he exhibited ten "found" roots as abstract sculpture (pl. 15).

After the revolution Matiushin and his students conducted experiments on the perception of space, color, form, and sound. In his studio for spatial realism at the Petrograd State Free Art-Teaching Studios, he tried to teach his students (among whom were Boris,

12
PAVEL FILONOV
Formula of Spring, c. 1923
Oil on canvas
30 11/16 x 38 3/4 in.
(78 x 98.5 cm)
Russian Museum, Leningrad
·

13
MIKHAIL MATIUSHIN
Crystal, c. 1920
State Museum of the History
of Leningrad, Leningrad
·

14
BORIS ENDER
Movement of Organic Form,
1919
Oil on canvas
40 15/16 x 39 3/8 in.
(104 x 100 cm)
The George Costakis
Collection (owned by Art
Co. Ltd.)
© George Costakis,
1981
·

15
MIKHAIL MATIUSHIN
Movement of Roots, 1919
Tree root
Dimensions unknown
Location unknown
·

Maria, Xenia, and Yuri Ender [pls. 16–20])[40] to expand their peripheral vision, to develop the ability to see first at a wider than usual angle, then at an angle of 180 degrees, and finally behind themselves, through the back of the head, in a complete 360 degrees. To widen the vision he developed exercises to teach the artist to see with each eye independently, to purposely cultivate a kind of strabismus. He called this phenomenon "expanded viewing" and believed it was the analogue in vision to the expansion of consciousness in Yoga, particularly as it was described by Lodyzhenskii.[41]

For Matiushin expanded viewing was a way for the artist to plunge into the real space of the universe, to see the world as it appeared in meditation and as it would appear to everyone in the future, without barriers and lacking all directional references. Only with such vision, which he specifically associated with abstraction in art, could the artist be expected to cultivate an art that would reflect the true nature of reality.[42] Matiushin's group and the process as a whole was dubbed *Zorved* (see-know); in 1923 they published a manifesto explaining: "*Zorved* signifies a physiological change from former ways of seeing and entails a completely different way of representing what is seen. *Zorved* for the first time introduces ob-

servation and experience of the hitherto closed 'back plane,' all that space which remains outside the human sphere because of insufficient experiment."[43]

Matiushin was quite serious about the ability to see through the back of the head. Much of the Eastern-influenced literature of the time spoke of a special organ for perceiving visual impressions, which did not rely on the physical eye. This organ, or visual center in the brain, was invoked to explain statements by sleepwalkers that they "see" and their obvious ability to negotiate obstacles. Vivekananda explained it this way: "The eyes do not really see. Take away the nerve center which is in the brain; the eyes will still be there, with the retinae complete, as also the picture of objects on them, and yet the eyes will not see. So the eyes are only a secondary instrument, not the organ of vision. The organ of vision is a nerve centre in the brain."[44] It was this nerve center that Matiushin hoped to train in young artists to increase their sensitivity to the new space and the forms within it. Boris Ender noted in his diary in March 1920: "There exists an internal eye analogous to the internal sense of hearing

with which Beethoven worked without a direct sense of hearing. . . . The figurative picture is a subordination of the internal eye to the direct vision."[45]

Complementing his studies of spatial perception Matiushin also explored the action and interaction of color, shape, and sound. He believed that just as the perception of space was evolving in mankind so also was the perception of color. With time the color-receiving cones in the eye would spread from the center of the retina toward its periphery. Man was not only developing a capacity for better color vision, he was also sharpening his ability to see color in motion because the perception of motion is more acute at the edge of the retina than at the center. In Matiushin's world view such an ability is extremely important because color and motion are two irreducible properties in man's relation with his environment. Although in the 1920s his

work on color and space assumed the character of scientific experiments, the specifically theosophical inspiration of Matiushin's ideas, acknowledged early in his career, did not diminish at this time. The effects he was investigating continued to be similar to those described by Hinton, Ouspensky, and others (pls. 21–22).

Matiushin experimented with movable models of simple forms and colors in a controlled environment (pl. 23). Altering one or more conditions of the environment or the method of viewing, he observed changes in both the color and form of the models. He found that sound influences the perception of color: a low, rough noise darkened and reddened a given color, while a high, sharp note made it transparent and bluish. He and the Enders studied the simultaneous contrast of complementary colors and the deformations induced by color changes in static figures (pl. 24). Much of the art produced by the Enders in this period is in fact a recording of the results of these experiments. In particular they documented, with great care and sensitivity, the tendency of color to affect perceived shape (pl. 25).

21
Watchful Jealousy, fig. 25 from
Annie Besant and Charles W.
Leadbeater, *Thought-Forms*
(1905)

.

22
MIKHAIL MATIUSHIN
Color-Form, c. 1929
Painted wood
Russian Museum, Leningrad

.

A 1925 bureaucratic document of the State Institute of Artistic Culture characterized the activities of Matiushin's studio:

The Organic Culture Section, consisting of M. I. [sic] Matyushin, as the Head, B. V. Ender and K. V. [Xenia] Ender, as scientific collaborators, is studying the perception of pictorial elements by the human organism. The basic questions in this case are, on the one hand, the variability of colour and form depending upon the varying conditions of visual perception in time and space (broadening of the angle of vision) and, on the other, the participation in visual perception of the entire cerebro-neural system, and not merely the mechanism of the eye alone. In this case, the outcome of the experimental work was the elaboration of tables showing the variability of the primary colours of the spectrum and of the most elementary forms, as well as a series of observations in the field of so-called "additional sight."[46]

In 1929, after the State Institute of Artistic Culture had been liquidated and the subsequent Institute of the History of Arts closed, Matiushin began to compile his work on color into a book that described his experiments and conclusions. After three years of planning and work Matiushin's *Zakonomernost izmeniaemosti tsvetochnykh sochetanii. Spravochnik po tsvetu* (The natural law of variability of color combinations. A color guide) was published in 1932.[47] It consisted of a printed brochure written by Matiushin and a packet of hand-colored, foldout tables illustrating basic colors and their color environment. Maria Ender wrote the introduction and the explanation of the tables. In some respects the concept is similar to those of M. E. Chevreul and Ogden N. Rood,[48] but Matiushin introduced a middle, or "coupling," color that supposedly links any two colors, creating color balance without destroying the expressiveness of the basic pair. The tables are without a doubt works of art in themselves, so exquisite and luminous is their color.[49]

Matiushin is quite correctly considered a pioneer of color studies that had applications for the fledgling science of industrial design, and his may be considered some of the most interesting experiments in the formal properties of painting. Matiushin's whole program, however, had another, more ambitious purpose.

23
Mikhail Matiushin with movable color apparatus in laboratory, 1920s

·

24
MIKHAIL MATIUSHIN
Deformations Due to Color: Original Form, Alteration of Form, First Afterimage, Second Afterimage, 1926–27
Gouache on paper
Stedelijk Museum, Amsterdam

He and the Enders sought to take the measure of an ultimate reality and, through painstaking experiments done on one part of it, to determine the nature of the whole universe. For Matiushin, as for the Indian mystics and their various descendants, the sensible world concealed a continuous animate universe of mental life. Matiushin found that not only mystics but also scientists supported this view. Fechner's well-known 1860 study of psychophysics was motivated by his belief in the indivisible unity of the world, in the unbroken continuity between matter and spirit.[50] So too for Matiushin the changes in color and form observed in the laboratory were not merely perceptual; they were real. In their slight, barely observable variations he felt he was detecting the subtle connections between all things. Like Fechner, who had experimented with several kinds of threshold phenomena, including extremely faint shades of color, Matiushin believed that the psychic is the inner side of the physical. Subtle, barely observable changes in phenomena as fun-

damental as color, sound, and form give evidence of the unseen world, accessible through meditation but of which we are normally unaware.

The Cubo-Futurists and many of the artists associated with them believed that they were in the vanguard of an immense change that was occurring or about to occur in the world. They strongly felt the universal laws that governed such changes, on both the personal and the aesthetic levels. They saw the stylistic transitions in art, especially the transition to abstraction as a fine art, as already an immense change and a sign of greater things to come. The political revolution, when it happened, seemed only to confirm this.

In Russia many of the new artistic styles were motivated by the desire to deal more adequately than before with what was "real," insofar as that reality could be grasped. Reality for the Cubo-Futurists was defined by late nineteenth-century science: an amalgam of evolutionary ideas, German psychophysics, and resurrected eighteenth-century vitalism. Ultimately it was the practices of Yoga and similar mystically inclined religious dis-

ciplines that provided the practical methods of applying these concepts to art.

Malevich and his circle were concerned with the cultivation of styles that were compatible with scientific ideas, and to that extent at least, their approach may be considered rational. Their aesthetics resulted from a unified world view that encompassed all dichotomies; for them science and Eastern mystical ideas were seamlessly joined in a conceptual continuum, and knowledge of the world might be obtained by beginning at any point.

Strangely, in the end the art of the Russian Cubo-Futurists seems to give us not the future but the eternal present. In their art, as in the transcendent state of zaum, the observer is conscious only of an everlasting now, a self-sufficient being, in a world radically transformed. It was their awareness of this other world, whose living presence could only be shadowed forth, that allowed artists to number themselves among the new, advanced species; it was only in this sense that they considered themselves people of the future. Their art was intended both to induce and reflect this new consciousness, to serve as a passport to and report from the transcendent order of reality. Clearly, only an objectless art could fulfill this role.

25
MIKHAIL MATIUSHIN AND
XENIA ENDER
Lake, 1925
Watercolor on paper
9 ½ x 10 ¹³⁄₁₆ in.
(24.4 x 27.7 cm)
The George Costakis
Collection (owned by Art
Co. Ltd.)
© George Costakis,
1981

1. P. Filonov, *Propeven o prorosli mirovoi* (Chant of universal flowering) (Petrograd: Mirovyi raztsvet, 1915).

2. Mikhail Matiushin began his studio of spatial realism at the Petrograd State Free Art-Teaching Studios, the reorganized Academy of Arts, in 1918. The following year this school was renamed the State Free Art Studios, and in 1921 it was again called the Academy of Arts. In addition to teaching at this studio, at the end of 1922 Matiushin began to do experimental work in the research division of the Museum of Artistic Culture. In October 1924 this museum was reorganized into a research institute, the State Institute of Artistic Culture.

3. Pavel Filonov's collective continued until 1932, when it was officially dissolved by the general decree "Reconstruction of Literary and Artistic Organizations."

4. A. Kruchenykh, "Poshchechina obshchestvennomu vkusu" (A slap in the face of public taste), in *Poshchechina obshchestvennomu vkusu* (Moscow: Kuzmin, 1912); *Vzorval* (Exploded) (Saint Petersburg: EUY, 1913); *Sadok sudei II* (A jam for judges II) (Saint Petersburg: Zhuravl, 1913); "Novye puti slova" (New ways of the word), in *Troe* (Trio) (Saint Petersburg: Zhuravl, 1913); *Deklaratsiia slova, kak takovogo* (Declaration of the word as such) (Saint Petersburg, 1913).

5. Kazimir Malevich, "About Zangezi," in *K. S. Malevich: The Artist, Infinity, Suprematism (Unpublished Writings 1913–33),* ed. Troels Andersen (Copenhagen: Borgens Forlag, 1978), 97.

6. Quoted in William James, *The Varieties of Religious Experience* (1902; New York: New American Library, 1958), 307.

7. Swami Vivekananda, *Filosofiia Ioga: Lektsii o Radzha Ioge, so vkliucheniem aforizmom (sutr) Patandzhali* (The Yoga philosophy: Lectures on Raja-Yoga, with Patanjali's Yoga aphorisms), trans. Ia. Popov (Sosnitsa, 1906). Other works in Russian by Vivekananda include *Bkhatki Ioga* (Bhakti-Yoga) (1914), *Karma Ioga* (Karma-Yoga) (1913, 1914), and *Dzhnana Ioga* (Jnana-Yoga) (1914).

8. The appearance of books on mystical topics in Russia at this time was due in part to the general expansion of publishing activities in the wake of the 1905 liberalization of the censorship laws. The Novyi Chelovek (New man) publishing house in Saint Petersburg was especially active in the translation of books in this area; in addition to most of the Vivekananda books, it issued Swami Abedananda, *Kak sdelatsia Iogom* (How to become a Yogi) (1914); the works of Yogi Ramacharaka [William Walker Atkinson], including *Puti dostizheniia indiiskikh iogov* (Paths to attainment of the Indian Yogis) (1913), *Osnovy mirosozertsaniia indiiskikh iogov* (Fundamentals of the world view of the Indian Yogis) (1913), *Nauka o dykhanii indiiskikh iogov* (The Indian Yogi's science of breathing) (1913), *Religiia i tainyia ucheniia vostoka* (Religion and the secret doctrines of the East) (1914), *Zhnana-Ioga* (Jnana-Yoga) (1914), *Radzha-Ioga* (Raja-Yoga) (1914), and *Khatkha Ioga* (Katha-Yoga) (1914); and works by Helena P. Blavatsky, Annie Besant, Charles W. Leadbeater, Charles Howard Hinton, Richard Maurice Bucke, and P. D. Ouspensky.

9. A version of James's *Principles of Psychology* appeared in Russian in 1905 as *Psikhologiia*, trans. Lapshin (Saint Petersburg, 1905); and *The Varieties of Religious Experience* (1902) was published as *Mnogoobrazie religioznago opyta,* trans. V. G. Malakhieva-Mirovich, ed. S. V. Lurie (Moscow: Russkaia mysl, 1909). Every major work of Henri Bergson that appeared by the middle of 1914 had been translated into Russian, including *Creative Evolution* as *Tvorcheskaia evoliutsiia,* trans. M. Bulgakov (Moscow: Sotrudnichestvo, 1909); *Time and Free Will* and *An Introduction to Metaphysics* as *Vremia i svoboda voli, s prilozheniem stati "Vvedenie k metafizike"* (Moscow: Russkaia mysl, 1911); and *Matter and Memory* as *Materiia i pamiat,* trans. A. Bauler (Saint Petersburg: Zhukovskii, 1911). A five-volume collection of Bergson's writings

was published in Russian translation in 1913–14. Although Hinton was quoted early by Russian sources, notably by Ouspensky in *Tertium Organum: Kliuch k zagadkam mira* (Tertium Organum: The key to the enigmas of the world), complete translations of his books did not appear until 1915 in Russia. These included *Vospitanie voobrazheniia i chetvertoe izmerenie* (Training the imagination and the fourth dimension), with introduction by P. D. Uspenskii (Petrograd: M. Pirozhkov, 1915) and *Chetvertoe izmerenie i era novoi mysli* (The fourth dimension and an era of new thought) (Petrograd: Novyi chelovek, 1915).

10. P. D. Uspenskii, *Chetvertoe izmerenie: Opyt izsledovaniia oblasti neizmerimago* (The fourth dimension: A study of an unfathomable realm) (Saint Petersburg: Trud, 1909); and *Tertium Organum: Kliuch k zagadkam mira* (Saint Petersburg: Trud, 1911). Bucke and Edward Carpenter were also individually published in Russia. Bucke's *Cosmic Consciousness* (Philadelphia: Innes, 1901) appeared in Russian in 1915 as *Kosmicheskoe soznanie* (Petrograd: Novyi chelovek, 1915). Carpenter was published in Russia from 1906, and his ideas were widely discussed in the popular press. Ouspensky translated Carpenter's *The Intermediate Sex* as *Promezhutochnyi poll* (Petrograd: Pirozhkov, 1916) and wrote introductions to the Russian versions of Carpenter's *Love and Death* in *Liubov i smert* (1915; Petrograd: Pirozhkov, 1916) and Hinton's *Fourth Dimension* in *Vospitanie voobrazheniia i chetvertoe izmerenie* (Petrograd: Pirozhkov, 1915).

11. Matiushin's archive, Pushkin House, contains a manuscript dated 1912–13, "The Sensation of the Fourth Dimension" (in Russian). See Alla Povelikhina, "Matiushin's Spacial System," *Structurist,* 15–16 (1975–76): 70 n. 15. In March 1913 he excerpted *Tertium Organum* in a commentary on Albert Gleizes and Jean Metzinger's *Du Cubisme;* for an English translation of this text, see Linda Dalrymple Henderson, *The Fourth Dimension and Non-Euclidean Geometry in Modern Art* (Princeton: Princeton University Press, 1983), 368–75.

12. P. D. Uspenskii, *Iskaniia novoi zhizni: Chto takoe Ioga* (Search for the new life: What Yoga is) (Saint Petersburg: Novyi chelovek, 1913), 12–13, in which his discussion of Yoga concludes with a description of the work of James, Bucke, and Hinton; and M. V. Lodyzhenskii, *Sverkhsoznanie i puti k ego dostizheniiu* (The superconsciousness and ways to achieve it) (1911) (Saint Petersburg: by the author, 1912). The third edition (1915), entitled simply *Sverkhsoznanie*, brings the references to Yoga up to date and adds an appendix, "Hindu Satanism," in which Lodyzhenskii explains that he had since become a believing Christian. *Sverkhsoznanie i puti k ego dostizheniiu* was the first volume of a mystical trilogy; the other volumes were *Svet nezrimyi: Iz oblasti vysshei mistiki* (Invisible light: From the realm of higher mysticism) (1912) (Saint Petersburg: by the author, 1915) and *Temnaia sila* (The dark force) (1913) (Saint Petersburg: by the author, 1914).

13. Uspenskii, *Tertium Organum,* 260.

14. More recently panpsychic views have been held by such philosophers as Alfred North Whitehead, Charles Hartshorne, Pierre Teilhard de Chardin, and C. H. Waddington.

15. For a discussion of neovitalism and other biological ideas in Russian modernism, see Charlotte Douglas, "Evolution and the Biological Metaphor in Modern Russian Art," *Art Journal* 44, no. 2 (Summer 1984): 153–61.

16. D. G. Konovalov, *Religioznyi ekstaz v russkom misticheskom sektantstve* (Religious ecstasy in Russian mystical sectarianism) (Sergiev Posad: Troitse-Sergiev Monastery, 1908), was also serialized in the periodical *Bogoslovskii vestnik* (Theological messenger). Lodyzhenskii mentions another book by Konovalov, *Psikhologiia sektantskago ekstaza* (The psychology of sectarian ecstasy) (Sergiev Posad: Troitse-Sergiev Monastery, 1908), but I have been unable to find any trace of this work.

17. Lodyzhenskii, *Sverkhsoznanie* (1915), 225.

18. Konovalov, *Religioznyi ekstaz,* 168.

19. Quoted in Kruchenykh, "Novye puti slova," in Vladimir Markov, *Manifesty i programmy russkikh futuristov* (Manifestos and programs of the Russian Futurists) (Munich: Wilhelm Fink Verlag, 1967), 66. The quotation is from *Tertium Organum* and was probably taken from Matiushin's publication of excerpts from this book in the *Union of Youth* journal six months earlier.

20. Kruchenykh, "Novye puti slova," in Markov, *Manifesty,* 68, 72.

21. Alexei Kruchenykh, *Vzorval* "letter," 61–62, and "Novye puti slova," 67, both in Markov, *Manifesty*. Kruchenykh does not credit Konovalov, but the quotations are exact. Markov notes Kruchenykh's source in both *Russian Futurism* (Berkeley: University of California Press, 1968), 202, and in the notes to the texts in *Manifesty*.

22. Compare Konovalov, *Religioznyi ekstaz,* 168 — "Able people understand these new languages and talk to everybody" — with Kruchenykh, *Vzorval* "letter," 61, and "Novye puti slova," 67, both in Markov, *Manifesty*. It is interesting to note that as part of the ideological criticism suffered by Filonov in 1931, the language and rhythm of his *Propeven o prorosli mirovoi* of 1915 was disparagingly compared with sectarian rites. See Nicoletta Misler and John E. Bowlt, *Pavel Filonov: A Hero and His Fate* (Austin: Silver Girl, 1984), 41.

23. M. V. Matiushin, "O knige Metsanzhe-Gleza 'Du Cubisme'" (On Metzinger and Gleizes's *Du Cubisme*), *Soiuz molodezhi* (Union of youth) 3 (March 1913): 25–34.

24. Malevich to Matiushin, summer 1913, undated, archives of the Tretiakov Gallery, Moscow, f. 25, no. 9, sheets 11–12.

25. Judging by Malevich's correspondence with Matiushin, Suprematism was developed during the few months preceding May 1915.

26. Claude Bragdon, *Man the Square: A Higher Space Parable* (Rochester: Manas Press, 1912); and idem, *A Primer of Higher Space (The Fourth Dimension), to Which Is Added "Man the Square: A Higher Space Parable"* (Rochester: Manas Press, 1913). For a discussion of this problem, see Henderson, *The Fourth Dimension,* chap. 5.

27. Swami Vivekananda, *Raja-Yoga,* in *Vivekananda: The Yogas and Other Works,* ed. Swami Nikhilananda (New York: Ramakrishna-Vivekananda Center, 1953), 616.

28. Ibid., 577.

29. Swami Vivekananda, *Jnana-Yoga,* in *Vivekananda,* 316. The theme of the identity of self with the world should be familiar to readers of the American poet Walt Whitman. The Russian Cubo-Futurists' well-known admiration for Whitman is due in part to the congeniality they felt with his view of the world, which coincides remarkably with Vedantic philosophy (see V. K. Chari, *Whitman in the Light of Vedantic Mysticism* [Lincoln: University of Nebraska Press, 1964, 1976]).

30. Kazimir Malevich, "Korre rezh . . ." and "I am the beginning . . ." in *K. S. Malevich: The Artist, Infinity, Suprematism,* 29, 12. During the same period Malevich worked on a reinterpretation of Christianity to accommodate the idea of successive reincarnations and progress toward self-perfection.

31. The notion of the strenuous nature of intuition is carried over from Eastern spiritual practice into the work of Bergson and Ouspensky. For Malevich's familiarity with Bergson, see Charlotte Douglas, "Suprematism: The Sensible Dimension," *Russian Review* 34 (July 1975): 266–81.

32. Kasimir Malewitsch, *Die gegenstandslose Welt* (1927; Mainz and Berlin: Florian Kupferberg, 1980), 65.

33. Kazimir Malevich, "I Am the Beginning," in *K. S. Malevich: The Artist, Infinity, Suprematism,* 12.

34. K. S. Malevich, "Suprematicheskoe zerkalo" (The Suprematist mirror), *Zhizn iskusstva* (The life of art), 22 May 1923, 15–16; published in English in idem, *Essays on Art 1915–1933,* ed. Troels Andersen (London and Chester Springs, Pa.: Dufour, 1969), 1:224–25. At this time Malevich was exploring his ideas about objectlessness in a dialogue with Arthur Schopenhauer's *The World as Will and Representation.* See Troels Andersen, preface to *The World as Non-Objectivity: Unpublished Writings 1922–25* (Copenhagen: Borgens Forlag, 1976), 7–10. Schopenhauer must have seemed particularly relevant to Malevich because he also relied heavily on Vedantic mystical ideas.

35. Konstantine Tsiolkovsky was a prolific and popular self-published writer. Among his many publications are *Nirvana* (Kaluga, 1914); *Gore i genii* (Grief and genius) (Kaluga, 1916); *Bogatstva vselennoi* (The wealth of the universe) (Kaluga, 1920); *Monizm vselennoi* (The monism of the universe) (Kaluga, 1925); *Prichina kosmosa* (The cause of the cosmos) (Kaluga, 1925); *Obshchechelovecheskaia azbuka, pravopisanie i iazyk* (A communal alphabet, orthography, and language) (Kaluga, 1927); *Voliia vselennoi: Neizvestnye razumnye sily* (The will of the universe: Unknown rational forces) (Kaluga, 1928); and *Budushchee zemli i chelovechestva* (The future of the earth and mankind) (Kaluga, 1928). The importance of Tsiolkovsky for Malevich and the Russian avant-garde has not yet been examined fully. Tsiolkovsky's many ideas, extremely popular in Russia during the first third of this century, must have appealed strongly to the Cubo-Futurists. As late as 1930 he is known to have been in correspondence with David Burliuk, who wrote to him about a brochure (*Ethics of the Earth*): "It is beautiful. With the years you have acquired the ability to look with earthly sight into the future development of human thought, a great world of ideas." See *K. E. Tsiolkovskii i nauchno-tekhnicheskii progress* (K. E. Tsiolkovsky and scientific-technical progress), ed. B. M. Kedrov (Moscow: Nauka, 1982), 189.

36. Matiushin, "O knige Metsanzhe-Gleza 'Du Cubisme,'" 25.

37. Quoted in Misler and Bowlt, *Pavel Filonov,* 135.

38. Quoted ibid., 168.

39. M. V. Matiushin, "Tvorchestvo Pavla Filonova" (The work of Pavel Filonov), in *Ezhegodnik rukopisnogo otdela Pushkinskogo doma na 1977 g.* (1977 Annual of the manuscript division of Pushkin House), ed. E. F. Kovtun (Leningrad: Nauka, 1979), 232–33.

40. Boris Ender met Matiushin and his wife, the poet Elena Guro, in the studio of the noted painter Ivan Bilibin in 1911. See Zoia Ender and Claudio Masetti, "Boris Ender 1893–1960," in *Boris Ender,* exh. cat. (Rome: Calcografia Nazionale, 1977), 22. Guro had been particularly partial to him because he reminded her of the young knight Wilhelm, the hero of her play *Autumnal Dream.* Ender's diary indicates that he began to study in the Petrograd Studios in 1919 under Kuzma Petrov-Vodkin, worked some time with Malevich, and finally "pitched his tent" with Matiushin on 4 August 1919. See Larissa A. Zhadova, *Malevich* (London: Thames & Hudson, 1982), 130 n. 39.

41. The Soviet historian Nikolai Khardzhiev claims to have found direct evidence of the connection between Lodyzhenskii and Matiushin's "expanded viewing": "As I have been able to establish, Matiushin's term 'expanded viewing' goes back to the 'expanded consciousness' of M. Lodyzhenskii, the author of the book *Sverkhsoznanie i puti k ego dostizheniiu* (1912)." See N. I. Khardzhiev, preface to *K istorii russkogo avangarda/The Russian Avant-Garde* (Stockholm: Hylea Prints, 1976), 132.

42. Matiushin prepared a manuscript describing the history of human spatial perception and explaining in detail his laboratory experiments. On 14 May 1920 he read a public lecture on this topic at the Free Philosophical Society. The work was not published in Russian during his lifetime, although a shortened version did appear in Ukrainian. It has now been published as "Opyt khudozhnika novoi mery" (An artist's experience of the new dimension), in *K istorii russkogo avangarda/The Russian Avant-Garde,* 159–87. Excerpts in English have appeared in Charlotte Douglas, "The Universe: Inside and Out," *Structurist* 15–16 (1975–76): 74–77.

43. M. V. Matiushin, "Ne iskusstvo a zhizn" (Not art but life), *Zhizn iskusstva* 20 (1923): 15; translated in Christina Lodder, *Russian Constructivism* (New Haven: Yale University Press, 1983), 206.

44. Vivekananda, *Raja-Yoga,* 625.

45. Quoted in "Boris Ender: Diario," in *Boris Ender,* 32.

46. Quoted in Zhadova, *Malevich,* 318–19. Tables showing the variations in form and color were exhibited by Matiushin in November 1925 at the Moscow Exhibition of All the Institutions of Central Science. See B. N. Kapelish, "Arkhivy M. V. Matiushina i E. G. Guro" (The archives of M. V. Matiushin and E. G. Guro), in *Ezhegodnik rukopisnogo otdela Pushkinskogo doma na 1974 g.* (1974 Annual of the manuscript division of Pushkin House) (Leningrad: Nauka, 1976), 16.

47. M. V. Matiushin, *Zakonomernost izmeniaemosti tsvetochnykh sochetanii. Spravochnik po tsvetu* (The natural law of variability of color combinations. A color guide) (Leningrad and Moscow: Ogiz-Izogiz, 1932).

48. M. E. Chevreul, *De la loi du contraste simultané des couleurs* (1839); translated into English as *The Principles of Harmony and Contrast of Colours, and Their Application to the Arts,* trans. Charles Martel (London, 1854); and Ogden N. Rood, *Modern Chromatics, with Application to Art and Industry* (New York, 1879).

49. Matiushin exhibited a mock-up of the book in 1930, but the political climate at the time made it very difficult to publish anything that might be interpreted as "formalism." It was finally issued in just 425 copies. The tables were hand-colored by Matiushin's students.

50. Gustav Fechner, *Elemente der Psychophysik,* 2 vols. (Leipzig, 1860) applied methods used in physics to an investigation of the subjective effects of sensory stimulation. By the end of the century Fechner's work had become a standard text for students in the sciences. The first volume has been published in English as *Elements of Psychophysics* (New York: Holt, Rinehart, & Winston, 1966). The soul, or psyche, in Fechner's conceptual realm is a transcendental principle associated with the structure of matter. His work in psychophysics was intended to show that mind and matter were two parallel aspects of a single realm. Like many other panpsychists, he also believed in a world soul, a cosmic reservoir of consciousness, and regarded God as the universal consciousness in which all lesser souls are contained.

OVERLEAF

JOHANNES ITTEN
Study for "The Meeting,"
1915–16
Pencil and watercolor on paper
15 1/8 x 11 in. (38.5 x 28 cm)
Anneliese Itten, Zurich, Switzerland

EXPRESSIONISM, ABSTRACTION, AND THE SEARCH FOR UTOPIA IN GERMANY

ROSE-CAROL WASHTON LONG

The rapid industrialization of Germany during the last decades of the nineteenth century had profound implications for the Wilhelmine empire. Reactions against industrialism and materialism dominated intellectual thought. Artists, writers, philosophers, and political thinkers struggled to discover alternate directions for Germany as it entered the twentieth century. Some intellectuals advocated socialism or anarchism as alternatives to the empire. Others studied such German mystics as Meister Eckhart and Jakob Böhme for clues to a new direction. Still others turned to a study of non-Western religions — Buddhism and Hinduism — or such esoteric religions as Rosicrucianism and Theosophy. Serious artists and architects looked upon their work as instruments for transforming society and searched for a style that would effectively change the moral and ethical climate.

Expressionism was one of these styles. From the moment in 1911 when it was first described in Germany as the manifestation of a rebellion against the established forces until the early 1920s when its death knell was sounded, Expressionism was associated with a new religion of mysticism, with the cosmic, and with universalism.[1] At first the brilliant colors and loose, painterly texture of French Fauve painting and its German variations in the works of the Brücke and the Blaue Reiter were called Expressionist. By 1912 abstraction became linked with the idea of Expressionism. Antinaturalism became equated with antimaterialism and antipositivism to such an extent that this new art was soon viewed as a means for creating a vision of a better world. Architects urged their colleagues to learn from the new painting and applied the term *Expressionist* to their own work. Expressionism became identified as a weltanschauung with a unique spiritual point of view. During World War I the Expressionist absorption of other modernist styles, including French Cubism and Italian Futurism, was viewed as reflecting its synthesizing universalism.

After the war the Expressionist break with tradition was viewed as the visual symbol of utopian socialism,[2] which represented a radical break from the former imperial government. But socialism under the Weimar Republic could not meet the utopian expectations raised by the November Revolution of 1918. Just as the ruling Social Democrats disappointed many of their followers, so too did Expressionism begin to be criticized as not being able to reach the people. Abstraction increasingly came under attack as esoteric, decorative, and without meaning. As utopian

attitudes gave way to more pragmatic ones, artists who had been linked with Expressionism moved toward a more precise style and hastened to remove suggestions of mysticism from their work. Abstract artists moved away from the amorphous styles developed before the war and toward a more geometric abstraction that related to the new emphasis on technology. Nonetheless, the utopian, universalist, even mystical orientation of Expressionism was continued during the Weimar Republic in the methodology and output of the new school for all the arts, the Bauhaus.

In 1908 the young art historian Wilhelm Worringer had published the treatise *Abstraction and Empathy,* in which he linked abstract styles with transcendental points of view. He subsequently connected the new directions in German art of 1911 and earlier with Parisian Synthetists and Expressionists and praised the new German art for establishing connections with "the most elementary possibilities": mysticism and the very origins of art, the primitive.[3] Although he did not directly connect Expressionism with abstraction, he described it as overcoming the "European classical prejudice" and "the rationalistic optics of European upbringing."[4] Worringer gave the new art the weight of history and emphasized that its antinaturalism, distortions, and simplicity were only the beginning of a new approach to artistic creation.

The publication early in 1912 of Wassily Kandinsky's *On the Spiritual in Art* began the equation of abstraction, Expressionism, and mysticism in the minds of critics and the public. By the spring of 1912 works by Kandinsky and other members of the Blaue Reiter, many of whom knew Worringer's writings, were being discussed under the rubric of Expressionism,[5] and Kandinsky's work in particular was being described as the outgrowth of a theosophical program.[6] *On the Spiritual in Art* links a new style of painting, abstraction, with the coming of a new utopia; the messianic tone of his book and the radical nature of his paintings contributed to the assessment that Kandinsky was "nothing less than the representative of a new idealism."[7] In such assessments the critics were reacting to Kandinsky's praise of Theosophy and other occult groups, to his assimilation of brilliant, painterly Fauve and Expressionist colors and textures, and to his claim that abstraction had the greatest potential for the forceful expression of cosmic ideas.

Like other intellectuals, the Russian-born Kandinsky, who had moved to Munich in 1896, interpreted his age as one dominated by a struggle between the forces of good, the spiritual, and the forces of evil, materialism. In 1911 he wrote, "Our epoch is a time of tragic collision between matter and spirit and of the downfall of the purely material worldview; for many, many people it is a time of terrible, inescapable vacuum, a time of enormous questions; but for a few people it is a time of presentiment or of precognition of the path to Truth."[8] Because he felt that abstraction had the least connection with the materialism of the world, he believed that abstract painting might help awaken the individual to the spiritual values necessary to bring about a utopian epoch. In his effort to involve the spectator, Kandinsky chose vivid colors, amorphous shapes floating in indeterminate space, painterly, directional brushstrokes, and remnants of apocalyptic and paradisiacal images. Geometric forms and flat patterning were too closely connected with the ornamental designs of applied art to be the basis for his paintings; geometric ornament could seem too much like a "necktie or a carpet"[9] to be a stimulant for social change.

Kandinsky's steps toward abstraction were bolstered by his readings in mystical and occult tracts and his absorption of the antinaturalism of Symbolist and Fauve art. Like other artists and writers of the Symbolist generation, Kandinsky searched for forms that would be suggestive of "the higher realities, the cosmic orders" rather than descriptive of the mundane physical world. He believed a new interest in abstraction was being awakened, "both in the superficial form of the movement towards the spiritual, and in the forms of occultism, spiritualism, monism, the 'new' Christianity, theosophy, and religion in its broadest sense."[10] Although Kandinsky disliked the theorizing tendencies of the Theosophists, he praised the international theosophical movement for bringing "salvation" to many "desperate hearts" and expressed strong interest in the theosophical experiments with music and color parallels.[11] He referred his readers to the color-music charts made by the Russian Theosophist, A. Zakharin-Unkovsky.[12] He also recommended the writings of the leader of the German Theosophical Society, Rudolf Steiner, whose Christian theosophical teachings were of particular significance to him and other Russians living in Germany.[13] Steiner's presence in Munich and his belief that artistic experiences strongly stimulate the development of spiritual understanding contributed to Kandinsky's interest in him when writing *On the Spiritual in Art*. Kandinsky also praised the Symbolist dramatist Maurice Maeterlinck for his use of ambiguity and mystery to reflect the age's anxieties.[14]

Symbolists and Theosophists, Maeterlinck and Steiner among them, stressed that the truths of the universe are obscured by the physical world's veil. They believed that indirect methods, not direct ones, would lead to heightened consciousness and that the process of deciphering messages would strengthen comprehension. In the preface to *Theosophie* Steiner warned the reader: "One cannot read this book as one is accustomed ordinarily to read books in our era. . . . In certain respects every page and even many a sentence will have to be 'worked out' by the reader. This has been intentionally aimed at. For only in this way can the book become to the reader what it ought to become."[15] Because Steiner believed that the uninitiated could not directly experience the cosmic worlds where colors and forms floated in space,[16] he advised such preliminary practices of meditation as contemplating a natural object: crystal, plant, or animal. Eventually the student would begin to see things that were not visible before.

Although Kandinsky did not explicitly state that his paintings had to be "worked out," he did write that they would seem at first to be composed of "forms apparently scattered at random upon the canvas, which — again, apparently — have no relationship one to another." He explained that "the external absence of any such relationship here constitutes its internal presence."[17] By forcing the viewer to decipher his mysterious paintings, filled with a dislocated space and ambiguous images, Kandinsky involved the viewer in the process of replacing confusion with understanding. If both content and form were too readable and the painting did not reflect the confusions of life with which people could identify, the work would not be meaningful.

Kandinsky felt that the artist and the spectator needed to become more familiar with the new universal language of abstraction.[18] He advised that abstract forms be balanced with semiabstract forms and explained that the object or image has, in addition to color and form, its own psychic effect, its own spiritual possibilities. If the physical aspects of the object were dematerialized through the process of "veiling and stripping," a "hidden construction" would be created;[19] Kandinsky believed that image could have extraordinary

power. He looked to the Symbolist interpretation of language, which emphasized that words create a strong emotional impact if their literal meanings are disguised, for his theoretical basis. For visual examples he studied the mysterious paintings of Odilon Redon and Maurice Denis and the highly colored works of Henri Matisse, whom he described as one of the greatest living French painters.[20]

Kandinsky sought to discover color and line equivalents for the themes of struggle and redemption so central to his world view, frequently reinforcing these themes with motifs of an apocalyptical and paradisiacal nature. He viewed his age as fraught with turmoil and believed, like Steiner and a number of Russian Symbolists, that the Revelation of Saint John the Divine contained secret keys to understanding the universe. Kandinsky chose imagery of storms, battles, angels with trumpets, and tumbling city towers for a number of major works completed between 1910 and 1913[21] and gave them such titles as *Deluge, Last Judgment,* and *Horsemen of the Apocalypse.*[22] Although the apocalyptic motifs frequently originated in folk art depictions of the Last Judgment — Russian *lubki* and Bavarian glass paintings — and in Gothic fifteenth-century woodcuts, Kandinsky radically transformed the original motifs to make them more suggestive. When the cover design of *On the Spiritual in Art,* 1911 (pl. 1), is compared with a watercolor sketch, *Sound of Trumpets,* 1911 (pl. 2), itself based upon folk art depictions of the Last Judgment (pls. 3–4), the source of the curving black line on the cover can be found in the watercolor's central motif: a walled city on a mountaintop, its towers tumbling at the sound of the trumpet of Judgment Day. The transformations in the large oils based on apocalyptic motifs are even more startling: swirls of amorphous color catch the viewer's eye, hiding the image and creating spatial dislocations at the same time.

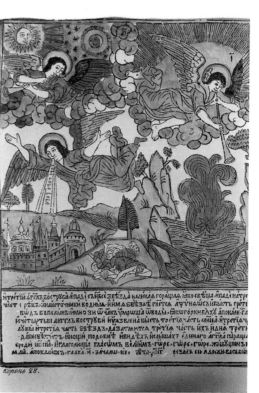

1
WASSILY KANDINSKY, cover for *On the Spiritual in Art,* 1911

.

2
WASSILY KANDINSKY *Sound of Trumpets* (study for *Large Resurrection*), 1911 Ink over pencil, watercolor on light gray board 8 %₁₆ x 8 %₁₆ in. (21.7 x 21.8 cm) Städtische Galerie im Lenbachhaus, Munich

.

3
VASILII KORAN, *Scene from Rev. XI:7–11,* 1696 (detail), colored woodcut, from D. Rovinskii, *Russkiia narodnyia kartinki sobral i opisal* (Russian folk pictures collected and listed) (1881), 3:32

.

4
VASILII KORAN, *Scene from Rev. VIII:10–13,* 1696, colored woodcut, from D. Rovinskii, *Russkiia narodnyia kartinki sobral i opisal* (Russian folk pictures collected and listed) (1881), 3:28

.

5
WASSILY KANDINSKY
Study for "Composition VII,"
1913
Oil on canvas
30 ¾ x 39 ¼ in.
(78 x 99.5 cm)
Städtische Galerie im
Lenbachhaus, Munich
.

6
WASSILY KANDINSKY
Picture with White Border, 1913
Oil on canvas
55 ¼ x 78 ⅞ in.
(140.3 x 200.3 cm)
Solomon R. Guggenheim
Museum, New York
.

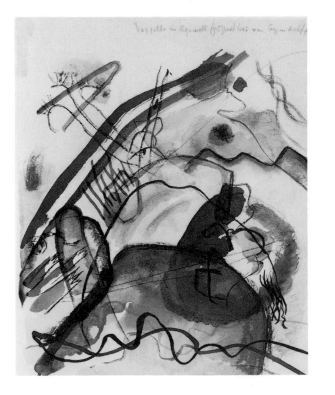

7
WASSILY KANDINSKY
*Study for "Picture with White
Border,"* 1913
Watercolor on paper
10 ¹³⁄₁₆ x 14 ⅞ in.
(27.5 x 37.8 cm)
Städtische Galerie im
Lenbachhaus, Munich
.

8
WASSILY KANDINSKY
*Study for "Picture with White
Border,"* 1913
Watercolor on paper
11 ¹⁵⁄₁₆ x 9 ½ in.
(30.3 x 24.1 cm)
Städtische Galerie im
Lenbachhaus,
Munich
.

In one of the large oil studies for *Composition VII,* 1913 (pl. 5), the golden trumpet outlined in blue in the upper right-hand corner is still quite visible. Yet the viewer must work, not only to find the red-outlined, walled city amidst the brilliantly chaotic colors but also to experience the resolution. In *Picture with White Border,* 1913 (pl. 6), Kandinsky not only disguised the trumpet visible in many preparatory studies (pls. 7–8) but also hid, with billowing colors, another major motif of the battle for salvation: a Saint George figure, with extended lance, fighting the dragon of materialism.[23]

Other Kandinsky paintings of the period relate to his utopian vision of the "new spiritual realm" that would emerge after the "terrible struggle . . . going on in the spiritual atmosphere."[24] In a watercolor called *Paradise,* 1911–12 (pl. 9), Kandinsky suggested the original paradise, the Garden of Eden, and the one after Redemption by using the sign of a couple with the Eve-like figure holding an apple and by using pale, amorphous colors to suggest the heavenly spheres that such Theosophists as Steiner and such poets as Paul Scheerbart had described as filled with floating pastel colors. In *Improvisation 27,* 1912 (pl. 10), three couple motifs, which can be seen more clearly in the study (pl. 11), warm yellow-orange pastel colors in the center of the painting, and the use of the subtitle *Garden of Love* evoke the theme of paradise. Contemporary Dionysian beliefs in the transcendence of sexual love, including those espoused by Stanislaw Przybyszewski, Erich Gutkind, and D. S. Merezhkovsky, also influenced Kandinsky's depictions of paradise.[25] A number of large paintings, including *Black Spot I* (see p. 142) and *Improvisation 28,* done between 1910 and 1913,[26] have motifs of destruction, primarily derived from the Last Judgment paintings, on one side of the canvas and motifs of paradise, usually represented by images of a couple, on the other side. This arrangement reinforces Kandinsky's belief that redemption emerges from struggle.

In a few works of 1913 and 1914 Kandinsky tried to suggest a heavenly paradise without employing recognizable motifs. Instead he used color to signify themes and define space. In *Light Painting,* 1913 (pl. 12), he again used the colors of the watercolor *Paradise,* arranging them so that they advance and recede to

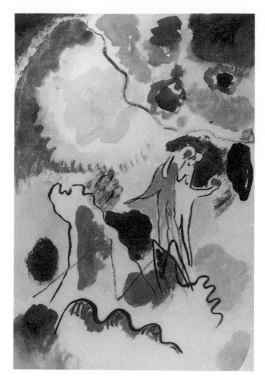
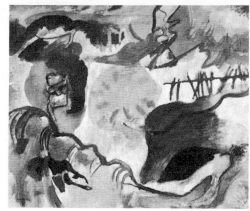
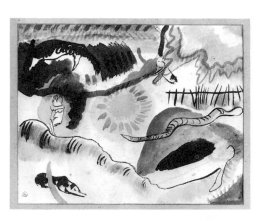
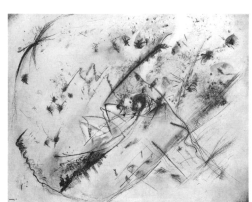

9
WASSILY KANDINSKY
Paradise, 1911–12
Watercolor
9 ⅜ x 6 ¼ in. (24 x 16 cm)
Städtische Galerie im
Lenbachhaus,
Munich

10
WASSILY KANDINSKY
Improvisation 27 (Garden of Love), 1912
Oil on canvas
47 ¼ x 55 ³/₁₆ in.
(120 x 140 cm)
The Metropolitan Museum
of Art, New York
Alfred Stieglitz Collection,
1949

11
WASSILY KANDINSKY
Study for "Improvisation 27" (Garden of Love), 1912
Watercolor
9 ¹¹/₁₆ x 12 ⁵/₁₆ in.
(24.8 x 31.6 cm)
Städtische Galerie im
Lenbachhaus,
Munich

12
WASSILY KANDINSKY
Light Painting, 1913
Oil on canvas
30 ⅝ x 39 ⁷/₁₆ in.
(77.8 x 100.2 cm)
Solomon R. Guggenheim
Museum, New York

make the painting "a being floating in air."[27] Kandinsky had written that although flatness was one of the first steps away from naturalism in painting, the artist had to go beyond this superficial approach to destroy the tactile, material surface of the canvas. He advised the construction of an ideal picture plane not only by using color but also by using a linear expansion of space through the "thinness or thickness of a line, the positioning of the form upon the surface, and the superimposition of one form upon another."[28] *Light Painting* reflects all these processes.

Kandinsky's interest in creating the illusion of a new kind of space on the flat canvas coincided with a burgeoning fascination among artists with the concept of the fourth dimension. The French critic Guillaume Apollinaire had explained in 1911 that "the fourth dimension represents the immensity of space externalized in all directions at a given moment. It is space itself, or the dimension of infinity."[29] In Russia a number of artists and poets interpreted the fourth dimension as a metaphor for a new elevated consciousness that would lead mankind to utopia.[30] When Kandinsky had to leave Germany for his native Russia at the outbreak of World War I, he came into closer contact with artists espousing these views. The creation of a new dimension in painting became a crucial goal for Kandinsky when he returned to Germany in 1921 and was confronted with the "failure" of Expressionism and abstraction.

Other intellectuals before the war sought utopian political solutions to the problems brought on by the excessive materialism of the Wilhelmine empire, but Kandinsky considered political solutions to be on a lower level and less effective than spiritual or transcendental ones. He did, however, have a certain respect for anarchism; he attacked those "liberals and progressives" who denounced anarchism, explaining that "they knew nothing save the terrifying name."[31] A number of artists and writers were fascinated by anarchism at that time; many were also advocates of internationalism, religious utopias, and mysticism. Steiner, for example, before he became involved with Theosophy around 1900, had close contacts with various socialists and anarchists, particularly among the Friedrichshagen group, where the mystic-socialist Gustav Landauer had lived.[32] Kandinsky would have been aware of anarchist theories espoused by Landauer and the Russian writer Lev Tolstoy.[33] In an exchange of letters with Gutkind, who had met with Landauer and other anarchist pacifists in June 1914, Kandinsky wrote about the organization of an international group to work against war.[34] In Russia in 1919 he referred to his earlier interest in breaking down barriers between nations but recalled that many German artists and intellectuals "were outraged by this 'anarchistic idea!'"[35] After the Russian revolution Kandinsky was involved for a period with the new government and urged an international collaboration of artists. He belonged to the Visual Arts Section of the People's Commissariat for Enlightenment and in 1920 became director of the Institute of Artistic Culture, Moscow. Intense disagreements with his colleagues[36] and dismay over the conditions in Russia led him to return to Germany in 1921.

While Kandinsky was in Russia his name remained known in Germany because his work was so frequently cited as exemplifying the transcendentalism of Expressionism. The German avant-garde and the public could see Kandinsky's paintings and graphics at exhibitions organized by his dealer Herwarth Walden at the Sturm Gallery in Berlin. For young artists interested in modern art, Walden's gallery was the place to visit. Poets, writers, critics, architects, musicians, and dramatists, indeed the cultural world of Berlin, frequented the gallery. An entire generation learned about Expressionism and abstraction from Walden's publications and catalogues and *Der Sturm,* the periodical he edited.[37] Walden viewed Expressionism as the essence of the international modern movement, and Kandinsky was one of his featured artists.[38] Walden's publicity helped maintain Kandinsky's reputation as the leading prewar Expressionist in Germany even during his absence.

Architects and critics began to claim the term *Expressionism* for architectural innovations and also to use Kandinsky's theories and interpretations of color as support for new approaches to architecture. The young architect Bruno Taut was closely connected to the Sturm circle, especially to the poet Scheerbart, whom Walden called the "first Expressionist."[39] Taut urged young architects to be aware of the new direction in painting. In a 1914 essay published in *Der Sturm* he praised painting for moving toward abstracting, synthesizing, and "constructing." He cited the "spirited" compositions of Kandinsky as an example.[40] Taut emphasized the "religious intensity" that he felt motivated artists in all media to strive for forms corresponding to metaphysical thoughts. Extolling the Gothic period as a time when artists had collaborated to create monumental works, Taut urged architects to use contemporary materials — glass, iron, and concrete — in designs that would "intensify" spiritual feelings as they worked with other artists to create a temple to art. Just before the outbreak of the war, at the Deutsche Werkbund exhibition in Cologne, Taut collaborated with Scheerbart on a glass pavilion where colored glass and Scheerbart's mystical inscriptions evoked a meditative atmosphere. Scheerbart's aphorisms reflected both men's mystical faith in color and light: "Light wants to penetrate the whole cosmos and is alive in the crystal."[41]

Since the 1890s Scheerbart had associated with a number of Theosophists, and his descriptions of the colored light of astral planes reflect not only theosophical writings but also Eastern mysticism and an understanding of the German mystics Böhme and Meister Eckhart.[42] Theosophists such as Steiner praised Scheerbart's ability to uncover hidden meanings through his use of words.[43] In the years before 1914 Scheerbart associated with numerous figures of both the literary and artistic avant-garde, including Alfred Kubin,[44] a member of Kandinsky's Blaue Reiter group. Taut is reported to have met Scheerbart in 1912 when he was involved with renovations for the building in which the Sturm exhibitions took place.[45] Scheerbart viewed architecture as a fantastic art that would transform man's ethical and spiritual sensibilities through a meditative process inspired by its beauty. This vision had a significant influence on Taut and through Taut on Walter Gropius and the formation of the Bauhaus. Kandinsky's similar call for artists to work together to build "a monumental work of art"[46] contributed to Taut's admiration of Kandinsky's art.

Others besides Taut and critics from Walden's circle wrote about Kandinsky's abstraction in connection with Expressionism. The publication of Paul Fechter's book *Expressionismus* (1914) ensured Kandinsky's reputation as a leading Expressionist painter. Fechter praised Expressionism for communicating the essence of human existence. He differed from Walden and other defenders of Expressionism who viewed it as part of an international drive against materialism; instead he emphasized that Expressionism grew out of an ancient

Germanic tradition: the need for metaphysics. He discussed two directions within Expressionism by praising Max Pechstein of the Brücke for using aspects of nature to evoke a higher state and Kandinsky for moving away from nature to evoke the transcendental. Fechter stressed that both Pechstein and Kandinsky rejected the classical Renaissance tradition in favor of the communal, metaphysical tradition of the Gothic.[47] In contrast the Austrian critic Hermann Bahr described Expressionism as related to the anxiety and anguish of his day. In 1916 he wrote:

Never was there a time shaken by such terror, by such dread of death. Never was the world so silent as a grave. Never was man so small. Never was he so afraid. Never was joy so far and freedom so dead. Anguish cries out, man cries for his soul, the entire time is a single scream of distress. Art too cries into the deep darkness, she cries for help, she cries for the spirit. That is Expressionism.[48]

Citing Worringer as his guide, Bahr compared the "violations" of the world of appearances in the works of Kandinsky, Oskar Kokoschka, and others to Martin Buber's and Steiner's views of the "invisible" world.[49]

The comparison of Expressionism with Steiner's thinking was expanded by Gustav Hartlaub, the young assistant director of the Kunsthalle in Mannheim. In 1917 Hartlaub equated Expressionism with gnosticism and with Theosophy. Like Bahr, Hartlaub saw Expressionism as part of the "spiritual upheaval" intensified by the war. He believed that the artists were responding to the antimaterialist forces at work within European culture. He praised abstract and semiabstract (which he called "symbolic") painting for moving away from the external, material world. The Expressionists' tendency to abandon the local color of an object was evidence to Hartlaub of their ability to reflect cosmic elements such as the colors of the higher worlds, of the astral planes, in their painting. He emphasized that the artists he described most likely did not practice occultism, but he pointed out the parallels between Franz Marc's animal paintings and "Steiner's experiences into ethereal and astral planes." He also referred to the auras in Edvard Munch's and Kokoschka's portraits, compared the paintings of Paul Klee and Georg Muche with "the astral world of color," and stressed that Kandinsky's paintings reflected the basic elements of the universe: "water, air and earth." Hartlaub maintained that contemporary painting and Theosophy as it had developed in Germany under Steiner were leading to a new under-

standing of the world, "opening in modern man the vision of an immense reintegration of long lost archetypes of mystical forms of thought and experience."[50]

Hartlaub attacked the association of Expressionism with German medieval mystics;[51] he maintained that the two periods were very different and that the Expressionist use of color and nonperspectival space revealed a completely different consciousness from the medieval one. Coming out of a Rosicrucian tradition and interested in the Christian theosophical teachings of Steiner, Hartlaub was eager to stress the parallels between Steiner's ideas and the new art and not its connections to mystical thought, which he felt were no longer vital.

After the war Hartlaub rejected his earlier linkage of Expressionism, abstraction, and Steiner's Theosophy. But others, writing after the events of the November Revolution helped to establish the Weimar Republic, continued to associate Expressionism with a religious revolution. The art historian Eckhart von Sydow was one of those who identified the religious fervor of Expressionism as mystically inspired, and he described its dominant form and content as abstract Expressionism. In an essay written for the radical Dresden periodical *Neue Blätter für Kunst und Dichtung,* von Sydow tied Expressionism to the activist, socialist forces of the period. He thought that medieval mysticism had been otherworldly, whereas the mysticism of Expressionism was dualistic, embracing both the spiritual and the earthly. Like Fechter he saw two directions of Expressionism: one, more general and universal, he called abstract Expressionism or the absolute, and the other, connected to a passionate intensification of natural events, he called ecstatic or baroque Expressionism.[52]

Von Sydow emphasized that the religion of the Expressionist was a universalist, international one that embraced all religions. He quoted from the writings of Kandinsky and Marc to reinforce his point that "the current modernism" was permeated with a transnational spirituality.[53] Because Germany had become a republic with the Social Democrats in control and many young artists were looking to the Soviet Union as the embodiment of utopia, von Sydow tried to establish the international heritage of Expressionism by referring to the German and Russian nationalities of the early Expressionist leaders

of the Blaue Reiter. The radical young artists emerging after the war did look to Russia for artistic direction. For example, the artist Oskar Schlemmer wrote: "Moscow is said to be flooded with Expressionism. They say Kandinsky and the moderns are splashing whole quarters with color, using blank walls and the sides of houses as the surfaces on which to paint modern pictures."[54] Von Sydow also carefully disassociated Expressionism from capitalism,[55] an indication of his hope that the Weimar Republic would free society not only from materialism but also from capitalism and nationalism. The utopian expectations of the earlier Expressionists to rid the Earth of materialism and transform values were now being affixed to a political system with similar messianic fervor.

During the first few months after the November Revolution, before disillusionment set in, other artists and critics linked Expressionism, mysticism, socialism, and abstraction. The critic Herbert Kühn proclaimed that Expressionism, "the transformation of the spirit," reflected the same attitudes as socialism: "The same outcry against matter, against the unspiritual, against machines, against centralization, for the spirit, for God, for the human in man."[56] Both desired "humaneness, unity of the spirit, freedom, brotherhood of the pure human" and despised "the border-post insanity, chauvinism, nationalism."[57] Although Kühn insisted that Expressionism was not a style, he cited 1910 as the year in which the revolution in art began, and he listed Pablo Picasso and Kandinsky as advancing the cause of the new art.

The high expectations surrounding the new art were soon to become a source of disappointment, and before long both the Social Democrats and the Expressionists were attacked. In 1919 the murders of the radical left Sparticist leaders Karl Liebknecht and Rosa Luxemburg were a major factor in discrediting the Social Democrats. Because of the initial connection between Expressionism and the Weimar Republic, Expressionism was also discredited. The major critique was that it was too metaphysical, too removed from the world in both its form and content. Wilhelm Hausenstein, who had been one of the major supporters of Kandinsky and Expressionism, attacked Expressionism in 1919 for "esoteric formalism" and declared that the movement "was dead."[58] Less than a year later Kasimir Edschmid, a poet associated with literary Expressionism, decried the "cosmic wallpaper" quality of much

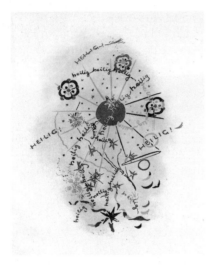

Expressionist painting and graphics.[59] As many artists and critics became increasingly radical in their politics, they rejected an art they felt was too remote from their everyday activities. One critic of the Expressionist posters for the National Assembly elections pointed out that these posters could not be effective because people would need an education to understand the meaning of the exaggerated lines and color.[60]

Artists associated with Dada were particularly severe in attacking Expressionism, even though a year or two earlier they had identified with it. In their manifesto, written primarily by Richard Hülsenbeck, the Dadaists said no to Expressionism and dismissed abstraction as "pathetic gestures which presuppose a comfortable life free from conflict and strife."[61] The Dadaist Georg Grosz, influenced by the extreme left's insistence that art should have a direct involvement with the world, attacked Expressionism with even greater disdain than Hülsenbeck. Grosz declared that it was no longer a question of "conjuring up on the canvas colorful, Expressionist soul tapestries" and claimed that "the reality and clarity of engineer's drawings" were better teachers than the "uncontrolled twaddle from the cabala, metaphysics, and holy ecstasy."[62]

During the postwar period Expressionism was not only attacked by various leftist groups. Critics such as Hartlaub began to call for a return to the object on the grounds that mysticism would thus be more clearly communicated. In a review of the 1920 Expressionist exhibition in Darmstadt, Hartlaub wrote that it was time to abandon "cosmic swirls" and declaimed, "Back to the object!"[63] A year earlier he had written that while form and color freed from the object had the potential to transmit "elementary and universal feelings," neither artist nor public could respond to this method for very long. He called Kandinsky's compositions "curiously limited and monotonous."[64] Hartlaub now wrote that Steiner, whose philosophy about color auras he had related to abstract Expressionist painting, was not a "true mystic" and even implied that he was a charlatan.[65] The divisions among German Theosophists and Rosicrucians contributed to Hartlaub's criticisms and led him to attack the very abstraction he had once positively connected with Steiner's description of the spiritual world.

The rightists and the nationalists also used the link with mysticism and internationalism to attack Expressionism and abstraction. Nowhere was this more evident than in the battle waged in the Thüringer State Assembly over the funding of the Bauhaus, its new school for the arts in Weimar. Newspaper accounts in late 1919 and 1920 reported how the Bauhaus was criticized for following the "false path of Expressionism." Its director, Gropius, was said to be "full of philosophical, metaphysical, and mystical thoughts," which were sarcastically explained as being part of the Expressionist aim of "deepening the inner being."[66] The same journalist derogatorily insinuated that the "mystic-philosophical" community of the Bauhaus was related to freemasonry.

The Bauhaus, which had opened in April 1919, was a prominent example of the utopianism so prevalent in the first few months of the Weimar Republic. Stimulated by the general expressionistic messianic fervor of the day, Gropius dedicated himself to creating a school where all artists, regardless of class or background, would build together a "cathedral of the future"[67] that would change all aspects of man's environment. In the first pamphlet announcing the Bauhaus goals, Gropius called out to painters, sculptors, and architects to "desire, conceive, and create the new structure of the future . . . which will one day ride toward heaven from the hands of a million workers like the crystal symbol of a new faith."[68] For the pamphlet's cover Gropius chose a Lyonel Feininger woodcut of a crystalline, faceted cathedral flanked by three heavenly stars (pl. 13). Gropius's choice of the name *Bauhaus,* from the medieval word *Bauhutte* with its reference to artists' guilds and secret lodges, reinforced comparisons with a medieval communal society.

For the Bauhaus basic staff Gropius turned primarily to painters who shared his proselytizing view of art and whose work belonged to the abstract, transcendental branch of Expressionism. With the exception of Gerhard Marcks, the major early instructors — Johannes Itten, Muche, and eventually Kandinsky — shared Gropius's mystical, utopian vision of transforming society through architectural and educational reform. Gropius was aware that these instructors would be criticized for their internationalism, their political views, and their connection with Expressionism. When he wanted to appoint Klee and Schlemmer to the staff, Gropius had to write to Edwin Redslob, minister of culture, for assistance in dealing with the new government's fears that the two Swiss-born

artists were "more wildly expressionistic than the artists already present."[69] During the Bauhaus's first few years Gropius referred to the times as part of a catastrophic period of world history in which much misery and privation had to be endured before "spiritual and religious ideas" would find their "crystalline expression" in a great "cathedral [shining] its light into [the] smallest things of everyday life."[70] In a speech given at the Bauhaus in July 1919, Gropius reminded the students that they were part of a "secret lodge" that would help work out a "new, great world idea."[71]

Gropius's views were influenced to a great extent by Taut. They had known each other before the war, when both were members of the Deutsche Werkbund. Immediately after the November Revolution, Taut and Gropius formed an artists' council based on the Soviet model; the Arbeitsrat für Kunst (Work Council for Art) was intended to unite art and the people by reforming art education, organizing more accessible exhibitions, and bringing together all the arts to build a great temple to the future.[72] Although in February 1919 Gropius took over the directorship of the council, raising money, arranging meetings, and continuing to be listed as director even when he was called to Weimar, Taut's theories are thought to have dominated the formulation of the Arbeitsrat program.[73] For years Taut had advised architects to learn from such painters as Kandinsky methods that could assist in the creation of an ideal communitarian society. The monumental colored-glass temples of culture that he envisioned rising over small, decentralized communities are a testament to his faith in the transcendent power of abstract color and reflect his absorption of Scheerbart's vision of a cosmic world filled with floating color forms. In his description of the great temples of the star in *The Dissolution of the Cities* (1920), which he called a parable for the "third millennium,"[74] Taut advocated the combination of colored glass and music to create a meditative environment in which individuals would become one with their group and ultimately with the universe. Taut's drawings (pl. 14) combine amorphous colors, curving lines, and words to suggest the illusion of the temples merging with the cosmos.

Gropius subscribed to many of Taut's ideas, especially the merging of all arts as a means of transforming society. Gropius, Taut, and Adolf Behne, to whom Gropius left the running of the Arbeitsrat,[75] organized an exhibition by calling upon nonarchitects and architects to submit visionary drawings for monumental temples of the future. The *Exhi-bition of Unknown Architects,* held in April 1919, included work by architects, painters, and sculptors who had "faith in the future" and believed that "one day a philosophy of life [would] exist and then its symbol, its crystallization — architecture — [would] also exist."[76] A great majority of the exhibitors did attempt to draw visionary structures, and a pencil drawing (pl. 15) by Johannes Molzahn illustrates the crystalline tower shapes favored in many of these monuments to a future utopian society.[77]

Molzahn is an example of an abstract Expressionist painter who had turned briefly to architecture during the euphoric period after the November Revolution. At the time of the *Exhibition of Unknown Architects,* he was also exhibiting paintings at Walden's Sturm Gallery. His mystical utopian interpretation of Expressionism is evident in the subjects of his paintings and in the highly emotional tone of his essays. In "The Manifesto of Absolute Expressionism," written for a Sturm exhibition in October 1919, Molzahn demanded that the artist's work reflect the pulsating energy of the universe so it could become a symbol of the "cosmic will." He wrote in incendiary language, "We want to pour oil into the fire — spark the tiny glow — make it flame — span the earth — make it quiver — and beat stronger — living and pulsating cosmos — steaming universe."[78] Molzahn's belief that art must manifest Earth's cycles of creation and destruction is revealed in his predominantly abstract paintings of 1918–20, in which arrows and swords partly obscured by painterly colored circles radiate from diagonal axes at the centers of the paintings.[79] Titles such as *HE Approaches* and *Mysterium — Man* (pls. 16–17) evince his mystical disposition. Like many artists caught up in the utopian optimism of the time, Molzahn was attracted to the radical politics of the Sparticists. When the Sparticist leaders were murdered, Molzahn's memorial in oil bore a trinitarian title, *The Idea — Movement — Struggle;* the dedication "to you Karl Liebknecht" was later painted over.[80]

Although Molzahn lived in Weimar, he never joined the Bauhaus faculty. He did contribute a graphic work to the third Bauhaus print portfolio[81] and is reported to have recommended other young artists such as Muche for appointment to the school. Muche, who arrived in Weimar in April 1920, is another artist whose quest for metaphysical truths led him to a painterly abstract form of Expres-

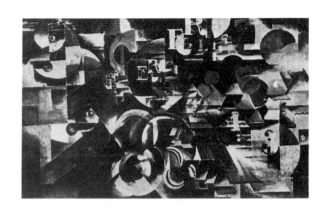

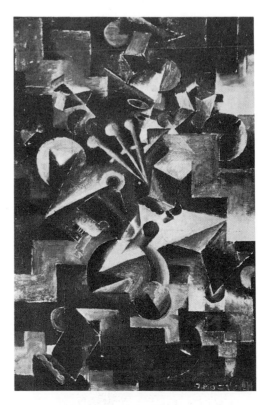

16
JOHANNES MOLZAHN
HE Approaches, 1919
Oil on canvas
43 5/16 x 74 13/16 in.
(110 x 190 cm)
Staatsgalerie,
Stuttgart

·

17
JOHANNES MOLZAHN
Mysterium–Man, 1919
Oil on canvas
Dimensions unknown
Location unknown

·

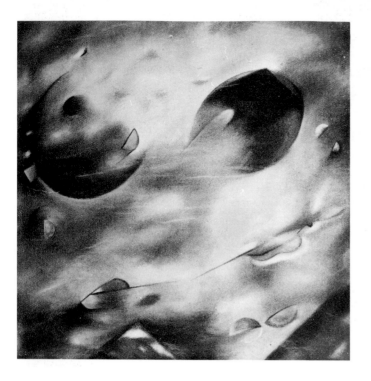

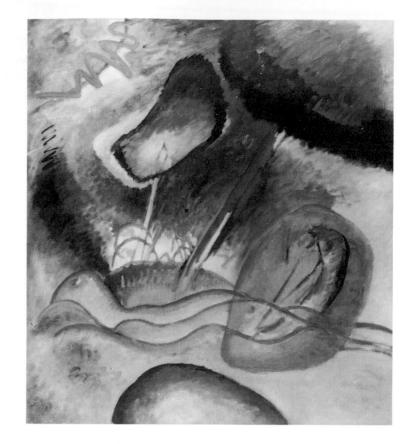

sionism and then to experiment with architectural design at the Bauhaus. Like many of the painters appointed to the faculty, Muche came from the Sturm circle.

Muche had become aware of the group of artists around the Sturm Gallery when he attended an exhibition of the anthroposocially inspired painter Jacoba van Heemskerck in March 1915.[82] He began working at the gallery as Walden's exhibition assistant and displayed paintings there early in January 1916. By September Muche had become an instructor in the newly founded Sturm Art School. He admired the works of Kandinsky, Marc, and other members of the Blaue Reiter.[83] His paintings of 1916, some with biblical titles, such as *And the Light Parted from the Darkness* (pl. 18), and others with titles descriptive of the shapes used, such as *Painting with Open Form,* resemble in their textured use of amorphous colors such Kandinsky paintings of 1913 as *Red Spot* (pl. 19). In a 1917 book on Der Sturm, Muche was praised along with Kandinsky for dispensing with objects and using only colors and forms to create "absolute painting."[84] It was during this period that Muche met Itten, with whom he would develop a close friendship at the Bauhaus, and Molzahn and first became involved with the teachings of the Mazdaznan sect. His fiancée,

Sophie van Leer, another of Walden's assistants, reportedly introduced him to the theories and practices of this esoteric philosophy.[85]

After the war Muche's interest in mysticism intensified as he moved away from Sturm and Expressionism. A number of letters written in 1919 indicate that the year was one of crisis for him. In one letter to Ernst Hademan he criticized Berliners for their materialism and superficiality but praised the Sturm circle for their "honest passion" about Expressionism.[86] In another letter to van Leer he complained that he felt alone and had found only one other student, Paul Citroen, with whom he could discuss Mazdaznan and other "religious things"; he was torn between his search for "divine truths" and his sensual enjoyment of color in his painting.[87] By the time he arranged to move to Weimar, Muche had decided that Expressionism, Cubism, and Dadaism belonged to the past.[88] He continued to paint abstractly, sometimes using grid patterns within the painterly texture, until 1922, when he began to paint objects and more hard-edged geometric forms in his oils.

When Muche settled in Weimar in the spring of 1920, Itten had already established himself

at the Bauhaus, having arrived the preceding October. Of all the painters whom Gropius invited to teach at the Bauhaus, no one has been more closely associated with mysticism and Expressionism than Itten. Accounts of Itten's attempt to establish a Mazdaznan regime at the Bauhaus often obscure his achievement as an abstract painter and his originality in organizing the preliminary course that all students had to take as their introduction to the school.

Like Muche, Itten had been acquainted with the Expressionist circles around Walden and had exhibited at the Sturm Gallery in the spring of 1916. He remembered attending the First Autumn Salon in Berlin in 1913, where he saw the works of Marc and Kandinsky.[89] Also in the fall of 1913 Itten began studying with the Swiss painter Adolf Hölzel,[90] through whom he met Schlemmer. Itten's

interest in and experimentation with abstraction intensified during 1915 and 1916. He explained in a letter to Walden that his paintings would become closer to "primary matter" through his search for crystalline shapes; he referred to the crystal as "fermenting mother's milk."[91] Itten, like Scheerbart, used the crystal metaphor to convey his own commitment to communicating spirituality through the purest means.

In *Resurrection,* 1916 (pl. 20), Itten simplified figurative and landscape motifs to flattened geometric shapes. The figure that appears with a cross in the center of the study for *Resurrection* (pl. 21) is no longer visible within the elongated, flat triangle that dominates the center of the painting. To convey the sensation of ascent so crucial to the meaning of *Resurrection,* Itten placed the smallest point of the triangle close to the bottom of the painting and used a number of diagonal and circular accents to convey an upward motion. For Itten, conveying the feeling of movement in painting would continue to be a crucial theme during later years (pl. 22). He explained that movement was evocative of vitality, of life: "But movement, movement must be in an artwork. Everything living, existing lives, that is, it is in movement."[92]

In the fall of 1916 Itten moved to Vienna, where he remained until he was invited by Gropius to teach at the Bauhaus. During his Vienna period he read Indian philosophy and grew interested in theosophical teachings to which Gropius's first wife, Alma Mahler, is said to have introduced him.[93] In 1918 he noted that he found *Thought-Forms* (1905) by Annie Besant and Charles W. Leadbeater in a

20
JOHANNES ITTEN
Resurrection, 1916
88 9/16 x 55 1/2 in.
(225 x 141 cm)
Anneliese Itten,
Zurich, Switzerland

.

21
JOHANNES ITTEN
Study for "Resurrection," 1916
Anneliese Itten,
Zurich, Switzerland

.

22
JOHANNES ITTEN
Ascent and Pause, 1919
Oil on linen
90 1/2 x 45 1/4 in.
(230 x 115 cm)
Kunsthaus Zürich,
Switzerland

.

23
JOHANNES ITTEN
Sheet with a Text by Jakob Böhme, 1922
Watercolor on paper
11 13/16 x 11 13/16 in.
(30 x 30 cm)
Anneliese Itten,
Zurich

.

24
Johannes Itten in the Bauhaus
costume he designed,
c. 1921

.

theosophical bookstore,[94] and after comparing their charts with his paintings he was impressed by their color equations.

Itten was interested in a wide variety of mystically inspired writers, including Böhme (pl. 23).[95] At the Bauhaus, however, Mazdaznan principles of purification and regeneration were central to his life and painting. Schlemmer, appointed to the Bauhaus in December 1920, reported: "The Indian and oriental concept is having its heyday in Germany. Mazdaznan belongs to the phenomenon. . . . The western world is turning to the East, the eastern to the West. The Japanese are reaching out for Christianity, we for the wise teachings of the East. And then the parallels in art. The goal and purpose of all this? Perfection? Or the eternal cycle?"[96] After Itten and Muche attended a Mazdaznan congress in Leipzig, Itten tried to convert much of the school to the dietary and meditative principles of this esoteric group. Schlemmer wrote that the congress had convinced Itten that "despite his previous doubts and hesitations, this doctrine and its impressive adherents constituted the one and only truth"[97] and that Itten created a crisis at the Bauhaus with his insistence on following these principles. Schlemmer explained that it was not the conversion of the student cafeteria to vegetarianism but Itten's

favoritism toward students who followed Mazdaznan ideology that split the Bauhaus into "two camps."[98] This was one of the major issues that eventually led to Itten's resignation from the Bauhaus in the fall of 1922.[99]

While Itten was at the Bauhaus, he created a very distinctive persona. His shaved head, monk's robe (pl. 24), and the very intensity of his methods both attracted and repelled students. His insistence on meditation exercises before working, his urging students to feel a certain movement before they drew it, his exploration of free abstract drawing, and his emphasis on experimenting with unusual materials affected not only the instruction at the Bauhaus but much of art education since that period. Some of Itten's exercises can be traced back to his studies with Hölzel[100] and to reform theories in education, but Itten was also greatly influenced by mystical practices. The process of releasing the student's innate energies and feelings into art was a liberating methodology. The preparatory breathing, basic movement exercises, and rhythmic stroking of the brush helped the student's hand follow directly the impulses of the mind.[101] The numerous free abstract

drawings (pl. 25) found among Bauhaus student portfolios are indicative of Itten's influence.

In several prints and notebooks Itten left visual testimony to what he felt was the positive impact of Mazdaznan principles. In the print *Dictum,* 1921 (pl. 26), Itten used words and amorphous shapes to create a colorful tribute to Dr. Otoman Hanish, the modern founder of the Mazdaznan sect, and to the illumination and hope that Mazdaznan principles could bring to the individual. The words *greeting, heart, love, hope,* and *heaven* are set in flowing, cursive script against a background of floating, colorful shapes.[102] Itten's spiral sculpture made of colored glass, the *Tower of Fire,* 1919–20 (pl. 27), stood outside his studio and is but one mark of the Bauhaus artists' faith that they were working to create a cathedral of the future.[103]

When Kandinsky arrived at the Bauhaus in June 1922, Gropius's emphasis had changed. He had been defending the Bauhaus against attacks from numerous directions, including assertions that all Bauhaus students were communists, foreigners supported by state

money, mystical Expressionists, or wild bohemians. Gropius had become especially concerned with the divisions within the Bauhaus, particularly the cliques created by Itten's excessive adherence to Mazdaznan principles. In a February 1922 circular to the Bauhaus instructors Gropius warned against "wild romanticism" and stressed that they should not cut themselves off from the outside world and cultivate excessive isolation.[104] Gropius had become convinced that it was necessary to provide some independent financing for the Bauhaus and had begun to urge that creative work be associated not only with craft design but also with industrial design. Schlemmer characterized the change as "turning one's back on utopia": "Instead of cathedrals, the 'Living Machine.' Repudiation of the Middle Ages and of the medieval concept of craftsmanship . . . replaced by concrete objects which serve specific purposes."[105] He prophesied that Kandinsky would fill Itten's place for Gropius.[106] Despite Gropius's call for art to relate to technology, he did not repudiate his original insistence that the fine arts and design were the foundation of all Bauhaus courses. Kandinsky's interest in abstraction continued at the Bauhaus, but his choice of the forms to be used in an abstract painting changed radically.

He also moved away from Expressionism but not from the idea that art should transform values in the service of utopian goals.

Kandinsky was very sympathetic with Gropius's original plans for the Bauhaus. In 1919, while living in the Soviet Union, Kandinsky had stressed his commitment to forming an international art society, where artists from different disciplines and nations could work together for egalitarian goals. He not only praised the Arbeitsrat für Kunst, citing Taut and Gropius, but also gave special attention to "the new Weimar Academy," where painters, sculptors, and architects blended "into one whole the element of all three arts."[107] Kandinsky lived in Berlin for a short period before he moved to Weimar and probably heard the discussions about the death of Expressionism and the criticisms of the Bauhaus. For example, Theo van Doesburg denounced the Bauhaus for "mixing Expressionist hysteria with a half-baked religious mystique, and elevating it to a dogma (Mazdaznanism)."[108] Such outbursts must have been troubling to Kandinsky, who continued to link Expressionism and abstraction as late as 1922.[109] Moreover, in his program for the Institute of Artistic Culture in

25
WERNER GRAEFF
Rhythm Study for Itten's Preliminary Course, c. 1920
Tempera on paper
22 1/16 x 29 13/16 in.
(56 x 75.7 cm)
Bauhaus Archiv, West Berlin
.

26
JOHANNES ITTEN,
Dictum, 1921,
lithograph
.

27
JOHANNES ITTEN
Tower of Fire, 1919–20
Mixed media
Dimensions unknown
Destroyed
.

Moscow, Kandinsky had called for the study of occult sciences and supersensory experiments to reinforce research on the interrelationships of color, sounds, and smells.[110]

In Weimar Kandinsky continued to believe his work would bring about the "Epoch of the Great Spiritual,"[111] but he aimed to disassociate his art from the criticism that abstraction was merely a "pathetic gesture" or "cosmic swirls." Instead of using the amorphous shapes and painterly textures that were associated with Expressionism, he worked with precisely drawn geometric forms. He had begun to experiment with such forms in Russia; the exposure to the theories and works of Kazimir Malevich, Ivan Kliun, and other members of the Russian avant-garde contributed to his growing belief that geometric forms could become a universal language for abstraction.

At the Bauhaus Kandinsky changed aspects of his style, but he did not turn away from his mystical and utopian goals. He continued to experiment with different methods to create the illusion of cosmic infinity on the flat plane of the canvas. He had begun this process before the war, and his exposure to the avant-garde in Russia reinforced his use of space as a metaphor for a utopian world. In Russia

Malevich, Mikhail Matiushin, and other artists emphasized that the illusion of space on the canvas could be a sign for the fourth dimension, one of their metaphors for the transcendent consciousness necessary for the perception of a new world.[112] Malevich frequently used the term *fourth dimension* in his titles and wrote that "a plane of painterly color suspended on a sheet of white canvas immediately gives our consciousness a strong sensation of space. It transfers [one] into a fathomless desert where one can sense around one the creative points of the universe."[113] Kandinsky did not use the fourth dimension in any of his titles, but in a letter to Will Grohmann written at the Bauhaus he stated that "the circle of all the primary forms points most clearly to the fourth dimension."[114] During his Bauhaus period he frequently used precise circular forms in his paintings. In *Circles within a Circle,* 1923 (pl. 28), Kandinsky played off one dimension against another by contrasting the central, large, flat, black circle with smaller, slightly modeled circles, placed at angles to the picture plane. The diagonal rays of beige and gray, larger at the bottom and smaller at the top, further convey the sensation of depth.

Kandinsky continued to experiment with spatial illusions when the Bauhaus moved from Weimar to Dessau. In *Several Circles,* 1926 (pl. 29), he used a dark rather than a light background to create a sense of "indefinable space."[115] The colors and sizes of the several circles create a tension and movement as the small purple orbs appear to come forward and float against the black background, suggesting a chart of star clusters similar to the one (pl. 30) that Kandinsky included in his second treatise on abstraction, *Point and Line to Plane.* This was published by the Bauhaus in 1926 and is less didactic and more analytical than *On the Spiritual in Art.* But again Kandinsky discussed the problem of dematerializing the picture plane, urging the artist to transform it into a sensation of indefinable space, so that the spectator might experience the extension of "the dimension of time."[116]

Kandinsky may have turned to geometric forms and away from the vague shapes associated with Expressionist cosmic visions, but he did not abandon his underlying mystical belief in the power of color and line to evoke

transcendent states. In the preliminary Bauhaus course he continued his earlier synesthetic experiments of relating color and form to universal emotional equivalents. Because he felt that color and form were interrelated, Kandinsky had his students arrange colors in connection with geometric shapes.[117] He also emphasized that entire compositions could have universal equivalents: compositions leading the eye upward could seem light, those directing the eye downward could seem heavy and oppressive. He even went so far as to equate the upper portion of the canvas with heaven and the lower part with earth.[118] Although he warned that these explanations were metaphoric, his choice of words clarifies to some degree the complex orientation of his paintings.

Kandinsky had been associated with reform in Soviet art education, and although he stood apart from the Constructivists by continuing to believe in easel painting, his connection with the Soviet avant-garde as well as his dignified demeanor and his calm certainty brought his pronouncements on color and form correspondences wider acceptance than Itten's. Even as Gropius lashed out at "wild romanticism" and escapism and sought to combine art and technology in his attempt to have industry underwrite Bauhaus projects, he continued to let Kandinsky run one of the preliminary courses that all students were required to take. Gropius, the pragmatic administrator, never lost his faith in the power of the fine arts to affect all design. The essence of Expressionism — the utopian belief in art's potential to transform humanity, the faith in the interrelationship of the arts, and the equation of antinaturalism and abstraction with purity and spirituality — persisted at the Bauhaus. The search for transcendence through art continued to prevail.

1. For a discussion of the term *Expressionism* and its early use in Germany, see Marit Werenskiold, *The Concept of Expressionism: Origin and Metamorphoses,* trans. Ronald Walford (Oslo: Universitetsforlaget, 1984); and Victor Miesel, "The Term Expressionism in the Visual Arts (1911–1920)," in *The Uses of History,* ed. Hayden White (Detroit: Wayne State University Press, 1968), 135–51.

2. For a discussion of the association of Expressionism and socialism, see Ida Katherine Rigby, *An alle Künstler! War — Revolution — Weimar* (San Diego: San Diego State University Press, 1983).

3. Wilhelm Worringer, "Zur Entwicklungsgeschichte der modernen Malerei," *Der Sturm* 2, no. 75 (August 1911): 597–98.

4. Ibid., 598.

5. C. G. [Curt Glaser], "Expressionismus: Ausstellung der 'Neuen Sezession' im Frankfurter Kunstsalon Goldschmidt," *Frankfurter Zeitung,* 30 April 1912. For a brief discussion of Kandinsky's contacts with Worringer, see Klaus Lankheit, "A History of the Almanac," in *The Blaue Reiter Almanac* (1912), ed. Wassily Kandinsky and Franz Marc; documentary edition edited by Klaus Lankheit (New York: Viking, 1974), 17, 26, 30.

6. [Curt] Glaser, "Berliner Ausstellung," *Die Kunst für Alle* 27, no. 15 (1 May 1912): 362.

7. Wilhelm Hausenstein, "Für Kandinsky," *Der Sturm* 3, nos. 150/51 (March 1913): 277.

8. Wassily Kandinsky, "Whither the 'New' Art?" (1911), in *Kandinsky: Complete Writings on Art,* ed. Kenneth C. Lindsay and Peter Vergo (Boston: G. K. Hall, 1982), 1:103.

9. Wassily Kandinsky, *On the Spiritual in Art* (1912), in *Complete Writings,* 1:197.

10. Kandinsky, "Whither the 'New' Art?" 1:101.

11. Kandinsky, *On the Spiritual in Art,* 1:145. For a more complete discussion of Kandinsky's knowledge of Theosophy and his interest in other aspects of occultism see Rose-Carol Washton Long, *Kandinsky: The Development of an Abstract Style* (Oxford: Clarendon Press, 1980), 14ff.

12. Kandinsky, *On the Spiritual in Art,* 1:159. Kandinsky learned of A. Zakharin-Unkovsky from Maria Strakosch-Geisler, a former pupil, and her husband, Alexander, who wrote to him on 21 June 1909 about Unkovsky's theories. According to a letter written to Gabriele Münter on 10 November 1910, Kandinsky visited Unkovsky in Moscow (Gabriele Münter-Johannes Eichner Stiftung, Städtische Galerie im Lenbachhaus, Munich).

13. For a discussion of the interest in Kandinsky's circle in Rudolf Steiner, see Long, *Kandinsky,* 26ff.; and Robert C. Williams, "Concerning the German Spiritual in Russian Art: Vasilii Kandinskii," *Journal of European Studies* 1, no. 4 (1971): 325ff. For an analysis of Kandinsky's annotations of Steiner's essays, see Sixten Ringbom, "Die Steiner-Annotationen Kandinskys," *Kandinsky und München: Begegnungen und Wandlungen 1896–1914,* exh. cat. (Munich: Städtische Galerie im Lenbachhaus, 1982), 102–5.

14. Kandinsky, *On the Spiritual in Art,* 1:146ff.; and Long, *Kandinsky,* 67ff.

15. Rudolf Steiner, *Theosophie* (1904), 5th ed. (Leipzig: Max Altmann, 1910), IV.

16. Ibid., 109–10. See also Ringbom, "Die Steiner-Annotationen Kandinskys," 103.

17. Kandinsky, *On the Spiritual in Art,* 1:209. Kandinsky also wrote, "[It is] not an obvious ('geometrical') construction that will be the richest in possibilities, hence the most expressive, but the hidden one, which emerges unnoticed from picture and hence is destined less for the eye than for the soul." See Wassily Kandinsky, *Über das Geistige in der Kunst,* 7th ed., based on 2d ed. of 1912 (Bern: Benteli, 1963), 129.

18. Ibid., 169, 171; and Wassily Kandinsky, "Rückblicke," in *Kandinsky 1901–1913* (Berlin: Der Sturm, 1913), XXVI.

19. For a discussion of Kandinsky's process of veiling and stripping to create hidden constructions, see Long, *Kandinsky,* 66ff.

20. Wassily Kandinsky, "Letters from Munich" (1910), in *Complete Writings,* 1:68–69. For a discussion of Kandinsky's interest in Matisse and in Symbolist painters, see Long, *Kandinsky,* 44ff.

21. For a more complete account of the relationship of Kandinsky's choice of motifs to the themes of struggle and redemption, see Long, *Kandinsky,* 28–41, 77–136.

22. Kandinsky and his companion Gabriele Münter kept a house catalogue or house list of most of his major oils. The list included titles and frequently small sketches for many works. It also included subtitles to a number of works he called Improvisations.

23. Long, *Kandinsky,* 125–28.

24. Quoted in Michael Sadler, *Modern Art and Revolution* (London: Hogarth Press, 1932), 18–19.

25. Long, "Kandinsky's Vision of Utopia as a Garden of Love," *Art Journal* 43, no. 1 (Spring 1983): 50–60.

26. Long, *Kandinsky,* 123–36.

27. Kandinsky, *Über das Geistige* (1963), 112; see also a variant translation in *Complete Writings,* 1:195.

28. Kandinsky, *On the Spiritual in Art,* 1:195.

29. Guillaume Apollinaire, "The New Painting: Art Notes," (1912), in *Apollinaire on Art: Essays and Reviews 1902–1912,* ed. LeRoy C. Breunig and trans. Susan Suleiman (New York: Viking, 1972), 222.

30. Linda Henderson, *The Fourth Dimension and Non-Euclidean Geometry in Modern Art* (Princeton: Princeton University Press, 1983), 238ff.; and Charlotte Douglas, *Swans of Other Worlds: Kazimir Malevich and the Origins of Abstraction in Russia* (Ann Arbor: UMI Research Press, 1980), 30–32, 60–62.

31. Kandinsky, *On the Spiritual in Art,* 1:139.

32. For a discussion of the interrelationships among writers, artists, anarchists, and other intellectuals in Berlin in the 1890s and early years of the twentieth century, see Janos Frecot, "Literatur zwischen Betrieb und Einsamkeit," and Ulrich Linse, "Individualanarchisten, Syndikalisten, Bohemiens," in *Berlin um 1900,* exh. cat. (Berlin: Akademie der Künste, 1984), 328–37, 442–45; for a more specific account of Steiner's contacts with socialists, anarchists, and Berlin poets, see also Walter Kugler, "Rudolf Steiner in Berlin," ibid., 394–400.

33. Kandinsky commented negatively on Tolstoy's approach to art (see Kandinsky, *On the Spiritual in Art,* 1:130).

34. Kandinsky to Gutkind, 2 July 1914, private collection, West Germany. Kandinsky was an admirer of Gutkind's *Siderische Geburt* (1910) (see Long, "Kandinsky's Vision," 58). Kandinsky could also have heard about Gustav Landauer's theories from Karl Wolfskehl, who knew Landauer's close friend Martin Buber (see Long, *Kandinsky,* 17). For a discussion of the Potsdam conference, see Eugene Lunn, *Prophet of Community: The Romantic Socialism of Gustav Landauer* (Berkeley and Los Angeles: University of California Press, 1973), 245.

35. Wassily Kandinsky, "The 'Great Utopia'" (1920), in *Complete Writings,* 1:445.

36. For a discussion of Kandinsky's contribution to the Institute of Artistic Culture and the divergence between his views and those of other members, see Christina Lodder, *Russian Constructivism* (New Haven: Yale University Press, 1983), 78–82.

37. For an introduction to the artists and writers involved with Sturm, see *Der Sturm: Herwarth Walden und die Europäische Avantgarde, Berlin 1912–1932,* exh. cat. (Berlin: Nationalgalerie, 1961); and more recently Georg Brühl, *Herwarth Walden und Der Sturm* (Cologne: DuMont Buchverlag, 1983). Walden and his first wife, the poet Else Lasker Schuler, were involved in some of the same intellectual circles as Steiner in the early years of the century (see Frecot, "Literatur," 337–38).

38. [Rudolf Blümner], *Der Sturm: Eine Einführung* (Berlin: Der Sturm, [1917]).

39. Herwarth Walden, "Paul Scheerbart," *Der Sturm* 6, nos. 17/18 (December 1915): 98.

40. Bruno Taut, "Eine Notwendigkeit," *Der Sturm* 4, nos. 196/97 (February 1914): 175. For a discussion of Taut's debt to Kandinsky, see Marcel Franciscono, *Walter Gropius and the Creation of the Bauhaus in Weimar: The Ideals and Artistic Theories of Its Founding Years* (Urbana: University of Illinois Press, 1971), 98ff.

41. For a thorough analysis of Taut and Scheerbart, see Rosemarie Haag Bletter, "Bruno Taut and Paul Scheerbart's Vision: Utopian Aspects of German Expressionist Architecture" (Ph.D. diss., Columbia University, 1973), 78–85ff.

42. Ibid., 107ff. For a brief discussion of Fechner's influence on Scheerbart, see Mechthild Rausch, "Paul Scheerbart: Eine Art Barbar," in *Berlin um 1900,* 350.

43. Ibid., 108.

44. Alfred Kubin, *The Other Side: A Fantastic Novel* (1909), with Alfred Kubin's autobiography, trans. Denver Lindley (New York: Crown, 1967), XXXIII.

45. Bletter, "Bruno Taut," 78.

46. Kandinsky, *On the Spiritual in Art,* 1:155.

47. Paul Fechter, *Expressionismus* (Munich: R. Piper, 1914), esp. 24–29.

48. Hermann Bahr, *Expressionismus* (Munich: Delphin, 1916), 123.

49. Ibid., 45ff.

50. G. F. Hartlaub, "Die Kunst und die neue Gnosis," *Das Kunstblatt* 6 (June 1917): 178, 177, 166ff.

51. Paul Westheim's *Das Kunstblatt,* which made Expressionism accessible to a wide audience, had published Gustav Landauer's translation of Meister Eckhart's writings in its first and second issues: *Das Kunstblatt,* nos. 1–2 (January–February 1917): 23ff., 53ff.

52. Eckhart von Sydow, "Das religiöse Bewusstsein des Expressionismus," *Neue Blätter für Kunst und Dichtung* 1, no. 8 (1918/19): 199.

53. Ibid., 193.

54. Schlemmer to Otto Meyer, 25 March 1919, in *The Letters and Diaries of Oskar Schlemmer,* ed. Tut Schlemmer (Middletown, Conn.: Wesleyan University Press, 1972), 65.

55. Von Sydow, "Das religiöse Bewusstsein," 194. In Eckhart von Sydow, *Die Deutsche expressionistische Kultur und Malerei* (Berlin: Furche, 1919/20), the author took a more nationalistic point of view, praising German Expressionism in contrast to its French counterpart.

56. Herbert Kühn, "Expressionism und Sozialismus," *Neue Blätter für Kunst und Dichtung* 2, no. 2 (May 1919): 29.

57. Ibid. See Rigby, *An alle Künstler,* esp. 29–31, 51–57, for connections between Expressionism, internationalism, and socialism.

58. Wilhelm Hausenstein, "Was ist Expressionismus" (1919), in *Literatur — Revolution 1910–1925,* ed. Paul Pörtner (Neuwied am Rhein: Hermann Luchterhand, 1961), 2:309, 311.

59. Kasimir Edschmid, "Stand des Expressionismus" (1920), in *Expressionismus: Der Kampf um eine literarische Bewegung,* ed. Paul Raabe (Munich: Deutscher Taschenbuch, 1965), 175.

60. Hans Friedeberger, "Das Künstlerplakat der Revolutionszeit," *Das Plakat* 10, no. 4 (July 1919): 275; and Rigby, *An alle Künstler,* 35–39.

61. Richard Hülsenbeck, "Collective Dada Manifesto" (1920?), in *The Dada Painters and Poets: An Anthology,* ed. Robert Motherwell (Boston: G. K. Hall, 1981), 244.

62. Georg Grosz, "Zu meinen neuen Bildern," *Das Kunstblatt* 5, no. 1 (1921): 14.

63. G. F. Hartlaub, "Deutscher Expressionismus, zur Darmstädter Ausstellung," *Frankfurter Zeitung,* 13 July 1920.

64. G. F. Hartlaub, *Kunst und Religion* (Leipzig: Kurt Wolff, 1919), 109.

65. Ibid., 108.

66. "Das staatliche Bauhaus in Weimar," *Beilage zur Thüringer Tageszeitung,* 3 January 1920, Bauhaus Archiv, Berlin. This journalist also criticized the Bauhaus for its internationalism, stating that unified work only emerged from a national spirit. Others emphasized that the Bauhaus should not receive state funds as the school included too many non-Germans.

67. Walter Gropius, untitled essay, in *Exhibition of Unknown Architects* (1919), in *The Architecture of Fantasy,* ed. Ulrich Conrads and Hans G. Sperlich (New York: Praeger, 1962), 137.

68. Walter Gropius, "Bauhaus Program" (1919), in *The Bauhaus,* ed. Hans M. Wingler (Cambridge, Mass.: MIT Press, 1969), 31.

69. Gropius to Redslob, 13 December 1920, Bauhaus Archiv, Berlin.

70. Walter Gropius, typescript of speech to Bauhaus students, July 1919, Bauhaus Archiv, Berlin.

71. Ibid.

72. The program of the Arbeitsrat, which appeared in loose pamphlets and in several magazines, is reprinted in *Arbeitsrat für Kunst: Berlin 1918–1921,* exh. cat. (Berlin: Akademie der Künste, 1980), 87–89. The program that appeared in *Mitteilungen des deutschen Werkbundes* is translated into English in Iain Boyd Whyte, *Bruno Taut and the Architecture of Activism* (Cambridge: Cambridge University Press, 1982), 232–33.

73. For a discussion of Taut's contribution to the formation of the *Arbeitsrat,* see Bletter, *Bruno Taut,* 397–451; Franciscono, *Walter Gropius,* 142–47; and Whyte, *Bruno Taut,* 108–19.

74. Bruno Taut, *Die Auflösung der Städte* (1920), in *Architettura dell'Espressionismo,* ed. F. Borsi and G. K. König (Genoa: Vitalie Ghianda, 1967), 276.

75. Gropius to Behne, 6 March 1919, in *Arbeitsrat für Kunst,* 119.

76. Bruno Taut, untitled essay, in *Exhibition of Unknown Architects* (1919), in *Architecture of Fantasy,* 138.

77. See Whyte, *Bruno Taut,* 132–33.

78. Johannes Molzahn, "Das Manifest des absoluten Expressionismus; zur Ausstellung Oktober 1919," *Der Sturm* 10, no. 6 (1919–20): 92.

79. For discussion of Molzahn's work, see Robert L. Herbert et al., *The Société Anonyme and the Dreier Bequest at Yale University: A Catalogue Raisonné* (New Haven: Yale University Press, 1984), 468–78; and Herbert Schade, *Johannes Molzahn* (Munich: Schnell & Steiner, 1972).

80. See Ernst Scheyer, "Molzahn, Muche and the Weimar Bauhaus," *Art Journal* 28, no. 3 (Spring 1969): 271–72; also Schade, *Johannes Molzahn,* 36.

81. For a reproduction of the Molzahn woodcut, see *Graphic Work from the Bauhaus,* ed. Hans M. Wingler (Greenwich, Conn.: New York Graphic Society, 1969), pl. 38; see also 12, 15–16.

82. Magdalena Droste et al., *Georg Muche: Das künstlerische Werk 1912–1927,* exh. cat. (Berlin: Bauhaus Archiv, 1980), 11; and *Jacoba van Heemskerck 1876–1923: Kunstenares van het expressionisme,* exh. cat. (The Hague: Haags Gemeentemuseum, 1982).

83. Droste et al., *Georg Muche,* 18–20, 59–60.

84. [Blümner], *Der Sturm: Eine Einführung,* 4.

85. Droste et al., *Georg Muche,* 11.

86. Muche to Hademann, draft, 1919, ibid., 66.

87. Muche to van Leer, draft, 1919, ibid., 61.

88. Muche to Citroen, March 1920, ibid., 65.

89. Johannes Itten, "Aus meinem Leben" (1948), in *Johannes Itten: Werke und Schriften,* ed. Willy Rotzler (Zurich: Orell Füssli, 1972), 23.

90. For a discussion of the Adolf Hölzel circle and Itten, see Karin von Maur, "Es wuchs ein Kristall: Johannes Itten in Stuttgart 1913–1916," in *Johannes Itten: Künstler und Lehrer,* exh. cat. (Bern: Kunstmuseum, 1984), 55–65.

91. Itten to Walden, 21 April 1916, in *Schriften,* 48. In a note of 10 April 1916, Itten may refer to Scheerbart's 1910 book, *Das Perpetuum Mobile,* when he writes: "Ein Kunstwerk sollte so fabelhaft in sich selbst leben wie ein Perpetuum mobile" (An artwork should be in itself so incredible [that it] exists as if it were in "perpetual motion"); quoted ibid. See also, von Maur, "Es wuchs ein Kristall," 60.

92. Johannes Itten, note, 20 October 1916, in *Schriften,* 49.

93. Ibid., 399 nn. 65–66.

94. Johannes Itten, note, 6 July 1918, ibid., 54.

95. *Johannes Itten: Künstler und Lehrer,* 6 repro., 58, 119.

96. Oskar Schlemmer, diary, 28 July 1921, in *Letters and Diaries,* 111–12.

97. Schlemmer to Meyer, 7 December 1921, ibid., 113–15.

98. Ibid. Schlemmer described himself as "caught in the middle" between Gropius and Itten. See also Frank Whitford, *Bauhaus* (New York: Thames and Hudson, 1984), 51–59.

99. See Schlemmer to Meyer, June 1922, in *Letters and Diaries,* 123. For a discussion of the Itten-Gropius conflict, see Franciscono, *Walter Gropius,* 215–18.

100. Franciscono, *Walter Gropius,* 198ff.

101. Ibid., 193–94. Franciscono vividly conveys the ritualistic methods Itten used to stimulate the release of an individual's creative forces.

102. The full text of the lithograph reads, "Greeting and salutation to hearts which live illumined by the light of Love, and are not led astray either by hope of a heaven or fear of a hell."

103. Although *Tower of Fire* was formerly dated as late as 1922, the early date of 1919/20, which Itten scholars now give the work, brings it closer to the utopian structures that so many artists under Taut's Scheerbartian influence presented for the *Exhibition of the Unknown Architects.* For the most recent discussion of the dating of the *Tower of Fire,* see Andreas Franzke, "Zu den plastischen Werken Ittens," in *Johannes Itten,* 94–97.

104. Walter Gropius, circular, 3 February 1922, in Wingler, *Bauhaus,* 51–52.

105. Oskar Schlemmer, diary, June 1922, in *Letters and Diaries,* 124.

106. Schlemmer to Meyer, June 1922, ibid., 123.

107. Wassily Kandinsky, "Steps Taken by the Department of Fine Arts in the Realm of International Art Politics" (1920), in *Complete Writings,* 1:449, 451.

108. Theo van Doesburg, "Ausstellung von Arbeiten der Lehrlingen im Staatlichen Bauhaus" (1922), in Claudine Humblet, *Le Bauhaus* (Lausanne: L'Age d'Homme, 1980).

109. See Wassily Kandinsky "On Reform of Art Schools" (1923), in *Complete Writings,* 2:490. In 1920 Kandinsky explained that Expressionism was the beginning of "contemporary painting," and he pointed to abstraction as one variant of this direction (see Wassily Kandinsky, "The Museum of the Culture of Painting" [1920], in *Complete Writings,* 1:442).

110. Wassily Kandinsky, "Program for the Institute of Artistic Culture" (1920), in *Complete Writings,* 1:460.

111. Wassily Kandinsky, "Foreword to the Catalogue of the First International Art Exhibition, Düsseldorf" (1922), in *Complete Writings,* 2:479.

112. See M. V. Matyushin, "Of the Book by Gleizes and Metzinger *Du Cubisme*" (1913), in Henderson, *Fourth Dimension,* 368–75; and Matiushin, notebook entry, 29 May 1915, in Douglas, *Swans of Other Worlds,* 61.

113. Malevich to Matiushin, June 1916, in Eugenii Kovtun, "The Beginning of Suprematism," *From Surface to Space: Russia, 1916–24,* exh. cat. (Cologne: Galerie Gmurzynska, 1974), 36.

114. Kandinsky to Grohmann, 12 October 1930, in *Künstler schreiben an Will Grohmann,* ed. Karl Gutbrod (Cologne: DuMont Schauberg, 1968), 56. Henderson believes that Kandinsky's awareness of fourth-dimension theories may have influenced others at the Bauhaus (see Henderson, *Fourth Dimension,* 240, 339).

115. Wassily Kandinsky, *Point and Line to Plane* (1926), in *Complete Writings,* 2:671.

116. Ibid. For a discussion of Kandinsky's application of these ideas when he was in Paris, see Long, untitled essay, in *Kandinsky: Parisian Period 1934–1944,* exh. cat. (New York: Knoedler, 1969), 15–20.

117. For a discussion of Kandinsky's parallels of color and form, see Whitford, *Bauhaus,* 98–100, 110–12; and Clark V. Poling, *Kandinsky: Russian and Bauhaus Years 1915–1933,* exh. cat. (New York: Solomon R. Guggenheim Museum, 1983), 43–45, 63–67.

118. Kandinsky, *Point and Line,* 2:645.

OVERLEAF

BARNETT NEWMAN
Onement II, 1948
Oil on canvas
60 x 36 in. (152.4 x 91.5 cm)
Wadsworth Atheneum,
Hartford, Connecticut
Anonymous gift

MYSTICISM, ROMANTICISM, AND THE FOURTH DIMENSION

LINDA DALRYMPLE HENDERSON

In 1904 the American architect and occult author Claude Bragdon (pl. 1) wrote an article on the Belgian Symbolist Maurice Maeterlinck that brought together several vital spiritual concerns of the new century. Of Maeterlinck, Bragdon wrote, "Actualities have value to him only as they image . . . that spiritual world in which souls meet and dwell, and he communicates to our inner consciousness his interest in this immanent, but invisible universe much as a mathematician is able to make plain the nature of four dimensional space, intangible to the senses." If Maeterlinck's essays seem "strange and ineffable," it is only because "the infinite refuses to be expressed in terms of the finite." Maeterlinck is "the mystic of the modern world," and "the oneness of the individual with the absolute is the recurrent refrain of his every song." Moreover, his "widening influence and his increasing popularity" establish that "after centuries of purely objective consciousness a spiritual epoch is at last upon us, in which the soul draws near the surface of life."[1]

Bragdon's text contains one of his first published references to the fourth dimension, a subject that he would make his own in a series of books published from 1912 onward. If in 1904 he had not yet developed the connections between a fourth dimension and mysticism, as he would do later, his text nevertheless sets forth certain mystical themes that became central to early twentieth-century discussions of a fourth dimension: the infinite, the evolution of consciousness, and the philosophical monism implied by Maeterlinck's belief in "the oneness of the individual with the absolute." Transcending national boundaries, these three themes weave a thread reaching back to Romanticism and forward to Surrealism, two movements in which the mystical tradition played an important role.

Although interest in a fourth dimension of space was an outgrowth of the development of n-dimensional geometries during the first half of the nineteenth century, the notion of a fourth dimension had become highly popularized by the turn of the century. By that time the term had accumulated a variety of nonmathematical associations, the primary one being an idealist philosophical interpretation of it as a higher reality beyond three-dimensional, visual perception. In fact, the concept enjoyed a symbiotic relationship with the mystical tradition. Early writers on the fourth dimension often drew upon the terminology of mysticism, and conversely writers of a mystical bent such as Bragdon found in the idea of a fourth dimension a means to make the ineffable more concrete.

This essay examines the three earliest and most influential twentieth-century statements on art and the fourth dimension. Two of these texts were written by figures within the art world: Max Weber's *Camera Work* article, "The Fourth Dimension from a Plastic Point of View" (1910), and Guillaume Apollinaire's discussion of *la quatrième dimension* (the fourth dimension), printed first in a 1912 article and later in his *Les Peintres Cubistes* (1913). The third text, *Tertium Organum,* published in Saint Petersburg in 1911, was written by the mystic philosopher P. D. Ouspensky and was read by artists from the Russian Futurists and Malevich through the Surrealists and beyond. Although published in widely separated locales (New York, Paris, Saint Petersburg), the three statements share sources in the mystical and occult tradition. Considered in relation to the issues of infinity, monism, and the evolution of consciousness, the texts have far more in common than has been noted previously.

Variations within the mystical tradition help explain the differing artistic ramifications of each text, respectively, for Weber's painting, for Cubist painters in Apollinaire's circle, and for Kazimir Malevich and the Surrealists who read Ouspensky.[2] Indeed, a wholly or partly mystical interpretation of the fourth dimen-

sion underlies styles ranging from Symbolist and Cubist evocations of higher space, which utilized some degree of recognizable form, to the total abstractions of Malevich's geometric Suprematism and the organic inner worlds of the Surrealists Matta and Gordon Onslow-Ford.[3]

INFINITY

Before considering the statements of Weber, Apollinaire, and Ouspensky in their individual contexts, it is helpful to provide some historical background for these writers' concepts of infinity as well as monism and the evolution of consciousness. Because infinity has a more complex cultural history than either of the other two issues, it serves particularly well to demonstrate the remarkable similarities in the language of mysticism, Romanticism, and literature on the fourth dimension. Thus we begin with the words of Weber, Apollinaire, and Ouspensky on the subject of infinity.

Compared with Ouspensky's lengthy book on the fourth dimension, the essays of Weber and Apollinaire offer succinct statements on

the relation of the fourth dimension to infinity. In his 1910 article, Weber explained that the fourth dimension is "the immensity of all things" and "the dimension of infinity."[4] Apollinaire in his 1912 article described the fourth dimension as "the immensity of space eternalizing itself in all directions at any given moment" and asserted that "it is space itself, the dimension of the infinite."[5] The closeness of these two texts may be explained in part by Weber's having met Apollinaire in Paris in 1908 and Apollinaire's subsequent translation of Weber's essay before he wrote his own article.[6]

Ouspensky's *Tertium Organum* presents his mystical philosophy based on the evolution of consciousness to comprehend higher-dimensional space. For Ouspensky (pl. 2) "art [including poetry and music] is a path to cosmic consciousness," and a "sensation of infinity" characterizes the first moments of the transition to the new consciousness of four-dimensionality: "The sense of the infinite is the first and most terrible trial before initiation. Nothing exists. A little miserable soul feels itself suspended in an infinite void. Then even the void disappears. There is only infinity, a constant and continuous division and dissolution of everything."[7]

According to Ouspensky the "sensation of infinity" and the attendant recognition of "an abyss everywhere" will be accompanied by an "impression of utter and never-ending illogicality."[8] With the transition to four-dimensional consciousness comes a radical reversal of what had been seen in the three-dimensional world as real and unreal or logical and illogical. Ouspensky proposed his new alogical logic of "Tertium Organum" as a means for an individual to prepare for the revelation of four-dimensional reality. Once achieved, "cosmic consciousness" brings further reversals. In the fourth dimension, the self-oriented sense of up-down and left-right fades away, and objects can be viewed from all sides at once. Even more startling is the discovery that time and motion, as understood in three dimensions, had been mere illusions produced by inadequate perception of four-dimensional extension. Not only a new logic but a new language is needed for the world of higher consciousness. "*New parts of speech* are necessary, an infinite number of words," Ouspensky argued.[9]

In addition to infinity, these last two issues (freedom from up-down and left-right orientation and the inadequacy of present language) also indicate the debt of Ouspensky and others to mysticism and Romanticism. For example, William James in *The Varieties of Religious Experience* (1902) lists as the first characteristic of mystical experience "ineffability" or "incommunicableness."[10] Writers on the fourth dimension in the early twentieth century frequently pointed out the inadequacy of present language to deal with higher dimensionality. The experiments of Weber and Pablo Picasso in art, Gertrude Stein in prose, and Edgard Varèse in music were all discussed as attempts to create a new language that would reveal a higher truth. Similarly, given the mystical sources of Romanticism, it is not surprising that Ouspensky's call for "new parts of speech" to deal with the fourth dimension finds a striking parallel in the words of the Irish poet Thomas Moore upon viewing the "awful sublimities" of Niagara Falls in 1804: "We must have new combinations of language to describe the Fall of Niagara."[11]

Ouspensky's specific source for his views on freedom from traditional spatial orientation was the Englishman Charles Howard Hinton, who developed the first system of "hyper-space philosophy" in his books *A New Era of Thought* (1888) and *The Fourth Dimension* (1904). In order to educate one's "space sense" and achieve higher consciousness, Hinton believed that an individual must cast out such "self-elements" in perception as the sense of gravity (up-down) and left-right orientation.[12] A similar transcendence of space and time frequently occurs in accounts of mystical illumination, such as that of the German Romantic painter Philipp Otto Runge in an 1802 letter: "I throw myself on the grass sparkling with dewdrops. Every leaf and every blade of grass swarms with life, the earth is alive and stirs beneath me, everything rings in one chord, the soul rejoices and flies in the immeasurable space around me. There is no up and down any more, no time, no beginning and no end."[13] Only in the twentieth century would abstract artists like Malevich and Theo van Doesburg, inspired by Hinton's and Ouspensky's writings on the fourth dimension, succeed in depicting a gravity-free, directionless space.[14]

A few key aspects of the history of the elemental concept of infinity help explain the significance of the term as it came to be linked with the fourth dimension by Weber, Apollinaire, and Ouspensky. As quoted by Ouspensky in *Tertium Organum*, a statement on the infinite by Plotinus (the third-century founder of Neoplatonism) stands as an early signpost in the mystical tradition:

You ask, how can we know the Infinite? I answer, not by reason. It is the office of reason to distinguish and define. The infinite, therefore, cannot be ranked among its objects. You can only apprehend the infinite by a faculty superior to reason, by entering into a state in which you are your finite self no longer — in which the divine essence is communicated to you. This is ecstasy. It is the liberation of your mind from its finite consciousness. Like can only apprehend like; when you thus cease to be finite, you become one with the infinite. In the reduction of your soul to its simplest self, its divine essence, you realize this union — this identity.[15]

If Plotinus himself did not overtly identify infinity with the One, or God, that identification was made directly in the Zohar, the codification of the cabala. There the term *Ein-Sof* (Infinite) is used to denote the unknowable, hidden God.[16]

The Cambridge Platonist Henry More, grounded in Neoplatonism and the cabala, made a divine, infinite space central to the philosophy he set forth in his *Enchiridion metaphysicum* (1671). Blending mystical sources with the new astronomy of Copernicus and Galileo, More found in the heavens the possibility of infinite space and time, and he transferred to space itself the qualities of God.[17] More's ideas were a vital impetus for the emergence of the "natural sublime" and the "aesthetics of the infinite" in seventeenth- and eighteenth-century English literature.[18] Thus the eternity and infinity More sensed in the heavens were gradually transferred to the terrestrial landscape, which could then evoke feelings of sublimity and a Promethean desire to exceed the finite bounds of existence.[19]

The link between infinity and the Romantic sublime was codified for subsequent generations in Edmund Burke's *Philosophical Inquiry into the Origin of Our Ideas of the Sublime and the Beautiful* (1756). Drawing also upon the theories of Longinus on the "rhetorical sublime," Burke distinguished the sublime from the beautiful and included infinity in his catalogue of the sources of sublime passion: "Infinity has a tendency to fill the mind with that sort of delightful horror which is the most genuine effect and truest test of the sublime."[20] The fourth dimension, through its connection to infinity, became a twentieth-century code name for the sublime.

If Burke's text seemed to secularize the sublime, the infinite nevertheless retained its original mystical associations among Romantic writers and artists in Germany, England, and France.[21] Thus there is a mystical current that unifies Romantic references to infinity, from August Wilhelm Schlegel's description of beauty as a "symbolic representation of the infinite" to Charles Baudelaire's characterization of Romanticism in 1846 as "intimacy, spirituality, colour, aspiration towards the infinite, expressed by every means available to the arts."[22] In the case of Baudelaire (as well as William Blake and certain German Romantics), another mystical source had intervened: Emanuel Swedenborg.[23]

Swedenborg published his treatise *The Infinite and the Final Cause of Creation* (1734) eleven years before an experience of "spiritual enlightenment" in 1745 changed the nature of his writing from a more scientific to his better-known mystical mode.[24] If the 1734 treatise emphasized the division between the finite world and an infinite deity, Swedenborg's later use of the doctrines of "correspondence" and "series and degrees" suggested a greater continuity. Ralph Waldo Emerson included Swedenborg in *Representative Men* (1850) and, despite his criticisms of certain aspects of the later Swedenborg, praised him for recognizing "the primary relation of mind to matter."[25] And Bragdon, in *Four-Dimensional Vistas* (1916), noted parallels between Swedenborg's ideas on the infinite and aspects of his own "higher space" theory.[26]

From Henry More (and even Plotinus) through the nineteenth century, infinity retained its connection with divinity. In fact, even a statement in Apollinaire's *Les Peintres Cubistes,* when read in context, bears a Romantic and clearly spiritual association. After describing the fourth dimension as the "dimension of the infinite," he commented that the Cubist painters "live in the anticipation of a sublime art" and that "contemporary art, even if it does not directly stem from specific religious beliefs, nonetheless possesses some of the characteristics of great, that is to say, religious art."[27]

One last nineteenth-century reference to infinity must be mentioned because it bears the closest resemblance yet found to Weber's and Apollinaire's references to infinity. In *Isis Unveiled* (1877) Helena P. Blavatsky described the relation of man's "astral soul" to the "sidereal *anima mundi,*" or world soul, as follows: "He is in it, as it is in him, for the world-pervading element fills all space, and *is* space itself, only shoreless and infinite."[28] Here the similarity to Apollinaire's description of the fourth dimension is particularly striking: "It is space itself, the dimension of the infinite."

Throughout the first volume of *Isis Unveiled,* Blavatsky gave a series of definitions of the anima mundi that establish its connections to the Western mystical tradition of infinity as well as to the ancient wisdom of India and to modern science. She described the anima

mundi variously as the "Chaos" of the ancients; "the Soul of the World" of Plato and the Pythagoreans; "the Deity in the shape of Aether pervad[ing] all things" of the Hindus; "the Astral Light of the Kabalists"; "the *modern* Ether, not such as is recognized by our scientists, but such as it *was* known to the ancient philosophers"; "the great universal, magnetic agent, which [Newton] called the *divine sensorium*"; and the "Nirvana" of Buddha.[29]

The ether (the mysterious light-carrying medium believed by scientists before Albert Einstein to fill all space) is the explanation of the anima mundi to which Blavatsky returned again and again. Her primary source for these discussions was the remarkable text *The Unseen Universe; or, Physical Speculations on a Future State,* published anonymously in 1875. Its authors, British scientists Balfour Stewart and Peter Guthrie Tait, speculated that the ether might function as a "bridge into the invisible universe," as Blavatsky quoted them in her book.[30]

Perhaps a fourth dimension was not mentioned in Blavatsky's *Isis Unveiled* because Stewart and Tait did not incorporate the idea in *The Unseen Universe* until the revised edition of 1876. Yet the mysterious ether came to be associated frequently with the fourth dimension in subsequent decades. Already in 1876 Stewart and Tait found it useful to answer certain criticisms of their book by suggesting that "our (essentially three-dimensional) matter [is] the mere skin or boundary of an Unseen whose matter has *four* dimensions."[31] Similarly, Hinton in *A New Era of Thought* would propose that the ether was perhaps the boundary or surface of contact between two four-dimensional existences.[32] With such an identification established, an early twentieth-century reader of *Isis Unveiled* might well have felt that Blavatsky's equation, anima mundi equals infinity equals ether, also implied "equals the fourth dimension."

MONISM AND THE EVOLUTION OF CONSCIOUSNESS

Unlike infinity, with its long and independent history, monism and the evolution of consciousness were often closely associated with one another. Philosophical monism posits the unity of all things, both spiritual and material. Interpreted from a mystical viewpoint, monism also implies an absolute One with which the individual self may ultimately achieve union or, as in Neoplatonic emanation theories like that of Plotinus, reunion. In the Hindu Upanishads emphasis is placed on overcoming distinctions between the perceiving subject and the objects of the world, as a step toward achieving the union of self and Brahma. The phrase *Tat tvam asi* (that art thou) from the Upanishads appears repeatedly in early twentieth-century sources, including James's *The Varieties of Religious Experience* and the writings of Edward Carpenter, Rudolf Steiner, Ouspensky, and Bragdon.[33] And such a monist and at times pantheistic view underlies much of German and English Romantic thought and Emerson's transcendentalism.

Just as the fourth dimension came to be linked with infinity, the concept of a higher fourth dimension was an ideal monist tool to explain the blending of spirit and matter. For the Theosophists Blavatsky and Steiner, developments in nineteenth-century science, particularly atom theory, supported the dematerialization of matter and interpretations ranging from spirit as "finer matter" to matter as "condensed spirit."[34] Yet a fourth dimension of space offered an even more graphic demonstration of the way in which three-dimensional matter might be subsumed within a higher spiritual realm. Charles W. Leadbeater used the idea to explain "astral vision."[35] And Ouspensky, who based his entire philosophy upon the "monism of the universe," explained in *Tertium Organum:* "Nobody ever saw *matter,* nor will he ever — it is possible only to *think* matter. From another point of view it is an illusion accepted for reality. Even more truly it is the incorrectly perceived form of that which exists in reality. Matter is a section of *something;* a nonexistent, imaginary section. But that of which matter is a section, exists. This is the real, *four-dimensional* world."[36]

For Ouspensky, four-dimensionality, monism, and infinity were all linked to the attainment of a higher level of consciousness as a result of evolution. Ouspensky's primary sources for his ideas on evolving conscious-

ness were *Cosmic Consciousness* (1901) by the Canadian physician Richard Maurice Bucke[37] and the writings of the Englishman Edward Carpenter (pl. 3). Carpenter's first discussion of evolving consciousness, published in *From Adam's Peak to Elephanta* (1892), preceded Bucke's, and, unlike Bucke, Carpenter linked "cosmic consciousness" specifically to the fourth dimension. Just as Ouspensky had relied on Hinton's views on developing a four-dimensional "space-sense," so may Carpenter have been influenced by Hinton, with whom he shared the acquaintance of Olive Schreiner and Havelock Ellis.[38]

Carpenter, a disciple of Walt Whitman, became increasingly interested in the evolution of individual consciousness during the 1880s, following his introduction to Hindu literature.[39] Inspired by Whitman's *Leaves of Grass* and the Bhagavad Gita, Carpenter wrote and published a book-length poem *Towards Democracy* (1883). For the socialist Carpenter, like Whitman, the term *democracy* reflected an optimistic belief in the potential for individual development in the coming millennium. He combined his belief in the possibility of mental evolution, based on the model of Indian Yogis, with an awareness of contemporary psychological research, as represented by the British Society for Psychical Research and such figures as Frederic W. H. Myers, one of the society's founders. His ideas paralleled Theosophy and provided a model for Ouspensky. Like Theosophy's founders and Ouspensky, Carpenter traveled to India and Ceylon in search of the ancient wisdom, a visit he chronicled in *From Adam's Peak to Elephanta*.[40]

Carpenter's 1892 text presented his first explication of "*universal* or *cosmic* consciousness,"[41] based on his meetings with an Indian Yogi. In the chapter "Consciousness without Thought," Carpenter made clear his monist orientation by describing cosmic consciousness as "a consciousness in which the contrast between the *ego* and the external world, and the distinction between subject and object, fall away."[42] He then supported his assertion of "another form of consciousness" by citing two developments in modern science. The first was the proof offered by hypnotism that there exists a "secondary consciousness" that allows an individual to perform "unconscious" acts. The second supporting idea was that of a fourth dimension: "If this fourth dimension were to become a factor of our consciousness it is obvious that we should have means of knowledge which to the ordi-

nary sense would appear simply miraculous. There is much to suggest that the consciousness attained by the Indian gñánis in their degree, and by hypnotic subjects in theirs is of this fourth-dimensional order."[43]

Carpenter's most fully developed statement of his belief in a monistic higher consciousness occurs in *The Art of Creation* (1904). In the chapter "The Three Stages of Consciousness," Carpenter, as Bucke had done in *Cosmic Consciousness,* posits "Simple Consciousness" and "Self-Consciousness" as the stages preceding the attainment of "Cosmic, or Universal Consciousness."[44] According to Carpenter, self-consciousness is characterized by the sense of separation of self from objects in the world and by knowledge based only on intellect. Only in the third, cosmic stage does the illusion of separation of subject and object, "of 'self' and 'matter,'" disappear, as knowledge based on emotion replaces thought: "There is a consciousness in which the subject and object are felt, are *known,* to be united and one — in which the Self is felt to *be* the object perceived . . . or at least in which the subject and object are felt to be parts of the same being, of the same including Self of all."[45]

Although in *The Art of Creation* Carpenter referred only in passing to the fourth dimension,[46] he did use it to explain the central element in the book: the "great Self" with which union is realized in cosmic consciousness.[47] Quoting extensively from mystical sources, including Plotinus and the Upanishads, Carpenter also suggested an identification of this "great Reality" with Plato's world of ideas, a common association made with the fourth dimension in this period.[48] Carpenter's potentially four-dimensional "great Self" could easily have been interpreted as the counterpart of Blavatsky's anima mundi.

While the themes of infinity, monism, and the evolution of consciousness can all be detected to some degree in the writings of Weber, Apollinaire and his circle, and Ouspensky, the latter two are least evident in Apollinaire and Cubism. For Weber and the New York avant-garde as well as for Ouspensky and the Surrealists, however, monism and the evolution of consciousness were central issues. In fact, Weber and Ouspensky read many of the same mystical sources.

3
ALVIN LANGDON COBURN, *Edward Carpenter,* 1905, photograph, International Museum of Photography at the George Eastman House, Rochester, New York

The intellectual climate of pre–World War I America is aptly described by the title of a 1909 review in *Current Literature:* "The New Spiritual America Emerging." The article by Michael Williams being reviewed had cited the contribution of William James and suggested to the reviewer the lineage of the new mystical/spiritual orientation:

Emerson was one of the prophets of the 'New America,' and Walt Whitman wrote its psalms. Among those who have sensed its coming have been the friends of Whitman, Richard Maurice Bucke and Edward Carpenter. . . . [Mr. Williams's] 'New America' is nothing else than that mystical and spiritual America which centers predominantly about the recognition of new and hitherto unrecognized *powers of Mind*. . . . From the Orient, too, have come contributing influences — Madame Blavatsky with her Theosophy and Swami Vivekananda with his Vedanta philosophy.[49]

Although Bucke's *Cosmic Consciousness* has been discussed in connection with the numerous references to evolving consciousness by members of Alfred Stieglitz's circle and with Marsden Hartley's creation of "cosmic Cubism," the importance of Carpenter for the New York avant-garde has not been examined.[50] Bucke included Carpenter among his examples of cosmic consciousness and reprinted Carpenter's "Consciousness without Thought" chapter from *From Adam's Peak*. And a comparison of Weber's *Camera Work* essay, along with his *Essays on Art* (1916), with Carpenter's *Art of Creation* establishes that Carpenter's views were central to the development of Weber's artistic philosophy.

When Weber published his essay in 1910, it joined a host of earlier texts on the fourth dimension that had appeared in American magazines ranging from *Popular Science Monthly* to *Harper's Weekly*.[51] Weber's title, "The Fourth Dimension from a Plastic Point of View," however, emphasized his artistic orientation and revealed his debt to French art theory and especially to the ideas of Leo Stein on tactile values and plasticity in Paul Cézanne's painting.

Weber had been in Paris from 1905 through 1908 and would have first heard about the fourth dimension's possible significance for modern painting through his connections to such avant-garde figures as Jean Metzinger,

Apollinaire, and Picasso.[52] Apollinaire subsequently responded to Weber's essay in his own texts by referring to the infinite, the ideal, and "the immensity of space eternalizing itself in all directions at any given moment."[53] Yet much of the rest of Weber's text, with its emphasis on matter, contrasts sharply to the highly idealist, antimaterialist stance of Cubist literature. Of the "dimension of infinity" Weber wrote in part:

In plastic art, I believe, there is a fourth dimension which may be described as the consciousness of a great and overwhelming sense of space-magnitude in all directions at one time, and is brought into existence through the three known measurements. . . . It is the immensity of all things. It is the ideal measurement . . .

. . . The ideal dimension is dependent for its existence upon the three material dimensions, and is created entirely through plastic means, colored and constructed matter in space and light. Life and its visions can only be realized and made possible through matter. . . .

The stronger or more forceful the form the more intense is the dream or vision. Only real dreams are built upon. Even thought is matter. It is all the matter of things, real things or earth or matter.[54]

Weber's remark that "even thought is matter" is a far cry from the assertion by the mathematician Henri Poincaré, the hero of the Cubists Albert Gleizes and Metzinger, that "all that is not thought is pure nothingness."[55] A parallel for Weber's view can be found, however, among early modern artists, especially in a statement by Kandinsky in *On the Spiritual in Art* (1912): "Thought which, although a product of the spirit, can be defined with positive science, is matter, but of fine not coarse substance."[56] The remarkable similarity of these two artists' statements stems from their common roots in a monist interpretation of the spirit-matter question. For Kandinsky that view came by way of Steiner and the standard theosophical literature of Blavatsky, Annie Besant, and Leadbeater.[57] For Weber it came generally from the monist mood of the "new spiritual America" and specifically from the writings of Carpenter.

Weber was most likely introduced to Carpenter's writings by his close friend the Stieglitz-circle photographer Alvin Langdon Coburn, who was the group's most prominent connection to international Symbolism

and mysticism.[58] Coburn photographed Carpenter in 1905 (pl. 3) and later included the photograph in *Men of Mark* (1913), in which he described his great admiration for the poet-philosopher and his fond memory of a subsequent visit to Carpenter a year later.[59] In his autobiography Coburn stated that "the book of Carpenter . . . which had the most influence on me at the time of our meeting was *The Art of Creation*."[60]

Carpenter prefaced that book with Lao-tzu's saying, "These two things, the spiritual and the material, though we call them by different names, in their Origin are one and the same." This is also a major theme of Weber's *Camera Work* text, although Weber refrained from using the word *spirit* as a counterpoint to matter. Instead, following Carpenter's terminology, Weber phrases his ideas in terms of the mind-matter problem and used the words *ideal, dream, vision,* and *thought* to stand for the mental or spiritual pole. In his later *Essays on Art,* by contrast, Weber would speak frequently of spirit and soul, perhaps under the influence of Kandinsky's *On the Spiritual in Art*. Nevertheless, beneath his temperate language, Weber clearly echoed Carpenter's monist message.

For Carpenter the attainment of cosmic consciousness brings the union of self and matter and the triumph of emotion over thought as the basis of knowledge: "It is not merely that the object is seen by the eye or touched by the hand, but it is felt at the same instant from within as a *part* of the ego; and this seeing and touching wake an infinite response — a reverberation through all the chambers of being — such as was impossible before."[61]

Weber likewise emphasized emotion and feeling in the individual's response to objects in nature: the fourth dimension "is real, and can be perceived and felt. It exists outside and in the presence of objects, and is the space that envelops a tree, a tower, a mountain, or any solid; or the interval between objects or volumes of matter if receptively beheld. . . . It arouses imagination and stirs emotion."[62] The artist became more specific about this empathy with objects in *Essays on Art,* where he wrote, "To imagine one's self discharging the functions of inanimate bodies is to ally one's self to the inanimate for a time and penetrate the world of matter, that asserts itself to us through the forms of art."[63]

Although Carpenter associated thought with self-consciousness and considered it capable

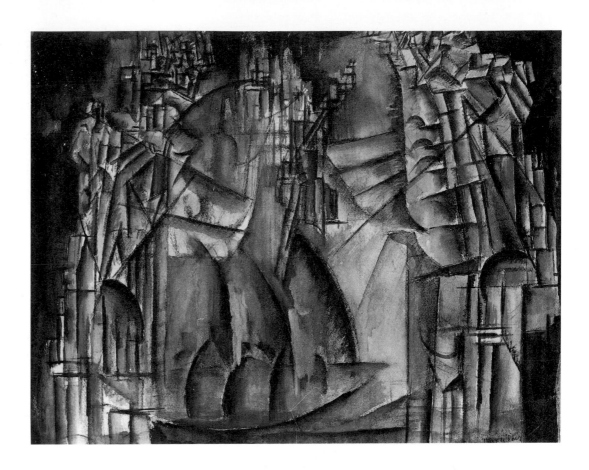

4
MAX WEBER
*Study for "Interior of the Fourth
Dimension,"* 1913
Gouache on paper
18 ½ x 24 in. (47 x 61 cm)
The Baltimore Museum
of Art
Saidie A. May Bequest
Fund

of bringing an individual only to the edge of cosmic consciousness, he discussed the positive contributions of creative thought in shaping man's environment: "There is in Man a Creative Thought-source continually in operation, which is shaping and giving form not only to his body, but largely to the world in which he lives. . . . This world of civilised life, with its great buildings and bridges and wonderful works of art, is the embodiment and materialisation of the Thoughts of Man."[64]

Similarly Weber followed his monist statement, "even thought is matter," with this echo of Carpenter: "Dreams realized through plastic means are the pyramids and temples, the Acropolis and the Palatine structures; cathedrals and decorations; tunnels, bridges, and towers; these [dreams] are all of matter in space — both in one and inseparable."[65]

In painting Weber achieved a sense of fluidity between spirit and matter only in works from 1913 onward, such as *Interior of the Fourth Dimension,* 1913 (pl. 4). His primary stylistic source in such works was the analytical Cubism of Picasso and Georges Braque, which had achieved a suggestion of higher dimensions by denying a clear reading of three-dimensional space and objects. Like the writings of Maeterlinck and the pictorial photography of his friends Coburn and Clarence White, Weber's painting functions as a Symbolist evocation of mystery, an attempt in Cubist language to express the infinite by means of the finite.

The difference between the styles of Weber and a totally abstract painter like Malevich derived in part from the type of mystical source upon which each artist drew. Although the evolution of consciousness was a central element in the philosophies of Carpenter, Bragdon, and Ouspensky, for Carpenter the object of cosmic consciousness, the "great Self," was only incidentally four-dimensional. Carpenter used the analogy of a fourth dimension primarily to clarify his argument, and his major emphasis remained upon a monistic empathy with objects in this world. By contrast, both Bragdon and Ouspensky firmly believed in the reality of four-dimensional existence and considered the world of three dimensions an illusion.

Weber's object-oriented Cubism is the counterpart of the "extrovertive" mysticism of Carpenter, and Malevich's abstract Suprematism parallels Ouspensky's more "introvertive" views.[66] Weber, like Carpenter, sought a union with and a spiritual transformation of nature: his fourth dimension is "brought into existence through the three known measurements."[67] Malevich and Ouspensky rejected the three-dimensional world and sought to achieve the mystical experience of infinity and four-dimensional consciousness. Ouspensky's "abyss everywhere" finds its equivalent in Malevich's statement, "I have transformed myself into a zero of form," and in the negation repre-

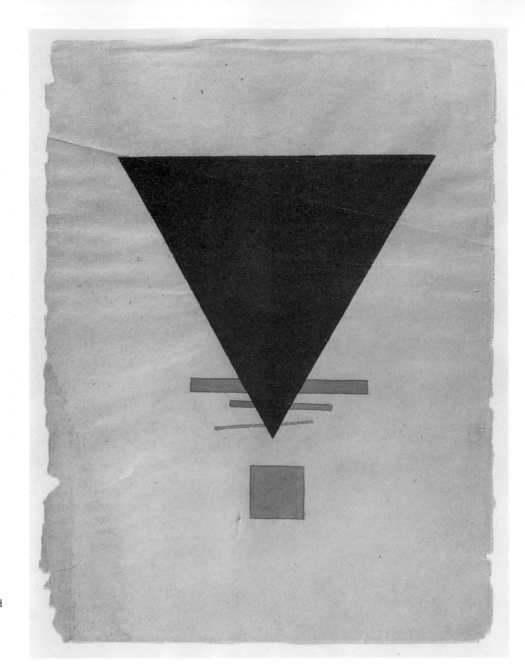

THE PROJECTIONS MADE BY A
CUBE IN TRAVERSING A PLANE

'A' REPRESENTS
THE SERIES OF
CROSS-SECTIONS TRACED BY THE
CUBE IN ENTERING THE PLANE
VERTICALLY BY ONE OF ITS ANGLES
'B' REPRESENTS THE SERIES
RESULTANT ON ITS ENTERING
BY ONE OF ITS EDGES
'C' REPRESENTS THE
UNCHANGING CROSS-
SECTION TRACED BY THE
CUBE MEETING THE
PLANE SQUARE-
LY BY ONE OF
ITS SIDES
ALL POSSIBLE PROJEC-
TIONS ARE MODIFICA-
TIONS OF THESE 3 CLASSES

THE CUBES IN THE ABOVE
DIAGRAM, SYMMETRICAL
SOLIDS OF A 3-DIMENSION-
AL SPACE, TRACE VARIOUS EPHEMERAL, AND CHANGING CROSS
SECTIONS IN THE PLANE 'D' A 2-SPACE, THE CHARACTER OF
THE CROSS-SECTION BEING DETERMINED BY THE ANGLE AT
WHICH THE CUBE MEETS THE PLANE — IF THE CUBES BE
TAKEN TO REPRESENT THE HIGHER-SELVES OF INDIVIDUALS
IN A HIGHER-SPACE WORLD, THE PLANE OUR PHENOMENAL
WORLD, THE CROSS-SECTIONS WOULD THEN REPRESENT THE
LOWER-SPACE-ASPECTS OF THESE HIGHER SELVES — PERSONALITIES

5
KAZIMIR MALEVICH
Suprematism, 1920
Watercolor and gouache
on paper
11 ⅝ x 8 ½ in.
(29.5 x 21.5 cm)
Los Angeles County
Museum of Art
Purchase with funds provided
by Kay Sage Tanguy,
Rosemary B. Baruch, Mr.
and Mrs. Charles Boyer

.

6
*The Projections Made by a Cube
in Traversing a Plane,* pl. 30
from Claude Bragdon, *A
Primer of Higher Space* (1913)

.

sented by his Suprematist compositions
(pl. 5).[68] Malevich replaced natural forms
with a pure geometry that bears a striking
resemblance to the language Bragdon utilized
in *Man the Square* (1912) and *A Primer of
Higher Space* (1913) to illustrate the relation of
a lower dimension to the next higher dimen-
sion (pl. 6).

Bragdon's 1904 article on Maeterlinck
reflected the mystical tone and the themes of
infinity, monism, and the evolution of con-
sciousness that were to dominate the intellec-
tual mood of the next decade. His mature
publications on the fourth dimension from
1912 onward, such as *A Primer of Higher Space*
and *Four-Dimensional Vistas* (1916), built upon
Theosophy and recast each of those themes in
terms of his theory of higher space. An out-
growth of the previous decade, Bragdon's
books utilized many of the same mystical
sources, for example, the Upanishads,
Swedenborg, and Emerson, upon which Car-
penter, Bucke, James, and others had drawn.
Bragdon also read the works of Carpenter and
James, along with earlier mystically oriented
writers on the fourth dimension, such as J. C.
F. Zöllner and Hinton.[69] And, in 1921,
Bragdon's Manas Press would publish the
first English translation of Ouspensky's

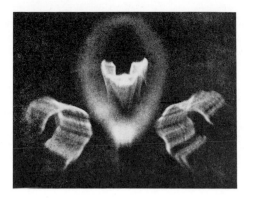 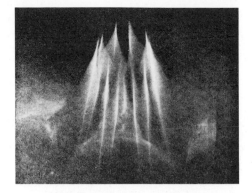 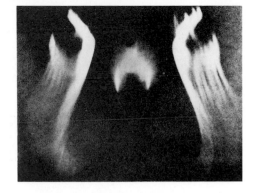

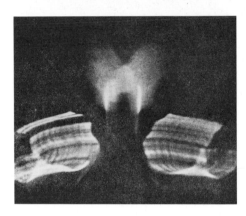 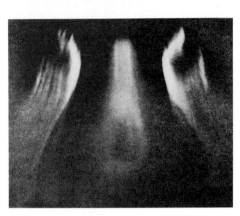

Tertium Organum, which was based on many of these same sources.[70]

Bragdon also shared with his milieu an affinity for Romanticism;[71] when he and several friends joined forces in 1919 to explore the possibilities of color music, they adopted the name the Prometheans.[72] The specific source for Bragdon's term may have been the Russian composer Aleksandr Scriabin's own mystical exploration of color symbolism in his *Prometheus: The Poem of Fire,* which had been performed in New York in 1915.[73] The end product of the American Prometheans' efforts was Thomas Wilfred's silent clavilux organ of 1921, which produced dematerialized configurations of colored light, subsequently photographed by Francis Bruguière (pl. 7). These images moved a reviewer to use the language of mysticism and Romanticism: "What we see is impossible to describe; this mobile color is a new art and we have no images of speech for it."[74] In *A Primer of Modern Art* (1924) the critic Sheldon Cheney associated the new language of color music specifically with the fourth dimension: "In the projection of this art in space, I sensed a new dimension, a new direction."[75]

A friend of Bragdon, Cheney frequently noted Bragdon's theories on four-dimensionality and mysticism in his *A Primer of Modern Art* and subsequent *Expressionism in Art* (1934). By 1934 Cheney's own orientation was becoming increasingly mystical, and in a chapter of *Expressionism,* "Abstraction and Mysticism," Cheney echoed the mystical language of Carpenter, Bragdon, and Weber when he asserted of the tendency toward abstraction in Expressionist painting that "in its finite way, it echoes, in one more manifestation, in one further push of evolutionary achievement, the harmonious order of the infinite."[76] Ultimately the interaction of mysticism with modern art and theory would come full circle in 1945, when Cheney published a history of mysticism entitled *Men Who Have Walked with God.* That Cheney praised Carpenter in the book testifies further to the Englishman's impact on early twentieth-century America.[77]

Beyond the general notion of evolving consciousness, it was Carpenter's monist belief in the unity of spirit and matter that was most important for Weber's ideas on the fourth dimension. Infinity was rarely mentioned by Carpenter, who seems to have been little touched by that concept's mystical and Romantic associations. Weber's use of the term *infinity* may have come from any number of sources, including the cabala (part of his own Jewish heritage), Blavatsky's *Isis Unveiled,* or one of the numerous popular articles that speculated on infinity and eternity in this period.[78] If Weber actually knew the Blavatsky text, it might have been through his friend Coburn or possibly through his brief acquaintance with Apollinaire in Paris. Just as textual comparisons establish the previously unknown link between Weber and the mystical views of Carpenter, so do Apollinaire's statements suggest that he had indeed read Blavatsky's *Isis Unveiled.*

APOLLINAIRE AND CUBISM

In the history of French art and literature, the presence of mysticism and occultism is far more overt in the periods of Symbolism and Surrealism than in the intervening decade before World War I. (The esoteric tradition was central to Symbolist art and theory; indeed, Ouspensky drew early inspiration from books popular in Paris during the 1890s, such as Éliphas Lévi's *Dogme et rituel de la haute magie* [1856] and Stanislas de Guaita's *Le Temple de Satan* [1891].[79]) Nevertheless mysticism

7
FRANCIS BRUGUIÈRE, *Thomas Wilfred's Color Organ: Progressive Stages in a Movement,* photographs, from Stark Young, "The Color Organ," *Theatre Arts Magazine* (January 1922): 24–26

and occultism were part of the complex intellectual milieu of the prewar years in Paris.[80] Figures such as Paul Sérusier, Alfred Jarry, and Maeterlinck provided personal connections to the esoteric interests of the 1890s. Throughout this period the Symbolist periodical *Mercure de France* maintained an "Ésotérisme et spiritisme" section that provided a wealth of information on topics ranging from the Zohar, Paracelsus, and Jakob Böhme to recent books by Camille Flammarion, Papus (Gérard Encausse), and Baron Karl du Prel. And in 1912 Édouard Schuré's *Les Grands Initiés: Esquisse de l'histoire secrète des religions* (1889) was in its twenty-fifth edition, confirming that early twentieth-century Frenchmen continued to be fascinated by the mystical and occult.

Among the group of Cubists at Puteaux, the presence of František Kupka and the spiritualist orientation of the writer Alexandre Mercereau and the Cubists' publisher Eugène Figuière assured that such ideas must have entered into the fabled discussions at Puteaux.[81] For example, Mercereau, secretary of the Société Internationale de Recherches Psychiques and contributor to the Symbolist journal *La Vie mystérieuse,* cited a variety of mystical and occult sources in his *La Littérature et les idées nouvelles* (1912), including Böhme, Swedenborg, the cabala, Flammarion, Schuré, Besant, and the *Book of Dzan,* which had been introduced to the world in Blavatsky's *Secret Doctrine* (1888).[82]

Mystical and occult sources would have joined with recent developments in science and mathematics, such as X rays and the theories of Poincaré, to support the Puteaux group's general philosophical idealism and specific interest in a higher four-dimensional reality.[83] If Gleizes and Metzinger came to adopt Poincaré's geometric and scientific approach to the fourth dimension, they nonetheless revealed the impact of Mercereau in their *Du Cubisme:* "Among the Cubist painters there are some who painfully pretend to be self-willed and profound; there are others who move freely on the highest planes. Among the latter — it is not our place to name them — restraint is only the clothing of fervor, as with the great Mystics."[84]

Apollinaire's connections with occultism, most likely through his friendships with Jarry and with the mystical poet Max Jacob, considerably predate those of Gleizes and Metzinger and the other Puteaux Cubists.[85] In

Le Bestiare, written about 1906, Apollinaire applied to Orpheus a quote from Hermes Trismegistus: "His the speaking voice of light / As Hermes Trismegistus said in his Pimander."[86] Robert Delaunay, one of the original members of the circle around Mercereau and the artist whom Apollinaire first termed *Orphist,* subsequently echoed Apollinaire's use of the *Pimander* quote in his 1912 article "Light," published in *Der Sturm* in February 1913.[87] One possible route for Apollinaire's discovery of the *Pimander* may have been Schuré's *Les Grands Initiés,* which devotes chapters to both Hermes and Orpheus. Schuré's text has highly evocative language that correlates to Apollinaire's poetry, including the description of Hermes's vision of divinity as "*the voice of light* filled infinity."[88]

From Schuré and the *Pimander* it is not far to Blavatsky's *Isis Unveiled.* Apollinaire's description of the fourth dimension as "space itself, the dimension of the infinite" is even closer to Blavatsky's wording than Weber's generalized "the dimension of infinity." More importantly Apollinaire's statement in a letter of 1915 — "I firmly believe that [man] is a microcosm; moreover, is not every particle of the universe — including the immaterial ether — a microcosm?"[89] — echoes the very passage of *Isis Unveiled* in which Blavatsky described the anima mundi. Of the anima mundi, which she associated elsewhere with the ether, Blavatsky wrote:

Man is a little world — a microcosm inside the great universe. Like a foetus, he is suspended, by all his *three* spirits, in the matrix of the macrocosmos; and while his terrestrial body is in constant sympathy with its parent earth, his astral soul lives in unison with the sidereal *anima mundi.* He is in it, as it is in him, for the world-pervading element fills all space and *is* space itself, only shoreless and infinite.[90]

Given this additional evidence, it seems clear that Blavatsky's books functioned as one of Apollinaire's connections to the mystical-occult tradition, just as Carpenter's writings had done for Weber.

Although Apollinaire and Weber may have shared ideas on infinity and a mystical fourth dimension during their brief Paris meetings in 1908, their final statements on the subject differ in important ways. One difference is the greater degree of Romanticism evident in Apollinaire's writings, which was due to his grounding in French literature from Baudelaire to the Symbolist Stéphane Mallarmé. Thus Baudelaire's characterization of Romanticism as "aspiration towards the

infinite" and Mallarmé's struggle with an infinite absolute and his preoccupation with the sublime stand behind Apollinaire's views:[91] "Until now, the three dimensions of Euclid's geometry were sufficient to the restiveness felt by great artists yearning for the infinite. . . . The art of the new painters takes the infinite universe as its ideal, and it is to the fourth dimension alone that we owe this new norm of the perfect."[92] Rejecting the "mechanical rhythm" of Greek proportions, like Samuel Taylor Coleridge, who saw Greek art as too "finite" to be sublime, Apollinaire found a new meaning for the Romantic sublime in an infinity equated with four-dimensionality.[93]

Apollinaire shared an interest in the theme of infinity with Weber and Ouspensky, but the issues of a monist blending of spirit and matter and the evolution of consciousness are not generally apparent in Cubist literature. In contrast to Weber, who returned from Paris in 1908 to an America where monism was a major philosophical issue, Apollinaire and the Cubists developed their theories in a milieu dominated by a more clearly dualistic idealism. As a result, even though Cubist paintings retain elements from nature and are never totally abstract, the Cubist artist emphasizes the gap between Kantian phenomena and noumena and in the words of Gleizes and Metzinger, "rejects the natural image as soon as he has made use of it."[94] Instead of identifying with objects in nature, as Carpenter's extrovertive mysticism encouraged Weber to do, *Du Cubisme*'s authors asserted, "There is nothing real outside ourselves, there is nothing real except the coincidence of a sensation and an individual mental direction."[95]

When in 1913 the Russian Futurist Mikhail Matiushin translated excerpts of *Du Cubisme* and published them along with selections from Ouspensky's *Tertium Organum,* he managed to portray the Cubists as fellow believers in a coming mystical transformation of consciousness.[96] In reality the Cubists differed from Weber and Ouspensky on the subject of evolving consciousness just as they did on monism. Their reliance on the geometric fourth dimension of Poincaré distanced them from the Russians and from Weber and the Americans who, like Ouspensky, were reading Carpenter and Bucke. Among French artists only the Surrealists focused on the issue of evolving consciousness.

Beyond the Russian Futurists and Malevich, who drew upon Ouspensky's alogical logic of Tertium Organum and his descriptions of the "sensation of infinity" that would accompany higher-dimensional consciousness, Ouspensky's writings found one of their most receptive audiences among the Surrealists. A similar antirationalism and desire to transcend logical language unite Ouspensky, the Russian Futurist poet Alexei Kruchenykh, and Surrealist founder André Breton.[97] More importantly, in the work of Breton and his painter friends Onslow-Ford and Matta there occurs a last major manifestation of the themes of infinity, monism, and evolving consciousness. This manifestation is linked both with mysticism and Romanticism. Anna Balakian has described Breton as "the seeker of the infinite, the absolute, the eternal."[98] Both Balakian and Michel Carrouges have emphasized the monism underlying Breton's preoccupation with finding the "*point de l'esprit*" (point of the spirit) at which all oppositions are resolved, and Carrouges connected it specifically with the *Kether* (supreme point) in the Zohar of the cabala.[99] Breton's description of the point of the spirit in the *Second Manifesto of Surrealism* (1930) also resembles Ouspensky's discussions of the resolution of all contradictions in the fourth dimension. Breton wrote, "Everything tends to make us believe that there exists a certain point of the spirit at which life and death, the real and the imaginary, the past and the future, the communicable and the incommunicable, high and low, cease to be perceived as contradictory."[100]

Beyond monism Breton shared with Ouspensky common sources in late nineteenth-century psychology. In 1892 Carpenter justified the idea of an evolving universal or cosmic consciousness by citing hypnotism and the work of Frederic W. H. Myers.[101] In *The Varieties of Religious Experience,* James quoted from Myers's series of essays on "the subliminal consciousness," published between 1891 and 1894: "Each of us is in reality an abiding psychical entity far more extensive than he knows — an individuality which can never express itself completely through any corporeal manifestation."[102] Like Carpenter, James, and especially Ouspensky, who associated the evolution of consciousness with the perception of higher dimensions, Myers referred to the fourth dimension in *Human Personality and Its Survival of Bodily Death* (1903): "Just as the baby fails to grasp the third dimension, so may we still be failing to grasp a fourth; — or whatever be the law of that higher cognizance which begins to report fragmentarily to man that which his senses cannot discern."[103]

Although Breton's development of Surrealism is usually associated primarily with Freud, Breton noted the importance of Myers in 1934: "We are, I believe, much more in debt than we know to what William James has quite correctly called the gothic psychology of F. W. H. Myers who, coming chronologically before Freud, is still regrettably unknown."[104] Myers's studies of "automatic writing" and "sensory automatism" are central to the tradition from which Breton developed his ideas on "pure psychic automatism."[105]

Breton's and Freud's preoccupation with dreams also has sources in late nineteenth-century psychical research, which was often linked to mysticism and the evolution of consciousness. For example, du Prel's *Philosophie der Mystik* (1884) centers on his study of somnambulism and its suggestion of other types of consciousness.[106] Moreover, Blavatsky, Steiner, Carpenter, James, Bragdon, and Ouspensky all discussed the dream state.[107] In view of Freud's debt to Jewish mysticism as well, it is clear that Surrealism owed much to the prevalence of mysticism and mystically oriented psychical research at the turn of the century.[108]

Soon after Matta and Onslow-Ford joined Breton's Surrealist movement in 1937 and 1938, respectively, they spent the summer of 1938 together in Brittany, reading, among other things, Ouspensky's *Tertium Organum*. In 1948 Onslow-Ford remembered their reaction to Ouspensky: "His conceptions of space-time and his creatures conscious of different dimensions were very inspiring, though I realize today that such abstractions as he made may not correspond to anything in reality."[109] Ouspensky's influence made itself felt immediately in the 1939 paintings of the two artists. Matta's lush, organic painting *Inscape* (also published as *Psychological Morphology*), 1939 (pl. 8), suggests Ouspensky's interest in the changing morphology of consciousness. Onslow-Ford's coulage (poured) painting *Without Bounds,* 1939 (pl. 9), like its title, evokes infinity and boundlessness by means of a reversing perspective scheme, applied over amorphous pools of paint, which cannot be precisely measured.

In an article in the May 1939 *Minotaure,* Breton described Matta's and Onslow-Ford's desire "to move beyond the universe of three dimensions" and connected it with the four-dimensional space-time world of Einstein.[110] Although Breton did not mention Ouspensky's name, Onslow-Ford's statement placed beneath the illustration *Man on a Green Island,* 1939 (pl. 10), echoes Ouspensky's belief that matter is merely a section of a four-dimensional world. Onslow-Ford concluded, "We can say that matter is only the misshapen shadow of reality."

Onslow-Ford's publications document the continued relevance of the mystical, four-dimensional themes of Ouspensky, even as his painting and philosophy have developed beyond their origins in Surrealism. "Modern art has been moving towards a consciousness of its profound role, the reawakening of the unity of mind and matter," he wrote in *Painting in the Instant* (1964). And in *Creation* (1978) he asserted, "The painter's place is to be at the growing edge of consciousness."[111] Emphasizing the role of the artist as seer, as Ouspensky and painters from Romanticism to Surrealism had done, Onslow-Ford has continued to pursue the "Great Spaces," "the vast expanses of the inner-worlds and their correspondences to the nature of the universe."[112] His more recent paintings, such as *There There One,* 1961–62 (pl. 11), and *Being Space,* 1985 (pl. 12), demonstrate the ongoing evolution of the calligraphic language with which he expresses the mystic unity of self and world.

Breton's article in the May 1939 issue of *Minotaure* is followed immediately by an essay on Caspar David Friedrich, which treats the issues of infinity and mystical transcendence in Romantic painting.[113] The importance of Romanticism for the Surrealists, documented

8

MATTA
Inscape, 1939
Oil on canvas
28 ¾ x 36 ½ in.
(73 x 92.7 cm)
Collection of Gordon
Onslow-Ford
On loan to San Francisco
Museum of Modern Art

.

9
GORDON ONSLOW-FORD
Without Bounds, 1939
Ripolin enamel on canvas
28 ½ x 36 in. (72.4 x 91.5 cm)
Collection of Gordon
Onslow-Ford
On extended loan to San
Francisco Museum of
Modern Art

.

10
GORDON ONSLOW-FORD
Man on a Green Island, 1939
Oil on canvas
28 ¾ x 36 ¼ in.
(73 x 92.1 cm)
Anonymous
loan

.

11
GORDON ONSLOW-FORD
There There One, 1961–62
Parle's paint on canvas
72 ½ x 52 ½ in.
(184.2 x 133.4 cm)
Anonymous
loan
.

12
GORDON ONSLOW-FORD
Being Space, 1985
Acrylic on canvas
81 ¾ x 138 ¾ in.
(207.6 x 352.4 cm)
Private collection
.

13
MARK ROTHKO
Plum and Dark Brown, 1964
Oil on canvas
93 x 75 ¾ in.
(236.2 x 192.4 cm)
Marlborough Gallery,
New York
.

14
BARNETT NEWMAN
Jericho, 1968–69
Acrylic on canvas
114 x 106 in.
(289.6 x 269.2 cm)
Annalee Newman
.

in Surrealist scholarship, is made clear by this juxtaposition and by the fact that during their summer holiday in 1939, Breton read to Onslow-Ford and Matta from German Romantic literature as well as from Baudelaire and the Symbolists.[114]

Minotaure's Friedrich article with its illustration of his *Monk by the Seashore,* 1809, a painting that Robert Rosenblum has compared with works by Mark Rothko,[115] brings to mind the question of the fate of the fourth dimension as an equivalent for the sublime and infinite in modern art after the 1930s. It is telling that in 1948, when *Tiger's Eye* published answers by Robert Motherwell, Barnett Newman, and others to the question "What Is Sublime in Art?" no respondent mentioned the fourth dimension. On the contrary, the artists sought to disentangle the sublime and the infinite from the geometry associated with a fourth dimension by ignoring the modern tradition and going back to sources for the idea of the sublime in Longinus and Burke.[116]

Sensing a strong kinship with the Romantics and even utilizing similar mystical sources, particularly the cabala, painters like Newman and Rothko attempted to evoke the infinite and the sublime in their large chromatic abstractions (pls. 13–14).[117] Yet the fourth

dimension, so integrally linked with these ideas earlier in the twentieth century, was no longer a concern for Abstract Expressionists. In the wake of the popularization during the 1920s of Einstein's general theory of relativity, which replaced a fourth dimension of space with time itself, and given the increasing antagonism of modern art theory toward deep space in painting, the fourth dimension's dominance as an artistic issue waned markedly after 1930. Only the Surrealists and such strongly mystical artists as Mark Tobey and Irene Rice Pereira remained loyal to the idea during the 1940s and later.[118]

Since the 1970s, however, there has been a marked renewal of interest in four-dimensional space among painters who have moved beyond formalist flatness to explore the spaces suggested by contemporary developments in physics and computer graphics.[119] In light of this renewal, Onslow-Ford's nearly fifty-year dedication to higher-dimensional realities is all the more tenacious and remarkable. Like Carpenter and Weber, Onslow-Ford feels a deep communion with nature. Yet because of his awareness of issues in modern physics,

including Einsteinian space-time, his understanding of nature is far more complex than that of early twentieth-century painters and writers.[120] As a result, his monistic vision of the infinite inner worlds of higher consciousness has been embodied in abstract paintings that do not make a reductivist denial of nature as Malevich's Suprematism had done. Transcending the distinction between extrovertive and introvertive mysticism, Onslow-Ford's works are a testament to the vitality and rich possibilities of the mystical and Romantic concept of a fourth dimension.

1. Claude Bragdon, "Maeter-linck," *The Critic* 45 (August 1904): 156–58. For a fuller discussion and documentation of many of the ideas and individuals presented here, see Linda Dalrymple Henderson, *The Fourth Dimension and Non-Euclidean Geometry in Modern Art* (Princeton: Princeton University Press, 1983), of which the present essay is an extension.

2. For an account of P. D. Ouspensky's impact upon Kazimir Malevich and the Russian Futurists, see Henderson, *Fourth Dimension,* 265–94.

3. On the inner worlds, see Gordon Onslow-Ford, *Creation* (Basel: Galerie Schreiner, 1978), 57–68.

4. Max Weber, "The Fourth Dimension from a Plastic Point of View," *Camera Work* 31 (July 1910): 25.

5. Guillaume Apollinaire, "La Peinture nouvelle: Notes d'art," *Les Soirées de Paris,* no. 3 (April 1912): 90; and *Les Peintres Cubistes: Méditations esthétiques* (Paris: Eugène Figuière, 1913), 16.

6. On Apollinaire's translation, see Willard Bohn, "In Pursuit of the Fourth Dimension: Guillaume Apollinaire and Max Weber," *Arts* 54 (June 1980): 166–69; for the relation of the two texts, see Henderson, *Fourth Dimension,* 168–73.

7. P. D. Ouspensky, *Tertium Organum, the Third Canon of Thought: A Key to the Enigmas of the World* (1911), trans. Claude Bragdon and Nicholas Bessaraboff, 2d Amer. ed. rev. (New York: Knopf, 1922), 331, 257. For Ouspensky, see, in addition to Henderson, *Fourth Dimension,* James Webb, *The Harmonious Circle: The Lives and Works of G. I. Gurdjieff, P. D. Ouspensky, and Their Followers* (New York: Putnam, 1980).

8. Ibid., 258, 244, 246.

9. Ibid., 122.

10. William James, *The Varieties of Religious Experience: A Study in Human Nature* (London: Longmans, Green, 1902), 380, 405.

11. Quoted in Robert Rosenblum, *Modern Painting and the Northern Romantic Tradition: Friedrich to Rothko* (New York: Harper & Row, 1975), 19–20.

12. Charles Howard Hinton, *A New Era of Thought* (London: Swan Sonnenschein, 1888), 21–34.

13. Philipp Otto Runge to Daniel Runge, 9 March 1802, quoted in *From the Classicists to the Impressionists: Art and Architecture in the Nineteenth Century,* ed. Elizabeth Gilmore Holt (Garden City, N.Y.: Doubleday, 1966), 68.

14. For Theo van Doesburg the diagonal in his Counter-Compositions seems to have functioned as a condensed symbol for the freedom from gravity associated with the fourth dimension (see Henderson, *Fourth Dimension,* 330–32).

15. Quoted in Ouspensky, *Tertium Organum,* 242.

16. See Gershem Scholem, *Kabbalah* (New York: New American Library, 1978), 88.

17. For Henry More's theories, see Marjorie Hope Nicolson, *Mountain Gloom and Mountain Glory: The Development of the Aesthetics of the Infinite* (Ithaca, N.Y.: Cornell University Press, 1959), 134–40. In *Enchiridion metaphysicum* More also made the first known use of the term *fourth dimension,* to locate the imperceptible extension in space that he believed characterized things of the spirit, and disproved

Descartes's dualistic opposition of matter (as extension) to spirit. See *Philosophical Writings of Henry More,* ed. Flora Isabel Mackinnon (New York: Oxford University Press, 1925), 213. For More and his mystical sources, see also Max Jammer, *Concepts of Space: The History of Theories of Space in Physics* (Cambridge: Harvard University Press, 1954), 38–47.

18. Nicolson, *Mountain Gloom,* chap. 3.

19. Ibid., chap. 7.

20. Edmund Burke, *A Philosophical Inquiry into the Origin of Our Ideas of the Sublime and the Beautiful* (1757), ed. J. T. Boulton (London: Routledge & Kegan Paul, 1958), 73. For the literary history of the sublime and its association with infinity from Edmund Burke to Stéphane Mallarmé, see Kari Elise Lokke, "The Role of Sublimity in the Development of Modernist Aesthetics," *Journal of Aesthetics and Art Criticism* 40 (Summer 1982): 421–30.

21. For the roots of German and English Romantic theory in Neoplatonism and the esoteric tradition, see Meyer Abrams, *Natural Supernaturalism: Tradition and Revolution in Romantic Literature* (New York: Norton, 1971), 146–63, 169–72.

22. Quoted in Linda Siegel, *Caspar David Friedrich and the Age of German Romanticism* (Boston: Branden, 1978), 28; Charles Baudelaire, "Salon de 1846" (1846), in idem, *Curiosités*

esthétiques: L'Art romantique, et autres oeuvres critiques, annotated by Henri Lemaître (Paris: Garnier Frères, 1962), 103.

23. See, for example, Anna Balakian, *The Symbolist Movement: A Critical Appraisal* (New York: New York University Press, 1977), chap. 2.

24. See Emanuel Swedenborg, *The Infinite and the Final Cause of Creation; Also the Intercourse between the Soul and the Body* (1734), trans. J. J. Garth Wilkinson (London: Swedenborg Society, 1902).

25. Ralph Waldo Emerson, *Representative Men; Poems* (1850) (New York: Collier, 1903), 132.

26. Claude Bragdon, *Four-Dimensional Vistas* (New York: Knopf, 1916), 105–16.

27. Apollinaire, *Peintres Cubistes,* 17–18.

28. Helena P. Blavatsky, *Isis Unveiled: A Master-Key to the Mysteries of Ancient and Modern Science and Theology* (New York: Bouton, 1877), 1:212.

29. Ibid., 1:129–30, 134, 177, 291.

30. Ibid., 1:188.

31. Balfour Stewart and P. G. Tait, *The Unseen Universe; or, Physical Speculations on a Future State* (1875), 4th ed. rev. (London and New York: Macmillan, 1876), 220; *Unseen Universe* was republished at least fifteen times between 1875 and 1901 and was translated into French in 1883.

32. Hinton, *New Era,* 53.

33. James, *Varieties of Religious Experience,* 419; Rudolf Steiner, *Theosophy: An Introduction to the Supersensible Knowledge of the World and the Destination of Man* (Chicago and New York: Rand, McNally, 1910), 148; Carpenter, *The Art of Creation: Essays on the Self and Its Powers* (1904), rev. ed. (London: Allen, 1907; New York: Macmillan, 1907), 65; Ouspensky (quoting from Max Müller's *Theosophy*), *Tertium Organum,* 271–72; Bragdon, "Maeterlinck," 158. Although James was to become known as the champion of pluralism after the publication of *A Pluralistic Universe* (London: Longmans, Green, 1909), *Varieties of Religious Experience* had made it possible to associate him with the popular monist viewpoint.

34. Sixten Ringbom, *The Sounding Cosmos: A Study in the Spiritualism of Kandinsky and the Genesis of Abstract Painting,* Acta Academi Aboensis, ser. A, XXXVIII (Åbo, Finland: Åbo Akademi, 1970), 35–39. Emphasizing the spiritual side of the equation, Steiner presented the materialist views of the best-known monist at the turn of the century, the scientist Ernst Haeckel, as a preliminary stage in the evolution of Theosophy's mystical monism (Rudolf Steiner, *Three Essays on Haeckel and Karma* [London: Theosophical Publishing Society, 1914]).

35. C. W. Leadbeater, *The Astral Plane: Its Scenery and Phenomena* (1895) (London: Theosophical Publishing House, [1910]), 18–19. Although Steiner lectured on the fourth dimension in 1905, he did not pursue the idea in his subsequent publications. See Guenther Wachsmuth, *The Life and Work of Rudolf Steiner* (1941), 2d ed. (New York: Whittier, 1955), 68.

36. Ouspensky, *Tertium Organum,* 190.

37. Richard Maurice Bucke, *Cosmic Consciousness: A Study in the Evolution of the Human Mind* (Philadelphia: Innes, 1901).

38. Phyllis Grosskurth, *Havelock Ellis: A Biography* (New York: Knopf, 1980), 101–4. In *A New Era of Thought* Hinton set forth a series of exercises with colored cubes by which an individual might develop a higher level of spatial consciousness. One source for Carpenter's evolutionary view was undoubtedly Karl du Prel's *Philosophie der Mystik* (1884), translated by C. C. Massey as *The Philosophy of Mysticism*, 2 vols. (London: George Redway, 1889). Du Prel's "transcendental psychology" posited a "movable threshold of sensibility" (2:129) based on a Darwin-like evolution of psychical faculties in man (2:119). Associating the "transcendental world" with the fourth dimension of the spiritualist astronomer Johann Karl Friedrich Zöllner and his mathematical predecessors (2:149), du Prel proposed that "the veil can be lifted which hides the transcendental world from consciousness, and the transcendental subject from self-consciousness" (2:152). For Zöllner, see Henderson, *Fourth Dimension*, 22–24.

39. For Carpenter, see his autobiography, *My Days and Dreams (Being Autobiographical Notes)* (London: Allen & Unwin, 1916); and Chushichi Tsuzuki, *Edward Carpenter 1844–1929: Prophet of Human Fellowship* (Cambridge: Cambridge University Press, 1980). Tom Gibbons describes

Carpenter as a "mystico-socialist poet" in his *Rooms in the Darwin Hotel: Studies in English Literary Criticism and Ideas 1880–1920* (Nedlands: University of Western Australia, 1973), an excellent study placing Carpenter in the context of an optimistic "Age of Evolutionism."

40. Carpenter visited the headquarters of the Theosophical Society in Adyar, India; see Edward Carpenter, *From Adam's Peak to Elephanta: Sketches in Ceylon and India* (London: Sonnenschein, 1892; New York: Macmillan, 1892), 231–32.

41. Carpenter, *From Adam's Peak*, 156.

42. Ibid., 155.

43. Ibid., 161.

44. Carpenter, *Art of Creation*, 59.

45. Ibid., 60.

46. Ibid., 7–8, 83 n. 1.

47. Ibid., 79–91.

48. Ibid., 69, 132–33.

49. "The New Spiritual America Emerging," *Current Literature* 46 (February 1909): 180.

50. For discussions of Bucke's *Cosmic Consciousness*, see William I. Homer, *Alfred Stieglitz and the American Avant-Garde* (Boston: New York Graphic Society, 1977), xi, 161; and Henderson, *Fourth Dimension*, chap. 4, and for the widespread preoccupation with evolving consciousness among members of the avant-garde, 201–15. Ileana B. Leavens's study *From "291" to Zurich: The Birth of Dada* (Ann Arbor: UMI Research Press, 1983) came to my attention after I had completed this essay. Leavens notes Bucke's quoting of Carpenter's discussion of the fourth dimension but does not deal with Carpenter's other texts or his monistic philosophy.

51. For a list of relevant articles published in American periodicals between 1877 and 1920, see Henderson, *Fourth Dimension*, app. B.

52. For Weber's Paris experience and his subsequent relation to the Stieglitz circle, see Henderson, *Fourth Dimension*, 63–64, 167–73.

53. Apollinaire, "Peinture nouvelle," 90; and idem, *Peintres Cubistes*, 16.

54. Weber, "Fourth Dimension from a Plastic Point of View," 25.

55. Henri Poincaré, *The Value of Science* (1904), in *The Foundations of Science: Science and Hypothesis, the Value of Science, Science and Method*, trans. G. B. Halsted (New York: Science Press, 1913), 355.

56. Wassily Kandinsky, *Concerning the Spiritual in Art* (1912), trans. M. T. H. Sadler (1914; New York: Dover, 1977), 9 n. 3.

57. Ringbom, *Sounding Cosmos*, 35–39.

58. A friend of the Symbolist writer Arthur Symons, Alvin Langdon Coburn produced the illustrations for Maurice Maeterlinck, *The Intelligence of Flowers* (New York: Dodd Mead, 1907). For Coburn's involvement in mysticism and occultism and the relevance of Carpenter for his photography, see Mike Weaver, "Alvin Langdon Coburn, Man of Mark: A Centenary Essay," in *Alvin Langdon Coburn*, exh. cat. (Bath: National Centre of Photography, 1982), 24–25.

59. Alvin Langdon Coburn, *Men of Mark* (London: Duckworth, 1913; New York: Mitchell Kennerley, 1913), 16–17.

60. Alvin Langdon Coburn, *Alvin Langdon Coburn: Photographer*, ed. Helmut and Alison Gernsheim (1966), rev. ed. (New York: Dover, 1978), 34. Carpenter's admirers, Weber and Coburn, may have been predisposed to appreciate his ideas (and possibly those of Blavatsky) by their studies with Arthur Wesley Dow during 1898–1900 and summer 1903, respectively. Long interested in spiritual-

ism, Dow shared Ernest Fenellosa's devotion to Japanese art and thought and was a frequent visitor to Green Acre, Sarah Farmer's progressive religious colony in Maine. More importantly, in 1903–4, at the end of a trip to Japan, Dow undertook a Carpenter-like pilgrimage to sites in India with Theosophists as his guides. See Frederick C. Moffatt, *Arthur Wesley Dow (1857–1922)*, exh. cat. (Washington, D.C.: National Collection of Fine Arts, 1977), 102–3. Weber's interest in Eastern religions is apparent in one of his "Cubist poems," published in London in 1914 with Coburn's aid. Entitled "Buddhas," the poem concludes, "Will I know when I am a Buddha?" (Max Weber, *Cubist Poems* [London: Elkin Mathews, 1914], p. 16).

61. Carpenter, *Art of Creation*, 61.

62. Weber, "Fourth Dimension from a Plastic Point of View," 25.

63. Max Weber, *Essays on Art* (New York: William E. Rudge, 1916), 49.

64. Carpenter, *Art of Creation*, 24–25.

65. Weber, "Fourth Dimension from a Plastic Point of View," 25.

66. The terms *extrovertive* and *introvertive mysticism* are those of W. T. Stace, who distinguished between these two types of mystical insight in his *Mysticism and Philosophy* (Philadelphia: Lippincott, 1960), 61–62.

67. Weber, "Fourth Dimension from a Plastic Point of View," 25.

68. Ouspensky, *Tertium Organum*, 244; and Malevich, *From Cubism to Suprematism* (1915), translated in Charlotte Douglas, *Swans of Other Worlds: Kazimir Malevich and the Origins of Abstraction in Russia* (Ann Arbor: UMI Research Press, 1980), 110.

69. Bragdon sent Carpenter a copy of *A Primer of Higher Space* (Rochester, N.Y.: Manas Press, 1913) in November 1914; in

March 1921 he sent Coburn a copy of the 1915 second edition of *Primer* ("Publishing Ventures," Bragdon Family Papers, University of Rochester Library, New York).

70. On the subsequent impact of Ouspensky and G. I. Gurdjieff in New York, see Webb, *Harmonious Circle*; and Suzanne Shelton, *Divine Dancer: A Biography of Ruth St. Denis* (New York: Doubleday, 1981). The New York art patron Katherine Dreier included *Tertium Organum* on the suggested reading list for a series of lectures she gave at the New School for Social Research in 1931 (Dreier to Alvin Johnson, 10 November 1930, Société Anonyme Archive, Beinecke Rare Book and Manuscript Library, Yale University, New Haven, Connecticut).

71. Carpenter, Bucke, and Bragdon all admired Romantic poetry, and Bucke's first experience of cosmic consciousness followed an evening's reading of William Wordsworth, Percy Bysshe Shelley, John Keats, and Robert Browning as well as Whitman. See Carpenter, *My Days and Dreams*, 28; Bucke, *Cosmic Consciousness*, 9; Bragdon, *Four-Dimensional Vistas*, 121–22. On Ouspensky's Romanticism, see Webb, *Harmonious Circle*, 101–12.

72. Claude Bragdon, *More Lives Than One* (New York: Knopf, 1938), 120–21.

73. *New York Times*, 19 March 1915, sec. 1, 11; 21 March 1915, sec. 2, 12; and 28 March 1915, sec. 5, 15. See also "Color Music: Scriabin's Attempt to Compose a Rainbow Symphony," *Current Opinion* 58 (May 1915): 332–33.

74. Stark Young, "The Color Organ," *Theatre Arts* 6 (January 1922): 20.

75. Sheldon Cheney, *A Primer of Modern Art* (New York: Boni & Liveright, 1924), 187.

76. Sheldon Cheney, *Expressionism in Art* (New York: Liveright, 1934), 323.

77. Sheldon Cheney, *Men Who Have Walked with God* (New York: Knopf, 1945), 378–79. Another indication of Carpenter's influence, especially in New York, is the fact that the New York attorney and collector John Quinn owned a large collection of Carpenter's writings, along with those by the occultist poet William Butler Yeats (Quinn's close friend), Bragdon, William James, and Maeterlinck. See *Complete Catalogue of the Library of John Quinn*, 2 vols. (New York: Anderson Galleries, 1924).

78. See, for example, George M. Gould, "The Infinite Presence," *Atlantic Monthly* 94 (December 1904): 785–95.

79. P. D. Ouspensky, *A New Model of the Universe* (1931), 2d ed. rev. (1934; New York: Vintage, 1971), 4.

80. In addition to the author's *Fourth Dimension*, the present essay sets forth further initial observations on this issue, which will be explored in depth in a future publication. Tom Gibbons, "Cubism and 'The Fourth Dimension' in the Context of the Late Nineteenth-Century and Early Twentieth-Century Revival

of Occult Idealism," *Journal of the Warburg and Courtauld Institutes* 44 (1981): 130–47, also deals with the role of mysticism and occultism in pre–World War I Paris.

81. For the history of the Puteaux Cubist group, see Henderson, *Fourth Dimension,* 65–67; specifically for František Kupka and the fourth dimension, 103–9.

82. Alexandre Mercereau, *La Littérature et les idées nouvelles* (Paris: Eugène Figuière, 1912), 50–59.

83. For Theosophy as a vehicle for the popularization of the fourth dimension, see Henderson, *Fourth Dimension,* 31–33, 34–46, 78; on Poincaré and the Puteaux Cubists, especially Gleizes, Metzinger, and Duchamp, 71–73, 81–85, 98–99, 120–21, 131–32, 140–41, 148–49.

84. Albert Gleizes and Jean Metzinger, *Du Cubisme* (Paris: Eugène Figuière, 1912), 41. In their rejection of easily read "common" signs, the two authors, however, assert that they do not replace them with "cabalistic" signs or "fanciful occultism" (p. 25).

85. For Apollinaire and occultism, see Virginia Spate, *Orphism: The Evolution of Non-Figurative Painting in Paris 1910–1914* (Oxford: Clarendon Press, 1979), 64–66; and Cecily Mackworth, *Guillaume Apollinaire and the Cubist Life*

(New York: Horizon, 1963), 124–26. For Alfred Jarry and occultism, see Keith Beaumont, *Alfred Jarry: A Critical and Biographical Study* (New York: St. Martin's, 1984), 62–63; on Max Jacob's eclectic mysticism, see Judith Morganroth Schneider, *Clown at the Altar: The Religious Poetry of Max Jacob* (Chapel Hill: University of North Carolina, Department of Romance Languages, 1978).

86. Guillaume Apollinaire, *Bestiary, or The Parade of Orpheus,* trans. Pepe Karmel (Boston: Godine, 1980), 2. For the dating of the *Bestiare* and evidence of Apollinaire's awareness of hermetic literature, see Francis J. Carmody, *The Evolution of Apollinaire's Poetics 1901–1914* (Berkeley and Los Angeles: University of California Press, 1963), 44–46.

87. Robert Delaunay, "Light" (1912), in *The New Art of Color: The Writings of Robert and Sonia Delaunay,* ed. Arthur A. Cohen and trans. David Shapiro and Arthur A. Cohen (New York: Viking, 1978), 85–86.

88. Édouard Schuré, *The Great Initiates: Sketch of the Secret History of Religions* (1889), trans. Fred Rothwell (Philadelphia: David McKay, 1922), 2:197.

89. Apollinaire to Madeleine Pagès, 14 October 1915, in Guillaume Apollinaire, *Tendre comme le souvenir* (Paris: Gallimard, 1952), 209.

90. Blavatsky, *Isis Unveiled,* 1:212.

91. For Baudelaire, Mallarmé, and the changes in the mystical quest for the infinite from Romanticism to Symbolism to Surrealism, see Anna Balakian, *Literary Origins of Surrealism: A New Mysticism in French Poetry* (New York: New York University Press, 1947), especially chap. 4. For Mallarmé and the sublime, see Lokke, "Role of Sublimity," 427–28.

92. Apollinaire, "Peinture nouvelle," 90–91.

93. For Apollinaire's use of the term *sublime,* see *Peintres Cubistes,* 6, 17, 25; for his rejection of Greek art, 16. For Samuel Taylor Coleridge and the sublime, see Lokke, "Role of Sublimity," 426.

94. Gleizes and Metzinger, *Du Cubisme,* 14.

95. Ibid., 30.

96. Mikhail Matiushin, "Of the Book by Gleizes and Metzinger *Du Cubisme,*" *Union of Youth,* no.

3 (March 1913): 25–34; trans. in Henderson, *Fourth Dimension,* app. C; see also Henderson, 265–68.

97. On André Breton's wish to destroy logical language, see Balakian, *Literary Origins,* 18.

98. Ibid., 9.

99. Michel Carrouges, "Surréalisme et occultisme," *Les Cahiers d'Hermès,* no. 2 (1947): 194–200; and idem, *André Breton and the Basic Concepts of Surrealism* (1950), trans. Maura Prendergast (University: University of Alabama Press, 1974), 10–20. Anna Balakian, *André Breton: Magus of Surrealism* (New York: Oxford University Press, 1971), 34–39, emphasizes the importance for Breton of Éliphas Lévi's monist blending of spirit and matter.

100. André Breton, *Second Manifesto of Surrealism* (1930), in *Manifestos of Surrealism,* trans. Richard Seaver and Helen R. Lane (Ann Arbor: University of Michigan Press, 1972), 123. Van Doesburg had made a similar point in *What Is Dada????????* (1923): "Dada completely negates the generally acknowledged duality of matter and mind, woman and man, and in so doing creates the 'point of indifference,' a point beyond man's understanding of space and time." See Joost Baljeu, *Theo van Doesburg* (New York: Macmillan, 1974), 134.

101. Carpenter, *From Adam's Peak,* 159; also idem, *Art of Creation,* 202.

102. James, *Varieties of Religious Experience,* 511–12, see also 233–35. Myers's articles on "the sub-

liminal consciousness" appeared in the *Proceedings of the Society for Psychical Research* 7–9 (1891–94), which had published his essays on "automatic writing" between 1884 and 1889.

103. Frederic W. H. Myers, *Human Personality and Its Survival of Bodily Death* (London: Longmans, Green, 1903), 1:277.

104. Quoted in Carrouges, *André Breton,* 120.

105. André Breton, *Manifesto of Surrealism* (1924), in *Manifestos of Surrealism,* 26. For Breton's debt to the psychologist Pierre Janet, whose *L'Automatisme psychologique* (1889) studied mediums and cited Myers's findings, see Balakian, *André Breton,* 27–34.

106. Du Prel, *Philosophy of Mysticism,* 1: chaps. 2–5. Carrouges (*André Breton,* 20–27) emphasizes the contrast between Surrealism's goal of regaining lost levels of consciousness (shared by the mystical tradition and Romanticism) and the evolutionary view of individuals like du Prel, Carpenter, and Bucke. Significantly, Ouspensky rejected passive evolution and, more like Hinton and his system of exercises, believed an individual could actively prepare himself for higher consciousness by practicing the "logic" of "Tertium Organum" (Ouspensky, *Tertium Organum,* 322).

107. Blavatsky, *Isis Unveiled,* 1:170, 179; Rudolf Steiner, "Dream Life," chap. 3 in *Initiation and Its Results,* trans. Clifford Bax (London: Theosophical Publishing Society, 1909); Carpenter, *Art of Creation,* 72, 105; James, *Varieties of Religious Experience,* 405, 483–84; Bragdon, "Sleep and Dreams," chap. 6 in *Four-Dimensional Vistas;* and Ouspensky, *Tertium Organum,* 239.

108. David Bakan, *Sigmund Freud and the Jewish Mystical Tradition* (Princeton: Van Nostrand, 1958); and James Webb, *The Occult Establishment* (La Salle, Ill.: Open Court, 1976), chap. 6.

109. Gordon Onslow-Ford, *Towards a New Subject in Painting,* exh. cat. (San Francisco: San Francisco Museum of Art, 1948), 11.

110. André Breton, "Des tendances les plus récentes de la peinture surréaliste," *Minotaure,* nos. 12–13 (May 1939): 17; for the fourth dimension as time in Einstein's general theory of relativity, see Henderson, *Fourth Dimension,* 355–58.

111. Gordon Onslow-Ford, *Painting in the Instant* (New York: Abrams, 1964), 42; and idem, *Creation,* 46.

112. Onslow-Ford, *Creation,* 95, 111. In the tradition of Carpenter (*Art of Creation,* 64), Onslow-Ford emphasizes that thought can operate only in a stage preliminary to creation (*Creation,* 50, 69).

113. Madeleine Landsberg, "Caspar David Friedrich: Peintre de l'angoisse romantique," *Minotaure,* nos. 12–13 (May 1939): 25–26.

114. Onslow-Ford, *Towards a New Subject,* 15.

115. Rosenblum, *Modern Painting,* 10–14.

116. "The Ides of Art: Opinions on 'What Is Sublime in Art?'" *Tiger's Eye,* no. 6 (December 1948): 46–57.

117. On Newman and the cabala, see Thomas B. Hess, *Barnett Newman,* exh. cat. (New York: Museum of Modern Art, 1971), 55 85.

118. Apart from her references to Eistein's general theory of relativity, Irene Rice Pereira's views are remarkably close in mood to early twentieth-century publications in which the fourth dimension is linked to infinity, monism, and evolving consciousness. See, for example, I. Rice Pereira, *The Transcendental Formal Logic of the Infinite: The Evolution of Cultural Forms* (New York: by the author, 1966), 10, 20, 27, 56–57).

119. See Henderson, *Fourth Dimension,* 350–52.

120. Gordon Onslow-Ford, interview with author, Inverness, California, 2 August 1985.

OVERLEAF

JEAN ARP
*Elementary Construction
(According to the Laws of
Chance),* 1916
Collage
15 ⅞ x 12 ¹¹⁄₁₆ in.
(40.4 x 32.2 cm)
Kunstmuseum Basel,
Kupferstichkabinett,
Switzerland

ARP, KANDINSKY, AND THE LEGACY OF JAKOB BÖHME

HARRIETT WATTS

In Jean Arp's 1944 essay "Concrete Art," Wassily Kandinsky is the first example cited of an early concrete artist. Universally acknowledged as the father of abstract art, Kandinsky would seem an unlikely artist to designate as an initial master of concrete art. Yet Kandinsky himself appropriated the term in his final Paris years (1934–44); by 1938 he indicated in several essays his preference for the adjective *concrete* rather than *abstract* to describe his work.

Problems inherent in the use of the word *abstract* had already resulted in any number of alternative designations, including *nonrepresentational, nonfigurative,* and *objectless.* By 1930, with Theo van Doesburg's coinage *concrete art,* the terminology became almost diametrically opposed to the original implications of the term *abstract art.* Van Doesburg's notion of concrete art, art conceived wholly in the mind without any formal information from nature or from the sentiments, was one of the more restrictive definitions that emerged in the pursuit of a proper name for what was becoming an ever more diversified style.[2] In 1933 Arp took over van Doesburg's term and transformed it into a title for a series of sculptures, some of the first he produced (pl. 1). He called them *concrétions humaines* (human concretions): "Concretion signifies the natural processes of condensation, hardening, coagulation, thickening, growing together. Concretion designates the solidification of a mass. Concretion designates the curdling, the curdling of the earth and the heavenly bodies. Concretion designates solidification, the mass of the stone, the plant, the animal, the man. Concretion is something that has grown. I want my work to find its humble place in the woods, the mountains, in nature."[3]

Once in Paris, Kandinsky resumed a friendship with Arp that had begun in 1912, and in 1938 he wrote three essays that reflected their renewed association. In all three essays — "Abstract of Concreet?," "L'Art concret," "La Valeur d'une oeuvre concrète"[4] — he argued for the use of the new terminology. Kandinsky's willingness to designate his own paintings as concrete signaled a shift from his earlier interest in compositional tactics whereby the artist could create an impression of dematerialization in the painting. He now declared every true work of art to constitute a unique instance of materialization: "Each genuine new work of art expresses a new world which has never before existed. Thus

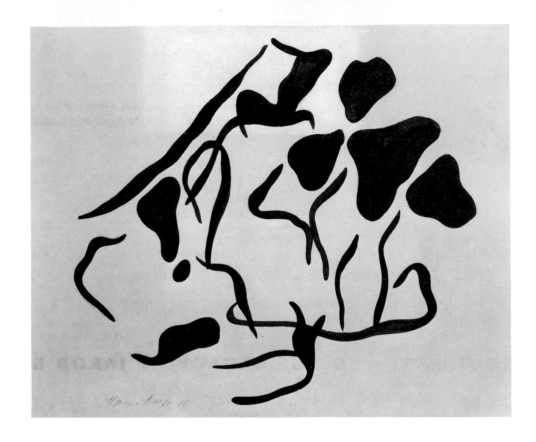

1
JEAN ARP
Concrétion humaine sur coupe,
1935
Bronze and limestone
7 ½ x 28 ⅜ x 21 in.
(19 x 72 x 53.3 cm)
Fondation Arp, Clamart,
France

.

2
JEAN ARP
Automatic Drawing, 1917–18
Brush and ink over traces of
pencil on gray paper
16 ¾ x 21 ¼ in.
(42.6 x 54 cm)
The Museum of Modern Art,
New York
Given anonymously

.

every genuine work constitutes a new discovery. A world which was not known up to this point takes its place alongside the world that we know already. Every genuine work of art must announce: 'Here I am!'"[5]

In 1935 Kandinsky acknowledged that the "universal laws of the cosmic world" are also the inner laws that govern the imaginative process through which unique works of art come into being.[6] The artist, as microcosmic creator, must actually experience these laws of nature in the creative process if he is to produce a "genuine work of art." Spiritual energies reveal themselves in discrete, materialized forms in nature, and the physical universe, which includes man's artifacts, is the means through which the divine spirit may make itself manifest. With each new instance of materialization, the divinity discovers yet another facet to its limitless potential.

Arp's amorphous concrétions humaines — natural objects produced directly by man but in accordance with the laws of nature — were realized for the most part in limestone, a material immediately identifiable as a product of natural concretion. Later, Arp even began to entitle certain of his sculptures "stone produced by the human hand."[7] Arp's experience with this new mode of production, three-dimensional sculpture in stone, seems to have led naturally to his thinking of the work of art as a concretion. Sculpture became the means by which he renewed his earlier investigation of biomorphic forms. Suggesting organic growth without defining any specific organism, biomorphic forms capture life at its undifferentiated inception and convey its potential for metamorphosis rather than representing any end form of physical development.

Arp's previous intense focus on processes of natural genesis and transformation had been in the Dada years (pl. 2). In 1917 he discovered the structural principle of what he called "fluid ovals,"[8] an emblem of all natural growth and change. Following this discovery Arp produced a series of drawings and reliefs that came to be subsumed under the title he gave to one relief, *Earthly Forms,* 1917.[9] His designation of his sculpture of 1933–36 as concrétions humaines seems to parallel this earlier interpretation of the Dada drawings, woodcuts, and reliefs as earthly forms.[10] Following the intervening "object language" and "object titles," such as *Fork, Knife, and Navel,* that he developed in the 1920s, the concrétions humaines signaled a renewed preoccupation with organic growth and morphology.

During 1912–22 Kandinsky occasionally expressed thoughts on the relation of natural generation to artistic creation. In 1918 he compared the process of human conception, gestation, and birth to the process of producing a painting. Biomorphic forms had already been present in Kandinsky's Munich work (1906–14), but there is no direct pictorial evidence of any special interest in the actual physical processes of organic growth that had so fascinated the Romantics, especially Johann Wolfgang von Goethe, as well as the German Theosophist whom Kandinsky read and admired, Rudolf Steiner. In his Bauhaus treatise of 1926, *Point and Line to Plane,* Kandinsky included illustrations of lines observed in nature: crystals, plant patterns, skeletal structures, tissue specimens, streaks of lightning.[11]

During his Bauhaus years (1922–33) these observed natural forms, however, did not become a dominant part of his iconography as they did in the work of Paul Klee, his close friend and associate. Kandinsky's primary interest in natural form at this time seems to have been an analysis of geometry in nature rather than the observation of organic growth patterns, and his Bauhaus images were largely geometric, not biomorphic (pls. 3–4).

When Kandinsky resumed painting in 1934 after a half-year hiatus following his move to Paris, an important new element appeared in his work, a veritable swarm of zoological forms with motifs based on illustrations and photographs of amoebas, embryos, larvae,

3
WASSILY KANDINSKY
Sign, 1925
Oil on cardboard
27 ⅛ x 19 ¼ in.
(68.9 x 48.9 cm)
Los Angeles County
Museum of Art
Museum acquisition by
exchange from David E.
Bright Bequest

.

4
WASSILY KANDINSKY
Cool Concentration, 1930
Oil on board
19 ⁵⁄₁₆ x 14 ⁹⁄₁₆ in.
(49 x 37 cm)
Private collection,
Switzerland

.

5
WASSILY KANDINSKY
Accompanied Center, 1937
Oil on canvas
44 ⅞ x 57 ½ in.
(114 x 146 cm)
Collection of Mr. and Mrs.
Adrien Maeght, Paris

·

6
JEAN ARP
Torn Paper Collage, 1933
Collage on paper
10 ¹¹⁄₁₆ x 7 ¾ in.
(27.1 x 19.7 cm)
Kupferstichkabinett, Basel,
Switzerland
Schenkung Marguerite Arp-
Hagenbach

·

and marine invertebrates (pl. 5).[12] The appearance of these elements in Kandinsky's work at this point could be explained in part by the Paris context: the first two painters with whom Kandinsky established contact in Paris were Arp, whom he had known since the days of the Blaue Reiter in Munich, and the Spanish Surrealist painter Joan Miró. He was also introduced to the work of other Surrealists, such as Yves Tanguy, who were painting in a style, designated as biomorphic abstraction, using biomorphic forms.

Kandinsky resumed his dialogue with Arp at precisely the moment Arp was branching out into sculptural concretions and experimenting with two other compositional techniques that he felt reenacted natural processes of birth, development, decay, and regeneration: torn-paper collages and constellations (executed as reliefs and poems). For his collages (pl. 6) Arp ripped up either his own works on paper or sheets of black, coarse-fibered paper and out of this destruction created a new work by

pasting selected fragments on a white page. The multiple recombinations of minimal elements in his constellation suites (pl. 7) were regarded by Arp as illustrations of how nature works, with infinite constellations of a limited number of basic elements and forms. During this period of renewed interest in natural processes, the sculptural concretions embodied for Arp the natural process of coagulation and solidification, while the collages and constellations reenacted nature's endless cycle of growth, disintegration, and rebirth. These compositional approaches and the concerns they reflected were certain to have been topics of discussion between the two artists during Kandinsky's first years in Paris.

In 1948 Arp characterized Kandinsky's artistic evolution in terms of organic maturation: "Kandinsky grew to perfection as naturally as a fruit develops and ripens. Anyone not resisting nature will become beauty and spirit. In time and space, those divine mirrors, his work is aglow with spiritual reality. Kandinsky loved life, he was intoxicated with the riches of earth and sky. . . . Things blossom, sparkle, ripple in his paintings and poems. They speak of old blood and young stones."[13]

When organic images finally entered Kandinsky's work (pl. 8), it is significant that they were all drawn from the most primal stages of animal development: amoebas, which are unicellular organisms; invertebrate marine life, a very early stage of animal evolution; embryos, as yet undiversified although bearing the genetic message that will determine the future course of their development. By choosing these stages as the sources for his biomorphic images, Kandinsky, like Arp, was able to suggest unlimited potential for individual materialization without having to depict any particular end form of natural development. Although Kandinsky was now presenting a world in the process of materialization rather than dematerialization, the advent of zoological images in his work did not mean a total break with his earlier approach to composition in painting. Recognizable individual plant and animal forms remain veiled when presented at a unicellular or embryonic level. Because they have not yet differentiated themselves from other primal life forms, any final form they may assume is suggested obliquely rather than represented directly.[14]

7
JEAN ARP
*Four Constellations: Identical
Forms Arranged on a Surface,*
1951
Reliefs
Each 17 ¹¹⁄₁₆ x 14 ¹³⁄₁₆
(45 x 38 cm)
Kunstmuseum Basel,
Switzerland

.

8
WASSILY KANDINSKY
Surroundings, 1936
Oil on canvas
39 ³⁄₈ x 32 ¹⁄₈ in.
(100 x 81.6 cm)
Solomon R. Guggenheim
Museum, New York

.

Kandinsky's attraction to the undifferentiated levels of animal development may be seen as paralleling Goethe's fascination with the notion of an *Urpflanze,* a primal plant from which all other plants could have developed. Goethe did not limit his speculation to the plant world, and over the course of his life he also proposed the existence of Ur-particles of clouds and seeds, designated granite as an Ur-stone, and recast orphic myths in what he called Ur-words.[15] Goethe's pursuit of hypothetical *Urformen* was characteristic of the German Romantic search for the fundamental structural principles and elements in the physical world, which could reveal themselves to human intellect and intuition and then be interpreted as the manifestations of divine forces operative throughout the universe.

Both Kandinsky and Arp employed their versions of biomorphic abstraction to express the world as being not yet completed, the microcosm and macrocosm as ongoing, infinitely renewable concretions. Klee, Kandinsky's close collaborator at the Bauhaus and Arp's acquaintance since his Zurich days, summed up the intent of all three artists when he argued for the concept of forming over that of

form: "Forming determines form and for that reason stands above it. Form, therefore, is never to be seen as completion, as result, as the end but rather as genesis, as becoming, as being. Form as movement, as action, is good, is active form. Bad is form as repose, as termination."[16] Klee, like Arp and Kandinsky, arrived at his concept of forming through the observation and analysis of processes of natural metamorphosis. Infinite metamorphosis of natural form was an assurance, in the context of a twentieth-century Romantic aesthetic shared by the three artists, that divine energies in the universe could find ever new formal possibilities for self-revelation in nature and art.

The affinities between Arp's and Kandinsky's work during Kandinsky's early Paris years are unquestionable. On occasion Kandinsky seemed actually to have taken over Arp's formal vocabulary (pl. 9).[17] The question under discussion is how their common interest in specific and general biological forms and natural growth contributed to their mutually

acknowledged quest for mystical insight into the universe, insight that could then be communicated through the work of art. One must emphasize that none of the mystical import disappeared from Arp's and Kandinsky's work with their substitution of the adjective *concrete* for *abstract.* Both artists continued to insist that they were attempting to present spiritual realities, but now believed that spirit was in no way distinct from matter and the evolving world of natural forms. They believed that the concrete world embodies the spirit and that the concretion, or work of art, embodies the spiritual to be found in man and nature. This integration of spirit into nature indicated the extent to which Kandinsky and Arp were rooted in the German Romantic tradition, Kandinsky as a Russian perhaps more via Symbolist intermediaries than Arp,[18] who had begun reading the Romantics as a child and continued to do so enthusiastically throughout his life.

The question of mystical revelation through nature leads beyond the Romantic movement itself, back to Jakob Böhme, a seventeenth-century German mystic whose dialectical vision of the universe incorporated the most important components of Renaissance occult science and laid the foundation for Romantic aesthetics and metaphysics.[19] Böhme, born in

1575, autodidact, poet, philosopher, and shoe-maker by profession, wrote all but one of his works under an official ban imposed upon him by the Lutheran church; at his death in 1624 he had seen only one of his books in print. Circulated clandestinely throughout Europe, his writings began to be published in the middle of the seventeenth century, first in the Netherlands and soon thereafter in England. They became the basis of a main-stream tradition of Western mysticism, in which it is believed that matter is redeemed through a dialectical process and that the natural universe constitutes the materialized body of God. Böhme's contribution, direct and via Romanticism, to a mystical content that can be conveyed by abstract or concrete art is quite different from the Eastern mystical sources that became important to Theosophy in the early twentieth century and were incorporated into the aesthetics of numerous abstract artists.

In Böhme's cosmos, matter, neither transcended nor dismissed as illusion, is subject to progressive transmutations through which it may reach the sublime state of divine corporeality, the materialized form in which the divinity is able to recognize and take pleasure in itself. This divine self-awareness is predicated on the confrontation and interaction of contraries, whereby the undifferentiated One — for which Böhme created a new word in German, the *Ungrund* — can manifest itself through division into two, revealing each aspect of itself in terms of its opposite: "The being of all being is but a single being, yet in giving birth to itself, it divides itself into two principles, into light and darkness, into joy and pain, into evil and good, into love and wrath, into fire and light, and out of these two eternal beginnings into a third beginning, into the Creation itself as his own love-play between the qualities of both eternal desires."[20]

Without this split into two principles, the divine force can exist only as pure potential, as Ungrund, the Oneness that cannot be fathomed, delineated, or perceived, even by itself. Böhme's initial mystical revelation of duality came as he gazed at the reflection of the sun in a darkened pewter plate and realized that he recognized the brightness only in contrast to the darkness of the surface from which it was reflected. Darkness was essential if the light was to be made manifest. This fundamental dialectic was introduced in Böhme's first treatise, the *Aurora* (1612), a book in wide circulation among German intellectuals and European Symbolists at the beginning of the twentieth century.

In 1613 Böhme was forbidden to write further, and he spent the next five years in silence, studying with followers of the sixteenth-century doctor and alchemist Paracelsus. By the end of this period he had elaborated a metaphysical structure that accommodated Renaissance astrological schemes of planetary opposition and interaction and, most importantly, the tradition of alchemy, in which base matter, known to the alchemists as *prima materia,* is gradually transmuted into a higher level of corporeality. Depending upon the set of references used by the alchemical theorist, this ultimate state of transmutation could manifest itself as gold, the end product traditionally associated with alchemy; as the tincture, a liquid, all-permeating solution of gold; as the philosopher's stone with miraculous powers of divination and healing; or as the *rebis,* androgynous offspring of mercury and sulfur, whose male-female configuration embodies the polar oppositions at play in the alchemical marriage of contraries.

Böhme integrated the alchemical progression, whereby the transmutation and glorification of prima materia is set into motion through the sexual unification of contraries, into his own dialectical vision of a universal, perpetually renewable, and infinitely enhanceable materialization of the divinity. Transforming an alchemical terminology based upon the physical sense of taste into his own cycle of transmutation, Böhme outlined a seven-step progression, which he insisted was actually one simultaneous state even though it was inaccessible to human temporal understanding as such. For each stage Böhme designated a state of motion, which he then labeled with an alchemical term. The first three stages take place in the realm of prima materia: the first motion is that of contraction and concentration, the sour source; the second, that of expansion and dispersion, the sweet source; the third, that of agitation precipitated by the conflict between sour and sweet, contraction and expansion. This third stage Böhme called the bitter source. Agitated base matter is propelled into bitter motion through the opposition of centripedal and centrifugal forces and driven to a fourth stage of ignition, the fire source, which can either result in a fall back into the corrosive, tormented realm of prima materia or lead to a sublimation of mat-

ter in the paradisiac realm of divine corporeality. The fifth source is that of love, characterized by sustaining light and warmth, and the sixth, that of Mercurius, Böhme's variation on the planet and god Mercury. Böhme also characterized his sixth source as that of the Logos, the differentiating, spoken word that makes possible the propagation of form through sound. The seventh source is a successful realization of and participation in the embodied divinity. Böhme often designated this final stage as the holy Sophia, embodiment of divine wisdom, a concept that he probably received indirectly from the Jewish cabala.

The Marxist humanist and philosopher Ernst Bloch, a contemporary of Arp and a friend of the Dadaist Hugo Ball, proclaimed Böhme as the first thinker since Heraclitus to establish an objective dialectic in Western philosophy. Bloch summarized Böhme's ontology: "The contracted and the expansive must coexist, the sour and the sweet, the shock and the light; the very coming into being of the world is cradled by negation. If this negation, this contradictory were not to be, there would be no revelation, no manifestation of the good. That which drives to manifestation is corrosive willfulness, differentiation, separation, independence, that which condenses, coagulates."[21] Bloch's recourse to the alchemical terminology of condensation and coagulation parallels Arp's definition of concretion. In his *Spirit of Utopia* (1918) Bloch introduced Böhme's material dialectic to Marxist historical analysis in his argument that man and society still have the potential to transmute the physical world into a future utopia. This process of transmutation into some as yet unrealized future will occur in the sense of Böhme's dialectic as Bloch characterized it: "that everywhere one thing opposes the other, not in enmity, but so that each thing be set in motion to make itself manifest."[22]

The setting in motion toward self-manifestation is what Böhme defined as the bitter quality, and it was this quality that Arp presented to the Cabaret Voltaire in a reading from Böhme's *Aurora* on 12 and 19 May 1917.[23] There are numerous references by Arp's acquaintances in the Zurich years to his interest in Böhme. Indeed his younger brother François maintained that Arp read Böhme from early childhood onward and that Arp had often read passages from Böhme to him rather than giving him a piece of candy.[24]

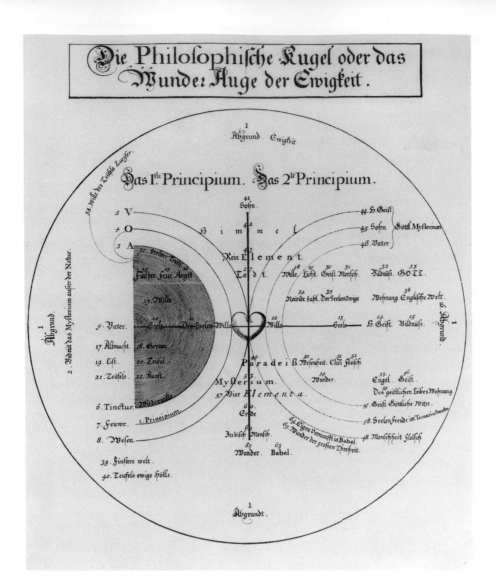

10
Diagram from Jakob Böhme,
*Forty Questions of
the Soul*

Böhme was probably the first philosopher to leave a lasting impression on Arp's imagination, and his work was of obvious importance to Arp in the years 1912–17. During this period Arp attempted to break through to an abstract painting style that could represent the processes rather than the end products of natural genesis. There is a strong possibility that immediately prior to his stylistic break-through Arp was involved in intense discussions with Hugo Ball about Böhme, Paracelsus, and Böhme's Romantic disciple Franz von Baader. Ball's diary entries for two months before the Cabaret Voltaire soirées at which Arp read Böhme record speculations on Böhme, Paracelsus, Romantic philosophy, and the crisis of mysticism in a secular twentieth-century context. At the end of one particularly detailed entry concerning these questions, Ball noted that Arp had left that day for Ascona.[25] This visit to Ascona before the evenings of Böhme readings in Zurich seems to have been the moment when Arp discovered his structural emblem of the fluid ovals, a principle identical to Böhme's own structural representation of his metaphysical system.

The diagram that Böhme designed for *Forty Questions of the Soul* (pl. 10) and his explication of this drawing achieved a visual structure that could accommodate all his propositions.[26] He gave the illustration two titles: *The Philosophical Sphere* and *Wondrous Divine Eye of Eternity.* Böhme explained that the divine eye, a circle, must be split into two and the two resulting arcs placed back to back and rotated in opposite directions. One eye becomes two eyes, which propel one another through their mutual opposition to one another. One arc issues from the corrosive fire eye of the Father, the other, from the loving eye (of sustaining warmth and illumination) of the Holy Spirit. The heart at the center point of contact between the two arcs is the Son. Although the circle that contains the system has a center focal point, this center is in fact engendered by the two foci of the opposing arcs, which project their respective arcs to the point of contact, which is also the spark of ignition. Only when ignited can this center point engender the outer circle that contains and unifies the entire system.

The geometrical figure of a perfect circle with a single center point has been used for millennia as a metaphysical symbol of unity and equilibrium.[27] Böhme strains the confines of this figure to the limits by insisting upon the initial split into two eyes, the two foci that between them generate a center to the circle. At the beginning of the nineteenth century, the two foci within a circle caught the attention of German Romantic poets and philosophers, such as Baader, Friedrich von Schelling, Ludwig Tieck, and Friedrich von Schlegel. The Romantics sought a symbolic representation of a unity that could embrace diversity, even polarities, two foci rather than one, and Böhme was the Western philosopher to whom they looked for suggestions. Taking his bifocal, polarized eye as a starting point, they made one simple geometrical adjustment: rather than retaining the closed curve of the perfect circle, they shifted to the figure of an ellipse, a closed, unified curve generated by two foci rather than one center point.[28] In this way they obtained a geometrical figure that could symbolize a bipolar unity. The ellipse offered the most direct geometrical representation of duality, as Schlegel explained in his philosophical lectures: "The ellipse, the circle, the parabola and hyperbola are but explosions, developments of the point, which must be conceived in a highly mystical fashion. In the primitive point is duality. Ellipse the first symbol of the same; circle and parabola but deviations."[29] The closed elliptical curve immediately became one of the most frequently used symbols in Romantic poetry, fiction, and philosophy, but it was not appropriated as a structural principle by Romantic painters. Not until Arp discovered the fluid oval as his fundamental emblem of natural metamorphosis did the Romantic ellipse create within the domain of painting a structural means for conveying Böhme's dialectical vision of divine materialization in the natural world.[30]

Arp's interest in Romantic literature and in Böhme suggests familiarity with the poetics of a two-foci ellipse, and one assumes that early in his life he had seen illustrations of cells and observed them through a microscope. His fluid oval is a structure that can be identified not only in natural forms observed by the naked eye but also as the most basic unit of all organic life: the cell. The closed elliptical curve with its two foci can represent two modes of generation: cross-fertilization of po-

lar opposites, male and female, and replication by means of fission. In the more advanced forms of organic life two highly specialized reproductive nuclei — male and female, both with half the chromosome count of the species — meet in the egg cell to engender a new individual, genetically unique in its chromosome constellation. The second mode of general cell production, a process shared by all living organisms, is that of mitosis, in which halving of the chromosomes precedes cytoplasmic fission. In this process two genetically identical cells separate out of the initial cell, which does not split until nuclear division is completed. Thus any cell, immediately before its cleavage into two, will contain within its one wall two independent and identical nuclei.

This model of cellular fission is at the heart of Arp's creative imagination. Of great importance is the necessity for two nuclei, rather than one, at the moment of division and growth. If the process of cellular fission is represented on a two-dimensional plane, which curve can represent the cell at the moment just prior to its division? The perfect circle with its one center focus is obviously inadequate; the closed curve that can encompass two foci must be elliptical. After 1917 the ellipse provided Arp with a visual structure that enabled him to realize his own dictum in "Concrete Art": the artist should produce as nature produces.[31] Arp's fluid oval represents natural reproduction at the cellular level, just as it also corresponds to the generative principle the Romantics wished to express with their symbolic use of the two-foci ellipse.

The fluid ovals make their first appearance in Arp's work with the india-ink drawings he produced while trying to define characteristics of natural form in the organic debris cast up on the shores of Lake Maggiore in Ascona (pls. 11–13). Many of these drawings were converted into woodcuts that Arp used to illustrate Dada publications, including his own first collection of poems. From the moment the fluid ovals entered his drawings, Arp was playing with the presence of two foci. One example is a woodcut included in Tristan Tzara's *Cinéma calendrier du coeur abstrait*

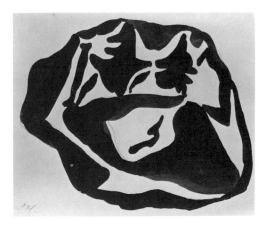

11
JEAN ARP
Pre-Dada Drawing, c. 1915
India ink and pencil on paper
7 x 8 11/16 in. (17.8 x 22.1 cm)
Fondation Jean Arp et Sophie
Taeuber-Arp, Bahnhof
Rolandseck, West Germany

·

12
JEAN ARP
Pre-Dada Drawing, 1915
Brush and ink, pencil
on paper
7 1/16 x 8 3/4 in.
(17.9 x 22.2 cm)
Kunstmuseum Basel,
Kupferstichkabinett,
Switzerland

·

13
JEAN ARP
Pre-Dada Drawing, c. 1915
Brush and ink, pencil
on paper
7 1/16 x 8 3/4 in.
(17.9 x 22.2 cm)
Kunstmuseum Basel,
Kupferstichkabinett,
Switzerland

·

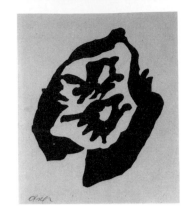

(1920), in which there are two oval foci within a roughly elliptical form (pl. 14). The two centers intensify a sense of movement and impending development suggested by the ellipse in contrast to the equilibrium inherent to the perfect circle. The two ovals are each enclosed by black frames. They echo one another in shape, and the configuration suggests that of a cell at the last stage of mitosis, with its two genetically identical nuclei constituted to dominate their soon-to-be-separated cells.

Two doubled ovals make up the left side of a woodcut design for the 1919 cover of the Dada publication *Der Zeltweg* (pl. 15). Arp reprinted this work among the illustrations he provided for Tzara's *Cinéma calendrier du coeur abstrait* (pl. 16). Later, in torn-paper-collage illustrations for Tzara's *Vingt-cinq et un poèmes* (1946), he created new variations of the wood-

cut in three collages, each of which isolates and presents one or two oval elements from the original drawing (pls. 17–20). The *Zeltweg* woodcut had also appeared in 1933 in one of Arp's earliest torn-paper collages, titled *Navel and Winged Navel*. The perceptual oscillation produced by the ambiguity of figure and frame in the two ovals of the woodcut is a device that Arp refined throughout his career.

In Arp's Dada drawings the oval also functions as a seed. A black oval center gives rise to two white oval growths on either side of *Cinéma calendrier No. 6* (pl. 21). This figuration is repeated in a drawing of 1928, *Flower,* in which the black oval center has become more regular and is more obviously designated as the source of growth. The simplified center gains in suggestiveness, evoking an egg as well as an oval seed.

Arp often used bisected ovals to create a sense of work in progress. In a collage of 1922 entitled *Constellation* (pl. 22), a dark oval on a light background generates a light oval on a dark background. The pair of oval opposi-

tions is about to be replicated by two alternate oval halves in the process of materializing. The partial ovals, cut off by their rectangular frames, suggest an ongoing development that could lead to their emergence as complete figures. This collage is framed in a slightly askew rectangle, in the manner of the cut-paper collages Arp produced in 1916, just before his discovery of the fluid ovals. The counterpoint of light and dark is underlined by the empty paper rectangles on both sides of the "constellation." The rectangle to the lower left is dark, the one to the upper right is light. A potentially endless series of alternating dark and light oval production is initiated by these

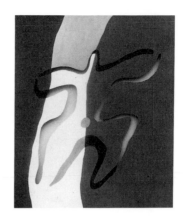

two empty rectangles and their implicit potential for producing an oval of the opposite color. Not only is the constellation ongoing in terms of the developing ovals on the right, but the two as yet empty papers create a top-to-bottom open-ended chain for further generation of dark and light ovals.

In Arp's iconography the oval functions as a multivalent sign. According to its context in his visual configurations and in his poetry, it can be read as navel, egg, head, or eye. Each of these signs is seminal and designates literally or mythologically generative forces and the possibility of new birth. In the Romantic context every new birth attests to the divinity unfolding and discovering itself as it materializes within the physical universe.

Arp's calling forth of bipolar, generative energies was not limited to his and interpretation of the oval. The interaction of black and white, another obvious way to establish bipolar tensions, is one of the means by which both Kandinsky and Arp set up an ambiguity between figure and frame in works that immediately preceded their breakthroughs to an abstract style. It is also a means by which Arp introduced a metaphorical reading to his reliefs, woodcuts, and drawings. An obvious example is a relief executed in 1922 and published in 1927 by Eugène Jolas in the Paris-based American journal *transition* under the title *Arping*. In 1922 Arp produced another similar relief with the same thematic treatment of the human figure and gave the work the title *Homunculus*. Reproduced here is Arp's 1955 reworking of the second relief (pl. 23). In both versions the figure of the man is split into a white and a dark half. The line of demarcation bisects the oval of the navel. In *Arping* the surface plane is also divided by a

diagonal into roughly two halves, one white and one dark, both of which function as a contrapuntal background to the white and dark halves of the human figure. In addition to the split focal point of the navel, each half has the additional focus of an eye. Although the figure is bisected into its white and dark parts, the two eyes and navel are perceived against the unified figure of the torso. The two halves are roughly symmetrical, echoing the bilateral symmetry of Arp's earliest Dada woodcuts and embodying the left-right, black-white polarities that so often structure his poems in the collection *weisst du schwarzt du* (if you white, you black). This collection, published in 1930, was actually written in 1922, the year in which Arp produced the two black-white relief torsos.

24
JEAN ARP
Two Profiles, 1959
Painted cardboard
32 ¹¹/₁₆ x 28 ⅜ (83 x 72 cm)
Collection Carlos Raùl
Villanueva, Caracas

·

25
JEAN ARP
Human Leaf, 1945
Wood relief
30 ¹¹/₁₆ x X 33 ⅞ in.
(78 x 83 cm)
Private collection, Basel,
Switzerland

·

26
JEAN ARP
Amphora, 1931
Painted wood relief
55 ⅛ x 43 ⁵/₁₆ in.
(140 x 110 cm)
Kunstsammlung Nordrhein-
Westfalen, Düsseldorf

·

The title *Homunculus* provides in itself an interpretation of the figure. The prototype of man, synthesized alchemically in the womb of the hermetic vessel, must embody all of human potential. In Arp's visual iconography this human germ manifested itself in terms of black and white halves, of a visually rendered coincidence of contraries. In his essay on a modern-day gnosis in the *transition* issue featuring *Arping,* Jolas declared that man must be conceived in terms of a "night mind and a day mind."[32] This gnostic opposition is visually rendered by the black-and-white configuration of Arp's torso. Arp's *Homunculus* configuration, in contrast to *Arping,* is explicitly dynamic: it promises future materialization. The figure here must be perceived as moving, even running, through the opposing black and white fields.

The counterpoint of black and white was also basic to many of Arp's configurations of the human head. One example related to *Arping* is *Eyes and Nose,* a print of 1930. The white oval eye on the right materializes out of a dark field, thereby generating a white field that is the figure of the nose. This white nose/field in

turn generates a dark oval eye, and all three elements interact so as to constellate one figure, the human face. Again the movement of perception is from the dark to the light to the dark fields. The biomorphic form of the nose suggests further potential for growth and implies a renewal of the white field beyond the frame of the relief itself. The white and dark ovals of the eyes recall Böhme's initial split of the divine eye into two opposing sources of energy. Arp was still working with this split into the black-and-white opposition of two eyes in *Two Profiles,* 1959 (pl. 24). Here the head itself is split as well into two profiles.

Processes of organic metamorphosis and human development are merged and expressed in the opposition of black and white in a 1945 relief entitled *Human Leaf* (pl. 25). The division of the leaf into black and white fields is the principle of construction that renders the leaf human. There are three focal points to the black-white pairing: first, the two heads at the top of the relief; second, the white budlike intrusion into the upper half of the black field, echoed in a black budlike intrusion from the lower half of the figure into the white background of the relief plane; third, the tapering points that meet in a black-

and-white stem or foot to the total configuration of *Human Leaf.* The bottom figure in black also strongly suggests an embryo in fetal position, much like Kandinsky's embryos of the early Paris period. The title *Human Leaf* suggests the metamorphic combinations most often found in the titles Arp gave to his sculptures. Both the metamorphoric unit and the budlike incursions of one component into another are characteristic features of Arp's sculpture. *Human Leaf* is a statement in black and white of the sculptural principles that Arp had begun to realize as concrétions humaines in 1933.

In 1955 Arp specifically characterized one element of his iconography, the amphora, as a concretion that he had worked on for years in his reliefs (pl. 26).[33] Arp had also elaborated on the amphora as an image in his poetry, where it functions as the vessels of the head and heart, as well as the hermetic vessel in which opposites are united. Two versions of this amphora, in particular the 1929 relief *Infinite Amphora,* recall Böhme's diagram of the bipolar divine eye and the figure of the heart at the contact point of the two opposing arcs. Illustrators of Böhme's works in the late sev-

enteenth and eighteenth centuries were versed in occult iconography, and the heart in Böhme's diagram received an alchemical, Rosicrucian rendering at their hands. The heart itself is first the hermetic vessel in which the marriage of contraries takes place and then the womb, nurturing the sublimated manifestation of base matter that will be achieved if the alchemical process is successful. In the frontispiece to the 1730 edition of Böhme's *Christi testamenta* the vessel of the heart is doubled and converted into a circulatory system that assures perpetual interchange and interaction between the upper arc of divine light and lower arc of corrosive fire (pl. 27). The left-right opposition of the divine bipolar eye in Böhme's original diagram has been rotated to the left ninety degrees into a bottom-top opposition. The trunk of the tree/cross sinks its roots/veins into prima materia, and the life blood of the system is conveyed through alchemical transmutations into the heart of the upper realm. At the point of intersection of the horizontal and vertical of the cross, the blood with its source in base matter is converted into the wine/blood of the Son, and the tree itself, rooted in the devouring flames, becomes the tree of eternal life. The circulatory system is constructed so that there need be no end to this process of alchemical transmutation.

Rosicrucian imagery resurfaced in various late nineteenth-century and early twentieth-century theosophical treatises with which Arp, Kandinsky, and other abstract artists were familiar. A particularly striking example is to be found in Edwin Babbitt's model for the atom in *The Principles of Light and Color* (1878) (pl. 28).[34] This heart-shaped configuration provides for an interaction with and conversion from the negative vortex at one end of the atom to the positive torrent at the other. If one were to upend the atomic model drawn by Babbitt, the reversed upward flow of the positive current would replicate the pattern of alchemical circulation through the heart depicted in the Böhme frontispiece.

Schelling, the Romantic philosopher perhaps most strongly influenced by Böhme, elabo-

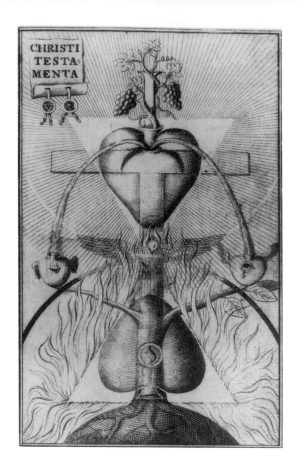

27
Frontispiece from 1730 edition of Jakob Böhme, *Christi testamenta*

.

28
Model for the atom, from Edwin Babbitt, *The Principles of Light and Color* (1878)

.

rated a similar model of the heart in which he envisioned the entire universe as a divine heartbeat with its source in the pulsating point between Böhme's first two principles: "The whole spatially extended universe is nothing but the swelling heart of the godhead. Held by invisible powers, it persists in a continual pulsation, or alternation of expansion and contraction."[35] This image of the universal heartbeat, the endless divine oscillation between systole and diastole, was one of Schelling's most important contributions to Romantic nature philosophy, but its initial formulation existed already in the contact point of the heart in Böhme's diagram of the divine eye. From macrocosm of the universe to microcosm of the atom, the Western occult tradition has continued to enact the marriage of contraries in the pulsating hermetic vessel of the heart. Arp's amphora, his hermetic vessel of the heart, is a concretion that serves as the pulsating, materialized conduit through which the infinity of an undifferentiated Ungrund must pass in order to manifest itself in the infinite richness and diversity of divine corporeality.

In Böhmian-Romantic mystical tradition the idea of a universal pulse created by the oscillation between contraries is a crucial bridge between the ideas of divinity as unknowable pure spirit and divinity as made manifest in matter. The materializing cosmos sets itself into motion by the split into two and develops and perpetuates itself as divine corporeality in a dynamic oscillation between polar opposites. This oscillation is the living pulse of the universe, a pulse conveyed as vibration. *Oscillation, pulse, vibrations* — all are terms for the divine energy that reveals itself in matter. The artist's perception of individual pulsations throughout the microcosm and macrocosm was described by Kandinsky in 1935:

This experience of the hidden soul of all things that we can observe with the naked eye, with the microscope or through a telescope is what I call the inner eye. This inner eye penetrates the hard shell, the outer form to the inner life of things and enables us to perceive with all our senses their inner pulsation. . . . Thus dead matter vibrates. And even more: the inner voices of things do not sound in isolation but rather all together, harmoniously, in the music of the spheres.[36]

This inner pulsation of things is none other than the inner sound of *On the Spiritual in Art* (1912), where Kandinsky characterized all of existence as a vast network of interacting and communicating vibrations in which even "dead matter" is alive.[37] In his essay "On the Question of Form" (1912), Kandinsky

insisted further on the propagation of form through sound or vibration: "Sound, therefore, is the soul of form, which only comes alive through sound and which works from the inside out."[38] In 1913, recounting the arduous process of painting his *Composition VI,* Kandinsky criticized himself for having first tried to express the thematic content of the word *deluge* (*Sintflut* in German) rather than responding directly to the sound or inner pulse of the word itself.[39]

Kandinsky's interchangeable use of his concepts of "inner sound," "inner pulse," and "inner necessity" and his belief in the power of the Logos, as the spoken word, to initiate the process of formation through sound, again recall the work of Böhme, who directed the mystical tradition of the Logos into the mainstream of Western philosophical thought. With his definition of the sixth source as Mercurius and sound, Böhme was able to integrate the theology of the word into his metaphysical alchemy. In *De Signatura rerum,* he specifies at length the presence of an inner and outer Mercurius in all things: the inner Mercurius as the spoken word of the divinity and thus the impetus to forming, the outer Mercurius as the spoken word of materialized form. The potential for form is transmitted from the inner to the outer Mercurius via sound, the vibrations awakened by the spoken word:

Chap. IX, 23. The inner word dwells in the outer word and with the outer word makes all exterior things, and with the inner word, all interior things. The inner Mercurius is the life of the divinity and all divine creatures. And the outer Mercurius is the life in the outer word and all outward corporeality in men and beasts, in all that grows and gives birth and constitutes its own principle as a likeness to the divine essence, and it is the manifestation of the divine wisdom.[40]

Although Kandinsky may have taken into account Eastern notions of vibration from the Theosophists while arriving at his theoretical formulation of the inner sound of things and words,[41] his speculations have a Western, Böhmian component as well.[42] For example, his 1913 description of the creative process reads like a paraphrase of Böhme's account of creation: "The act of painting is a thundering collision of different worlds, which are desig-

nated to create new worlds in their conflict with one another — through catastrophes, which, out of the chaotic roar of all the instruments, create in the end a symphony known as the music of the spheres."[43] It is possible that Kandinsky borrowed directly from Böhme's texts to articulate his own theoretical position on the vibrations that constitute the music of the spheres. Kandinsky's well-known metaphor in which color, form, and objects become the artist's hands striking the keys of a piano and setting the strings into vibration[44] may have been taken from the initial two images in *De Signatura rerum,* with which Böhme illustrated the propagation of inner identity to outer form. The Logos initiates a resonance that then manifests itself as discrete form. On the first page of *De Signatura rerum,* Böhme explicated the process first in terms of a bell, with the clapper that rings it, and then as a lute, with each string tuned according to its own signature and waiting to be sounded by the artist's hand:

Chap. I, 2. If I see that someone is speaking, teaching and writing about God, and, at the same time, I am hearing and reading the same thing as he, I still have not understood enough: but if his sound and his spirit proceeds from his signature and form into my own form and inscribes his form in mine, then I can understand him at the proper depths; be it spoken or written, he has the hammer which can ring my bell.

Chap. I, 5. Secondly we understand that the signature or form is not itself a spirit, but rather the receptacle, or chamber for the spirit that resides within it: for the signature is grounded in the essence and is like a lute that stands silent, neither heard nor understood: but as soon as someone plays upon it, one understands the form, its shape and its preparation and to which voice it is tuned. Likewise, the designation of nature in its form is a silent being: it is like a prepared lute upon which the will's spirit plays; whichever string he hits will sound according to its quality.[45]

These two instruments combined, with their potential for initiating vibrations and conveying outwardly their inner sound, are, in effect,

Kandinsky's twentieth-century piano, the percussive hammer-clavier whose strings come to life through the artist at the keyboard. Kandinsky's 1935 description of the music of the spheres as a chorus of individual things, each singing the song of its own unique pulse, echoes Böhme's description of the seventh realm of divine corporeality, or the materialized word, to which each individually sounded signature makes its own particular contribution.

Böhme in his own organic terms reworked the Pythagorean concept of the harmony of the spheres, an order transposed from mathematical and geometrical consonances to the cosmic instrument of a myriad sounding signatures, all participating joyfully in the multifaceted harmony that is the signature of the divinity itself, which plays this harmony on the many-stringed instrument of its own materialized body. Each individual can participate in and contribute to this universal harmony:

Chap. v, 13. I should become the manifestation of the spiritual divine world and an instrument of God's spirit, wherewith he may play upon himself, upon this sound that I am, as if he were playing upon his own signature: I shall be his instrument and the play of strings of his spoken word and its resonance, and not only I, but all my fellow participants in the magnificently prepared divine instrument. We are all strings in his joyful play of melody; it is the spirit of his mouth that sounds our strings of his voice.[46]

Arp's lifelong interest in Böhme was reflected not only in his preference for bipolar structures and images but also in his adaptation, like Kandinsky's, of Böhme's vibrating Logos as the impulse that initiates form. In poem after poem Arp wrote of human powers of genesis residing in the tongue, which pronounces words that propagate themselves through space and matter as if they were rung from a bell. There are numerous variations of the resonant bell in Arp's poetry, including the flower calyx with its pistil, the human head as bell with its tongue as clapper, and the pulsating, alchemical chamber of the heart. Arp's words and images become resonant by generating within themselves an oscillation between polar opposites. A "black ribbon resonance" of flowers enters the poem "À fleur des fleurs" of 1939, accompanied by geometrical images of vibration taking place within the head, which functions as a hermetically sealed vessel. With their pistil tongues, the flowers initiate a process of alchemical distillation that transforms the head of the poet

into a vibrating bell, oscillating between the moon and sun:

les têtes de fleurs sont remplies de rubans noires
sur leurs langues longues on donne des concerts aux
couleurs endormies
des concerts comme les vrombissements des hélices de
la lune qui chassent le soleil de miel
je ferme les yeux et j'ouvre les fenêtres
j'ouvre la bouche et ferme la porte
la moisson métallique carillonne dans ma tête.[47]

[The heads of flowers are filled with black ribbons, slumbering colors in concert performance on their long tongues.
Concerts that hum like throbbing propellers of moonlight in pursuit of a honeyed sun.
I close my eyes and open the windows.
I open my mouth and close the door.
Metallic harvests ring out in my head.]

Arp's folio collection of poems and graphics, *Vers le blanc infini* (1960), in memory of his wife and fellow artist, Sophie Taeuber-Arp, who had died in 1943, is also an homage, with strong Romantic and Böhmian overtones, to all human potential for creativity. The artist's hand must initiate vibrations that lead to the realization of individual works and, at the same time, contribute to a cosmic resonance — a process Arp illustrates with a description of Sophie at work in the early morning hours. The inner pulse of Sophie's living presence, her beating heart, is transmitted to the expanse of sky in the poem "À travers les myrtes du rêve":[48]

Le ciel battait clair et calme.
Le coeur de Sophie battait clair et calme
contre le coeur du ciel.
Des ondes surgissaient de Sophie
scintillaient
et envahissaient sa table de travail.

[The sky was beating clear and calm.
Sophie's heart beat clear and calm against the heart of the sky.
Waves welled up from Sophie, scintillating,
inundating her work bench.]

Sophie, like Arp's bell-flowers, resounds with concerts of color:

Des petits soleils de couleur tourbillonnaient
de ses pinceaux de ses crayons de couleur.
Sophie étalait autour d'elle
des harmonies lumineuses.

[Little suns of color whirled from her brush and her colored pencils.
Sophie radiated all around her harmonies of light.]

The vibrations she has initiated spread through sails of color, cascades of light, and the ringing of a morning bell at sunrise:

Des voiles d'émeraude
se glissaient parmi les voiles bleues.
Des cascades de lumière
au rire pur de la cloche du matin
se déployaient.

[Emerald sails
gliding through sails of blue.
Cascades of light
deployed
by the morning bell's pure laugh.]

After further stanzas in which the moon joins in the dispersal of light, the pure laugh of the morning bell returns. Ultimately it extends to the vibrating arc of light that spans the sky and in turn is transmitted to the tympan of the earth, which then resounds with the song first set into motion by Sophie's pulsating heartbeat:

L'archet immense de la lumière touchait la terre
et la terre chantait.

[The vast arc of light touched the earth and the earth sang.]

The singing earth of Arp's hymn to Sophie echoes Böhme's concept of the seventh realm, divine corporeality realized through vibrations initiated by the Logos. Arp must have been particularly aware of the fact that Böhme repeatedly identified this seventh realm with the holy Sophia, divine wisdom, reflected by the corporeal mirror in which the divinity recognizes and completes itself as an androgynous and simultaneously spiritual and physical being. The divinity rejoices and plays

upon itself in joy the song of divine corporeality with all its myriad signatures. In Arp's tribute to Sophie her signature, and that of Arp himself as poet, can be distinguished in a vibrant harmony of earth, light, and sky, the resounding cosmos itself.

Arp considered poetry to be another realm in which concrete art might be realized. Not surprisingly, the artist he cited as being one of the first poets of the century to produce concrete poems was also the painter he cited as the first to produce concrete art: Kandinsky. In his essay "Kandinsky the Poet," Arp referred specifically to Kandinsky's 1913 collection of poems, *Sounds,* as concrete.[49] The themes of resonance and vibration-generated form were certain to have been topics of discussion between Arp and Kandinsky as early as their first meeting in Munich in 1912. In 1943 Kandinsky wrote one final essay just before his death, a tribute to the work and life of Sophie Taeuber-Arp, who had recently died. This was one of only four written appreciations of other artists produced by Kandinsky during his entire career; the fact that it exists attests to the closeness Kandinsky felt toward Arp and Taeuber-Arp. Kandinsky's homage to Sophie is filled with images of musical resonance:

Her arsenal of expressive means is of inexhaustible richness. The greatest contrasts are "loud" and "soft." The thunder of drums and trumpets in Wagner overtures are opposed by the quiet, "monotone" fugue of Bach. Here, the thunder and lightning that rip up the sky, shake the earth: there, a sky smooth and gray, in all of its vastness, and the wind has retired far into the distance. The smallest, most naked shoot remains motionless, the weather is neither warm nor cool. The language of stillness.[50]

Resonance versus the stillness of death is Arp's theme in his highly personal *Vers le blanc infini:*

a world made resonant by Sophie's presence and her work, a world stultified and rendered mute by her departure. The only potential for resonance remaining in Sophie's absence is Arp's memory of her and her concrete art. His re-creation of Sophie's song of vibrant life, played upon the earth and rung out in the arc of the sky, is Arp's poignant realization, this time in words, of a concrétion humaine in the face of death. His homage ends with the poem "Une onde blanche" and a final image in which vibration and concretion become one, the white wave etched on an infinite whiteness:

But the grayness gnawed where your dreams were harbored.
The mirrors of your eyes
of your lips
of your words
were emptied, their echos lost.
Your words fell into the grayness
where no trace remains.
Gray into gray your life was flowing away
like a gray fount of extinguished tongues.
But the last time I saw you
you were a white wave,
poised to return forever
into the whiteness.[51]

Research for this article was made possible in part by the Alexander von Humboldt Stiftung.

1. Hans Arp, "Concrete Art" (1944) in idem, *Arp on Arp*, trans. Joachim Neugroschel (New York: Viking, 1972), 139.

2. The narrowness of Theo van Doesburg's definition is discussed in Christian Derouet, "Kandinsky in Paris: 1934–1944," in *Kandinsky in Paris*, exh. cat. (New York: Solomon R. Guggenheim Museum, 1985), 52–53.

3. *Arp*, exh. cat., ed. James Thrall Soby (New York: Museum of Modern Art, 1958), 14–15.

4. Wassily Kandinsky, "Abstract or Concreet?," in *Tentoonstelling abstracte kunst*, exh. cat. (Amsterdam: Stedelijk Museum, 1938); idem, "L'Art concret," *XXe Siècle*, no. 1 (1938); idem, "La Valeur d'une oeuvre concrète," *XXe Siècle* 1, nos. 5–6 (Winter–Spring 1939).

5. Wassily Kandinsky, "Abstrakt oder Konkret" (1938), in *Kandinsky: Essays über Kunst und Künstler* (Teufen, Switzerland: Arthur Niggli & Willy Verkauf, 1955), 214.

6. Wassily Kandinsky, "Zwei Richtungen" (1935), in idem, *Kandinsky: Essays*, 184.

7. Hans Arp, "Stone Formed by the Human Hand" (1948), in idem, *Arp on Arp*, 242.

8. Hans Arp, "Signposts" (1955), in idem, *Arp on Arp*, 271.

9. Ibid.

10. Arp's breakthrough to the fluid ovals and their relation to the "earthly forms" has been identified and discussed in Jane Hancock, "Form and Content in the Early Work of Hans Arp 1903–1930" (Ph.D. diss., Harvard University, 1980), chap. 4.

11. Wassily Kandinsky, *Point and Line to Plane* (1926; New York: Dover, 1979), 103–9.

12. The source of these images was first identified and discussed by Vivian Endicott Barnett, "Kandinsky and Science: The Introduction of Biological Images in the Paris Period," in *Kandinsky in Paris*, 63.

13. Arp, "Stone Formed by the Human Hand," 227.

14. See also the discussion of embryo as abstraction in Barnett, "Kandinsky and Science," 86.

15. Ronald Gray provides an extensive discussion of the early influence of the mystical alchemical tradition on Johann Wolfgang von Goethe's poetic imagination. Gray also draws a hypothetical model of Goethe's Urpflanze based upon the seven stages of transmutation outlined by Jakob Böhme for the progression to divine corporeality. See Ronald Gray, *Goethe the Alchemist: A Study of Alchemical Symbolism in Goethe's Literary and Scientific Works* (Cambridge: Cambridge University Press, 1952), especially chap. 2, "Jacob Böhme and Alchemy," and chap. 4, "The Metamorphosis of Plants."

16. Paul Klee, *Unendliche Naturgeschichte*, ed. Jürg Spiller (Basel: Schwabe, 1970), 43.

17. Barnett, "Kandinsky and Science," 64–66.

18. See the discussion of Wassily Kandinsky and the Symbolist movement in Rose Carol Washton-Long, *Kandinsky: The Development of an Abstract Style* (Oxford: Oxford University Press, 1980).

19. The best philosophical introduction to Böhme and most comprehensive account of his use of Renaissance astrology and alchemy is the study written by the historian of the philosophy of science Alexandre Koyré, *La Philosophie de Jacob Böhme* (Paris: Librairie Philosophique J. Vrin, 1929).

20. Jakob Böhme, *Sämtliche Schriften*, ed. W. E. Peuckert, vol. 16 (Stuttgart: Frommann, 1957), 233.

21. Ernst Bloch, *Zwischenwelten in der Philosophie Geschichte* (Frankfurt: Suhrkamp, 1977), 241.

22. Ibid., 235.

23. Hugo Ball, *Flight out of Time*, trans. Ann Raines (New York: Viking, 1974), 112.

24. François Arp, interview with author, Paris, September 1981.

25. Ball, *Flight out of Time*, 104.

26. Jakob Böhme, *Sämtliche Schriften*, ed. August Faust, vol. 3, pt. 2 (Stuttgart: Frommann, 1942), 31.

27. Two most comprehensive and helpful studies of circle symbolism in the Western literary and philosophical tradition have been written by Dietrich Mahnke, *Unendliche Sphäre und All-mittelpunkt* (Halle: Niemeyer, 1937) and Georges Poulet, *La Métamorphose du cercle* (Paris: Plon, 1961).

28. The extreme importance of the ellipse in Romantic thought, specifically to Jakob Böhme as the source of this figure, was first identified by the critic Marshall Brown, *The Shape of German Romanticism* (Ithaca: Cornell University Press, 1979), especially chap. 3, "The Ellipse."

29. Cited by Brown, *Shape of German Romanticism*, 172.

30. An excellent introduction to the Romantic, northern contribution to twentieth-century abstract painting is provided by Robert Rosenblum, *Modern Painting and the Northern Romantic Tradition: Friedrich to Rothko* (New York: Harper & Row, 1975). Rosenblum, however, does not address the structural question of ellipse versus perfect circle, nor does he investigate the sources of German Romantic thought.

31. Arp, "Concrete Art," 139.

32. Eugène Jolas in *transition* (1927).

33. Arp, "Signposts," 326.

34. Edwin Babbitt, *The Principles of Light and Color* (London: Kegan, Paul, Trench, Trübner, 1878), 94–165; illustration of atomic model, 102.

35. Friedrich Schelling, *The Ages of the World*, trans. Frederick Bohman (New York: Columbia University Press, 1942), 215.

36. Kandinsky, "Zwei Richtungen," 183.

37. Wassily Kandinsky, "On the Question of Form," in *The Blaue Reiter Almanac* (1912), ed. Wassily Kandinsky and Franz Marc; documentary edition edited by Klaus Lankheit (New York: Viking, 1974), 173.

38. Ibid., 149.

39. Wassily Kandinsky, *Rückblicke* (1913; Bern: Benteli, 1977), 39.

40. Jakob Böhme, *Sämtliche Schriften*, ed. A, vol. 6 (Stuttgart: Frommann, 1957), 102.

41. For his original discussion of possible contributions by Theosophy to Kandinsky's breakthrough to a nonrepresentational style see Sixten Ringbom, *The Sounding Cosmos: A Study in the Spiritualism of Kandinsky and the Genesis of Abstract Painting*, Acta Academiae Aboensis, ser. A, XXXVIII (Åbo, Finland: Åbo Akademi, 1970); also idem, "Kandinsky und das Okkulte," in *Kandinsky und München: Begegnungen und Wandlungen 1896–1914*, exh. cat., ed. Armin Zweite (Munich: Städtische Galerie im Lenbach-haus, 1982).

42. A comprehensive survey of Böhme's influence in Russia is to be found in Zalenek David, "The Influence of Jakob Böhme on Russian Religious Thought," *Slavic Review* 21 (March 1962): 42–64. This article documents the importance of Böhme and Friedrich von Schelling to the Russian philosopher Vladimir Solov'ev, who in turn had a great impact on the Russian Symbolist movement and the aesthetics of those artists, such as Kandinsky, who were rooted in the Russian Symbolist tradition.

43. Kandinsky, *Rückblicke*, 24.

44. Wassily Kandinsky, *Concerning the Spiritual in Art* (1912), trans. M. T. H. Sadler (1914; New York: Dover, 1977), 25.

45. Böhme, *Sämtliche Schriften*, 6:4–5.

46. Ibid., 169.

47. Jean Arp, *Jours effeuillés*, ed. Marcel Jean (Paris: Gallimard, 1966), 151.

48. Ibid., 521–22.

49. Ibid., 370.

50. Wassily Kandinsky, "Die farbigen Reliefs von Sophie Taeuber" (1943), in *Kandinsky: Essays*, 242.

51. Arp, *Jours effeuillés*, 526.

OVERLEAF

MARCEL DUCHAMP AND
MAN RAY
Rotary Glass Plates, 1920,
remade 1976
Motorized construction,
painted plexiglas, metal, and
wood
67 x 48 x 55 in.
(170.2 x 121.9 x 139.7 cm)
The Museum of
Contemporary Art, Los
Angeles

MARCEL DUCHAMP: ALCHEMIST OF THE AVANT-GARDE

JOHN F. MOFFITT

Marcel Duchamp was a central contributor to twentieth-century avant-garde art and culture, first as an artist himself, usually referred to as a Dadaist, and later, beginning in the late 1950s, as a role model, or "granddada," for the pop and conceptualist artists of the 1960s and 1970s.[1] There is a general perception that buried somewhere in his apparently anomalous works there is a connective link, some hidden subject matter that suggests a larger motivation. Accordingly one of the main lines of interpretation now taken when considering Duchamp's works deals with his hypothetical involvement with various kinds of occultism.[2] Not only did Duchamp borrow specific ideas from alchemy but, unlike his artistic peers immersed in often generalized antimaterialistic pursuits, he also made esotericism the essential basis of his iconography, expressing specific alchemical motifs both pictorially and textually.[3] During his schooldays at the Lycée Corneille in Rouen, from 1897 to 1907, Duchamp was exposed to a rigorous classical curriculum consisting of "a heavy academic menu — philosophy, history, rhetoric, math, science, English, German, Latin and Greek."[4] That in itself did not necessarily lead to his appropriation of hermetic esotericism, but given the occultism current in Symbolism, the avant-garde culture of that time, such hermetic ideas were readily available to any developing artist. To many scholars of Duchamp's esotericism, topics such as hermeticism in general and alchemy in particular play a coherent and valid role within the history of modern ideas.[5]

The occult interpretation of Duchamp's art and ideas is fraught with difficulties. The major lacuna is essentially bibliographic: where specifically did Duchamp get his unquestionably learned knowledge of alchemical ideas and iconography? Knowledge of Duchamp's sources is largely limited to Pierre Cabanne's reference to having seen some unnamed "books on the occult in Marcel Duchamp's New York studio, but that was in 1967."[6] Even if we did know all the titles of those occult publications, we still could not prove that the artist had referred to any of them before, especially as early as the summer of 1911, when he painted his first clearly alchemical opus. Since the documentation needed to establish his working bibliography on alchemical ideas and iconography seems irretrievable, one can only reconstruct this knowledge hypothetically.[7]

Distinctions must be drawn between traditional (medieval and Renaissance) and modern

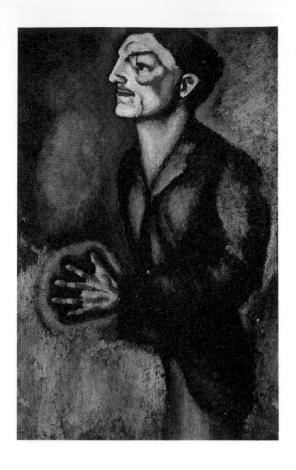

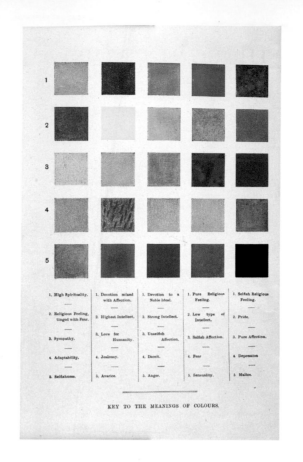

(Symbolist) interpretations of the hermetic sciences and also between older and newer publications. It is plausible that Duchamp was first influenced by contemporary publications, that initially his occult bibliography was composed largely of inexpensive, popular publications on esoterica in French. It may be presumed that Duchamp's interest in alchemy later became sufficiently strong to motivate him to go directly to the primary sources, the often vividly illustrated treatises, written predominantly in Latin, that could be found in the major Parisian libraries, including the Bibliothèque Sainte-Geneviève, where Duchamp worked as a librarian in 1913.

Duchamp's first clearcut venture into generally occult, not yet specifically alchemical iconography occurred in a canvas of April 1910, *Portrait of Dr. Dumouchel* (pl. 1). The painting is characterized by large, thickly painted masses of iridescent colors on the figure and by swirling blue and purple clouds in the background. Dumouchel, wearing a bottle-green coat, is encircled by a bizarre, greenish-purplish irradiation. His extended left hand seems to blaze with fiery otherworldly vibrations. This striking halo sets the painting apart from Duchamp's preceding works, particularly if this nimbuslike device is read as an iconographic attribute.

Duchamp himself obliquely referred to Dumouchel's aura in an inscription on the back of the canvas: "à propos de ta / 'figure' / mon cher Dumouchel / Bien cordialement / Duchamp." As the word *figure* was carefully set off in quotation marks, it suggests qualities inherent in the personality of the sitter. Raymond Dumouchel was a recently graduated physician and one of Duchamp's oldest friends; they had met in 1897 while attending the Lycée Corneille. According to a later statement by Duchamp, "This is a portrait of a medical student, a friend of mine, Dr. Dumouchel, showing my interest in fauvism around 1910. It recalls the violent color schemes of a van Dongen; at the same time certain details, such as the haloed hand, indicate my calculated intention to add a touch of willful distortion."[8] There are two ways to explain this willful distortion. The first is pragmatic, having a scientific basis: Dr. Ferdinand Tribout, another classmate of Duchamp and "a pioneer of radiology in France, perhaps drew Duchamp's attention to certain extra-retinal phenomena caused by radiation, perhaps including the 'electric' halo surrounding the hand of his co-worker, Dr. Dumouchel."[9] The second explanation is

nonrational, antimaterialist, and occult: the distortion may express the idea of spiritual emanations, a commonplace in occult thought since the late eighteenth century.

Walter Arensberg, Duchamp's esoteric-minded patron, later acquired the Dumouchel portrait and questioned whether the halo device was indeed a specifically occult reference. Duchamp replied that it had nothing to do either with radiology or even with Dumouchel's hand as such: "The 'halo' around the hand, which is not expressly motivated by Dumouchel's hand, is a sign of my subconscious preoccupation with a 'metarealism.' It has neither a specific significance nor any explanation, except for the satisfaction of a need for the 'miraculous' that antedated the cubist period."[10] Reference to an occult source describing a very similar "metarealist" and "miraculous" symbolic motif, however, shows that Dumouchel's halo-sign could, in fact, have had an easily understood "figurative" meaning for the artist and his sitter. Annie Besant and Charles W. Leadbeater's *Thought-Forms* (1905), which appeared in translation as *Les Formes-Pensées* (1905), explains an esoteric system of color-coded psychological perceptions:

What is called the aura of man is the outer part of the cloud-like substance of his higher bodies, interpenetrating each other, and extending beyond the confines of his physical body, the smallest of all. . . . Man, the thinker, is clothed in a body composed of innumerable combinations of the subtle matter of the mental-plane. . . . Every thought gives rise to a set of correlated vibrations in the matter of this body, accompanied with a marvelous play of color. . . . The body under this impulse throws off a vibrating portion of itself, shaped by the nature of the vibrations . . . and this gathers from the surrounding atmosphere matter, like itself in fineness, from the elemental essence of the mental world. . . . Where man is of a gross type, the desire-body is of the denser matter of the astral-plane, and is dull in hue, browns and dirty greens and reds playing a great part in it. . . . A man of a higher type has his desire-body composed of the finer qualities of astral-matter, with the colors, rippling over and flashing through it, fine and clear in tone. . . . When a sudden wave of some emotion sweeps over a man, for example, his astral body is thrown into violent agitation. . . . The radiating vibration, therefore, will be a complex one, and the resultant thought-form will show several colors instead of only one.[11]

Such were the overall meanings ascribed to colorful vibrating and flashing body-auras by clairvoyants. The frontispiece of *Thought-Forms* (pl. 2) helps us pin down the specific iconographic relation of body-auras to *Portrait of Dr. Dumouchel*. This plate has twenty-five colored squares accompanied by captions stating the exact link of each color to a psychological state. From this color key, we learn that the bluish and purplish hues in Dumouchel's vibrating body-aura signify an overall "Love of Humanity," complemented by the desirable attributes of "High Spirituality" and "Devotion to a Noble Ideal." The greenish hues in the lower left of the background as well as those on the young physician's coat, allude to his endearing qualities of "Sympathy" and "Adaptability." These color coded thought-forms provide a fitting iconographic scheme for the "healing hand" of a recently graduated physician.[12]

Duchamp's initial flirtation with occult iconography in *Portrait of Dr. Dumouchel* took an essentially naturalistic form, as is the case with other paintings of the transitional period of 1910–11, which we may call his "theosophical period." Relative naturalism, with an increasing measure of abstraction, also characterizes *Young Man and Girl in Spring,* or *Spring,* made in August 1911 (pl. 3); this is the first painting in which Duchamp unmistakably turned to alchemical iconography.[13] The all-important shift in occult subject matter from generalized theosophical imagery — the body-aura — to specifically alchemical iconography — the *coniunctio oppositorum* (marriage of opposites) — is easily understood given the personal motivation behind the painting. This was, in fact, a wedding present, painted for his younger sister, Suzanne. Moreover, the bridegroom, Georges Desmares, was a registered pharmacist, or chemist. Hence the double appropriateness of the painting's alchemical subject matter.

The entire composition of *Spring* was derived from a conventionalized type of imagery found in old alchemical emblem books. The underlying narrative element clearly deals with an image basic to all alchemical symbolism: the coniunctio oppositorum figured by the voluptuous union of sulfur (sun, or king) and mercury (moon, or queen) and the offspring of their heated encounters, the hermaphroditic *rebis* (two-thing). According to the text of the ancient *Tabula smaragdina* (The emerald tablet) attributed to the mythic Hermes Trismegistus, "whatsoever is below is like that which is above . . . as all things are made from one," and "all things are made from one thing by conjunction," including alchemical gold.[14] The allegorical alchemical process is based upon a complex sequence of

3
MARCEL DUCHAMP
Young Man and Girl in Spring,
1911
Oil on canvas
25 ⅞ x 19 ¾ in.
(65.7 x 50.2 cm)
Vera and Arturo Schwarz
Collection, Milan

anthropomorphizations of inanimate substances; the world and all its components are potentially infused with life. Alchemical symbolism is rife with sexual dualisms proceeding from the fundamental opposition of two complementary anthropomorphic principles: the active, male principle — sulfur — and the passive, female principle — mercury. The philosophic couple were to be placed in a large glass vessel, the nuptial chamber, where their erotic union was to be consummated in great ardor, the result of which was their son: the *lapis philosophorum* (philosopher's stone), itself a sign of the artist's *aurea apprehensio* (golden enlightenment).

The alchemical components of Duchamp's *Spring* can be deciphered both textually and iconographically. The upper register of an engraving from an early eighteenth-century hermetic handbook (pl. 4), the *Bibliotheca chemica curiosa* (1702), shows two handsome, winged youths, who have been placed on either side of a glass flask. Trapped within the crystal walls of this heated prison, which represents the hermetically sealed philosopher's egg, is a homunculus. In the engraving's lower register the alchemist and his mythic *soror mystica* (spiritual sister) energetically

pray over an empty glass egg, which they have just placed into the *athanor* (alchemical furnace). In *Spring* these two allegorical laborers have been transmuted into the nude figures of Duchamp and his sister, and these two eagerly stretching figures enframe a centrally placed round object. Trapped within this sphere is a tiny figure, the homunculus, and, as in the alchemical engraving, the greenish sphere is deliberately rendered to indicate that it is indeed made of glass, a visual fact made unmistakable by the highlights carefully painted on the upper part of its curving surface. That this is a ubiquitous image within alchemical illustrations is shown by a plate from *Mutus liber* (1677) (pl. 5), which shows two similar figures flanking mercury in the philosopher's egg.[15] An authoritive textual explanation for this pairing, including a reference to spring as the season of its occurrence, is provided by Martin Rulandus in *Lexicon alchemiae* (1612):

There is no term in more frequent use among the philosophers than the word "marriage." They say that the sun and the moon must be joined in marriage together . . . and all these expressions have reference exclusively to the union between the fixed and the volatile, which takes place in the vase by the intermediation of fire. All the seasons are fitting for the celebration of this marriage, but the philos-

ophers especially recommend spring as that period in when nature is most impelled to generation.[16]

Following his apparently casual use of alchemical lore and imagery in *Spring,* Duchamp evidently continued to study the subject, perhaps under the tutelage of his Puteaux neighbor and fellow artist, František Kupka. As early as November or December 1911 Duchamp was apparently dealing with *circulatio* (rotation), the single sign, usually rendered as a circle or wheel, representative of the entire alchemical operation. Thus the formal and iconographic diversity of circular forms — for example, *Coffee Mill,* late 1911, *Bicycle Wheel,* 1913, *Precision Optics,* 1920, *Roto-Reliefs,* 1923–35, and the disks and spirals in *Anemic Cinema,* 1925–26 — in Duchamp's works may be seen as alluding to a common rotative process of alchemical significance. Of his spiraling efforts of the 1920s, Duchamp stated:

At the time I felt a small attraction toward the optical without really calling it that. I made a little thing that turned, that visually gave a corkscrew effect, and this attracted me; it was amusing. At first I made it with spirals, not even spirals — they were off-center circles which, inscribed one inside

the other, formed a spiral, but not in the geometric sense; rather in the visual effect. . . . What interested me most was that it was a scientific phenomenon which existed in another way than when I had found it.[17]

Of Duchamp's many spinning devices, most important is the *Bicycle Wheel* (pl. 6) for it is also the first of the "ready-mades." Duchamp blandly described the genesis of this anti-materialist emblem: "To see that wheel turning was very soothing, very comforting, a sort of opening of the avenues onto other things than the material life of every day. I liked the idea of having a bicycle wheel in my studio. I enjoyed looking at it, just as I enjoy looking at the flames dancing in a fireplace."[18] *Bicycle Wheel* incorporates the imagery of both alchemy and the fourth dimension, yet another pseudoscientific concept known to have enthralled Duchamp.[19] It reminds one of a metaphor employed by the Russian occultist P. D. Ouspensky in *Tertium Organum* (1911) to illustrate the mysterious workings of the fourth dimension: the open spokes of a bicycle wheel, once put into rapid spinning motion, paradoxically become a plane through which an object like a stick or a ball cannot penetrate.[20] Although Duchamp could not have known directly the details of Ouspensky's Russian text, which was not translated until years later, he certainly could have studied one of the textual sources of this idea, which was carefully cited by Ouspensky: Camille Flammarion's *Les Forces naturelles inconnues* (1865).[21]

In Ouspensky and Flammarion what we have is a metaphor expressing the transmutation of nonmatter into apparent matter. Others have interpreted *Bicycle Wheel* as an axiomatic neo-Euclidean demonstration, which seems too dry and too unlikely;[22] a generally dematerialized or occult pseudophilosophical interpretation of its fourth-dimensional significance seems more probable in the light of then-current popular opinion.[23] In a 1912 theosophical treatise by André de Noircarme the fourth dimension was described as relating to the occult conception of a "superior vision which functions independent of physical vision."[24] The fourth dimension is "the reflection, the limited reproduction of an ideal form or archetype";[25] the author thus affirms the hermetic idea that all Creation begins above and moves below. According to Noircarme, the fourth-dimensional materializing-dematerializing process is best summed up by reference to the alchemical motto *solve et coagula* (dissolve and coagulate),[26] which expresses the very essence of alchemy as defined by Rulandus: "To Convert the

6
MARCEL DUCHAMP
Bicycle Wheel, 1913 (1964 ed., Schwarz no. 2/8)
Wheel mounted on painted wooden stool
Diameter 25 in. (63.5 cm); height 49 ¾ in. (126.4 cm)
DRA Wierdsma, French Farm, Greenwich, Connecticut

7

*Cadmus-Mercury Spinning the
Alchemical Wheel,* from
Speculum veritatis,
(manuscript, c. 1660)

·

8

*The Hermetic Squaring of the
Circle,* from Michael Maier,
Atalanta fugiens
(1617)

·

Elements: This expression of Hermetic Chemistry signifies 'to Dissolve and to Coagulate,' meaning to change body into spirit, and spirit into body; to volatize that which is fixed, and to fix that which is volatile. All these terms refer to one only operation which Nature, assisted by Art, performs . . . when the matter has been thoroughly purified and sealed in the Hermetic Egg."[27]

A similar fourth-dimensional–alchemical formulation was employed by Ouspensky to explain the larger, purely occult significance underlying his citation of Flammarion's bicycle wheel motif:

Occultists of different schools often use the expression "fourth dimension" in their literature, assigning to the fourth dimension all phenomena of the "astral sphere" [which] may be defined as the *subjective world,* projected outside us and taken for the *objective world.* If anybody actually succeeded in establishing the objective existence of even a portion of what is called "astral" then it would be the world of the fourth dimension. . . . Occult theories generally start from the recognition of one basic substance, the knowledge of which provides *a key* to the knowledge of the mysteries of nature [and] Philosopher-Alchemists call this fundamental substance "*Spiritus Mundi.*" . . . The transformation into the astral state of matter composing visible bodies and objects is recognized as possible; this is *dematerialization.* . . . Also, the reverse process . . .

is recognized as possible; this is *materialization,* that is, the appearance of things, objects and even living beings from no one knows where. . . . In this way alchemical processes are explained by the temporary transference of some body, most often some metal, into an astral state, where matter is subject to the action of will.[28]

The mandalalike wheel motif — which is a sign of alchemical "gold, or the sun," according to the French alchemist Albert Poisson — was a constant factor in hermetic imagery.[29] For instance, the anonymous seventeenth-century manuscript of the *Speculum veritatis* (The mirror of truth) shows Cadmus spinning an eight-spoked wheel symbolizing the dynamic circulatory process of alchemy (pl. 7).[30] All the symbolism inherent in the image of a spinning wheel, except for the fourth dimension, had been well known to the alchemists of the Renaissance. This commonplace motif was explained in detail by Rulandus:

A circle signifies the circulation of the matter in the egg of the philosophers [or] the circular revolution of the elements, and they also name the great work the "quadrature of the physical circle." . . .

To turn in a circle is to cause the matter to circulate in the vessel. . . .

To make the wheel revolve is to recommence operations, either for the confection of the stone, or for the multiplication of its virtue: the elementary wheel of the sages is the conversion of the philosophical elements.[31]

Rulandus's reference to the elementary wheel in connection with the "quadrature of the physical circle" is a link also made in *Bicycle Wheel* — a circle fixed upon a quadrature, the four-legged base of the stool — as Maurizio Calvesi recognized:

As it turns the wheel not only alludes to mobility, itself the contrary of the "fixed" (or masculine principle), but also to the fixed nature of the stool itself, which brings the image back to itself by a symbiosis of contraries. The stool, as a four-sided body having a square base, maintains a dialectic with the wheel, itself a circle and also the rounded crown of the ensemble: hence, the "Squaring of the Circle," the opposition–integration of the Four Elements into the One. . . . Following calcination by fire, the volatile and the mobile materials ascend and "circle," while the corporeal, or fixed material (the stool) remains below, in the "earth."[32]

The notion of the squaring of the circle, a key idea in hermetic geometry, is perhaps better explained by reference to a well-known engraving (pl. 8) found in Michael Maier's book of alchemical emblems, *Atalanta fugiens*

9
MARCEL DUCHAMP
*Nine Disks with Inscriptions
Made for Anemic Cinema,* 1926
Pasted letters on cardboard
Diameter each
11 ¼ in. (28.6 cm)
a. Private collection, West
 Germany
b. Collection Francis M.
 Naumann, New York
c–d. Collection Robert
 Shapazian
e. Collection Timothy Baum,
 New York
f–i. Collection Carroll Janis,
 New York

10
MARCEL DUCHAMP
*Disks Bearing Spirals Made for
Anemic Cinema,* 1923–26
Ink and pencil on paper
mounted on board
45 ¼ x 45 ¼ in.
(114.9 x 114.9 cm)
Seattle Art Museum
Eugene Fuller Memorial
Collection

·

11
The Alchemical Ouroboros,
from Michael Maier,
Atalanta fugiens
(1617)

·

(1617), where the significance of this provocative image was stated: "Make a circle out of a man and a woman, out of this a square, out of this a triangle. Make a circle, and you will have the philosophers' stone . . . that is, if you understand the theory of [hermetic] geometry." Maier further explained:

The natural philosophers [alchemists] did know the squaring of the circle. . . . By the circle they mean a simple body, and by the square they mean the four elements. . . . The philosophers want the square to be changed into a triangle, that is to say, into body, spirit and soul, the three of which appear in three colors preceding the red color; namely, the body, or the earth, appears in the black color of Saturn; the spirit, as it were, the water, appears in the white of the moon; and the soul, or the air, appears in the yellow color of the sun. . . . By this action, woman turns into man, and they become a unity.[33]

Duchamp's *Anemic Cinema,* a seven-minute silent film made in collaboration with Man Ray, shows the complex nature of Duchamp's developed symbolism. The original sequences displayed ten painted optical disks and nine rotating disks bearing punning sentences (apparently a functional parallel to the "alchemy of the word" in Arthur Rimbaud's Symbolist poetry) (pls. 9–10).[34] By reference to Duchamp's notes we learn that as an

ensemble these kinetic sequences serve as metaphors for the multiple viewpoints needed to achieve four-dimensional vision ("a picture of different dimensions mixed together"),[35] and that this represents the higher expression of a continuity that really has little to do with what Duchamp called the "cinematographic film that it resembles" to some degree.[36] On another level, the overall scheme of the film represents the fundamental occult dialectic explained by Ouspensky and others: materialization and dematerialization.

As is also apparent, there is a ubiquitous hermetic symbol that links the spiraling images of *Anemic Cinema.* The key to this symbol is provided by Jean Clair's observation, "the sentences bite their tails just as the circles roll up upon themselves."[37] The resulting motif is the alchemical *ouroboros* (pl. 11), which, as explained by Maier, is "the dragon that devours its own tail. . . . This dragon will have to be conquered, by the sword, hunger and imprisonment, till it devours itself and spits itself out, kills itself and generates itself again."[38] The ouroboros "is the symbol of the circular movement of the alchemical process,

consisting of a repeated dissolving, evaporating and distilling of matter, in which the finer parts ascend and the coarser ones remain on the bottom."[39] It is most likely that Duchamp's circle-disk imagery originated in an inexpensive modern publication (a five-franc paperback), Poisson's *Théories et symboles des alchimistes* (1891), where he could have read about "the serpent ouroboros of the gnostics," which could be represented by "a simple circle."[40]

The key work of Duchamp's career is the massive tableau with the puzzling narrative title, *The Bride Stripped Bare by Her Bachelors, Even,* known as *The Large Glass* (pl. 12). Construction of this work began in 1915, but it was abandoned, unfinished, in 1923; the first drawings, studies, and notes date at least to 1912. In 1934 the artist gathered and published much of this material in a facsimile edition, which he called *La Mariée mise à nu par ses célibataires, même* (*The Green Box*).

Duchamp's lifelong commitment to *The Large Glass* was revealed in 289 additional notes, some dated in the 1960s, found after his death in 1968.[41] As Duchamp observed, "To see the *Glass* . . . one should consult the book [the notes] and see them together."[42] On the basis of these texts, which provide a kind of narrative map of the puzzling iconography of *The Large Glass*, several strictly alchemical interpretations have already been published, the most comprehensive and detailed of which is by Calvesi.[43]

The formal title of Duchamp's *The Large Glass* was first proclaimed in a signed and dated pencil drawing (pl. 13) executed in July or August 1912 during the artist's four-month stay in Central Europe, which included a lengthy sojourn in Munich.[44] Other than its title, the 1912 sketch bears little physical resemblance to the work begun three years later. Nevertheless, according to Duchamp's neatly inscribed statement placed in the lower left corner of the drawing, this drawing represents the "First investigation for: *The Bride Stripped Bare by the Bachelors*." In this radically abstracted version the two bachelors aggressively hover around a central female figure; according to another inscription, she is a representation of a "*Mécanisme de la pudeur / Pudeur mécanique*" (modesty mechanism / mechanical modesty). The flanking males point sharp weapons, which look like bayonets, at the modesty mechanism, which turns out to be a "hermaphrodite" once its iconographic model is known. Anyone familiar with alchemical symbolism, as we must presume Duchamp was by then, would have recognized that the bachelors' wounding, cutting instruments are a symbol of the "fire of the alchemist." According to Poisson, "The symbols of fire are the chisel, the sword, the lance, the scythe, the hammer, in a word, all the instruments capable of wounding."[45]

12
MARCEL DUCHAMP
The Bride Stripped Bare by Her Bachelors, Even, or *The Large Glass,* 1915–23
Oil, varnish, lead foil, lead wire, and dust on two glass panels (cracked)
109 ¼ x 69 ¼ in.
(277.5 x 175.9 cm)
Philadelphia Museum of Art
Bequest of Katherine S. Dreier

.

13
MARCEL DUCHAMP
Study for "The Bride Stripped Bare by Her Bachelors," 1912
Pencil and wash on paper
9 ⅜ x 12 ⅝ in.
(23.8 x 32.1 cm)
Musée National d'Art Moderne, Centre Georges Pompidou, Paris

.

It appears that the specific graphic source of this image is an engraving that appeared in at least three alchemical publications, beginning with Basile Valentine's *Die zwölf Schlüssel,* published in Basel in 1599. The engraving reappeared in Daniel Stoltzius's emblem book *Chymisches Lustgärtlein* (1624), published in Frankfurt (pl. 14). The verses inscribed below this engraving unmistakably reveal its thematic relationship to Duchamp's drawing *The Bride Stripped Bare by the Bachelors.* According to Stoltzius's text, his print deals with "the garment which is taken off"; the central figure is a bisexual creature identified as "Precipitated Mercury" by the symbol placed over its head. This is also "the bride," here being stripped for "her groom," just as Stoltzius's poem "The Other Key of Basilius" states:

When the garment is taken off,
Then the Sun [gold] appears.
 Diana [the virgin goddess] no longer wears
 her garment,
 So that marriage becomes more desirable.
From two noble suitors, both fencers,
The Bride receives delicious water,
 So that she can bathe her own body
 For her Groom.[46]

In a larger sense, according to Rulandus, the "Stripping of Diana" stands for the *gaudium philosophorum* (joy of the philosophers):

The Joy of the Philosophers is when the Stone, or Matter of the Philosophers, has arrived at the perfect White Stage which is the Philosophical White Gold, or White Sulphur, or Endica of Morien, or the Swan. Then all the Philosophers say that this is the time of joy, because they behold the unveiling of Diana, and they have avoided all the rocks and dangers of the sea. . . . When the Matter has arrived at the White State, nothing but clumsiness can prevent the success of the Work, and its education towards the perfection of the Red State, since all the volatile portion is then fixed in such a manner that it can withstand the most active and violent fire.[47]

The same engraving was exactly reproduced in a later and more standard alchemical anthology, *Musaeum hermeticum, reformatum et amplicatum* (Frankfurt, 1677), where the accompanying commentary reads like a condensed version of Duchamp's scenario for *The Large Glass.* The hermetic text, attributed to Basile Valentine, explains the allegorical stripping of the bride:

A virgin brought forth to be married is gloriously decked out in a variety of splendid and costly garments in order to please her groom and his inspection internally lights the amorous fires in him. When the bride must indeed copulate in the carnal ritual, then her various garments are stripped away from her, leaving the bride only with that with which she was arrayed by the Creator at birth. . . . So, my friend, note principally here how the suitor and his bride must be both nude when they are conjoined. They must be stripped of their clothing and, thus unornamented, they must lie down together in the same state of nakedness in which they were born in order that their seed cannot be corrupted by mixing with any foreign matter.[48]

A Poisson-Duchamp textual linkage has already been demonstrated by Ulf Linde:

The fact remains, as I believe, that it is sufficient to allow that he [Duchamp] read but *one* book on alchemy, and this explains the alchemy in the *Large Glass.* This book is the *Théories et symboles des alchimistes* by Albert Poisson, which was published in Paris in 1891. There also exists the probability that Duchamp additionally read others, but what makes me think that he read *this* one book, at the very least, is a specific passage on page 23, where Poisson quotes Albertus Magnus as follows:

La génération des métaux est circulaire; on passe facilement de l'un à l'autre suivant un cercle. Les MÉTAUX VOISINS ont des propriétés semblables; c'est pour cela que l'argent se change facilement en or.

[The generation of metals is circular; one state passes to the next following a circular path. Neighboring metals have similar properties; this is the reason why silver is easily changed into gold.]

I have never seen this phrase ("métaux voisins") in any other book. It scarcely seems probable that Duchamp would have entitled an important part of the *Large Glass* — as he in fact did — without having read this passage. Of course, I am thinking of [that part of the *Large Glass* called] "*Glissière contenant un moulin à eau en MÉTAUX VOISINS.*" When one consults the invaluable index in Poisson's *Théories,* one encounters there any number of other passages of equal interest. . . . The concordance of synonyms in Poisson's text to numerous terms in the "Notes" (not all of which are even now explainable) is so striking that it would be absurd to doubt now that alchemy was anything but very familiar material to Duchamp.[49]

Linde was absolutely correct: Poisson's book provides a single and highly plausible contemporary bibliographical means by which to interpret generally the alchemical organization of *The Large Glass,* as revealed by its accompanying notes.[50] The largely anthropomorphic symbolic elements in *The Large Glass* notes have a clear-cut alchemical significance largely derived from or explained by Poisson's book, and it may be assumed that the philosophical, even cosmological import of *The Large Glass* itself also relates to Poisson.

14
Two Swordsmen Stripping Precipitated Mercury, from S. von Stoltzenberg, *Chymisches Lustgärtlein* (1624)

Duchamp stated that his bride is the "apotheosis of virginity," "a steam engine on a masonry substructure on a brick base."[51] These phrases call to mind a passage in Poisson's text, speaking of that "royal cement or glue, which is composed of four parts of pulverized bricks, one part of calcinated green or red vitriol . . . and one part of common salt. Of this one forms a paste, mixing into this water or urine, and then this paste is put into a crucible with the gold, then laying on top of this mixture alternative layers of gold and cement."[52] There are any number of other individual motifs (admittedly of secondary or ornamental importance) appearing in *The Large Glass* notes that have textual parallels in Poisson's *Théories et symboles des alchimistes*.

In his notes Duchamp repeatedly stated the basic compositional scheme of *The Large Glass:* there is a bride, dark, silver colored, above, and there are the bachelors, generally red, black, and brown, below. This follows the schematicized hermetic format of the endlessly repeated text of the *Tabula smaragdina*. The ubiquitous above-below hermetic dichotomy was also explicated in some detail by Poisson:

That which is below, without wings, is the fixed, or male; that which is above, this is the volatile, or,

to put it another way, the black and obscure female, she who is about to seize control [of the alchemical work] for several months. The first (below) is called sulfur, or, instead, heat and dryness, and the second (above) is called quicksilver [*l'Argent-Vif,* that is, literally, 'swift silver,' like '*Nus vites,*' or 'swift nudes'], or frigidity and humidity.[53]

In 1918, when he was only thirty-one years old, Duchamp completed the last oil painting of his career, inexplicably called *Tu m'*… (pl. 15). "The title of this canvas is generally interpreted as the vigorous expression of ennui that painting from now on inspired in Duchamp."[54] Nonetheless this canvas appears to represent another fusion of the fourth dimension and alchemy. It is clearly a summation of the artist's previous oeuvre; as he later explained, "It's a kind of inventory of all my preceding works, rather than a painting in itself."[55] The artist's method of creating this extremely unusual work was unprecedented. Duchamp carefully traced shadows cast by four of his ready-mades, which makes the painting a projection of his artistic persona. In the middle of the canvas he had a sign-painter render a pointing hand, signed, "A. Klang."[56]

The idea for this painting had been in the artist's mind well before 1918. From Duchamp's

notes we learn that the underlying idea was somehow related to both "fourth-dimensional perspective" and the "hypo-physical transformations of objects," a kind of parallel to alchemical transmutation:

After the Bride [*The Large Glass*] make a picture of cast shadows from objects; first on a plane and [then] on a surface of such curvature, [and] third on several transparent surfaces. Thus one can obtain a hypo-physical analysis of the successive transformations of objects (in their form-outline). To do this, first determine the sources of light (gas, electricity, acetylene, etc.) for the differentiation of the colors. Second, determine their number; third, their situation with respect to the receiving planes. Obviously, the object will not be just any object. It shall have to be constructed sculpturally in three dimensions. The execution of the picture [is to be] by means of luminous sources, and by drawing the shadows on these planes, simply following the *real* outlines projected. All this [is] to be completed, and specifically to relate to the subject.[57]

Tu m'… is triadic, having a left zone, a central zone, and a right zone. Objects appear to move in from either side, gathering together in the central, or intermediary, zone, where they seem ready to pass through an imaginary jagged rent in the canvas (held together by real safety pins), thence to fly away into a great void, the fourth dimension. This illu-

15
MARCEL DUCHAMP
Tu m'…, 1918
Oil on canvas with long
brush attached
27 ½ x 122 ¾ in.
(69.9 x 311.8 cm)
Yale University Art Gallery,
New Haven, Connecticut
Bequest of Katherine S.
Dreier
.

16
Helix Penetrating Space and Time, from Claude Bragdon, *A Primer of Higher Space* (1913)

sory rip is a visual paradox, representing two-dimensional illusionism, three-dimensional reality, and four-dimensional potentiality. This system of visual paradox is stated again by a real golden bolt screwed into the last of the colored squares in the left-hand zone, as though to keep these pinned onto the canvas. Below this sequence of colored squares, steadily advancing from the upper left edge of the canvas and toward the center, are the cast shadows of *Bicycle Wheel*, a corkscrew (not known to have existed as a ready-made), and *3 Standard Stoppages*, 1913–14. Cast upon the right-hand zone is the shadow of the ready-made *Hatrack*, 1917. To the right of center, a real bottlebrush projecting from the trompe l'oeil rip creates a fourth shadow, this time a very real one, making a wry comment on levels of reality and illusion. The right-hand zone has a perspective system wholly different from that in the left-hand zone, which is fixed upon the upper edge of the canvas. The vanishing point for the right-hand zone is located exactly on the bottom edge of the composition, in line with the tip of the extended index finger painted by Mr. Klang, which points to a solid white vertical plane seen in oblique perspective. From each of the four corners of the white plane extend, in horizontal rows, four pairs of lines, either black or red. From several points on the red and black lines, multicolored "bands" recede into space and uniformly converge at the vanishing point at the bottom center of the canvas. The color changes on the twenty-four bands occur according to a system of lateral, metric measurements; these bands also function as indicators of the axis points for the linear circles that encase each of the bands, and the appearance of each circle corresponds to a banded color change.

Tu m'... was commissioned by Katherine Dreier, a committed and outspoken adherent of theosophical beliefs.[58] As this painting was designed to fit a space over a bookcase in Dreier's apartment, it has been suggested that it might have been composed to complement the texts, possibly theosophical, gathered below it.[59] Dreier was an admirer of the occult writings of Claude Bragdon, who published his translation of Ouspensky's *Tertium Organum* in 1920.[60] Bragdon's classic study on the fourth dimension, *A Primer of Higher Space* (1913), offers a plausible explanation for the corkscrew and protruding bottlebrush in Duchamp's canvas,[61] as well as for the fourth-dimensional significance of Duchamp's *Roto-Reliefs* and *Anemic Cinema*. Bragdon explained his picture of a spiral passing through a plane (pl. 16):

If we pass a helix (a spiral in three dimensions) through a film (a 2-space), the intersection will give a point moving in a circle . . . represented in the film by the consecutive positions of the point of intersection. The permanent existence of the spiral will be experienced as *a time series*. . . . We consider the intersections of these filaments with the film as it passes to be the atoms of a filmar [or two-dimensional] universe. . . . Now imagine a *four*-dimensional spiral passing through a *three*-dimensional space, the point of intersection, instead of moving in a circle, will trace out a sphere. . . . Its presentiment in 3-space will consist of bodies built up of spheres of various magnitudes moving harmoniously among one another, and requiring *Time* for their development. May not the Atom, the Molecule, the Cell, the Earth itself, be so many paths and patterns of an unchanging Unity?[62]

Bragdon's discussion of the transmutations of "the atoms of a filmar universe" complements the alchemical interpretation of *Tu m'*.... Both the left and right zones of the painting display a deliberated scheme of chromatic progressions. This scheme is particularly apparent in the left-hand sequence, where the order is exactly that of the color progressions in the alchemical opus. According to Poisson, the proper order, from the beginning to the end of the hermetic operation, is "1. black. 2. white. 3. purple. 4. red or yellow."[63] Yellow is indeed the last color, properly "fixed" by Duchamp's golden bolt. Between the four major color groups are "the secondary, or intermediary colors, serving as a transition," including, "gray, green, blue, yellow, orange, red," and so forth; "these colors appear one after the other in an unvarying order; their regular succession indicates that the

alchemical work is going well."[64] The pointing hand painted by "A. Klang" calls attention to the large white plane, which leads to the higher realms of the fourth dimension. Using Poisson's reckoning, this large white plane stands for "the white stage," which clearly announces "the intermediary stage" of the alchemical Great Work.[65]

Tu m'... represents a synthesis of the fourth dimension, a new pseudoscientific concept, and alchemy, a very ancient one. Indeed, the parallel underpinnings of the fourth dimension and alchemy were underscored in a published work that Duchamp acknowledged to have read, Gaston de Pawlowski's *Voyage au pays de la quatrième dimension*. As Pawlowski explained:

I do not know how to explain these [fourth-dimensional] displacements by only borrowing from current language, which is only constructed upon three-dimensional principles. In spite of everything, I have been forced, therefore, to employ commonplace imagery, to have recourse to certain ancient expressions, which one would have believed exclusive to alchemy, in order to describe such an obvious fact: the unity of the point of view which characterizes the fourth dimension. . . . Whereas in three-dimensional displacement the atoms constituting a body are pushed aside and replaced by other atoms, thus forming another body, [to the contrary,] displacement in the land of the fourth dimension is enacted by what one used to call a transmutation [and] a displacement is made through an exchange of qualities between neighboring atoms. . . . The same commonplace comparison allows one to perceive that this [fourth-dimensional] phenomenon is equally a displacement within time. . . . Therefore, just as was the case for a displacement in space, displacement in time is carried out by means of a transmutation of the atoms of time, that is to say of moments of that atom obeying the action of that philosopher's stone, or, better yet, of this monad which is our spirit.[66]

Given the weight of the largely circumstantial evidence examined here in relation to a wide variety of works by Duchamp,[67] we feel justified in calling him an anomalous alchemist of the avant-garde. Still, we must not ignore Duchamp's rebuttal to Lebel in 1959: "If I have practiced alchemy, it was in the only way it can be done now, that is to say, without knowing it [*sans le savoir*]."[68] Calvesi rightly questions whether this remark actually constitutes an outright denial. As he puts it, "sans le savoir" could just as well imply "without the (full) Knowledge," that is, "*le grand Savoir de l'Alchimie*" (the great knowledge of alchemy). Thus Calvesi takes Duchamp's linguistic loophole to mean, "If I have indeed done alchemy, I have only done it in an unworthy manner, that is, as a dilettante; besides, it is just not possible to do it in any other manner in our times because we have become so removed from that *Savoir*."[69] Perhaps Duchamp was finally being candid about the whole covert business when, a few years later, he had a brief encounter with the American conceptual artist Robert Smithson, who later recalled: "I met Duchamp once, in 1963, at the Cordier Ekstrom Gallery [in New York]. I said just one thing to him; I said, 'I see you are into alchemy.' And he said, 'Yes!'"[70]

1. See John Tancock, "The Influence of Marcel Duchamp," in *Marcel Duchamp*, exh. cat., ed. Anne d'Harnoncourt and Kynaston McShine (Philadelphia Museum of Art and Museum of Modern Art, New York, 1973), 160–78. Duchamp's influence upon American avant-garde artists largely dates from the publication in English translation of the first biography-catalogue: Robert Lebel, *Marcel Duchamp*, trans. George Heard Hamilton (New York: Grove Press, 1959). The nature of Duchamp's sources was initially brought to light by Lebel, who first put forth a hypothesis of esotericism.

2. An especially cabalistic approach is championed by Jack Burnham, "La Signification du Grand Verre," *VH 101* 6 (1972): 63–110; and idem, *Great Western Salt Works: Essays on the Meaning of Post-Formalist Art* (New York: Braziller, 1974), 71ff.

3. For these texts, see Marcel Duchamp, *Notes and Projects for the Large Glass*, ed. Arturo Schwarz and trans. George Heard Hamilton, Cleve Gray, and Arturo Schwarz (New York: Abrams, 1969); *Marcel Duchamp: Notes*, ed. and trans. Paul Matisse (Paris: Musée National d'Art Moderne, 1980; Boston: G. K. Hall, 1983), which contains nearly three hundred more notes discovered after 1969; *Duchamp du signe: Écrits*, ed. Michel Sanouillet (Paris: Flammarion, 1975); and *Entretiens avec Marcel Duchamp: Ingénieur du temps perdu*, ed. Pierre Cabanne (Paris: Belfond, 1977).

4. Alice Goldfarb Marquis, *Marcel Duchamp: Éros, c'est la vie: A Biography* (Troy, N.Y.: Winston, 1981), 32.

5. For example, see Arturo Schwarz, "The Alchemist Stripped Bare in the Bachelor, Even," in d'Harnoncourt and McShine, *Duchamp*, 81–98; idem, "Duchamp et l'alchimie," in *Abécédaire: Approches critiques*, vol. 3 of *Marcel Duchamp* (Paris: Musée National d'Art Moderne, 1977), 10–21; idem, various essays in *L'immaginazione alchimica* (Milan: La Salamandra, 1980); John Golding, *Marcel Duchamp: The Bride Stripped Bare by Her Bachelors, Even* (Harmondsworth: Penguin, 1972), especially 85–92; Ulf Linde, "L'Ésotérique," in *Abécédaire*, 60–85 (Linde's highly

convincing alchemical analyses were first reported by K. G. Pontus Hultén, *The Machine as Seen at the End of the Mechanical Age*, exh. cat. [New York: Museum of Modern Art, 1968], 79–80); and Maurizio Calvesi, *Duchamp invisibile: La costruzione del simbolo* (Rome: Officina, 1975).

6. Pierre Cabanne, *The Brothers Duchamp* (Boston: New York Graphic Society, 1976), 101.

7. Alexina (Teeny) Duchamp, the artist's wife, to author, 16 August 1985: "he never kept any letters or papers, and once he was through with a book he generally gave it to someone else." Lacking documentation of a Duchamp "library," one instead builds plausible hypotheses based upon numerous textual parallels.

8. Quoted in *Catalogue raisonné*, ed. Jean Clair, vol. 2 of *Marcel Duchamp* (Paris: Musée National d'Art Moderne, 1977), 33.

9. Ibid.

10. Duchamp to Arensberg, 22 July 1951, in *Catalogue raisonné*, 34.

11. Annie Besant and C. W. Leadbeater, *Thought-Forms* (1905; Wheaton, Ill.: Theosophical Publishing House, 1975), 7–12.

12. This theosophical interpretation of *Dr. Dumouchel* has also been championed by John Dee, "Ce façonnement symétrique," in *Marcel Duchamp: Tradition de la rupture, ou rupture de la tradition?*, ed. Jean Clair (Paris: Union général d'éditions, 1979), 351–402: "the red and orange auras denote nonegotistical affection and sharp intellect, respectively; the green denotes sympathy" (p. 396).

13. For the alchemical iconography of Duchamp's *Spring*, see Schwarz, "The Alchemist Stripped Bare."

14. Although innumerable transcriptions of the *Tabula smaragdina* can be cited, the reader is referred to a French transcription of the Symbolist period: François Jollivet-Castellot, "La table d'émeraude: Paroles des Arcanes d'Hermès," in *Comment on devient alchimiste: Traité d'hermétisme et d'art spagyrique* (Paris: Chamuel, 1897), 1–2.

15. Jacques van Lennep, *Art & alchimie: Étude de l'iconographie hermétique et de ses influences* (Paris and Brussels: Meddens, 1971), 123.

16. *A Lexikon of Alchemy, by Martin Ruland, the Elder*, ed. A. E. Waite (1893; New York: Samuel Weiser, 1984), 394. Rulandus's definitions set a definitive standard for interpreters of alchemical symbolism; his explanations were often repeated verbatim by later authors. One such borrower was Antoine-Joseph Pernety, *Dictionnaire mytho-hermétique* (1758); this compilation was likely known to Duchamp. Accordingly Calvesi often referred to Pernety for his interpretations of a variety of Duchamp's motifs and terms, particularly those encountered in the notes to *The Large Glass*.

17. *Entretiens*, 126–27.

18. In Arturo Schwarz, *The Complete Works of Marcel Duchamp* (New York: Abrams, 1969), 442.

19. Besides Linda Dalrymple Henderson's essay in this volume, see her *Fourth Dimension and Non-Euclidean Geometry in Modern Art* (Princeton: Princeton University Press, 1983). See also Dee, "Ce façonnement symétrique"; Tom Gibbons, "Cubism and 'The Fourth Dimension' in the Context of the Late Nineteenth-Century and Early Twentieth-Century Revival of Occult Idealism," *Journal of the Warburg and Courtauld Institutes* 44 (1981): 130–47; Craig E. Adcock, *Marcel Duchamp's Notes from the Large Glass: An n-Dimensional Analysis* (Ann Arbor: UMI Research Press, 1983); and John F. Moffitt, "Hermeticism and the Art of the Fourth Dimension: A Review Essay," *Cauda Pavonis: The Hermetic Text Society Newsletter* 3, no. 2 (1984): 4–6.

20. P. D. Ouspensky, *Tertium Organum: A Key to the Enigmas of the World* (1911), trans. and ed. Claude Bragdon (1920; New York: Vintage, 1970), 57–58, in which the reference was to a bicycle wheel "with the spokes painted different colors."

21. P. D. Ouspensky, *A New Model of the Universe* (1931), 2d ed. (1934; New York: Vintage, 1971), 96–97.

22. Adcock, *Marcel Duchamp's Notes*, 102–4, calls the *Bicycle Wheel* "an analogue for Jouffret's diagrams illustrating his discussion of 'Riemannian lines.'"

23. For contemporary occult interpretations of the fourth dimension, see Gibbons, "Cubism"; and Moffitt, "Hermeticism."

24. André de Noircarme, *Le Quatrième Dimension* (Paris: Éditions Théosophiques, 1912), 33. For Noircarme, see Henderson, *The Fourth Dimension*, 46.

25. Noircarme, *Le Quatrième Dimension*, 53.

26. Ibid., 77.

27. *Lexikon of Alchemy*, 351.

28. Ouspensky, *New Model*, 97–99.

29. Albert Poisson, *Théories et symboles des alchimistes: Le Grand-Oeuvre, suivi d'un essai sur la bibliographie alchimique du XIXe siècle* (Paris: Chacornac, 1891), 18. Poisson also illustrated and explicated wheel motifs; see especially pl. 3.

30. Stanislas Klossowsky de Rola, *Alchemy: The Secret Art* (New York: Bounty, 1973); this drawing is illustrated as pl. 19 and explained in a commentary.

31. *Lexicon of Alchemy*, 347, 431, 460.

32. Calvesi, *Duchamp invisibile*, 263.

33. Michael Maier, *Atalanta fugiens, hoc est: Emblemata nova de secretis naturae chymica* (Oppenheim, 1617), emblema XXI.

34. *Catalogue raisonné*, 118–19, cites letters from Duchamp denying authorship of the "realist part" of the film, an "intercalation" by an unknown hand; originally the film was wholly abstract. Duchamp cited Arthur Rimbaud and Stéphane Mallarmé as "literary exemplars" (*Marcel Duchamp: Notes*, no. 185).

35. *Marcel Duchamp: Notes*, no. 200.

36. *Duchamp du signe: Écrits*, 107.

37. *Catalogue raisonné*, 119.

38. Maier, *Atalanta fugiens*, emblema XIV.

39. H. M. E. de Jongh, *Michael Maier's "Atalanta Fugiens": Sources of an Alchemical Book of Emblems* (Leiden: E. J. Brill 1969), 132–33.

40. Poisson, *Théories et symboles*, 52.

41. *Marcel Duchamp: Notes.*

42. Quoted in *Entretiens*, 71.

43. Calvesi, *Duchamp invisible*, 83–291.

44. *Catalogue raisonné*, cat. no. 71, pp. 54–55. See also John F. Moffitt, "An Emblematic Alchemical Source for Duchamp's *Large Glass* (1915–1923): *La Mariée mise à nu par les célibataires* (1912)," *Cauda Pavonis: The Hermetic Text Society Newsletter* 2, no. 2 (1983): 1–4.

45. Poisson, *Théories et symboles*, 110.

46. Daniel Stoltzius, *Chymisches Lustgärtlein* (Frankfurt: Lucas Jennis, 1624), emblem II.

47. *Lexikon of Alchemy*, 379.

48. *Musaeum hermeticum* (1677; facsimile, Graz: Akademische Druckerei Verlagsanstalt, 1970), 397–98.

49. Linde, "L'Ésotérique," 68; for the "Glissière," see *Catalogue raisonné*, cat. no. 101, pp. 82–83.

50. Other examples of Poisson-derived imagery are the drawing *Le Roi et la Reine traversés par des Nus vites*, 1912 (*Catalogue raisonné*, cat. no. 68), along with the King-Queen series of April–May 1912 (immediately preceding the Munich-period works), which includes the drawing *Le Roi et la Reine traversés par des Nus en vitesse* (cat. no. 69) and painting *Le Roi et la Reine entourés de Nus vites* (cat. no. 70). The evidently Poisson-derived titles of the three works were inscribed on them by the artist; in addition to Poisson's influence, an alchemical illustration may account for the basic compositional scheme common to all three (see "Solidonius Figura VI," quoted in Linde, "L'Éesotérique," 60–62).

51. Duchamp, *Notes and Projects*, no. I, p. 21.

52. Poisson, *Théories et symboles*, 85.

53. Ibid., 71.

54. *Catalogue raisonné*, cat. no. 114, pp. 92–93; see also Robert L. Herbert et al., *The Société Anonyme and the Dreier Bequest at Yale University: A Catalogue Raisonné* (New Haven: Yale University Press, 1984), 230–33.

55. Quoted in Schwarz, *Complete Works*, 471.

56. Duchamp explained his working procedures for *Tu m'*… in *Entretiens*, 102–3.

57. Duchamp, *Notes and Projects*, no. 85, pp. 136–37.

58. For Dreier and Theosophy and related occult beliefs, see Ruth L. Bohan, *The Société Anonyme's Brooklyn Exhibition: Katherine Dreier and Modernism in America* (Ann Arbor: UMI Research Press, 1982), 15–23ff.

59. Henderson, *The Fourth Dimension*, 199.

60. For Dreier and Bragdon, see ibid., 197–99.

61. Bohan, *Société Anonyme's Brooklyn Exhibition*, makes no mention of points of contact between Duchamp's compositional devices and Dreier's mystical beliefs other than citing a letter of April 1917 in which Dreier commended Duchamp for his "spiritual sensitiveness" (p. 12).

62. Claude Bragdon, *A Primer of Higher Space (The Fourth Dimension), to Which Is Added "Man the Square: A Higher Space Parable"* (Rochester: Manas Press, 1913), commentary to pl. 16; also perhaps relevant to Duchamp's composition, particularly to the encircled parallel bands in the right-hand third of *Tu m'*…, are Bragdon's illustrations *Magic Tesseracts*, pls. 20–21. Duchamp might also have been aware of Charles Howard Hinton's important publications on the fourth dimension (see Henderson, *The Fourth Dimension*), but he was probably encouraged to direct his fourth-dimensional thinking along the lines of Dreier's preferred author, Bragdon, for such matters.

63. Poisson, *Théories et symboles*, 128; for greater detail on alchemical color symbolism, see also pp. 128–44.

64. Ibid., 128.

65. Ibid.

66. Gaston de Pawlowski, *Voyage au pays de la quatrième dimension* (Paris: La Boétie, 1977), 79–81, first published in book form in 1912, with some portions originally appearing serially in 1908 in the magazine *Comoedia*. As was kindly pointed out to me by Linda Henderson, the striking mention of the "*transmutation des atomes*" did not appear in 1908 in *Comoedia* nor in the context of the serializations published later in *Comoedia* as part of "Le Léviathan" (from 24 December 1909 to 31 October 1910, when in fact the first overt, although still sparse, mentions of the "*quatrième dimension*" [fourth dimension] do appear). The phrase "transmutation of the atoms" only appeared in print on 20 May 1912 in the final serialization of Pawlowski's *Voyage* (see Henderson, *The Fourth Dimension*, 107). Whatever the internal chronolgy of these terms, unquestionably they were all in print by the time Duchamp arrived at the conception for his *Tu m'*….

67. Some major works, most notably the *Nude Descending the Staircase*, 1912, and the final opus *Étant donnés: 1. La Chute d'eau 2. Le Gaz d'éclairage*, 1946–66, are not discussed in light of the esoteric hypothesis in this essay. These and other works and Duchampian gestures will receive full attention in the author's monograph in progress, dealing with Duchamp's entire career.

68. Lebel, *Marcel Duchamp*, 73.

69. Calvesi, *Duchamp invisible*, 203.

70. Quoted in Moira Roth, "Robert Smithson on Duchamp: An Interview," *Artforum* 12, no. 2 (1973): 47.

OVERLEAF

RICHARD POUSETTE-DART
Fugue No. 4, 1947
Oil on canvas
92 x 62 in. (233.7 x 157.5 cm)
Richard Pousette-Dart

RITUAL AND MYTH:
NATIVE AMERICAN CULTURE AND ABSTRACT EXPRESSIONISM

W. JACKSON RUSHING

A number of incipient Abstract Expressionists of the New York School paid studious attention to Native American art in response to two interrelated trends in American intellectual life that gained strength throughout the 1930s and found full expression in the early 1940s. The confluence of these trends with the spiritual crisis created by the failure of modernism to generate social and political utopia, and heightened by the rise of fascism, instilled in the "myth-makers" of the American avant-garde a profound desire to transcend the particulars of history and search out universal values.[1] The first trend that fueled artistic interest in Indian art was the belief that the vitality and spirituality of Indian culture, as embodied in its art, could make a positive contribution to the America of the future.[2] The second trend, more central to the present discussion, was the belief that primitive art was a reflection of a universal stage of primordial consciousness that still existed in the unconscious mind. The New York artists' awareness of Carl Gustav Jung's concept of a collective unconscious that includes early man's symbolic mode of thinking prompted their fascination with the mythic and ceremonial nature of primitive art. Because it had continued unbroken from ancient times up to the present, Indian art was perceived as being different from other prehistoric or primitive arts. A cultural continuum bridging the gap between primordial and modern man, Native American art was seen as having special relevance for modern art and life.

Although there was never a scarcity of interest in Native American art in twentieth-century America, the early 1930s saw increased production of books, articles, and exhibitions about Indians and their art. Beginning with the *Exposition of Indian Tribal Arts* at the Grand Central Galleries in New York in 1931, the awareness of Native American culture as a spiritual and aesthetic resource grew exponentially through the 1930s. By 1941 the idea had such validity in American artistic and intellectual life that when the Museum of Modern Art staged the now-legendary exhibition *Indian Art of the United States,* it was making concrete a set of values that were already within its audience's expectations. This popular exhibition — along with the fine permanent collections at the Museum of the American Indian, Heye Foundation; the American Museum of Natural History; and the Brooklyn Museum — provided New York painters such as Jackson Pollock, Richard Pousette-Dart, and Adolph Gottlieb with sources of imagery and ethnographic information that shaped their perceptions of the

1

House Screen of Chief Shakes, Tlingit House Partition
Wrangell Village, Alaska,
c. 1840
Cedar, native paint,
human hair
179 ¹⁵/₁₆ x 107 ⅞ in.
(457 x 274 cm)
Courtesy of The Denver Art
Museum, Colorado
Collected at Wrangell in 1939
by Wolfgang Paalen

·

vitality and spiritual potential in Native American art.

Within the early New York School, painters who also functioned as critics, theorists, and curators contributed in these roles to the integration of Indian art into modernist painting. As critics and provocateurs, John D. Graham, Wolfgang Paalen, and Barnett Newman were important for stressing the spiritual quality inherent in Indian art. Essential to their theories and criticism of Native American and other primitive arts was an understanding of myth, totem, and ritual that relates to Jung's ideas and reveals these artists as the advocates of a new, transformed consciousness for modern man.

During the late 1930s in America, Graham was perhaps the single most credible purveyor of the idea that atavistic myth and primitivism are an avenue to the unconscious mind and primordial past. His *System and Dialectics of Art* (1937) is replete with ideas and language similar to Jungian psychology. The book also reflects the tenor of the times in its revelation of a connoisseur's aesthetic and psychological, not purely ethnological, appreciation of primitive art. As Graham explained, "The purpose of art in *particular* is to reestablish a lost contact with the unconscious (actively by producing works of art), with the primordial

racial past and to keep and develop this contact in order to bring to the conscious mind the throbbing events of the unconscious mind."[3] The reason for bringing events of the unconscious into the conscious mind is related to Jung's belief that the emergence of the basic elements of the unconscious, the primitive stages of civilization, into waking consciousness could help modern man meet his need for spiritual transformation.[4]

In "Primitive Art and Picasso" (1937) Graham continued to emphasize the dichotomies between conscious and unconscious mind and between modern and primitive culture. He explicitly stated the therapeutic importance of probing the unconscious: "The Eskimos and the North American Indian masks with features shifted around or multiplied, and the Tlingit, Kwakiutl, and Haida carvings in ivory and wood of human beings and animals, these also satisfied their particular totemism and exteriorized their prohibitions (taboos) in order to understand them better and consequently to deal with them more successfully."[5] After examining the relationship of primitive art to evolution, psychology, and plastic form, Graham concluded: "The art of the primitive races has a highly evocative quality which allows it to bring to our conscious-

ness the clarities of the unconscious mind, stored with all the individual and collective wisdom of past generations and forms. . . . An evocative art is the means and result of getting in touch with the powers of our unconscious."[6]

This passage emphasizes that primitive art, such as Eskimo masks and Northwest Coast carvings, has a powerful and purposive role to play in a spiritual transformation of modern experience through the merging of the conscious and unconscious mind. Such words may have encouraged Pollock, Gottlieb, and possibly Pousette-Dart, all of whom knew Graham well, to make painterly reference to the unconscious, as well as validating their appreciation of Indian art.

The interest in Northwest Coast art, however, was spread by the Austrian-born Surrealist Wolfgang Paalen more than Graham or anyone else, including Max Ernst.[7] Paalen had studied with Hans Hofmann in Germany and had been associated with André Breton's circle in Paris. When he left Paris in May 1939, Paalen, like his fellow Surrealist Kurt Seligmann, went directly to the Pacific Northwest Coast, where he collected a number of masterpieces of Indian art,[8] including the *House Screen of Chief Shakes,* circa 1840 (pl. 1). Paalen was more than a mere collector of

2

Cover of the Amerindian
Number, *Dyn,* nos. 4–5
(December 1943),
with drawing of a killer whale
by Kwakiutl artist James
Speck
.

primitive art; even anthropologists were impressed by his writings on the totemic underpinnings of Northwest Coast art.[9]

Although he resided in Mexico, Paalen was frequently in New York in the early and mid-1940s. Beginning in the spring of 1942 Paalen published in Mexico the art journal *DYN,* which was distributed primarily in New York at the Gotham Book Mart, a regular meeting place for artists. In "Le Paysage totémique," published in three installments that year in *DYN,* he effectively conveyed the complexity and the mythological basis of Northwest Coast art. In December 1943 Paalen published a special double issue of *DYN,* the Amerindian Number (pl. 2). Besides Northwest Coast art, the Amerindian Number contained articles, illustrations, and book reviews dealing with a variety of Native American topics. In an editorial preface, sounding very much like Graham, Paalen announced, "Art can reunite us with our prehistoric past and thus only certain carved and painted images enable us to grasp the memories of unfathomable ages."[10] Occidental art had experienced an osmosis with Asia, Africa, and Oceania, and "now it has become possible to understand why a universal osmosis is necessary, why this is the moment to integrate the enormous trea-

sure of Amerindian forms into the consciousness of modern art. . . . To a science already universal but by definition incapable of doing justice to our emotional needs, there must be added as its complement, a universal art: these two will help in the shaping of the new, the indispensable world-consciousness."[11]

In "Totem Art," Paalen's essay in the issue, he wrote of the magnificent power of totem poles, counting them "among the greatest sculptural achievements of all times,"[12] and observed, as did critics of *Indian Art of the United States,* "It is only in certain modern sculptures that one can find analogies to their surprising spatial conception."[13]

Paalen's analysis of Northwest Coast sculpture reflected an interest in Jung: "Their great art . . . was of an entirely collective purpose: an art for consummation and not individual possession."[14] As early as 1941, in *Form and Sense,* Paalen had shown an awareness of Jungian theory.[15] As with Graham's Jungian conception of primitive art, Paalen understood

that it was necessary to consider totemic systems . . . as corresponding to a certain developmental stage of archaic mentality, the vestiges of which can

be found throughout mankind. For we can ascertain successive stages of consciousness: in order to pass from emotion to abstraction, man is obliged, in the maturation of each individual to pass through the ancestral stratifications of thought, analogously to the evolutionary stages of the species that must be traversed in the maternal womb. And that is why we can find in everyone's childhood an attitude toward the world that is similar to that of the totemic mind.[16]

The third artist to play a major role in drawing attention to Indian art, Newman, met Paalen in 1940 when the latter exhibited at Julien Levy's gallery along with Gottlieb. Newman shared Paalen's interest in the art of the Northwest Coast.[17] He was aware of Paalen's and Ernst's interest in its totemic aspects.[18] Newman shared Paalen's conviction that primitive art gave modern man a deeper sense of the primordial roots of the unconscious mind and that understanding and even adapting primitive art values would create a more universal art in the present. Therefore, the internal bisection of form in Newman's own work, such as *Onement I,* 1948, his commitment to the validity of abstraction, and his metaphysical ambitions as a painter may be ascribed, at least in part, to the influence of Indian, and in particular, Northwest Coast art. But perhaps Newman's

conviction that the ritual Dionysian purpose, the reference to myth, and the abstract form of Northwest Coast art could significantly shape the direction of avant-garde art in New York is more strongly revealed in his activities as a curator and critic of primitive and neoprimitive art from 1944 to 1947.

In 1944, with the assistance of the American Museum of Natural History, Newman organized the exhibition *Pre-Columbian Stone Sculpture* for the Wakefield Gallery in New York.[19] Lenders to the exhibition included Graham and publisher Frank Crowninshield, whose collection of primitive art Graham helped assemble. In his brief introductory comments to the catalogue Newman insisted that pre-Columbian art be judged and appreciated as art "rather than works of history or ethnology [so] that we can grasp their inner significance."[20] For Newman the result of a new inter-American consciousness, based on an aesthetic appreciation of pre-Columbian art, would be the comprehension of "the spiritual aspirations of human beings" and the building of permanent bonds.[21] Experiencing this art is a way, Newman wrote, of "transcending time and place to participate in the spiritual life of a forgotten people."[22] But Newman believed that ancient American art is more than an avenue to the past, stating that

it has a "reciprocal power" that "illuminates the work of our time" and "gives meaning to the strivings of our artists."[23]

In 1946 Newman organized the exhibition *Northwest Coast Indian Painting* for the Betty Parsons Gallery. He was once again assisted by the American Museum of Natural History, and Graham once again lent objects, as did Ernst. One of Pollock's closest New York friends, Fritz Bultman, recalled that this was a very popular exhibition, which Pollock attended.[24] Writing in the catalogue, Newman began with a polemic based on Wilhelm Worringer's theory of primitive abstraction[25] and went on to describe the ritualistic paintings in the exhibition as "a valid tradition that is one of the richest of human expressions."[26] In explaining how these Indians "depicted their mythological gods and totemic monsters in abstract symbols, using organic shapes,"[27] Newman established the grounds for defending abstract art: "There is answer in these [Northwest Coast] works to all those who assume that modern abstract art is the esoteric exercise of a snobbish elite, for among these simple peoples, abstract art was the normal, well-understood, dominant tradition."[28] And, as in his comments on pre-

Columbian art, Newman stressed that an awareness of Northwest Coast art illuminates "the works of those of our modern American abstract artists who, working with the pure plastic language we call abstract, are infusing it with intellectual and emotional content, and who . . . are creating a living myth for us in our own time."[29]

In January 1947 *The Ideographic Picture,* another Newman-organized exhibition, opened at the Betty Parsons Gallery. It featured some of the artists, including Mark Rothko, Theodoros Stamos, Clyfford Still, and Newman himself, who were using a "pure plastic language" to create the "living myth of our own time." Newman's catalogue introduction evoked the image of a Kwakiutl painter whose abstract shapes were "directed by ritualistic will toward a metaphysical understanding."[30] The paintings exhibited were the modern American counterpart to the "primitive impulse."[31] In explaining just what an ideographic picture might be, Newman quoted from the *Century Dictionary:* "Ideographic — a character, symbol or figure which suggests the idea of an object without expressing its name."

Although New York School artists Pousette-Dart, Gottlieb, and Pollock did not exhibit in *The Ideographic Picture,* they were indeed inventive and powerful manipulators of signs from the Native American past for the purpose of creating the myth of their own time. Despite dissimilar backgrounds and temperaments, these three painters produced a body of work in the 1940s with many more common elements than they would ever have wanted to admit.[32] No small measure of the commonality in these myth-oriented, neoprimitive canvases may be attributed to the artists' shared interest in and experience with Native American art. Pousette-Dart, Gottlieb, and Pollock all created works whose respective titles, imagery, and coarse surfaces evoke the dark, totemic otherworld of subterranean ritual: *Night World,* 1948 (pl. 3); *Night Forms,* circa 1949–50; and *Night Sounds,* circa 1944 (pl. 24). Pousette-Dart recently alluded to such an evocation: "Many times I felt as if I were painting in a cave — perhaps we all felt that way, painting then in New York."[33] Likewise, all three artists made what are best described as telluric pictures — elemental signs, zoomorphs, and petroglyphs in stratified layers on seemingly primordial surfaces — the visual remembrances of archaic experience in the Americas.

Although this essay ultimately focuses more extensively and intensively on Pollock's transformations of Indian art, this interest cannot be ignored in Pousette-Dart's and Gottlieb's paintings. Pousette-Dart's awareness of primitive arts, like Pollock's, dates from his youth. His father, noted painter, lecturer, and art critic Nathaniel Pousette-Dart, owned primitive Indian objects and books on the subject and supported his son's interest in it. (Indeed, Pousette-Dart still has in his home two pieces of Northwest Coast sculpture: one had previously hung in his father's studio and the other he had given to his father.[34]) Later Pousette-Dart came to know more about Native American and other primitive arts from his frequent trips to the American Museum of Natural History as well as from books and various exhibitions.[35] Like Pollock and Gottlieb, Pousette-Dart was acquainted with Graham, whose personally inscribed *System and Dialectics of Art* he owned and from whom he purchased primitive objects.

Pousette-Dart's notebooks from the late 1930s and early 1940s show that he, too, noted the distinction between the conscious and unconscious mind: "Art is the result manifestation of the conscious mind reacting upon a submind spirit — the crystallization resulting when they meet — unknown experience reacting upon known experience creating a superhuman mystic body."[36] He recently reaffirmed this belief, saying, "Every whole thing has to do with the conscious and the unconscious — the balance, the razor's edge between the two. My work is the spirituality of that edge."[37]

A reappraisal of Pousette-Dart in the context of Native American traditions is timely, for he believes that his early work "had an inner vibration comparable to American Indian art . . . something that has never been perceived. I felt close to the spirit of Indian art. My work came from some spirit or force in America, not Europe."[38] *Desert,* 1940 (pl. 4), with its masks, birdlike forms, and tight interplay on the surface of organic and geometric forms locked together with a dark linear grid, is highly reminiscent of the carved and painted Northwest Coast designs he saw at the American Museum of Natural History. More than forty years later he still felt moved by the Northwest Coast images he saw on "painted boards, tied together and painted with heavy black lines."[39] His painting's title, *Desert,* and its rough, earthy surface also suggest the Southwest. Thus it is instructive to note that Pousette-Dart felt sympathetic to the idea of

4
RICHARD POUSETTE-DART
Desert, 1940
Oil on canvas
43 x 72 in. (109.2 x 182.9 cm)
The Museum of Modern Art,
New York
Given anonymously
·

Pousette-Dart's *Palimpsest,* 1944 (pl. 5), still looks as radically new and as much a modernist paradigm as it must have in 1944, but it is nevertheless a reflection of an ancient American tradition of painting and incising abstract images on the earth itself. The compelling images of Native American rock art are composite creations consisting of countless layers built up on the surface, sometimes over millennia. So too Pousette-Dart, as the word *palimpsest* suggests, obscured or partially erased earlier versions of the surface by "rewriting," inscribing new visual information on top of old. The title appealed to him because he "liked the idea of engraving over and over," an idea that simulated his own "process of evolving."[41] Rock art, especially that found in caves and rock shelters, has often been linked to shamanic activity. This recalls Pousette-Dart's memory of "painting in a cave," and such paintings as *Night World* do

imply the dark realm of myth, memory, and dream that the shaman seeks to explore in his state of transformation. As Pousette-Dart himself described the affinity between that idea and the function of painting, "an artist is a transformer."[42]

Gottlieb also explored the realms of the other, both ancient and psychological, in his paintings. And like his contemporaries, he had intellectual and aesthetic justification for his belief in the value of Native American art. By his own recollection, for example, Gottlieb knew through his reading about Jung's idea of the collective unconscious.[43] From Graham he derived an understanding of the collective nature and spontaneous, unconscious expression of the primitive arts. The primitivism of his own Pictograph series, 1941–51, is a reflection of these ideas.[44] Graham gave Gottlieb a copy of *System and Dialectics of Art,* parts of which can be interpreted as instructions for making pictographs.[45] It was at Graham's urging that Gottlieb began to collect primitive art in 1935.[46] He expressed great interest in the Indian art that he saw at the Arizona State Museum during his stay in Tucson in 1937–38; he wrote of the weavings and ancient pottery on display, "I wouldn't trade all the shows of a month in New York for a

visit to the State Museum here."[47] He also came to know Indian art from his visits to New York museums with Newman. In particular he would have been familiar with the collection of Indian art at the Brooklyn Museum, which was close to his home and where he exhibited watercolors in various exhibitions between 1934 and 1944.[48] Gottlieb probably saw the Indian paintings and sculptures from Arizona and New Mexico exhibited at the Brooklyn Museum in 1940. Given his admiration for Indian art and his museum outings with Newman, it also seems likely that Gottlieb would have attended *Indian Art of the United States* at the Museum of Modern Art in 1941. The exhibition included a full-scale canvas mural facsimile of the ancient pictographs found at Barrier Canyon in Utah.[49]

Gottlieb's inclusion of Native American forms in his paintings was predicated on his belief that all primitive and archaic art had a spiritual content accessible to anyone familiar with the "global language of art," which functioned as the "language of the spirit."[50] He defended the use of primitive art as a model for contemporary art, saying that the "apparitions seen in a dream, or the recollections of our prehistoric past" were real and a

part of nature.[51] This might well be the description of his own Pictograph series: apparitions seen during shamanic trances or mythical images from the collective prehistory, preserved in the primal stages of symbol and image making. Although Gottlieb's Pictographs do make reference to African, Oceanic, and other archaic arts, the significant impact of Native American art on his enigmatic and eclectic series of paintings is revealed by two critical facts. First, Gottlieb himself chose to call his series of neoprimitive paintings Pictographs. Second, he began them only after ancient pictures-on-the-earth from Barrier Canyon were reproduced at the Museum of Modern Art. Indeed, there is a provocative similarity between *Pictograph-Symbol,* 1942, and the illustration on the front endsheet of the 1941 catalogue *Indian Art of the United States* (pls. 6–7). Both might be described as having totemic masks, zoomorphs, and abstract forms, both geometric and organic, painted in a palette of earth tones and contained in rectangular compartments in a grid formation.

The influence of Southwest Indian art was apparent even before that of Northwest Coast art in Gottlieb's Pictographs. The earth, clay, and mineral colors that came into his palette when he was still in Arizona, and that continued in many of the Pictographs, are reminiscent of the buffs, browns, tans, and rust colors of the Pueblo pottery on display at the Arizona State Museum. Likewise, Gottlieb adopted the rough surfaces of real pictographs, as well as noting how the Pueblo potter adjusted figurative and abstract images to an overall design on a flat surface. A number of these modern Pictographs, including *Evil Omen,* 1946, contain "site and path" motifs — concentric circles that straighten out into a line of travel — which are typical of Southwest rock art and pottery in general and specifically resemble the Barrier Canyon pictographs.

The structure of Gottlieb's Pictographs is no doubt related to Northwest Coast art, particularly the Chilkat (Tlingit) type blanket, as well as to other precedents in twentieth-century art.[52] Gottlieb's purchase of one such blanket in 1942 postdates the beginning of his Pictograph series, but from his museum visits he certainly would have known the Northwest Coast convention of bisecting animal forms and presenting these flat and seemingly abstract sections of the body in compartments.[53] Some of the later Pictographs, such as *Night Forms,* do have a surface organization reminiscent of Gottlieb's Chilkat blanket.[54] After the Newman-curated exhibition of Northwest Coast art in 1946, totemic imagery appeared more frequently in Gottlieb's

7
Inner front cover, Frederick H. Douglas and René d'Harnoncourt, *Indian Art of the United States* (1941)

Pictographs and ensuing Unstill Lifes. *Pendant Image,* 1946 (pl. 8), has as the lower part of its central image a pair of bear's ears, in turn animated with eyes. This is a typical convention of Northwest Coast painting and sculpture, seen for example in the *House Screen of Chief Shakes. Vigil,* 1948 (pl. 9), shares with a number of Gottlieb's paintings after 1946 a vertical format derived from carved totem poles. The two pole units left of center in *Vigil* feature mysterious hybrid animals that transform themselves into other totemic forms. This organic transformation of one pictorial unit into another is, again, a standard form of Northwest Coast art.[55]

Gottlieb used this totem pole format for the iconic central form of *Ancestral Image,* 1949 (pl. 10), one of the early Unstill Lifes.[56] Besides the painting's obvious verticality, its title also points to totem poles, which are representations of ancestral, mythical clan progenitors. The description of totem poles in the catalogue *Indian Art of the United States* points out that "they either display family crests or relate family legends, and were erected as memorials to dead leaders."[57] The mask/face that Gottlieb placed atop the pole in *Ancestral Image* is nearly a direct quotation of a Northwest Coast mythic figure, Tsonoqua. A female ogre who devours children after luring them to the woods with her whistling, Tsonoqua is always shown with a puckered mouth, as is Gottlieb's figure. A mask of this type, from the permanent collection of the Museum of the American Indian, was exhibited at the Museum of Modern Art in 1941 (pl. 11).[58]

Many of Gottlieb's Pictographs have titles suggesting ritual and, by implication, transformation.[59] In 1947 he made explicit his own awareness of the need to redeem modern experience and the artist's function in that transformation: "The role of the artist, of course, has always been that of image-maker. Different times require different images. Today when our aspirations have been reduced to a desperate attempt to escape from evil . . . our obsessive, subterranean and pictographic images are the expression of the

neurosis which is our reality."[60] In creating different images of a neurotic reality, Gottlieb subjected the primal imagery of Native Americans, the unconscious mind, to the conscious plastic order inherent to a modern painter. Estranged from their original context, the Indian motifs are transfigured and become more than mere references to ancient American art. They become revitalized and take on new meaning as components in paintings that attempt to redeem the darkness of the war years by bringing to the surface the atavistic roots of modern experience.

In contrast to Gottlieb, whose brief residence in Arizona was his first real break from an essentially urban experience, Pollock grew up in the Western states and his interaction with Native American art and culture began early in life. In 1923, when Pollock was eleven, he, his brothers, and their friends explored the Indian ruins (cliff dwellings and mounds) north of their home near Phoenix.[61] Pollock's youthful exploration of this site was not an isolated encounter with Indian culture, as his brother Sanford reported, "In all our experiences in the west, there was always an Indian around somewhere."[62] Later, in New York, Pollock often spoke to his friends as if he had actually witnessed Indian rituals as a boy.[63]

Once in New York, Pollock enhanced his knowledge of Indian art and culture. Sometime between 1930 and 1935 he and his brother purchased twelve volumes of the *Annual Report of the Bureau of American* Indian sand painting. He likens the courage and the spirit of the sand painters and the impermanence of their materials to his own description of "the meaning of the artist" as one "who deals with the moment and eternity."[40] The surface and structure of *Symphony Number 1, The Transcendental*, 1944, continues the investigation of Indian traditions, orchestrating them on a heroic scale.

10
ADOLPH GOTTLIEB
Ancestral Image, 1949
Oil on canvas
38 x 30 in. (96.5 x 76.2 cm)
Destroyed by fire in 1953
Adolph and Esther Gottlieb
Foundation, New York
© 1977

11
Tsonoqua Mask
19th century
Carved wood
Height 10 in. (25.4 cm)
Museum of the American
Indian, Heye Foundation,
New York

JACKSON POLLOCK
Bird, 1941
Oil and sand on canvas
27 ½ x 24 in. (69.8 x 61 cm)
The Museum of Modern Art,
New York
Gift of Lee Krasner
in memory of Jackson Pollock

Ethnology [hereafter cited as *BAE Report*],[64] which feature detailed scholarly field reports on a variety of topics related to the ethnology and archaeology of Native Americans and are profusely illustrated with hundreds of re-productions, including color plates, of ancient and historic Indian art objects. In particular there are illustrations of ritual paraphernalia and rare documentary photographs of late nineteenth-century and early twentieth-century Indian rituals. Over the years Pollock used these reports as a rich and authentic source of Indian imagery. He also read *DYN,*[65] and other titles in his library attest to his broad interest in mythology, anthropology, and the primitive art of Indian and other cultures.[66]

Textual materials on the Indian helped Pollock understand the Indian images he absorbed during museum visits in New York. Bultman reported that he and Pollock "went every-where looking at Indian art" and that their outings took them more than once to the Museum of the American Indian and to the American Museum of Natural History, where they saw Northwest Coast art.[67] Pollock's interest was not limited to the Southwest Indian art of his youth but rather "included the whole range of Indian arts in which he

found very positive images."[68] Pollock would also have learned about Northwest Coast art from the Amerindian Number of *DYN,* which published his painting *Moon Woman Cuts the Circle.* Pollock also saved an issue of the new journal *Iconograph* that dealt with Northwest Coast art and its influence on New York's painters of "Indian space."[69]

Naturally, Pollock was one of the many mem-bers of the New York art community who attended *Indian Art of the United States.*[70] Bultman recalls that the 1941 exhibition "gen-erated a great deal of interest."[71] When asked if there was a broad interest by artists in Indian art, he replied, "*Everyone* was aware of Indian art at that time."[72] Dr. Violet Staub de Laszlo, then Pollock's Jungian psychotherapist, re-ported that the exhibition fascinated Pollock. After his extended visits, they discussed the sand paintings made at the museum by visit-ing Navajo artists,[73] and during analysis Pol-lock's comments revealed a "kind of shamanistic, primitive attitude toward [their] images."[74] As Bultman attests, Pollock was aware of the "whole shamanistic dream cul-ture of Indians."[75] Pollock was deeply

involved with Paalen's idea of passing through "emotion to abstraction," "ancestral stratifications," and "evolutionary stages of the species," and he may have met Paalen through their dealer Peggy Guggenheim or their mutual friend Robert Motherwell.

During this period Pollock also read the writings of Graham. Graham's "Primitive Art and Picasso" had impressed Pollock to the degree that he made a point of meeting him, probably in 1937.[76] Indeed, Pollock still had a copy of that article and *System and Dialectics of Art* at the time of his death.[77] Graham's knowledge of the literature on Russian shamanism paralleled Pollock's awareness of Native American shamanic art.[78] They shared a "coinciding and reinforcing interest in primitivism and Indian art."[79] Because of Pol-lock's well-established and deep involvement with the art and ideas of Native Americans, his intellect and artistic sensibility were fertile ground for Graham's conclusions about primitive art and the unconscious mind. In his discussion of Eskimo masks and Northwest

Coast carvings Graham referred to primitive art as the result of immediate access to an unconscious mind that is both collective and ancient. Graham wrote, "Creative images are circumscribed by the ability to evoke the experiences of primordial past . . . and the extent of one's consciousness."[80] Pollock pointed out unequivocally the importance of these ideas in his own work: "The source of my painting is the unconscious."[81]

According to Bultman, the direct, simplified nature of Graham's writings made him a friendly source of Jungian theory for Pollock. In addition, Bultman recalls, "Jung was available in the air, the absolute texts were not necessary, there was general talk among painters. . . . Tony Smith also knew the Jungian material firsthand when he became a friend of Pollock. Smith was a walking encyclopedia of Jung, shamanism, magic in general, ritual, the unconscious. People were alive to this material [Jung, dreams, Indian shamanism] and hoped this material would become universally known and used."[82]

Pollock was a logical participant in the wider American interest in Indian culture reflected in the enthusiasm for *Indian Art of the United States*. His personal and psychological motivations drew him to the formal power and mythic content of Indian art. In retrospect it seems only natural that Pollock, of all the New York artists interested in myth and primitivism, had the most intense and innovative response to the influence of Native American art. Careful scrutiny of selected works in Pollock's oeuvre reveals conclusively that between 1938 and 1950 (pls. 12–13) he borrowed with specificity and intent from particular works of Indian art known to him. The degree of similarity is so high as to disprove Pollock's assertion in 1944: "People find references to American Indian art and calligraphy in parts of my paintings. That wasn't intentional; probably was the result of early enthusiasms and memories."[83]

All of Pollock's varied incorporations and transfigurations of Indian art were informed and sustained by a shamanic intent. In the first period of Pollock's artistic dialogue with Native American art, from 1938 to 1947, he experimented with the visual grammar and ancient motifs of Indians as a way of penetrating the unconscious mind. This painterly method of shamanic self-discovery was related to two Jungian principles widely known in the late 1930s and early 1940s: that myths are archetypal forms that codify basic human experiences[84] and that "conscious and unconscious are interfused," therefore transformed by allowing the consciousness to be drawn into the realm of the symbolic image.[85] In such paintings as *Guardians of the Secret,* 1943 (pl. 17), Pollock relied on Indian myths, symbols, totems, and masks associated with rituals. The Indian images themselves are quoted, distorted, transformed and always serve as a vehicle for Pollock's inimitable improvisations. In this period he often used an intentionally primitive, pictographic style of painting/drawing to refer to both archaic consciousness and the evolutionary stages of art.

13
JACKSON POLLOCK
Untitled, 1943
Brush and pen and ink, colored pencil brushed with water on paper
18 ¾ x 24 ¾ in.
(47.6 x 62.9 cm)
Lorna Poe Miller, Los Angeles

In the second period of Pollock's pictorial dialogue with Native American art, from 1947 to 1950, his overt use of Indian motifs gave way to an emphasis on art as a shamanic process for healing. Thus the drip paintings use the information about the self, which Pollock discovered by exploring the symbolic realm, by making the mythic/pictographic paintings in his earlier period. Pollock developed a personal art-as-healing-process derived in part from the concepts of Navajo sand painting, which he had witnessed at the Museum of Modern Art in 1941.

Perhaps the earliest examples of Indian influence in Pollock's work are the pictographic drawings in his sketchbooks from around 1938 (pl. 14). This kind of intentionally primitive drawing may have had its original impetus not in Surrealist automatism but in Pollock's knowledge of pictographs.[86] For

example, *BAE Report* 1 (1881) contained numerous images of Indian pictographs,[87] and its information about rock art ran parallel to Graham's ideas about primitive art: "The record of all human intercourse is perpetuated through the medium of symbols."[88] BAE Director John Wesley Powell wrote, "Nature worship and ancestor worship are concomitant parts of the same religion, and belong to a status of culture highly advanced and characterized by the invention of pictographs. . . . These pictographs exhibit the beginning of written language and the beginning of pictorial art."[89]

Stressing the primacy of Indian pictographs in the development of Pollock's mythic pictures is not necessarily a denial of Surrealist influence. Pollock was cognizant that the unconscious was the source of imagery for both Surrealist and shamanic art but that the resources of the unconscious had not been fully explored.[90] What Pollock found acceptable in Surrealism, because it mirrored his own conclusions, was not so much a stylistic vocabulary but the idea of painting from the

unconscious.[91] His loose, crude, linear language in these early drawings and mythic paintings is an effort to evoke an ancient, more authentic kind of automatic writing.

For Pollock pictographs were also significant as an organic, visual record of the development of consciousness from primordial times to the present. René d'Harnoncourt described the Barrier Canyon pictographs as a blend of past and present: "They are still made today in certain sections. In the Southwest . . . modern Navajo drawings in charcoal may be found on top of ancient Pueblo rock paintings. . . . It is usually impossible to date rock pictures, though they were obviously made over a long period of time."[92] Rock art, with its "masterly treatment of flat spaces,"[93] represents superimposed layers of artistic activity from different prehistoric and historic periods. The stratification of human cultural activity is an important idea in Jungian theory. Jung wrote, "Through the buried strata of the individual we come directly into possession of the living mind of ancient culture."[94] Pollock responded in 1941 by mixing sand and oil paints and painting *The Magic Mirror,* which has a faded and textured surface very much like the replicas of Barrier Canyon pictographs exhibited at the Museum of Modern Art that same year.

One of the objects seen by Pollock at *Indian Art of the United States,* a pottery bowl made by the prehistoric Hohokam culture of southern Arizona, circa 800 (pl. 15), inspired *Mural, 1943* (pl. 16), which he painted for Peggy Guggenheim. Pollock was an ardent admirer of the figurative motifs found on ancient Southwestern pottery, and he no doubt recognized the painted figure on the Hohokam bowl as being the kachina (a supernatural Pueblo spirit) Kokopelli, a humpbacked flute player associated with fertility. According to Pueblo mythology, Kokopelli, because of his misshapen appearance, slyly seduces and impregnates young women without their knowledge.[95] These women are usually shown clinging to Kokopelli's back as in the Hohokam bowl: "the figures are often repeated in long rows" and "the drawings are executed with a broad, free-flowing line."[96] Likewise, Pollock created in *Mural* a rhythmic line of black, humpbacked flute players who dance from left to right with female figures clinging to their backs. Guggenheim herself noted, "The mural was more abstract than Pollock's previous work. It consisted of a continuous band of abstract figures in a rhythmic dance painted in blue and white and yellow, and over this black paint was splashed in

a drip fashion."[97] The manner in which Pollock created *Mural* suggests a shaman's psychic preparation before a round of ritual activity. After weeks of brooding contemplatively in front of the blank canvas, "he began wildly splashing on paint and finished the whole thing in three hours."[98] That Pollock, after finally beginning to paint, did not stop until the image was complete suggests that for him creating the image was a kind of ritual performance.

In 1943, in addition to painting other Indian-inspired works, Pollock continued to produce, in the style of *The Magic Mirror,* surface-oriented paintings covered with nonspecific stenographic marks, hieroglyphic slashings, numbers, and primitive symbols. For Pollock, like Gottlieb, pictographic elements must have represented archaic kinds of writing that signify the strata of consciousness and culture. Through the manipulation of primitive calligraphy, stick figures, zoomorphs, and totems, Pollock touched, as a shaman does, a world beyond ordinary perception.

Prior to the drip paintings, *Guardians of the Secret* (pl. 17) is Pollock's most dramatic and successful visual statement about the shamanic potential of Indian art and the unconscious mind. At the heart of the image is a rectangular space filled with pictographic secrets.[99] Here, in an agitated linear code, is the timeless seed of human ritual. Flanking and guarding the secrets are two totemic figures highly reminiscent of Northwest Coast pole sculpture. Pollock made a more overt reference to Northwest Coast art just to the left of the center at the top of the canvas. Outlined in white is the mask of the mythical Tsonoqua (seen in Gottlieb's *Ancestral Image*), which Pollock knew from visits to the Museum of the American Indian and *Indian Art of the United States.* This confirms the overriding sense that *Guardians of the Secret* is the painterly evocation of a ritual scene. D'Harnoncourt's description of the Northwest Coast tradition also supports this idea: "Beside the dark sea and forest there developed an art in which men, animals, and gods were inextricably mingled in strange, intricate carvings and paintings. Religion and mythology found their outlet in vast ceremonies in which fantastically masked figures enacted tense wild dramas."[100]

16
JACKSON POLLOCK
Mural, 1943
Oil on canvas
95 ¾ x 237 ½ in.
(243.2 x 603.2 cm)
Museum of Art, University of Iowa, Iowa City
Gift of Peggy Guggenheim, 1948
·

17
JACKSON POLLOCK
Guardians of the Secret, 1943
Oil on canvas
48 ⅜ x 75 ⅜ in.
(122.9 x 191.5 cm)
San Francisco Museum of
Modern Art
Albert M. Bender Collection,
Albert M. Bender
Bequest Fund
Purchase
.

In its formal arrangement *Guardians of the Secret* refers to Southwest, not Northwest Coast, rituals. Immediately to the right of the Tsonoqua image Pollock placed a black insect. This curious creature, curled up in a fetal position, derives from the painted decoration on a Mimbres pottery bowl (pl. 18).[101] The painting's three flat, horizontal registers of activity, hieratically framed by the totemic figures, suggests that it is a "picture-within-a-picture."[102] The probable source of this device is a pair of illustrations accompanying an article on the Indians of Zia Pueblo in *BAE Report* 11 (1894).[103] The first of these (pl. 19) shows the altar and sand painting of the Zia Snake Society. This image, like *Guardians of the Secret*, has its two-dimensional surface divided into flat, horizontal planes. Uppermost in the picture is a roughly rectangular wood altar, which is braced by two hieratic posts topped by totemic heads. Below the altar are two sand paintings, the lower of which shows an animal with sharply pointed ears framed in a rectangular space. Thus this illustration of a ceremonial setting has a compositional arrangement similar to *Guardians of the Secret*, is a picture of a (sand) picture, and depicts at the bottom an animal similar to the dog/wolf in the bottom register of Pollock's painting. The second illustration (pl. 20) shows the altar of the Knife Society hieratically flanked by two clan officials who are theurgists. Again, the two-dimensional surface is organized in flat, horizontal planes, and the central altar and fetishes are protected, braced by the two officials. This Zia custom, the report explains, is different from the Zuni, "some of [whose] altars have but one guardian."[104] Pollock's image may now be seen to indicate a pair of secret society guardians who protect a ritual painting made for healing purposes.

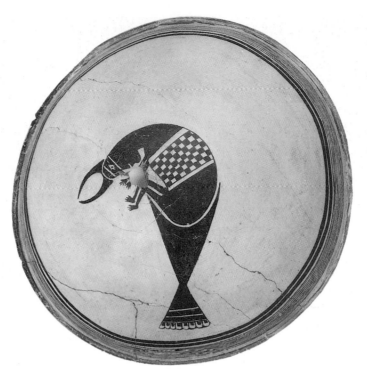

18
Pottery Bowl
Mimbres, Swarts Ruin, New Mexico, c. 1200
The Taylor Museum, Colorado Springs, Colorado

19
Altar and Sandpainting of the Snake Society at Zia Pueblo,
illustrated in *Annual Report of the Bureau of American Ethnology*
11 (1894)

20
Guardians of the Knife Society,
from *Annual Report of the Bureau of American Ethnology*
11 (1894)

21
JACKSON POLLOCK
Night Mist, c. 1944
Oil on canvas
36 x 74 in. (91.4 x 188 cm)
Norton Gallery and School of
Art, West Palm Beach,
Florida

·

The following year Pollock continued his exploration of primitive kinds of writing, pictographic elements, which indicate cultural, especially artistic, evolution. In *Night Mist,* circa 1944 (pl. 21), Pollock overlaid a hard, flat space with a ritual frenzy of rough and fast passages of paint. The surface was painted over with layers of symbols and forms, recalling cave walls or ritual chambers. Like Indian pictographs, each variety of mark or line, whether drawn, slashed, or inscribed in paint, is the record of a different and enduring age of image making on the pictorial surface. Paintings like this and *Guardians of the Secret* explored that point in cultural history when the creation of symbols was a ceremonial activity. Pollock produced other works in 1944 that show both continued interest in the writings of Graham and the expressive potential of mask forms.[105] Graham's "Primitive Art and Picasso" was illustrated with an Eskimo mask (pl. 22) chosen to support his reference to Eskimo masks with the facial features rearranged.[106] This article alerted Pollock specifically to the formal power of Indian art, attracting him to it in much the same way that Picasso felt drawn to the conceptual treatment of the human figure in African art, but Pol-

lock was already familiar with this tradition of masks. An Inuit mask of the same variety (pl. 23) illustrated an article on masks and aboriginal customs in *BAE Report* 3 (1884),[107] which Pollock had owned for at least two years before the publication of "Primitive Art and Picasso." This ceremonial mask has the eyes stacked one above the other, a twisted mouth curving up the side of the face, and knobs carved in relief to suggest teeth. Pollock's awareness of these Eskimo masks served as the inspiration for his painting *Night Sounds,* circa 1944 (pl. 24). Pollock distorted and exaggerated the mask even further so it practically fills the composition. Despite this accentuated elongation, the derivation of this image from Eskimo masks is still quite obvious.

22
Wooden Mask
Eskimo, Yukon River region,
Alaska, c. 1900
The University Museum,
University of Pennsylvania,
Philadclphia
·

23
Wooden Mask, Inuit,
illustrated in *Annual Report of
the Bureau of American
Ethnology* 3 (1884)
·

24
JACKSON POLLOCK
Night Sounds, c. 1944
Oil and pastel on paper
43 x 46 in. (109.2 x 116.8 cm)
Estate of Lee Krasner Pollock
·

25
JACKSON POLLOCK
Totem Lesson 1, 1944
Oil on canvas
70 x 44 in. (177.8 x 111.8 cm)
Mr. and Mrs. Harry W.
Anderson
.

Like his *Totem Lesson 1,* 1944 (pl. 25), Pollock's *Totem Lesson 2,* 1945 (pl. 26), once again makes reference to ritual transformation. The large, dark zoomorph in the center, with upraised arm and white pictographic writing on its body, is probably a painterly variation of the hard-edged Sky Father image in a Navajo sand painting illustrated in *Indian Art of the United States* (pl. 27).[108] In the Southwest, sand paintings are an integral part of elaborate ceremonies designed to cure illnesses by restoring the patient to wholeness and to harmony with nature. Both physical and psychic ailments are cured by the pictures, whose iconography and process of creation are known only by special medicine men, called *singers* among the Navajo. These singers generate flat, linear images by sprinkling colored sand or pulverized minerals in a freehand manner directly onto the buckskin canvas on the ground or onto the ground itself. The Indian artist squeezes the colored sands tightly between thumb and forefinger and releases them in a controlled stream, resulting in a "drawn" painting. Pollock, too, achieved "amazing control" in a seemingly freewheeling process by using a basting syringe "like a giant fountain pen."[109] The other similarities between the sand painter's

process and that used by Pollock are at once obvious. Just as the sand painter works strictly from memory, Pollock also worked without preliminary drawings, characterizing his paintings as "more immediate — more direct."[110] The Navajo sand painting mentioned here measured eight by ten feet. This meant it "functioned between the easel and mural," which is how Pollock described the increased scale in his painting.[111]

In the face of bouts with alcoholism and deep depression Pollock struggled, like the Indian patient, for self-integration. Perhaps this was the basis of his fascination with Indian sand paintings like those shown in *BAE Report* 16 (1897)[112] and the ones made in New York in 1941 by Navajo singers. Because of Pollock's own search for wholeness and his obvious interest in sand paintings, his drip paintings, such as *Autumn Rhythm,* 1950 (pl. 28), may be interpreted as ritual acts in which Pollock stands for the shaman who is his own patient. In 1947 Pollock made the following statement about his work: "My painting does not come from the easel. I hardly ever stretch my canvas before painting. I prefer to tack the unstretched canvas to the hard wall or floor. I need the resistance of a hard surface. On the floor I feel nearer, more a part of the painting, since this way I can walk around it, work

from the four sides and literally be *in* the painting. This is akin to the method of the Indian sand painters of the West."[113] By being *in* the painting (pl. 29) Pollock became like the Navajo patient, the one sung over, who sits atop the sand painting, the focal point of the curing ceremony (pl. 30). The Navajo believe that contact with the numinous power of the image unifies the patient with nature by putting him in touch with mythic progenitors.[114] As Pollock said, "When I am *in* my painting . . . I have no fears about making changes, destroying the image, etc., because the painting has a life of its own. . . . When I lose contact with the painting the result is a mess. Otherwise there is a pure harmony, an easy give and take, and the painting comes out well."[115] Sand paintings also have lives of their own from sunrise to sunset, after which they are ritually destroyed. The Indian sand painter, too, must not lose "contact with the painting" and demonstrates great concentration; he is free to correct and adjust the composition so that, according to the Navajo, "all is in accord again."[116] In both Pollock's and the singer's situation the process and the experience have as much importance as the image created.

28
JACKSON POLLOCK
Autumn Rhythm, 1950
Oil on canvas
105 x 207 in.
(266.7 x 525.8 cm)
The Metropolitan Museum
of Art
George A. Hearn Fund,
1957

In 1947, the year the drip paintings emerged, Pollock said, "I have always been impressed with the plastic qualities of American Indian art. The Indians have the true painter's approach in their capacity to get hold of appropriate images, and in their understanding of what constitutes painterly subject matter. . . . Their vision has the basic universality of all real art."[117] There is a significant correlation between Pollock's perception of Indians as those who "get hold of appropriate images" and Graham's belief that exposure to the unconscious is a "journey to the primordial past for the purpose of bringing out some relevant information."[118] The result of the first is a painterly subject matter and of the second, a spontaneous expression of the primal self; both are primary characteristics of the drip paintings. For Pollock immersion in the ancient imagery of Indians was a mode of access to the unconscious. He knew and valued the Indian concept of "discovering one's own image" through shamanic experience, and he and Bultman often discussed "magic and the shamanistic cult of traveling to spirit worlds."[119] The world of the spirit is the ultimate nature of the self, and Pollock believed that nature as self was approachable through

dreams and visions, which yielded his imagery.[120] The gripping brilliance of *Guardians of the Secret* indicates that for Pollock coming to know the self was like standing at the heart of a flame. It is a painting that exudes the ecstasy of ceremony, and yet the violent energy of its surface and the elusive meaning of the pictographic secrets suggest that realization of the discovered self was an arduous task. The loosening up, the automatic quality of the linear movement in the drip paintings, was an attempt to reveal the intangible contents of the unconscious mind.

The abandonment of figuration and the sweeping poetic gesture in such works as *Autumn Rhythm* may again refer to Native American art. As stated in *BAE Report* 1 (1881), "The reproduction of apparent gesture lines in the pictographs made by our Indians has, for obvious reasons, been most frequent in the attempt to convey those subjective ideas which were beyond the range of an artistic skill limited to the direct representation of objects."[121]

The move away from overt representation to convey subjective content is Pollock's "strongest point about Indian culture"[122] and is illuminated by his legendary reply to Hans Hofmann, "I am nature."[123] The strongest, most poignant fact of Indian life to Pollock

was that "people living close to nature found nature in themselves rather than nature as a motif."[124] It follows that if Pollock were going to paint from nature, the resulting image would be an observation of the self. Lee Krasner's comments on the "I am nature" statement support this idea: "It breaks once and for all the concept that was more or less present in the Cubist derived paintings, that one sits and observes nature that is out there. Rather it claims a oneness."[125]

The drip paintings speak of a oneness, for Pollock must have felt they were the pictorial realization of his transformed consciousness. Elements of his unconscious mind had merged with his waking conscious, and the result was a lengthy period of abstinence from drink (1947 to 1950), a sense of wholeness, and a marked transformation of his painting style. Typically, the drip paintings themselves are the merger of opposites: the image and pictorial ground become one, the gesture and image become one, drawing and kinds of writing become painting, and, finally, the work of art is the ritual process. In these paintings made between 1948 and 1950 Pollock sought unity between conscious decision and primitive instinct, and with the impetus of Native American art he found it.

While Pollock asserted a oneness with nature, Gottlieb spoke of "going forward to nature," and Pousette-Dart speaks of believing "in the primal" and "whole thinking."[126] In their search for holistic experience these painters helped resolve the crisis of subject matter common to American artists in the 1940s by establishing themes of universal relevance based on Native American traditions, images, and art processes. Through myth making, evocation of archaic surfaces, and transformation of indigenous primitive forms in a manner both intuitive and calculated, they incorporated ancient American art into a modern Abstract Expressionism. Each in his own way helped fulfill the prophecy so often heard in New York during the 1930s and 1940s, particularly in the critical voices of Newman, Graham, and Paalen, that Native American art and culture could be the wellspring for a modern art that portrayed the collective experience.

29
HANS NAMUTH, *Jackson Pollock in Studio — Painting,* 1951, photograph

.

30
Navajo mother holding sick child and sitting on sand painting

.

1. Mark Rothko first used the term *myth-maker* in 1946 in reference to the work of Clyfford Still, whose "pictorial conclusions" Rothko found allied to those of a "small band of Myth-Makers" then making an impression on the New York scene. See Mark Rothko, introduction to *Clyfford Still*, exh. cat. (New York: Art of This Century, 1946).

2. A complete discussion of this and numerous other issues relating to the present essay are contained in my master's thesis, "The Influence of American Indian Art on Jackson Pollock and the Early New York School" (University of Texas at Austin, 1984). It should be noted that working independently I have arrived at some conclusions similar to those expressed by J. Kirk Varnedoe in his essay, "Abstract Expressionism," in *"Primitivism" in Twentieth Century Art*, exh. cat. (New York: Museum of Modern Art, 1984), 615–59. As my essay here demonstrates, however, the influence of Native American art on both the style and content of early Abstract Expressionism was much stronger than suggested by Varnedoe.

3. John D. Graham, *System and Dialectics of Art*, with critical introduction by Marcia Epstein Allentuck (1937; Baltimore: Johns Hopkins Press, 1971), 95.

4. For a discussion of the relevance of this aspect of Carl Gustav Jung for New York artists in the early 1940s, see Stephen Polcari, "The Intellectual Roots of Abstract Expressionism: Mark Rothko," *Arts* 54 (September 1979): 126.

5. John D. Graham, "Primitive Art and Picasso," *Magazine of Art* 30 (April 1937): 237.

6. Ibid.

7. Fritz Bultman, telephone conversation with author, 26 April 1984. For information on Max Ernst's (and the other Surrealists') preoccupation with Native American and Eskimo art, see Elizabeth Cowling, "The Eskimos, the American Indians, and the Surrealists," *Art History* 1 (December 1978): 484–99.

8. Dore Ashton, *The New York School* (New York: Penguin, 1972), 125.

9. Ibid.

10. Wolfgang Paalen, editorial, *DYN*, nos. 4–5 (December 1943): verso frontispiece.

11. Ibid.

12. Wolfgang Paalen, "Totem Art," *DYN*, nos. 4–5 (December 1943): 17.

13. Ibid., 13.

14. Ibid., 18.

15. Ashton, *New York School*, 105.

16. Paalen, "Totem Art," 18.

17. Paalen, in fact, had given Barnett Newman an autographed copy of *Form and Sense*. See Barbara Reise, "'Primitivism' in the Writing of Barnett Newman: A Study in the Ideological Background of Abstract Expressionism" (Master's thesis, Columbia University, 1965), 26.

18. Ibid.

19. I am grateful to Irving Sandler for sharing with me hard-to-obtain primary source material relating to Newman's activities as a curator of primitive art.

20. Barnett Newman, introduction to *Pre-Columbian Stone Sculpture*, exh. cat. (New York: Wakefield Gallery, 1944).

21. Ibid.

22. Ibid.

23. Ibid.

24. Bultman, interview with author.

25. Ashton, *New York School*, 132.

26. Barnett Newman, introduction to *Northwest Coast Indian Painting*, exh. cat. (New York: Betty Parsons Gallery, 1946).

27. Ibid.

28. Ibid.

29. Ibid.

30. Barnett Newman, introduction to *The Ideographic Picture*, exh. cat. (New York: Betty Parsons Gallery, 1947).

31. Ibid.

32. Richard Pousette-Dart still feels that "there was a great difference between his work and his contemporaries" (Richard Pousette-Dart, telephone conversation with author, 16 March 1985).

33. Ibid.

34. Pousette-Dart, interview with author, Suffern, New York, 5 May 1985.

35. Gail Levin, "Richard Pousette-Dart's Emergence as an Abstract Expressionist," *Arts* 54 (March 1980): 125–26; confirmed by Pousette-Dart, telephone conversation with author.

36. Quoted in Levin, "Pousette-Dart's Emergence," 126. Levin writes that Pousette-Dart "diagrammed the polarity between the 'subconscious mind' and the 'conscious mind.'"

37. Pousette-Dart, telephone conversation with author.

38. Ibid.

39. Ibid.

40. Ibid.

41. Ibid.

42. Ibid.

43. See Adolph Gottlieb, interview with Dorothy Seckler, 1967, quoted in Mary Davis MacNaughton, "Adolph Gottlieb: His Life and Art," *Adolph Gottlieb: A Retrospective*, exh. cat. (New York: Arts Publisher in association with the Adolph and Esther Gottlieb Foundation, 1981), 31.

44. It must also be remembered that Gottlieb studied with John Sloan at the Art Students League in 1920. For comments on Sloan's appreciation and patronage of Indian art (especially his involvement with the *Exposition of Indian Tribal Arts* in New York in 1931), see Rushing, "Early New York School," 3–4, 101 n. 4.

45. On John D. Graham's gift to Gottlieb, see MacNaughton, "Gottlieb," 20. Sanford Hirsch, telephone conversation with author, 3 April 1985. Special thanks are due Hirsch for his cooperation with my research.

46. MacNaughton, "Gottlieb," 20.

47. Quoted in Sanford Hirsch, "Adolph Gottlieb in Arizona: 1937–38" (unpublished manuscript, 1984), 13.

48. Hirsch, interview with author.

49. This replica of Utah pictographs was made for the exhibition by Works Progress Administration (WPA) artists. The catalogue illustration was a photograph taken by Robert M. Jones, Utah Art Project, WPA; see Frederick H. Douglas and René d'Harnoncourt, *Indian Art of the United States*, exh. cat. (New York: Museum of Modern Art, 1941), 24.

50. Quoted in MacNaughton, "Gottlieb," 171.

51. Quoted in "The Ides of Art: The Attitudes of Ten Artists on Their Art and Contemporaneousness," *Tiger's Eye* 2 (December 1943): 43.

52. For modern influences on Gottlieb's grid, see MacNaughton, "Gottlieb," 32.

53. Ibid., 38. MacNaughton notes there the influence of Chilkat blanket patterns and Haida totem pole forms on Gottlieb's early Pictographs. As she rightly observes, Haida poles were on display at both the Brooklyn Museum and in the exhibition *Indian Art of the United States*. Hirsch also reports (interview with author) that "totems were prominently displayed at the Brooklyn Museum."

54. Varnedoe, "Abstract Expressionism," 632.

55. See, for example, the Haida carved pole exhibited at the Museum of Modern Art in 1941 and illustrated in the catalogue (Douglas and d'Harnoncourt, *Indian Art*, 176).

56. According to Hirsch (interview with author), the earliest Unstill Lifes were Pictographs adapted or repainted "in order to isolate some massive, central form."

57. Quoted in Douglas and d'Harnoncourt, *Indian Art*, 176.

58. Although not reproduced in the catalogue, this Tsonoqua mask was reproduced in *Art News* (39 [1 February 1941]: 6, frontispiece) in conjunction with a review of the exhibition.

59. Such Gottlieb titles include *The Alkahest of Paracelsus*, 1945; *Oracle*, 1947; *Sorceress*, 1947; and *Altar*, 1947.

60. Quoted in "Ides of Art," 43. For a discussion of Gottlieb in relation to Jung's *The Idea of Redemption in Alchemy*, see MacNaughton, "Gottlieb," 44.

61. See Francis V. O'Connor, *Jackson Pollock* (New York: Museum of Modern Art, 1967), 13; Elizabeth Langhorne, "A Jungian Interpretation of Jackson Pollock's Art through 1946" (Ph.D. diss., University of Pennsylvania, 1977), 102.

62. Quoted in Francis V. O'Connor, "The Genesis of Jackson Pollock: 1912–1943" (Ph.D. diss., Johns Hopkins University, 1965), 7.

63. Bultman, interview with author.

64. Francis V. O'Connor and Eugene V. Thaw, *Jackson Pollock: Catalogue Raisonné* (New Haven: Yale University Press, 1978), 4:192.

65. Bultman (interview with author) confirmed that Pollock read *DYN*.

66. For a complete listing of the contents of Pollock's library at the time of his death, see O'Connor and Thaw, *Catalogue Raisonné*, 4:187–99.

67. Bultman, interview with author.

68. Ibid.

69. In addition to the early Abstract Expressionists, there were a number of young American painters in New York in the late 1940s (some of whom were associated with Kenneth Beaudoin's journal *Iconograph* and exhibited at his Galerie Neuf in the spring of 1946), including Will Barnet, Peter Busa, Robert Barrell, Gertrude Barrer, Sonia Sekula, and Oscar Collier, who experimented with forms inspired by Northwest Coast and Pueblo Indian art. See Ann Gibson, "Painting outside the Paradigm: Indian Space," *Arts* 57 (February 1983): 98–103.

70. Bultman, interview with author.

71. Ibid. Among the newspaper clippings Pollock saved was one from the Sunday *New York Times*, 19 January 1941. On this page were "ten photographs of Indian masks to be shown at the Museum of Modern Art starting January 22 in an exhibit of American Indian Art" (O'Connor and Thaw, *Catalogue Raisonné*, 4:199).

72. Ibid.

73. See Donald E. Gordon, "Pollock's *Bird*, or How Jung Did Not Offer Much Help in Myth-Making," *Art in America* 68 (October 1980): 48, 53 n. 50.

74. Dr. Violet Staub de Laszlo quoted in Langhorne, "A Jungian Interpretation," 140 n. 139.

75. Bultman, interview with author.

76. O'Connor, *Jackson Pollock,* 21. See also Irving Sandler, "John D. Graham: The Painter as Esthetician and Connoisseur," *Artforum* 7 (October 1968): 52. Some sources place Pollock and Graham's first meeting as late as 1941. For information that may support the later date, see Gordon, "Pollock's *Bird,*" 51.

77. O'Connor and Thaw, *Catalogue Raisonné,* 4:197. Willem de Kooning recalled Pollock's unusual insistence that a borrowed Graham article be returned to him; see Ashton, *New York School,* 68. Pollock's biographer B. H. Friedman noted that Pollock admired "Primitive Art and Picasso" sufficiently to write Graham a letter; B. H. Friedman, *Jackson Pollock: Energy Made Visible* (New York: McGraw-Hill, 1972), 50.

78. Bultman, interview with author.

79. Ibid.

80. Graham, *System and Dialectics,* 102–3.

81. This remark was part of a draft for Jackson Pollock, "My Painting," *Possibilities* 1 (Winter 1947–48): 78.

82. Bultman, interview with author.

83. Jackson Pollock, "Jackson Pollock," *Arts and Architecture* 61 (February 1944): 14.

84. See Carl Gustav Jung, *The Integration of the Personality* (New York: Farrar & Rhinehart, 1939), 53.

85. Ibid., 91.

86. For a discussion of the possibility that Pollock saw pictographs on his camping trips in the Mojave Desert in 1934, see Rushing, "Early New York School," 43.

87. See J. W. Powell, "On Limitations to Use of Some Anthropological Data," *Bureau of American Ethnology Report* 1 (1881): 371–75, 378 [hereafter *BAE Report*]. Likewise there were literally hundreds of Native American pictographs reproduced in "Picture Writing of the American Indians," *BAE Report* 10 (1893): see especially pp. 37–329 and pl. 54.

88. Graham, *System and Dialectics,* 23.

89. Powell, "On Limitations," 75.

90. Bultman, interview with author.

91. See Robert Motherwell's comments quoted in William Rubin, "Notes on Masson and Pollock," *Arts* 34 (November 1959): 36.

92. Douglas and d'Harnoncourt, *Indian Art,* 97–98.

93. Ibid., 84.

94. Quoted in Polcari, "Roots," 126.

95. In addition to the information on Kokopelli in the exhibition catalogue *Indian Art of the United States* and in *BAE Report* 17, three articles on the erotic flute player appeared in the *American Anthropologist* in the late 1930s; see Rushing, "Early New York School," 48–50.

96. Douglas and d'Harnoncourt, *Indian Art,* 86.

97. Peggy Guggenheim, *Out of This Century* (New York: Universe Books, 1946), 263.

98. Ibid. According to O'Connor, "Lee Krasner recalls that he [Pollock] would sit in front of the blank canvas for hours. Sometime in December of 1943 . . . he suddenly locked himself in his studio and finished the painting in one day" (O'Connor and Thaw, *Catalogue Raisonné,* 1:94).

99. See Frank O'Hara, *Jackson Pollock* (New York: Braziller, 1959), 20.

100. Douglas and d'Harnoncourt, *Indian Art,* 146.

101. Shown in the exhibition *Indian Art of the United States* and illustrated ibid., 104.

102. In discussing this painting the term *picture-within-a-picture* is used in William Rubin, "Pollock as Jungian Illustrator: The Limits of Psychological Criticism," *Art in America* 67 (December 1979): 88.

103. Matilda Coxe Stevenson, "The Sia," *BAE Report* 11 (1894): pls. XIV, XV.

104. Ibid., 73.

105. Sandler noted that three Pollock paintings produced between 1938 and 1941 — *Masqued Image, Head,* and *Birth* — incorporate Eskimo mask forms; see Sandler's rejoinder to Rubin, in William Rubin, "More on Rubin on Pollock," *Art in America* 68 (October 1980): 57.

106. Graham, "Primitive Art," 237.

107. See W. H. Dall, "On Masks, Labrets, and Certain Aboriginal Customs, with an Inquiry into the Bearing of Their Geographical Distribution," *BAE Report* 3 (1884), pl. XXVII, fig. 70.

108. See Douglas and d'Harnoncourt, *Indian Art,* 29.

109. Lee Krasner, interview with B. H. Friedman, quoted in *Jackson Pollock: Black and White,* exh. cat. (New York: Marlborough Gallery, 1969), 10.

110. Jackson Pollock, interview with William Wright, 1951, quoted in O'Connor, *Jackson Pollock,* 81.

111. Quoted ibid., 39.

112. Jesse Walter Fewkes, "Tusayan Snake Ceremonies," *BAE Report* 16 (1897): pls. LXIII, LXXII.

113. Pollock, "My Painting," 78.

114. Robert F. Spencer et al., *The Native Americans* (New York: Harper & Row, 1977), 308–9. See also Clyde Kluckhohn and D. C. Leighton, "An Introduction to Navajo Chant Practice," in *American Anthropological Association Memoir* 52 (1946).

115. Pollock, "My Painting," 76.

116. Franc J. Newcomb and Gladys A. Reichard, *Sandpaintings of the Navajo Shooting Chant* (New York: Dover, 1937), 12, 20, 24.

117. Pollock, "Jackson Pollock," 14.

118. Graham, "Primitive Art," 237.

119. Bultman, interview with author.

120. Bultman informed me of Pollock's interest in the relationship between magic, shamanism, and "the nature of self." Bultman's statement about the dream vision as a source of imagery for Pollock is quoted in Langhorne's rejoinder to Rubin, "More on Rubin," 63.

121. Garrick Mallery, "Sign Language among the North American Indians," *BAE Report* 1 (1881): 370.

122. Bultman, interview with author.

123. Quoted in O'Connor, *Jackson Pollock,* 26.

124. Bultman, interview with author.

125. Quoted in Bruce Glaser, "An Interview with Lee Krasner," *Arts* 41 (April 1967): 38.

126. Gottlieb, "Ides of Art," 10; Pousette-Dart, telephone conversation with author.

ABSTRACT FILM AND COLOR MUSIC

WILLIAM MORITZ

The dream of creating a color music for the eye comparable with auditory music for the ear dates to antiquity, but so far no universal technical formula has given it the durable, popular basis of the other art forms. Each major figure in color music had to spend a sizable portion of his career inventing or struggling with clumsy, intractable, and ultimately obsolescent machinery. Light is harder to manipulate than sound, but current technology, combining lasers, computers, and video, promises standard console instruments for the composition and reproduction of color music before the turn of the century. Color music is not painting; nevertheless it was a significant precursor for nonobjective painting, both in the aesthetic sense of wrestling with the arrangement and development of color gestures and in the spiritual sense of bringing to painting the cumulative meaning of meditative philosophy.

Pythagoras understood that the music of the spheres implied cosmic fusion: the universe embodies a divine geometrical harmony that is mirrored in all natural phenomena, both in the microcosm and macrocosm. The harmonies of celestial orbit parallel the seeming irregularities of life-forms on earth. The bases of these correspondences are mathematically precise vibrations that are manifested as light, sound, fragrance, and other sensual stimuli. Fusing one's perceptions of these seemingly discrete sensory inputs constitutes synesthesia, which Pythagoras considered the greatest philosophical gift and spiritual achievement because it ultimately reconciles the illusory quotidian world with the authentic world of universal, enduring, abstract concepts.[1]

The quest for synesthesia has led dozens of artists to compose color music over the last four centuries, but discussion of the work of artists before World War I is hampered severely by the loss of their artifacts and the paucity of biographical detail.[2] Each of these artists favored a general mystical perspective, but we lack evidence regarding the spiritual disciplines they practiced or the effect, superficial or profound, of mysticism on their compositions. No substantial monograph has yet appeared on any artist whose career was devoted exclusively to color music. Several artists published their own theoretical texts, which were usually so apologetic, because of the prejudice and ignorance they encountered, that the artists' intimate spiritual beliefs were concealed behind charts, graphs, and scientific testimonials.[3]

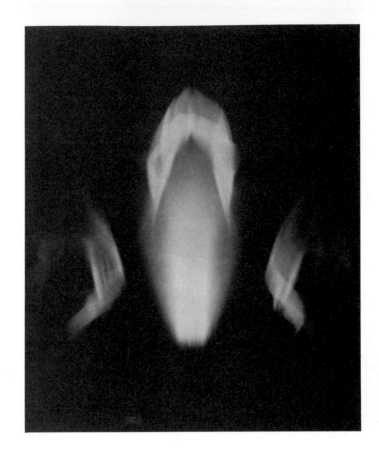

A good example of the problems caused by lack of artifacts and biographical detail is the case of Russian composer Aleksandr Scriabin, perhaps the best-known practitioner of color music. His auditory compositions are in the standard symphonic repertory, and his theories of color music are regularly described in program notes as curiosities. Despite unconcealed hostility to mystical ideas, Faubion Bowers's biography of Scriabin leaves little doubt that the composer's fascination with Theosophy grew into a messianic obsession with revealing the cosmic *mysterium* (an apocalyptic synesthesia) to humanity.[4] Only two overt references to Theosophy appear in Scriabin's writings,[5] but Bowers repeatedly reported testimony on the depth of Scriabin's involvement with Theosophy and surmised that the composer joined an advanced theosophical group called Sons of the Flames of Wisdom.[6]

Bowers admitted that *Prometheus: The Poem of Fire* (1910), although it "reeks of theosophical symbolism," is "the greatest symphony Scriabin ever wrote."[7] Clearly Scriabin's theosophical interest informed and enriched the successful musical qualities of the symphony. Bowers was forced to describe the music in synesthetic terms: "Some passages emit sparks and flames, many of which are of dark, opalescent hue and others wound the eye with their sharp colors. . . . The symphony begins with chaos — blue and green inertia of matter. The opening chord sounds the 'active beginning' . . . that mythical Prometheus which serves to open the symbol on the first state of consciousness."[8]

Despite this unusually complete spiritual pedigree for *Prometheus,* the artifact of the color music component is virtually lacking. Scriabin never intended the music to be played without colored light projections. In the orchestral score he included a line for *luce* (lights). In the seventy-five years since its composition, however, *Prometheus* has been performed with lights only some half-dozen times and never exactly following the composer's instructions. He intended both the audience and performers to be dressed entirely in white, and some lights would have been projected on them as well as on walls. But because Scriabin died without supervising a performance, we cannot know what exact formation of ambient versus configured light might express his vision. Yet even in its unrealized form *Prometheus* exerted significant influence. Kandinsky, for example, referred to it in writing several times during the crucial period when he turned toward abstraction.[9]

Thomas Wilfred's *lumia* (his term for kinetic color projections) stand as the earliest surviving color music about which we can make fair aesthetic judgments.[10] Wilfred turned from a flourishing career as a singer to creating color music under the direct influence of the American architect Claude Bragdon, who relentlessly propagandized for Theosophy and the fourth dimension.[11] Bragdon himself had experimented with color organ mechanisms and large visual music spectacles, such as the "cathedral without walls" in New York's Central Park in 1916, before patron Walter Kirkpatrick Brice offered to build a studio on Long Island where Bragdon and a society of Prometheans (color music visionaries) could labor at perfecting color music instruments. Wilfred gradually coopted the space and created his first clavilux (a console instrument for projecting lumia) there in close association with Bragdon in 1921 (pls. 1–2).

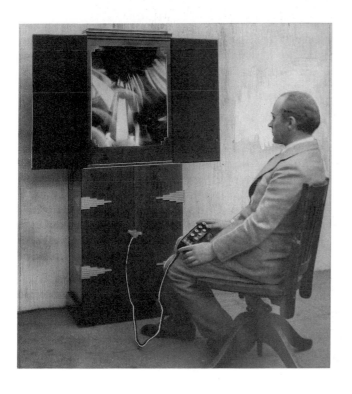

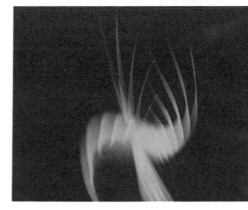

Evidence of the relationship between Wilfred and Bragdon is scattered throughout their papers, in the letters, for example, from Fennimore Germer to Wilfred. Wilfred trained Germer as an assistant clavilux performer for the historic Exposition des Arts Décoratifs in Paris in 1925, where lumia shows played regularly. Germer wrote, "Wonder if Mr. Bragdon could project his four-dimensional designs in motion by using transparent material sensitive to sound . . . much as a fixed brass plate is affected when a resined bow is drawn across its edge so that grains of sand on its surface arrange themselves into sound-forms."[12] This suggests that fulfilling the potential of Bragdon's four-dimensional theories was a vital issue to the correspondents.

After 1926 Wilfred concentrated on creating self-contained, programmed "lumia compositions," many of which, with a two-foot square screen in a decorative cabinet, resemble modern television sets (pl. 3). What we know about Wilfred's earlier, hand-manipulated lumia (from still photographs, written descriptions, and technical diagrams) indicates that they must have produced imagery nearly identical to that of the later automatic compositions. The programmed lumia compositions offer a remarkable reification of

some of Bragdon's fourth-dimensional conceptions. Because time is the key factor in these compositions, each can be identified not only by the dimensions of its individual cabinet but also by an absolute time cycle (the elapsed time before a particular image is replicated, a matter of hours or days) and an apparent, or "virtual," time cycle (an incremental repetition requiring just a few minutes). These temporal coordinates reflect the mechanical constitution of the lumia: several different gem-encrusted disks and distorting mirrors revolving at various speeds. The technical formula manifests a fourth-dimensional conception because no single static image exists (no image represents a full cycle) and each incremental movement, both in space and time, reveals another facet of a multidimensional event or phenomenon, which cannot be described fully in a two-dimensional or three-dimensional format.

The obvious resemblances in the lumia to planetary and galactic orbits not only suggest alchemical, music-of-the-spheres connotations but also indicate that Wilfred was grappling with the scientific issues behind n-dimensional theory (pl. 4). The two-dimensional screens, or projection surfaces, for these lumia function in the same way as the

plane that Bragdon used to make personality tracings and projections of tesseracts (two systems that the English hyperspace philosopher Charles Howard Hinton had devised to render fourth-dimensional phenomena observable in two-dimensional formats). For example, Wilfred's *Counterpoint in Space, Opus 146,* 1956, plays two cycles in tandem. One configuration, a streaming nebula of white and golden turbulence, surges up in a pointed wedge, piercing through and fanning open to occupy the entire field, then oozing upward with another pointed wedge briefly lingering behind, pulling loose from the field; the sequence describes a double pyramid passing through a two-dimensional plane of vision. The second configuration of thin green and golden currents outlines an arched triangle in black negative space, implying the presence of a fourth-dimensional personality, which manifests as an antimatter tesseract whose traces leave an upwardly aspiring, triangular "black hole."

Wilfred's less geometrical lumia (pl. 5), such as *Vertical Sequence II, Opus 137,* 1941, more clearly reflect the mystical, theosophical

3
Thomas Wilfred with the first home clavilux, 1930
Courtesy Sterling Memorial Library, Yale University, New Haven, Connecticut

.

4
THOMAS WILFRED
From *Unfolding, Opus 127,* 1941
Courtesy Sterling Memorial Library, Yale University, New Haven, Connecticut

.

5
THOMAS WILFRED
From *Abstract, Opus 59,* 1923
Courtesy Thomas Wilfred, Jr.

.

aspect of Bragdon's fourth-dimensional vision. The attack and decay of colors as they fade in and out, the metamorphoses of brilliant reds into rich wines and saturated purples that dissolve into luminous white, the intense gold of a sunset refusing to blend with a simultaneous apparition of a green or peach streak, the subtle directional flows with slight curling or bending just as they leave the screen, the interaction between nearly palpable veils and clouds of turbulence boiling up — these elements recall the thought-forms of Annie Besant and Charles W. Leadbeater,[13] the auras that seem to be apparitions of a fourth dimension. An analogy with alchemy is probably not gratuitous; the coupling of alchemical thought with Theosophy and the fourth dimension occurs also in the work of Marcel Duchamp,[14] for example, and in that of Oskar Fischinger, one of the great masters of color music.[15]

Before discussing Fischinger's films, it is interesting to consider one of the other pioneer efforts at bringing nonobjective spiritual art to life through film. In 1908 eighteen-year-old Arnaldo Ginna, working with his brother, Bruno Corra, in Ravenna, Italy, began painting the abstract States of the Soul (pl. 6), a series of canvases undoubtedly suggested by Besant and Leadbeater's thought-forms and Édouard Schuré's concept of the "theater of the soul," which the brothers knew from Theosophical Society lectures they attended in Florence and Bologna.[16] In 1910, possibly under the additional influence of Bragdon (whose book *The Beautiful Necessity* [1910] is discussed in Corra's 1912 article "Chromatic Music"), they started working on color organ mechanisms, visualizing, as was Scriabin, a white room flooded with colors, all the spectators and performers robed in white.[17] Finding the exigencies of performing on clumsy machinery unsatisfactory, in June 1911 they began a series of abstract films, of which four were completed by October 1911 and another five finished in 1912 (pl. 7). Ginna painted them frame by frame on blank film stock; Corra helped on broader colors but lacked the painting skills to do the fine details. Although the actual films have long since decomposed, Corra's descriptions allow a reconstruction and commentary.[18]

6
ARNOLDO GINNA
States of the Soul: Forms Expressing Joy and Pessimism,
1911
Pencil on paper
9 x 11 in. (22.9 x 27.9 cm)
Professor and Mrs. Stanislao Ginanni-Corradini

·

7
ARNOLDO GINNA
The Music of a Dance (study for an abstract film), 1912
Pencil on paper
8 x 10 in. (20.3 x 25.4 cm)
Mario Verdone,
Rome

·

The first four films were experimental in the purest sense. Each explored a specific technical and aesthetic problem: *Film No. 1* took a divisionist painting of a blooming meadow by Giovanni Segantini as the starting point for an investigation of the effect of film time on painterly practices; *Film No. 2* tested the optical properties of complementary colors in duration and of retinal fatigue afterimages; *Film No. 3* offered an interpretation of music (Felix Mendelssohn's "Spring Song" and a Frédéric Chopin waltz); and *Film No. 4* translated Stéphane Mallarmé's poem "Flowers" into terms of color. Nowhere is the striving for synesthesia so clear as in Ginna and Corra's films, where color embraces not only music but also the fragrance of flowers and inflections of poetry.

The results of these experiments with synesthesia seem to have been somewhat unsatisfactory to Ginna and Corra. Their next three films, designed to prepare the spectator to accept and better appreciate "chromatic music," contained no references to auditory music, fragrance, or poetry but relied instead on the sort of symbolic color drama dear to the Theosophists. *Film No. 5,* for example, employed only the complementary colors red and green, but (in contrast to *Film No. 2*) it used them in a theosophical color drama. The color red appeared in a pure green field as a six-pointed star, growing larger, rotating with its points vibrating like tentacles until the whole screen was consumed in red. A rash of green spots broke out in the red field and festered ever larger until the screen was pure green again. The six-pointed star (overlapping triangles) is a key symbol in all spiritual disciplines — alchemy, tantric Buddhism, Theosophy — as is the opposition of red and green (active-passive, ending-beginning, passionate gesture-brooding contemplation). The struggling and ultimately triumphant green suggests theosophical thought-forms and Schuré's theater of the soul, as well as the terms with which Fischinger would choose to describe his films. The surviving descriptions of *Film No. 6, Film No. 8,* and *Film No. 9* are too ambiguous for very precise interpretation, but Corra's notes about *Film No. 7,* in which the seven colors of the spectrum were embodied in seven cubes that "shatter and reform, interpenetrate and warp to other shapes,"[19] suggest Bragdon's fourth-dimensional manifestations. Unfortunately these films were known only by a limited audience of Futurist artists in Italy and had little influence abroad. Even the question of Ginna and Corra's influence on Italian painters remains largely unexplored.

For Fischinger's first film experiments (in Germany in 1921–23, exactly when Wilfred was perfecting his clavilux) he invented a wax-slicing machine that could literally show multidimensional forms passing through the plane of the screen to leave personality tracings. The mechanism synchronized the shutter of a camera with the blade of a slicer so that one frame of film would be shot each time a slice was cut from a prepared block of colored kaolin and wax into which any sort of shape could be modeled. The resulting film when projected shows a "living cross section" of the wax block. For example, a cone pointed toward the camera would show a dot growing into a larger circle as paper-thin slices disappeared. Fischinger modeled some of the shapes for the wax machine by heating the kaolin and wax and pouring it into cold, swirling oil and water, so that the resulting irregular form arises from the aleatory characteristics of the material rather than from the artist's control.

Fischinger's motivation for constructing this apparatus was partly a concern with the fourth dimension, which he viewed as an issue engaged with physics and mathematics as well as with spirituality (Theosophy/Anthroposophy); the idea that scientific and mystical thought were gradually growing together excited him.[20] Having studied Pythagoras, alchemy, and Buddhism, he was fascinated by the notion that every element and object contained an essential personality that could be revealed by the visionary artist who found a technical formula through which the material could speak for itself. These ideas survived throughout Fischinger's work and bore fruit in the 1930s, when he filmed representational shapes and abstract ornaments onto the sound-track area of the filmstrip in order to release the innate sounds locked inside silent, or nonmusical, objects — a theory he explained to Edgard Varèse and John Cage with crucial effect on their compositions.[21]

Unfortunately none of Fischinger's Wax Experiments films survives intact, although some fifteen minutes of footage, in fragments from thirty seconds to two minutes in length, can be studied (pl. 8). The originals were tinted and probably had live musical accompaniment, while now we see these mostly black-and-white excerpts silent. The artist's various concepts are exemplified in n-dimensional forms, radiating auras, and, in two of

8
OSKAR FISCHINGER
Trinity of Ouroboros before the Alchemical Rose, from *Wax Experiments,* 1923
Courtesy Fischinger Archive

the most striking images, a slowly unfolding rose (which Fischinger associated with the alchemical "great work") and a roselike image over which is superimposed a triple *ouroboros* (the snake devouring its tail, symbol of cycles). Fischinger's other early film experiments also suggest fourth-dimensional speculations: in one film the superimposition of two concentric circular patterns, rotating in opposite directions, seems to be the personality tracing of a double helix passing through the plane of the screen.

Fischinger modified these philosophical concerns, as well as inventively reaffirming them, during the course of his career. In some films of the late 1920s he showed a growing interest in the warped space suggested by Einstein's relativity theory. For example, in *Study No. 6* flying wedges bend and swirl into mobile vortices and pierce an eye, which is transfigured into a radiating mandala that spawns a cluster of fragmenting dots, which Fischinger specifically associated with splitting atoms (also in

Study No. 8 and *Study No. 9*). Fischinger considered such visual icons to have the linguistic value of hieroglyphs and thought of his films as "optical discussions" with a genuine power to reason in purely visual terms.

Composition in Blue, 1935 (pl. 9), for example, was such a discussion confined to a single issue: the yin-yang exchange of positive-negative energy, in which both form and color play significant roles. The interplay between two-dimensional (female/passive) and three-dimensional (male/active) shapes is paralleled by an interchange between colors related to blue (passive) and red (active). The discussion revolves around the possible fourth-dimensional consummation or reconciliation between the apparent polar opposites. Flat, passive blue walls enclose the room in which the action takes place, allowing solid objects to pass through, like personality tracings. These walls gradually take on an active role — by reflecting the three-dimensional forms, by radiating flat projections and active grids of changing colors, by fanning into a spiral twist of flat strips, by layering infinite (flat) parallel reflections. At the same time solid red cylinders, which are continually passing up and

down through the flat planes, generate a frenzy that finally frees two-dimensional disks (now turned to red) to fly off into a free, warped space and cover (and so become identical with) the all-red screen.

I have elsewhere described Fischinger's brilliant *Radio Dynamics,* 1943 (pl. 10), in specifically spiritual terms,[22] but it is important to add here that this meditation on consciousness and relativity uses color as a significant active factor. The colors in *Radio Dynamics* continually change from frame to frame, usually in smooth fades from one hue to another, but during the dazzling climax they do so by a sharp intermittency of flicker between contrasting colors. Although the emphasis of the optical discussion is the relativity of time and space (and illusion), the fourth dimension is not entirely forgotten. The parallel lines, pale and ghostly, that move back and forth through each other remind the viewer of two-

dimensional planes interfacing, of the screen itself, and of the possibility that all the layered concentric circles are composed of planes (as the animation cels actually are) that merely reflect personality tracings of fourth-dimensional events. This possibility is supported by Fischinger's preparatory sketches, which describe the *n*-dimensional intersection and projection of ray trajectories.[23]

A further indication of Fischinger's lingering fondness for fourth-dimensional theory appears in his last major film, *Motion Painting No. 1,* 1947 (pl. 11), about which he often commented, smiling, with the alchemical riddle: "In my end is my beginning, in my beginning is my end." Indeed *Motion Painting No. 1* is a living cross section, as the Wax Experiments were, only this time as the personality tracing of Fischinger's "mind," as projected in thin layers of paint. In the opening images luminous "comets" rise vertically, and around them materialize spirals, circling the comets in widening orbits. Then flat spirals begin to appear, growing from their own centers and winding wider and wider around themselves. Surely the flat coils are the personality tracings of the orbiting spirals (seen from above) as they pass through the two-dimensional plane of the screen.

After 1936 Fischinger lived in California, where there developed a significant school of color music artists, including James Whitney, Jordan Belson, Harry Smith, and Charles Dockum. These artists shared a broad base of spiritual and theoretical influences, encompassing such local figures as Swami Prabhavananda, Swami Paramahansa Yogananda, Krishnamurti, Arnold Schönberg, Aldous Huxley, Alan Watts, Timothy Leary, the Beats, and hippies. Institutional resources included the Philosophical Research Library with its fine collection of classic occult texts, the Theosophical Society publishing house (in Altadena, near the Whitney family home and

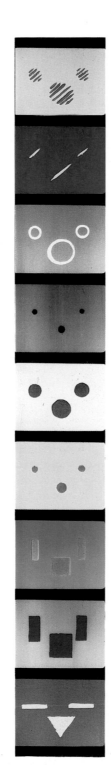

10
OSKAR FISCHINGER
From *Radio Dynamics,* 1943
Courtesy Fischinger
Archive

11
OSKAR FISCHINGER
From *Motion Painting
No. 1,* 1947
Courtesy Fischinger
Archive

across the street from Dockum's studio), and the California Institute of Technology, where so much advanced physics and perceptual physiology has been promulgated. Large resident Asian communities practiced Taoism and Buddhism as living religions. All of these influences more or less promoted synesthesia, and all were well known. Each color music artist formulated his own spiritual viewpoint by augmenting preferred influences with selected reading.

James Whitney studied Yoga and meditation briefly at Prabhavananda's Vedanta Center and Yogananda's Self-Realization Fellowship during the mid-1940s, but found Prabhavananda too lovable and charismatic and Yogananda's philosophy too ecstatically romantic or perhaps sentimental.[24] Whitney was more attracted to the ascetic and nonprescriptive writings of Sri Ramana Maharshi. He was seriously tempted to move to Sri Ramana's ashram in India, but the scarcity of electricity and film services there deterred him. Whitney could not give up his film work; he had great faith that the nonverbal synesthesia of his films possessed a special power to communicate difficult mystical concepts.

On the basis of Sri Ramana's references to Vedic alchemy as spiritual refinement and fulfillment, Whitney pursued a detailed study of alchemy in the writings of Carl Gustav Jung, the European occult tradition, Taoism, tantric and Zen Buddhism, and Krishnamurti, who after the death of Sri Ramana became increasingly the sounding board for Whitney's meditations. During World War II Whitney worked as a draftsman at the California Institute of Technology. He continued to follow the latest advances in science throughout his life, convinced, like Fischinger, that the graphs and photos in *Scientific American* were a natural nonobjective art form dealing with the same concepts as Jung or Krishnamurti.

The results of Whitney's spiritual exercises show themselves both in the form and content of his major films. For all his mature films he arbitrarily limited himself to using the dot, which is symbolic of the oneness of Buddhism, the atom of physics, the one-pointedness of meditation. He has used this dot not merely to construct wonderful patterns but — by employing specifically filmic techniques and processes, such as unfocused rear projections and solarization — to create fluid auras of halation and crusty textures so tactile that they enhance the sense of palpable synesthesia between color and sound.

For *Yantra,* 1955 (pl. 12), Whitney prepared the images silent before connecting them, with Jordan Belson's help, to electronic music. Fischinger procured a charming, convincing synesthesia from an uncannily precise synchronization of shape and music, but Whitney allowed a broader relationship of sound to color: the music sometimes coincides with the visual images, but at other times it is almost independent, thus heightening our perception of a genuine physical synesthesia comparable with the visionary state induced by mescaline. The Sanskrit word *yantra* refers to a variety of systems, from mandalas (meditation instruments) to the flux of cosmic energy or, in alchemy, to the vessel or grail in which the mystical transmutation is bred. The motions of the dots in *Yantra* indeed describe each of these processes in the creation, entropy, and refining of forms. Whitney's later films — *Lapis,* 1965 (pl. 13); *Wu Ming,* 1977; and *Kang Jing Xiang,* 1982 — have developed this remarkable spiritual fusion to the point at which the totally silent images of the last Taoist films create their own ethereal music, truly a music of the spheres.

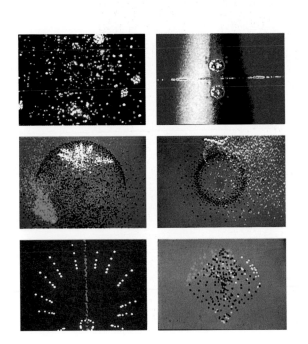

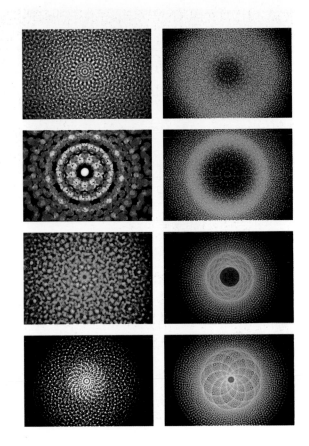

The paintings, films, and video compositions of Whitney's friend Belson are well known for their spiritual integrity.[25] Belson was greatly influenced by Wilfred's lumia, which he perceived as offering a key visual access to the primal phenomena that are the shared concern of Vedic Yoga, speculative fiction, and scientific theory. Unlike Wilfred, Belson is not bound by a specific mechanical cycle; he blends numerous lumia manifestations together with hard-edged geometry (as in *Allures,* 1961 [pl. 14]) and occasional brief allusions to ordinary earthly activities. The resulting flow of images, coupled with Belson's own sound collages, evokes a complex synesthetic microcosm/macrocosm, which refers to the spiritual fourth dimension of Bragdon and Wilfred as well as to later relativity theory. Over a series of fifteen films Belson has reused specific lumia images as symbolic hieroglyphs (for "light," "chakra," "meditative stare," "flight," and so forth). The hieroglyphs function as words and phrases in a nonobjective language, which Belson uses for discussion of such topics as the scientific aspect of transferring from one state to another (*Re-Entry,* 1964) and celestial ecstasy (*Samadhi,* 1967).

The spiritual and filmic endeavors of Harry Smith are also well documented.[26] In his earliest film preserved with its original sound track, *Film No. 11,* 1958, the sense of synesthesia as a spiritual fusion becomes obvious by the mixture of symbols: Tibetan Buddha dissolves to a Crowleyite goat-god, theosophical auras emanate from psychological textbook photos of emotions — all in a fluid fourth-dimensional space where anything is possible. These symbols and geometric forms are exactingly, comprehensively synchronized to an ambling jazz score so that everything seems linked in a cosmic dance. The last of Smith's purely nonobjective films, *Film No. 7,* 1951 (pl. 15), presents a comparable abstract fusion, in which layer upon layer of geometric forms (influenced by Fischinger) interact in an orchestral complexity that, like Whitney's films, creates its own synesthetic sense of music made visible as well as an impression of intricate cosmic functions laid bare.

Although barely twenty minutes of Charles Dockum's color organ compositions survive, their quality warrants mention among the works of other California school artists.[27] Dockum suffered respiratory problems throughout his life, and in his twenties he once came so close to death that he had the sort of out-of-body experience in which one's spirit seems to detach itself and fly off through cosmic realms, able to see auras and emanations, the orbits of galaxies and electrons, and the abandoned body in its earthly context. His urge to create "mobile-color" projectors (console instruments for live performances of color imagery) arose from his compulsion, like Belson's, to recreate and communicate his personal revelation, which he later found confirmed by theosophical writings, Fischinger's

12
JAMES WHITNEY
From *Yantra,* 1955
Courtesy Creative Film
Society

.

13
JAMES WHITNEY
From *Lapis,* 1965
Courtesy Creative Film
Society

.

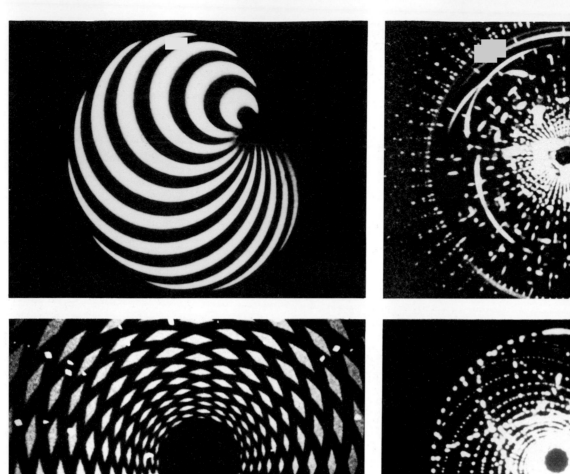

14
JORDAN BELSON
From *Allures*, 1961
Courtesy Jordan Belson

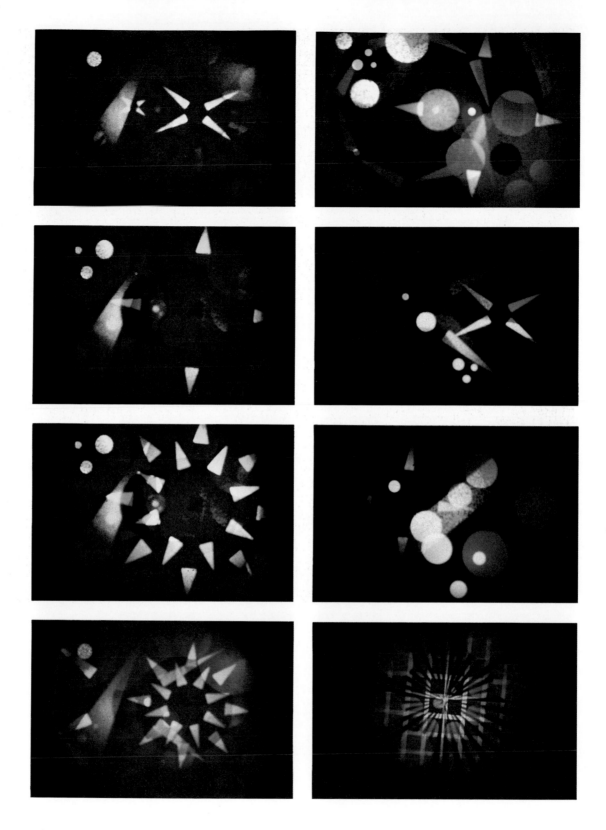

15
HARRY SMITH
From *Film No. 7*, 1951
Courtesy Anthology Film
Archive, New York, and
Harry Smith

16
CHARLES DOCKUM
From *Mobile Color Projections,*
1950s
Courtesy Greta Dockum

conversations about Buddhism, and especially the cabalistic Jewish mysticism of artist Peter Krasnow, his best friend for nearly forty years.

In a documentary film of Dockum's 1952 performances at the Solomon R. Guggenheim Museum and a filmed record of a performance at his studio in 1966, the three sequences, or movements, of each performance seem to be the inspiration and raison d'être of the unwieldy machinery itself (pl. 16). In one sequence patterns of small dots implode and explode as if flying along keen perspective lines and radiating in emanations of apotheosis. A second sequence follows thin veils of color meandering in seemingly random trails that sometimes cross in intricate biomorphic knots. A third sequence consists of pure color fields, mostly wedge shaped, which overlap in a constant sensual movement, growing larger and smaller to form triangles, rhomboids, and interlocking chains of diamonds. The intense, pure colors of these shapes create a serene, otherworldly synesthetic spectacle; the sheer force of the colors, pushing and pulling their overlapping areas, creates configurations impossible to a three-dimensional geometry.

A fascinating adjunct to the California school is sculptor Harry Bertoia, who lived in Los Angeles during the 1940s and was Fischinger's best friend as well as philosophical partner, sharing his whole range of mystical speculations.[28] Inspired by Fischinger's animistic Buddhism, Bertoia conceived the idea of nonobjective, sounding sculptures in which bronze, beryllium, and nickel parts would speak for themselves (pl. 17). Over a quarter-century he collected more than one hundred of these "sounding brasses" in his studio, most of them with clusters of geometric movable parts, some in graduated sizes, all able to produce rich metallic tones and visible vibrations. Their perfect synesthesia physically overwhelmed the fortunate few for whom Bertoia lithely danced among the

17
Harry Bertoia with sounding
sculptures, 1975
Courtesy Brigitta Bertoia

arrangement, composing with graceful and powerful gestures a veritable symphony of musical tones, using a dazzling array of rippling metal, shimmerings of sympathetic vibration.

A similar animistic passion moved Len Lye to create nonobjective kinetic sculptures as well as abstract films.[29] During his youth in New Zealand and Australia, Lye gained deep respect for the integrity of the aboriginals' philosophy of dreamtime and their art. Dreamtime is the aboriginals' belief that the visions of dream and trance represent a higher, spiritual dimension (a fourth dimension) that — true, perfect, and eternal — is superior to the corrupt reality of the waking state. Lye called dreamtime "the original Surrealism" and blended its notion of the superior validity of dream and trance with old-brain/new-brain psychology and automatic writing to create a film (*Tusalava,* 1928) based on aboriginal sacred drawings as they appeared in his dreams and a series of drawn-on-film abstractions (beginning with *Colour Box,* 1935 [pl. 18]) that metamorphose continually into new unexpected realms. In effect these films, like Fischinger's *Motion Painting No. 1,* are living cross sections of the artist's mind.

The apotheoses of Lye's automatic visionary Surrealism (letting the mind speak for itself) are his sublime electric sculptures, created in New York in the 1960s, in which metal parts are twisted, shaken, tossed, and struck. Unlike the pure musical tones of Bertoia's sculptures, Lye's strips of metal, bent under tension, emit almost anthropomorphic wails and whines and spine-tingling flutters, purely metallic sounds that Lye (like Fischinger, whom he idolized) believed were the voices of the spirits of metal.

This brief survey of a handful of masters of the art of visual music, and the close relationships among them, has left open the question of how much influence their work might have had on abstract painting. Unfortunately factual details related to such influence rarely appear. Even critical and biographical studies of painters such as Duncan Grant, Morgan Russell, and Stanton Macdonald-Wright, who dabbled in color music themselves, take little notice of the influence of color music on their painting, which may have been considerable. There is also the example of Jackson Pollock, about whom some unexploited details are available. Pollock's various aesthetic sources — Native American art, Thomas Hart Benton, the Mexican muralists, Pablo Picasso, Surrealism, the sublime — have been

much discussed, but his consistent contact with color music has largely been ignored.[30]

At Manual Arts High School in Los Angeles in 1928–30, Pollock's first art teacher, Frederick Schwankovsky, was a Theosophist and a devotee of Krishnamurti (he drove Pollock to Ojai to hear him) and other mystics, such as Manly P. Hall of the Philosophical Research Society. It was "Schwanny," as Pollock affectionately called him, who introduced Pollock to the concept of poured and dripped painting. Schwankovsky encouraged students to experiment with swirling together oils and water or watercolors and alcohol, and he taught them to paint stage sets by laying huge canvases on the ground and then dripping white starscapes onto a blue background or dribbling layers of creepers onto a jungle scene.[31]

Schwankovsky was also a color music enthusiast. He published a booklet for his students on color theory, which contained a color wheel: each color was assigned an equivalent musical tone, astrological sign, and emotion — values suggestive of theosophical and other occult interests. Schwankovsky often gave public performances with his wife, Nelly, playing on the piano the correct notes to

match the colors he painted on a canvas. Pollock's rapport with Schwankovsky prepared him for a sensitive appreciation of color music and its spiritual roots.

When Pollock moved to New York in September 1930 to continue his studies at the Art Students League, he avidly visited Wilfred's studio, sitting for hours to watch the lumia, his head moving up, diagonally, around, down, following the trajectories, the gestures of the various colors.[32] Further color music reinforcement came in 1943 during Pollock's brief stint working at the Guggenheim Museum of Non-Objective Painting, where he saw Fischinger's films, which were projected regularly. He may also have seen Dockum's mobile-color projections there. He certainly saw Whitney's early films, because his friend Tony Smith, one of Whitney's best friends in Los Angeles, took Pollock to a screening of Whitney's films in New York in 1945.[33] (Smith himself had done some remarkable paintings with poured wet paint before he left Los Angeles.)

During this crucial period in Pollock's career when he was changing his art from a semirepresentational abstraction (related to trends in easel painting) to a revolutionary nonobjective painting created by active gestures, he was repeatedly exposed to color music. Some of it, like Wilfred's lumia, was extremely gestural. Perhaps the concept of color music — a spiritual, surreal, and sublime nonobjective art in motion on a mural-sized screen — contributed to the hieratic dance, grand meanderings, and exquisitely refined color sense of Pollock's mature masterpieces.

In the near future sophisticated, standardized instruments for the composition and reproduction of color music should make the practice of synesthetic art commonplace. It is then likely that new research will reveal yet undisclosed instances, like Pollock's, of artists' connections with color music. If a critical language develops that is capable of describing synesthetic art — its motions, metamorphoses, gradations, and synergies — then the spiritual ideas that caused pioneering artists to create color music will be more clearly and subtly discussed. Those earlier artists may one day seem like the primitives that preceded the Renaissance in painting, but their spiritual integrity and dedication to the refinement of a complex synesthetic art will firmly establish them as old masters.

1. Jérôme Carcopino, *La Basilique pythagoricienne de la Porte Majeure* (Paris: Artisans du Livre, 1944); and Manly P. Hall, *Pythagoras* (Los Angeles: Philosophical Research Society, 1970).

2. The best survey of the early materials is Adrian B. Klein, *Coloured Light: An Art Medium,* rev. ed. (London: Technical Press, 1937); the first edition (1926) was entitled *Colour-Music.* See also Donald Schier, *Louis Bertrand Castel: Anti-Newtonian Scientist* (Cedar Rapids: Torch Press, 1941).

3. For two such artists, see Alexander Wallace Rimington, *Colour Music: The Art of Mobile Colour* (London: Hutchinson, 1911); and Mary Hallock Greenewalt, *Nourathar: The Fine Art of Light Color Playing* (Philadelphia: Westbrook, 1946).

4. Faubion Bowers, *Scriabin* (Tokyo and Palo Alto: Kodansha, 1969), 2:49.

5. Ibid., 52.

6. Ibid., 116–18, 206.

7. Ibid., 206–7.

8. Ibid., 207–8.

9. *The Blaue Reiter Almanac* (1912), ed. Wassily Kandinsky and Franz Marc; documentary edition edited by Klaus Lankheit (New York: Viking, 1974), 57ff.; and Wassily Kandinsky, *Über das Geistige in der Kunst,* 2d ed. (Munich: Piper, 1912), 48.

10. For general biographical details, see Donna M. Stein, *Thomas Wilfred: Lumia, A Retrospective Exhibition* (Washington, D.C.: Corcoran Gallery of Art, 1971).

11. Linda Dalrymple Henderson, *The Fourth Dimension and Non-Euclidean Geometry in Modern Art* (Princeton: Princeton University Press, 1983), 186–201; and Claude Bragdon, *More Lives Than One* (New York: Knopf, 1938).

12. Germer to Wilfred, 11 February 1924, Thomas Wilfred Papers, Sterling Memorial Library, Yale University.

13. Annie Besant and Charles W. Leadbeater, *Thought-Forms* (London and Banares: Theosophical Publishing Society, 1905).

14. Henderson, *The Fourth Dimension,* 117–63; and Arturo Schwarz, "Duchamp et l'alchimie," in *Abécédaire/Approches critiques,* vol. 3 of *Marcel Duchamp* (Paris: Musée National d'Art Moderne, 1977), 10–21.

15. William Moritz, "The Films of Oskar Fischinger," *Film Culture,* nos. 58–60 (1974): 37–188; idem, "The Importance of Being Fischinger," in *Oscar Fischinger Retrospective,* film festival cat., Ottawa '76; idem, "You Can't Get Then from Now," *Los Angeles Institute of Contemporary Art Journal* 29 (Summer 1981): 26–40, 70–72.

16. Mario Verdone, "Ginna e Corra: Cinema e letteratura del Futurismo," *Bianco e Nero* 28 (October–December 1967): 9–12, 21–22. This three-hundred-page special issue reprints many of the Ginna-Corra writings, quotes copiously from correspondence, and includes illustrations.

17. Ibid., 244, 248. The reference to Bragdon is omitted in the English translation (of only half the Italian original) in Umbro Apollonio, *Futurist Manifestos* (New York: Viking, 1973), 66ff. Bruno Corra, "Chromatic Music" (1912) also appears in Arnaldo Ginna and Bruno Corra, *Manifesti futuristi e scritti teorici,* ed. Mario Verdone (Ravenna: Longo Editore, 1984), 155–66.

18. Verdone, "Ginna e Corra," 248, 250.

19. Ibid., 250.

20. Fischinger's precise sources are often difficult to establish: he was an avid reader throughout his life, but, being poor, he rarely bought books. He spent hours in libraries, sometimes daily, reading both periodicals and books. When an idea caught his fancy, he would obsessively read everything he could find on the topic. This particular background for the wax films was recounted by Fischinger to both Harry Bertoia (in the early 1940s, twenty years after the fact) and James Whitney (in the 1950s). Harry Bertoia, interviews with author, Los Angeles, 1974, Barto, Pennsylvania, 1976–77; and James Whitney, interviews with author, Studio City, California, 1969, 1973, 1981.

21. Calvin Tomkins, *The Bride and the Bachelors* (New York: Viking, 1968), 86–87; and John Cage, interview with author, New York, 1974.

22. Moritz, "Films of Fischinger," 67–68, 156–57, 180–83; and idem, "You Can't Get Then from Now," 70–71.

23. Moritz, "Films of Fischinger," 125 ill., 183.

24. William Moritz, "Who's Who in Filmmaking: James Whitney," *Sightlines* 19 (Winter 1985/86), 25–27; idem, "James Whitney Retrospective," in *Toronto '84,* film festival cat., 9–14; idem, "You Can't Get Then from Now," 35–40; James Whitney, interviews with author, Studio City, California, 1969, 1973, 1976, 1981; and Jordan Belson, interviews with author, San Francisco, 1970, 1975, 1980, 1984–85.

25. Gene Youngblood, *Expanded Cinema* (New York: Dutton, 1970), 157–77, 388–91; P. Adams Sitney, *Visionary Film* (New York: Oxford University Press, 1979), 262–74; Whitney, interviews with author; and Belson, interviews with author.

26. Sitney, *Visionary Film,* 232–62; and Harry Smith, interviews with author, New York, 1971, 1976–77, 1985.

27. Steven A. Smith, Greta J. Dockum, and Gretchen Evans Dockum, "Kinetic Art: The Mobilcolor Projectors of Charles R. Dockum (1904–1966)," *Leonardo* 12 (Spring 1979): 144–50; and William Moritz, "Towards a Visual Music," *Cantrills Filmnotes* (August 1985): 35–42.

28. Harry Bertoia, interviews with author.

29. Roger Horrocks, *Len Lye: A Personal Mythology,* exh. cat. (Auckland: Auckland City Art Gallery, 1980); and Len Lye, interview with author, New York, 1977.

30. *Jackson Pollock,* exh. cat. (Paris: Musée National d'Art Moderne, 1982); and B. H. Friedman, *Jackson Pollock: Energy Made Visible* (New York: McGraw–Hill, 1972), 9–10.

31. Interviews with Frederick Schwankovsky and Manuel Tolegian (a friend of Pollock and fellow Manual Arts High School student) as well as Schwankovsky's color booklet are in the Archives of American Art, Smithsonian Institution.

32. Palmer Schoppe, interview with author, Los Angeles, 1985; and Tony Smith, interview with author, New York, 1977.

33. James Whitney, interviews with author, Studio City, California, 1969, 1981; Tony Smith, interview with author, Santa Barbara, 1969; and Schoppe, interview with author.

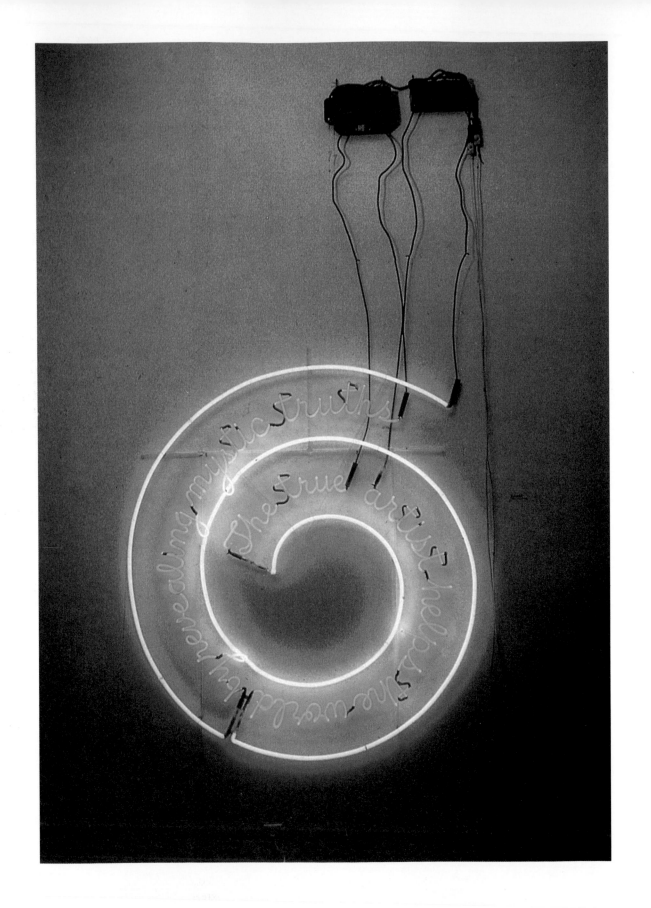

CONCERNING THE SPIRITUAL IN CONTEMPORARY ART

DONALD KUSPIT

The "spiritual" is a problem concept in contemporary art. When in 1912 Wassily Kandinsky published *On the Spiritual in Art,* the nature of spirituality in art was clearer than it is today. For Kandinsky the spiritual was identified with "the search for the abstract in art,"[1] and it existed in opposition to "the nightmare of materialism."[2] Art was unequivocally regarded as "one of the mightiest elements" in "the spiritual life . . . a complicated but definite and easily definable movement forward and upwards."[3] Today art does not seem so mighty an element in spiritual life, and spiritual life does not seem so evident in art or in general. After three-quarters of a century of abstract art and the development of an abstract art that seems to have deliberately purged the spiritual *Stimmung* (atmosphere) that Kandinsky expected abstraction to distill,[4] abstraction itself has become materialistic (Frank Stella's work is a major example), and it is hard to know how artists can create works that have, in Franz Marc's words, a "mystical inner construction."[5] The artist today seems to have less of Kandinsky's "inner necessity,"[6] less of an impulse for spiritual expression. The denial of the spiritual dimension of abstract art, its conversion into a purely formal, material, external enterprise, has made it into still another "art for art's sake," a "condition of art" that Kandinsky described as "vain squandering of artistic power," a "neglect of inner meanings."[7] It is indeed, as Marc wrote, "terribly difficult to present one's contemporaries with spiritual gifts."[8]

What has happened in part is that today abstract art is no longer an oppositional art, especially in critical opposition to what Meyer Schapiro called the "arts of communication." For Schapiro the problem is the pressure on the artist "to create a work in which he transmits an already prepared and complete message to a relatively indifferent and impersonal receiver."[9] In the case of most contemporary abstract art, this means that abstraction itself has become a prepared and complete message, "calculated and controlled in its elements," a predictable aesthetic experience impersonally transmitted. Abstract art is no longer understood as a mystical inner construction, transmitting inner meanings through the "quality of the whole," available only when "the proper set of mind and feeling towards it" have been achieved.[10] The abstract work of art tends to become another "reproducible" communication.

Some contemporary abstract art struggles to resist this tendency. The enemy of today's spiritual abstract art is not simply the ongoing "harsh tyranny of the materialistic philosophy"[11] and a society that is determined to reduce art to another ordinary communication but also the unconscious inclination of much art itself to take the line of least resistance to materialistic society by becoming facile, if slightly unconventional, communication. It is the desire to enter the mainstream of societal communication itself that must be resisted, for it usurps inner necessity. The difficulty for abstract art today is to sustain the sense of spiritual Stimmung in the face of a society that assimilates abstract art as simply another kind of communication and so makes us insensitive and unresponsive to it. As Schapiro wrote, experiencing art as well as creating it involves "a process ultimately opposed to communication as it is understood now."[12] Authentically spiritual abstract art does not so much "communicate" as "induce an attitude of communion and contemplation." It offers "an equivalent of what is regarded as part of religious life: a sincere and humble submission to a spiritual object, an experience which is not given automatically, but requires preparation and purity of spirit." "It is primarily [in this art] that such contemplativeness and communion with the work of another human being, the sensing of another's perfected feeling and imagination, becomes possible."[13] The most significant abstract art today reflects an inner conflict between the socially encouraged will to conventional communication and the personal will to spiritual experience.

Authentically spiritual abstract art also faces an inherent conflict with another kind of material destiny, that brought about by its commercialization, its inevitable reduction to a luxury product. It is institutionalized not only as emptily decorative but as the most useless or ornamental or spectacular of consumer goods. As Schapiro wrote, abstract art, more than any other art, is exposed "to dangerous corruption" because of its "concreteness":

The successful work of painting . . . is a unique commodity of high market value. Paintings are perhaps the most costly man-made objects in the world. The enormous importance given to a work of art as a precious object which is advertised and known in connection with its price is bound to affect the consciousness of our culture. It stamps the painting as an object of speculation, confusing the values of art. The fact that the work of art has such a status means that the approach to it is rarely innocent enough; one is too much concerned with the future of the work, its value as an investment, its capacity to survive in the market and to symbolize the social quality of the owner.[14]

This situation can only intensify the struggle between communication and spirituality in abstract art, for if its spirituality is reduced to merely communicating a prepared message, its value as a specially made, unique object becomes more important. It is this aesthetic and material uniqueness that is commercially valued. At the same time, spirituality is an especially unique quality today. Thus the spiritual in artistic form — spiritual atmosphere as a surplus of indefinable uniqueness added to the materially unique abstract work of art — further enhances the work's commercial value and social status. Spirituality legitimatizes the abstract work's worldly success.

In the face of such obstacles, the means by which today's best abstract art achieves its spiritual integrity are the same as they were when abstract art originated, but they are now insisted upon with great urgency: silence and alchemy. Both were already evident in Kandinsky and converged in his sense of "total abstraction" and "total realism" as different paths to the same goal.[15] Total abstraction is a kind of silence: "the diverting support of reality has been removed from the abstract." Total realism is a kind of alchemy: "the diverting idealization of the abstract (the artistic element) has been removed from the objective. . . . With the artistic reduced to a minimum, the soul of the object can be heard at its strongest through its shell because tasteful outer beauty can no longer be a distraction." In both total abstraction and total realism the diverting outer has been eliminated, generating a sense of inner necessity. Total abstraction (complete silence about the world) and total realism (alchemical transmutation of the worldly object) involve the same process of reducing the "artistic" to a minimum. Art that seems to be "pure" in its being results; it no longer represents, but "presents," as a subjective indication of inner necessity and as radical "objectivity." Thus for Kandinsky the sense of art's inner necessity and the purity of the being it articulates converge in authentically spiritual abstraction. As Kandinsky said, the result is "the most intensely effective abstraction," that is, spiritual atmosphere or effect.[16]

The directing of art toward silence, the goal of radical abstraction, is inseparable from the understanding of abstract art as a kind of iconoclasm, as Renato Poggioli noted.[17] Poggioli connected iconoclasm with the "mystique of purity," and viewed silence, especially as Stéphane Mallarmé conceived it, as purity's instrument. Theodor W. Adorno connected "the posture of vanishing and falling silent"[18] with the modern "tendency for works of art to divest themselves of the atmospheric element while at the same time preserving it through deliberate negation."[19] This "atmospheric element" is what Kandinsky called the work's spiritual Stimmung, or "transcendent tendency." Deliberate silence, deliberate negation, is a major way of sustaining the elusive spiritual atmosphere of the abstract work by ruthlessly reducing the artistic ("tasteful outer beauty") to an absolute minimum. Indeed silence attempts to eliminate beauty altogether. Paradoxically the absolutely silent becomes the radically beautiful, just as for Hegel absolutely abstract spirit becomes radically concrete being. The silence evokes an ecstatic sense of immediacy, an experience of radical beauty, breaking all the habits of mediation conventionally associated with perception. The achievement of silence is the logical conclusion of the process of negation that abstraction is. Conclusive silence is the irreducible outcome of reductive abstraction.

According to Poggioli, the purity of silence implies that art can free itself "from the prison of things" (the noisy sound of reality). Silence is also art's way of suggesting its transcendence of the conditions of its creation and appearing to be self-created, which is another of the implications of Mallarmé's definition of the work of art as "hyperbolic." Finally silence "transcends the limits not only of reality but those of art itself, to the point of annihilating art in attempting to realize its deepest essence."[20] Silence is "an ever increasing process of distillation and condensation": purification. Poggioli remarked that Amédée Ozenfant was correct in thinking that silence represents "the need for extreme liberty and extreme intensity of feeling": absolute spiritual freedom. The problem is how to create essential silence in abstract art today.

Abstract art must pursue ever more complicated ways of becoming silent. Schapiro noted that Kandinsky was aware of the difficulty of achieving silence, which in part explains his shift from gesture to geometry, which seemed quieter. In 1931 Kandinsky wrote: "Today a point sometimes says more in a painting than a human figure. . . . The painter needs discreet, silent, almost insignificant objects. . . . How silent is an apple beside Laocoön. A circle is even more silent."[21] Many abstract artists have increased silence by abandoning even geometry, except for the minimal geometry of the canvas shape, which is sometimes echoed in the order of a grid, as in works by Agnes Martin. Touch itself exists under enormous constraint; it often becomes increasingly inhibited. As Adorno wrote, "The more spiritual works of art are, the more they erode their substance."[22] In the case of Robert Irwin and James Turrell the works seem almost substanceless. Silence can be understood as the eroded substance of the completely spiritual work of art.

The alchemical approach offers a different way of using abstract art to articulate the spiritual. By converting material, even the most random and outrageous material, into the "mystical inner construction" of art, the artist

gives the material inner meaning and thus uses it to generate spiritual atmosphere. This is less destructive of art itself, using its material nature to extend its spiritual possibilities rather than obliterating both. The alchemical approach emphasizes art's transformative power. Art has not only the power of transforming materials by locating them in an aesthetic order of perception and understanding but also of transforming the perception and understanding of different kinds of being by making explicit their hidden connection. Both silence and alchemy are spiritual in import, but where silence is an articulation of the immaterial, alchemy is a demonstration of the unity of the immaterial and the material. Joseph Beuys (pls. 1–5) said that "man does not consist of chemical processes, but also of metaphysical occurrences."[23] Alchemical abstract art can be understood as a place of major metaphysical occurrences, as a spiritual place. Abstract art as an alchemical-spiritualizing process, however, is a means, not of offering disguised imagistic support to religious dogmas, but of exploring the possibilities of "bringing together what has come apart," as Bruno Ceccobelli put it.[24]

Alchemical abstraction attempts to evoke a sense of unity. In alchemical abstraction formal contrast is read as metaphysical unity, and every pictorial element becomes subliminally symbolic.

The abstractions of silence and of alchemy converge in their common pursuit of what Ernst Cassirer called "symbolic pregnance," their gnosticism. The picture produces "a sensory experience [which] by virtue of the picture's own immanent organization, takes on a kind of spiritual articulation."[25] The symbolic pregnance, which the abstract work is experienced as possessing, returns perception to "zero-degree" appearance, on the order of Roland Barthes's "zero-degree writing"; the work as a whole is read spiritually rather than empirically. What this means was indicated by Max Kozloff, who pointed out, writing about Mark Rothko's version of silent painting

1
JOSEPH BEUYS
Dance of the Shaman, 1961
Pencil and oil on paper
Two parts each 8 ¼ x 11 ¾ in.
(21 x 29.8 cm)
Anthony d'Offay Gallery,
London
.

2
JOSEPH BEUYS
Blue on Centre, 1984
Painted metal and cardboard
12 ⁷⁄₁₆ x 9 ½ in.
(31.7 x 24.2 cm)
Anthony d'Offay Gallery,
London
·

3
JOSEPH BEUYS
Yellow on Centre, 1984
Painted metal and cardboard
14 ⁹⁄₁₆ x 10 ¾ in.
(37 x 27.3 cm)
Anthony d'Offay Gallery,
London
·

4
JOSEPH BEUYS
Red on Centre, 1984
Painted metal and cardboard
12 ⅜ x 8 ½ in.
(31.5 x 21.6 cm)
Anthony d'Offay Gallery,
London
·

5
JOSEPH BEUYS
Green on Centre, 1984
Painted metal and cardboard
12 ½ x 8 ¹¹⁄₁₆ in.
(31.8 x 22.1 cm)
Anthony d'Offay Gallery,
London
·

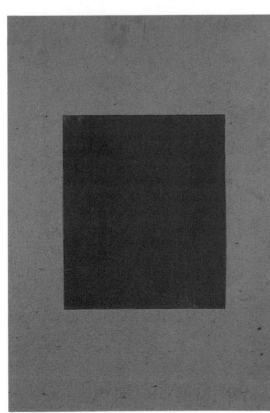
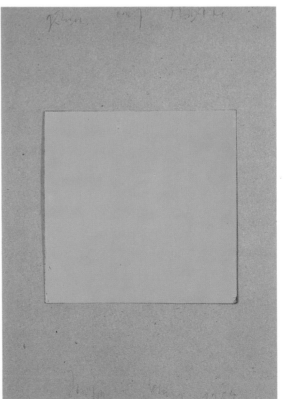

(pl. 6), that it is necessary "to find that lever of consciousness which will change a blank painted fabric into a glow perpetuating itself into the memory." Without this lever there is no reason to "belie the suspicion that he [Rothko] is but the creator of pigmented containers of emptiness."[26] The problem was put another way by Michel Conil-Lacoste, who remarked that there are "two readings of Rothko: not only the technician of color, but also the engaged heart of mysticism."[27] As Kozloff said, only when "the spectator himself, growing more intent on the color vibrations [of Rothko's paintings], learns to discount the surface, [so that] the whole painting ceases to *be,* as a concrete thing," does its "mystical" or "spiritual" character, its "transcendental beauty," become evident.[28] This beauty is materially actualized as color, but color itself becomes a transcendental experience, acquires symbolic pregnance, when it seems immaterial and thereby all the more immediate. What Yves Klein called the "mystical system" of "universal impregnation of color"[29] is central to the effect of transcendental immediacy or symbolic pregnance in much silent painting. When Marc spoke of the abstract work as a "mystical inner construction," in effect he was speaking of its power to ecstatically convert the empirically given into the transcendent.

Lucy Lippard noted that the tradition of silent painting, or "monotonal paintings" of "'empty' surface," has no "nihilistic intent."[30] Their emptiness is really a form of spiritual expression:

The ultimate in monotone, monochrome painting is the black or white canvas. As the two extremes, the so-called no-colors, white and black are associated with pure and impure, open and closed. The white painting is a "blank" canvas, where all is potential; the black painting has obviously been painted, but painted out, hidden, destroyed. An exhibition of all-black paintings ranging from Rodchenko to Humphrey to Corbett to Reinhardt, or an exhibition of all-white paintings, from Malevich to Klein, Jusama, Newman, Francis, Corbett, Martin, Irwin, Ryman, and Rauschenberg, would be a lesson to those who consider such art "empty."[31]

In this context one recalls Ad Reinhardt's insistence that "you can only make absolute statements negatively,"[32] a statement that is inseparable from the basic understanding of abstraction as negation. Reinhardt connected his own painting with "a long tradition of negative theology in which the essence of religion, and in my case the essence of art, is pro-

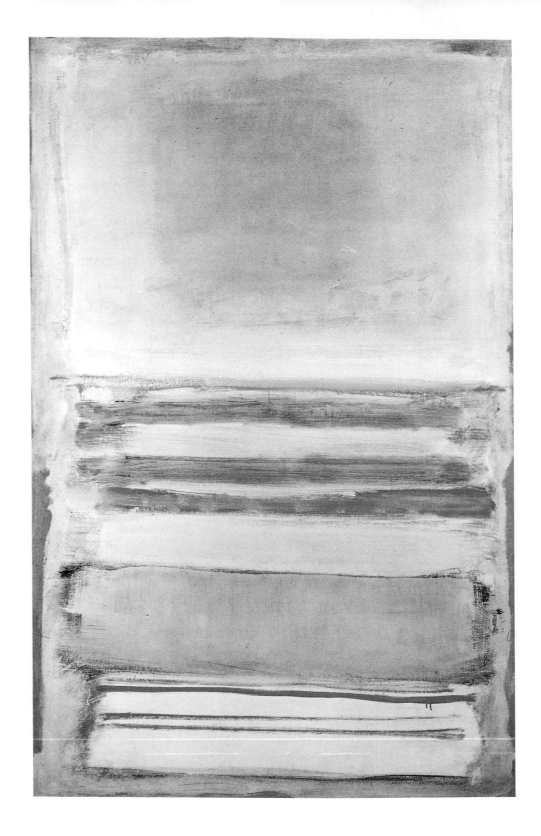

6
MARK ROTHKO
Number 11, 1949
Oil on canvas
68 x 43 ¼ in.
(172.8 x 109.9 cm)
National Gallery of Art,
Washington, D.C.
Gift of the Mark Rothko
Foundation

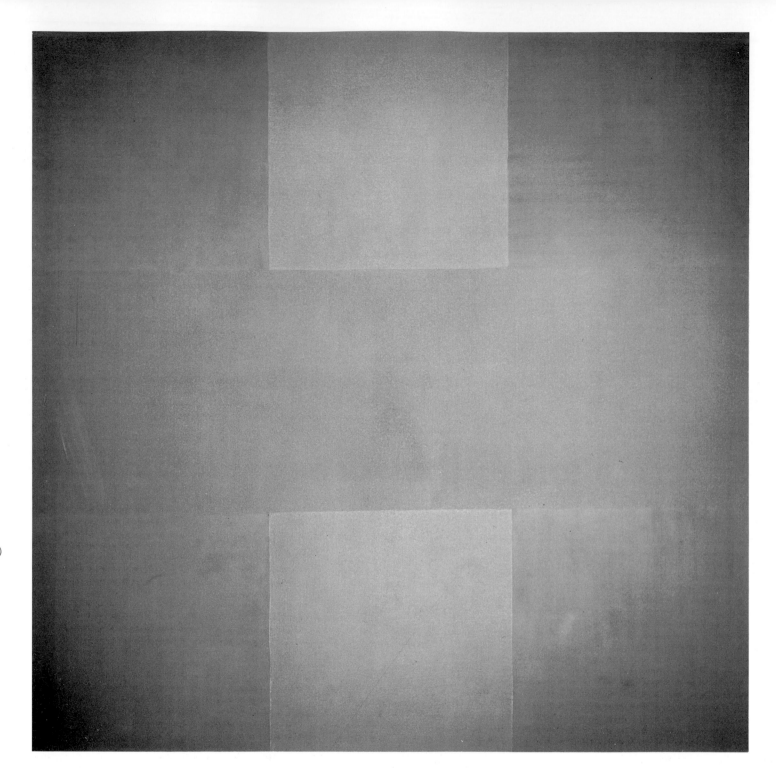

7
AD REINHARDT
Abstract Painting, 1960
Oil on canvas
60 x 60 in. (152.4 x 152.4 cm)
Marlborough Gallery, New
York
.

8
ALFRED JENSEN
*A Circumpolar Journey, Per I,
Per II, Per III, Per IV,* 1973
Oil on canvas
96 x 96 in. (243.8 x 243.8 cm)
Mr. and Mrs. M. A. Gribin
.

tected or the attempt is made to protect it from being pinned down or vulgarized or exploited."[33] For Reinhardt the "square, cruciform, unified absolutely clean"[34] mandala shape he utilized in his famous "black," or negative, paintings (pl. 7) serves the same purpose as Rothko's "disembodied chromatic sensations," namely, to preserve the spiritual atmosphere. While, as Lippard noted, some artists, such as Barnett Newman, welcome spiritual "symbolic or associative interpretation," and others are "vehemently opposed to any interpretation and deny the religious or mystical content often read into their work as a result of the breadth and calm inherent in the monotonal theme itself,"[35] there is no denying the numinous effect generated by the negativity of silent abstraction. The silent painting, contemplated in a more than casual way, has a numinous effect simply by reason of its radical concreteness, its unconditional immediacy. This can be iconographically interpreted or not, but it is functionally mystical — that is, it is not the vehicle of communication of religious dogma but of a certain kind of irreducible, nondiscursive experience. Many of the silent painters who refuse their work an overt religious meaning are afraid

that their art will be appropriated by a belief system, becoming a dispensable instrument of faith rather than an end in itself. It will thereby lose the full power of its negativity. The question of religious belief is separate from the question of spiritual experience, which is what silent painting engages.

Silent abstract painting works through its holistic effect. It seems to articulate an irreducible unity, one that survives any attempt to differentiate it. In the painting of mandalas, this unity remains but is communicated through finite forms that acquire symbolic import. The symbolic in this context is a kind of borderline between the communicative and the spiritual, in the sense of Schapiro's distinction. The symbol is a kind of limit of materiality and as such an approach to the immaterial. It offers as much communication, as much of a prepared and complete message, as the abstract spiritual painting allows. The problem with the spiritual symbolism used by such painting is that it tends to become a communicative cliché by reason of its cultural familiarity or traditional character or else tends not to communicate spirituality at all, simply becoming a boring, empty shape. Symbolic spiritual art, a communicative extension of silent painting, must dramatize (respiritualize, revitalize) the forms it uses

to make them spiritually convincing. It does this by fusing their eternal character with a worldly content that is shown to have mystical import, inner meaning. This interaction and reconciliation generates spiritual atmosphere.

Alfred Jensen's work (pl. 8) accomplishes this in an exemplary way. Jensen, an avowed mystagogue, established a correlation between the mandala-diagram forms he used and actual events of the contemporary world, events that bespeak spiritual reality. With great daring, he united the technological and spiritual worlds, usually thought of as impossibly at odds. Thus his painting *A Film Ringed the Earth*, 1961 (pl. 9), deals with the first space flight as a spiritual event on the borderline between the physical and metaphysical, alchemically synthesizing the two in the person of the first astronaut, the Russian Yuri Gagarin. The work brings together the *New York Times* article on the flight and Jensen's diagrams of some of the "visions" it produced. The newspaper headline — "Gagarin Floated, Ate and Sang in Ecstasy on Trip into Space" — describes the event. The handwritten headlines — "In space the polarities separate and

9
ALFRED JENSEN
A Film Ringed the Earth, 1961
Ink and collage on paper
22 x 28 in. (55.9 x 71.1 cm)
Regina Bogat
.

10
ALFRED JENSEN
*My Oneness: A Universe of
Colors,* 1957
Oil on canvas
26 x 22 in. (66 x 55.9 cm)
Edward R. Downe,
Jr.
.

again unite when a boundary of darkness to light is crossed"; "First space-man sees color along the spherical space of the earth"; "Gagarin seeing the horizon from the bright surface of the earth sees a delicate blue color. Gagarin emergeing [sic] from the shadow of the earth sees the horizon a bright orange strip along it" — suggest the event's spiritual significance. Color is ecstatically perceived, where ecstasy has the weight of its original etymological meaning, a standing-out: the perception of the dynamic in the static. Jensen identifies with Gagarin and recreates what is for Jensen the most essential aspect of Gagarin's experience: the lyricism of perception in space. This lyricism involves the direct experience of color as an oscillation between poles. The direction of the movement determines the very nature of the color as well as its quality.

This painting is Jensen's spiritual credo and links with an earlier credo, *My Oneness: A Universe of Colors,* 1957 (pl. 10). This work surrounds a tantric circle mandala, not unrelated to those painted by Kenneth Noland around the same time, with two boldly written words — "Self-Identity" and "Self-Integration" — and two quotations: "So we'll live and pray and sing and tell old

tales and laugh at gilded butterflies" (William Shakespeare) and "No repeated group of words would fit their rhythm and no scale could give them meaning" (Nathanael West). Self-identity and self-integration are the "gilded butterflies" that can never be captured in a net of words, for no words nor scale of meaning can fit or measure them.

Jensen's way of working seems applicable to many successful mandala-diagram, or symbolically spiritual, types of painting. The use of vibrant color, the sense of empirical events that are inherently spiritual, and the emphasis on the ecstatic experience of the self leading to an identification of the abstract-symbolic work with the self — all of this is central to an understanding of the symbolic spiritual painting. What is pursued in Jensen's paintings is pursued in most significant symbolic spiritual paintings: the achievement of integration out of which a sense of identity or self emerges. That viewing experience comes from a complex physical integration of the material of the work and the symbol, as well as of the symbol and its exemplification. The dynamics of this integrative process are crucial, for the symbol is already an integrated form. The symbol is given a fresh sense of ecstatic immediacy by the dynamic materiality that gives it new body.

It is not that the use of such geometrical gestalts as the circle, whether rendered in a painterly or a smooth manner, must be justified by having spiritual import or deep meaning imposed on them but that they have spontaneous spiritual effect when rendered through carefully particular paint, which acquires a special articulateness and immediacy through the obsessional care with which it is presented. It is as though the manifestation of the symbolic form is the result of a spiritual force trying to break through the empirical surface of the painting. There is nothing didactic or mystifying about Jensen's paintings. There is only the effort to break down the distance between the painted gestalt and us by creating an experience of unity out of impossibly disparate sources. So effective is the integration that the unity seems to have existed before its manifestation and seems transcendental.

Jensen makes explicit the issues of self-identification and self-integration that are latent in the meaning of the spiritual today. The correspondence he seeks to effect between different visual systems in his mandala paintings — a correspondence that seems inevitable, generating an aura of the eternal (*Eternity,*

1959, makes the point succinctly) — is given added significance by the explicitness with which it is asserted as a self-system.[36] It is the self that Beuys called "metaphysical occurrence." When Jensen painted *Unity in the Square, Per I and Per II,* 1967, he was painting a "self-portrait." He also converges with Beuys, who thought of the work of art as "an energy center" — a convergence that indicates the consistency of spiritual conception, or the unavoidability of certain elements in every conception of spiritual experience — in his acknowledgment of the nineteenth-century physicist Michael Faraday as the source of the idea of space, "vacant or filled with matter," as nothing but "forces and the lines in which they are exerted." This idea conceives of objects as materialized fields of energy or lines of force. Ecstasy and eternity, the experience of self-integration and self-identification, are manifest through the dynamic experience of color-space.

The spiritual reliance on mandalas — lines of force organized in a field of space, interlock-ing systems or grids generating an expansive, sublime energy and implying a cosmic energy beyond the given space of earth — has an ancient history. Perhaps the most uncompli-cated, naturally available mandala is the golden section: a relationship of two parts to a whole in which the ratio of the smaller part to the larger is the same as the ratio of the larger part to the whole. This mystical proportion, existing beyond invention, is usually not understood as a mandala, but that is exactly what it is. Dorothea Rockburne's work (pl. 11) is dominated by an increasingly coloristic articulation of the golden section:

One of its aspects that makes the Golden Section so fascinating to Rockburne is the correspondence it suggests — for example, the musical chord that seems most satisfying to the ear — the major sixth — vibrates at a ratio that approximates the Golden Section. The same ratio is equal to the relationship between any two numbers of the Fibonacci num-bering system, invented by a thirteenth-century Italian mathematician. In turn, the Fibonacci num-bering system is the basis for such diverse "sys-tems" as the spiral patterns in certain types of pine cones and the spiral shells of certain sea creatures. All of these correspondences fascinate the artist, and she has said that working with the proportions of the Golden Section is magical for her. The proportions give the magic as she puts them together.[37]

It is the magic of coming to consciousness, of alchemical recognition of secret relationship and identity. This magic is also something else: a revelation of the mystical content directly available in the universal symbolic form of the golden section, immanent in natu-ral reality — that is, a revelation of the mys-tical inner construction of nature. It is a structure that seems to represent reason but in fact points to the transrational. The prev-alence of the golden section in nature is inex-plicable, which is why it can be described as mystical. For Rockburne the golden section is in effect a metaphysical occurrence on the borderline between physics and metaphysics, a spiritual experience, an articulation of spiri-tual meaning. The golden section is the mandala fundamental to Rockburne's attempt to objectify her feelings in color, in line with Jean-Paul Sartre's conception, quoted by Rockburne in her diary, that "a feeling is not an inner disposition, but an objective tran-scending relation which has as its object to learn what it is."[38] The logical ratio that con-stitutes the golden section structures the color relationships that express a feeling. Indeed the golden section is a kind of philosopher's stone — "transformer/transmitter," as Beuys put it

— charging inert colors with spiritual meaning, changing them into that spiritual experience called a self-reflexive feeling. The equilibration of colors established by the golden section ratio is simultaneously physical and metaphysical, like self-aware feeling (what Beuys called the "provocative I" and the "idea" evoked through that I's artistic activity; what Kozloff called the "lever of consciousness").

Along with finding the eternal element in the contemporary event, as in Jensen, and along with communicating the immediacy of color, as in Rothko and Klein, objectifying ahistorical, mathematical truth is certainly an indisputable basis for creating and recognizing spiritually resonant abstract painting such as Rockburne's. If color is nature at its most conspicuous and forceful, then the golden section is the spiritual at its most self-evident, having the quiet force of a symbol that conveys at once a sense of the inevitability and incomprehensibility of the cosmic order. The golden section shows that an authentic symbol is a direct manifestation of the mystical inner construction of nature, as well as a sign that suggests the spiritual experience of that construction. In Rockburne's work color activates the symbol to make it suggestive of

spiritual experience, to make it hypnotic and talismanic, a fetish that points to an ecstatic relation with the whole of being and that present this oneness in essential form. For all the sophistication of the mandala users, their goal is an innocent relationship to an ultimate.

William James offered " 'four marks' of the mystic state, Ineffability, Noetic Quality, Transiency, and Passivity." Evelyn Underhill, finding them inadequate, proposed four alternative "rules or notes which may be applied as tests to any given case":

1. True mysticism is active and practical, not passive and theoretical. It is an organic life-process, something which the whole self does; not something as to which its intellect holds an opinion.

2. Its aims are wholly transcendental and spiritual. It is in no way concerned with adding to, exploring, rearranging, or improving anything in the visible universe. The mystic brushes aside that universe, even in its supernormal manifestations. Though he does not, as his enemies declare, neglect his duty to the many, his heart is always set upon the changeless One.

3. This One is, for the mystic, not merely the Reality of all that is, but also a living and personal Object of Love; never an object of exploration. It draws his whole being homeward, but always under the guidance of the heart.

4. Living union with this One — which is the term of his adventure — is a definite state or form of enhanced life. It is obtained neither from an intellectual realization of its delights, nor from the most acute emotional longings. Though these must be present, they are not enough. It is arrived at by an arduous psychological and spiritual process — the so-called Mystic Way — entailing the complete remaking of character and the liberation of a new, or rather latent, form of consciousness; which imposes on the self the condition which is sometimes inaccurately called "ecstasy," but is better named the Unitive State.[39]

Applying Underhill's criteria to abstract art that claims to articulate the mystic state, one recognizes that while most works do not satisfy all the criteria, many satisfy one or more, suggesting that they articulate not only aspects of the mystic state but also the process of realizing it. Many of the paintings that seem to show "heart" through their immersion in color also use it to create the silence that renounces the visible universe, to wipe out "the many," except in the residual form of

color differences and nuances of tone within a single color. The alchemical-symbolic paintings seem concerned to force, not simply, evoke, latent consciousness of the unitive state. Holistic works in general seem to symbolize it as concretely as possible, as if the materialization of oneness could produce on demand latent consciousness of it. All of these works attempt to renew art as a mystical process and show that the work of art can function as a surrogate absolute reality.

Many abstract works show an "active and practical" process of working through the empirically given to the spiritually articulate. (This is not the same as Alfred Jensen's synthesis of the empirical and the spiritual.) On the one hand, there are works that attempt to articulate the mystic state by working through the appearances of nature toward a unified symbol of the supernatural. The works of Morris Graves, Mark Tobey, and more recently Bill Jensen (pls. 12–13) are important examples. On the other hand, there are works that attempt to evoke a sense of the prehistorical, a primitive state that becomes emblematic of the mystic state. Eric Orr (pl. 14) and Bruno Ceccobelli (see p. 57), in their very different ways, are major examples. In both kinds of work the artist is attempting to function shamanistically.

In general it can be argued that a shamanistic intention motivated the turn to abstraction from the start: the artist was trying to give new form to an archaic social definition of himself. The attempt to convert "the configuration of sensuous moments" into "spiritual facets," to demonstrate that in a work of pure art "nothing is to be taken literally," that its materiality and sensuality make experiential sense only through their spiritual atmosphere,[40] is the essence of shamanism. It is the heart of what the artist Mimmo Rotella called the "mythical metamorphosis,"[41] a metamorphosis that is art's responsibility. The attempt to articulate what Klein called "the great emptiness"[42] or what Group O called the "zone of silence"[43] as demonstrations, not simply signs, of spiritual presence is pure shamanism. When Klein, in his 1961 Cosmogonies (pl. 15), regarded such marks of the earth's atmosphere as rain, wind, and sunrays as spiritual presences, he revealed a shamanistic intention (see also pl. 16). Perhaps he was most shamanistic when he insisted that the bare walls of his exhibition at the Iris Clert Gallery in Paris in 1958, "zones of immaterial pictorial sensibility," be paid for in pure gold,

for "the highest quality of the immaterial should be paid for with the highest quality of the material."[44] While such shamanistic efforts can seem to fall flat — one of Klein's most famous uses of his immaculately conceived blue, the decoration of the opera house at Gelsenkirchen with two large monochrome panels in blue and two large relief murals of natural sponges in blue, 1957–59, seems as material as mystical — their intention may be more crucial than their result, as an indication that spiritual intention survives in art. Indeed one of the paradoxes of trying to understand manifestations of the spiritual in art is that one is not always sure of the result, which itself is a sign that the art is in arduous spiritual process.

Orr's *Sunrise*, 1976, for example, seems to dwell purposefully on such ambiguity, as though in and of itself it was the Mystic Way. It is a work that summarizes the methods of mystical achievement, bringing together the silent and the alchemical, showing silence as alchemical and alchemy as entailing a certain silent response to material:

14
ERIC ORR
Crazy Wisdom II, 1982
Lead, gold leaf, human skull bone, ground AM/FM radio, and blood on linen
43 x 32 x 2 in.
(109.2 x 81.3 x 5.1 cm)
James Corcoran Gallery, Los Angeles

.

15
YVES KLEIN
Cosmogony (COS 27), 1961
Acrylic on canvas
36 5/8 x 29 1/8 in. (93 x 74 cm)
Private collection

.

16

YVES KLEIN

a. International Klein Blue
(IKB 67), 1959
Pigment and synthetic resin
on canvas and wood
36 x 29 in.
(91.4 x 73.7 cm)
Private collection

b. Monogold (MG 8), 1962
Gold leaf, gesso on wood
32 x 29 in. (81.3 x 73.7 cm)
Private collection

c. Monopink (MP 19), 1962
Pigment and synthetic resin
on canvas and wood
36 x 29 in. (91.4 x 73.7 cm)
Private collection

.

Sunrise introduced silence, alongside space and light, as a third primary material in Orr's work. A room 9 by 9 by 18 feet in exterior dimensions was built indoors, its outer surfaces sheathed with sheets of lead which by screening out most radiation created, inside, a partial cosmic ray void. The dimensions of the interior space were arithmetically related to those of the King's Chamber of the Great Pyramid. A ceiling channel at one end of the interior of the room extended through the rooftop of the outer building; on the roof a tracking device followed the sun from dawn to dusk and reflected it, through the channel, onto the back interior wall of the lead-sheathed room. Each sunrise, an upright silvery panel set into the rear wall of the black, light-tight inner space, would catch a thin strip of light at its bottom edge. This swath of light would grow through the day, holding tightly to the edges of the silvery ground, until sunset, when it would fade quickly. In late afternoon the bar of light palpably throbbed in the darkness, like a solid gleaming substance floating several inches in front of the wall. Heavy insulation of the interior walls created an acoustically dead zone; in the unrelenting silence one's interior body sounds, as well as the quiet and fragmentary thoughts which usually go unnoticed, bubbled to the surface. The sense of one's body, in that black silence, become overpoweringly present and absorbing; at the same time the sense of one's material boundaries receded.[45]

This spatialization of silence and light, two traditionally mystical "materials," confirms the shamanistic ritual that Orr's construction is because it implies the easy convertibility of the immaterial into the material and vice versa. It is such magical convertibility that is the source of the work's ambiguous spirituality. Yet, as suggested, it is just this ambiguity that is responsible for the work's spiritual atmosphere. The insecurity of that atmosphere secures the work for the spirit. It is worth noting that Orr's elaborate reconstruction of an officially spiritual space in the Great Pyramid shows a further insecurity with the very idea of the spirit, a reliance on a traditional sense of its manifestation. But this sense of a tradition that can be archaeologically

reconstructed is part of the spiritual atmosphere of such work, a confirmation of it as a mystical inner construction, for the sense of tradition is a screen memory for a more archaic sense of the spirit, an eternally returning memory of the eternal. The symbols used by spiritual art are another form of this eternal return, another proof that the spirit has stable modes of appearance however much such modes may, for the uninitiated, seem purely material and mechanical.

1. Wassily Kandinsky, *Concerning the Spiritual in Art* (1912), trans. M. T. H. Sadler (1914; New York: Dover, 1977), 17.

2. Ibid., 2.

3. Ibid., 4.

4. Ibid., 2.

5. Franz Marc, "Spiritual Treasures," in *The Blaue Reiter Almanac* (1912), ed. Wassily Kandinsky and Franz Marc; documentary edition edited by Klaus Lankheit (New York: Viking, 1974), 59.

6. Kandinsky, *Concerning the Spiritual in Art,* 26.

7. Ibid., 3.

8. Marc, "Spiritual Treasures," 55.

9. Meyer Schapiro, "Recent Abstract Painting" (1957) in idem, *Modern Art, Nineteenth and Twentieth Centuries: Selected Papers* (New York: Braziller, 1978), 222–23.

10. Ibid., 223.

11. Kandinsky, *Concerning the Spiritual in Art,* 2.

12. Schapiro, "Recent Abstract Painting," 223.

13. Ibid., 224.

14. Ibid.

15. Wassily Kandinsky, "On the Question of Form" (1912), in *Blaue Reiter Almanac,* 158.

16. Ibid., 160–62.

17. Renato Poggioli, *The Theory of the Avant-Garde* (New York: Harper & Row, 1971), 181.

18. T. W. Adorno, *Aesthetic Theory* (London: Routledge & Kegan Paul, 1984), 297.

19. Ibid., 386.

20. Poggioli, *Avant-Garde,* 201–2.

21. Quoted in Schapiro, "Recent Abstract Painting," 205.

22. Adorno, *Aesthetic Theory,* 130.

23. Quoted in Willoughby Sharp, "An Interview with Joseph Beuys," *Artforum* 8 (December 1969): 45.

24. Quoted in Frans Haks, *Domenico Bianchi, Bruno Ceccobelli, Gianni Dessi, Giuseppe Gallo,* exh. cat. (Groningen: Groninger Museum, 1981), 15.

25. Quoted in Donald Kuspit, "Symbolic Pregnance in Mark Rothko and Clyfford Still," *Arts* 52 (March 1978): 120.

26. Max Kozloff, "Mark Rothko," in *Renderings* (New York: Simon & Schuster, 1969), 152.

27. Michel Conil-Lacoste, "La Transcendence de Rothko," *Le Monde des arts* (29 March 1972): 13.

28. Kozloff, "Mark Rothko," 151.

29. Quoted by Aldo Pellegrini, *New Tendencies in Art* (New York: Crown Publishers, 1966), 238.

30. Lucy R. Lippard, "Silent Art: Robert Mangold," in *Changing* (New York: Dutton, 1971), 130, 132, 134.

31. Ibid., 134.

32. Quoted in Robyn Denny and Phylisann Kallick, "Ad Reinhardt," *Studio* 174 (December 1967): 264.

33. Ibid., 267.

34. Ad Reinhardt, "Angkor and Art," *Art News* 60 (December 1961): 44.

35. Lippard, "Silent Art," 136.

36. For a discussion of "self-system" see Heinz Kohut, *The Analysis of Self* (New York: International Universities Press, 1971) and *The Restoration of the Self* (New York: International Universities Press, 1977).

37. Michael Marlais, *Dorothea Rockburne, Drawing: Structure and Curve,* exh. cat. (New York: John Weber Gallery, 1978), 4–5.

38. Quoted in Naomi Spector, *Dorothea Rockburne: Working with the Golden Section 1974–76,* exh. cat. (New York: John Weber Gallery, 1976), 7.

39. Evelyn Underhill, *Mysticism* (New York: Noonday Press, 1955), 81.

40. Adorno, *Aesthetic Theory,* 129.

41. Quoted by Pellegrini, 262.

42. Ibid., 253.

43. Ibid., 263.

44. Ibid., 252.

45. Selection by Eric Orr from Thomas McEvilley, "Negative Presences in Secret Spaces: The Art of Eric Orr," *Artforum* 20 (Summer 1982): 58–66. In *Eric Orr: A Twenty-Year Survey,* exh. cat. (San Diego: San Diego State University Art Gallery, 1984), 43.

OVERLEAF

Pages 326–53.
A portfolio of works
from the exhibition

.

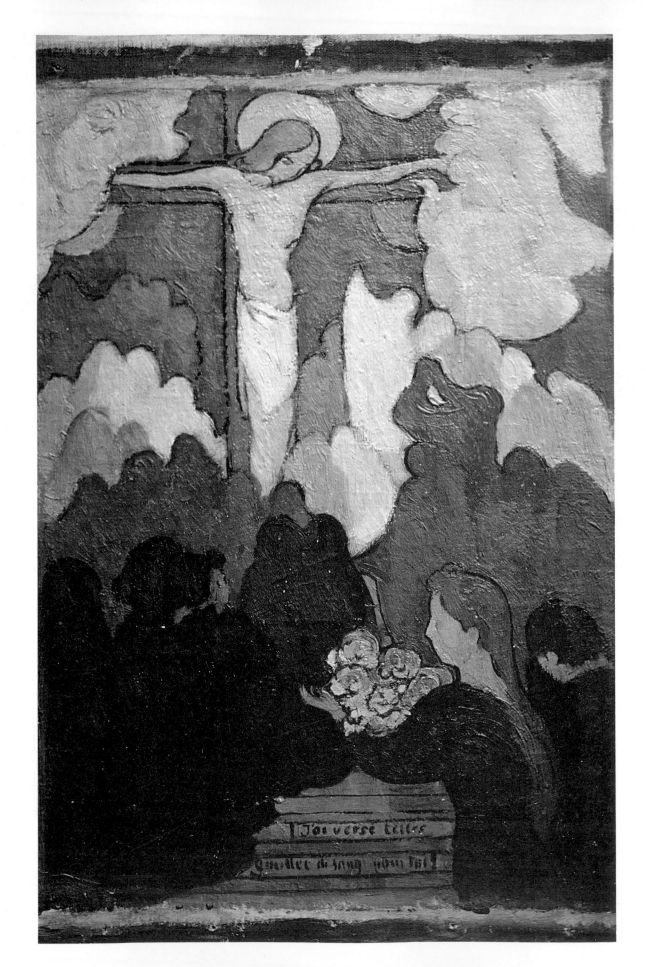

MAURICE DENIS
Offering at Calvary, 1890
Oil on canvas
12 9/16 x 9 11/16 in.
(32 x 24.6 cm)
Private collection, France

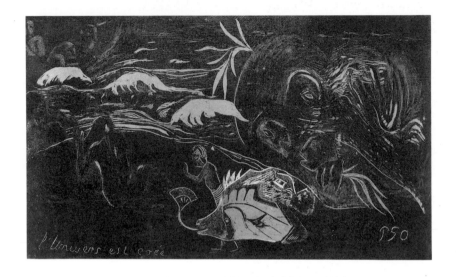

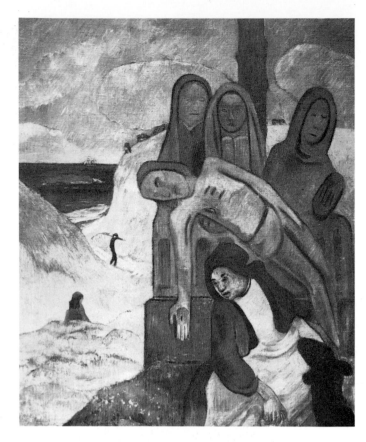

PAUL GAUGUIN
The Universe Is Created,
1893–94
Hand-colored wood
engraving
8 x 13 ⅞ in. (20.3 x 35.2 cm)
Memorial Art Gallery of The
University of Rochester,
New York
Anonymous gift

·

PAUL GAUGUIN
*The Breton Calvary: The
Green Christ*, 1889
Oil on canvas
36 ¼ x 28 ¾ in.
(92.1 x 73 cm)
Musées Royaux des Beaux-
Arts, Brussels

·

FERDINAND HODLER
Sunset on Lake Geneva, 1915
Oil on canvas
24 x 35 ⁷⁄₁₆ in. (61 x 90 cm)
Kunsthaus Zürich,
Switzerland

·

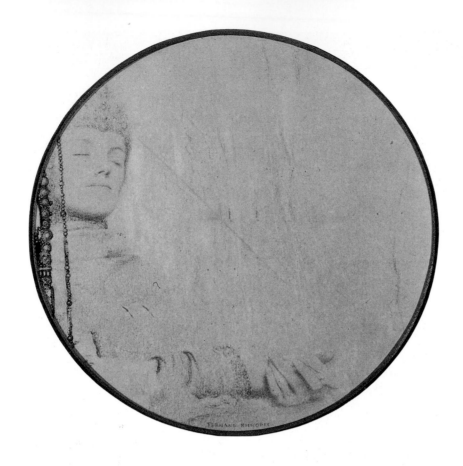

FERNAND KHNOPFF
A Dreamer, c. 1900
Colored pencil on paper
Diameter 5 ¼ in. (13.3 cm)
Barry Friedman, Ltd., New
York

.

FERNAND KHNOPFF
Study for "The Incense," c.
1917
Charcoal and colored pencil
on paper
11 ½ x 7 ¾ in.
(29.2 x 19.7 cm)
Barry Friedman, Ltd., New
York

.

EDVARD MUNCH
The Sun II, c. 1912
Oil on canvas
64 ³⁄₁₆ x 80 ¹⁵⁄₁₆ in.
(163 x 205.5 cm)
Munch-Museet,
Oslo

.

EDVARD MUNCH
Metabolism, 1899
Oil on canvas
67 ¾ x 55 ¹⁵⁄₁₆ in.
(172 x 142 cm)
Munch–Museet,
Oslo
.

WASSILY KANDINSKY
The Blue Mountain, 1908–9
Oil on canvas
41 ¾ x 38 ¹⁄₁₆ in.
(106 x 96.6 cm)
Solomon R. Guggenheim
Museum, New York
·

WASSILY KANDINSKY
Black Spot, from *Klange*
(1913)
Woodcut
6 ⅝ x 8 ⁷⁄₁₆ in.
(16.9 x 21.4 cm)
Los Angeles County
Museum of Art
Robert Gore Rifkind Center
for German Expressionist
Studies
·

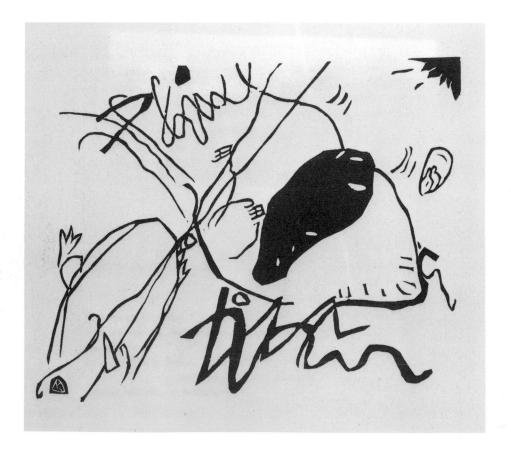

FRANTIŠEK KUPKA
Water; The Bather, 1909
Oil on canvas
24 13/16 x 31 1/8 in. (63 x 79 cm)
Musée National d'Art
Moderne, Centre Georges
Pompidou, Paris

.

FRANTIŠEK KUPKA
The Primitive, 1910–11
Oil on canvas
39 3/8 x 28 9/16 in.
(100 x 72.5 cm)
Musée National d'Art
Moderne, Centre Georges
Pompidou, Paris

.

FRANTIŠEK KUPKA
Woman in Triangles, 1911
India ink on paper
9 7/16 x 8 11/16 in. (24 x 22 cm)
Musée National d'Art
Moderne, Centre Georges
Pompidou, Paris

.

FRANTIŠEK KUPKA
Curling Black Contours,
1911–12
Oil on canvas
26 x 26 in. (66 x 66 cm)
Musée National d'Art
Moderne, Centre Georges
Pompidou, Paris
.

FRANTIŠEK KUPKA
Animated Oval (Birth),
1911–12
Oil on canvas
28 ¾ x 31 ⅝ in.
(73 x 80.3 cm)
Joseph H. Hazen
Collection
.

FRANTIŠEK KUPKA
Nondescript Space, 1914
Oil on canvas
44 ½ x 45 ¼ in.
(113 x 115 cm)
Galerie Louis Carré et Cie,
Paris
.

FRANTIŠEK KUPKA
Hindu Motif or Range of Reds,
1920
Oil on canvas
48 9/16 x 48 in.
(124.5 x 122 cm)
Musée National d'Art
Moderne, Centre Georges
Pompidou, Paris
.

FRANTIŠEK KUPKA
Abstraction, c. 1930
Black and white gouache on
cream paper
11 x 11 in. (28 x 28 cm)
Musée National d'Art
Moderne, Centre Georges
Pompidou, Paris
.

PAUL KLEE
Still Life, 1929
Watercolor on paper
10 ⁷⁄₁₆ x 8 ¼ in. (26.5 x 21 cm)
Galerie Rosengart, Lucerne,
Switzerland

·

PIET MONDRIAN
*Composition No. 2 with Black
Lines,* 1930
Oil on canvas
19 ⅞ x 19 ⅞ in.
(50.5 x 50.5 cm)
Stedelijk van Abbemuseum,
Eindhoven, Netherlands

·

AUGUSTO GIACOMETTI
Growth, 1919
Oil on canvas
41 ⁵⁄₁₆ x 41 ⁵⁄₁₆ in.
(105 x 105 cm)
Kunsthaus Zürich,
Switzerland
Vereinigung Züricher
Kunstfreunde

·

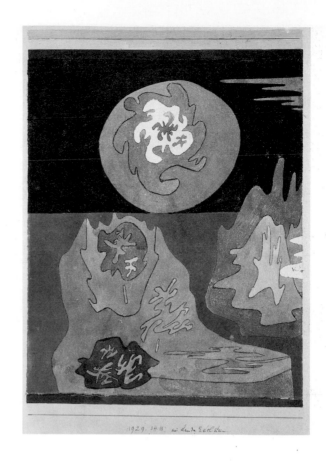

PAUL KLEE
In the Land of Edelstein, 1929
Watercolor on paper
14 13/16 x 11 1/16 in.
(37.7 x 28.1 cm)
Kunstmuseum Basel,
Kupferstichkabinett,
Switzerland

.

IVAN KLIUN
Untitled, 1922
Gouache on paper
8 3/8 x 4 11/16 in.
(21.3 x 11.9 cm)
The George Costakis
Collection (owned by Art
Co. Ltd.)
© George Costakis,
1981

.

IVAN KLIUN
Untitled, 1923
Watercolor, pencil, and chalk
on paper
16 1/2 x 12 5/16 in.
(41.9 x 31.3 cm)
The George Costakis
Collection (owned by Art
Co. Ltd.)
© George Costakis,
1981

.

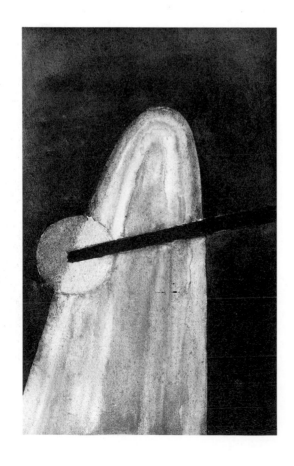

WILHELM MORGNER
Friendly Apparition, 1911–12
Oil on canvas
44 ½ x 28 ¹⁵⁄₁₆ in.
(113 x 73.5 cm)
The Robert Gore Rifkind
Collection, Beverly Hills,
California

WILHELM MORGNER
Fields, 1912
Oil on board
29 ⁵⁄₁₆ x 39 ³⁄₁₆ in.
(74.5 x 99.5 cm)
Museum Bochum,
Kunstsammlung, West
Germany

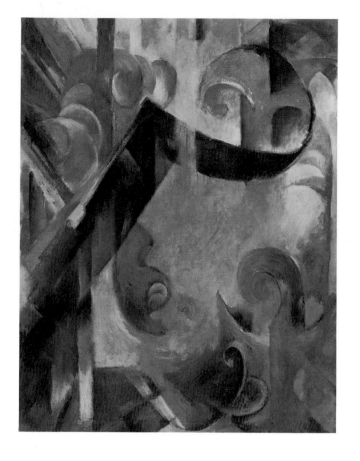

GEORG MUCHE
Picture, 1916
Oil on linen
26 ¾ x 21 ⅝ in. (68 x 55 cm)
Private collection
.

FRANZ MARC
Broken Forms, 1914
Oil on canvas
44 x 33 ¼ in.
(111.8 x 84.5 cm)
Solomon R. Guggenheim
Museum, New York
.

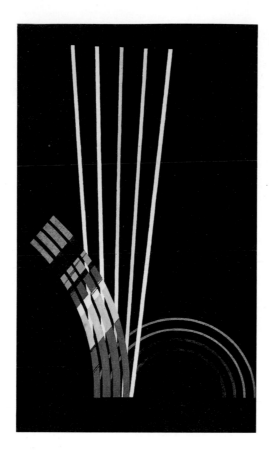

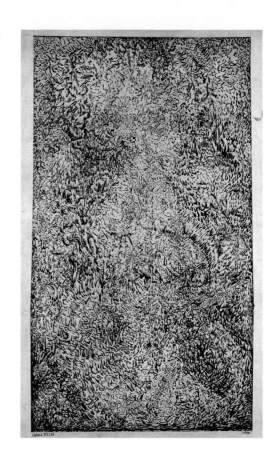

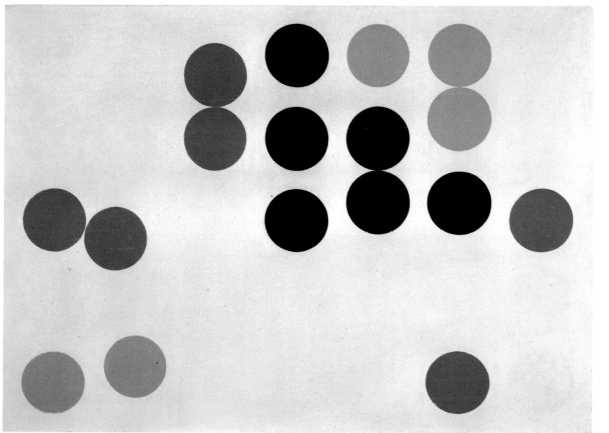

FRANCIS PICABIA
Music Is Like Painting, c.
1913–17
Watercolor and gouache
on board
48 x 26 in. (121.9 x 66 cm)
Collection Manoukian,
Paris
.

ALBERT PLASSCHAERT
Opus 1528, 1918
Pastel on paper
55 ⅛ x 31 ½ in. (140 x 80 cm)
Rijksdienst Beeldende Kunst,
The Hague
.

SOPHIE TAEUBER-ARP
Moving Circles, 1933
Oil on canvas
28 ⁹⁄₁₆ x 39 ⅜ in.
(72.5 x 100 cm)
Öffentliche Kunstsammlung,
Kunstmuseum Basel,
Switzerland
.

339

GEORGES VANTONGERLOO
Triptych, 1921
Oil on wood
Center panel 4 ⅞ x 4 ⁵⁄₁₆
(12.5 x 11 cm)
Side panels, each 4 ⁵⁄₁₆ x 2 ⁹⁄₁₆
in. (11 x 6.5 cm)
Haags Gemeentemuseum,
The Hague
Loan from Wies and Jan
Leering
·

GEORGIA O'KEEFFE
Black Spot No. 1, 1919
Oil on canvas
24 x 16 in. (61 x 40.6 cm)
Mr. and Mrs. Jon B. Lovelace
·

MARSDEN HARTLEY
Painting No. 47, Berlin,
1914–15
Oil on canvas
39 ½ x 31 ⅝ in.
(100.3 x 80.3 cm)
Hirshhorn Museum and
Sculpture Garden,
Smithsonian Institution,
Washington, D.C.

JACKSON POLLOCK
The Blue Unconscious, 1946
Oil on canvas
84 x 56 in. (213.4 x 142.1 cm)
Private collection

JOHN MCLAUGHLIN
Untitled, 1948
Oil on board
27 ¾ x 24 in. (70.5 x 61 cm)
Edward Albee and Jonathan
Thomas
·

LUCIO FONTANA
Spatial Concept, 1952
Oil and glitter on canvas
50 x 50 in. (127 x 127 cm)
Gladys Arias
Marcotulli
·

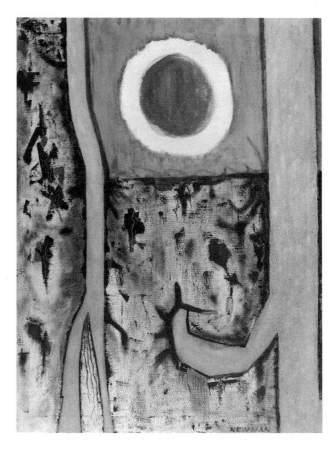

BARNETT NEWMAN
Pagan Void, 1946
Oil on canvas
32 ½ x 37 ½ in.
(82.6 x 95.3 cm)
Annalee Newman

.

BARNETT NEWMAN
Genetic Moment, 1947
Oil on canvas
37 ½ x 27 ½ in.
(95.3 x 69.9 cm)
Annalee Newman

.

AD REINHARDT
How to Look at a Spiral, 1946
Collage of ink and paper
13 x 10 ¼ in. (33 x 26 cm)
Whitney Museum of
American Art, New York
Gift of Mrs. Ad
Reinhardt
.

JASPER JOHNS
Canvas, 1956
Encaustic and collage on
wood and canvas
30 x 25 in. (76.2 x 63.5 cm)
Collection of the
artist

.

JASPER JOHNS
Gray Target, 1958
Encaustic and collage on
canvas
42 x 42 in. (106.7 x 106.7 cm)
Ileana and Michael
Sonnabend, New
York

.

JASPER JOHNS
Targets, 1966
Encaustic and collage with
old newspaper on canvas
72 ¹⁄₁₆ x 48 ¼ in.
(183 x 122.5 cm)
Museum für Moderne Kunst,
Frankfurt am
Main

.

ELLSWORTH KELLY
White Square, 1953
Oil on wood
43 ¼ x 43 ¼ in.
(109.9 x 109.9 cm)
Private collection,
courtesy of the
artist

·

ELLSWORTH KELLY
Yellow Relief, 1955
Oil on canvas, two joined
panels
24 x 24 in. (61 x 61 cm)
Private collection,
courtesy of the
artist

·

RICHARD POUSETTE-DART
Imploding Light No. 2,
1968–69
Oil on canvas
80 x 80 in. (203.2 x 203.2 cm)
Richard Pousette-
Dart
.

ARNULF RAINER
Painted-Over Cross, 1968
Oil on galvanized sheet iron
72 $^{13}/_{16}$ x 37 $^{13}/_{16}$ in.
(185 x 96 cm)
Galerie Ulysses,
Vienna
.

AD REINHARDT
A Portend of the Artist as a Yhung Mandala, 1956
Collage of ink and paper
20 ¼ x 13 ½ in.
(51.4 x 34.3 cm)
Whitney Museum of
American Art, New York
Gift of Mrs. Ad
Reinhardt
.

MARK ROTHKO
Sketch for Mural No. 1, 1958
Oil on canvas
105 x 120 in.
(266.7 x 304.8 cm)
Estate of Mark Rothko
Courtesy Pace Gallery,
New York
© Estate of Mark Rothko
.

TONY SMITH
Untitled, 1962
Oil on canvas
44 x 42 ½ in. (111.8 x 108 cm)
Xavier Fourcade, Inc., New
York; Paula Cooper Gallery,
New York; Margo Leavin
Gallery, Los Angeles
.

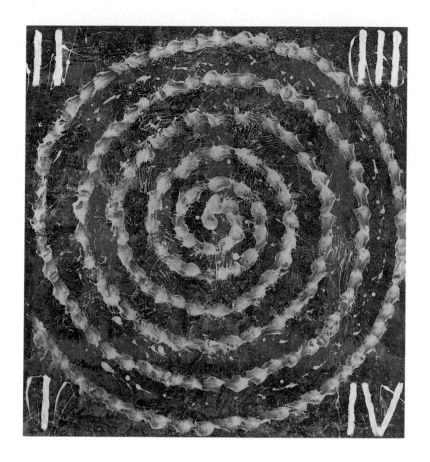

CRAIG ANTRIM
Center of Gravity, 1984
Acrylic on canvas
96 x 90 in. (243.8 x 228.6 cm)
Ruth Bachofner Gallery, Los
Angeles

·

DOMENICO BIANCHI
Untitled, 1984
Watercolor, encaustic, and
oil on canvas
96 ½ x 84 ½ in.
(245.1 x 214.6 cm)
PaineWebber Group
Inc.

·

HELMUT FEDERLE
Tree of Life and Family, 1982
Dispersion, tempera on
canvas
84 ¹⁄₁₆ x 119 ½ in.
(213.5 x 303.5 cm)
Haags Gemeentemuseum,
The Hague

·

JASPER JOHNS
Untitled, 1975
Oil and encaustic on canvas
50 ⅛ x 50 ⅛ in.
(127.3 x 127.3 cm)
Collection of Eli and Edythe
Broad
.

ELLSWORTH KELLY
Black White, 1970
Oil on canvas, two jointed
panels
70 x 107 in. (177.8 x 271.8
cm)
Private collection
.

RICHARD POUSETTE–DART
*Time Is the Mind of Space,
Space Is the Body of Time, No.
1, 2, 3*, 1982
Acrylic on linen
Three panels, each
89 ½ x 62 ½ in.
(227.3 x 158.8 cm)
Richard Pousette-Dart

.

MARIO MERZ
(*"Spiral"*), 1982
Acrylic, charcoal, spray
paint, and shell on canvas
50 x 50 in. (127 x 127 cm)
Sperone Westwater,
New York

.

351

TOM WUDL
The Dream of Gabriello, 1973
Laminated tissue, acrylic, and
other mixed media
84 x 120 in.
(213.4 x 304.8 cm)
Laura-Lee W.
Woods

NORMAN ZAMMITT
Untitled, 1977–78
Oil on canvas
77 x 133 (195.6 x 337.8 cm)
Los Angeles County
Museum of Art
Gift of William J. and
Marilyn Lasarow
.

OVERLEAF

MAURICE DENIS
Orange Christ, 1889
Oil on board
9 ¹¹/₁₆ x 7 ½ in. (24 x 19 cm)
Collection J. F. Denis,
Alençon, France
.

OCCULT LITERATURE IN FRANCE

GEURT IMANSE

It is a negative image that Édouard Schuré presents in the introduction to his *Les Grands Initiés: Esquisse de l'histoire secrète des religions* (1889): "And what is it that produces positivism and skepticism today? A dry generation, without ideals, without light and beliefs, neither believing in the soul nor God, neither the future of humanity nor in this life or the other, without energy of the will, doubting itself and human freedom."[1] Still, it correctly describes the state of mind of the French intelligentsia, including artists, at the end of the nineteenth century. Schuré indicated one of the situation's main causes: "literature and art have lost the sense of the divine."[2] This was, however, not the only cause. The boundless materialism evoked by positivist philosophy, the negative implications of Charles Darwin's theories of evolution, the pessimistic views on life in general of Arthur Schopenhauer and Eduard von Hartmann, and the religious skepticism exemplified by Ernest Renan's *Vie de Jésus* (1863)—all contributed to the spiritual climate described by Schuré. The entire cosmos was seen as being governed by strict scientific laws. Thus the "great unknown" no longer existed, and imagination became a word of the past.

Schuré was convinced that "the worst thing of our times is that Science and Religion appear to be two hostile and unyielding powers."[3] The reigning opinion was more or less that if the Roman Catholic church would give up the strict dogma into which it had withdrawn and accept the achievements of science and if the practitioners of science would acknowledge that not all phenomena can be explained empirically, then church and science could be reconciled with each other and a harmonious society would be the direct result. Progress in that direction was slow, however, and in the meantime artists tried to escape the tedious and banal reality of everyday life. One immediate result was a flow of decadent literature, of which Joris-Karl Huysmans's *À rebours* and "Sâr" Joséphin Péladan's *La Vice suprême,* both published in 1884, are the best examples.[4] An expansive interest in occultism, often mixed with a vaguely Catholic, aesthetic mysticism, fit within this escapist tendency toward the decadent. Symbolism, emerging in the same period, aspired to visualize and evoke images that referred to a higher reality, and it was within Symbolism that the interest in occultism found its clearest expression.

Mysticism and occultism became important sources of artistic inspiration. Huysmans's

preface to Rémy de Gourmont's *Le Latin mystique*, published scarcely three years after *Les Grands Initiés,* bears witness to this situation: "It seems that the literary youth is turning mystical. This rumor is running through Paris recently, and the shrewd reporters are eager to announce this amazing windfall."[5] It is important to remember that no sharp distinction between mysticism and occultism was being made at this time, and curious mixtures of the two developed during the 1880s and 1890s, the doctrines of Péladan being the best-known example. In fact, most occult writers, whether tolerated or excommunicated, never rejected the traditional beliefs of the Catholic church, traces of which can be found in their writings.

By the turn of the century interest in traditional occultism had almost disappeared; most adherents of occultism chose other directions by returning to Catholicism with a new idealism, joining organizations such as the Theosophical Society, or trying to create a new harmonious society through socialism. Already in 1894 one of the best-known propagators of French occultism, Papus (pseudonym of Gérard Encausse), could write: "Occultism is fashionable, and that is the greatest danger that could beset it. . . . We have decided to leave the society folk to amuse one another and to retreat more than ever into the closed groups from which we were obliged to emerge in 1882 only to stop the propagation of doctrines that were leading the nation's intellectual life to destruction."[6]

ÉLIPHAS LÉVI (1810–1875)

Even though *Les Grands Initiés* satisfied a great want, Schuré was nothing more than a link in the long chain of French occultism that had prospered since the revolution of 1789; the field he was to sow was well prepared.[7] Schuré was highly influenced by the ex-priest Éliphas Lévi (pseudonym of Abbé Adolphe-Louis Constant), the great renovator of the occult in nineteenth-century France. Among Lévi's numerous publications, *Dogme et rituel de la haute magie* (1856), its sequel *Histoire de la magie* (1860), and *La Clef des grandes mystères* (1861) were the most influential. As one of his biographers wrote: "To attempt to extract a coherent teaching from Lévi's books is like trying to fit together a jigsaw puzzle whose pieces are constantly changing shape and color."[8] But there are a number of identifiable doctrines that recur in all his writings, which directly or indirectly influenced the avant-garde artists at the end of the nineteenth century.

Lévi's most important contribution was that he popularized age-old ideas of Western occultism and made them accessible to a large public. One of these ideas was that man is a microcosm of the universe, which is the macrocosm, and that all elements of the visible world refer to corresponding elements of the invisible world. "There is only one dogma in magic and this is it: the visible is a manifestation of the invisible or, in other words, the perfect word stands, in perceivable and visible things, in exact ratio to the things that cannot be perceived by the senses and that are not visible to our eyes. . . . This is true for both visible and invisible things."[9] This theory of correspondences, or analogy, had already been put forth in Plato's *Timaeus* and had been common knowledge among most occult writers of the past. Lévi was particularly influenced by Emanuel Swedenborg, who was the first to apply the terminology of "correspondences" (*Entsprechungen*) to the theory of analogy. Lévi read Swedenborg's works in 1841, and the fact that he wrote a poem entitled "Correspondences" in 1846 suggests that he was impressed by them. There is another, better-known poem of the same title, probably written later, by Lévi's friend Charles Baudelaire.[10] Swedenborg's works were first published in French in 1820, and he became popular through the extensive passages devoted to him in Honoré de Balzac's novel *Séraphîta* (1835),[11] which later became popular with the Nabis. The Dutch artist Jan Verkade recalled: "My friend Sérusier often spoke of a book by Balzac, 'Séraphîta,' in which the theosophy of the Swedish philosopher Swedenborg is developed. . . . 'Séraphîta' was the first of all books I read, in which God was spoken of with enthusiasm, and as the Highest Good."[12]

The importance of the theory of analogy, or correspondences, for the Symbolists is well known. It allowed painters and poets to rise above traditional symbolism in their desire to express "higher" reality. It allowed them to develop a personal symbolic language in which higher reality, being invisible and without a definite form of appearance, could be evoked by any imaginable image. The Synthetists and the Nabis carried this theory furthest, starting from the principle that not only a representation or a part of one could refer to the higher reality but also lines and colors alone. Thus the road to an abstract art was opened: "Symbolism is the art of inter-

preting and evoking the conditions of the soul by means of colors and lines."[13]

The theory of analogy frequently recurred in the works of later occult writers, such as Stanislas de Guaita and Papus, who in a sense were followers of Lévi. Guaita wrote in his *Au seuil du mystère* (1886):

High Magic is not a compendium of more or less *spirited* wanderings, arbitrarily made into an absolute dogma; it is a general synthesis — hypothetical, but rational — based both on positive observation and induction through analogy. . . . Magic acknowledges three worlds or spheres of activity: the divine world of reason; the intellectual world of thought; and the perceivable world of phenomena. One in essence — triple in its manifestations — Being is logical and the things above are analogous with and in ratio to the things below: so that the same cause engenders, in each of the three worlds, series of corresponding effects strictly determinable by analogous calculations. . . . It is by virtue of the same principle that the mollusk secretes the mother-of-pearl and the human heart love: the same law rules the communion of the sexes and gravitation of the suns.[14]

And Papus wrote in his *L'Occultisme* (1890):

What the occult searches and wishes to provide for its followers is the *bond* that unites all of today's antitheses in battle: Power and Law, Science and Faith, Reason and Imagination, etc., etc. . . . This discovery proceeds from the application of a method almost unknown today: *Analogy.* Analogy permits, given one sole phenomenon, to deduce with certainty one general law applicable to all phenomena, even those of a totally different order.[15]

Another important idea of Lévi's was his theory of "astral light," which he used to explain all magical appearances:[16] "The primordial light, which is the vehicle of all ideas, is the mother of all forms. . . . Hence the astral light, or terrestrial fluid, which we call the great magical agent, is saturated with all kinds of images and reflections."[17] Elsewhere he calls the astral light a "*médiateur plastique*" (plastic medium), which "receives and trans-

mits the impressions of the imaginary power."[18] Consequently, "the soul, while having an effect on this light by its own volition, can dissolve or coagulate it, project or attract it. It [the light] is the mirror of the imagination and dreams. . . . It can take on all forms evoked by thought."[19] It is possible to manipulate the astral light through the imagination because thought can be transferred to the light. The power of the imagination "belongs exclusively to the domain of magic. . . . The imagination is, indeed, as the eye of the soul, through which we see the reflections of the visible world, it is the mirror of visions and the mechanism of magical life . . . it exalts the will and holds grip over the universal agent [the astral light]."[20]

Lévi also compared the astral light with the Holy Ghost and the *ouroboros* (cosmic snake), which bites its own tail: "The active principle searches the passive principle, the full is in love with the empty. The mouth of the serpent attracts its tail, turning on itself, it flees from itself and pursues itself."[21] With this, Lévi identified the two opposing forces active in the astral light. In the microcosmos of mankind these are expressed in the active man, "the initiator, who breaks, ploughs, and sows," and the passive woman, "the creator, who unites, waters, and harvests."[22]

In order to possess the astral light, one has to "understand the balance of power called the magical equilibrium."[23] The frontispiece of *Rituel,* the second volume of *Dogme et rituel de la haute magie,* visualizes the magical equilibrium of the opposing forces as being one figure, half animal, half human, man and woman at the same time, one hand up, the other hand down; on one arm is written "solve" (dissolve), on the other, "coagula" (solidify). Lévi called the whole figure "magical androgyny."[24]

Lévi's ideas contained a number of key elements in relationship to art. Of primary importance was his notable emphasis on the power of the imagination. Any artist only slightly interested in the occult could hardly have wished for a better stimulus than Lévi's for leaving all power to the imagination. In their antipathy to banal reality, many late nineteenth-century artists fully accepted this primacy of the imagination.[25] Also of impor-

tance is that Lévi's descriptions of the astral light as "médiateur plastique" seem to anticipate the theory of "thought-forms" introduced around 1900 by the Theosophists Annie Besant and Charles W. Leadbeater.[26] Although the relationship of Theosophy to Lévi is not certain, it is known that Helena P. Blavatsky was quite familiar with his publications.

In 1892 Victor-Émile Michelet, a friend of Guaita and admirer of Lévi, related Lévi's theory of the astral light to art in "Occultisme: Kunst en Magie" (Occultism: Art and magic), published anonymously in a slightly altered version in the Amsterdam student newspaper *Propria Cures:*

Art is magic. . . . a work of art is a living being, like a human being. It is subject to the double law of *involution + evolution.* Just like human beings, a purely inspired work of art actually *existed* already before it penetrated the sphere of the artist, who is a means to [its] incarnation. It was living in the soul of the artist before he became conscious of it.[27]

Lévi's theory regarding the antithetical forces active within the astral light is even more intriguing in terms of art, particularly his translation of the active into male and the passive into female. Astral light has to contain these opposing forces, otherwise it would not be active: this binary quality, *le binaire,* is the source of creative power. "The binary quality is the unity multiplying itself in order to create; it is for this reason that the sacred symbols made Eve leave the very chest of Adam." Adam is visually represented by the mysterious Hebrew character "yod," "image of the cabalistic phallus." Lévi continued: "The creative principle is the ideal phallus; and the created principle is the formal *cteïs* [Greek for "a comb," which Lévi was using to define the female sexual organ]. The insertion of the vertical phallus into the horizontal cteïs forms the cross of the gnostics, or the philosophical cross of the Freemasons.[28] In *Isis Unveiled* (1877) Blavatsky almost literally transcribed this theory of the creative principle as Lévi deduced it from the story of Adam and Eve.[29] In a note in which she referred to Lévi's *Dogme et rituel de la haute magie* she concluded: "While the male principle is active, the female is passive, because they are *Spirit* and *Matter.*"[30] In the cabalistic cross, which Lévi discussed, the vertical axis represents the active, spiritual, male principle, and the horizontal axis the passive, material, female principle. Michelet ascribed similar roles to man and woman: the

woman is supposed to enliven and inspire the creative power in the man.[31] This antithesis of male and female, visualized by vertical and horizontal lines, recurred in Piet Mondrian's sketchbooks, where he ascribed almost the same powers to the opposing poles as did Lévi in *Dogme.*[32]

Lévi influenced other occult writers by emphasizing that the West had an occult tradition of its own, something that no one before him had done. His spiritual heirs, such as Guaita and Papus, spread this concept, which various French occult writers perceived as signifying a resistance to the Eastern influences that were particularly strong in Blavatsky's Theosophy.[33] Most significant, Lévi maintained that his goal was to reunite religion and science, those two hostile powers, under the banner of the occult.[34] Later occult writers remained faithful to this goal as well.[35]

ÉDOUARD SCHURÉ (1841–1929)

Lévi particularly influenced Schuré. The theory that all great religions have both an external and an internal history constitutes the central theme of Schuré's *Les Grands Initiés.* The external is clearly perceivable: "By external history I mean the dogmas and the myths taught publicly in the temples and schools, acknowledged in the cult and the popular superstitions." The internal history is hidden; Schuré interpreted it as "the profound science, the secret doctrine, the occult activity of the great initiated, prophets and reformers, who created, maintained, and propagated these religions."[36] Because the church estranged itself from science through its external history, it is occult activity that will bridge the abyss between religion and science. Lévi made a further distinction between the two aspects of religion: "He [Lévi] says that there is an exterior and an interior morality. The exterior morality is the observance of laws and customs; the interior morality is piety which, he declares, 'is absolutely independent of religious formulas and priestly prescriptions.'"[37]

Schuré dealt with the lives and ideas of *les grands initiés* (the great initiated) in eight chapters: Rama, Krishna, Hermes, Moses, Orpheus, Pythagoras, Plato, and Jesus. His mixture of Eastern and Western religious notions launched a trend. *Les Grands Initiés* quickly became popular and was soon followed by various books that continued its aesthetic mystical direction — for example, François Paulhan's *Le Nouveau Mysticisme* (1891), Gourmont's *Le Latin mystique* (1892)

with its preface by Huysmans, and Maurice Maeterlinck's *Le Trésor des humbles* (1896), which should be interpreted in this respect.[38] *Les Grands Initiés* was especially popular among the later Nabis; Verkade spoke extensively about his own and Paul Sérusier's admiration for the book.[39]

It would probably be incorrect to assume that Schuré was a Theosophist, a follower of Blavatsky's ideas, and that *Les Grands Initiés* was influenced by *Isis Unveiled* or other writings of the theosophical movement.[40] Indeed the word *theosophy,* literally meaning "knowledge of God," existed long before Blavatsky's Theosophical Society.[41] Thus the use of the words *theosophy* and *theosophical* did not always refer to Blavatsky's Theosophy. The only Blavatskian theosophical publication available in France around 1889 was *La Théosophie universelle et la théosophie bouddhiste* by Lady Caithness, head of the Theosophical Society's French section, which was founded in 1884.[42] Considering the fact that the Theosophical Society did not become very popular in France, it is very unlikely that Schuré or the Nabis were followers of Blavatsky. In fact, going further back in French occult tradition to the early nineteenth century, it might be said that the writings of Antoine Fabre d'Olivet stood at the cradle of both *Isis Unveiled* and *Les Grands Initiés.*[43]

Schuré, more than Lévi, hoped for a deepening of mysticism within the boundaries of a more liberal Roman Catholic church. Most of the Nabis were deeply religious artists who were especially interested in a Swedenborgian occultism but did not want to reject the church as fiercely as Guaita and Papus did. Paul Ranson and Georges Lacombe were the only rather antichurch Nabis.[44] Schuré's basically optimistic point of view formed a kind of religious-philosophical basis for the Nabis' art. More than with any other symbolistic expression of the time, the Nabis aimed at transforming spiritual sensations into color and form. The Eastern elements from Schuré's book are expressed most clearly in the works of Sérusier, Ranson, and Lacombe. For example, Ranson's painting *Rama* was directly inspired by a passage from the chapter on Rama in *Les Grands Initiés.*[45] Eventually, most of the Nabis eliminated all Eastern elements and developed a purely religious art, a kind of aesthetic Catholicism. The art of the school of Beuron, which included Verkade, and of Charles Filiger were extreme examples of those aesthetics.[46] Filiger finally achieved the restoration of "the cult of the IDEAL, based on TRADITION, by means of BEAUTY," which was the sole purpose of Péladan's Salon de la Rose + Croix.[47]

JOSÉPHIN PÉLADAN (1858–1918)

Péladan undoubtedly published more than any other occult French writer of the last two decades of the nineteenth century: forty-five books (four published posthumously), thirty articles, and one catalogue.[48] If one thinks that it is difficult to deduce a coherent doctrine from Lévi's writings, the effect is quadrupled when reading Péladan. Besides his writing of novels and doctrines, Péladan was one of the few occult writers who was consistently engaged in the arena of art. It is therefore appropriate to discuss his aesthetic ideas as well as the theory of androgyny that permeates his oeuvre.

The Romantic period had turned the artist into a visionary of the sublime.[49] Lévi wrote in 1860, "The true poets are the messengers of God on this earth."[50] The holy mission that Péladan ascribed to art was one of the reasons that the salons of the Rose + Croix were popular with certain artists:

Artist, thou art priest: Art is the great mystery; and if your attempt turns out to be a masterwork, a divine ray descends as on an altar. . . . Artist, thou art king: art is the real kingdom. . . . Drawing of the spirit, outline of the soul, form of understanding, you embody our dreams, . . . Artist, thou art magician: art is the great miracle and proves our immortality. . . . You may close the church, but the museum? The Louvre will be the temple, when Nôtre Dame is desecrated.[51]

It was ingenious of Péladan to connect occultism and mysticism, already intriguing to many artists, with the cult of beauty and art. He declared the creation of art to be a mystical religion, and the artist to be its priest: "Pray to geniuses as saints and practice admiration, so that you will be illuminated; this is the meeting point between culture and mysticism."[52]

Not only numerous minor artists but also more significant ones such as the Nabis listened to Péladan's call; indeed the word *Nabi* means prophet in Hebrew. The Nabis Émile Bernard and Filiger exhibited at the first Salon de la Rose + Croix in 1892.[53] The Dutch painter Johan Thorn Prikker wrote in November 1892 to his friend Henri Borel regarding a recent lecture by Péladan in The Hague: "The Sâr said many nice things about art, he considered the landscapes of the modern painters [Impressionists] awful, saying 'that is not painting. . . .' [Péladan] Wanted to see more of the soul of the landscape and not a portraiture of trees."[54] And this was exactly the goal of many Symbolist artists.

Péladan declared: "The Salon de la Rose + Croix wants to *ruin realism,* reform Latin taste and create a school of idealist art. . . . The order favors first the Catholic Ideal and Mysticism. After Legend, Myth, Allegory, the Dream, the Paraphrase of great poetry, and finally all Lyricism, the Order prefers work that has a mural-like character, as being of superior essence!"[55] Little of real occult ideas can be found in these artistic rules, which were written after Péladan's break with Guaita and Papus, who had both been members of the Ordre de la Rose + Croix + Kabbalistique. Péladan's new order was named Rose + Croix + Catholique du Temple et du Graal. Péladan intentionally removed himself from the more pagan elements of the cabalistic Rosicrucians and remained within the confines of the Catholic church. This was the beginning of a tendency that became visible around 1900: the growth of an aesthetic Catholic art.

Occult ideas are more prevalent in Péladan's literary oeuvre, his cycle of novels entitled *La Décadence latine: Ethopée.* There are also occult remnants in Péladan's doctrinal writings, which are largely based on ideas from Lévi. Péladan wrote in his "Deuxième geste esthétique," regarding the purpose of the Ordre de la Rose + Croix + Catholique: "[It] comforts the Holy Spirit for the absurdity of the human experience by illuminating this experience through the mystery of faith; it is an agreement between religion and science."[56] This was also one of Lévi's starting points and recurred in Schuré as well.

Péladan's theory about androgyny is occult in nature.[57] For Péladan the real artist should be androgynous because androgyny implies the highest creative principle. The androgynous princess Leonora d'Este laments in *La Vice suprême:*

Oh! Being two! two hearts and the same heartbeat, two spirits and the same thoughts, two bodies and the same desire! These two hearts blend into one adoration, these two spirits into one admiration, these two bodies entwined into one delight. Two! the voice and the echo. Two! the double existence! One being joined to his being; two in themselves, next to the desire the satisfaction; the holy dream of androgyny realized according to the laws, the original creation recovered.[58]

The idea of human nature being androgynous stems from Plato's *Symposium*. The androgynous figure occurs relatively often in a number of French novels from the first half of the nineteenth century, the most important being Théophile Gautier's *Mademoiselle de Maupin* and Balzac's *Séraphîta,* both published in 1835.[59] Gautier had already connected the androgynous with being an artist: "The double being, it is the *double* of the artist which makes him an exemplary and different being, a new Adam so close to God that he is almost divine."[60]

Lévi had indicated that the combination of the active, male element with the passive, female element creates a perfect unity, the creative principle: "Adam is the human tetragram, which is summarized in the mysterious 'yod,' image of the cabalistic phallus. Add the ternary name of Eve to the yod, and you have the name of Jehovah, the divine tetragram, which is the cabalistic and magical word above all."[61] In his frontispiece to *Rituel,* Lévi had visualized the magical equilibrium, necessary to rule the astral light, as being the figure of an androgyne.

The universal meaning of the androgynous concept is the unity of antitheses, a unity that was already part of Lévi's theory of the astral light. Although Blavatsky's Theosophy was among the sources for the spread of the androgynous myth in France, the concept appears to have been rooted as deeply in the occult tradition of the West as in the mythology of Eastern religions.

Péladan, combining Gautier's notion with Lévi's, wanted the artist to be androgynous. As Michelet wrote:

In order to be born as form, the idea has to penetrate the fluid atmosphere of the artist; it has to answer his call, obey his incantation. In order for it to be born, effort of a human being is required, of an androgynous being, the absolute unity of man and woman. . . . The idea asks the matter, the effort, from the man, whom it chose, from the artist, whom will bear it; it feeds itself with the fluid of his brains.[62]

1. Édouard Schuré, *Les Grands Initiés: Esquisse de l'histoire secrète des religions* (1889; Paris: Perrin, 1899), XII.

2. Ibid., X.

3. Ibid., VIII.

4. The cover illustration of Joséphin Péladan's *La Vice suprême, Finis Latinorum* by Alexandre Séon, can be interpreted as illustrating the conclusion of Péladan's manifesto of the Rose + Croix (1891): "We believe neither in progress or salvation. For the Latin race which is about to die, we prepare a last splendor, in order to dazzle and soften the barbarians who are coming" (quoted in Robert Pincus-Witten, *Occult Symbolism in France: Joséphin Péladan and the Salons de la Rose + Croix* [New York and London: Garland, 1976], 210).

5. Joris-Karl Huysmans, preface to Rémy de Gourmont, *Le Latin mystique: Les Poètes de l'antiphonaire et la symbolique au moyen âge* (Paris: Mercure de France, 1892), VII, with cover illustration by Charles Filiger.

6. Quoted in Jean Pierrot, *The Decadent Imagination 1880–1900,* trans. Derek Coltman (Chicago and London: University of Chicago Press, 1981), 109.

7. For the occult tradition in France, see Christopher McIntosh, *Éliphas Lévi and the French Occult Revival* (1972; London: Rider, 1975); James Webb, *The Occult Underground* (La Salle, Ill.: Open Court, 1974); and Alain Mercier, *Le Symbolisme français,* vol. 1 of *Les Sources ésotériques et occultes de la poésie symboliste (1870–1914)* (Paris: Nizet, 1969).

8. McIntosh, *Éliphas Lévi,* 141; see McIntosh for extensive biography, mainly based on the first biography of Lévi, Paul Chacornac, *Éliphas Lévi: Rénovateur de l'occultisme en France (1810–1875),* with preface by Victor-Émile Michelet (Paris: Chacornac Frères, 1926). The Polish mathematician and philosopher Jozef Maria Hoene-Wronski was the

most important source for Lévi (Webb, *Occult Underground,* 257–63), and Charles Henry, whose articles about the effects of color would influence Georges Seurat, was one of Hoene-Wronski's students (Mercier, *Le Symbolisme français,* 196; and Sven Loevgren, *The Genesis of Modernism: Seurat, Gauguin, Van Gogh and French Symbolism in the 1890s* [1959; Bloomington and London: Indiana University Press, 1971], 89–90).

9. Éliphas Lévi, *Dogme et rituel de la haute magie* (1856; Paris: Chacornac Frères, 1930), vol. 1: *Dogme,* vol. 2: *Rituel;* quote in *Dogme,* 119; see also 182.

10. For Lévi's poem, see Enid Starkie, *Baudelaire* (1957; Harmondsworth: Penguin, 1971), 262. Baudelaire probably came in touch with Emanuel Swedenborg through Honoré de Balzac (Hendrik Roelof Rookmaaker, *Gauguin and Nineteenth-Century Art Theory* [Amsterdam: Swets and Zeitlinger, 1972], 29; and Starkie, *Baudelaire,* 261). For Lévi's influence on French poetry, see Mercier, *Le Symbolisme français,* 62–72.

11. Honoré de Balzac, *Oeuvres complètes: Séraphîta* (Paris, n.d.), 53ff. For a brief summary of *Séraphîta,* see McIntosh, *Éliphas Lévi,* 195–97. For Swedenborg, see Webb, *Occult Underground,* 21ff.; McIntosh, *Éliphas Lévi,* 87; and Rookmaaker, *Gauguin,* 26–30.

12. Dom Willibrord [Jan] Verkade, *Van ongebondenheid en heilige banden: Herinneringen van een schilder-monnik* (Of licentiousness and holy bonds: Recollections of a painter-monk) (1919; 's Hertogenbosch, Netherlands: Teulings' Uitgevers-Maatschappij, 1920), 100–101.

13. Maurice Denis, *Nouvelles théories sur l'art moderne, sur l'art sacré 1914–1921* (Paris: Rouart & Watelin, 1922), 175, quoted in Caroline Boot and Marie-Hélène Cornips, introduction to *Kunstenaren der Idee: Symbolistische tendenzen in Nederland ca. 1880–1930* (Artist of the idea: Symbolist tendencies in the Netherlands c. 1880–1930), exh. cat. (The Hague: Haags Gemeentemuseum, 1978), 16.

14. Stanislas de Guaita, *Essais de sciences maudites: I. Au seuil du mystère* (1886; Paris: Durville, 1915), 15–17.

15. Papus [Gérard Encausse], *L'Occultisme* (Paris, 1890), 5.

16. I owe my explanation of astral light largely to McIntosh, *Éliphas Lévi,* 149–50, where McIntosh says that Lévi may have derived this theory from Franz Mesmer. This is highly likely, considering the long passage devoted to Mesmer in Lévi, *La Clef des grands mystères, suivant Hénoch, Abraham, Hermès Trismégiste, et Salomon* (Paris: Alcan, [1861]), 117ff. As to the magical appearances that Lévi ascribed to the astral light, see Lévi, *Dogme,* 83–84.

17. Ibid., 171.

18. Lévi, *La Clef des grands mystères,* 111, 217.

19. Ibid., 111.

20. Lévi, *Dogme,* 117.

21. Ibid., 125, 131, 208–9.

22. Ibid., 126.

23. Ibid., 192.

24. Lévi, *Rituel,* 52 and frontispiece, drawn by Lévi.

25. Baudelaire had also emphasized the role of the imagination. See Rookmaaker, *Gauguin,* 26.

26. Annie Besant and Charles W. Leadbeater, *Thought-Forms* (London and Banaras: Theosophical Publishing Society, 1905).

27. Adapted from Victor-Émile Michelet, "Occultisme: Kunst en Magie," *Propria Cures* 4 (23 November 1892): 103–6, quotation on 103; Michelet wrote the preface to Chacornac's *Éliphas Lévi* and a book about the principal figures of the French occult, *Les Compagnons de la Hiérophanie: Souvenirs du mouvement hermétiste à la fin du XIXe siècle* (Paris: Dorbon Aîné, 1937).

28. Lévi, *Dogme,* 122–24.

29. Helena Petrovna Blavatsky, *Isis ontsluierd: Een sleutel op de mysterien van de oude en de hedendaagse wetenschap en Godgeleerdheid* (Isis unveiled: A key to the mysteries of ancient and modern science and theology), trans. J. D. Ketwich Verschuur, 2 vols. (1877; The Hague: Couvreur, n.d.), 2:321–22, and Lévi, *Dogme,* 122ff.

30. Blavatsky, *Isis ontsluierd,* 2:322.

31. [Michelet], "Occultisme," 103.

32. Robert P. Welsh and J. M. Joosten, *Two Mondrian Sketchbooks 1912–1914* (Amsterdam: Meulenhoff, 1969), 16–25.

33. McIntosh, *Éliphas Lévi,* 157: "Bringing Theosophy to France was rather like taking coals to Newcastle"; see also Papus, *L'Occultisme,* 10: "Theosophy made its appearance in France in 1884. Its propaganda was characterized by the effects of quantity rather than quality, that is to say its aim was to spread, as much as possible, the teachings of science that were till then only reserved for the few."

34. Lévi, *La Clef des grands mystères,* 104–5; and Lévi, *Dogme,* 95.

35. Pierrot, *Decadent Imagination,* 113.

36. Schuré, *Les Grands Initiés,* XIII–XIV.

37. McIntosh, *Éliphas Lévi,* 154.

38. Webb, *Occult Underground,* 276: "in the first thirty-seven years after its publication in 1889, [*Les Grands Initiés*] ran through eighty-five editions." For a history of the influence of Schuré's book, see Lucien Roure, *La Légende des "Grands Initiés"* (Paris, 1926). For an interpretation of Maeterlinck's book, see Pierrot, *Decadent Imagination,* 94–95.

39. Verkade, *Van ongebondenheid en heilige banden,* 78–81, 124–25.

40. Both Charles Chassé (*The Nabis and Their Period,* trans. Michael Bullock [London: Lund Humphries, 1969], 13) and George Mauner ("The Nature of Nabi Symbolism," *Art Journal* 23, no. 2 [1963–64]: 99–100) were inclined to conclude that a few of the Nabis were actually members of the Theosophical Society. Mauner's and Chassé's conclusions are probably based on the evidence of Verkade, who wrote that Paul Sérusier and Paul Ranson were "theosophists" (Verkade, *Van ongebondenheid en heilige banden,* 65, 75). It is not certain, however, that he meant Blavatsky's Theosophy because of his reference on page 101 to "the theosophy" of Swedenborg and because Blavatsky is never mentioned in the book.

IVAN KLIUN
Untitled, 1920
Watercolor on paper
6 11/16 x 4 3/8 in. (17 x 11.2 cm)
The George Costakis
Collection (owned by Art
Co. Ltd.)
© George Costakis,
1981
.

41. Webb, *Occult Underground*, 82.

42. Guaita, *Essais de sciences maudites*, 78; Guaita mentioned Lady Caithness's book. In 1876, a year before Blavatsky's *Isis Unveiled*, Lady Caithness published *Old Truths in a New Light or, An Earnest Endeavor to Reconcile Material Science with Spiritual Science and with Scripture* (London: Chapman & Hall, 1876).

43. Mercier, *Le Symbolisme français*, 226; Webb, *Occult Underground*, 270, 276; and McIntosh, *Éliphas Lévi*, 53.

44. Chassé, *The Nabis and Their Period*, 13.

45. Mauner, "Nature of Nabi Symbolism," 100. Mauner also delineated occult influences in a drawing by Ranson from 1893 and in the works of the sculptor Georges Lacombe and Jan Verkade. Mauner's comment that Papus was a member of the Theosophical Society is only partially true. Papus was a member for only a brief period (McIntosh, *Éliphas Lévi*, 157–64) and subsequently founded his own Groupe Indépendent d'Études Ésotériques.

46. Pierrot, *Decadent Imagination*, 92–98; this elimination of Eastern influence and emphasis on pure religion was also true for literature.

47. Joséphin Péladan, "Règle du Salon Annuel de la Rose + Croix," originally published as *Salon de la Rose + Croix règle et monitoire* (Paris: Dentu, 1891), reprinted in a somewhat revised version in *Catalogue officiel du second Salon de la Rose + Croix avec la règle esthétique et les constitutions de l'ordre, 28 mars au avril, 1893 Paris, Palais Champ-de-Mars (Dôme Central)* (Paris: Nilsson, 1893), XLII–XLVI, quotation on XLII. For an extensive history of Péladan and his Salons de la Rose + Croix, see Pincus-Witten, *Occult Symbolism in France*.

48. Pincus-Witten, *Occult Symbolism in France*, 225–30.

49. For a brief history of the status of artists, see Webb, *Occult Underground*, 282–84; and Mercier, *Le Symbolisme français*, 65.

50. Éliphas Lévi, *Histoire de la magique* (Paris, 1860), 1.

51. Péladan, in catalogue of the first Salon de la Rose + Croix, quoted in Pincus-Witten, *Occult Symbolism in France*, 105.

52. Péladan, "Constitutiones Rosae Crusis Templi et Spiritus Sancti Ordinis," in *Catalogue officiel du second Salon de la Rose + Croix avec la règle esthétique et les constitutions de l'ordre, 28 mars au avril, 1893 Paris, Palais Champ-de-Mars (Dôme Central)* (Paris: Nilsson, 1893), XXXII. It is not by chance that Péladan used the word *geniuses*. The French translation of Cesare Lombroso's well-known study about the genius, *L'Homme de génie*, was published in 1884; Lombroso declared the genius a special case of madness and artists exceptions to the rule (Pierrot, *Decadent Imagination*, 53–54).

53. Pincus-Witten (*Occult Symbolism in France*, 118–31, 140–45), concluded that the eventual failure of the Salons de la Rose + Croix was due to Péladan's dissociating himself from the Nabis, who never again exhibited with him after the first salon of 1892.

54. Quoted in Joop Joosten, *De brieven van Johan Thorn Prikker aan Henri Borel en anderen 1892–1904* (The letters of Johan Thorn Prikker to Henri Borel and others 1892–1904) (Nieuwkoop: Heuff, 1980), 77. Péladan visited the Netherlands 12–16 November 1892 to spread his ideas through lectures; the first days of his visit coincided with the last days of Paul Verlaine's visit to the Netherlands, 2–15 November (ibid., 73–76).

55. Péladan, quoted in Pincus-Witten, *Occult Symbolism in France*, 211–12.

56. Péladan, *Catalogue officiel du second Salon*, XXVII.

57. For Péladan's concept of androgyny, see Pincus-Witten, *Occult Symbolism in France*, 43–44: "the androgyne is the plastic ideal"; William R. Olander, "Fernand Khnopff's 'Art of the Caresses,'" *Arts Magazine* 51 (June 1977): 116–22; and Robert Knott, "The Myth of the Androgyne," *Artforum* 14 (November 1975): 38–46.

58. Joséphin Péladan, *La Vice suprême*, vol. 1 of *La Décadence latine: Ethopée* (1884; Paris: Dentu, 1891), 62.

59. Mario Praz, *The Romantic Agony* (1930; London and New York: Oxford University Press, 1970), 332–42.

60. Michel Crouzet, "Le 'Banquet' romantique," introduction to Théophile Gautier, *Mademoiselle de Maupin* (Paris: Gallimard, 1973), 19.

61. Lévi, *Dogme*, 123; see also Lévi, *Rituel*, 48–49: "The human body is submissive, like the earth, to a double law: it attracts and it radiates: it is magnetized with an androgynous magnetism."

62. [Michelet], "Occultisme," 104. The Dutch painter Jan Toorop visualized this process in a similar manner in his drawing *The Sphinx*, 1892–97, underneath which he wrote: "The male and female (duality) are lying on the hemisphere (the earth), forever striving for the ideal. The male pulls the attire of the female over his body toward the lyre to indicate that her inner forever enriches and elevates his inner" (quoted in H. M. van Nes, *De nieuwe mystiek* [The new mysticism] [Rotterdam: Bredee, 1900], 140–41).

OCCULT LITERATURE IN RUSSIA

EDWARD KASINEC AND BORIS KERDIMUN

From the first days of its appearance in Russia, occult writing bore the stamp of a dissident literature. The open involvement of Russian society with mystical and occult literature through the nineteenth and early twentieth centuries was inhibited by the prohibition of Freemasonry by Empress Catherine II and Emperor Aleksandr I. Catherine II's abolition of the state monopoly on publishing 15 January 1783 permitted the "creation of private printing presses and [authorized] the publication of books in these typographies under police censorship."[1] The first book published that year by Ivan V. Lopukhin's publishing house (active 1756–1816) was a work on alchemy.[2]

In a spring 1875 issue of *Vestnik Evropy* (Herald of Europe) Nikolai P. Wagner, professor of zoology at Saint Petersburg University, became the first Russian scholar to declare his belief in mediumism.[3] Within months Aleksandr M. Butlerov professed similar beliefs in an article in *Russkii Vestnik* (Russian herald).[4] As a consequence of these articles and the urging of Dmitrii I. Mendeleev, members of the Physical-Chemical Society of Saint Petersburg University formed a Medium Commission for the study of spiritualist phenomena. The commission intended to study the results of forty séances but declined to continue after examining only eight

because the members felt it to be a complete waste of time. The commission proclaimed that spiritualism was a form of superstition.[5]

Despite the damage done to the spiritualist movement as a result of the commission's work, some Russian spiritualists remained faithful. One of the most loyal and influential of their number was Aleksandr Nikolaevich Aksakov, scion of a noble family that had produced many important Russian literati. "After having become interested in the spiritualist movement in 1855," he wrote, "I never ceased to study it in all of its details, in all parts of the world, and in all literatures."[6] Aksakov began his studies with the ideas of Emanuel Swedenborg, wrote his first book in 1863, and in 1874 began to edit and publish the journal *Psychische Studien* in Leipzig; it was impossible to publish on such proscribed topics in Russia. Aksakov worked more than four years on his most important book, *Animizm i spiritizm* (Animism and spiritualism) (1893), in which he advanced his ideas concerning animism, spiritualism, and "personism"; to the latter he attributed the

basic manifestations of mediumism: conversations in trance, table turning, in short, everything that takes place outside the body. He considered telepathy and telekinesis animistic phenomena, that is, psychic phenomena "exteriorized" beyond the physical body. "The soul is not an individual 'I' . . . but an envelope, a fluid or an astral body of that 'I.'" Spiritualism he defined as an expression of both personism and animism, in which the actual cause of manifestations is located not only outside the medium but "beyond the sphere of our existence."[7]

Aksakov attempted to popularize spiritualism in Russia by inviting mediums to come from Europe at his expense and by supporting the publication of the journal *Rebus*. Indeed his support of the journal was so critical that when he died its editor and publisher, Viktor Ivanovich Pribytkov, was unable to continue publication, and in 1904 the journal fell into the hands of Petr A. Chistiakov. Pribytkov recalled in 1906 that from the first *Rebus* was persecuted by the censor: "Only a year after the first appearance of the journal [1881] did I dare to offer [the censor] the most innocuous articles dealing with spiritualism, namely, the biographies of Aksakov, Butlerov, and Wagner, but I received a categorical refusal. And only after many complications was I successful in having them published."[8] Beginning in the mid-1880s *Rebus* published ethnographic studies of popular Russian traditions and folklore, protocols of spiritualist séances, and information on the spiritualist movement and activities of European and American psychological societies. It was during this period, in 1886, that Baron Karl du Prel, one of the most popular occult authors, began publication of his "Filosofiia mystiki" (The philosophy of mysticism) in *Rebus* (published separately in 1895).

The 1880s and 1890s saw the appearance of other Russian translations of Western occult literature as well as the publication of original works: Louis Jacolliot, *Spiritizm v Indii: Fakiry ocharovateli* (Spiritualism in India: The fakir-charmers) (1883); Charles Richet, *Sonambulizm, demonizm i iady intellekta* (Sonambulism, demonism, and the diseases of the intellect) (1885); Butlerov, *Statii po mediumizmu* (Articles on mediumism) (1889); Edwin Arnold, *Svet Azii* (The light of Asia) (1893); Helena P. Blavatsky, *Iz peshcher i debrei Indii: Zagadochnye plemena na "Golubykh*

Gorakh" (From the caves and jungles of India: The mysterious people of the "Blue Mountain") (1893); and Edmund Gurney, Frederic Myers, and Frank Podmore, *Prizhizennye prizraki i drugie telepaticheskie iavleniia* (Phantasms of the living and other telepathic phenomena) (1893).

The occult revival in France was undoubtedly an important factor in sustaining the mystical movement in Russia. The son of the Grand Duchess Aleksandra Petrovna, under the influence of his wife, Anastasiia Nikolaevna, "became very much involved with [Dr.] Philippe and Papus [Gérard Encausse], and almost enticed the Empress Aleksandra Fedorovna [into their circle], a fact much commented on by Petersburg society."[9] Evidently they were successful in involving the empress: "It became known to me [General Aleksandr Mosolov, head of the chancellery of the minister of the court] that one of the mediums was exiled on orders of the emperor; the other individual, Philippe, was much courted. . . . Philippe's name, unlike Papus's, was often mentioned in the empress's correspondence, especially in connection with predictions to which the empress evidently attached much significance."[10] It was rumored that when Papus returned to France, he commented to a neighbor, "Those people over there are mad; they are at the mercy of the first rogue who knows how to pander to their obsession; they are sliding toward the abyss."[11]

Despite the fact that Papus was not received at court during his periodic visits to Russia (1901–6), the writings he published there became very popular. Among his best-known publications were *Tainstvennaia khiromantiia, fiziognomiia, astrologiia i tainaia kabbalistika* (The secret palmistry, physiognomy, astrology, and the secret cabalism) (1897); *Pervonachal'nye svedeniia po okkul'tizmu* (Basic information on occultism) (1904); *Filosofiia okkul'tista: Analiz teorii filosofii v prilozhenii k okkultizmu* (The philosophy of the occultist: An analysis of the theory of occult knowledge) (1908); and *Chelovek i vselennaia: Obshchii obzor okkul'tnykh znanii* (Man and the universe: A general review of occult knowledge) (1909).

By the beginning of the twentieth century the interest in occult literature was burgeoning, enhanced in 1905 by two events: the dismissal of Konstantin Pobedonostsev, the powerful procurator general of the Holy Synod, the governing body of the Russian Orthodox Church, and the abolition of the preliminary censorship of publications. In this atmosphere

the noted Russian religious philosopher Nikolai Berdiaev observed:

All sorts of occult tendencies flourished about me. Anthroposophy was one of the most interesting tendencies. It attracted the more cultivated peoples. [Viacheslav] Ivanov was familiar with occultism, and at one time, [Anna] P. Mintslova, the emissary of Steiner to Russia, had an influence on him. Andrei Bely made himself into a philosopher. The young people who were grouped around Musaget [a publishing house] were all taken with anthroposophy or other forms of occultism. They searched for secret societies and adepts. They suspected one another of belonging to occult societies. Their conversations had occult allusions. They tried to expose occult knowledge, which in actuality did not exist.[12]

It is noteworthy that women played an important role in the Russian mystical movement during this period. First among them, curiously, was an émigré, Helena P. Blavatsky, the founder in New York in 1875 of the Theosophical Society and author of a number of monumental works, including *Isis Unveiled* (1877), *The Secret Doctrine* (1888), and *The Key to Theosophy* (1889). For a long period she was not nearly so well known in Russia as abroad. The first mention of her in *Rebus* appeared only late in the 1880s, and in 1893 the well-known Russian writer Vsevolod Solov'ev published a book about her in which he voiced his disillusionment with the theosophical movement. Blavatsky's sister, Vera P. Zhelikhovskaia (née Gan), published an impassioned response.[13] As the debate continued throughout the year, Blavatsky's popularity grew, and her *Zagadochnye plemena* (The mysterious people), which had been serialized in the journal *Russkii Vestnik* in 1883, appeared in book form. An edition of her *Golosa bezmolviia* (Voices of silence) appeared in 1908 in Kaluga, and on 17 November 1908 the Russian Theosophical Society was founded by Anna A. Kamensky in Saint Petersburg.

The society undertook the translation of Blavatsky's basic work, *The Secret Doctrine*, and intended to publish it as well, but the translation was confiscated by the Soviet government along with other theosophical literature found in the headquarters of the society. Elena F. Pisareva, another active participant in the society, began in 1905 translating from English and French the majority of theosophical texts that would be published in Russia. Her husband, N. V. Pisarev, founder of the Lotus publishing house in Kaluga, was the sponsor of his wife's original

works as well. In addition to *Golosa bezmolviia*, Lotus published her translations of Édouard Schuré, *Velikie posviashchennye: Ocherk ezoterizma religii* (The great initiates: A sketch of esoteric religion), second revised edition (Kaluga, 1914); first edition, (Saint Petersburg, 1910) and Bankin Chandra Chatterjee, *Sokrovennaia religioznaia filosofiia Indii* (The secret religious philosophy of India), with an introduction and translation from the third French edition (Kaluga, 1906). The Lotus publishing house was successful in issuing twenty-one titles. (Pisareva's translation of Annie Besant's *Drevniaia mudrost': Ocherk teosoficheskikh uchenii* [The ancient wisdom: An outline of theosophic teaching] appeared in Saint Petersburg, second revised edition, in 1913.)

Another female mystic, Anna Nikolaevna Shmidt, first became famous as a result of her strange infatuation with Vladimir Sergeevich Solov'ev, a Russian religious philosopher of the late nineteenth century and brother of Blavatsky's critic, Vsevolod Solov'ev. Solov'ev's popularity was extraordinary, and Shmidt decided that he was the embodiment of Christ, while she was the embodiment of the Divine Sophia, who on several occasions, according to his writings, came to him in visions. Shmidt wrote letters to Solov'ev revealing her belief and imploring him to meet with her. Solov'ev was reluctant to imagine himself as Shmidt portrayed him, yet out of compassion he began to visit and reason with her, hoping to convince her to cease her foolishness. Following Solov'ev's death in 1908, Shmidt attempted to prove that at their last meeting she had been successful in convincing him of the truth of her assertions.

Her manuscripts fell into the hands of the philosopher Reverend Sergei Bulgakov, who decided to publish them in 1916. This explains the appearance of her mystical revelation, *Tretii zavet* (The third commandment), a work described by Bely as a "half-insane, theosophical-scholastic work."[14] If for Bely the *Tretii zavet* was insanity, for Bulgakov "it was one of the most remarkable monuments of mystical literature. . . . [Because of the book's] absence of any literary influences, the unusual tone, and the special way in which mystical questions are resolved . . . Shmidt occupies a totally unique position, even in the Pleiad of famous mystics."[15]

Bulgakov speculated that Shmidt, poorly educated, was something of an autodidact, ignorant in particular of the cabala, but in this it seems likely he was incorrect. Under the pseudonym of A. Timshevsky, she published articles on mysticism and religion in the provincial city of Nizhnyi Novgorod.[16] In *Tretii zavet* (written about 1886) she posited the immediate end of the world as a result of the conflict between good and evil, averring that "everyone who fosters the destruction of the world . . . emerges victorious in the end, the person to whom such great promises are given in the Apocalypse."[17] In her writings the resurrection in Christ's body is interpreted, as in Christian doctrine, as eternal life. What Bulgakov considered the most important new idea in *Tretii zavet,* in fact in all Shmidt's work, was her alternative notion of recurrent resurrection. This echoes the idea, familiar in occult thought, of reincarnation, repetitive death that occurs not once and for all time but over and over again.[18]

The Russian intelligentsia experienced the influence of occultism and expressed it in varied ways. The journalist and occult writer P. D. Ouspensky inherited mathematical talents from his father and a literary gift and love of fine arts from his mother. By the age of sixteen he had begun to study Friedrich Nietzsche and later studied mathematics, physics, biology, and psychology with devotion.[19] He then undertook the study of the fourth dimension and dreams, subjects then very much in vogue. In 1905 Ouspensky decided to devote all his energies to journalism, and three years later he initiated a closer relationship with the Theosophists, reading extensively in the literature of Theosophy and occultism. In 1910 his first book, *Chetvertoe izmerenie: Opyt issledovaniia oblasti neizmerimogo* (The fourth dimension: An essay in the study of the immeasurable), was published as a tribute to his father.

During this period Ouspensky became acquainted with the critic Akim L. Flekser, who probably introduced him to Saint Petersburg's bohemian life and to M. V. Lodyzhenskii. Ouspensky also began his association with the publisher Aleksei A. Suvorin (pseudonym, Aleksei Poroshin) of the Novyi Chelovek publishing house. This slightly unbalanced and contradictory person, who combined both brilliance and stupidity, liberalism and "folly in Christ,"[20] published a series of books intended to reveal the essence and methods of the "new thinking." Among these were works by Swami Vivekananda, Swami Abkhedananda, and Ramachazaka

(William Walker Atkinson) on Yoga; Dr. Khinkhede (Kincaid) on diet; Suvorin's own *Novyi Chelovek* (The new man) (1912); and Ouspensky's *Simvoly taro: Filosofiia okkul'tizma v risunkakh i chislakh* (1912), translated into English by A. L. Pogossky as *The Symbolism of the Tarot: Philosophy of Occultism in Pictures and Numbers* (1913). In 1913 Ouspensky published *Iskaniia novoi zhizni: Chto takoe ioga: Novye techeniia v psikhologii Zapada i ikh skhodstvo s drevnimi ucheniiami Vostoka* (The search for a new life. What is Yoga? New tendencies in the psychology of the West and their similarities to the ancient teachings of the East) and *Vnutrennii krug: O poslednei cherte i sverkhcheloveke — 2 lektsii* (The inner circle: On the last line and superman — Two lectures). The first lecture in *Vnutrennii krug* deals with the eternal questions of life and death, love and suffering. In the second lecture Ouspensky analyzed the idea of the superman from the vantage of mysticism and materialism.

Also in 1913 Ouspensky departed for Egypt and India in "search of the miraculous." After his return he corrected and supplemented his second book, *Tertium Organum: Kliuch k zagadkam mira* (Tertium Organum: A key to the enigmas of the world) (1911). This second Russian edition (1915) was translated into English, and through it Ouspensky subsequently became famous in the United States and England. In fusing the ideas of the early Theosophists with those of Nietzsche, Ouspensky synthesized his ideas on the psychic evolution of man and illustrated them with a special table placed at the end of the book. The evolution of man toward superman is inevitably tied with education and the development of new degrees of consciousness and sense of space, he argued. Only in this way can humankind attain internal unity and harmony.

One of the authors cited by Ouspensky in *Tertium organum* is Lodyzhenskii, whose mystical trilogy *Sverkhsoznanie* (Superconciousness) consists of three independent works brought together by a common theme: *Sverkhsoznanie i puti k ego dostizheniiu* (Superconsciousness and the way to its attainment) (1911), a comparison of Indian Yoga and Christian asceticism; *Svet nezrimyi* (The invisible light) (1915), a comparison of the mystical attainments of Seraphim of Sarovsk (1760–1833), a mystic canonized by the Russian Orthodox Church in 1905, with those of Francis of Assisi, and an analysis of the mys-

tical traditions of the East and West; and *Temnaia sila* (The dark force) (1914), a study of the peculiarities of superconsciousness that developed as a result of the appearance of the dark side of man's nature, and an analysis of demonic mysticism. Lodyzhenskii, who lived not far from Lev Tolstoy and occasionally visited him, was successful in involving Tolstoy in the study of the *Dobrotoliubie (Philokalia),* a five-volume collection of the works of the mystics of the Greek Orthodox Church.[21]

In 1915, in connection with a move to Moscow, Suvorin relinquished all his rights to publications at Novyi Chelovek to Mikhail V. Pirozhkov. Pirozhkov, continuing in the tradition of Suvorin, instituted a series of books, both original Russian-language works and translations, which were devoted to questions of spirituality and culture, under the editorship of D. V. Stranden and N. P. Taberio, both of whom had worked with Ouspensky on the publication of earlier books of their own at Novyi Chelovek: Stranden, *Germetizm* (Hermetism) (1914), which contained his brief summary of *The Kybalion: A Study of the Hermetic Philosophy of Ancient Egypt and Greece by Three Initiates* (Chicago: 1908);[22] and Taberio, *Parsifal: Ocherki istoricheskogo proiskhozhdeniia legendy, soderzhanie i kratkii muzikal'nyi razbor (s notnymi primerami) dramy mysterii togo zhe nazvaniia R. Vagnera* (Parsifal: A sketch of the historical origin of the legend, its contents, and a short musical analysis [with examples of notes] of the drama-mystery of that name by R. Wagner). In Moscow Suvorin inaugurated the newspaper *Nov'* (New soil), to which Ouspensky contributed articles. Ouspensky wrote the introduction to *Liubov' i smert'* (Love and death) by Edward Carpenter (1915); *Razgovory s diavolom: Okkul'tnye rasskazy* (Conversations with the devil: Occult stories) (1916); and *Kinemodrama ne dlia kinematografa* (A cinema drama not for the cinematographer) (1917), the last work he completed in Russia.

The year 1916 saw the publication of *Sviashchennaia kniga Tota* (The holy book of Toth) by the twenty-five-year-old Vladimir Alekseevich Shmakov. In the fall of 1912, after returning from a round-the-world journey, Shmakov had met with his friend, V. I. Zhdanov. Shmakov conveyed his enthusiasm for American technology to Zhdanov — he had even brought Thomas Edison's autograph home in his diary — while Zhdanov told Shmakov of the impression, equally

strong, that the work of Chatterjee had made on him. So began Shmakov's involvement with Chatterjee and his devoted study of occult literature and hypnosis. In *Sviashchennaia kniga Tota,* the result of his philosophical and occult studies, Shmakov cited more than fifteen hundred authors of various periods and cultures and in the footnotes and commentaries he noted titles that substantially supplement Ivan K. Antoshevskii's bibliography of occult literature (1911).[23] In focusing his attention on esoteric cosmology as the sole method for studying the relationship between God and man, Shmakov dealt with a number of doctrines: magnetism, fluids, the theory of binaries, problems of sexuality, and epistemology. Shmakov considered his work far from perfect and continued to refine it in succeeding years. At the end of October 1918 he began to work on his second book and after three months completed it; *Osnovy pnevmatologii: Teoreticheskaia mekhanika stanovleniia dukha* (The fundamentals of pneumatology: The theoretical mechanics of the emergence of the soul) was published in two fascicles in 1922. The title page displayed a swastika (a sun symbol), a fact that played no small role in its subsequent fate. According to rumors, virtually the entire printing was destroyed soon after publication. It is remarkable that the head of the Political Section of the State Publishing House, Pavel I. Lebedev (pseudonym, Valerian Polians'kyi) permitted such a book to be published at all.

In the form in which it appeared, *Osnovy pnevmatologii* consists of only two of three contemplated books. The first reviews the categories of knowledge, a synthetic explication of esoterism based on a comparison

between Apollo and Dionysus as well as a comparison of esoteric epistemology with the system of Arthur Schopenhauer. The second contains an overview of pneumatological categories and reviews the development of monads as a dialectical process distinct from Hegelian dialectics. The author turned then to kinematics, empirical consciousness, the dialectical process, and dynamics, that is, intuition and its various forms.

Shmakov is an exemplar of Russia's occult milieu, both because of the nature of his researches and the constraints under which they were carried out: "I believe that my work and many hundreds of evenings of anxious spiritual searchings will not be lost," he wrote. "But if I shall not survive until that day when this book will be published, let the reader recall the conditions under which it was written and forgive me for its shortcomings and errors."[24]

The authors wish to acknowledge the assistance of Charlotte Douglas, Bernice G. Rosenthal, and Arkady Rovner in reading an earlier version of this essay and making helpful suggestions for its improvement.

The reader should note the publication of Thomas E. Berry, *Spiritualism in Tsarist Society and Literature* (Baltimore: Edgar Allan Poe Society, 1985), which appeared after this essay was written.

1. Mikhail N. Longinov, *Novikov i moskovskie martinisty* (Novikov and the Moscow Martinists) (Moscow: Tipografiia Gracheva, 1867), 204.

2. *Khrizomander: Allegoricheskaia i satiricheskaia povest, razlichnogo ves'ma vazhnogo soderzhaniia* (Khrizomander: An allegorical and satirical tale of very diverse, important contents), trans. (from German) A. A. Popov (Moscow: Ivan V. Lopukhin, 1783).

3. Nikolai P. Wagner, "Po povodu spiritizma: Pis'mo k redaktoru" (On spiritualism: A letter to the editor), *Vestnik Evropy* (Herald of Europe) 4 (March–April 1875): 855–75.

4. [Aleksandr M. Butlerov], "Mediumicheskiie iavleniia" (Medium phenomena), *Russkii Vestnik* (Russian herald) 112 (November 1875): 200–48.

5. [Dmitrii I. Mendeleev], *Materialy dlia suzhdeniia o spiritizme* (Materials for judging spiritualism) (Saint Petersburg: Obshchestvennaia Pol'za, 1876). See also "Kratkii ocherk razvitiia spiritualizma v Rossii" (A short history of the development of spiritualism in Russia), *Rebus* 20 (1887): 207.

6. Aleksandr N. Aksakov, *Animizm i spiritizm: Kriticheskoe izsledovanie mediumicheskikh iavlenii i ikh obiasneniia gipotezami "nervnoi sily," "galliutsinatsii," i "bezsoznatel'nogo" v otvet Hartmanu s 30 fototipiiami* (Animism and spiritualism: A critical study of the medium phenomena and their explanation of the hypotheses of "nervous force," "hallucination," and the "unconscious" in response to Hartman with thirty photographic examples), 2d ed. rev. (1893; Saint Petersburg: V. Demakova, 1901), 3.

7. Ibid., 7.

8. Viktor I. Pribytkov, "Pervyi vserossiiskii s'ezd spiritualistov" (First all-Russian meeting of spiritualists), *Rebus* 52 (15 February 1906): 4.

9. Aleksandr Mosolov, *Pri dvore imperatora* (At the emperor's court) (Riga: Filin, 1937), 72.

10. Ibid.

11. James Webb, *The Occult Establishment* (La Salle, Ill.: Open Court, 1976), 168–70.

12. Nikolai Berdiaev, *Samopoznanie* (Self-knowledge) (Paris: YMCA Press, 1947), 187.

13. Vera P. Zhelikhovskaia, *E. P. Blavatskaia i sovremennyi zhrets istiny: Otvet g-zhi Igrek g-nu Vsevolodu Solov'evu* (E. P. Blavatskaia and a contemporary prophet of truth: The answer of Madame Igrek to Mr. Vsevolod Solov'ev) (Saint Petersburg: Izdanie A. S. Suvorina, 1893).

14. Andrei Bely, *Nachalo veka* (The beginning of the century) (Moscow and Leningrad: Gosizdat, 1933), 125.

15. Anna N. Shmidt, *Iz rukopisei* (From the manuscripts) (Moscow: Put', 1916), XI.

16. Oleg Maslenikov, *The Frenzied Poets* (Berkeley and Los Angeles: University of California Press, 1952), 58–60.

17. Shmidt, *Iz rukopisei,* 103.

18. Ibid., XIV.

19. James Webb, *The Harmonious Circle: The Lives and Works of G. I. Gurdjieff, P. D. Ouspensky, and Their Followers* (New York: Putnam, 1980), 99.

20. Don Aminado [A. P. Shpolianskyi], *Poezd na tre'tem puti* (The train on the third rail) (New York: Chekhovskoe Izdatel'stvo, 1954), 181–82.

21. Petr D. Ouspensky, *Tertium Organum: Kliuch k zagadkam mira* (Tertium Organum: A key to the enigmas of the world) (Saint Petersburg: Trud, 1911), 227–28.

22. Vladimir A. Shmakov, *Osnovy pnevmatologii: Teoreticheskaia mekhanika stanovleniia dukha* (The fundamentals of pneumatology: The theoretical mechanics of the emergence of the soul), 2 fascs. (Moscow: Gosizdat, 1922), 271.

23. Ivan K. Antoshevskii, *Bibliografiia okkul'tizma,* 2d ed. rev. (1910; Saint Petersburg: M.S.K., 1911). Antoshevskii's bibliography is incomplete and was not compiled on the basis of *de visu* verification of entries. It contains, therefore, many errors. During the 1930s the Leningrad branch of Mezhdunarodnaia Kniga, the Soviet export agency, compiled a sales catalogue of Russian books, entitled *Okkul'tizm,* intended for the Western market.

24. Shmakov, *Osnovy pnevmatologii,* unpublished preface in the collection of Boris Kerdimun, 2.

OVERLEAF

From Rhabanus Maurus, *De laudibus sancte crucis* (Pforzheim: Thomas Anselm, 1503), Bibliotheca Philosophica Hermetica, Amsterdam

·

A GLOSSARY OF SPIRITUAL AND RELATED TERMS

ROBERT GALBREATH *With additional contributions by Judi Freeman and W. Jackson Rushing*

ABSTRACTION

Abstraction is characterized by the notion of cloaking the relationship between the observed world and a created image. To abstract means to "withdraw"; to "take away secretly"; to "draw off or apart"; to "disengage from"; to "separate in mental conception"; to "consider apart from the material embodiment, or from particular instances" (*Compact Edition of the Oxford English Dictionary,* s.v. "abstract"). These meanings can be documented as far back as the sixteenth century. Taken individually or in combination, they were central to discussions about abstraction in the early years of the century. Descriptions of the process of abstraction have ranged throughout the twentieth century from secret removal to the creation of something visionary.

The association of abstraction in art with meaninglessness is derived in large measure from Wilhelm Worringer's *Abstraction and Empathy: A Contribution to the Psychology of Style,* originally published in Munich in 1908. Worringer equated *abstract* with *angular* and *antinaturalistic.* Guillaume Apollinaire further divorced the abstract from reality when he devised the concepts of "pure painting" and "pure art": an art that would be to painting "what music is to poetry." In a 1913 or early 1914 sketchbook annotation Piet Mondrian elaborated: "One passes through a world of forms ascending from reality to abstraction. In this manner one approaches Spirit, or purity itself" (quoted in Robert P. Welsh and J. M. Joosten, *Two Mondrian Sketchbooks 1912–14* [Amsterdam: Meulenhoff, 1969]). Wassily Kandinsky similarly distinguished the abstract, a style of painting with few references to representational motifs, from the *gegenstandlos,* literally "without object or objectless."

Art criticism from the 1940s through the early 1970s has encouraged the association of abstraction with nonrepresentation. Recent scholarship, however, has reasserted the subject in abstraction and has begun to rediscover meanings that were neglected by these previous generations of scholars and critics. In this new work scholars are echoing Worringer's thoughts of nearly seventy years earlier: "Now what are the psychic presuppositions for the urge to abstraction? We must seek them in these peoples' [artists, writers, philosophers] feeling about the world, in their psychic attitude toward the cosmos . . . the urge to abstraction is the outcome of a great inner unrest inspired in man by the phenomena of the outside world; in a religious respect it corresponds to a strongly transcendental tinge to all notions" (Wilhelm Worringer, *Abstraction and Empathy* [Cleveland: Meridian, 1967], 15).
JUDI FREEMAN

ALCHEMY

Alchemy is the art of transmutation. The intent may be to transmute base elements into precious metals or to transform the individual into spiritual gold — to achieve salvation, perfection, longevity, or immortality. Alchemy is known in Chinese (see TAOISM), Indian, Hellenistic, Arabic, and Western forms. The word *alchemy* comes from the Arabic *al-kimiya'* (the art of transmutation), which may be derived via Greek (although a Chinese etymology has also been proposed) from the Egyptian name for Egypt, *khemet* (the black land), referring to the rich soil deposited by Nile floods. The connection with Egypt was established early: Hellenistic alchemy emerged in Alexandria, Egypt, by about the second century and flourished for several centuries in a context of HERMETICISM and Gnosticism. It was rediscovered by the Arabs in the seventh and eighth centuries and then, after further development, transmitted to Europe beginning in the twelfth century. Alchemy reached its zenith in Europe during the Renaissance and seventeenth century when it was considered to be *the* hermetic art, founded by Hermes Trismegistus, and was deemed worthy of study by such early scientists as Robert Boyle and Isaac Newton. During the six-teenth century PARACELSUS and his many followers emphasized the medical and pharmaceutical applications of alchemy and devised a wide-ranging chemical philosophy of nature. In the early seventeenth century the English alchemist and physician Robert Fludd prominently advocated a "true" Christian understanding of nature, based on the principles of alchemy, hermeticism, and NEOPLATONISM, in which the Creation account in Genesis was interpreted as an alchemical process involving the three primary elements: darkness, light, and water. Fludd sought to show the linkage between humanity and divinity through nature by describing at considerable length the intricate relationships between the microcosm (the human being as a miniature universe) and the macrocosm (the larger universe conceived as a greater being).

The original Hellenistic alchemical operation, essentially adopted by later Arabic and Western alchemists, drew upon Greek philosophical assumptions and redemptive processes. Material objects all consisted of the same matter, differing only in the properties of shape, color, and weight. To transmute one metal into another, it was necessary to strip away the original properties, reducing the object to its prime matter, and then to introduce the new properties in the form of a "seed" that would grow as moisture, warmth, and breath were applied. The operation was likened to the redemptive process of suffering, death, and rebirth, and the language in which it was expressed was highly allegorical, secretive, and obscure. For Arabic and Western alchemy, the object of the alchemical operation was the creation of the philosopher's stone, whose touch would transmute metals, cure disease, and bestow immortality. The stone was the product of the perfect balancing of opposites (sulphur and mercury, male and female) and was symbolized by the sacred marriage of king and queen, the androgyne, the red lion and white eagle, and other images. The psychologist Carl Gustav Jung interpreted the alchemical operation as a projection of the individuation process leading to the development of an integrated personality.

Rudolf Steiner, 1915

ANTHROPOSOPHY

A term introduced during the sixteenth and seventeenth centuries, constructed from Greek roots meaning "human wisdom," or "wisdom concerning man," *Anthroposophy* is the name adopted by Rudolf Steiner (1861–1925) for his system of OCCULT teachings, which he also called *Geisteswissenschaft* (spiritual science). Steiner defined Anthroposophy in 1924 as "a path of knowledge, to guide the Spiritual in the human being to the Spiritual in the universe" (Rudolf Steiner, *Anthroposophical Leading Thoughts,* trans. George and Mary Adams [London: Rudolf Steiner Press, 1973], 13). Anthroposophy is both a body of teachings and a path or epistemology for attaining occult knowledge.

The term *Anthroposophy* is meant to stand in pointed contrast to THEOSOPHY ("divine wisdom," or "wisdom concerning God"). Although Steiner was the dominant figure in the Theosophical Society's German lodges after 1902, his relationship with the international society's leadership, Annie Besant and Charles W. Leadbeater, was stormy. His independent Christian ROSICRUCIAN teachings were at odds with their oriental emphasis, and he strongly rejected their promotion of the Hindu youth Krishnamurti as the vehicle in whom the World Teacher, Lord Maitreya, would next

incarnate. For Steiner the present age required occult knowledge that does not depend upon external revelation but upon the power of human cognition to penetrate the spiritual realms. In 1913 he left the Theosophical Society and established his own Anthroposophical Society.

Anthroposophy, or spiritual science, is presented by Steiner as the necessary means of stimulating spiritual awakening in the modern age. His teachings are derived from Goetheanism, philosophy (especially idealism), esoteric Christianity, Rosicrucianism, and various teachings of the Theosophical Society (karma and reincarnation, the stages of cosmic evolution, the inner constitution of the human being), and his own spiritual investigations. His emphasis on epistemology, the possibility of personal verification of his findings, and the role of Christ as the pivot of cosmic evolution is distinctive of Anthroposophy. Steiner's occult ideas were decisively shaped by the works of Johann Wolfgang von Goethe, from which Steiner extracted and developed an epistemology called "objective idealism." Steiner argued that at a certain level thinking becomes a "sense-free," or intellectual, perception

(*intellektuelle Anschauung*) of a realm of pure concepts that have objective content of their own. Steiner personally claimed to have perceived spiritual worlds through heightened powers of cognition. Again following the lead of Goethe, Steiner maintained that reality comprises several qualitatively distinct levels, each with its own laws and principles, each best understood on its own terms by the appropriate disciplines. The realm of physical reality is adequately comprehended by the physical sciences, the organic realm by the biological sciences, the cultural realm by the human sciences (history, psychology, ethnology), and the spiritual realm by spiritual science (Anthroposophy).

This epistemology was more than a theory of knowledge for Steiner. It was also a means for achieving higher cognitive levels. As such, it provided a sophisticated basis for an occult science that also claimed to study objective but transcendental phenomena by means of cognitive modes beyond the empiricism of the physical senses. In his works he suggested techniques for developing the necessary faculties of clear thinking and attaining "knowledge of the higher

worlds." Spiritual science is accordingly characterized by Steiner as both *Wissenschaft* (systematic knowledge) and *Erkenntnis* (cognition, perception); it is an "experiential metaphysics."

Steiner describes three stages of development through which the occult student must pass in order to secure valid and comprehensive knowledge of the higher worlds: Probation (*Vorbereitung,* "preparation"), Enlightenment (*Erleuchtung*), and Initiation (*Einweihung*). Associated with these three stages are corresponding modes of cognition: imagination, inspiration, intuition. The preparatory stage intensifies certain moral and practical qualities in the student, enabling him to distinguish truth from illusion in spiritual experience. Subsequent ordeals (mental or spiritual in nature, not physical) test the aspirant's maturity, stability, and fitness, especially during the transition from Enlightenment to Initiation. On entering the Initiation stage, the student experiences the equivalent to a spiritual death-and-rebirth experience, in which he leaves his former mode of existence and enters a higher life. Throughout the three stages the student's character is tested, purified, and strengthened; his cognitive powers of imagination, inspiration, and then intuition are awakened, and contemplative exercises strengthen them further. Increasingly the student is liberated from the phenomenal world. A pure thought-world is thereby opened in which interaction with the supersensible realms is said to become possible.

The need for such spiritual knowledge becomes clear from Steiner's account of the evolution of human consciousness. Following a modified theosophical structure, Steiner depicts the evolution of humanity through seven levels of consciousness, each corresponding to a phase or cycle of cosmic history. The current cycle is the fourth, in which humanity develops a physical form of existence, complete with sensory cognition and the capacity for evil and error. This cycle of history is divided in turn into seven stages; humanity has been in the fifth or Aryan (post-Atlantean) period for thousands of years. The people of this period have as their special task the development of the powers of reason. In this process, humanity falls increasingly under the influence of Luciferic and Ahrimanic forces that pose the temptations of self-sufficiency and materialism. The turning point back toward the spiritual comes with the death and resurrection of Christ. Current Western civilization has thoroughly dominated the physical environment through the application of reason. Further evolution, leading to the scientific understanding of spiritual realities (spiritual science), depends upon humanity's consciously choosing to pursue spiritual development. Anthroposophy plays a critical role in such a choice, Steiner believed, because modern Western humanity will only pay attention to spiritual teachings that are fully consonant with the findings of the physical sciences.

In claiming that spiritual science was truly scientific, Steiner was often accused of falling into contradiction or nonsense. The term *occult,* then as now, was frequently used to suggest the irrational, the ridiculous, superstition, or mental aberration. Steiner, however, sought to divorce his occult science from anything smacking of the irrational. He forcefully condemned other forms associated with occultism: mediumship (see SPIRITUALISM) for its use of trance states instead of clear consciousness and its quasi-materialistic pandering to the thirst for marvels and wonders; magic for its power orientation, its desire to manipulate forces rather than engage in spiritual awakening; and popular MYSTICISM for its emotionalism and self-indulgent escapism. For Steiner, the occult had to be confronted in clear consciousness on the level of thinking. Anything less marked a reversion to antiquated methods unsuited to the spiritual needs of modern society.

While some critics charged that public knowledge of the hidden (the meaning of *occult*) is a contradiction, Steiner maintained that open knowledge openly achieved is as true for occult science as it is for natural science. He believed that the data of occult science could be organized and written in logical form, comprehensible to the average intellect. The methods of occult science are publicly available and so is the possibility of independent verification. *Occult* refers merely to the objects of study, not to the methods or the findings. That which is occult is not disclosed to sense perception or by laboratory procedures, but it is not therefore intrinsically unknowable or secret. Steiner insisted that occult science "has no secret to conceal from anyone who is prepared to seek for occult knowledge by the appropriate methods" (Rudolf Steiner, *Occult Science — An Outline,* trans. George and Mary Adams [1910; London: Rudolf Steiner Press, 1963], 26n).

The Figure of the Wheel of Nature, from Jakob Böhme, *The Works of Jakob Böhme,* vol. 2 (London: M. Richardson, 1764), Philosophical Research Library, Manly P. Hall Collection, Los Angeles

BÖHME

German mystic (see MYSTICISM), theosophist (see THEOSOPHY), and "philosophical chemist," Jakob Böhme (1575–1624) was a devout Lutheran whose mystical experiences led him to formulate a strikingly original account of God and Creation, which he expressed in a complex, private terminology drawn in part from ALCHEMY. Although born of well-to-do farmers, he was apprenticed to a shoemaker at an early age and later moved to Görlitz, then one of the most important cities in what is now East Germany, to practice his trade. There, at age twenty-five, he had his first mystical experience, in which he felt himself penetrated by the "Light of God." He later wrote that "in one quarter of an hour I saw and knew more than if I had been many years together in a University. . . . I saw and knew the Being of Beings, the Byss and Abyss, the eternal generation of the Trinity, the origin and descent of the world, and of all creatures through Divine Wisdom" (quoted in Rufus M. Jones, *Spiritual Reformers in the Sixteenth and Seventeenth Centuries* [1914; Boston: Beacon Press, 1959], 159). Another major mystical experience occurred ten years later, in 1610. He published an account of his experiences and beliefs in 1612. He immediately ran into hostility from Lutheran authorities and was forbidden to continue publishing. Neverthe-

less, as a result of further internal growth, he resumed writing in 1618, but published nothing until 1623. From then until his death the following year, he was under constant attack by ecclesiastical officials who doubted his orthodoxy. His work in fact represents a strong protest against a rigid Christianity constructed on external practice and dogma. True Christianity for Böhme was based on personal experience and practicing a Christ-like life.

Böhme's theosophical writings attempt to express the knowledge he had gained through his mystical experiences, to explain, for example, the origin of evil, the relationship of the one and the many, and the nature of God. Böhme conceived of God essentially as "Divine Will," which is omnipotent, omnipresent, and eternal. Unlike human will, which in its imperfection must strive after some objective, Divine Will is absolutely free in itself, determined by nothing outside itself, having no external goal or motive. As pure will, it is without presupposition and beyond all description; it is, in Böhme's terminology, the *Ungrund:* the "groundless," the abyss, nothingness. Yet it is also the source of all things, both good and evil. Böhme depicts the Creation and the arising

of good and evil from the Ungrund as the result of the Divine Will's effort to know itself through self-manifestation. It knows itself, first, simply as blind force (the formless abyss). Then, through a process of inner conflict, the Divine Will manifests itself as pairs of opposites, such as will and desire, light and darkness, spirit and matter. In doing so, it produces nature and also evil, which is desire so limited in its focus that it cuts itself off from light and goodness. The Divine Will advances in self-knowledge as it manifests itself as human self-consciousness. Ultimately, human will, itself a manifestation of the Divine Will, is transformed into the Divine Will through a dialectical process: God becomes humanity and humanity becomes God.

Böhme's theosophical works have been constantly popular. English translations made in the midseventeenth century were studied by Isaac Newton. Böhme's impact was felt by the Quaker mystic William Law; by such philosophers as Georg Wilhelm Friedrich Hegel, Friedrich von Schelling, Arthur Schopenhauer, and Nikolai Berdiaev; and by the poets William Blake, Samuel Coleridge, and William Butler Yeats.

CABALA

The cabala (the Hebrew word for "tradition") is the body of traditional Jewish MYSTICISM, THEOSOPHY, and magic that developed from Hellenistic roots and coalesced in thirteenth-century Spain in the text of the *Sefer ha-Zohar* (The book of splendor). Like Gnosticism and NEOPLATONISM, the cabala seeks to explain the nature of reality, the levels of being, the origin of evil, and the ways of attaining knowledge of God. Cabalistic teaching focuses on the *Sefirot,* the ten qualities or powers of God (the *Ein-Sof*, the infinite, who is described as undifferentiated, absolute perfection). The Sefirot are simultaneously the emanations of God's power, the names of God, the realms or planes of the Godhead, and the inner foundation of every created being or thing. Cabalistic texts depict the ten Sefirot arranged in a Tree of Life pattern, linked by twenty-two paths corresponding to the twenty-two letters of the Hebrew alphabet. The resulting complexity of numbers, letters, names, and qualities provides a nearly inexhaustible source of study and manipulation.

The task of cabalistic study is to guide the soul back to its home in the Godhead. Through prayer and meditation (inner magic) on the Sefirot, corresponding qualities are developed in the individual and lead ultimately to harmonious integration with the world of the Sefirot. This type of cabala is essentially a form of mysticism. Practical cabala, by contrast, concentrates on the magical use of the names of the Sefirot, names of the angels, and names of God. Such magic is intended only for the public good, but in fact there is a considerable body of cabalistic literature on demonology and black magic. The cabalistic magician or *ba'al shem* (master of the name) could invoke angels and demons and also exorcise evil spirits. Through *gematria,* the numerical and alphabetical manipulation of words, the student of cabala could also decode sacred texts.

In the fifteenth and sixteenth centuries, the cabala began to be accepted by people outside the Jewish faith (Giovanni Pico della Mirandola, Johannes Reuchlin, and others) as a tradition originating with Moses. It was absorbed into the emerging Renaissance synthesis of "high magic," which included HERMETICISM, Neoplatonism, Gnosticism, ALCHEMY, and astrology. The cabala was also interpreted by theologians as supporting the Christian doctrines of the Trinity and Incarnation. Increasingly separated from their Jewish origins, cabalistic teachings and practices were widely diffused throughout European esotericism: the symbolism of alchemy, the sixteenth-century synthesis of magic by Agrippa, the teachings of Jakob BÖHME, the doctrines of ROSICRUCIANISM and Freemasonry, the practices of modern magic, the "ancient wisdom" of the Theosophical Society, and interpretations of the tarot cards.

Lower Space Systems in Our World, from Claude Bragdon, *A Primer of Higher Space* (1913)

FOURTH DIMENSION

In mathematics and philosophy, the fourth dimension has acquired at least three different meanings. Nineteenth-century geometry largely interpreted the fourth dimension as simply a higher dimension of space. Albert Einstein's general theory of relativity (1916) established the now-prevalent view of time as the fourth dimension. A third school of thought, which Linda Dalrymple Henderson has identified as "hyperspace philosophy," presented the fourth dimension as the true reality that can be perceived by means of higher consciousness. The principal exponents of hyperspace philosophy were the Englishman Charles Howard Hinton, author of *A New Era of Thought* (1888) and *The Fourth Dimension* (1904); the American architect Claude Bragdon in *A Primer of Higher Space* (1913) and *Four-Dimensional Vistas* (1916); and the Russian philosopher, occultist, and later disciple of G. I. Gurdjieff, P. D. Ouspensky, particularly in his books *The Fourth Dimension* (1910), *Tertium Organum* (1911), and *A New Model of the Universe* (1931). According to Ouspensky, humanity possesses an incomplete sense of space. Our perceptions of time and motion in the three-dimensional world are illusory. Through the cultivation of a new kind of logic (the "tertium organum") and especially through glimpses of the fourth-dimensional reality by means of cosmic consciousness, our understanding of space will increase and the illusory perceptions disappear. Ouspensky's hyperspace philosophy directly influenced the Russian Futurists and Kazimir Malevich's Suprematist compositions in the years just before the Russian revolutions of 1917.

HERMETICISM

Hermeticism is the name given to the traditions associated with the *Hermetica*, writings ascribed to Hermes Trismegistus, who was identified in Hellenistic times with the Egyptian god Thoth. Written in Greek and produced in Egypt mostly during the second and third centuries, the hermetic writings are contemporary with Gnosticism, Hellenistic ALCHEMY, and the beginnings of NEOPLATONISM. The hermetic works consist of the *Corpus hermeticum,* a collection of seventeen treatises (the first, the *Poimandres*, is the best known); the *Asclepius*; and fragments of other works, mostly astrological, alchemical, and magical. Although the astrological works may contain some genuine Egyptian material, the hermetic writings are essentially Greek in nature, reflecting a generalized Platonism, with some Jewish, Gnostic, Christian, and possibly Persian elements. The major hermetic works are philosophical and revelatory. A number of them are in dialogue form in which Hermes guides the disciple to an illumination concerning the true nature of the cosmos, thereby enabling the disciple to gain spiritual mastery over it and achieve personal salvation.

The reputation of Hermes Trismegistus was considerable in the Middle Ages, although only the *Asclepius* was then available. It was commonly believed that he was an actual person, at least as old as Moses, and that his works anticipated Plato, Christ, and possibly even Moses. His revelations were thought to be of immense antiquity and authority, perhaps constituting *the* primal revelation of God to humanity. When the Greek text of the *Corpus hermeticum* first reached Western Europe in 1460, the Florentine scholar Marsilio Ficino was ordered by his patron Cosimo de' Medici to translate it, as the older and far more significant work, before undertaking a translation of Plato's writings. Completed in 1463 and published in 1471, Ficino's translation marked the emergence of hermeticism in the Renaissance synthesis of "high magic," consisting of Neoplatonism, alchemy, astrology, magic, and the CABALA. The account of Creation in the *Poimandres* indicated to Renaissance humanists and occultists that man, in his very origin, is a divine being, a magus (magician), possessing the divine creative power and still capable of awakening to knowledge of his divine essence. This view of human nature is confirmed by the *Asclepius:* "Man is a great miracle, worthy of honor and veneration."

It was not until 1614 that the Swiss Protestant scholar Isaac Casaubon demonstrated that the hermetic writings, far from being of vast antiquity, were in fact post-Christian and that the supposed anticipations of Plato and Christ were really later borrowings and influences. The authority of Hermes, however, declined only slowly during the seventeenth century. Hermeticism gained new life in such nineteenth-century occult movements as the Theosophical Society (see THEOSOPHY) and the Hermetic Order of the Golden Dawn.

Māghayā Mandala, from *A Priest's Manual with Mandalas*
Nepal, 17th century
Ink and color on paper
3⅞ x 9 in. (9.8 x 22.8 cm) approx.
Los Angeles County Museum of Art
Gift of Dr. and Mrs. Robert S. Coles

MANDALA

In Hinduism and Buddhism, a mandala (Sanskrit for "round" or "circle") is a symmetrical image, usually circular but frequently square or floral, which is used to assist concentration and meditation. The mandala can be a purely geometrical composition — for example, interpenetrating triangles within concentric circles or alternating concentric circles and squares — or it can be figurative, depicting spiritual beings such as Buddhas, bodhisattvas, demons, and deities, whose placement forms geometrical patterns from the center to the perimeter of the image. Mandalas can be drawn, painted, sculpted, embroidered, or danced. Regardless of medium, each mandala is a microcosm or spiritual diagram of the universe, illustrating the various principles, qualities, and forces (personified by the beings depicted) in the world, their derivation from the ultimate, and the process by which the individual can return to the original source. By "reading" or meditating upon the components of the mandala in sequence, moving inward toward the center, the student moves simultaneously toward his own center and toward the center of reality, the Hindu Brahma or Buddhist nirvana.

In the twentieth century, the psychologist Carl Gustav Jung contended that mandala images appear spontaneously in dreams of patients suffering from certain kinds of conflict and schizophrenia. For persons experiencing disorientation and fragmentation, dream mandalas are manifestations of the need for wholeness and integration of the self; they represent a natural attempt at self-healing by the psyche. Jung detected other instances of the mandala as the archetype of wholeness in the imagery of the Navajo Indians, the ancient Egyptians, Jakob BÖHME, ALCHEMY, HERMETICISM, and elsewhere.

MYSTICISM

The word *mysticism* comes from the mystery religions of antiquity (from Greek *mustēs,* "one initiated into secret rites," from *muein,* "to close the eyes (or mouth)," hence, to keep secret. In popular usage today, *mysticism* is often equated with *mystery* to signify the mysterious, the esoteric, or the nonrational. In comparative religion and other scholarly disciplines, however, mysticism carries a much more precise meaning that usefully differentiates it from occultism (see OCCULT), THEOSOPHY, SPIRITUALISM, and magic. Mysticism in this narrower sense has been defined by the historian Hal Bridges as the "selfless, direct, transcendent, unitive experience of God or ultimate reality, and the experient's interpretation of that experience" (Hal Bridges, *American Mysticism: From William James to Zen* [New York: Harper & Row, 1970], 4). The mystical experience is, in the words of the philosopher Walter T. Stace, the "apprehension of an ultimate nonsensuous unity in all things, a oneness or One to which neither the senses nor the reason can penetrate. . . . it entirely transcends our sensory-intellectual consciousness" (Walter T. Stace, *The Teachings of the Mystics* [New York: New American Library, 1960], 14–15). The mystical experience transcends the perception of multiplicity; there is no awareness of self, only consciousness of unity. Subject and object merge and there is only oneness; nothing is seen or heard, nothing is thought or communicated.

The absence of sensory content distinguishes mystical experience from visionary experience such as that afforded the author of Revelation or Emanuel SWEDENBORG's direct perception of the spirit worlds. The lack of cognitive content means that the mystical experience is not telepathic communication or messages from the dead (spiritualism), revelatory gnosis, or theosophical speculation, although mystics like Jakob BÖHME derived theosophical ideas from their mystical experiences. Unlike the magician who focuses on the control of specific forces and entities, the mystic is conscious only of oneness, a condition in which there can be no discrete objects nor a separate operator to manipulate them. Thus mysticism in this narrower sense is not concerned with the acquisition and development of unusual powers and abilities, control of hidden forces and entities, or access to special revelations and knowledge, all of which are more properly the focus of occultism.

The mystic regards the oneness that characterizes mystical experience as the ultimate reality. Depending on the mystic's religious or cultural tradition, the ultimate reality may be denoted as God, the One, Brahma, nirvana, Tao, or undifferentiated unity, among other possibilities. Mysticism is found universally among the world's major religions, including Hinduism (including Yoga, Vedanta, and other approaches), Buddhism, ZEN BUDDHISM, TAOISM, Judaism (the CABALA), Christianity, and Islam (Sufism), as well as in the philosophical tradition of NEOPLATONISM. Membership in a religion, however, is not necessary for a mystic. Independent and secular mystics are relatively

From Robert Fludd, *Utriusque cosmi* (Oppenheim, 1617), p. 29, Philosophical Research Library, Manly P. Hall Collection, Los Angeles

common in modern Western culture, for example, Walt Whitman, Aldous Huxley, and Arthur Koestler (who was a Communist at the time of his mystical experiences during the Spanish Civil War).

Although mystical experiences are often unsolicited and occur spontaneously, many mental and physical disciplines have been devised to prepare the aspirant for mystical union and enlightenment. Meditation is the principal means of achieving inner quietude and detachment. It can be practiced in various ways: exercises to focus consciousness; repetition of prayers, chants, names, or mantras; contemplative prayer; meditating on pictures, MANDALAS, or mental images; seeking the meaning of parables, teaching stories, and paradoxical questions (koans); and ascending to increasingly abstract levels of thought. Physical and bodily disciplines include breathing exercises; Zen sitting; the postures of Yoga; bodily austerities, such as fasting, purification, flagellation, and isolation; and ritual dances and movements. Devotional practices also serve as a path to enlightenment. Yet none of the disciplines can compel a mystical experience to occur. Their function is only preparatory.

In Western tradition a general tendency toward mysticism is noticeable in the first and second centuries: some detect hints of mysticism in the New Testament, and there are examples of near or partial mysticism in the Jewish Philo of Alexandria (c. 20 B.C.– A.D. 50), the Christian Origen (c. 183–253), and certain hermetic and Gnostic texts. The earliest indisputable examples of practicing mystics, however, are the Neoplatonists Plotinus and Porphyry in the third century. The first Christian mystic is usually said to be Saint Gregory of Nyssa (c. 335–c. 395). Catholic mysticism flourished in the twelfth and thirteenth centuries, but it reached its apogee in the fourteenth century, especially in Germany and England. Meister Eckhart (1260–1327), influenced by Neoplatonism, emphasized high levels of both intellectual and spiritual attainment. The church condemned a number of his propositions as pantheistic, but his influence was far-reaching on German and Flemish mystics. England in the fourteenth century witnessed the mysticism of Richard Rolle, Walter Hilton, the anonymous mystical text *The Cloud of Unknowing,* and Dame Julian of Norwich. The next great period of Catholic mysticism was sixteenth-century Spain with Saint Ignatius of Loyola, Saint Teresa of Avila, and Saint John of the Cross, all of them highly capable organizers and writers on the stages of mystical experience. The seventeenth century was perhaps as rich in mysticism as the fourteenth: the Lutheran Böhme in Germany; George Fox and the Quakers in England; the French Quietists; the French philosopher and mathematician Blaise Pascal; and various spiritual alchemists, Cambridge Platonists, and metaphysical poets in England, especially the poet Thomas Traherne. Mysticism was quite apparent in the poetry of English Romanticism and the philosophy of German idealism in the early nineteenth century. Among the best-known Western mystics of the twentieth century have been Pierre Teilhard de Chardin and Thomas Merton.

NATIVE AMERICAN ART

The category *Native American Art* is a pluralistic one, for *the* American Indian never existed. Rather, there were hundreds of distinctly different Indian societies that participated in more broadly defined cultural traditions: Woodlands, Plains, Southwest, Great Basin, Plateau, and Northwest Coast. Despite the disparate languages and cultural forms, the various Indian peoples of North America shared certain conceptions about the relationship between art, myth, ritual, and nature.

Just as most tribes had no single word for religion, most had no term indicating an aesthetic domain separate from the rest of life. In the world of the Indian the secular was sacred, and even commonplace artistic practices, such as the decoration of utilitarian ware, represented a celebration of man's unity with nature. The designs and motifs of the Indian's applied art — painted pottery, basketry, weaving, tepee covers, utensils — imply, in both abstract and representational form, the spiritual import of earth and sky, sun and rain, flora and fauna. The willingness of the Indian to convert into art virtually any material substance, including his own body, suggests more than the symbolic presence of the great-creator-all-things. Rather, the overt message of body painting and tattoo and of the use of fur and hide,

feathers and quills, teeth and talons, and rocks and clay is that the divine force imbues all natural forms.

The unity with nature felt by the Indian focused much of his art and ceremony on the bounty of the earth. For example, in the Green Corn Festival of the Woodlands, the Sun Dance of the Plains, and the Kachina Cult of the Pueblos, painting, sculpture, weaving, song, and dance were given over to both celebrating and maintaining a harmony with the spirits of nature. Oftentimes the essential elements of life provided by nature, as well as ancestral clan progenitors, were symbolized by significant animals, such as turtle, bear, eagle, raven, and snake, or zoomorphs, such as buffalo woman or spider woman. The mythologizing of the natural world and the linking of the origins of the clans to animal ancestors led to the creation of aesthetically powerful totemic forms. On the Northwest Coast especially, much attention was given to the validation of hereditary claims through highly valued ritual masks, rattles, feast dishes, songs, and even myths themselves.

Northwest Coast art, like that of the Plains, resulted from an ecstatic tradition that emphasized shamanic performance. The legendary rituals of the Kwakiutl Hamatsa

Society on the Northwest Coast centered on ritually taming the barbarism of one who, through fasting, was mad from mingling with darkness at the north end of the world. Thus, in true Dionysian fashion, the base elements of man were transformed by shamanism into something of great aesthetic beauty. Much of the mysterious symbolic presence felt in the art of the Plains (shield designs and medicine shirts) results from the pictorialization of personal totems found during the shamanic vision quest.

Shamanic art and performance cannot be disassociated from the Indian notion of ritual healing. Illness, both spiritual and physical, was often linked to disharmony, the breaking of ritual taboo, or the presence of evil. Sweat lodges and other rites of purification, such as using an eagle feather fan to envelop the victim in a cloud of sweet-grass smoke, are examples of attempts to heal through symbolic action. The Navajo sand-painting ritual, learned from Pueblo Indians, is perhaps the best example of Indian art as a healing process. During a rigid ritual process involving painting symbolic pictures on the earth and the singing of long song cycles, the patient becomes purified and rejoined with nature by direct contact with the created image. W. JACKSON RUSHING

Carte Philosophique et Mathématique, from Tycho Brahe and T. du Chenteau, *Magical Calendar of Tycho Brahe in Teletes* (Turin, 1866), Philosophical Research Library, Manly P. Hall Collection, Los Angeles

NEOPLATONISM

Neoplatonism is essentially a mystical (see MYSTICISM) version of the philosophy of Plato that originated in the third century — six centuries after his death — with Plotinus, who claimed simply to be restoring Plato's own doctrine. In general, Neoplatonism emphasizes the aesthetic, cosmological, and psychological aspects of Plato's thought at the expense of the political and ethical. Plotinus, a Greek philosopher who studied at Alexandria, Egypt, and taught in Rome for a quarter-century, regarded philosophy both as an account of reality and as a religious way of life. For Plotinus, reality is a dynamic hierarchy of levels of being, an eternal process of descent from the transcendent One or First Principle, down through a succession of stages to the material world of the senses, the lowest and least perfect level, and an opposite process of ascent by which the human soul can progressively purify itself and return to the One in an experience of complete union (mystical experience). The return to the One is not automatic and cannot be accomplished, according to Plotinus, by means of magic, techniques, grace, or secret knowledge (gnosis). It requires one to awaken from obsession with material needs and bodily desires, to turn inward and rediscover the inner self through rigorous intellectual and moral preparation.

Plotinus bequeathed to later Neoplatonists several major concepts: the hierarchical nature of reality; the material world as an organic whole animated by a World Soul and bound together by correspondences and sympathies; and the soul's ability to ascend the levels of reality back to the One. During the Renaissance, Neoplatonism provided, in conjunction with HERMETICISM and the CABALA, a cosmological framework for magic and astrology that made them intellectually respectable; its theories are central to Western occultism (see OCCULT), especially in the teachings of the Theosophical Society (see THEOSOPHY).

OCCULT

There is no fully satisfactory, succinct definition of *occult* (from Latin *occultus,* "hidden," from *occulere,* "to cover over, hide, conceal"). The occult is not simply equivalent to rejected knowledge, anomalies, superstition, or the supernatural, although it contains elements of each. In contemporary popular speech, *occult* is frequently used interchangeably with *psychical, esoteric, paranormal, mystical, magical, metaphysical,* among other words. Based on its etymology, the occult can be viewed as an attitude toward the world that emphasizes the hidden, or secret, aspects of reality. The association of *occult* with occult sciences (astrology, ALCHEMY, magic), matters kept secret, and matters beyond ordinary understanding and ordinary knowledge became common in Latin during the Middle Ages and Renaissance and entered English usage in the sixteenth and early seventeenth centuries.

In general, the occult can be said to pertain to matters (phenomena, experiences, modes of cognition, practices, interpretations, teachings, organizations) that are hidden or secret in one or more of the following senses:

1. Extraordinary matters that by virtue of their intrusion into the mundane are thought to possess special significance, for example, omens, prophetic dreams, apparitions, miracles;

2. Matters such as the teachings of the so-called "mystery" schools that are kept hidden from the uninitiated and the unworthy;

3. Matters that are said to be intrinsically hidden from ordinary cognition and understanding, but that are none the less knowable through the awakening of latent cognitive faculties of appropriate sensitivity.

Until the late seventeenth century, belief in the occult in all three senses was common at all levels of Western society, although particular formulations or practices might be rejected as heretical. Since the late seventeenth century, with the general displacement of occult beliefs from the public value structures of the middle and upper classes, there has arisen an additional connotation of *occult:*

4. Occult matters in the first three senses are also anomalous in the sense that they are regarded, often by critics and adherents alike, as not fitting into, and perhaps also directly criticizing, prevailing interpretations of science, historical scholarship, and "common sense."

A number of broad but overlapping categories of beliefs, phenomena, experiences, and practices seem to be subsumed under the occult today:

1. Mysteries of human and natural history. Disputed or imputed phenomena and unconventional theories concerning human history and natural history that do not agree with established scientific and historical knowledge. Examples: UFOs, the Loch Ness Monster, ancient astronauts.

The Soul of the World, from
Kurt Seligmann, *The History
of Magic* (1948)

2. Psi phenomena. The field studied by experimental parapsychology, comprising extrasensory perception, psychokinesis (mind over matter), and survival phenomena (presumed evidence for postmortem existence; see SPIRITUALISM) — all believed to be outside the individual's normal sensory and muscular processes.

3. Transpersonal experiences. Experiences in which the ordinary personality is transcended, erased, or replaced, as in trance mediumship (spiritualism), demonic possession, vampirism, and revelation.

4. Occult sciences, arts, or technologies. Disciplines based on the deliberate cultivation of natural or acquired psychic abilities to satisfy specific needs, such as magic, ALCHEMY, prediction and divination (including astrology, tarot cards, oracles), characterology (character analysis by means of astrology, phrenology, palmistry, numerology), and occult health and healing practices (faith healing, mind cure, psychic surgery).

5. Occult religions. Organized practices for the primary purpose of worshiping, celebrating, serving, or communicating with natural forces, supernatural beings, the dead, or pagan or mythological deities, as in traditional and modern witchcraft, Satanism, neopaganism, and spiritualism.

6. Metaphysical occultism. Systems of teachings and practices that lead the individual, by means of occult modes of cognition, to personal, empirical knowledge of metaphysical truths and principles, as in Gnosticism, ROSICRUCIANISM, the Theosophical Society (see THEOSOPHY), and ANTHROPOSOPHY.

In practice numerous occult organizations and teachings combine elements from two or more of these categories. It is also difficult always to differentiate clearly between the occult and such areas as millenarianism and apocalypticism, healing and charismatic movements, self-help and self-realization techniques, unconventional science, and a variety of other altered states of consciousness.

PARACELSUS

One of the most famous occultists of the Renaissance, Paracelsus (1493–1541) was an alchemist (see ALCHEMY), chemist, physician, and writer whose ideas are extraordinarily complex and difficult to separate from those of his numerous followers in the sixteenth and seventeenth centuries. Born Philippus Aureolus Theophrastus Bombastus von Hohenheim, he was later called Paracelsus, a name that may signify "beyond, or surpassing, Celsus" (a Roman medical writer of the first century) and thus indicate his advance over ancient medicine. The son of a Swiss country doctor, Paracelsus studied medicine, alchemy, and mining at many universities and may have earned a medical degree. He traveled widely as a physician, but his rash temper, outspoken nature, and melodramatic actions (such as publicly burning the works of medical authorities he disagreed with) cost him many positions. He was responsible for numerous medical innovations, among them chemical urinalysis, antisepsis of wounds, mercury as a treatment for syphilis, and combining the arts of the surgeon, doctor, and pharmacist. He wrote voluminously, but only a few of his works were published during his lifetime. After his death in 1541 in Salzburg, stories of his seemingly miraculous cures prompted people to collect and publish his manuscripts, often with commentaries. His subsequent impact on chemistry, medicine, and pharmacy was considerable.

As an alchemist, Paracelsus was not especially interested in the traditional tasks of transmutation and creating the philosopher's stone. For him alchemy was important primarily as a means of developing new medicines for the treatment of specific ailments. In his view alchemy and chemistry were the key to a new natural philosophy. Drawing from the Renaissance synthesis of NEOPLATONISM, HERMETICISM, and magic, Paracelsus and the Paracelsians saw the universe as animate, profoundly interconnected through sympathies and correspondences of microcosm and macrocosm. This world view encouraged the search for precise relationships that would lead to the discovery of medicines that were applicable to individual illnesses. It also supported the view, in Paracelsus's application, that Creation itself was a chemical process in which the *mysterium magnum* (prime matter) was separated into the four elements of earth, water, air, and fire, and the three principles that he called salt (governing the solid state or property of things), sulfur (the inflammable state), and mercury (the vaporous or fluid state). Illness was not the result of an imbalance among the four humors of the body (the prevailing view) but of chemical reactions to the exact mixture of elements and principles in the body, which could be identified through chemical analysis and treated with chemically prepared medicines.

The three Paracelsian principles also correspond to the spirit (mercury), soul (sulfur), and body (salt) of any object or person. Knowledge in general consists of the ability of the spirit of the person to merge with the spirit of the thing to be known. The preparation of effective medicines is dependent upon extracting the inner spirit or "philosophic mercury" from the appropriate herbs, minerals, and chemicals.

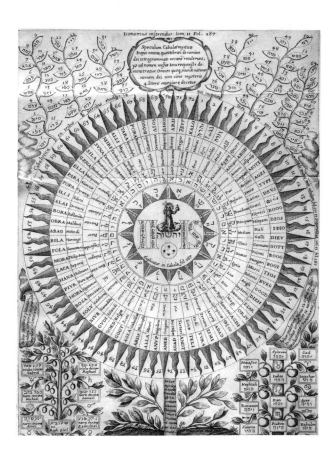

From Athanasius Kircher, *Oedipi aegyptiaci* (Rome, 1652), p. 358, Philosophical Research Library, Manly P. Hall Collection, Los Angeles

ROSICRUCIANISM

Rosicrucian is derived from the Latin translation (*rosae crucis*) of *Rosenkreutz* (German, "rose cross"), the name of the legendary founder of the Rosicrucian Brotherhood. The alleged existence of the brotherhood was publicly announced by two anonymous pamphlets published in Kassel, Germany, in 1614 and 1615. The pamphlets called for a general reformation of knowledge and society based on the principles of Christian Rosenkreutz (1378–1484), who is described as a wise man who studied numbers, magic, ALCHEMY, and the CABALA during his extensive travels in the East and in Europe. He established the brotherhood in Germany to minister to the sick and to extend knowledge. The pamphlets claimed that the recent rediscovery by the brotherhood of Rosenkreutz's tomb and the many records, inscriptions, and devices it contained was the signal for the general reformation of knowledge to commence. Readers were urged to join the brotherhood in its work of renewing society through Rosicrucian knowledge and returning to the state of Adam in Paradise.

The revelation in prophetic, even apocalyptic, language of a powerful secret society possessing advanced knowledge met with excited response throughout Europe, including publication of the alchemical ro-mance *The Chemical Wedding of Christian Rosenkreutz* (1616) by Johann Valentin Andreae and appeals from those seeking to join the order. Despite widespread searches, the Rosicrucian society was never found and probably never existed. It is possible, however, that the beginnings of speculative Freemasonry in England in the 1640s owes something to the idea of a secret Rosicrucian Brotherhood. From the mideighteenth century on, symbols, myths, and teachings, derived from the original Rosicrucian pamphlets, were widely incorporated into the rites and doctrines of secret societies and occult organizations; *Rosicrucianism* became an epithet for Western Christian occult tradition in general. Examples of Rosicrucianism can be found in Freemasonry, the Hermetic Order of the Golden Dawn, Joséphin Péladan's Ordre Kabbalistique de la Rose + Croix and Salons de la Rose + Croix, the Theosophical Society (see THEOSOPHY), and Rudolf Steiner's ANTHROPOSOPHY. Rosicru-cianism also forms the content of perhaps the most famous of all occult novels, Sir Edward Bulwer-Lytton's *Zanoni* (1842).

The Ancient and Mystical Order Rosae Crucis, founded in 1915 by H. Spencer Lewis (headquarters: San Jose, California), and the Rosicrucian Fellowship, founded in 1907 by Max Heindel (headquarters: Mount Ecclesia, California), are among the best-known explicitly Rosicrucian organizations functioning today.

SPIRITUALISM

Spiritualism is based on two fundamental propositions: first, that the human personality survives bodily death in some form; second, that it is possible to communicate with the surviving personality, or spirit, usually through a human medium. The immediate roots of modern spiritualism are found in the teachings of Emanuel SWEDENBORG and Franz Anton Mesmer. Swedenborg claimed to have direct perception into the spirit worlds in full waking consciousness and to be able to converse with the spirits and angels. His detailed descriptions of the spirit worlds and life after death prompted others to attempt communication with the spirits. In 1787–88 a Swedenborgian group in Stockholm claimed success by making use of persons in a state of mesmeric trance as the medium for communication. Mesmer was then attracting considerable notoriety in Vienna and Paris for his cures of various illnesses by manipulating the flow of magnetic fluid ("animal magnetism") through the body. The procedure sometimes induced a somnambulistic, or hypnotic, trance in the patient. It was discovered by one of Mesmer's associates that some trance patients experienced extrasensory perception and alleged communication with spirits of the dead. When the Stockholm group announced successful contact with spirits through the use of a medium and corroboration of Swedenborg's teachings, the practice of trance mediumship rapidly spread throughout Western Europe.

Following the turmoil of the French Revolution and Napoleonic wars, spirit communication was resumed, especially in Germany, France, and America. The American Shaker communities, for example, experienced massive spirit communications in the years 1837–44, resulting in many spirit-dictated hymns, books, messages, and visions. In 1847 the American seer Andrew Jackson Davis published *The Principles of Nature,* dictated to him in a trance by spirits. In this and numerous subsequent books, Davis developed a philosophy and geography of the spirit worlds that shows some similarities to Swedenborg's (Davis later claimed to have conversed with Swedenborg's spirit) and proved immensely influential on later spiritualism.

On 31 March 1848 in Hydesville, New York, near Rochester, two sisters, Margaretta and Kate Fox, discovered that the spirit of a murdered peddler was communicating with them, answering their questions through insistent rappings. This event marks the beginning of modern spiritualism. The subsequent publicity and exploitation initiated an almost epidemic wave of spirit rapping, or "spirit telegraphy," throughout New York, then the Eastern seaboard, the Midwest, and California. Within a few years every city had spiritualist groups that met in séances presided over by mediums whose personal magnetism elicited intelligent responses to questions asked of the spirits. Throughout the 1850s and again in the late 1860s and 1870s, following the Civil War, ever more remarkable phenomena were produced by or through mediums: physical rappings, table tipping, musical instruments played by unseen

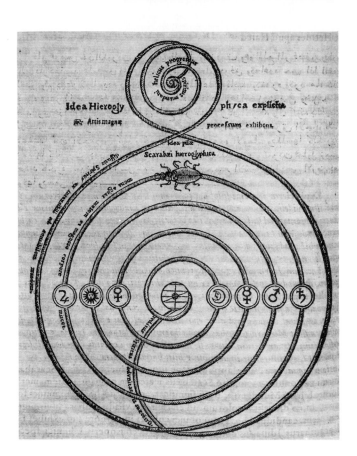

From Athanasius Kircher, *Oedipi aegyptiaci* (Rome, 1652), p. 358, Philosophical Research Library, Manly P. Hall Collection, Los Angeles

hands, spirit voices, automatic writing with a planchette (precursor of the Ouija board), slate writing (spirit messages written inside slates bound together), spirit photography, and materializations of spirit faces and full figures. Many of these phenomena were quickly exposed as fraudulent. Spiritualism's popularity began to decline in America after 1875, but in England and Europe it grew stronger.

In response to the exposure of fraudulent mediums, spiritualists began to establish professional and national organizations, such as the London Spiritualist Alliance (1884), the Spiritualists' National Union (Great Britain, 1890), and the National Spiritualist Association of Churches (United States, 1893), the latter established in part to train and certify honest mediums. Another, more significant response to spiritualist claims was the founding of the Society for Psychical Research (1882) in England and the American Society for Psychical Research (1884). Such organizations sought to impose rigorous critical and scientific methods on

the study of mediumistic phenomena in order to determine their authenticity. Prominent psychical researchers included Frederic William Henry Myers, William James, Henry Sidgwick, and Sir Oliver Lodge. Their investigations failed, however, to arrive at a consensus concerning the reality of survival of bodily death.

Despite this failure, one of the principal appeals of spiritualism has been its claim to provide empirical verification of life after death. Although the medium through whom the phenomena are channeled from the other world may be in a trance or employ clairvoyance, the phenomena themselves are perceptible to anyone in an ordinary state of consciousness. The empirical, publicly accessible nature of spiritualistic

phenomena became the basis for a scientific religion for some believers. Others were attracted by spiritualism's power to console the bereaved with messages from the departed and by its optimistic philosophy of spiritual progress, derived from Davis, in which there is no original sin or eternal damnation but rather individual responsibility for salvation and continuous progress after death through six spiritual realms toward God.

SWEDENBORG

Swedish scientist, philosopher, religious writer, and visionary, Emanuel Swedenborg (1688–1772) believed that as a result of a profound religious crisis in middle age he had been given the ability to see directly into the worlds of spirits and angels, and that he had been commanded to restore the spiritual meaning of Scripture in preparation for the Second Coming and the New Jerusalem. His already considerable reputation as a scientist no doubt gave his visionary and exegetical works, such as *Heaven and Hell* (1758) and *The True Christian Religion* (1771), an initial reception they might not otherwise have received.

Swedenborg divides reality into three worlds: the natural world of physical existence, the spiritual world or realm of spirits, and the celestial world consisting of three spheres of heaven and three spheres of hell. After death the individual moves immediately into the world of spirits, which Swedenborg said he had visited a number of times, guided by angels. The individual first exists in a state of exteriors, corresponding in all particulars to life on Earth except that he or she is now a spirit. Gradually, with the growth of self-knowledge, abetted by instruction from the angels, the individual moves into a state of interiors and then into a sphere of heaven or hell corresponding to the person's own nature. The individual's fate is thus self-determined, not imposed by an external authority.

The idea of correspondences is basic to Swedenborg's teachings. The human being is a microcosm that contains in itself each and every level of existence from the divine essence to physical matter. The human body corresponds to exteriors and the natural world, the human mind to interiors and the spiritual world. The heavenly worlds together form a "Grand Man," which is an image of the humanness of God and which is imaged in turn in human nature and the human body. Such correspondences, or linkages, are the basis for a profound spiritual knowledge of God and creation. Similarly, correspondences between words and divine reality revealed to Swedenborg deeper spiritual meanings in Biblical texts, especially Revelation.

Swedenborg's visionary writings are sometimes cited as an example of THEOSOPHY. They commanded widespread attention in the late eighteenth century. By the 1780s Swedenborgian groups were being organized, leading to the establishment of the Church of the New Jerusalem in 1787. Some occult groups attempted to contact Swedenborg's spirit worlds by means of mesmerism. His ideas had considerable impact on later SPIRITUALISM, New Thought, and Christian Science, and influenced such writers as William Blake, Honoré de Balzac, and Ralph Waldo Emerson.

TAOISM

Taoism (from the Chinese *tao,* meaning "way") exists both in philosophical and religious versions. In the *Analects* (fifth–sixth centuries B.C.) of Confucius, the Tao appears in an ethical context as the regulative principle established by Heaven for human affairs: the "Way" which a person, ruler, or state ought to follow. In philosophical Taoism, as in the *Tao Te Ching* (c. 350–300 B.C.) attributed to Lao-tzu and the *Chuang-tzu* (late fourth century B.C.) by the philosopher Chuang-tzu, the Tao becomes a metaphysical principle, the all-pervading, formless, unchanging, underlying unity. Yet the Tao is also said to be spontaneous, the creator of all things, and one with the natural world. The Tao is thus both being and nonbeing, a whole comprising interactive opposites: the cosmic yin and yang forces; the natural poles of life and death, light and dark, heat and cold; and the human contrasts of joy and sorrow, war and peace, wealth and poverty. Changes between the poles are spontaneous and constitute the metaphysical "Way." The appropriate attitude of the philosophical Taoist toward the Tao is inner quietude or noninterference (*wu wei*). The goal is to achieve complete accord between the Tao and one's inner nature. True wisdom consists, therefore, not of accumulated knowledge, which can hinder creativity and foster a false sense of security, but of intuition, spontaneity, and the elimination of self-conscious concern with technique. Human conduct should also be intuitive and natural, not contrived. Philosophical Taoism influenced the development of Ch'an ("meditation") Buddhism in China and thus of ZEN BUDDHISM in Japan.

Religious Taoism appeared by the second century A.D. Unlike philosophical Taoism, it tended to be sectarian, esoteric, and magical. The principal goal is the attainment of immortality, not in a separate spiritual state, but in a purified or transformed body. Through dietary, hygienic, gymnastic, sexual, and respiratory techniques and the practice of inner ALCHEMY, the microcosm of the body is harmonized with the cosmic forces. Longevity is one result; another is the production of the "immortal embryo" which survives the death of the physical body.

Religious Taoism continues to be practiced wherever traditional Chinese culture survives, with the strongest tradition found in Taiwan, where Taoist priests perform exorcisms, healings, sacrifices, and other rituals. Both esoteric (yogic-alchemical) and philosophical Taoism have attracted considerable interest in the West in the twentieth century. The former is represented best by the psychological commentary on *The Secret of the Golden Flower* written by Carl Gustav Jung. The quantum physicist Niels Bohr found close parallels between philosophical Taoism and his principle of complementarity (for a popular account, see Fritjof Capra's *The Tao of Physics* [1975]). Philosophical Taoism is also fundamental to the novels of Ursula K. Le Guin. The classical Taoist texts have appeared in numerous translations and adaptations, including those by Arthur Waley, Witter Bynner, and Thomas Merton.

THEOSOPHY

Theosophy (a seventeenth-century word coined from Greek roots meaning "God wisdom" or "divine wisdom") denotes metaphysical teachings and systems, derived from personal experience and esoteric tradition, which base knowledge of nature and the human condition upon knowledge of the divine nature or spiritual powers. The primary aim of theosophical teaching, which may seem highly speculative, is not to advance the theoretical understanding of nature, but to enhance awareness of the relationships between nature and spirit, and thus to enable the individual to achieve direct, intuitive knowledge (wisdom) and personal experience of the spiritual.

The term has been applied retroactively to such Hellenistic, medieval, and Renaissance currents of thought as NEOPLATONISM, HERMETICISM, Gnosticism, and spiritual ALCHEMY, as well as to the writings of Jakob BÖHME, Robert Fludd (see ALCHEMY), and Emanuel SWEDENBORG. In modern times Theosophy is more commonly identified with the specific theory developed by the Theosophical Society.

Founded in 1875 in New York City by Helena P. Blavatsky (1831–1891), Colonel Henry Steel Olcott (1832–1907), and others, the Theosophical Society became the most widely influential organization for the public promotion of OCCULT teachings in modern times. Among the society's early objectives were to combat materialism in science and dogmatism in religion, to investigate scientifically the laws of the universe (including the spiritual realms and their inhabitants), to develop the latent powers of man, to make known the esoteric teachings of the oriental religions, and to promote the brotherhood of humanity.

The classical formulation of the society's teachings is Blavatsky's *The Secret Doctrine* (1888). The world view presented by her is a mixture of Western occult traditions (HERMETICISM, Gnosticism, Neoplatonism, the CABALA, and other forms), nineteenth-century American SPIRITUALISM, and oriental religions, especially Buddhism and Hinduism, all placed within an evolutionary framework that was derived from both contemporary scientific evolution and traditional Indian concepts of cosmic cycles. *The Secret Doctrine* is thus appropriately subtitled "the synthesis of science, religion, and philosophy." Presented in the form of a commentary on an ancient and otherwise unknown text called the "Stanzas of Dzyan," *The Secret Doctrine* recounts the evolution of the cosmos and humanity. The cosmos is depicted as being in a dynamic process of emanation and return through seven stages: three of descent from God into increasing materialization, a middle stage of crystallization, and three stages of ascent into spiritualization and reabsorption into God. Within this framework individual planets move successively through seven stages of evolution. On Earth, which is now well into its fourth stage, the human species is similarly evolving through seven stages called *root-races*. The earliest root-races were primarily spiritual, lacked physical bodies, and functioned by means of mental powers; subsequent root-races, the Lemurians and Atlanteans, acquired bodies and physical powers; the present root-race, the fifth, is on the path toward the development of spiritual powers which will be fully realized by the final two root-races.

Helena P. Blavatsky

This entire process of cosmic and human evolution, according to *The Secret Doctrine,* is also the story of divine awakening, in which spirit interacts with matter and comes to know itself through the evolution of consciousness. The core of each individual possesses some of the divine essence, and through inner development each person contributes to the evolution of consciousness and the return of spirit, in fully awakened form, to the Deity. The human being is a complex of seven principles or "bodies." In later theosophical classifications, the lower four — the physical body, the etheric body (life principle), the astral body (emotions and desires), the mental body (mind) — are transitory and subject to various physical and psychological laws. The higher three, sometimes collectively called the Ego, are the causal body (higher intelligence), the spiritual soul (vehicle of the universal spirit), and the spirit. These three constitute the immortal divine element, which alone is subject to reincarnation and karma, the process of rebirth in new human bodies in conditions of happiness or suffering depending on actions in past lives.

Many lifetimes are required to complete spiritual development. Individuals who have achieved the highest degree of human evolution are known as mahatmas (great-souled ones) or masters. Their number includes the great religious leaders, mystics, and occultists of history. These highly evolved individuals, and others from earlier rootraces, guide and protect the evolution of humanity and preserve the teachings of the secret doctrine. These teachings, which Blavatsky believed could be known today only through occultism, are called the "ancient wisdom," "divine wisdom," "gnosis," and the "secret doctrine." They constitute the universal and hidden core of the world's great religions.

The Theosophical Society moved its headquarters from New York to India in 1879. From the mid-1880s on, the society attained notable popularity in England, America, the Continent, and India. The second generation of theosophical leaders, Annie Besant (1847–1933) and Charles W. Leadbeater (1847–1934), extended the society's activity into the investigation of THOUGHT-FORMS, occult chemistry, and past lives; involvement in Indian national politics; and the promotion of the young Hindu boy Krishnamurti as the human vehicle in whom Maitreya, the coming World Teacher or Buddha, would be manifested. With Krishnamurti's repudiation of this role in 1929 and the deaths of Besant and Leadbeater a few years later, the society declined in influence.

The society is historically important for popularizing ideas of reincarnation and karma, secret masters, and Tibet as the land of ageless wisdom; for fostering the revival of Buddhism in Ceylon (Sri Lanka) and Hinduism in India; for encouraging the comparative study of religion; and for persuading many that the essential teachings of the great religions are one.

THOUGHT-FORMS

According to the teachings of the Theosophical Society (see THEOSOPHY), thoughts and emotions create distinctive patterns of color and form in the human aura, which are visible to persons with a sufficient degree of clairvoyance (the ability to see beyond the normal range of sensory perception). According to Annie Besant and Charles W. Leadbeater's *Thought-Forms* (1905), the aura is the outer part of the cloudlike substance of the mental and astral bodies that envelop the human being's physical body. The mental body is the vehicle of mental activity, the astral body of emotions, desires, and passions; together they are the chief constituents of the aura. Each kind of thought or emotion causes corresponding vibrations in the substances of the mental and astral bodies, accompanied by displays of color. In the highly developed person, characterized by sublime thoughts and selflessness, the mental body and the less delicate astral body display radiant, clear, and rippling colors; but the aura of the gross, insensitive person shows heavy, dull, muddy colors. The vibrations in the mental and astral bodies also cause them to throw off portions of themselves. These free-floating forms, charged with the energy of the mind creating them, are the thought-forms. The quality of thought determines the color, the nature of the thought determines its form, and the definiteness of the thought determines its clearness of outline. Some thought-forms will simply be images of the thinker or other persons or material objects; such images can be represented by portraits, landscapes, and realistic depictions. But other thought-forms, those concerning feelings and abstract thoughts, take on forms of their own that are abstract or nonobjective. The color plates in *Thought-Forms* and also in Leadbeater's volume on auras, *Man Visible and Invisible* (1902), provide many examples of artists' impressions of these nonobjective forms.

Undisciplined, from
D. T. Suzuki, *Manual of Zen
Buddhism* (1960 ed.)

ZEN BUDDHISM

Zen (from the Chinese *ch'an,* shortened form of *ch'an-na,* transliteration of Sanskrit *dhyana,* "meditation") is the Japanese "sudden enlightenment" form of Buddhism. Its aim is the direct experience of enlightenment (satori), without reliance upon words, concepts, or other intermediaries that might divert the student. The essence of enlightenment is to experience the inner mind as the universal Buddha-mind, but this is to be achieved suddenly, not gradually by stages or through good works or esoteric practices. Zen teaching and meditation are set among everyday tasks to emphasize the identity of enlightenment and of ordinary mind. Instead of formal teachings, a Zen master may use shouts, slaps, paradoxical questions (koans), and surprising actions to trigger enlightenment in the student. Zen practice also depends upon *zazen,* seated meditation in the traditional lotus posture with regulated breathing. The Rinzai school of Zen uses zazen more as a tool for koan exercises, while the Soto school identifies enlightenment directly with zazen.

Introduced into Japan in the late twelfth century, Zen in time influenced many aspects of Japanese culture. In keeping with its belief that Zen activity is the expression of universal Buddha-mind in all details of life, however humble or refined, Zen style is manifested in ink painting (*sumi*), the martial arts of kendo and aikido, the tea ceremony, haiku poetry, No drama, and temple rock gardens. Zen was introduced into the United States by the master Soyen Shaku in 1893 for the World Parliament of Religions at the Chicago World's Fair. Zen groups were established from the 1920s on, but Zen exerted little influence until the 1950s and 1960s when the writings of D. T. Suzuki gained wide popularity. Zen themes are evident in writings by the Beat Generation (Jack Kerouac, Allen Ginsberg, Gary Snyder), the short stories of J. D. Salinger, the psychology of Erich Fromm, and the writings of the Trappist monk Thomas Merton.

OVERLEAF

LUDWIG GOSEWITZ
*Fifteen Different Proportions
(Birth Figures) and Legend,*
1979–80
Pencil and watercolor
on paper
Each 11 ¹³⁄₁₆ x 8 ¼ in.
(30 x 21 cm)
Private Collection,
West Germany

CHRONOLOGIES: ARTISTS AND THE SPIRITUAL

JUDI FREEMAN

The linkage between artists' interest in spiritual — mystical or occult — matters and their art and imagery is difficult to establish. The existence of these linkages provides the evidence for the relationship between spiritual interests and the genesis and development of abstract art. What follows are selective chronologies for each artist featured in the exhibition that address this matter specifically. In each chronology only events in the artist's life that involve spiritual material or contact with related figures are listed. Relevant associations with the artist's abstract work are noted. The reader is encouraged to see these highlighted events, excerpted from an artist's entire career, as occasions when the role of the spiritual in an artist's life can be identified.

Numerous interviews with artists and their families were conducted by Maurice Tuchman, Maria de Herrera, and me. Among those interviewed were Craig Antrim, Robert Irwin, Bill Jensen, Jess, Jasper Johns, Ellsworth Kelly, Brice Marden, Matta, Lee Mullican, Matt Mullican, Annalee Newman, Gordon Onslow-Ford, Eric Orr, Richard and Evelyn Pousette-Dart, Anna Reinhardt, Rita

Reinhardt, Dorothea Rockburne, Jane Smith, Kiki Smith, Keith Sonnier, James Whitney, Tom Wudl, and Norman Zammitt.

For providing data used in the compilation of these chronologies, I especially wish to thank Jennifer Anger, Carel Blotkamp, Flip Bool, John Bowlt, Peter Chametzky, Sherrye Cohn, Andrew Conner, Charlotte Douglas, Anne Carnegie Edgerton, Åke Fant, Nicolette Gast, Arnold Glimcher, Jane Hancock, Sara Hastings, Maria de Herrera, Robert Hobbs, Geurt Imanse, Kryzstina Passuth, Dennis Reid, Martica Sawin, MaLin Wilson, and Trudy Zandee.

CRAIG ANTRIM
UNITED STATES, BORN 1942

1946
Suffering from meningitis, spends long period in isolation in City General Hospital, Los Angeles.

c. 1964
Reads Carl Gustav Jung's *Man and His Symbols* (1964). First visits Europe. His uncle, Charles Dockum, an abstract light projections artist, introduces him to Peter Krasnow, whose abstract style encourages him to pursue abstraction. Assists Dockum with projection performances.

1965–67
Serves in Vietnam.

1968
In graduate school systematically studies color theories of Ogden Rood, Albert Henry Munsell, Michel Eugène Chevreul, Wilhelm Ostwald, and Josef Albers.

1973
Rereads *Man and His Symbols*. Becomes especially interested in the myths of Perceval and other masculine heroes as part of an attempt to understand man's former relationships to gods and spirits.

1974–75
Abandons abstract airbrush painting in favor of paintings that use both acrylic and airbrush techniques to express manifestation of light.

1976
Goes into psychoanalysis. Squares and circles emerge as dominant forms in Odyssey series. Paint application becomes thicker. Technique of scratching into thick surfaces resembles early cave painting.

1984
Visits stone formations in Great Britain and Ireland and prehistoric cave paintings in France. Researches Celtic culture and tradition.

JEAN (HANS) ARP
FRANCE, BORN GERMANY, 1886–1966

By 1900
Reads Jakob Böhme. Childhood friend, René Schwaller, becomes Theosophist.

1903–5
Writes poems that reveal interest in German Romanticism.

1912
Meets Paul Klee. Meets Wassily Kandinsky and is influenced by his nonrepresentational paintings and *On the Spiritual in Art*.

1914
Meets Max Ernst. Produces works on theme of the Crucifixion, which are his only overtly religious works.

1915
Moves to Zurich. Meets Sophie Taeuber. Begins reliefs.

1916–18
Corresponds with Hilla Rebay, devotee of Rudolf Steiner and later director of Solomon R. Guggenheim Museum, whom he meets through composer Ferruccio Busoni.

1916
Reads German mystics Johannes Tauler, Heinrich Suso, and Meister Eckhart with Taeuber. Discusses Lao-tzu and Böhme with friends. Begins lifelong interest in German mystics, the Gospel of John, and pre-Socratic philosophers. With Taeuber abandons oil painting and makes Pre-Dada collages, torn and pasted papers often arranged accidentally; they consider these to be spiritual exercises.

1917
Probably knows the Romantic poet Novalis's ideas on "secret writing." Evidence suggests he is deeply immersed in discussions on Böhme, Lao-tzu, and Paracelsus by spring. In May reads Böhme publicly at the Cabaret Voltaire. Becomes interested in biomorphic abstraction and "fluid ovals."

1918
Creates geometric compositions, which he and Taeuber equate with moral values. Makes Duo-Collages with Taeuber, which he describes as approaching "superior, spiritual reality."

1921
Marries Taeuber.

1920s
Shares interest in hermetic tradition and alchemical imagery with Surrealists.

1924
Probably discovers *I Ching* after its first publication in German.

1930
Frequent references to "law of the accident" indicate renewed interest in pre-Socratic philosophers, Lao-tzu, and *I Ching*.

1933
Begins *concrétions humaines* (human concretions) sculptures.

1950s–60s
Introduced to Zen by Japanese admirers; later becomes devout Catholic.

GIACOMO BALLA
ITALY, 1871–1958

1891–94
Attends lectures in Turin given by Cesare Lombroso, psychiatrist, criminologist, and author of *Madness and the Genius* (1887).

1910
Meets Marinetti and cosigns the *Futurist Manifesto*.

1912
Makes first abstract paintings.

1913
Auctions all his figurative works. Begins vortex drawings.

1916–17
Develops interest in spiritualism. Paints Transformations Forms Spirits series.

1919–20
Executes series, such as Science versus the Obscure and Numbers in Love, devoted to states of mind.

JOSEPH BEUYS
GERMANY, 1921–1986

1943
While serving in German air force his plane crashes in the Crimea, and he is found by Tatars, who cover his body in fat to help regenerate warmth and then wrap it in felt to maintain warmth. He recognizes that the experience of death and, therefore, the central issues of existence cannot be understood scientifically.

Early 1950s
Hare becomes central emblem of life in his work. Introduces idea of the shaman into his work; continues to incorporate it in work of 1960s.

1951-61
Lives hermitlike existence in a Lower Rhineland retreat, with foxes and hares for company. Interested in the ideas of Rudolf Steiner. Introduced by this time to the work of Morris Graves.

1960s
Participates in shamanistic activities, as in *The Chief,* 1963–64, where he remained rolled in felt for nine hours, or in *How to Explain Pictures to a Dead Hare,* 1965, where he covered his head with honey and gold.

1960
Makes *Bathtub,* a tub he used as a child, filled with plaster and fat-soaked gauze, the latter a reference to spirituality and the passage from one state to another. Fat, in its solid or liquid form, refers to transformation and change.

1968
Founds the German Student Party, which declares that art and life are identical.

1980
Stands for election to the parliament of North Rhine-Westphalia as a candidate for the Greens.

1982
Meets the Dalai Lama in Paris.

DOMENICO BIANCHI
ITALY, BORN 1955

1979 to present
Tries to achieve "objectivations" in the form of music, literature, painting, and sculpture. Feels that a painting must come from ideas and not from sensibilities.

EMIL BISTTRAM
UNITED STATES, BORN HUNGARY, 1895–1976

1918–25
Through his friend Jay Hambidge, who traced the roots of art and decoration to Egyptian and Greek sources, learns about Hambidge's discovery, "dynamic symmetry," the concept of ideal composition based on the proportional relationship of the golden section and the logarithmic spiral. Views Thomas Wilfred's color organ projections.

1925–30
Lectures at Nikolai Roerich's Master Institute of United Arts, New York, where theosophical and occult ideas are regularly discussed; its program emphasizes the fourth dimension, color organ, horoscope, and Émile Jaques-Dalcroze's eurythmics. Gradually develops a philosophy that includes occult ideas and variations of theosophical beliefs. Believes teaching means transmitting truths and ideas about proportional standards, symmetry, and the evolution of cosmos.

1930
Begins formulating ideas on transcendental painting. Dane Rudhyar's *Art as the Release of Power,* which urges meditation on cosmogenesis and geometric cosmogony, becomes inspiration for New Mexican Transcendentalist movement.

1931
While on Guggenheim Fellowship works with Diego Rivera in Mexico City; admires Rivera's faith in socialism. Settles in Taos, New Mexico, where he teaches weekly courses on pure design, color, and metaphysics.

1933
Paints series based on New Mexico Indian dances.

1936
Paints images reflecting Aristotelian writings on God as described in nature and various creation myths.

1938
Involved with founding the Transcendental Painting Group.

1941
Writes that his own meditation process reveals that the art of the present "must transcend the physical world and act as a vital spiritualizing force for the definite construction of a New Culture."

c. 1950s
Becomes practicing Zen Buddhist.

BRUNO CECCOBELLI
ITALY, BORN 1952

1985
Says, "My daily worship consists of observing things, of listening to interior voices. Religion is not a dogma, a church, but means putting things harmoniously together, to be in the rhythm of things." Believing artist's role is transcendence of reality, attempts representing transcendental experiences.

1986
Notes, "The body of man is like a bell resounding with progressive energy where the battle and the spirit, with its centripetal vibrations, creates a connection with the vitality of the cosmos."

SERGE CHARCHOUNE
FRANCE, BORN RUSSIA, 1888–1975

By 1910
Acquainted with Russian Symbolist philosophy, especially writings of Andrei Bely, Vladimir Solov'ev, and Nikolai Berdiaev. Interprets spiritual aspects of art, making numerous analogies with music.

1912
Arrives in Paris.

1916
Paints nonfigurative pictures often referred to as "Ornamental Cubism."

1917
Becomes aware of Dada, chiefly through contact with Francis Picabia, Man Ray, and Tristan Tzara.

1917–23
Participates in Dada soirées and exhibitions, in both Paris and Berlin.

1920s
Through Bely becomes especially interested in ideas of Rudolf Steiner. Reading of Zen Buddhist tracts reinforces search for "ecstatic" interpretation of music and ideal harmony of colors.

1922
Publishes and designs several Dada booklets, including his own *Dadaizm*.

1925-60
Regularly participates in anthroposophical conferences in Paris.

KONRAD CRAMER
UNITED STATES, BORN GERMANY, 1888–1963

1911
Meets Franz Marc in Munich. Influenced by Wassily Kandinsky's aesthetics and those of other members of Der Blaue Reiter. Emigrates to America.

1912–14
Creates series of symbolic abstractions that contain occult references and allude to apocalyptic themes and themes related to spiritual unity of love.

1913
Creates, after viewing Kandinsky's Improvisations and Marsden Hartley's Kandinsky-inspired compositions, Improvisations series.

JEAN CROTTI
FRANCE, BORN SWITZERLAND, 1878–1958

Christian spiritual convictions established during childhood.

1900–1902
Writes on man's relation to God and notion that art should be a type of magic conveying messages to man.

1910–14
Occasionally makes paintings with Christian subject matter.

1915–16
Goes to New York along with other Dada artists. Makes series of "creation" paintings and two abstract paintings with title *God*.

1919
Marries Suzanne Duchamp.

1921
Mystical experience in Vienna leads to birth of Tabu-Dada movement, whose goal is to express through form and color the mystery and divinity of the universe. Critic André Salmon refers to him as "the first restorer of a religious art." Breaks from Dada artists because of his belief in need for spiritual thought.

1922
Makes first cosmic painting.

1941
Writes about oriental transcendental philosophies, particularly Buddhism, as an influence on Tabu-Dada.

ROBERT DELAUNAY
FRANCE, 1885–1941

1910–12
Refers to work of these years as his "destructive period" or period of "pure painting," during which he studies dissolution of forms in light. Paints Disks series, attempting to express the cosmic in these works. Devotes many compositions to themes of flight and activity.

1912
In Window series, seeks to develop compositions that express sense of universal rhythm and include simultaneous images. At Wassily Kandinsky's suggestion, Paul Klee visits him in Paris. Kandinsky sends him copy of *On the Spiritual in Art*.

1913
Goes to Berlin with Guillaume Apollinaire and visits Der Sturm gallery.

1922–23
Active in Surrealist circles.

1930–35
Returns to Disks series and paints series called Rhythms and Rhythms without End.

JEAN DELVILLE
BELGIUM, 1867–1953

1885
Passionately devoted to writings of Comte Philippe de Villiers de L'Isle-Adam, Barbey d'Aurevilly, and Joséphin Péladan. In Paris often stays with Péladan, who encourages his involvement with the occult and magic.

1892–95
Participates in all salons of the Rose + Croix. All subsequent work incorporates occult, esoteric, and idealistic ideas. *Mysteriosa (Portrait of Mrs. Stuart Merrill),* 1892, summarizes his ideas about mysticism and the spiritual to date.

1895
Publishes *Dialogue entre nous: Argumentations kabbalistique, occultiste, idéaliste*.

1896
Conceives the Salon d'Art Idéaliste, whose goal is to provoke aesthetic renaissance in Belgium.

1895–97
Works testify to deep interest in esoterica, including *The Great Occult Hierarchy* and *The Messianic Ideal,* both 1897.

1898
Paints *The School of Plato*.

1900
Publishes *La Mission de l'art,* with preface in which Édouard Schuré describes relationship between Theosophy and this book.

MAURICE DENIS
FRANCE, 1870–1943

1884
Discusses in his diaries his love of medieval legends, such as the *Chanson de Roland,* his involvement with Roman Catholicism, and his interest in Italian art, especially that of Fra Angelico and Italian primitives.

1886
Vows to serve Roman Catholic faith as artist.

1888
Enters École des Beaux-Arts and Académie Julian, where he becomes disciple of Paul Sérusier.

1889–91
Absorbs wide variety of artistic influences: Paul Gauguin, Neo-Impressionism, and general Pont-Aven/Cloisonnist impulse, combined with late medieval precedents. Shows interest in Ernest Hello, a leading Christian mystic.

1890
Following discussion with Sérusier and viewing of Gauguin's paintings, writes essay "Neo-Traditionalism," in which he calls for antinaturalistic art aimed at "transformation of vulgar sensations . . . into sacred, hermetic, imposing icons." Despite knowledge of hermetic traditions, his art reflects a personalized, Catholic mysticism.

1942
States that Honoré de Balzac's *Louis Lambert* (1832) was inspirational.

THEO VAN DOESBURG
NETHERLANDS, 1883–1931

1907–12
Diaries contain numerous esoteric references and entries on spiritual worth of art. First wife, poet Agnita Henrica Feis, introduces him to mysticism and Theosophy.

1912
Writes articles on spiritual connotation of fine arts in the weekly *Eenheid* (Unity), a periodical with strong mystical orientation.

1913
Reads Wassily Kandinsky's *On the Spiritual in Art* (1912).

1914
Convinced of spiritual value of Kandinsky's art. Replaces naturalism with expressive semiabstract style.

1915–16
Makes contact with M. H. J. Schoenmaekers, founder of "Christophy," a mixture of Christianity and Theosophy. Reads *De zuivere Rede* (Pure reason) (1904) by the neo-Hegelian philosopher and theorist, G. J. P. J. Bolland. Meets Janus de Winter, whom he calls a "Priest-Artist." Influence of Kandinsky and de Winter evident in work. Produces abstract paintings, often featuring auras, in which musical sensations are visualized. Notes in a sketchbook that these are "expressionistic-theosophical." In other paintings imposes mathematical order upon human shapes and still life.

1916
Meets painters Piet Mondrian, Vilmos Huszar, and Bart van der Leck, all of whom found De Stijl group in 1917.
Expresses interest in Schoenmaekers's mystical mathematics, Hendrik Lorentz's and Albert Einstein's relativity theories, Sigmund Freud's psychoanalysis, and concepts of biologist Jakob Johann von Uexküll.

1917
Chief editor of *De Stijl.* Writes articles on art theory featuring fusion of science and mysticism, as well as emphasis on the fourth dimension and time in art.

1917–20
Creates paintings and stained glass windows that appear to be fully abstract and geometric but are derived from natural sources. Attempts to incorporate the fourth dimension in paintings and interior design.

1918
Reads Schoenmaekers's *Het Nieuwe Wereldbeeld* (The new image in the world) (1915) and *Beeldende Wiskund* (Principles of plastic mathematics) (1916).

1919
Increasingly skeptical about Mondrian's interest in Theosophy.

1923
Architectural explorations in paintings and architectural projects feature studies of relationship between space and time.

ARTHUR DOVE
UNITED STATES, 1880–1946

1909
Meets Alfred Stieglitz.

1910
First exhibits at "291," where he encounters idealism and antimaterialism of Stieglitz circle of writers and artists. Creates six unprecedented abstractions from nature; these are never exhibited during his lifetime.

1911–12
Ten Commandments series of pastel drawings features organic abstractions, which convey sense of nature as an animate force; ideas contained in these parallel vitalistic philosophy of Henri Bergson and others.

1912
Obtains copy of Wassily Kandinsky's *On the Spiritual in Art* from Stieglitz after excerpt is published in July *Camera Work.*

1913
Acquires copy of Kandinsky's and Franz Marc's *Der Blaue Reiter* almanac.

1920s
Adopts "God's eye format" in landscapes and abstractions.

1923–24
Stieglitz's niece Elizabeth Davidson and her husband, Donald, who are Vedantists, introduce him to Eastern mystical religion. The Davidsons frequently send him books on Hinduism and introduce him to Swami Nikhilanda.

1924
Mentions Theosophical Society in diary entry, although he never becomes a member. Develops interest in occult literature.

1925–40
Abstractions of nature endowed with new spiritual content influenced by exposure to Eastern religion and occultism. Develops motifs from textual precedents in occult literature.

MARCEL DUCHAMP
FRANCE, 1887–1968

c. 1910
Meets Francis Picabia.
1911
Work contains symbolic overtones. Clear evidence of interest in alchemical iconography is present in his painting *Spring*. Alchemical knowledge is obtained in part from Albert Poisson's *Théories et symboles des alchimistes* (1891). Marriage of his sister Suzanne to a pharmacist from Rouen.
1912
Visits Munich for two months in July and August. Begins sketches and notes for *The Large Glass*.
1913
Works as librarian at Bibliothèque Ste-Geneviève. Develops system of time-space measurement. Writes musical compositions based on laws of chance.
1914
Creates first ready-mades.
1921
Has hair cropped in shape of a comet.
1926
Makes film *Anemic Cinema,* in collaboration with Man Ray and Marc Allegret.

SUZANNE DUCHAMP
FRANCE, 1889–1963

Before 1905
Models for her brother Marcel Duchamp.
1911
Marries Charles Desmares, a pharmacist.
1916
At request of Marcel, completes ready-made, *Bottle Rack,* by adding an inscription. Collage *Un et Une menaces* reveals knowledge of mechanomorphic style.
1919
Marries Jean Crotti.
1921–22
Participates in Tabu-Dada, the goal of which is to express through form and color the mystery and divinity of the universe.

BORIS ENDER
RUSSIA, 1893–1960

Brother of Maria and Yuri Ender.
1911
Meets Elena Guro and Mikhail Matiushin, who share with him a strong interest in Eastern-oriented mysticism and Scandinavian Symbolism.
1919
Student in Matiushin's studio at Petrograd State Free Art-Teaching Studios and later at State Institute of Artistic Culture. With Matiushin, advocates cultivating the visual centers of the brain and explores the effects of altering space, color, and sound. As one of Matiushin's students, experiments with "expanded viewing," an effort to see 360 degrees. His works, including studies of color and sound and many small, lyrical landscapes, reveal interest in a monistic universe and the perception of a higher order of space. It is difficult to ascertain how long these interests continue, given their political ramifications in the 1930s.

MARIA ENDER
RUSSIA, 1897–1942

Sister of Boris and Yuri Ender.
1919
Works with Mikhail Matiushin at Petrograd State Free Art-Teaching Studios. Participates in Matiushin's spatial and color experiments designed to explore monistic and vitalistic concepts of the universe.
1925–26
Director of Matiushin's form-color perception laboratory at State Institute of Artistic Culture.
1927
Develops theory of "additional form" in art.
1932
Writes introduction to Matiushin's *Color Handbook*.

YURI ENDER
RUSSIA, DATES UNKNOWN

Nothing is known about Yuri Ender aside from his participation in Mikhail Matiushin's classes in 1919 and the early 1920s along with his brother Boris and his sisters Maria and Xenia.

HELMUT FEDERLE
SWITZERLAND, BORN 1944

1967
Lives in Tunis and travels to Afghanistan, India, and Nepal. Develops an interest in tantric art and Eastern philosophy.
1971–72
Paintings and drawings feature images of the Swiss mountains.
1979–83
Considers visit to Rothko Chapel in Houston to be an important inspiration for his work. Also attracted to the work of Ferdinand Hodler, Kazimir Malevich, and Piet Mondrian. His work is dominated by abstract geometries; these forms are used to express a psychic, emotional content.

CHARLES FILIGER
FRANCE, 1863–1928

1889
Visits Pont-Aven in summer.
1890–91
Contact with Paul Gauguin, Paul Sérusier, and Jan Verkade in Le Pouldu exposes him to Pont-Aven and Nabi beliefs.
1890–1903
Influenced by Byzantine icons and popular French religious prints known as Images of Épinal. Like the Nabis, admires Italian primitives and early Flemish schools of painting. Imagery reflects association between a mystical form of Christianity and religious heritage of Brittany.
1892
Exhibits at first Salon de la Rose + Croix, but subsequently leaves group, perhaps following his patron, Comte Antoine de La Rochefoucauld, who founds occult review *Le Coeur* (1893–94). Remains faithful to Christian imagery, refusing to align himself with Rochefoucauld's interest in the Egyptian goddess Isis.
1893–1900
Corresponds with Jules Bois, editor of *Le Coeur* and author of *Les Noces du Sathan* (1890), *Les Petites Religions de Paris* (1894), and *Le Satanisme et la magie* (1895).
1903–6
Familiar with mathematical art theories of Father Desiderius Lenz, especially after Sérusier's 1905 translation of *L'Esthétique de Beuron*. Deeply interested in Sérusier's theories on "sacred number system," which identifies a geometric canon inspired by Scriptures to be used in the representation of the human body so that the result would be

harmony and absolute beauty. His art becomes more abstract, presumably due to increased involvement with mathematically based art theories of Sérusier and the school of Beuron. The Chromatic Notations series may derive from a mixture of interests in scientific theories of color and line, geometric qualities found in traditional church ornamentation, and Hindu mandalas.

LUCIO FONTANA
ITALY, BORN ARGENTINA, 1899–1968

1928–29
Studies with Adolfo Wildt, Symbolist sculptor.
1934
Discusses possibility of opposing space and volume in work with Constantin Brancusi and Tristan Tzara. Participates in the group Abstraction-Creation.
1946
Publishes first spatial manifesto, in which he endorses an art of forms created by the subconscious.
1949
Creates an entirely black room lit by ultraviolet lamps in Galleria del Naviglio, Milan.
1956–57
Begins making tears in works.
1958
Makes first of Spatial Concepts paintings.
1959
Begins making knife incisions in canvases.
1961
Uses metallic foil and glitter in paintings.
1963
Begins The End of Gods series.

PAUL GAUGUIN
FRANCE, 1848–1903

c. 1885
Refers to sacred numerology and syncretic imagery in letter to Émile Schuffenecker and in "Notes synthétiques."
1886–91
Alternates stays in Paris with repeated visits to Pont-Aven and Le Pouldu in Brittany.
1887
Travels to Martinique.
By 1888
May be familiar with hermetic tradition through readings of so-called occult novels of Honoré de Balzac, especially *Séraphîta* (1835) and *Louis Lambert* (1832), and those of Gustave Flaubert, notably *Salammbô* (1862).
c. 1888–91
Establishes close contact with such relatively

sophisticated and religious-philosophical intellectuals as Émile Bernard, Jacob Meyer de Haan, and Paul Sérusier.
1889–90
Uses Breton religious monuments in paintings such *Yellow Christ* and *Green Christ*.
By 1891
Appears to have knowledge of the dualism attributed to all religions by such authors as J. A. Moerenhout, *Voyages aux îles du grand océan* (1837) and Gerald Massey, *A Book of the Beginnings* (1881), and writings contain references to Emanuel Swedenborg.
1891–1901
Residence in Tahiti.
1893–1895
Returns to Paris.
c. 1894
Closely familiar with writings by Moerenhout and Massey and with esotericism popular in Paris. Increasingly aware of hermetic teachings on oneness of all religions.
1901–2
Resides in the Marquesan Islands.

AUGUSTO GIACOMETTI
SWITZERLAND, 1877–1947

1894
While at art school in Zurich, develops a strong interest in Art Nouveau publications and in Ferdinand Hodler's sketches at the Schweizerisches Landesmuseum.
1897–1901
Continues to be influenced by Hodler and also by Giovanni Segantini, Puvis de Chavannes, and the Pre-Raphaelites, in whose work he detects a strong mystical quality.
1898
Makes first abstract compositions at the Jardin des Plantes in Paris. Also begins making mosaics and glass paintings.
1901–7
Work heavily influenced by Symbolism.
1902–15
After trip to Florence in 1902, develops deeper interest in Quattrocento art, especially that of Fra Angelico and Benozzo Gozzoli.
1918–39
Produces paintings referred to as "magical colorism," in which forms are freed from concrete space and conventional plasticity and often possess a "mystical phase."

LUDWIG GOSEWITZ
GERMANY, BORN 1936

1950s
Studies musical history, literature, history, philosophy, and linguistics at university in Marburg.
1960s
Becomes well known for his work in the field of concrete and visual poetry. As poet and composer, participates in various Fluxus and related manifestations.
1964
Embarks on serious study of astrology.
1965
Moves from Marburg to Berlin.
1979
Begins Artist-Constellation series.

ADOLPH GOTTLIEB
UNITED STATES, 1903–1974

1920s
Meets John D. Graham at Art Students League.
c. 1929
Meets Mark Rothko.
c. 1930
Strongly interested in poetry of T. S. Eliot and Ezra Pound.
1935
Impressed by African sculpture in Museum of Modern Art's *African Negro Sculpture* exhibition. During trip to Paris in summer, purchases several pieces of African sculpture from dealers recommended by Graham.
1937
Given inscribed copy of Graham's *System and Dialectics of Art* (1937). Texts by and conversations with Graham introduce him to Freudian and Jungian psychology. Graham also stimulates and encourages his interest in American Indian, Pre-Columbian, and African art.
1937–38
Expands knowledge of Indian art during stay in Arizona, where he visits State Museum in Tucson. Undoubtedly already well acquainted with holdings of American Museum of Natural History, Brooklyn Museum, and Museum of the American Indian in New York.
1941
Begins paintings devoted to Oedipal themes. Becomes more interested in Carl Gustav Jung than Freud. Most likely attends Museum of Modern Art exhibition *Indian Art of the United States*.
1941–51
Pictograph series reveals interest in myth, archetype, dreams, primitivism, magic, and

transformation. Several titles in series betray strong Native American influence.

1943
During radio broadcast with Rothko, says, "While modern art got its first impetus through discovering forms of primitive art, we feel that its true significance lies not merely in the formal arrangements, but in the spiritual meaning underlying all archaic works."

1945
A number of works contain alchemical references.

1957
Begins Burst series, in which paintings such as *Blast I,* 1957, *Aftermath,* 1959, and *Deep over Pale,* 1964, suggest primordial creation or cosmic cataclysm.

MORRIS GRAVES
UNITED STATES, BORN 1910

1928
Takes first trip to Orient as seaman. Spends time in Tokyo and environs, Shanghai, Hong Kong, Philippines, and Hawaiian Islands.

1930
Makes further trips to Orient.

1930s
Develops idea of painting as meditative, with audience a part of that meditative process.

1932
Returns to his native Seattle.

1935
Begins to attend Buddhist temple. Interest in Zen encouraged by contacts with John Cage, Mark Tobey, and Nancy Wilson Ross, author and Buddhist scholar.

1937
Lives five months in Father Divine's mission

in Harlem, New York (Father Divine had early association with Vivekananda, disciple of Ramakrishna). Returns to Seattle.

1938
Travels to San Juan, Puerto Rico, where he is deeply moved by Catholic piety exhibited at death of Pope Pius XI.

1938–39
Purification series features references to pagan and Christian symbolism. Becomes friends with Tobey, Kenneth Callahan, and Guy Anderson, three painters who are labeled the "Northwest School of Visionary Art."

1939
Moves to "The Rock," his secluded home on Fidalgo Island, Washington.

1941
Refers to "spiritually-realized form" of Asian art and its attempt to "draw clues to guide our journey from partial consciousness to full consciousness." Begins paintings that lead to Inner Eye series.

1942
Inducted into armed forces, despite registration as conscientious objector. His association with the Japanese leads to internment and delayed release.

1943
Begins using "white writing" in works. Paints "dark moody birds, wounded gulls, plovers by the sea, and night scenes," as he terms them, Journey series, and Joyous Young Pine series.

1946–47
Paints Chinese Bronze series, in which Chinese bronzes are transformed into self-contemplating birds.

1947
Meets Ananda K. Coomaraswamy.

1948
Preface to catalogue of exhibition at Willard Gallery, New York, features excerpts from *Elements of Buddhist Iconography* by Coomaraswamy.

1954
Travels to Japan and Ireland, where he establishes a home.

1956
Writes that "in Japan I at once had the feeling that this was the right way to do everything. It was the acceptance of nature — not the resistance to it."

1960
Meets Paul Tillich, Joseph Campbell, and Mark Rothko in New York.

1964
Leaves Ireland to return permanently to United States. Contributes to NASA's art program.

LAWREN HARRIS
CANADA, 1885–1970

Raised in devoutly Christian home.

1894
Mother becomes Christian Scientist.

1904–7
Receives academic training in Berlin.

1907
Returns to Canada. Makes initial attempt to organize a Canadian school of landscape painting, later known as the "Group of Seven."

c. 1918
Member-at-large of International Theosophical Society.

1923
Joins Toronto branch of Theosophical Society.

1926
Publishes essay on Canadian art in *The Canadian Theosophist,* citing spiritual potential of Canada and its distinctively "northern" qualities. Finds the wilderness to be uplifting and seeks to convey this in painting.

1927
Defends abstract art during *International Exhibition of Modern Art,* organized by Société Anonyme, of which he is the only Canadian member.

1930
Travels to Europe, where he visits Marcel Duchamp. Goes to eastern Arctic for two months; considers Arctic to possess continual spiritual flow.

1933
Delivers paper at theosophical convention in Niagara Falls, New York, on the subject of Theosophy and art.

1934
Moves to New Hampshire with second wife, a Theosophist, and finds sense of the Himalayan in northern New England landscape.

1936
By spring completely devoted to making abstract painting.

1938
Settles in Santa Fe, New Mexico. Meets Raymond Jonson, who introduces him to circle of

artists interested in Wassily Kandinsky and esoteric ideas. The group becomes known as the Trans-American Foundation for Transcendental Painting (or Transcendental Painting Group). Increasingly interested, as are other members of the Group, in ideas about dynamic symmetry.

1940
Due to war, returns to Canada.

1947–48
Makes two trips to New York. Possibly sees Mark Rothko's paintings.

c. 1955
Draws upon Abstract Expressionist ideas and technique to continue exploration of spiritual concepts in his painting. Begins investigating tantric imagery.

MARSDEN HARTLEY
UNITED STATES, 1877–1943

By 1895
Raised as active member of Episcopal Church. Early interest in fourteenth-century mystic Richard Rolle. Fleeting intention of becoming a minister.

1898
Reads essays by Ralph Waldo Emerson.

1905
Walt Whitman's home serves as subject of painting.

1907
Visits Green Acre, in Eliot, Maine, a retreat for pursuit of mystical beliefs.

1909
Paints "black landscapes" influenced by Albert Pinkham Ryder.

1912
Reads Richard Maurice Bucke's *Cosmic Consciousness* (1901) and fragments from Jakob Böhme. Acquires 1908 edition of Böhme's *The Supersensual Life* (1622). Travels to Europe.

1912–13
In Paris produces several works with mystical symbols. Writing to Alfred Stieglitz, describes new style of subliminal or cosmic Cubism, the product of "spiritual illuminations" from Wassily Kandinsky's *On the Spiritual in Art* (1912). Owns two sculptures of Buddha.

1913
Exposed to mystical beliefs of Kandinsky and Franz Marc. Meets Kandinsky in Munich. States, "My first impulses came from the mere suggestion in Kandinsky's book *The Spiritual in Art*. Naturally I cannot tell what his theories are completely [since the edition was in German] but the mere title opened up the sensation for me — and from this I proceeded." Reads wide variety of mystical literature, including Meister Eckhart, Bhagavad Gita, William James, and Henri Bergson. Writes to Stieglitz, "The German is most essentially a symbolist and there is every evidence that mysticism has had its home here . . . I am mystic too but what I want to express is not national but universal." Writes that he expects to meet Rudolf Steiner and Édouard Schuré. František Kupka and Walter Rummel, a musician interested in the occult, visit his studio in Paris.

1913–15
Lives in Berlin, with exception of visit to New York, November 1913 to March 1914. Military pictures, "musical" compositions, and Amerika series show influence of Kandinsky and Marc.

1918
Moves to Taos, New Mexico. Interest in Spanish mysticism of the Penitente evident in paintings produced there.

1920s
Announcing conversion to objectivism, states he could "hardly bear the sound of the words 'expressionism,' 'emotionalism,' 'personality' . . . because they imply the wish to express personal life and I prefer to have no personal life. Personal art is for me a matter of spiritual indelicacy."

1929
Suffers personal depression. Reads Meister Eckhart, Böhme, Jan van Ruysbroek, Saint Augustine's *Confessions,* Plotinus, and George Santayana's *Plotinus and the Spiritual Life* (1923).

1932–33
Reverts to mystic symbolism while in Mexico on Guggenheim Foundation Fellowship. Studies Mayan and Aztec anthropological findings. Mexico rekindles interest in spiritual inner necessity of primitive art. Access to his friend May Osplund's library on occult subjects reawakens spiritualist interests. Interested in writings of Richard Rolle and Paracelsus. Spends time with Hart Crane until Crane commits suicide in April. Sees Mark Tobey during spring and fall of 1932.

WALLY HEDRICK
UNITED STATES, BORN 1928

1940–60
Strongly influenced by Paul Klee.

1954
Marries a practicing witch. In her library finds alchemical diagrams and related books. A friend introduces him to tarot cards.

1961–82
Paints *Hermetic Image,* influenced by the cabala and alchemical writings; considers it to be a "self-portrait." Images of this type recur in works such as *No. 1 Tub Receiver,* 1978, and *Cloakroom,* 1982. Consistently refuses to work in a single style because he believes in the importance of content over form.

JACOBA VAN HEEMSKERCK
NETHERLANDS, 1876–1923

1906–10
Acquainted, while in Domburg, with Jan Toorop, with whom she shares interest in mysticism.

1908
Meets Piet Mondrian.

1909–10
Studies with Mondrian; her works very much influenced by his theories.

1913
Following Rudolf Steiner's lecture in The Hague, becomes anthroposophist.

1914
Breaks away from Cubist style, undoubtedly inspired by Wassily Kandinsky and other Blaue Reiter painters, whose work she sees in the Netherlands.

1914–23
Makes increasingly abstract, expressive paintings. In her landscapes these artistic elements are intended to express musical sensations associated with forests. Interest in musical sensations leads to "aura-paintings," abstract "portraits" in which line and color convey sense of an individual's character.

1916
Lectures on modern art for the Dutch Anthroposophical Society.

1919
Studies Steiner's theory of society.

FERDINAND HODLER
SWITZERLAND, 1853–1918

1860s–80s
Turns to religion at an early age because of deaths of father in 1860, mother in 1865, and majority of siblings by 1889.

1872
Settles in Geneva.

1880
Following trip to Spain, attends prayer meetings of small Swiss rural sect. After a religious crisis, decides to become minister. Reads German Romantic poets, such as Novalis.

1883
During trip to Munich sees work of Albrecht Dürer; particularly impressed by his *Four Apostles,* 1526.

1884
Meets Symbolist poet Louis Duchosal. Other artists and poets meet regularly on Tuesday evenings at his home. Meetings lead to journal *Revue de Genève.*

1885–86
Inspired by French poets Stéphane Mallarmé and Émile Verhaeren. Begins representing intangible ideas on canvas in works such as *View into Eternity,* 1885.

1890
Creates series of Symbolist works concerning times of day and night, states of soul, and dance.

1892–93
Participates in Joséphin Péladan's Salon de la Rose + Croix Esthétique in Paris.

1907
Landscapes feature themes of eternal sublimity.

VICTOR HUGO
FRANCE, 1802–1885

1820s
Romantic style strongly present in his literary works.

1827
First play, *Cromwell,* contains manifesto advocating a new literature, juxtaposing comedy and tragedy, the sublime and the grotesque.

1829
Writes volume of poetry, *Les Orientales,* on exotic Middle Eastern themes.

1843
Devastated by the drowning accident of his daughter Léopoldine.

c. 1850–53
Heavily involved in séances.

c. 1850–55
Produces remarkable group of abstract ink and wash drawings.

1852–70
Goes into exile in the Channel Islands and considers himself a magus whose role is to interpret the secrets of life.

1853–54
Writes *Satan pardonné,* epic and mystical poem.

1856
Publishes his two-volume *Les Contemplations* (1856), strongly influenced by theories of Emanuel Swedenborg and ideas on the cabala; contains poems on the apocalypse.

1859
Publishes first section of *La Légende des siècles.*

1862
Publishes *Les Misérables,* begun in 1845.

1886
La Fin de Satan, an examination of universal salvation, published posthumously.

1891
Dieu published posthumously. Summarizes man's efforts to express the divine.

ROBERT IRWIN
UNITED STATES, BORN 1928

1954
Goes to Ibiza and spends eight months in total isolation.

1957
Exhibits abstractions.

1957–62
With his fellow artists at Ferus Gallery, Los Angeles, explores Zen and other oriental philosophies. Exposed to Zen *raku* pottery in a private collection which was shared by its owner, according to Irwin, if "your Karma was okay."

1958
Paintings feature Zen themes.

c. 1960
Says that his work produced after this time was "an exploration of phenomenal presence."

1964–67
Makes dot paintings from canvases that curve at their center. Considers this to be a "Zen experience." He observes, "I wanted them to emanate but not have an image, not overtly; to be fourth dimensional."

1967–69
Produces disks, intended as paintings that did not begin or end at the edge.

1970
Exhibits scrim room at Museum of Modern Art. Following this exhibition, sells studio and its contents. Travels to Southwest desert. Begins marking the desert, laying concrete blocks and stretching wires over long distances, to "perceive...[himself] perceiving," as he later observed.

1971
As part of *Art and Technology* program at Los Angeles County Museum of Art, collaborates with James Turrell and scientist Dr. Ed Wortz. Studies anechoic chambers, alpha-wave conditioning, and Ganz fields (360-degree, light-filled visual fields in which there are no objects perceptible to the naked eye).

Mid-1970s
Reads Ludwig Wittgenstein's writings and other books, including Michael Polanyi's *The Tacit Dimension* (1966) and Maurice Merleau-Ponty's *The Primacy of Perception* (1964).

1985
Regarding his work, he says, "I make objects in a totally floating space . . . I focus on nothing."

JOHANNES ITTEN
SWITZERLAND, 1888–1967

1913
Pupil of Adolf Hölzel, whose teachings concentrate on picture as two-dimensional structure and on theory of color derived from Johann Wolfgang von Goethe; Hölzel's classes feature physical exercise as well as collage and free drawing. Attends First Autumn Salon in Berlin and sees works of Wassily Kandinsky and Franz Marc.

c. 1915
Interested in relationship between music and visual art. Attempts to come closer to "primary matter" by using crystalline shapes in his work.

1916
Meets Georg Muche, with whom he shares interest in Dr. Otoman Hanish's Mazdaznan sect. Moves to Vienna in fall. Color disk paintings are derived from Hölzel's color wheels.

1917
Meets Alma Mahler, a Theosophist since 1914, in Vienna. Reads Indian philosophy and the cabala. Contact with Viennese composers Arnold Schönberg and Alban Berg encourages interest in music's relationship to visual art.

1918
Absorbed in the theosophical writings of Charles W. Leadbeater and Annie Besant as well as the Chinese philosophy of Lao-tzu. Finds copy of *Thought-Forms* (1905) and is impressed by its color equations. Paints *The Red Tower,* featuring theosophical star.

1919
Becomes teacher at Bauhaus.

1920
Attends Mazdaznan Congress in Leipzig with Muche. Interested in Jakob Böhme and other German mystics. Tries to convert Bauhaus to Mazdaznan dietary and meditative principles.

1921
Executes lithograph *Dictum,* after a saying by Hanish, for First Bauhaus Portfolio.

1921–22
Painting *Child Picture* features Mazdaznan symbol.

1922
Resigns from Bauhaus in fall, in part because of his Mazdaznan philosophy. *Sheet of Writing with a Saying by Jakob Böhme* features breathing exercise "Inhale, Exhale."

1923–26
Resides at the Mazdaznan School of Life at Herrliberg near Zurich.

ALFRED JENSEN
UNITED STATES, BORN GUATEMALA, 1903–1981

1938
As the result of artist Auguste Herbin's encouragement, first reads Johann Wolfgang von Goethe's *Theory of Colors* (1820); rereads it repeatedly throughout his life.

1952
Meets Mark Rothko.

1952–58
Early work develops as result of study of Goethe's theory. Before painting, first makes studies that are diagrams of Goethe's theory.

1957
Mature style develops from Goethe's color theories, writings of Leonardo da Vinci, numerical systems, Pythagorean geometries, and Central American astronomical theories. Paintings such as *My Oneness, A Universe of Colors* use metaphor of circle confined by square of canvas to represent male and female. In other paintings explores the light and dark ends of the spectrum, which he later refers to as the white prism and the black prism. Murals feature checkerboards and brilliant colors.

1959
Interested in electromagnetism as a result of interest in Goethe. Reads theories of Michael Faraday, nineteenth-century physicist and chemist.

1960
Reads J. Eric S. Thompson's *Maya Hieroglyphic Writing* (1954), Joseph Needham's *Science and Civilization* (series begun in 1954), and *I Ching.* Study of numerical systems leads to series devoted to the Mayan calendar, gods, and architecture as well as the Chinese *I Ching,* mathematics, and magic squares. Examines symbolic qualities of odd and even numbers and other dualities: yin and yang, male and female, circle and square. Mathematics introduced into paintings such as *Square Beginnings-Cyclic Ending, Per I, 80 Equivalent Squares of Value 5; Per II, 48 Equivalent Squares of Value 5, Per III, 24 Equivalent Squares of Value 5, Per IV, 9 Equivalent Squares of Value 5, Per V, 1 Square Area of Value 5,* for which study of ancient Chinese numerical systems, based on five, provides source.

1961
Makes series of paintings related to Russian cosmonaut Yuri Gagarin's flight into space.

1962
Makes series of paintings on Greek architecture, color theory, and mathematics, including Pythagorean ideas.

1964–70
Subjects and organization of his paintings result from a study of the mathematical structure of planetary relationships.

1965
Paints gouaches, all called *Hekatompedon,* based on ancient Greek religious rituals.

1973–75
Studies DNA helix structure and growth hormones.

1975
Such paintings as *Physical Optics* and *Electromagnetic Charge* reveal interest in Faraday's theories on magnetics. Other paintings incorporate elements from *I Ching.*

BILL JENSEN
UNITED STATES, BORN 1945

1970
Leaves Minneapolis for New York, bringing ten drawings of spirals with him. Contemplates the transformation of these spirals into paintings.

1970–73
Work features cement, hand-ground pigments, and binding varnishes.

1973–75
Concentrates on making drawings.

1975
Begins using oil paint to create small-scale landscape and biomorphic images, influenced by Albert Pinkham Ryder and Arthur Dove. Final works emerge from application of wet paint to wet painted surfaces without preplanning result.

1977
Believes in idea of correspondence, drawn from Charles Baudelaire, in which different sensations can be correlated with one another. Paints *Redon,* acknowledging awareness of the meaning of Symbolist painting. States that what he paints are "feelings between people."

JESS (COLLINS)
UNITED STATES, BORN 1923

1928
Visits old prospector in Mojave desert whose "home is a small palace assembled from scrap wood, junk, tins, natural objects, with an interior paste-up decor."

1943–46
Serves as radio chemist for U.S. Army at Oak Ridge Laboratories.

1951
Becomes companion of poet Robert Duncan, who has strong mystical interests. Both become active in San Francisco Beat scene of 1950s.

Early 1950s
Begins making collages and assemblages, which are shown in 1953 exhibition he titles, "Necrofacts, or dead art."

1950s–60s
Makes "translations," works that are drawn from journal illustrations, diagrams, magazine photographs.

1961
Shows paste-ups on an environmental scale, conceived as "ephemeral votive objects," at Museum of Modern Art, New York.

JASPER JOHNS
UNITED STATES, BORN 1930

1951
Spends six months in Japan during military service. Reads Japanese literature and history.

1953
Decides to stop "becoming an artist and to be an artist"; consequently destroys most of earlier work.

1954
Meets Robert Rauschenberg and John Cage. Makes first Flag painting.

1955
Creates first Target and Number paintings.

1956–57
Produces first Alphabet painting. Reads about Marcel Duchamp in Robert Motherwell's *Dada Painters and Poets* (1951). With Rauschenberg, sees Duchamp's work at Philadelphia Museum of Art.

1959
Nicolas Calas introduces Duchamp to Johns. Duchamp gives him copy of *Lettre de Marcel Duchamp (1921) à Tristan Tzara* (1958).

1960
Writes review of *The Bride Stripped Bare by Her Bachelors, Even,* Richard Hamilton's book version of Duchamp's *Green Box.* Begins collecting Duchamp's work.

1961
Reads extensively in the philosophical writings of Ludwig Wittgenstein. Makes first large Map painting.

1967
Artistic advisor to Merce Cunningham Dance Company.

1968
Designs sets, based on Duchamp's *The Large Glass,* 1915–23, and costumes for Cunningham's "Walkaround Time."

1978
Makes *Celine,* first of a series of works of strong psychological intensity.

1981
Exhibits three paintings titled *Tantric Detail.* Creates several paintings based on works by Edvard Munch.

RAYMOND JONSON
UNITED STATES, 1891–1982

Father a Baptist minister.

1909
Studies art at the Portland Art Association with student of Arthur Wesley Dow.

1911
B. J. O. Nordfeldt, teacher at the Academy of Fine Arts and the Art Institute, Chicago, encourages him to seek out his own spirituality in painting.

1912
Declares that his aim in art is to work out his salvation.

1913
Sees Wassily Kandinsky's work at the Armory Show in Chicago.

Late 1910s–early 1920s
Images combine theosophical ideas and Symbolist motifs.

1917
In American West discovers inspiration for pantheist faith in immutable natural laws and ultimate goodness of nature.

1921
Reads copy of Kandinsky's *On the Spiritual in Art* (1912) given to him by art critic Sheldon Cheney and declares that it is "the greatest book concerning art I have ever read."

1922
Spends four months in Santa Fe, New Mexico.

1923
Studies Jay Hambidge's *Dynamic Symmetry and the Greek Vase* (1920).

1924
Moves to Santa Fe.

1927
Paintings become more abstract.

1934
The Cycle of Sciences mural, for the Works Progress Administration (WPA), at the University of New Mexico Library, represents spiritual life.

1937
Meets Alexander Archipenko and László Moholy-Nagy; admires their work. Prefers to use biomorphic forms in his work to express underlying life force.

1938
Cofounds Trans-American Foundation for Transcendental Painting (commonly known as Transcendental Painting Group) in order to expose the life force, the "inner significance of vibrations, and a certain sense of cosmic rightness, through the functioning of the intellect and the subconscious." Begins using airbrush in paintings.

WASSILY KANDINSKY
RUSSIA, 1866–1944

1896
Moves to Munich.
1900
Practices Yoga.
By 1904
Knows Alfred Kubin and probably Stefan George and Karl Wolfskehl, all of whom are interested in mysticism and the occult.
1906–7
Visits Paris.
1908–13
Exposed to Theosophy. Reads the writings of Helena P. Blavatsky, Annie Besant, and Charles W. Leadbeater as well as those of Rudolf Steiner. Hears Steiner's lectures in Berlin and Murnau. Several of his students, including Maria Strakosch-Giesler and Emy Dresler, become followers of Steiner. In paintings gradually ceases using recognizable forms from visible world. Replaces the missing object with a content dictated by "inner aspiration." Paintings and theories reveal strong influence of Steiner and Russian Symbolist poets, especially in focus on Biblical book of Revelation as key sign of transformation. Many major oil paintings, such as the Improvisations and the Compositions, and glass paintings contain apocalyptic motifs.
1912
Publishes On the Spiritual in Art. Praises the Theosophical Society. Recommends readings in Steiner's works. Refers readers to color-music charts made by Russian Theosophist A. Zakharin-Unkovsky.
1913
Writes "Reminiscences."
1914–21
Lives in Moscow.
1922–25
Lives in Weimar and teaches at Bauhaus. Continues to believe that his work would bring about "epoch of the great spiritual."
1922–44
Interested in creating the illusion of space on a canvas, as a signifier of the fourth dimension and cosmic transformation. Experiments with use of pure geometric forms.
1925–32
Lives in Dessau. Continues teaching at Bauhaus.
1926
Publishes Point and Line to Plane, in which dematerialization of picture plane is discussed.
1933–44
Lives in Paris.

ELLSWORTH KELLY
UNITED STATES, BORN 1923

1943–45
Enlists in military, assigned to camouflage unit.
1944
Makes first trip to Paris. Becomes interested in work of Sophie Taeuber-Arp.
1946–48
In Boston spends time studying early Indian artifacts at Peabody Museum. Sees two 1935 books on banner stones and bird stones; interested in meaning of Indian symbols on banner stones.
1948
Returns to Paris. Studies Far Eastern art at Musée Guimet, medieval art at Musée de Cluny, primitive art at Musée de l'Homme and Musée des Arts Décoratifs, and Romanesque and Byzantine buildings and designs. Focuses on the mandorla of the church of Notre-Dame-la-Grande in sketchbooks.
1949
Introduced by Surrealist technique of automatic drawing. Makes plant pictures, but searches for more abstract concepts to convey in his paintings.
1949–50
Michel Seuphor introduces him to Jean Arp, whom Kelly then visits in Meudon. May be encouraged by Arp's ideas about using chance in his art.
1954
Returns to New York.

FERNAND KHNOPFF
BELGIUM, 1858–1921

1858–64
Raised in Bruges, whose medieval architecture and legends preoccupy him.
1875–76
Attends law school, but prefers study of literature. Especially interested in writings of Charles Baudelaire, Gustave Flaubert, and Leconte de Lisle. Enters studio of Xavier Mellery, who has close links to Belgian Symbolist circles. Mellery's work focuses on themes of silence, solitude, death, and the inner life of objects.
1879
Hears Georges Rodenbach lecture on Arthur Schopenhauer, a philosopher of great interest to him.
1879–80
Sketchbooks feature drawings after Indian architecture, Egyptian jewelry, and Japanese vases.
1883
Paints one of his first Symbolist works,

D'après Flaubert. Cofounds Les XX group. Develops friendships with Rodenbach, Grégoire Le Roy, Charles van Lerberghe, Maurice Maeterlinck, and other Symbolist writers.
1884–85
Exhibits illustrations of Joséphin Péladan's La Vice suprême (1884), one of which, a pastel, features cabalistic writing probably drawn from Athanasius Kircher's Oedipi aegyptiaci (1652–55). Kircher's imagery and writings exert powerful influence throughout career.
1885
First meets Péladan, theoretician of the Rose + Croix. May become a member or, at very least, is closely associated with Rosicrucian order led by Péladan.
1888
Commissioned to design frontispieces of Péladan's novels Istar and Femmes honnêtes (1885).
1889
Frontispiece for Le Roy's Mon coeur pleure d'autrefois contains references to subjective versus objective mind and the occult significance of mirrors. Makes contact with Pre-Raphaelite painters in England.
1891
I Lock the Door upon Myself and Who Shall Deliver Me? are inspired by Christina Rossetti's poetry.
1892
Participates in first Salon de la Rose + Croix in Paris.
1894
Participates in first exhibition of La Libre Esthétique. Fellow painter Jules Dujardin notes Khnopff's debt to ideas found in Plato's Symposium, including those on love, beauty, and androgyny. Apparently reads Plotinus and other ancient and Renaissance Neoplatonists by this time. Reportedly burns "subtle perfumes to inspire him" while painting portraits.
1895
Illustrates "À la nue accablante tu" by Stéphane Mallarmé, published in German review Pan.
1896
Painting Des Caresses summarizes all the themes relevant to his mystical beliefs.
After 1896
Makes contact with group of English

Swedenborgians led by William Blake Richmond, godson of William Blake.

1898
Travels to Vienna for first Secession exhibition.

1900
Devotes majority of time to building house, a temple to himself, which he designs using only blue, gold, and white as decorations. Floor of the villa inscribed with a magic circle.

PAUL KLEE
SWITZERLAND, 1879–1940

1902
In his writings contrasts physical qualities and corporeal construction with spiritual qualities.

1903
Travels to Italy, where he is inspired to consider harmonic relations after viewing Italian architecture.

1905
Begins painting on back of glass, a technique probably borrowed from Bavarian folk art.

1908–9
Christian Morgenstern, a poet he knows and greatly admires, becomes follower of Rudolf Steiner.

1911
Meets Wassily Kandinsky and joins the Blaue Reiter exhibition the following year.

1912
Meets Robert Delaunay in Paris.

1913
Translates version of Delaunay's essay on light, which is then published in *Der Sturm*.

1914
With August Macke and Louis Moilliet, travels to Tunisia and Egypt. Inspired to create works using greater range of color.

1917–18
Reads books by Rudolf Steiner. Critical of theosophical color symbolism and spiritual training but agrees with idea of inner creation from "nebulous" spots.

1920
Writes *Creative Credo,* in which the opening line is "Art does not render the visible; it renders visible." In this essay expresses desire to create "cosmos of forms which is so similar to the Creation that only the slightest breath is needed to transform religious feeling, religion into fact."

1921
Joins faculty of Bauhaus in Weimar.

1923
Publishes "Wege des Naturstudiums," which calls for an expansion of ways in which nature is studied: the artist should find the innermost region of nature, the heart of creation, and visualize "secret visions." "The more the student ascends in his composition of the world, the more does his development in the observation and perception of nature help him to free creation of abstract forms, which by way of the willed-schematic, reach a new naturalness, the naturalness of the work. He then creates a work, or takes part in the creation of works that are a simile to the work of God."

1924
In *Pedagogical Sketchbook* discusses golden section and other harmonic principles in relation to growth. Focuses on the line and its ability to express extension and weight, inner pressure and movement, musical tones.

1928
In "Exakte Versuche im Bereich der Kunst" emphasizes role of intuition over rational methods.

1929
Paints largely abstract canvases drawn from nature.

YVES KLEIN
FRANCE, 1928–1962

1947
Studies judo, receiving white and yellow belts. Meets Armand Fernandez (Arman) and Claude Pascal (Pascal Claude). Reads Max Heindel's *Cosmogonie des Rose-Croix* (1925).

1948
Louis Cadaux initiates him, Arman, and Claude into the Rose + Croix. Joins the Rosicrucian Society, based in Oceanside, California. With Arman and Claude, becomes vegetarian and begins regular evening meditation in cave on property of Arman's family. Paints one wall of cave blue. Prints impressions of his hands and feet on his shirt.

1949
Conceives of *One-Note Symphony,* a single tone sounded continuously without beginning or end. Makes small rectangular monochrome paintings on paper or board.

1950
Finishes various courses of study as part of membership in Rosicrucian Society.

1951
Speaks of creating monochrome paintings with appropriate musical accompaniment that creates an allegory of color. Conceives of fountains of water and fire. Receives brown belt in judo.

1952
Spends four hours per day reading Heindel's *Cosmogonie des Rose + Croix*. Travels, via Southeast Asia, to Japan, where he joins Kodokan Judo Institute.

1953
Ends membership in Rosicrucian Society, but continues to read Heindel's book. By this time has read many Buddhist books.

1954
Writes *Les Fondements du judo*.

1955
In Paris publicly defends notion of pure color. Says monochrome pictures represent idea of absolute unity in atmosphere of perfect serenity. Submits orange monochrome for Salon des Réalités Nouvelles; it is rejected.

1956
Joins Order of the Archers of Saint Sebastian.

1957
Takes name Yves le Monochrome. Announces abolition of the figure in his work.

1958
Discovers the writings of Gaston Bachelard. Proposes coloring all future atomic test explosions blue. Begins "pinceau vivant," using nude models bathed in paint as "brushes"; these paintings are later known as "anthropométries." Further proposals for fountains of water and fire. Proposes sale of zones of "invisible pictorial sensibility" and later sells Parisian air.

1961
Makes paintings of fire at Centre d'Essais of the Gaz de France and Planetary Reliefs.

1962
Marries at Church of Saint-Nicholas-des-Champs, with the leader of the Archers of Saint Sebastian present.

HILMA AF KLINT
SWEDEN, 1862–1944

Born into a naval family trained in navigation, astronomy, and mathematics. In youth experiences extrasensory perception.
By 1879
Seriously involved in spiritualism.
1882–87
Studies at Royal Academy in Stockholm.
1887–1908
Works as professional portrait and landscape painter.
1890s
With four women, forms spiritualist group, "The Friday Group" or "The Five," which receives mediumistic messages and often produces automatic and collective drawings. Eventually she serves as group's sole medium.
1894
Edvard Munch exhibits in her studio building. May know that Munch and his friend August Strindberg have strong occult leanings.
1905
Promises one of her spirit-leaders, Amaliel, that she will devote one year exclusively to painting a message to mankind. Abandons portrait and landscape painting.
1906
Makes Paintings for a Temple series.
1907
Paints the Ten Large Paintings series between October and December.
1908
Meets Rudolf Steiner and shows paintings to him.
1908–12
Does not paint.
1914
S.U.W./Swan series features extraordinarily abstract paintings.
1915
Works with watercolors and oil paintings on smaller scale. Depicts different planes of experience through horizontal divisions in picture plane, which express theosophical convictions. This approach makes her less dependent on spiritual leaders.
1919
Takes up botanical studies and abstract geometric watercolors.
1920
Death of mother allows her to travel independently for the first time. Moves to southern Sweden. Visits Steiner in Dornach and is exposed there to his working method, which features a technique, "painting out of color," by which shadows and lines are eliminated.
1922
Takes up painting again, but in a more anthroposophical, Steiner-inspired fashion. Creates loose, fluid watercolors without any preparatory drawings.
1922–41
Continues to paint in this manner and regularly visits Dornach.
1944
Dies. Will stipulates oeuvre be kept together and not be exhibited publicly for twenty years, in the hope that a public more receptive to her pictures will then exist.

IVAN KLIUN
RUSSIA, 1873–1943

Born into peasant family and undoubtedly exposed to naturalistic, pre-Christian beliefs common in Russian countryside.
1908
Attracted to Symbolism, especially Russian Symbolists Pavel Kuznetsov and artists associated with the Blue Rose Group. Early models for his art included Viktor Borisov-Musatov, Pavel Kuznetsov, and Edvard Munch and other Scandinavian Symbolists.
1912
As friend of Kazimir Malevich and the Cubo-Futurists, shares in their discussion of Cubism, zaum ("beyond reason"), and mystical ideas.
1915
With Malevich and Alexei Kruchenykh, contributes to book Secret Vices of the Academicians, an attack on the decadent Symbolist past in literature and the arts.
1915–17
Inspired by both Malevich and Malevich's ideological opponent, Vladimir Tatlin. Attracted to Malevich's use of nonobjectivity as a way to communicate pure feeling.
1917
Investigates interactions of color and depicts the effects of transparency in a manner parallel to that of Matiushin.

IVAN KUDRIASHEV
RUSSIA, 1896–1970

1913–17
Enters Moscow Institute of Painting, Sculpture, and Architecture, where he makes contact with artists such as Kazimir Malevich and Ivan Kliun. Especially interested in Wassily Kandinsky's and Malevich's ideas.
1918–19
Learns Suprematism in Malevich's classes at the State Free Studios, Moscow.
By 1920s
Interested in writings of mystical philosopher Nikolai Fedorov and scientist and Orthodox priest, Pavel Florensky.
Early 1920s
Interested in space travel, science fiction, and cosmic phenomena. May introduce Malevich to these interests. Father is builder of working models for rockets. Reads Konstantin Tsioglinsky's rocketry theories and science-fiction novels. Executes paintings based upon principles of luminosity and refractivity. Work is geometrically based and depicts properties of dynamic motion through a deep and limitless space.
1925
Becomes member of Society of Easel Painting, where topical concerns such as Freudian thought, the creation of the universe, and Surrealism are discussed.

FRANTIŠEK KUPKA
FRANCE, BORN CZECHOSLOVAKIA, 1871–1957

1887
Takes up residence in Prague, where he is introduced to spiritualism.
1887–92
Reads the Veda, Plato, Immanuel Kant, Friedrich Nietzsche, Arthur Schopenhauer, and books on astrology, alchemy, chemistry, and astronomy.
1888
Studies color theory at the Crafts School in Jaromer, Bohemia. Reads Ernest Wilhelm von Brücke's Die Psychologie der Farben (1866) and A. Andel's Das polychrome Flächenornament (1880).
1892
Lives in Vienna where he becomes practicing

medium. Reads Kant, Paracelsus, and John Calvin.

1894

Meets Nazarene artist Karl Diefenbach, who advocates man's return to nature. Moves to Diefenbach's home and participates in communal life-style there, which features vegetarian cuisine, outdoor baths, nude exercising, discussions about spiritual issues, music, and painting. Visits Paris.

1896

Settles in Paris. Involved in Theosophy and oriental philosophy.

1897

Continues involvement with spiritualists, writing: "Unfortunately — or may it even be good luck — I came again in contact with the Spiritists. . . . Yesterday I experienced a split consciousness where it seemed I was observing the earth from outside. I was in great empty space and saw the planets rolling quietly. After that it was difficult to come back to the trivia of every day life."

1900

Makes *The Meaning of Life,* an etching and aquatint in which a lonely figure, surrounded by looming sphinxes and a night sky, contemplates life's meaning. Believes the true reality is a spiritual one and art's role is to restore the consciousness of reality. Illustrates some of Edgar Allan Poe's mystic stories. Develops friendships with Marcel Duchamp and Jacques Villon. Lives next to Villon in Montmartre.

1903–4

Commissioned to design pages for Élisée Reclus's *L'Homme et la terre,* a geography and history book published in six volumes between 1905 and 1908.

1904

Spends much of his time reading Henri Bergson, which leads him to rethink his idealist philosophy and reread scientific books. Attends courses on physiology and biology. Paints very little.

1906

Moves to Puteaux.

1907–8

Probably reads Joséphin Péladan's translations of Leonardo da Vinci's *Trattato della pittura* and texts from Leonardo's notebooks. Begins

systematic examinations of movement in paintings and drawings.

1909

Visits Onésime Reclus and may see large-scale model of the moon displayed at Uccle. Develops interest in astronomy and regularly visits Paris Observatoire, Palais de la Découverte, and Musée des Arts et Métiers.

1910

Influenced by non-Euclidean geometry and the philosophy of Bergson.

1911

Participates in meetings of Puteaux group, where he joins friend Alexandre Mercereau, a contributor to spiritualist journal *La Vie mystérieuse.*

1911–12

Begins writing "La Création dans les arts plastiques" (eventually published in 1923), a text on the nature of art, which reveals that he read Blavatsky's *The Secret Doctrine* (1888) and Rudolf Steiner's works.

1913

Learns about Kandinsky's *On the Spiritual in Art* (1912) through Walter Rummel, the musician, in July.

1957

Funeral held at a secret place by a secret society.

KAZIMIR MALEVICH
RUSSIA, 1878–1935

1912

Hopes his Cubist style of painting can function as visual equivalent of *zaum* ("beyond reason") poetry. Sees analogy between Cubist vision, with its implications of higher geometries, and zaum.

1913

Writes, "We have arrived at beyond-reason. . . . I am beginning to understand that in this beyond-reason there is also a strict law which gives pictures their right to exist." Belongs to the Leningrad-based group, Union of Youth, as does Pavel Filonov, who is working on theory of "made paintings" that would capture the inner laws of the natural world. Takes part in Futurist conference in Uusikirkko, Finland. Designs decor for Kruchenykh-Matiushin opera *Victory over the Sun.*

1914

Makes alogist pictures that contain dense collection of whole and partial images and words, collage elements, and objects fastened to canvas.

1915

Paints first Suprematist pictures. Seeks to give direct visual form on canvas to zaum percep-

tions; may have been influenced by Charles Howard Hinton or Claude Bragdon. Suprematist pictures are aids to attaining zaum state, that "empty place where nothing exists but sensation." Introduces nonobjective beliefs at the first exhibition of his compositions: *0-10.* Writings reveal that he is familiar with Yoga. Publishes first of theoretical essays, "From Cubism and Futurism to Suprematism: The New Painterly Realism."

1923

Writes, "Science and art have no boundaries because what is comprehended infinitely is innumerable and infinity and innumerability are equal to nothing." Exhibits blank canvases.

FRANZ MARC
GERMANY, 1880–1916

1900

Attends classes at Munich Academy.

By 1903

Studies philosophy. Reads Epicurus, Richard Wagner, and Friedrich Nietzsche and offers ideas about reconciling Stoicism and Christianity. Deeply interested in German Romantics, owns the complete works of Novalis and E. T. A. Hoffmann and reads Friedrich von Schiller and Friedrich von Schelling.

1902–7

Travels through Italy, France, and Germany. Very depressed, particularly following father's death in 1907. Explores the meaning of organic unity, and the harmonic relations among living things. Paints studies of animals.

1910

Meets August Macke and the collector Bernhard Köller, who was to become his leading patron. First viewing of works by Henri Matisse and Paul Gauguin leads to new interest in coloristic expressiveness. Exhibition of Neue Kunstlervereinigung München meets with severe criticism; Marc responds by praising the works for their "complete spiritualization and their dematerialized inwardness of perception."

1911

Joins Neue Kunstlervereinigung München. He and Kandinsky leave it several months later and found the Blaue Reiter group and its journal.

1912

Publishes *Der Blaue Reiter* almanac, which features illustrations of objects from throughout

the world. Marc's first article in it is titled "Spiritual Goods." He declares that his is a search for a new age that embodies profound spiritual values. With August Macke, goes to Paris and meets Robert Delaunay.

1914
Plans to produce series of illustrations of different books of the Bible. Kandinsky, Paul Klee, Erich Heckel, Alfred Kubin, and Oskar Kokoschka are to participate. Produces group of abstract canvases and works on paper.

BRICE MARDEN
UNITED STATES, BORN 1938

1963
Upon completion of graduate studies, concludes that painting must be expressive, must ask questions of itself and of the viewer if it is to renew and regenerate the tradition of painting, and be about painting.

1964–65
Makes first one-panel monochrome paintings.

1966
Becomes general assistant to Robert Rauschenberg, who tells him that the number five is the first of the complicated numbers.

1968–69
Makes first two- and three-panel paintings.

1973–85
Visits Greece each year except 1980.

1974
Publishes *Suicide Notes*.

1977
Visits Morocco. *Annunciation* series of five paintings interprets Virgin Mary's response to angel Gabriel.

1978
Commissioned to make designs for stained-glass windows in Basel Münster, a Protestant cathedral. Studies medieval color symbolism for the four elements (water, fire, earth, and air) and uses these colors in his approach to the project. Reads Revelation, especially regarding numbers and opposites. Studies astrological symbolism and alchemy. Reads Aleister Crowley's writings; continues to make extensive notes and charts based upon it through 1984.

1980
Visits Micronesia. Makes paintings dominated by the tau cross, a motif associated in Christian images with Christ's suffering, or by post-and-lintel motifs, drawn from Greek architecture.

1982
Travels to Thailand and Sri Lanka, where he acquires a tripartite prayer flag.

MIKHAIL MATIUSHIN
RUSSIA, 1861–1934

1909
Joins Nikolai Kulbin's Impressionist group. Kulbin's panvitalist aesthetic theories have strong impact. However, at the end of the year, breaks with Kulbin and forms the Union of Youth. Archives and diaries suggest that he and his wife, poet Elena Guro, were familiar with theosophical sources and Eastern religions (notably Indian philosophy).

1911–12
References to the fourth dimension appear in notes that outline ideas about the evolution of the world and mankind's future development. Begins investigating what role close observation and analysis could play in encouraging a heightened awareness of the world.

1913
Publishes excerpts from Albert Gleizes and Jean Metzinger's *Du Cubisme* (1912) with interspersed quotations from P. D. Ouspensky's *Tertium Organum* (1911). Also affected by M. Lodyzhensky's *Superconscious and Ways to Achieve It* (1911–15).

1914
Briefly joins Pavel Filonov's group, called World Flowering in anticipation of a future time of cosmic unity. Publishes two of Filonov's poems, "Chant of Universal Flowering," narratives on the horrors of war followed by man's transcendence in a vision of light and harmony.

1918
Appointed professor at the Petrograd State Free Art-Teaching Studios. Devoting his studio to "spatial realism," conducts laboratory experiments on perception.

1920
Landscapes developed through method of "expanded viewing," which is his effort to see 360 degrees. Color studies of the 1920s, including tables in *Color Handbook* (1932), are result of experiments in interaction of form and color motivated by monistic concerns.

1920s
Performs optical and sound-color experiments, using models based on geometry, mathematics, and organic chemistry.

1929–32
Compiles work on color into book *Color Handbook*.

MATTA (ROBERTO SEBASTIANO MATTA ECHAURREN)
FRANCE, BORN CHILE, 1911

1929
While attending Catholic university in Santiago, produces mammoth drawing of 147 nudes, each drawn in different places for different religions, and all united as one in a temple.

1933
Moves to France. Becomes assistant to Le Corbusier.

1934
Travels to Spain, where he meets Federico García-Lorca.

1934–35
Travels to Scandinavia and Soviet Union.

1936
Discovers article on Marcel Duchamp and photographs taken by Man Ray of mathematical objects. Writes scenario, *The Earth Is a Man*, and makes numerous drawings which Salvador Dali urges him to show to André Breton.

1937
Meets Gordon Onslow-Ford. Develops concept of "psychological morphologies," an attempt to use only lines and forms of transformation derived from energies of an object.

1938
Summers with Onslow-Ford in Brittany, where they discuss Ouspensky's *Tertium Organum* (1911) and theories of the various dimensions.

1939
Summers in Chemillieu with Onslow-Ford, Breton, Estéban Francés, and Yves Tanguy. Leaves for New York.

1942–43
His studio is a gathering place for Jackson Pollock, William Baziotes, Arshile Gorky, and others.

1944
Writes tract on Duchamp. Traumatized by the realities of war; as a result tries to develop a social morphology that depicts torture chambers and other horrors. Increasingly portrays human interactions.

1948
Returns to Europe.

JOHN MCLAUGHLIN
UNITED STATES, 1898–1976

1932
Begins painting.
1935
Spends time in Japan, studying the language.
Remains there for several years.
Late 1930s
Becomes dealer of oriental art in Boston
before entering military service in China,
Burma, and India theater during World War
II.
1941-42
Resumes study of Japanese while in military.
1946
Settles in southern California to paint full-
time.
1948-76
Restricts his palette to basic colors and rectan-
gular shapes to achieve neutral form.
1960
States that "I have been influenced by Sesshu
because to him empty space was the 'marvel-
ous void'; by Malevich because he was aware
of the 'feeling of the absence of an object'; by
Mondrian because he was conscious of the
vast significance of the neutral form."

MARIO MERZ
ITALY, BORN 1925

1950s–60s
Paints heavily impastoed biomorphic
abstractions.
1966–67
Begins using neon.
Late 1960s
Many works feature shamanistic qualities,
especially his mixed-media installations, for
example, the Igloo series.
1968
Associated with *arte povera,* characterized by
the use of scrap materials in art.
1970
Begins Fibonacci series, based on system
devised by mathematician Leonardo da Pisa,
author of *Liber abaci* (1202). Merz describes
the Fibonacci as "thinkable. It corresponds
with the proliferation of natural and corporeal
elements." The Fibonacci trace an organic
process intertwined with numeration.
1972
Makes works incorporating Fibonacci tables.
Late 1970s
Begins painting again, now using mythic
creatures and organic forms.

PIET MONDRIAN
NETHERLANDS, 1872–1944

Born into strict Calvinist family.
From 1900
Fascinated by esoteric beliefs, especially
Theosophy. Designs bookplate using an Art
Nouveau style but featuring theosophical
symbols such as lotus flower and hexagram.
After 1907
Reads Dutch translation of Édouard Schuré's
Les Grands Initiés (1889).
1908
Aware of Rudolf Steiner's ideas and Helena P.
Blavatsky's *The Secret Doctrine* (1888). Steiner
lectures in the Netherlands. Frequently in
contact with Cornelis Spoor, a Theosophist
painter. Summers with Jan Toorop in
Domburg, becoming acquainted with collec-
tor Maria Tak van Poortvliet and painter
Jacoba van Heemskerck, both Theosophists.
1908–11
Paintings document a strong interest in theo-
sophical principles, for example, *Devotion,*
1908, and *Evolution,* 1910–11.
1909
Joins Theosophical Society.
1910
In letter to Spoor, describes discussion with
Toorop: "He sees Roman Catholicism like
A[nnie] Besant in its ancient times: isn't Ro-
man Catholicism originally the same as
Theosophy? I agreed with Toorop on the
main line and noticed that he really delves
deeply and wants the spiritual." May be famil-
iar with esoteric interpretations of mathema-
tics, discussed at the Vahana Lodge meetings
of the Dutch Theosophical Society, through
articles in theosophical magazines.
1911
Evolution represents theosophical doctrine of
evolution, man's progression from a low and
materialistic stage toward spirituality and
higher insight.
1911–12
Moves to Paris and rents room in head-
quarters of French Theosophical Society
before finding studio.
1912–18
Uses underlying, or interrupted, grids and
oval borders, both of which may be inter-
preted along theosophical lines.
1913–14
Solicited to write article for Dutch journal
Theosophia about Theosophy and art, but the
article is rejected.
1914
Returns to Netherlands for duration of World
War I.
1915
Makes contact with M. H. J. Schoenmaekers,

founder of "Christosophy."
1916
Breaks with Schoenmaekers.
1917–18
Publishes *De Nieuwe Beelding in de
Schilderkunst* (The new plasticism in painting)
in *De Stijl,* a text that reflects esoteric inter-
ests; reads its introduction at evening meeting
of Theosophical Society.
1918
Asked by Theo van Doesburg whether any of
Schoenmaekers's books were useful to him,
he replies, "*I* got everything from the Secret
Doctrine (Blavatsky) not from Schoen-
maekers, although he says the same things."
1920
Publishes *Le Néo-Plasticisme.*
1922
Expresses disappointment in spiritual move-
ments and their leaders. Still declares that
neoplasticism "is purely a theosophical art."
1938
Rejoins Theosophical Society.

WILHELM MORGNER
GERMANY, 1891–1917

1891–1908
Lives in Soest, a small town east of
Dortmund.
1908
Christian Rohlfs and Emil Nolde working in
Soest; Morgner moved by their expressive
painting. Studies under Georg Tappert in
Worpswede. Tappert encourages him to
reveal his inner self through art and to rely on
his psychic or emotional reflexes.
1912
Invited to exhibit at Sonderbund Ausstellung
in Cologne. Impressed by works of Vincent
van Gogh, Robert Delaunay, Die Brücke and
Der Blaue Reiter artists. Fascinated by
thirteenth-century paintings in the Roman-
esque church of Maria zur Höhe in Soest.
Develops intense religious fervor, with em-

phasis on empathy with Joseph, who was sold into bondage in Egypt, and with the suffering Christ of the Passion. Paints highly symbolic compositions, astral landscapes, and numerous religious themes.

1913–14
Drafted into military service in Berlin. Sent to western front.

1915
Fills sketchbooks with demonic forms, haunted scenes, and visions of fear and despair.

1917
Last painting, *Kreuzigung,* alludes to relationship between his own suffering soul and that of Christ.

GEORG MUCHE
GERMANY, BORN 1895

1913
Meets Kandinsky and Alexei von Jawlensky in Munich.

1915
Sees exhibition of Anthroposophist painter Jacoba van Heemskerck's work at Der Sturm gallery.

1917
Introduced to esoteric theories and practices by Sophie van Leer, Herwarth Walden's assistant at Der Sturm.

1918
Returning from the front, considers becoming a monk; spends an introspective period in Ramholz.

By 1919
Reads German mystics and oriental philosophy. Especially interested in Francis of Assisi, Meister Eckhart, and Dr. Otoman Hanish's Mazdaznan sect.

1920
Appointed by Walter Gropius to Bauhaus, where he joins with Johannes Itten in interest in Mazdaznan philosophy. Travels with Itten to Mazdaznan Congress in Leipzig, home city of Hanish. With Itten, discusses a return to recognizable objects in paintings.

1922
Abstraction no longer dominates his paintings.

1924
Travels to New York and may meet Katherine Dreier, founder of Société Anonyme, known for her interest in Theosophy.

1926
Teaches at Johannes Itten's private art school in Berlin.

LEE MULLICAN
UNITED STATES, BORN 1919

1941–46
Drafted into the Army Corps of Engineers, serves as a topographic designer mapping the Pacific. Makes extensive use of aerial photographs and becomes fascinated with bird's-eye views of islands as well as by camouflage patterns. Spends a year drawing in New Mexico. Studies primordial religions and Indian myths. Discovers *DYN* magazine and the work of Wolfgang Paalen.

1946–47
Moves to San Francisco Bay area. Begins painting with knife. Meets Gordon Onslow-Ford. Strongly influenced by Herbert Read's *The Green Child* (1935) and writings of Carl Gustav Jung.

1948
Meets Wolfgang Paalen. Travels to Mexico with the Paalens and the Onslow-Fords.

1951
Exhibits in *Dynaton* exhibition with Onslow-Ford and Paalen. The three refer to their state of oneness with nature and with their materials and working methods.

Early 1980s
Makes several trips to India and Nepal, leading to his paintings of semi-abstract hieratic guardian figures.

MATT MULLICAN
UNITED STATES, BORN 1951

Parents collect Hopi, Egyptian, Greek, Native American, Aztec, and Mayan artifacts.

1959
Lives in Rome. Makes paintings of gods.

1974
Constructs imaginary rooms with stick figures.

1975
Paints first sign picture.

1978–present
Undergoes hypnosis regularly, which often leads to experience of past eras. Participates in group trance sessions.

1978–79
Begins making banners, flags, and posters that are ideograms, containing emblems representing the world, the elements, the subjective, and fate.

1982
Carves first images in stone, representing his model of world cosmology. Subsequently works in stained glass.

1986
Remains interested in medieval and tantric manuscripts. Owns a lingam with a six-pointed star incised on it, as well as shamanistic medicine bottles.

EDVARD MUNCH
NORWAY, 1863–1944

1885
Travels to Antwerp and Paris. Already well established in radical bohemian circles in Oslo that read Friedrich Nietzsche and Karl Marx and question Christian faith.

1889
Travels to Paris.

1890
In Berlin meets collector Albert Kollmann, who has strong occult interests.

1892–95
Moves to Berlin. Remains there, with the exception of several brief trips, through 1895. Friends include Stanlislaw Przybyszewski, who suffers from hallucinations, and August Strindberg, who practices alchemical experiments. Deeply affected by Strindberg's interest in the occult and Przybyszewski's interest in transmission of thoughts, he is also aware of Emanuel Swedenborg's belief in auras and has read Aleksandr Aksakov's *Spiritualism and Animism* (1890). Together with other Scandinavian, German, and Polish writers, poets, and composers, begins publication of the journal *Pan*. He frequently discusses the pathology and psychology of human passion and calls for an art liberated from realism and focusing on the soul. He uses the term *symbolism* to describe such art.

1893
Begins Frieze of Life series.

1895–96
Moves to Paris for a two-year period and is closely associated with Symbolist circles.

1908
Enters psychiatric clinic near Copenhagen. Hospitalized for eight months, subsequently returns to Norway and leads isolated existence.

1944
At his death, his library includes writings by Nietzsche, Søren Kierkegaard, Strindberg, André Gide, and volumes on Johann Wolfgang von Goethe.

BRUCE NAUMAN
UNITED STATES, BORN 1941

1965
Stops painting. Executes two performance pieces. Begins using neon while a graduate student. Light source in each piece is hidden.
1966
Reads Robert Morris's writings. Reading Frederick Perls's *Gestalt Therapy* (1951), relates it to his investigations of certain phenomena. Transcribes *Gödel's Proof* (1931), a mathematical theorem that states that any complete system is inconsistent.
1967
Reads Ludwig Wittgenstein's philosophical writings and is interested in his thoughts on ambiguity of language as a means of communication. Also reads Vladimir Nabokov. *Window or Wall Sign,* neon spiral wall sculpture, incorporates ideas from Wittgenstein. Its spiral-arranged maxim, "The true artist helps the world by revealing mystic truths," may be, according to composer Philip Glass, directly related to the optical spiral in Marcel Duchamp's *Rotative demi-sphére,* 1925.
1968–69
Exhibits holograms.
1972–74
Introduces geometric forms such as circles, cones, and ellipses into his work.
1974
Exhibits *Silver Grotto,* five lines from a neon sign providing the only illumination in a darkened gallery; refers to the hermetic existence of the artist in his metaphorical cave.
1975–80
Concentrates on sculptural work based on geometric configurations. Many refer to Nauman's proposals for buried tunnels and rings that date back to the mid-1960s.
1980–81
Work becomes more narrative in approach.

BARNETT NEWMAN
UNITED STATES, 1905–1970

1923
At City College of New York, studies writings of Benedict de Spinoza, from which he develops first aesthetic manifesto on intellectual intuition as key meaning of art.
1936
Visits Henry David Thoreau's Walden Pond.
1939–41
Studies ornithology, botany, and geology.
1941
Paints biomorphic and classical, myth-oriented images often concerned with genesis or with dominance of the intuitive over the rational.
1941–42
Drafted into army, claims he is a conscientious objector.
1943–45
Writes, "The present painter is concerned . . . with the presentation into the world mystery. His imagination is therefore attempting to dig into metaphysical secrets. To that extent his art is concerned with the sublime. It is a religious art which through symbols will catch the basic truth of life which is its sense of tragedy . . . the artist like a true creator is delving into chaos . . . the artist tries to wrest truth from the void . . . the truth is a search for the hidden meaning of life."
1944
Organizes *Pre-Columbian Stone Sculpture* exhibition for Wakefield Gallery, New York.
1945
Meets Tony Smith, who introduces him to writings of D'Arcy Thompson, especially *On Growth and Form* (1917). May also be interested in the writings of Jay Hambidge on dynamic symmetry.
1946
Organizes exhibition of Northwest Coast Indian painting for Betty Parsons Gallery, New York.
1947
Organizes *The Ideographic Picture* for Betty Parsons Gallery. In essay "The First Man Was an Artist" emphasizes importance of scientific inquiry for the contemporary artist.
1949
Visiting Akron, Ohio, sees nearby Indian mounds.
1958
Two paintings inaugurate series later known as The Stations of the Cross (completed in 1966).
1963
Creates synagogue model for exhibition *Recent American Synagogue Architecture* at the Jewish Museum, New York.

GEORGIA O'KEEFFE
UNITED STATES, 1887–1986

1912
Enrolls in summer class of Alon Bement, who teaches oriental- inspired aesthetics of Ernst Fenellosa and Arthur Wesley Dow.
1912–13
Refers to Kandinsky's *On the Spiritual in Art* (1912), although admits that some time passed "before I really began to use the ideas."
1914–15
Studies with Dow at Columbia University.
1915–19
Paints series of watercolors reflecting Dow's teachings and the Symbolist reaction against literal representation.
1916–17
First exhibition at "291" begins personal relationship with Alfred Stieglitz and his coterie of artists and writers.
1919
Interested in correlation between music and abstraction, paints several canvases related to this theme.
1920s
Nature imagery rendered with highly distilled forms conveys her spiritual apprehension of reality.
1933
States, "I found I could say things with colors and shapes that I couldn't say in any other way — things that I had no words for." Develops friendship with Claude Bragdon, who lives in Shelton Hotel where O'Keeffe and Stieglitz reside.

GORDON ONSLOW-FORD
UNITED STATES, BORN BRITAIN, 1912

1937
Meets Matta in Paris. With him, develops concept of "psychological morphologies," containing lines and forms of transformation derived from energies of an object. Makes automatic drawings and never returns to working from nature.

1937–38
Travels to Egypt, where Howard Carter, noted Egyptologist, introduces him to highlights of Egyptian civilization. Makes drawings of Egyptian frescoes and sculptures.

1938
During summer trip to Brittany with Matta, discusses mathematical objects and theories of P. D. Ouspensky, whose *Tertium Organum* (1911) both read. Considers concept of spacetime and how to paint things that are felt but not seen. Meets Wolfgang Paalen in Paris.

1938–39
With Matta and Estéban Francés, sees exhibition of mathematical objects at Palais de la Découverte in Paris, which encourages them to try to depict, through force lines, auras, and shifting perspective, the reality beyond what is visible. Begins working with poured paint.

1940–41
Moves to New York with Matta. Gives talks at the New School of Social Research on Giorgio de Chirico, Max Ernst, Joan Miró, André Masson, Yves Tanguy, Victor Brauner, Wolfgang Paalen, and Matta. William Baziotes, Jackson Pollock, Robert Motherwell, and Arshile Gorky are in audience for some of his lectures.

1941–46
Moves to Mexico, where Paalen had gone several months earlier. Lives in Erongaricuaro, a remote Mexican village, with the Tarascan Indians.

1957
Moves to a remote valley in Inverness, California.

1960s
Compositions evoke sense of atomically charged universe, the cosmic "web."

ERIC ORR
UNITED STATES, BORN 1939

1955
Becomes interested in Buddhism as alternative to Judeo-Christian tradition, which he considers a hollow ritual.

1964
Makes *Colt 45*, a mounted, cocked, automatic pistol facing an empty chair.

1964–65
Serves as civil rights worker in Mississippi. Becomes more aware of man's mortality. Begins making black paintings and, after studying welding, making sculpture.

1966
Moves to California. Becomes associated with group of light and space artists, including Robert Irwin and James Turrell.

1967–68
Sees exhibition at the University of California, Los Angeles, devoted to primitive objects from Congo, which encourages him to consider the "object" and its "invisible side." With a physician friend, begins experimenting with hypnotism. Under hypnosis, witnesses a woman's glowing eyeball.

1971
Travels to Egypt, then spends time in India, Burma, and Japan. Observes Zen ceremonies. With John McCracken, makes *Blood Shadow*, a blood-covered glass with a human silhouette scraped onto it; the blood is Orr's, the shadow, McCracken's. The work is transported to the pyramids at Giza and positioned there. He sees work as drawing on ancient funerary ritual. Begins incorporating empty spaces as seen in ancient tombs into his work. Goal is to create spaces that will focus viewer's attention on infinity.

Mid-1970s
Becomes fascinated by scientific concepts such as space-time curvature, black-hole theories, and cloning.

1976
Travels to Afghanistan.

1976–77
In New Mexico visits with Larry Bell. During evenings alone has out-of-body experiences.

c. 1980
Travels to New Hebrides, where he stays with members of the Tana cult.

1981
Goes to Zaire, where he is encouraged by tribal members to use blood as part of his art.

1981–83
Uses human blood, ground human carbon and bone, and human hair in his work.

1985
Attempts to isolate heat waves in works of art.

WOLFGANG PAALEN
AUSTRIA, 1905–1959

1925
After peripatetic childhood, arrives in Paris.

1927
Goes to Munich, where he studies briefly in Hans Hofmann's school, then returns to Paris.

1933
Visits caves of Altamira in Spain. Makes many paintings devoted to the theme of the cave.

1936
Travels to Greece. Increasingly fascinated by primitive and non-Western arts.

1937
Paints totemic landscapes. Invents "fumage," technique of moving a canvas covered with wet paint over a lit candle that traces marks in the paint.

1938
Meets Gordon Onslow-Ford in Paris.

1939
Travels in Canada for four months. Discovers Northwest totem poles. Settles in Mexico at the invitation of Frida Kahlo. Begins synthesizing ideas about Surrealist automatism, modern physics, and anthropology.

1940–52
Paints *Cosmogons*, containing numerous references to a cosmic or celestial vision. Adopts the compositionally dynamic form of a parabola. Paintings feature new notion of pictorial space, in which square and round dots and bits of color are dispersed on a canvas.

1942
Establishes journal *DYN*.

1951
Returns to Europe.

1954
Returns to reside permanently in Mexico.

AGNES PELTON
UNITED STATES, BORN GERMANY, 1881–1961

1900
Completes studies at the Pratt Institute, New York, where she studies with Arthur Wesley Dow. Assists Dow at his summer school in Ipswich, Massachusetts.

1909
Studies Italian painting in Italy. Begins "imaginative" painting, which she continues until 1914.

1913
Exhibits at Armory Show.

1914–19
Does not paint during World War I.

1919
Visits Mabel Dodge in Taos, New Mexico. Makes studies of Indians.

1919–24
Lives in Honolulu, Hawaii, where she makes increasingly abstract flower studies.

1926
Makes pure abstractions that show interest in the way light is conveyed through space and forms.

1933
Living in Cathedral City, California, corresponds with Raymond Jonson, who senses immediately a kinship between their paintings.

1938
Made honorary president of the Transcendental Painting Group. Participates in many of its exhibitions.

FRANCIS PICABIA
FRANCE, 1879–1953

1905–8
Paints in an Impressionist style, although his aesthetic concerns are based on the nineteenth-century notion of "correspondences," elaborated by poet Charles Baudelaire.

1909
Produces some of his first abstract work.

1912
Participates in the Section d'Or group.

1913–14
Creates what he calls abstract "psychological" studies, such as *Udnie* and *Edtaonisl*, both 1913, and *I See Again in Memory My Dear Udnie*, c. 1914.

1915
Begins machinist or mechanomorphic period in his oeuvre.

1919–21
Participates in Dada evenings.

1922
Produces Monsters series.

1928–32
Begins paintings Transparencies series, images that feature linear figures and objects in a dreamlike space.

1948–49
Creates abstract paintings of dots on color fields.

ALBERT PLASSCHAERT
NETHERLANDS, 1866–1941

After 1895
Produces stained glass windows. Identifies the lead strip as the male, the glass itself as the female; their fusion is aimed at complete perfection.

1900–1913
Develops a personal philosophy identifying himself with Jesus.

1912
As managing director of Kunsthandel Oldenzeel in Rotterdam, presents Wassily Kandinsky's work and Futurism for the first time in the Netherlands.

From 1912
Makes drawings with a maze of lines, featuring enclosed heads and eyes, intended to represent exposure to the divine.

1916
Directs the exhibition space Huis der zielekunst (Home for the art of the soul), presenting artists interested in depictions of the supernatural.

From 1916
Assigns opus numbers to pictures.

1918–19
Editor of the periodical *De Derde Weg* (The third road), in which he publishes poems and essays.

SIGMAR POLKE
GERMANY, BORN 1941

1961–67
Studies at the Düsseldorf Academy, where he feels strong influence of Joseph Beuys.

1963
Studies with Gerhard Richter and Konrad Fischer. Develops with them the German version of Pop Art known as Capitalist Realism. Paints ironic imagery, raising questions about the role of the object that is the subject.

1970s
According to Polke, the painter is nothing more than a medium of "high forces."

JACKSON POLLOCK
UNITED STATES, 1912–1956

c. 1917–28
During his youth frequently sees Indians and witnesses their rituals.

1923
Explores Indian ruins outside Phoenix, Arizona.

1928
Introduced to Theosophy and teachings of Krishnamurti by his art teacher at Manual Arts School, Los Angeles, Frederick Schwankovsky. Attends lectures by Krishnamurti.

1929
Considers following "occult mysticism."

1930
Moves to New York. Writes, "I am still interested in theosophy and am studying a book. . . . everything it has to say seems to be contrary to the essence of modern life but after it is understood and lived up to I think it is a very helpful guide."

1930–35
Purchases twelve to fifteen volumes of the annual reports of the Bureau of American Ethnology, which contain illustrations, photos, and field reports on Native American art and culture.

1930–50
Frequently visits museums, gallery exhibitions, and ethnographic collections featuring Native American art.

1934
Meets Helen Marot, who is deeply interested in psychology; they remain close friends until his death. Spends summer traveling across United States, spending considerable time in Mojave desert.

1937
Begins psychiatric treatment for alcoholism. Probably meets John D. Graham, who becomes his source for Freudian and Jungian theory after he reads Graham's "Primitive Art and Picasso." Receives inscribed copy of Graham's *System and Dialectics of Art*.

1938–47
Produces neoprimitive, myth-oriented, pictographic paintings with titles indicating

an interest in ritual, rites of passage, the unconscious, and transformation. Other titles reflect an interest in psychology and Jungian theory, alchemy, consciousness, union with nature, inner and outer spaces, and spirituality.

1939
Reenters therapy with a Jungian psychiatrist, who encourages use of drawings as therapy.

1941
Attends Museum of Modern Art's *Indian Art of the United States* exhibition with his psychiatrist, to whom he expresses a shamanistic attitude toward Indian sand painting.

RICHARD POUSETTE-DART
UNITED STATES, BORN 1916

Father, the noted painter, lecturer, and art critic Nathaniel Pousette-Dart, owns primitive Indian objects and books on primitive subjects.

1935
Becomes conscientious objector.

Late 1930s–early 1940s
Writes that art is a "manifestation of the conscious mind reacting upon a submind spirit — the crystallization resulting when they meet — unknown experience reacting upon known experience creating a superhuman mystic body." Reads Richard Maurice Bucke's *Cosmic Consciousness* (1901), Meister Eckhart, Bhagavad Gita, Krishnamurti, various editions of the Bible, Upanishads, Lao-tzu, early Christian and Hebrew mystics, and George Santayana.

1942
Painting *Symphony Number 1, The Transcendental* reflects interest in Indian tradition.

1947
In catalogue of one-man exhibition at Peggy Guggenheim's Art of This Century, writes, "I strive to express the spiritual nature of the Universe. Painting is for me a dynamic balance and wholeness of life; it is mysterious and transcending, yet solid and real."

ARNULF RAINER
AUSTRIA, BORN 1929

1950–51
Through Austrian journal *Plan* and writings of Austrian critic Max Holzer, becomes familiar with André Breton's theories. Learns about Spanish mystic Saint John of the Cross from a French exhibition catalogue.

1951
First visits Paris.

1952
Publishes fragments of several mystical texts, including Lao-tzu, Saint John of the Cross, Gautama Buddha, and Revelation, in an exhibition catalogue of his work. In another pamphlet, distributed at the exhibition's opening, he quotes from Jakob Böhme. Describes evolution of his work as a process from figuration to abstraction, which he calls "Stadia." For him, stadia is a mystical term, referring to the mystic's need to travel on the path, via ecstasy, to unity.

1954
Makes nearly monochrome paintings, created by adding lines spontaneously to one another until the entire surface becomes one color.

1956–57
Inspired by thirteenth- and fourteenth-century Italian crosses, begins painting crosses.

PAUL RANSON
FRANCE, 1864–1909

Born into Protestant, leftist, and anticlerical background. During childhood and adolescence becomes familiar with medieval traditions of decorative and applied arts in Limoges.

1890
Establishes atelier, "The Temple," where the Nabis hold weekly meetings. Sérusier paints portrait of him in which he is associated with various esoteric signs. Many of his own paintings from the first half of this decade feature alchemical, zodiacal, and other occult signs and themes. For example, *Rama* is derived from Édouard Schuré's *Les Grands Initiés* (1888).

1891–95
Corresponds regularly with Jan Verkade.

1896
Sérusier tries to interest him in mathematically based theories of the school of Beuron but has no success.

ODILON REDON
FRANCE, 1840–1916

c. 1860
Develops friendship with Antonin Clavaud, a Darwinian botanist, who introduces him to writings of Edgar Allan Poe and Charles Baudelaire and to precepts of oriental religions.

1870s
At the salons of Madame de Rayssac and others, is exposed to late Romantic theories of Orphism and the cult of Richard Wagner, especially Édouard Schuré's esoteric interpretations of it.

1879
Lithographic series *Dans le rêve* depends on influence of Baudelaire and the Orphic convictions found in Johann Wolfgang von Goethe's writings.

1880s
Reinforces esoteric interests through meetings with Stéphane Mallarmé, Joris-Karl Huysmans, the Nabis, Paul Gauguin, and the Rose + Croix group. Reported to be a habitué of the Bailly bookstore, which features esoterica.

AD REINHARDT
UNITED STATES, 1913–1967

1930s–40s
Becomes friends with Thomas Merton.

1940s
Participates, along with Louise Nevelson and Will Barnet, in meetings of the Indian Space Club, a group organized to study American Indian art.

1943
Tries to convince Merton not to become a Trappist monk.

1944
Studies Chinese and Japanese painting and Islamic architectural decoration.

1946–52
With the help of the G.I. Bill, studies Asian art history with Alfred Soloway.

c. 1947
Gives lecture "The Spiral Form in Modern Architecture."

1953
Renouncing color, makes "black" paintings until his death.

1954
Describes the Eastern perspective as beginning "with an awareness of the immeasurable vastness and endlessness of things out there, and as things get smaller as they get closer, the viewer ends up by losing (finding?) himself in his own mind." His art is affected by the

philosophical premises in Chinese art.
1956
Publishes last of his satirical cartoons on esoteric interests and the art world.
1958
Travels to Japan, India, Iran, Iraq, and Egypt.
1960
Writes about Buddha images.
1961
Visits Turkey, Syria, and Jordan.
1966
Reviews George Kubler's book *The Shape of Time*.

DOROTHEA ROCKBURNE
UNITED STATES, BORN CANADA, 1934

1952–56
Studies at Black Mountain College, North Carolina, where she meets Robert Rauschenberg and becomes interested in work of Max Dehn, a mathematician and lecturer at the college. Travels through Inca areas in South America.
1971
Seeks, in mathematical terms, the "elegant and perfect solution" in her work, which is heavily involved with Boolean mathematics and work of Edmund Husserl. Later noted that she wanted to use mathematical principles in her work at this time because they were otherwise imperceptible. Diaries contain passages from William Ivins's *Art and Geometry* (1946). Interested in topological geometry and in behavioral and especially perceptual psychology.
1972
Work based on the idea of syllogism.
1973
Travels to Italy and studies frescoes and altar paintings. In Greece realizes that everything she was attracted to had its basis in the golden section. Rereads Pythagoras.
1974–76
Bases paintings on principles of the golden section.
1979–81
Creates Egyptian paintings and White Angels series.
1982
Moves from interest in mathematics to notion of "dark angels" and becomes fascinated with notion of angelic orders.

MARK ROTHKO
UNITED STATES, BORN RUSSIA, 1903–1970

By 1910
Attends Hebrew school; studies scriptures and Talmud.
1913–21
During years in Portland, Oregon, becomes familiar with Northwest Coast Indian art, especially examples found in Portland Art Museum.
Late 1920s
Makes maps for biblical history book *The Graphic Bible* (1927) by Rabbi Louis Browne.
c. 1929–30
Meets Adolph Gottlieb.
1935
Interested in Aegean archaic art, African sculpture, and art of Nineveh, Egypt, and Mesopotamia.
c. 1936
Meets Barnett Newman.
By 1937
Probably knows John D. Graham's writings, with their emphasis on Jungian theory of collective unconscious.
1937–39
Moves to desert near Tucson, Arizona.
1938
First explores automatic drawing.
1938–40
Earlier reading of Friedrich Nietzsche's *Birth of Tragedy* (1870–71) may influence paintings of these years.
1941–43
With Gottlieb, formulates aesthetic grounded in interest in Greek, Roman, and Christian myth.
1942
First aquatic, oneiric images, inspired by classical myth and the New World's native mythologies.
1943
With Newman and Gottlieb writes letter to *New York Times,* which concludes: "We assert that the subject [of abstract painting] is crucial and only that subject matter is valid which is tragic and timeless. That is why we profess spiritual kinship with primitives and archaic art." In a radio broadcast with Gottlieb, notes interest in Jungian and eternal symbols, belief in myth, and importance of archaism and psychological content.
1945
Writes, "The abstract artist has given existence to many unseen worlds and tempi. But I repudiate his denial of the material existence of the whole of reality. For art to me is an anecdote of the spirit."

1945–47
Makes images of magic vessels which are very much influenced by Surrealism.
1947
During the summer teaches with Clyfford Still in San Francisco.
1948
Work no longer contains strong literary references and symbols or organic forms.
1949
Mature work of floating color shapes emerges. Begins using numbers as titles.
1964
Places parachute over studio skylight to keep studio relatively dark.
1965
Begins commission for paintings for the chapel of the Institute of Religion and Human Development in Houston, Texas.
1969
Begins black and gray or brown series: canvases with a black rectangle at top and a gray or brown rectangle at bottom; often interpreted by scholars as prefiguring his suicide.

ALBERT PINKHAM RYDER
UNITED STATES, 1847–1917

Paternal grandparents are highly religious, in strict Wesleyite sect.
1870–90
Probably reads Walt Whitman on individualistic Christianity of "noiseless, secret ecstasy, and unremitted aspiration."
1877
First travels to Europe.
1880s–90s
Exposed to tenets of "New Theology," a Protestant version of Darwinism.
1882
Takes second European trip to view old master paintings.
1882–90
Series of religious paintings.
1905
Says that the artist "should strive to express his thought and not the surface of it. . . . The artist has only to remain true to his dream and . . . must see naught but the vision beyond."

KURT SCHWITTERS
GERMANY, 1887–1948

1901
Experiences first of epileptic seizures that persist during childhood after local children destroy garden he cultivated for several years. Becomes an invalid for two years.
1917
Work becomes abstract.
1918
Meets Jean Arp. Begins using collage in his work.
1919
Begins *Merz* works.
1921
Meets Theo van Doesburg.
1923
Writes, "Art is a spiritual function of man, which aims at freeing him from life's chaos."
1924
In an article in *Der Sturm* states that his is a spiritual, Christian art.
1929
First travels to Norway.
1936
Makes group of collages using pages from the Koran and from Camel cigarette packs.
1944
Thanks Herbert Read for discussing the "philosophical . . . mystical justification" for his work.

PAUL SERUSIER
FRANCE, 1864–1927

1876–83
Studies at Lycée Condorcet, Paris, where special emphasis is placed on the philosophies of Plato and Plotinus.
1888
Under Paul Gauguin's supervision executes image he later calls *Talisman,* responding to Gauguin's instructions to paint most intense colors emanating from nature.
1890
Paints portrait of Paul Ranson, in which zodiacal and other mystical signs occur. Reads Édouard Schuré's *Les Grands Initiés* (1888) and Honoré de Balzac's *Louis Lambert* (1832).
1896
Introduced by Nabis painter Jan Verkade to the "holy measures" theories of Father Desiderius Lenz, leader of the school of Beuron, Germany.
1900
Work contains more Christian and pagan Greek themes, as well as those of Hindu and Egyptian mysteries.

1905
Translates Lenz's *L'Esthétique de Beuron* (1905).
1921
Publishes his own art theory as *ABC de la peinture*.

GINO SEVERINI
ITALY, 1883–1966

1908
Living in Paris, finds a studio behind Lugne-Poe's Théâtre de l'Oeuvre and develops friendships within the Symbolist circles around the theatre.
1911
Executes first "state of mind" painting, *The Black Cat,* in which he reduces Edgar Allan Poe's story to a spiritual state.
1914
Spherical Expansion of Light series.

TONY SMITH
UNITED STATES, 1912–1980

During his youth, receives Jesuit training.
1916
Visits New Mexican pueblos, of which he subsequently makes models.
1924
Becomes familiar with Jay Hambidge's *Dynamic Symmetry and the Greek Vase* (1920).
Late 1930s
Develops interest in notion of "close packing" of forms from D'Arcy Thompson's book *On Growth and Form* (1917). Sees reproductions of Alexander Graham Bell's tetrahedral kites, tower, and gliders built c. 1900–1910.
1938
Studies at Frank Lloyd Wright's Taliesin East.
Mid-1940s
Interested in Jacques Lipchitz's mythological sculptures, considers them to be related to geometric form, with a potency for organic flow.
1946
Moves into Mark Rothko's East Eighth Street studio.
1950
Discusses with Jackson Pollock and Alfonso Ossorio a design for a Catholic church; project is never realized.
1953
During residence in Bayreuth, West Germany, makes The Louisenberg series of paint-

ings, named after a geological site nearby. Visited by Ad Reinhardt, who makes suggestions about paintings.
1960–80
Until now a practicing architect, decides to concentrate on making sculpture, although continues to paint.

AUGUSTUS VINCENT TACK
UNITED STATES, 1870–1949

Raised in strict Roman Catholic family. Later refers to youthful beliefs in representational scriptural subjects.
1886
Views Symbolist paintings and considers Symbolist theories regarding "correspondence" and "synesthesia."
Early 1910s
Views paintings by Odilon Redon that "restored inner life to painting by drawing on decorative ideas of the Orient."
1913–14
Seeks "correspondence" between nature and metaphysical reality through line, form, and color used in stylized landscape imagery. Begins "landscapes of the mind," paintings of pure color fields expressing inherent mysticism.
1918–19
Mystic landscapes fuse with other landscapes in paintings.
1920
Begins mural work for Catholic churches. Acknowledges influence of Byzantine painters and mosaics.
1944
Makes *Creation* curtain for George Washington University auditorium, a work that expresses inspiration of God's creative forces.

SOPHIE TAEUBER-ARP
SWITZERLAND, 1889–1943

1915
Meets Jean Arp at Galerie Tanner exhibition in Zurich. Arp later recalled that at this time "she already knew how to give direct and palpable shape to her inner reality."
1916
Studies dance and theory at the school of Rudolf von Laban. Paintings may be influenced by von Laban's dance notation system. With Arp studies the German mystics and contemporary mandalas.
1916–18
Abandons oil painting, as does Arp, and works exclusively in paper, cloth, and embroidery, using these as "spiritual exercises."
1916–19
Participates in Dada activities in Zurich. Dances at Dada soirées.
1917–18
Compositions of this period, such as *Vertical, Horizontal, Square, Rectangular*, 1917, may be influenced by the golden section.
1922
Marries Jean Arp.
1926
Visits Pompeii.
1927–28
Works on designs and decorations for interior of Café de l'Aubette in Strasbourg with Arp and Theo van Doesburg.
1928–32
Moves to Meudon, where she makes "four-space, six-space, and twelve-space" paintings, static circles, and wooden reliefs.
c. 1930
Circle becomes for her the cosmic metaphor, a form encompassing all others.
c. 1935
Work becomes more organic in character and she begins to collaborate again with Arp.

JOHAN THORN PRIKKER
NETHERLANDS, 1868–1932

1890
Influenced by Jan Toorop, who introduces him to Belgian society of artists, Les XX.
1891
Interested in early Dutch and Flemish painters, especially Rogier van der Weyden's *Descent from the Cross*, before 1443.
1892
Meets Joséphin Péladan and joins the Rose + Croix group. Also meets French poet Paul Verlaine. Influenced by oriental art. Meets Henri van de Velde, Belgian Art Nouveau painter-architect.
1892–96
Begins overtly Symbolist period, with works featuring themes of mysticism and the Catholic ideal, anarchy, and fragile woman.
1893
Joins Les XX. Writes that he has started a large triptych of the Trinity to be interpreted, not in a biblical way, but in a mystical one. Triptych causes considerable difficulty and is eventually destroyed by the artist.
1905–7
Paints several biblical scenes.
1912–32
Produces stained glass windows commissioned by churches.

MARK TOBEY
UNITED STATES, 1890–1976

Born into strong Congregationalist family; considers becoming a preacher.
c. 1918
Meets portrait painter Juliet Thompson, who exposes him to literature from the Baha'i World Faith. Accepts invitation to Green Acre, Eliot, Maine, a spiritual retreat, where he is converted to Baha'i faith. Sees work by William Blake at Pierpont Morgan Library. Visits Marcel Duchamp.
1922
Settles in Seattle.
1923–24
Introduced to Chinese brush technique by Teng Kuei, Chinese student at University of Washington.
1926
Makes pilgrimage to tombs of Baha'u'llah in Acre and Abdul-Baha in Haifa, Palestine. Sees Persian and Arabic scripts.
1932
Travels to Europe. Visits Baha'i shrines in Palestine again.
1934
Travels to Far East, where he spends month in Zen monastery in Kyoto, Japan. Studies calligraphy, painting, meditation, and poetry writing.
1935
Initiates his "white writing" as a result of oriental experiences.
1940
Continues white writing. Explores multiple spaces and moving focus in paintings.
1954
Begins Meditation series.
1957
Paints *sumis* (Japanese ink paintings).
1958
Publishes "Japanese Traditions and American Art."
1966
Travels again to Haifa and Acre to visit Baha'i shrines.

JAN TOOROP
NETHERLANDS, BORN JAVA, 1858–1928

1885–93
As member of the Belgian society Les XX, influenced by several Belgian (Fernand Khnopff, Félicien Rops, James Ensor, George Minne) and French (Paul Gauguin and the Nabis) artists.
1887–93
Attracted to mystical literature such as Thomas à Kempis's *De Imitatione Christi* (1427) and Édouard Schuré's *Les Grands Initiés* (1888).
By 1890
Reads contemporary Symbolist writers and mystics like Jan van Ruysbroek, Thomas à Kempis, and Joséphin Péladan, leader of the Rose + Croix.
1892
Meets Péladan and joins Rose + Croix. Meets the French poet Paul Verlaine. Sometimes includes mystical Rosicrucian elements in his Symbolist drawings.
1908
Joined at summer retreat in Domburg by Piet Mondrian.

GEORGES VANTONGERLOO
BELGIUM, 1886–1965

1917–18
Influenced by so-called "Christosophy," a mixture of Christianity and Theosophy conceived by M. H. J. Schoenmaekers. Reads Schoenmaekers's *Het Nieuwe Wereldbeeld* (The new image of the world) (1915) and *Beginselen der Beeldende Wiskunde* (Principles of plastic mathematics) (1916).

1917
Explains genesis of painting *Study* as resulting from the interference between vibrations of volume (solid-line circles), vibrations of exterior or juxtaposed volumes (dashed circles), and vibrations of emptiness (dotted circles).

1918
Gradually reduces use of natural, human shapes in work until mathematical order is obtained.

1918–20
In article on sculpture, "Réflexions," in *De Stijl,* urges artists to visualize the invisible.

1921
Publishes booklet *L'Art et son avenir* (Art and its future) in which mathematical analyses of several early Flemish paintings, especially by Rogier van der Weyden, are inserted. Produces fully abstract paintings and one triptych, based upon form and composition analyses of paintings by van der Weyden.

JANUS (ADRIANUS JOHANNES JACOBUS) DE WINTER
NETHERLANDS, 1882–1951

1910
Interested in Western and Eastern philosophy, especially Theosophy. Refers to Annie Besant and Charles W. Leadbeater's *Thought-Forms* (1905) and G. J. P. J. Bolland's *De zuivere Rede* (Pure reason) (1904).

1912
Influenced by Kandinsky, whose first solo exhibition in Netherlands takes place at Kunsthandel Oldenzeel, Rotterdam. Later comments reveal how pervasive Kandinsky's influence was.

1913–25
Creates abstract aura paintings, in which he tries to depict visions and states of mind. Paints synesthetic color sensations influenced by music.

1914
Paints *Pure Reason,* based on ideas in Bolland's book of same title.

1917
Influenced by oriental, especially Japanese art.

TOM WUDL
UNITED STATES, BORN BOLIVIA, 1948

Although raised in Jewish tradition, has early interest in Buddhism.

1958
Moves to United States.

1970s
Influenced by Buckminster Fuller's theory of triangles and tetrahedrons, fusing the scientific with the spiritual. Reads writings of P. D. Ouspensky.

c. 1970–75
Makes perforated, large-scale cosmic works on paper.

c. 1975
Visits Japan. Subsequently begins practicing meditation and develops further interest in Zen.

1985
Teaches oriental art.

NORMAN ZAMMITT
UNITED STATES, BORN CANADA, 1931

Raised on a Mohawk Indian reservation across the river from Montreal. Sees spirits in the snow-covered surroundings.

1936
Has an out-of-body experience during which he sees his grandmother at her grave site.

1943–44
Moves to United States. Begins painting very small landscape paintings with thick impasto surfaces.

1962–64
Makes large paintings dominated by eyes and biomorphic bodies. Becomes increasingly concerned with dualities present in nature.

1964–65
Lives in New Mexico. Continues biomorphic style but increasingly incorporates geometries drawn from the form of the honeycomb. Begins stringing painted beads into long, thirty- to forty-foot chains. This leads to "band" paintings.

1970s
Begins using computer in preparation of paintings.

1985
Considers painting to be a "spiritual hunt analogous to that of the Indians."

CATALOGUE OF THE EXHIBITION

Paintings and works on paper in the exhibition are arranged in the following checklist in five sections:

SYMBOLISM
THE GENERATION OF THE ABSTRACT PIONEERS IN EUROPE
THE GENERATION OF THE ABSTRACT PIONEERS IN AMERICA
ABSTRACT PAINTING IN EUROPE AND AMERICA 1939–70
ABSTRACT PAINTING IN EUROPE AND AMERICA 1970–85

Unless otherwise noted, all works are exhibited at the Los Angeles County Museum of Art, the Museum of Contemporary Art, Chicago, and the Gemeentemuseum, The Hague.

The page reference given for each work indicates the page in this volume on which the work is illustrated.

In addition to the paintings and works on paper listed in this checklist, the exhibition presents numerous spiritual source materials. The books, manuscripts, and diagrams featured explore an array of antimaterialist ideas and philosophies. Featuring these source materials does not necessarily mean that any single painting resulted from an artist's reading of any one book, even though there are examples of such vivid connections. Artists who produced abstract paintings with spiritual content were not necessarily cult members or religious worshipers. What they did do was read, listen to lectures, and develop relationships with occult and mystical practitioners. The exhibition, through the inclusion of source materials, intends to convey the character of ideas that permeated individual artistic environments and played catalytic roles in artists' works.

SYMBOLISM

JEAN DELVILLE
Belgium, 1867–1953
Mysteriosa (Portrait of Mrs. Stuart Merrill), 1892
Chalk on paper
13 15/16 x 11 in. (35.5 x 28 cm)
Edwin Janss, Thousand Oaks, California
PAGE 78

MAURICE DENIS
France, 1870–1943
Orange Christ, 1889
Oil on board
9 7/16 x 7 1/2 in. (24 x 19 cm)
Collection J. F. Denis, Alençon, France
PAGE 354

The Mass, c. 1890
Oil on board
9 7/16 x 7 1/2 in. (24 x 19 cm)
Private collection, France
PAGE 76

Offering at Calvary, 1890
Oil on canvas
12 9/16 x 9 11/16 in. (32 x 24.6 cm)
Private collection, France
PAGE 326

CHARLES FILIGER
France, 1863–1928
Chromatic Notations, 1886
Watercolor on paper
10 5/8 x 9 7/8 in. (27 x 25 cm)
Beatrice Altarriba-Recchi
PAGE 77

Head of a Lion (recto), *Geometric Figure* (verso), c. 1903
Crayon, gouache, and watercolor on paper
9 1/4 x 11 1/16 in. (23.5 x 28.1 cm)
Mr. and Mrs. Arthur G. Altschul, New York
PAGE 77

PAUL GAUGUIN
France, 1848–1903
The Breton Calvary: The Green Christ, 1889
Oil on canvas
36 1/4 x 28 3/4 in. (92.1 x 73 cm)
Musées Royaux des Beaux-Arts, Brussels
The Hague only
PAGE 327

The Universe Is Created, 1893–94
Hand-colored wood engraving
8 x 13 7/8 in. (20.3 x 35.2 cm)
Memorial Art Gallery of The University of Rochester, New York
Anonymous gift
PAGE 327

FERDINAND HODLER
Switzerland, 1853–1918
The Dream, 1897
Watercolor on paper remounted on board
37 3/8 x 25 5/8 in. (95 x 65 cm)
Private collection, Zurich, Switzerland
PAGE 57

Sunset on Lake Geneva, 1915
Oil on canvas
24 x 35 7/16 in. (61 x 90 cm)
Kunsthaus Zürich, Switzerland
Los Angeles only
PAGE 327

VICTOR HUGO
France, 1802–1885
Planet-spots, c. 1853–55
India ink on paper
11 1/4 x 17 1/2 in. (28.5 x 44.5 cm)
Musée des Beaux-Arts, Dijon, France
PAGE 33

FERNAND KHNOPFF
Belgium, 1858–1921
A Dreamer, c. 1900
Colored pencil on paper
Diameter 5 1/4 in. (13.3 cm)
Barry Friedman, Ltd., New York
PAGE 328

Study for "The Incense," c. 1917
Charcoal and colored pencil on paper
11 1/2 x 7 3/4 in. (29.2 x 19.7 cm)
Barry Friedman, Ltd., New York
PAGE 328

EDVARD MUNCH
Norway, 1863–1944
The Son, after 1896
Oil on canvas
27 9/16 x 35 1/16 in. (70 x 89 cm)
Munch-Museet, Oslo
PAGE 34

Metabolism, 1899
Oil on canvas
67 3/4 x 55 15/16 in. (172 x 142 cm)
Munch-Museet, Oslo
PAGE 329

The Sun II, c. 1912
Oil on canvas
64 3/16 x 80 15/16 in. (163 x 205.5 cm)
Munch-Museet, Oslo
PAGE 328

PAUL RANSON
France, 1864–1909
Nabi Landscape, 1890
Oil on canvas
35 1/16 x 45 1/4 in. (89 x 115 cm)
Josefowitz Collection
PAGE 62

Christ and Buddha, c. 1890–92
Oil on canvas
28 5/8 x 20 1/4 in. (72.7 x 51.4 cm)
Mr. and Mrs. Arthur G. Altschul, New York
PAGE 74

ODILON REDON
France, 1840–1916
N'y a-t'il pas un monde invisible, 1887
Lithograph
8 9/16 x 6 5/8 in. (21.8 x 16.9 cm)
Haags Gemeentemuseum, The Hague
NOT ILLUSTRATED

The Buddha, 1895
Lithograph
12 3/4 x 9 13/16 in. (32.4 x 24.9 cm)
Haags Gemeentemuseum, The Hague
NOT ILLUSTRATED

The Spheres, c. 1895
Charcoal on paper
27 3/4 x 21 in. (70.5 x 53.3 cm)
Collection Manoukian, Paris
NOT ILLUSTRATED

ALBERT PINKHAM RYDER
United States, 1847–1917
Moonlight Cove, 1880–90
Oil on canvas
14 1/8 x 17 1/8 in. (35.9 x 43.5 cm)
The Phillips Collection, Washington, D.C.
PAGE 115

PAUL SÉRUSIER
France, 1864–1927
The Gold Cylinder, 1910
Oil on canvas
35 3/4 x 22 in. (90.8 x 55.9 cm) approx.
Musée des Beaux-Arts, Rennes, France
PAGE 70

Tetrahedrons, c. 1910
Oil on canvas
35 13/16 x 22 1/16 in. (91 x 56 cm)
TAG Oeuvres d'Art
PAGE 70

JOHAN THORN PRIKKER
Netherlands, 1868–1932
The Bride of Christ, 1892–93
Oil on canvas
57 1/2 x 34 5/8 in. (146 x 88 cm)
Rijksmuseum Kröller-Müller, Otterlo, Netherlands
PAGE 93

The Epic Monk, 1894
India ink, black chalk, and pencil on parchment
38 9/16 x 28 11/16 in. (98 x 72.8 cm)
Centraal Museum, Utrecht, Netherlands
PAGE 93

JAN TOOROP
Netherlands, born Java, 1858–1928
Organ Sounds, c. 1890
Pencil, black and colored crayon on board
21 1/4 x 27 3/16 in. (54 x 69 cm)
Rijksmuseum Kröller-Müller, Otterlo, Netherlands
PAGE 90

Ascendancy with Opposition of Modern Art, 1893
Crayon on paper
23 5/8 x 26 in. (60 x 66 cm)
Haags Gemeentemuseum, The Hague
PAGE 92

Song of the Times, 1893
Pencil and black crayon on paper
30 11/16 x 38 9/16 in. (78 x 98 cm)
Rijksmuseum Kröller-Müller, Otterlo, Netherlands
PAGE 91

The Three Brides, 1893
Pencil and black crayon on paper
30 11/16 x 38 9/16 in. (78 x 98 cm)
Rijksmuseum Kröller-Müller, Otterlo, Netherlands
PAGE 92

THE GENERATION OF THE ABSTRACT PIONEERS IN EUROPE

JEAN ARP
France, born Germany, 1886–1966
Pre-Dada Drawing, 1915
Brush and ink, pencil on paper
7 1/16 x 8 3/4 in. (17.9 x 22.2 cm)
Kunstmuseum Basel, Kupferstichkabinett, Switzerland
Los Angeles and The Hague only
PAGE 247

Pre-Dada Drawing, c. 1915
India ink and pencil on paper
7 x 8 11/16 in. (17.8 x 22.1 cm)
Fondation Jean Arp et Sophie Taeuber-Arp, Bahnhof Rolandseck, West Germany
PAGE 247

Pre-Dada Drawing, c. 1915
Brush and ink, pencil on paper
7 1/16 x 8 3/4 in. (17.9 x 22.2 cm)
Kunstmuseum Basel, Kupferstichkabinett, Switzerland
Los Angeles and The Hague only
PAGE 247

Elementary Construction (According to the Laws of Chance), 1916
Collage
15 7/8 x 12 11/16 in. (40.4 x 32.2 cm)
Kunstmuseum Basel, Kupferstichkabinett, Switzerland
Los Angeles and The Hague only
PAGE 238

Flower Veil, 1916
Oil on wood
24 7/16 x 19 11/16 x 3 1/8 in. (62 x 50 x 8 cm)
Haags Gemeentemuseum, The Hague
PAGE 44

Automatic Drawing, 1917–18
Brush and ink over traces of
pencil on gray paper
16 ¾ x 21 ¼ in.
(42.6 x 54 cm)
The Museum of Modern Art,
New York
Given anonymously
Los Angeles only
PAGE 240

GIACOMO BALLA
Italy, 1871–1958
Iridescent Interpenetration, 1914
Oil on canvas
39 ⅜ x 47 ¼ in.
(100 x 120 cm)
Private collection
PAGE 41

SERGE CHARCHOUNE
France, born Russia,
1889–1975
*Movement of a Painted Film
Based on a Folk Song,* 1917
Oil on canvas
18 ⅛ x 13 ¾ in. (46 x 35 cm)
Collection Raymond Creuze,
Paris
PAGE 166

JEAN CROTTI
France, born Switzerland,
1878–1958
Chainless Mystery, 1921
Oil on canvas
45 ⅞ x 35 ¼ in.
(116.5 x 89.5 cm)
Musée d'Art Moderne de la
Ville de Paris
PAGE 47

Circles, 1922
Oil on canvas
36 ³⁄₁₆ x 25 ⅝ in. (92 x 65 cm)
Musée d'Art Moderne de la
Ville de Paris
PAGE 47

ROBERT DELAUNAY
France, 1885–1941
Circular Forms, Moon No. 3,
1913
Oil on canvas
10 x 8 ⁵⁄₁₆ in. (25.5 x 21.1 cm)
Collection Charles Delaunay
NOT ILLUSTRATED

THEO VAN DOESBURG
Netherlands, 1883–1931
Cosmic Sun, 1915
Pastel on paper
9 ⁷⁄₁₆ x 12 ⁹⁄₁₆ in. (24 x 32 cm)
J. P. Smid, Art Gallery
Monet, Amsterdam
PAGE 107

Untitled, 1915
Pastel on paper
12 ⁷⁄₁₆ x 9 ⁷⁄₁₆ in.
(31.7 x 24 cm)
Rijksdienst Beeldende Kunst,
The Hague
PAGE 108

Winter, 1915
Pastel on paper
9 ⁷⁄₁₆ x 12 ⁹⁄₁₆ in. (24 x 32 cm)
J. P. Smid, Art Gallery
Monet, Amsterdam
PAGE 108

Untitled, c. 1915
Pastel on paper
12 ½ x 9 ½ in.
(31.8 x 24.2 cm)
Rijksdienst Beeldende Kunst,
The Hague
PAGE 106

MARCEL DUCHAMP
France, 1887–1968
Bicycle Wheel, 1913 (1964 ed.
Schwarz, no. 2/8)
Mounted on painted wooden
stool
Diameter 25 in. (63.5 cm);
height 49 ¾ in. (126.4 cm)
DRA Wierdsma, French
Farm, Greenwich,
Connecticut
PAGE 261

*Disks Bearing Spirals Made for
Anemic Cinema,* 1923–26
Ink and pencil on paper
mounted on board
45 ¼ x 45 ¼ in.
(114.9 x 114.9 cm)
Seattle Art Museum
Eugene Fuller Memorial
Collection
PAGE 264

*Nine Disks with Inscriptions
Made for Anemic Cinema,* 1926
Pasted letters on cardboard
Diameter each 11 ¼ in.
(28.6 cm)
 a. Private collection, West
 Germany
 b. Collection Francis M.
 Naumann, New York
 c–d. Collection Robert
 Shapazian
 e. Collection Timothy Baum,
 New York
 f–i. Collection Carroll Janis,
 New York
PAGE 263

MARCEL DUCHAMP
AND MAN RAY
United States, 1890–1976
Rotary Glass Plates, 1920,
remade 1976
Motorized construction,
painted Plexiglas, metal, and
wood
67 x 48 x 55 in.
(170.2 x 121.9 x 139.7 cm)
The Museum of
Contemporary Art, Los
Angeles
PAGE 256

SUZANNE DUCHAMP
France, 1889–1963
*Vibrations of Two Distant
Souls,* 1916–18–20
Oil and various collage
elements on canvas
28 ⁹⁄₁₆ x 19 ½ in.
(72.5 x 49.5 cm)
Private collection
PAGE 46

*Multiplication Broken and
Restored,* 1918–19
Oil and collage with silver
paper on canvas
24 x 19 ¹¹⁄₁₆ in. (61 x 50 cm)
Private collection
PAGE 46

Masterpiece: Accordion, 1921
Oil, gouache, and silver leaf
on canvas
39 ⁵⁄₁₆ x 31 ⅞ in.
(99.8 x 80.9 cm)
Yale University Art Gallery,
New Haven, Connecticut
Gift of Katherine S. Dreier to
the Collection Société
Anonyme
PAGE 46

BORIS ENDER
Russia, 1893–1960
Movement of Organic Form,
1919
Oil on canvas
40 ¹⁵⁄₁₆ x 39 ⅜ in.
(104 x 100 cm)
The George Costakis
Collection (owned by Art
Co. Ltd.)
© George Costakis, 1981
PAGE 193

Untitled, n.d.
Watercolor on paper
17 ⅛ x 12 ¹¹⁄₁₆ in.
(43.4 x 32.2 cm)
The George Costakis
Collection (owned by Art
Co. Ltd.)
© George Costakis, 1981
PAGE 194

MARIA ENDER
Russia, 1897–1942
Transcription of Sound, 1921
Watercolor on paper
8 ¾ x 12 in. (22.2 x 30.5 cm)
The George Costakis
Collection (owned by Art
Co. Ltd.)
© George Costakis, 1981
PAGE 194

Untitled, c. 1921
Watercolor and pencil on
paper
5 ¹⁵⁄₁₆ x 6 ⅞ in.
(15.1 x 17.5 cm)
The George Costakis
Collection (owned by Art
Co. Ltd.)
© George Costakis, 1981
PAGE 194

Untitled, n.d.
Oil on canvas
16 ⅜ x 20 ⅞ in.
(41.6 x 53 cm)
The George Costakis
Collection (owned by Art
Co. Ltd.)
© George Costakis, 1981
PAGE 194

YURI ENDER
Russia, dates unknown
Untitled, n.d.
Watercolor on paper
8 ¹¹⁄₁₆ x 12 in.
(22.1 x 30.4 cm)
The George Costakis
Collection (owned by Art
Co. Ltd.)
© George Costakis, 1981
PAGE 194

AUGUSTO GIACOMETTI
Switzerland, 1877–1947
Growth, 1919
Oil on canvas
41 ⁵⁄₁₆ x 41 ⁵⁄₁₆ in.
(105 x 105 cm)
Kunsthaus Zürich,
Switzerland
Vereinigung Züricher
Kunstfreunde
Los Angeles only
PAGE 334

JACOBA VAN
HEEMSKERCK
Netherlands, 1876–1923
Composition, 1914
Oil on canvas
29 ½ x 42 ¾ in.
(75 x 108.5 cm)
Haags Gemeentemuseum,
The Hague
PAGE 98

Picture No. 93, 1918–19
Oil on canvas
39 ⅜ x 47 ⁷⁄₁₆ in.
(100 x 120.5 cm)
Haags Gemeentemuseum,
The Hague
PAGE 98

JOHANNES ITTEN
Switzerland, 1888–1967
Study for "The Meeting,"
1915–16
Pencil and watercolor on
paper
15 ⅛ x 11 in. (38.5 x 28 cm)
Anneliese Itten, Zurich,
Switzerland
PAGE 200

Ascent and Pause, 1919
Oil on linen
90 ½ x 45 ¼ in.
(230 x 115 cm)
Kunsthaus Zürich,
Switzerland
Los Angeles only
PAGE 211

*Sheet with a Text by Jakob
Böhme,* 1922
Watercolor on paper
11 ¹³⁄₁₆ x 11 ¹³⁄₁₆ in.
(30 x 30 cm)
Anneliese Itten, Zurich,
Switzerland
PAGE 212

WASSILY KANDINSKY
Russia, 1866–1944
The Blue Mountain, 1908–9
Oil on canvas
41 ¾ x 38 ¹⁄₁₆ in.
(106 x 96.6 cm)
Solomon R. Guggenheim
Museum, New York
Los Angeles only
PAGE 330

Sound of Trumpets (study for
Large Resurrection), 1911
Ink over pencil, and
watercolor on light gray
board
8 ⁹⁄₁₆ x 8 ⁹⁄₁₆ in.
(21.7 x 21.8 cm)
Städtische Galerie im
Lenbachhaus, Munich
PAGE 203

Lady in Moscow, c. 1912
Pencil, watercolor, and
gouache on paper
12 ⅜ x 11 in. (31.5 x 28 cm)
Städtische Galerie im
Lenbachhaus, Munich
Gabriele Münter und
Johannes Eichner Stiftung
PAGE 140

Lady in Moscow, 1912
Oil on canvas
42 ⅞ x 42 ⅞ in.
(108.8 x 108.8 cm)
Städtische Galerie im
Lenbachhaus, Munich
PAGE 141

*Study for the Composition of
"Black Spot I,"* 1912
Pencil on gray support
8 ⅝ x 10 ¾ in.
(21.9 x 27.3 cm)
Städtische Galerie im
Lenbachhaus, Munich
Los Angeles only
PAGE 142

FRANCIS PICABIA
France, 1879–1953
Music Is Like Painting, c.
1913–17
Watercolor and gouache
on board
48 x 26 in. (121.9 x 66 cm)
Collection Manoukian, Paris
PAGE 339

ALBERT PLASSCHAERT
Netherlands, 1866–1941
Opus 1528, 1918
Pastel on paper
55 ⅛ x 31 ½ in. (140 x 80 cm)
Rijksdienst Beeldende Kunst,
The Hague
PAGE 339

KURT SCHWITTERS
Germany, 1887–1948
Constructivist Composition,
1923–24
Oil on canvas
23 ⅝ x 19 ¹¹⁄₁₆ in. (60 x 50 cm)
Private collection,
Amsterdam
PAGE 45

Abstract Composition, 1923–25
Oil on canvas
30 x 20 in. (76.2 x 50.8 cm)
Haags Gemeentemuseum,
The Hague
PAGE 45

GINO SEVERINI
Italy, 1883–1966
Expansion of Light, 1912
Oil on canvas
26 ¹⁵⁄₁₆ x 16 ¹⁵⁄₁₆ in.
(68.5 x 43 cm)
Thyssen-Bornemisza
Collection, Lugano,
Switzerland
The Hague only
PAGE 41

*Spherical Expansion of Light
(Centripetal)*, 1913–14
Oil on canvas
24 x 19 ½ in. (61 x 49.5 cm)
Private collection
Los Angeles and Chicago
only
PAGE 41

SOPHIE TAEUBER-ARP
Switzerland, 1889–1943
Moving Circles, 1933
Oil on canvas
28 ⁹⁄₁₆ x 39 ⅜ in.
(72.5 x 100 cm)
Öffentliche Kunstsammlung,
Kunstmuseum Basel,
Switzerland
PAGE 339

GEORGES
VANTONGERLOO
Belgium, 1886–1965
Triptych, 1921
Oil on wood
Center panel 4 ⅞ x 4 ⁵⁄₁₆ in.
(12.5 x 11 cm)
Side panels, each
4 ⁵⁄₁₆ x 2 ⁹⁄₁₆ in.
(11 x 6.5 cm)
Haags Gemeentemuseum,
The Hague
Loan from Wies and Jan
Leering
PAGE 340

JANUS DE WINTER
Netherlands, 1882–1951
Aura of an Egotist, 1916
Pencil on paper
22 ¹⁄₁₆ x 30 ¹⁄₁₆ in.
(56 x 76.3 cm)
Centraal Museum, Utrecht,
Netherlands
PAGE 105

Musical Fantasy, c. 1916
Gouache on cardboard
26 ⅜ x 33 ¾ in.
(67 x 85.7 cm)
Centraal Museum, Utrecht,
Netherlands
PAGE 105

THE
GENERATION
OF THE
ABSTRACT
PIONEERS IN
AMERICA

EMIL BISTTRAM
United States, born Hungary,
1895–1976
Pulsation, 1938
Oil on canvas
60 x 45 in. (152.4 x 114.3 cm)
Lee Ehrenworth
PAGE 43

KONRAD CRAMER
United States, born
Germany, 1888–1963
Abstraction, c. 1914
Oil on canvas
26 x 22 in. (66 x 55.9 cm)
Ahmet and Mica Ertegun
PAGE 120

ARTHUR DOVE
United States, 1880–1946
Abstraction No. 1, 1910
Oil on board
9 x 10 ½ in. (22.9 x 26.7 cm)
Private collection
PAGE 114

Abstraction No. 2, 1910
Oil on board
9 x 10 ½ in. (22.9 x 26.7 cm)
Private collection
PAGE 114

Abstraction No. 4, 1910
Oil on board
9 x 10 ½ in. (22.9 x 26.7 cm)
Private collection
PAGE 114

Abstraction No. 5, 1910
Oil on board
9 x 10 ½ in. (22.9 x 26.7 cm)
Private collection
PAGE 114

Golden Storm, 1925
Oil and metallic paint on
plywood
19 ¼ x 21 in. (48.8 x 53.3 cm)
The Phillips Collection,
Washington, D.C.
PAGE 125

Distraction, 1929
Oil on canvas
21 x 30 in. (53.3 x 76.2 cm)
Whitney Museum of
American Art, New York
Anonymous gift
PAGE 21

Thunder Shower, c. 1939–40
Oil and wax emulsion on
canvas
20 ¼ x 32 in. (51.4 x 81.3 cm)
Amon Carter Museum, Fort
Worth, Texas
Los Angeles and Chicago
only
PAGE 124

LAWREN HARRIS
Canada, 1885–1970
Untitled, 1939
Oil on canvas
56 x 46 in. (142.2 x 116.8 cm)
Georgia R. de Havenon,
New York
Courtesy Martin Diamond
Fine Arts
PAGE 44

MARSDEN HARTLEY
United States, 1877–1943
Painting No. 1, 1913
Oil on canvas
39 ¾ x 31 ⅞ in. (101 x 81 cm)
Sheldon Memorial Art
Gallery, University of
Nebraska, Lincoln
F. M. Hall Collection
Los Angeles and Chicago
only
PAGE 119

Painting No. 47, Berlin,
1914–15
Oil on canvas
39 ½ x 31 ⅝ in.
(100.3 x 80.3 cm)
Hirshhorn Museum and
Sculpture Garden,
Smithsonian Institution,
Washington, D.C.
PAGE 341

Yliaster (Paracelsus), 1932
Oil on canvas
25 x 28 ½ in. (63.5 x 72.4 cm)
Babcock Galleries Collection,
New York
PAGE 122

*The Transference of Richard
Rolle*, 1932–33
Oil on canvas
28 x 26 in. (71.1 x 66 cm)
Anonymous loan
PAGE 121

RAYMOND JONSON
United States, 1891–1982
*Composition Four —
Melancholia*, 1925
Oil on canvas
46 x 38 in. (116.8 x 96.5 cm)
Mr. and Mrs. Irwin L.
Bernstein, Philadelphia
PAGE 43

GEORGIA O'KEEFFE
United States, 1887–1986
Blue No. I, 1916
Watercolor on paper
16 x 11 in. (40.7 x 28 cm)
The Brooklyn Museum,
New York
Bequest of
Mary T. Cockcroft
Los Angeles only
PAGE 116

Blue No. II, 1916
Watercolor on paper
15 ⅞ x 10 ⁵⁄₁₆ in.
(40.3 x 27.8 cm)
The Brooklyn Museum,
New York
Bequest of
Mary T. Cockcroft
Los Angeles only
PAGE 116

Abstraction, 1917
Watercolor on paper
15 ¾ x 10 ⅞ in.
(40 x 27.6 cm)
Collection of Mr. and Mrs.
Gerald P. Peters
PAGE 112

Blue I, c. 1917
Watercolor on paper
30 ¾ x 22 ⅜ in.
(78.1 x 56.8 cm)
Robert L. B. Tobin
PAGE 117

Black Spot No. 1, 1919
Oil on canvas
24 x 16 in. (61 x 40.6 cm)
Mr. and Mrs. Jon B. Lovelace
PAGE 340

Music: Pink and Blue No. 1,
1919
Oil on canvas
48 x 30 in. (121.9 x 76.2 cm)
Mr. and Mrs. Barney A.
Ebsworth
Los Angeles only
PAGE 125

AGNES PELTON
United States, born
Germany, 1881–1961
White Fire, c. 1930
Oil on canvas
25 ½ x 21 in. (64.8 x 53.3 cm)
The Jonson Gallery of the
University Art Museum,
University of New Mexico,
Albuquerque
PAGE 44

AUGUSTUS
VINCENT TACK
United States, 1870–1949
Storm, 1920–23
Oil on canvas mounted on
composition panel
37 x 48 in. (94 x 121.9 cm)
The Phillips Collection,
Washington, D.C.
PAGE 126

MARK ROTHKO
United States, born Russia, 1903–1970
Vessel of Magic, 1946
Watercolor on paper
38 15/16 x 26 in. (98.9 x 66 cm)
The Brooklyn Museum, New York
Los Angeles only
PAGE 50

Number 11, 1949
Oil on canvas
68 x 43 1/4 in.
(172.8 x 109.9 cm)
National Gallery of Art, Washington, D.C.
Gift of the Mark Rothko Foundation
PAGE 317

Sketch for "Mural No. 1," 1958
Oil on canvas
105 x 120 in.
(266.7 x 304.8 cm)
Estate of Mark Rothko
Courtesy Pace Gallery, New York
Copyright © 1978 by the Estate of Mark Rothko
PAGE 348

Plum and Dark Brown, 1964
Oil on canvas
93 x 75 3/4 in.
(236.2 x 192.4 cm)
Marlborough Gallery, New York
PAGE 232

TONY SMITH
United States, 1912–1980
Untitled, 1962
Oil on canvas
44 x 42 1/2 in. (111.8 x 108 cm)
Xavier Fourcade, Inc., New York; Paula Cooper Gallery, New York; Margo Leavin Gallery, Los Angeles
PAGE 348

Untitled, 1962/80
Oil and alkyd on canvas
96 x 156 in.
(243.8 x 396.2 cm)
Xavier Fourcade, Inc., New York; Paula Cooper Gallery, New York; Margo Leavin Gallery, Los Angeles
PAGE 7

MARK TOBEY
United States, 1890–1976
The World Egg, 1944
Egg tempera on canvas
24 1/2 x 19 1/4 in.
(62.2 x 48.9 cm)
Carolyn Kizer Woodbridge
Los Angeles and Chicago only
PAGE 52

Totemic Disturbance, 1947
Egg tempera on canvas
14 1/2 x 24 1/2 in.
(36.8 x 62.2 cm)
Carolyn Kizer Woodbridge
PAGE 51

Space Rose, 1959
Tempera on paper
14 3/4 x 12 in. (40 x 30.5 cm)
Galerie Jeanne Bucher, Paris
PAGE 51

ABSTRACT PAINTING IN EUROPE AND AMERICA 1970–85

CRAIG ANTRIM
United States, born 1942
Center of Gravity, 1984
Acrylic on canvas
96 x 90 in. (243.8 x 228.6 cm)
Ruth Bachofner Gallery, Los Angeles
PAGE 349

JOSEPH BEUYS
Germany, 1921–1986
Blue on Centre, 1984
Painted metal and cardboard
12 7/16 x 9 1/2 in.
(31.7 x 24.2 cm)
Anthony d'Offay Gallery, London
PAGE 316

Green on Centre, 1984
Painted metal and cardboard
12 1/2 x 8 11/16 in.
(31.8 x 22.1 cm)
Anthony d'Offay Gallery, London
PAGE 316

Red on Centre, 1984
Painted metal and cardboard
12 3/8 x 8 1/2 in.
(31.5 x 21.6 cm)
Anthony d'Offay Gallery, London
PAGE 316

Yellow on Centre, 1984
Painted metal and cardboard
14 9/16 x 10 3/4 in.
(37 x 27.3 cm)
Anthony d'Offay Gallery, London
PAGE 316

DOMENICO BIANCHI
Italy, born 1955
Untitled, 1984
Watercolor, encaustic, and oil on canvas
96 1/2 x 84 1/2 in.
(245.1 x 214.6 cm)
PaineWebber Group Inc.
PAGE 349

BRUNO CECCOBELLI
Italy, born 1952
Etrusco Ludens, 1983
Oil and wax on paper mounted on wood
78 x 93 in. (198.1 x 236.2 cm)
Sperone Westwater, New York
PAGE 57

HELMUT FEDERLE
Switzerland, born 1944
Tree of Life and Family, 1982
Dispersion, tempera on canvas
84 1/16 x 119 1/2 in.
(213.5 x 303.5 cm)
Haags Gemeentemuseum, The Hague
PAGE 349

LUDWIG GOSEWITZ
Germany, born 1936
Fifteen Different Proportions (Birth Figures) and Legend, 1979–80
Pencil and watercolor on paper
Each 11 13/16 x 8 1/4 in.
(30 x 21 cm)
Private collection, West Germany
PAGE 392

MORRIS GRAVES
United States, born 1910
Twentieth-Century American Left-Handed Tantra Yantra, No. 1, 1982
Tempera on paper
43 3/4 x 26 1/2 in.
(111.1 x 67.3 cm)
Charles Campbell Gallery, San Francisco
PAGE 52

BILL JENSEN
United States, born 1945
Guy in the Dunes, 1979
Oil on linen
36 x 24 in. (91.5 x 61 cm)
Saatchi Collection, London
PAGE 322

Shaman, 1980–81
Oil on linen
20 x 15 in. (50.8 x 38.1 cm)
Mr. and Mrs. Edward R. Hudson, Jr.
PAGE 322

JASPER JOHNS
United States, born 1930
Untitled, 1975
Oil and encaustic on canvas
50 1/8 x 50 1/8 in.
(127.3 x 127.3 cm)
Collection of Eli and Edythe Broad
PAGE 350

ELLSWORTH KELLY
United States, born 1923
Black White, 1970
Oil on canvas, two jointed panels
70 x 107 in.
(177.8 x 271.8 cm)
Private collection
PAGE 350

BRICE MARDEN
United States, born 1938
Green Study, 1982
Oil on canvas
24 x 72 in. (61 x 182.9 cm)
Collection of Vance E. Kondon, M.D.
PAGE 55

MARIO MERZ
Italy, born 1925
("Spiral"), 1982
Acrylic, charcoal, spray paint, and shell on canvas
50 x 50 in. (127 x 127 cm)
Sperone Westwater, New York
PAGE 351

MATT MULLICAN
United States, born 1951
Untitled, (Subject, Sign, World Framed), 1985
Oil crayon on canvas
120 x 120 in.
(304.8 x 304.8 cm)
Collection of Eva and Murray Roman
Promised gift to The Santa Barbara Museum of Art, California
PAGE 56

ERIC ORR
United States, born 1939
Crazy Wisdom II, 1982
Lead, gold leaf, human skull bone, ground AM/FM radio, and blood on linen
43 x 32 x 2 in.
(109.2 x 81.3 x 5.1 cm)
James Corcoran Gallery, Los Angeles
PAGE 323

SIGMAR POLKE
Germany, born 1941
Yggdrasil, 1984
Silver, silver oxide, silver nitrate, and natural resin on canvas
119 x 88 1/2 in. (303 x 225 cm)
Saatchi Collection, London
PAGE 56

RICHARD POUSETTE-DART
United States, born 1916
Time Is the Mind of Space, Space Is the Body of Time, No. 1, 2, 3, 1982
Acrylic on linen
Three panels, each 89 1/2 x 62 1/2 in. (227.3 x 158.8 cm)
Richard Pousette-Dart
PAGE 351

DOROTHEA ROCKBURNE
United States, born Canada, 1934
Saqqarah (from the Egyptian Paintings), 1979
Oil, glue, pencil, and gesso on linen
70 x 92 3/8 in.
(177.8 x 234.6 cm)
Portland Art Museum, Oregon
Helen Thurston Ayer Fund
PAGE 321

TOM WUDL
United States, born Bolivia, 1948
The Dream of Gabriello, 1973
Laminated tissue, acrylic, and other mixed media
84 x 120 in.
(213.4 x 304.8 cm)
Laura-Lee W. Woods
PAGE 352

NORMAN ZAMMITT
United States, born Canada, 1931
Untitled, 1977–78
Oil on canvas
77 x 133 in.
(195.6 x 337.8 cm)
Los Angeles County Museum of Art
Gift of William J. and Marilyn Lasarow
PAGE 353

LENDERS TO THE EXHIBITION

Edward Albee and Jonathan Thomas
Beatrice Altarriba-Recchi
Mr. and Mrs. Arthur G. Altschul, New York
Amon Carter Museum, Fort Worth, Texas
Mr. and Mrs. Harry W. Anderson
Robert and Edith Anthoine
Anthony d'Offay Gallery, London
The Art Institute of Chicago
Babcock Galleries Collection, New York
William Baker and Peter A. Giarratano, New York
Barry Friedman, Ltd., New York
Collection Timothy Baum, New York
Mr. and Mrs. Irwin L. Bernstein, Philadelphia
Bibliotheca Philosophica Hermetica, Amsterdam
Collection of Eli and Edythe Broad
The Brooklyn Museum, New York
Centraal Museum, Utrecht, Netherlands
Charles Campbell Gallery, San Francisco
The George Costakis Collection (owned by Art Co. Ltd.)
Collection Raymond Creuze, Paris
Georgia R. de Havenon, New York
Collection Charles Delaunay
Collection J. F. Denis, Alençon, France
The Detroit Institute of Arts
Mr. and Mrs. Barney Ebsworth
Lee Ehrenworth
Ahmet and Mica Ertegun
Estate of Mark Rothko
Fondation Jean Arp et Sophie Taeuber-Arp, Bahnhof Rolandseck, West Germany
Frederick R. Weisman Foundation of Art
Galerie Jeanne Bucher, Paris
Galerie Louis Carré et Cie, Paris
Galerie Rosengart, Lucerne, Switzerland
Galerie Ulysses, Vienna
Milly and Arnold Glimcher
Mr. and Mrs. M. A. Gribin
Haags Gemeentemuseum, The Hague
Mr. and Mrs. James Harithas, New York
Mr. and Mrs. Marshall Hatch, Seattle
Joseph H. Hazen Collection
Hirshhorn Museum and Sculpture Garden, Smithsonian Institution, Washington, D.C.
Mr. and Mrs. Edward R. Hudson, Jr.
Pontus Hulten
Anneliese Itten, Zurich, Switzerland
James Corcoran Gallery, Los Angeles
Collection Carroll Janis, New York
Edwin Janss, Thousand Oaks, California
Jasper Johns
The Jonson Gallery of the University Art Museum, University of New Mexico, Albuquerque
Josefowitz Collection
Collection of Vance E. Kondon, M.D.
Kunsthaus Zürich, Switzerland
Kunstmuseum Basel, Switzerland
Los Angeles County Museum of Art
Mr. and Mrs. Jon B. Lovelace
Collection of Mr. and Mrs. Adrien Maeght, Paris
Collection Manoukian, Paris
Gladys Arias Marcotulli
Margo Leavin Gallery, Los Angeles
Martin Z. Margulies

Marlborough Gallery, New York
Memorial Art Gallery of The University of Rochester, New York
Lorna Poe Miller, Los Angeles
Mills College Art Gallery, Oakland, California
Matt Mullican
Munch-Museet, Oslo
Musée d'Art Moderne de la Ville de Paris
Musée des Beaux-Arts, Dijon, France
Musée des Beaux-Arts, Rennes, France
Musée National d'Art Moderne, Centre Georges Pompidou, Paris
Musées Royaux des Beaux-Arts, Brussels
Museum Bochum, Kunstsammlung, West Germany
Museum Boymans-van Beuningen, Rotterdam, Netherlands
Museum für Moderne Kunst, Frankfurt am Main
Museum of Art, Carnegie Institute, Pittsburgh
The Museum of Contemporary Art, Los Angeles
The Museum of Modern Art, New York
Narodni Galerie, Prague
National Gallery of Art, Washington, D.C.
Collection Francis M. Naumann, New York
Annalee Newman
Collection of Gordon Onslow-Ford
PaineWebber Group, Inc.
Herbert Palmer Gallery, Los Angeles
Paula Cooper Gallery, New York
Collection of Mr. and Mrs. Gerald P. Peters
Philadelphia Museum of Art
The Phillips Collection, Washington, D.C.
Philosophical Research Library, Manly P. Hall Collection, Los Angeles
Portland Art Museum, Oregon
Richard Pousette-Dart
The Robert Gore Rifkind Collection, Beverly Hills, California
Rijksdienst Beeldende Kunst, The Hague
Rijksmuseum Kröller-Müller, Otterlo, Netherlands
Collection of Eva and Murray Roman
Ruth Bachofner Gallery, Los Angeles
Saatchi Collection, London
San Francisco Museum of Modern Art
Seattle Art Museum
Collection Robert Shapazian
Sheldon Memorial Art Gallery, University of Nebraska, Lincoln
J. P. Smid, Art Gallery Monet, Amsterdam
Jane Smith, New York
Solomon R. Guggenheim Museum, New York
Ileana and Michael Sonnabend, New York
Städtische Galerie im Lenbachhaus, Munich
Stedelijk Museum, Amsterdam
Stedelijk van Abbemuseum, Eindhoven, Netherlands
Stiftelsen Hilma af Klints Verk
TAG Oeuvres d'Art
Thyssen-Bornemisza Collection, Lugano, Switzerland
Robert L. B. Tobin
Wadsworth Atheneum, Hartford, Connecticut
Sperone Westwater, New York
Whitney Museum of American Art, New York
DRA Wierdsma, French Farm, Greenwich, Connecticut
Carolyn Kizer Woodbridge
Laura-Lee W. Woods
Xavier Fourcade, Inc., New York
Yale University Art Gallery, New Haven, Connecticut
Several anonymous lenders